Earthly beauty, heavenly art

Art of Islam

Art of Islam

Heavenly art

Earthly beauty

Mikhail B. Piotrovsky
John Vrieze (general editor)

with contributions by
among others the lenders

De Nieuwe Kerk Amsterdam
Lund Humphries Publishers

This catalogue is published to coincide with the exhibition *Earthly beauty, heavenly art. The art of Islam*, held in De Nieuwe Kerk, Amsterdam, from 16 December 1999 to 24 April 2000.

The exhibition is organized by the Stichting Projecten De Nieuwe Kerk, (Foundation Projects De Nieuwe Kerk), Amsterdam, in cooperation with The State Hermitage Museum in St Petersburg, Russia, together with the Institut du Monde Arabe, in Paris, and the Museum of Ethnography/ Foundation Islamic Art and Culture, in Rotterdam.

The exhibition was made possible through the financial support of the following:

Mondriaan Stichting

Prins Bernhard Cultuurfonds

VSB Fonds

Gemeente Amsterdam

Ministerie van Buitenlandse Zaken

Ministerie van OC & W

Golden Tulip Grand Hotel Krasnapolsky

Finnair

The exhibition has been insured by:

AON Artscope Nederland

Fine Art Insurance Brokers

Lenders

Athens
Benaki Museum

Boston
Museum of Fine Arts

Damascus
National Museum of Syria, Ministry of Culture,
General Directorate for Antiquities and Museums,
Syrian Arab Republic

Istanbul
Topkapi Palace Museum

London
The British Museum
The Nasser D. Khalili Collection of Islamic Art

New York
The Metropolitan Museum of Art

Paris
Institut du Monde Arabe

Rotterdam
Museum voor Volkenkunde Rotterdam

Sanaa
Dar al-Makhtutat (House of Manuscripts)

St Petersburg
The State Hermitage Museum

Venice
Procuratoria di San Marco

Washington, D.C.
Arthur M. Sackler Gallery, Smithsonian Institution

Authors of the descriptions

Adel Adamova (A.A.)
Brahim Alaoui (B.A.)
Julia Bailey (J.B.)
Anna Ballian (A.B.)
Milo Cleveland Beach (M.C.B.)
Emine Bilirgen (E.B.)
Barbara Boehm (B.B.)
Hans-Casper Graf von Bothmer (H.C.B.)
Sheila Canby (SH.C.)
Stefano Carboni (S.C.)
Anatoli Ivanov (A.I.)
Mark Kramarovsky (M.G.K.)
Marta Kryzhanovskaya (M.K.)
Glenn Lowry (G.L.)
Boris Marshak (B.M.)
Yuri Miller (Y.M.)
Mona Al Moadin (M. AL M.)
Mina Moraitou (M.M.)
Süheyla Murat (S.M.)
Michael Rogers (M.R.), with the assistance of
Nahla Nassar, Tim Stanley and Manijeh Bayani
Abolala Soudavar (A.S.)
Natalya Venevtseva (N.V.)
John Vrieze (J.V.)
Daniel Walker (D.W.)
Rachel Ward (R.W.)

Editors
John Vrieze and Arnoud Bijl

Translations
Arnoud Bijl (from the Russian)
Wendie Shaffer (from the Dutch)
Michèle Hendricks (from the Dutch)
Igor Naftulyev (from the Russian)

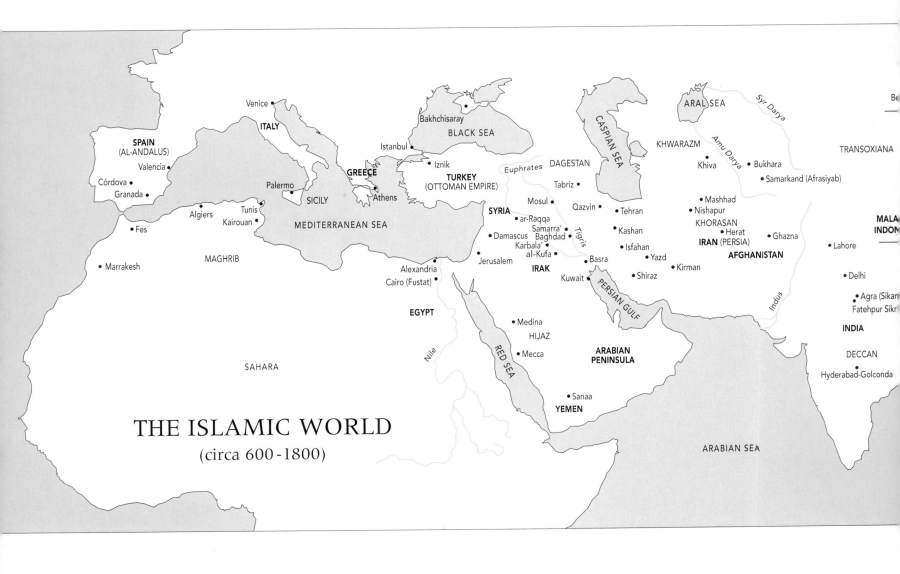

SPAIN
(AL-ANDALUS)

Venice •

ITALY

Bakhchisaray •

BLACK SEA

ARAL SEA

Syr Darya

KHWARAZM

Amu Darya

TRANSOXIANA

Valencia •

Istanbul •

Córdova •

Granada •

GREECE

• Iznik

Euphrates

DAGESTAN

Khiva •

CASPIAN SEA

• Bukhara

• Samarkand (Afrasiyab)

Palermo •

TURKEY
(OTTOMAN EMPIRE)

Tabriz •

Mosul •

Qazvin •

Tehran •

• Mashhad
• Nishapur

Athens •

SYRIA

KHORASAN

MAL
INDON

Algiers •

Tunis •

Kairouan •

SICILY

MEDITERRANEAN SEA

• ar-Raqqa

Damascus •
Karbala'
al-Kufa •

Samarra'
Baghdad •

Tigris

• Kashan

Herat •

• Ghazna

IRAN (PERSIA)

AFGHANISTAN

• Isfahan

• Lahore

• Fes

MAGHRIB

Jerusalem •

IRAK

Basra •

• Yazd

Kuwait •

PERSIAN GULF

• Shiraz

• Kirman

• Delhi

• Agra (Sikan
Fatehpur Sikri

• Marrakesh

Alexandria •

Cairo (Fustat) •

INDIA

EGYPT

Nile

RED SEA

• Medina

HIJAZ

• Mecca

**ARABIAN
PENINSULA**

Indus

DECCAN

• Hyderabad-Golconda

THE ISLAMIC WORLD
(circa 600-1800)

SAHARA

• Sanaa

YEMEN

ARABIAN SEA

Table of contents

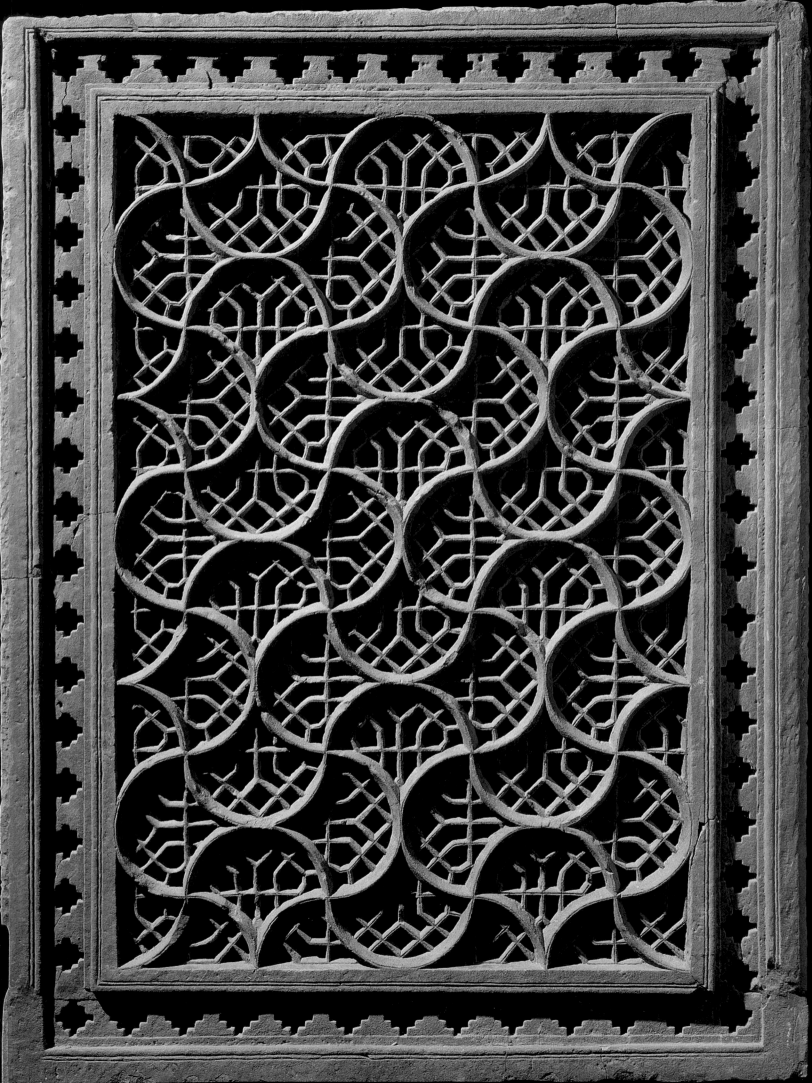

Foreword

In the Netherlands today a substantial portion of the population is Muslim. In fact, Islam is the second largest religion practised in the Netherlands, after Christianity. In global terms, one person in six is Muslim. But despite these figures, most Western Europeans know very little about the faith of Islam, let alone about the amazingly rich and varied culture which it has inspired. Indeed, in Christian cultures Islam is often represented as if it were a marginal phenomenon. It is, on the contrary, with all its splendid diversity, one of the religious foundations upon which our global culture is built.

So it was partly with the aim of setting things to rights that the exhibition *Earthly beauty, heavenly art* was projected. The exhibition management of De Nieuwe Kerk has over the past few years concentrated on illuminating cultures of both neighbouring and distant countries. It has done so by means of exhibiting a selection of highlights from these countries' artistic achievements and in this way demonstrating the shared historic roots of our contemporary culture. The world of the twentieth century has expanded, in the sense that the customs and objects that our ancestors would have found puzzling and frightening are today encountered with a curiosity and openness which was formerly rare. It is to be supposed that this will only increase as we enter the third millennium. The multi-cultural and multi-religious nature of our society will play a large part in the process.

This exhibition – which presents a selection of masterpieces from some of the major world collections – makes very clear how powerful is the voice of Islamic art. It is the voice of a deeply-felt belief, filled with a delight in the energy of life, and speaks of the joy of both the artisan and the owner. As one of the *Hadith*, or traditions about the Prophet Muhammad and his first followers, puts it: 'Verily,

God is Beauty and loves that which is beautiful.' Islamic art is radiant, it shines and dances with a divine splendour. To make a beautiful work is an act of devotion that sanctifies the maker; equally blessed is the person who gains enjoyment from the created object.

We are immensely grateful to the many museums and collectors who have lent us their precious objects. Without their confidence in us, we would never have been able to have put on this exhibition.

We should like to extend a special word of thanks to our guest curator, Professor Mikhail B. Piotrovsky, director of the State Museum The Hermitage in St Petersburg. His erudition, combined with his evident passion for Islamic art, have made an invaluable contribution to this exhibition and its accompanying catalogue. After showing in Amsterdam, the exhibition will travel to Russia and be seen at The Hermitage.

Many people have contributed to this exhibition and we are most grateful to them all. Scholarly authors have made fascinating contributions to the catalogue and many have helped and advised us with their expertise. We should like to mention in particular the staff of the Institut du Monde Arabe in Paris, who, at a very early stage nurtured the seedling concept of the exhibition and gave us their full support. Finally, we extend warm thanks to our many sponsors who with their generous support have made this beautiful and memorable exhibition possible.

It is our hope that this exhibition will lead to a greater awareness and appreciation of Islamic art and culture.

John Vrieze
Chief curator

Ernst W. Veen
Director, National Foundation
De Nieuwe Kerk

◀ cat.no. 102

The Foundation Projects De Nieuwe Kerk would like to thank
the following persons for their extremely valuable consults:

Amsterdam
Maarten Frankenhuis, Frits Laméris,
Maurits van Loon, Henk van Os, Najib Taoujni, Rik Vos

Ankara
H.E. Sjoerd Gosses, Alpay Pasinli, Nilüfer Ertan

Athens
H.E. Paul Brouwer, Angelos Delivorrias,
Mina Moraitou, Anna Ballian

Boston
Malcolm Rogers, Julia Bailey

Damascus
H.E. Willem Andreae, H.E. Victor Goguitidze,
Sultan Muhesen, Mohammed Quadour,
Monna al-Moazem, Mona Al Moadin

Gouda
Dineke Huizenga

The Hague
H.E. Bilgin Unan

Istanbul
Filiz Çagman, Emine Bilirgen, Süheyla Murat

London
Robert Anderson, Sheila Canby, Rachel Ward,
Rita Phillips, Nasser D. Khalili, Nahla Nassar,
J.M. Rogers, Tim Stanley, Manijeh Bayani

New York
Philippe de Montebello, Barbara Boehm,
Stefano Carboni, Daniel Walker, Lisa Yeung

Paris
Nasser El Ansary, Badr Arodaky, Brahim Alaoui

Saarbrücken
Hans-Casper Graf von Bothmer

Sanaa
H.E. Arend Meerburg, Yusuf Abdallah, Abdulmalik
al-Maqhafi, 'Ali A. Abu El-Rijal, Ursula Dreibholz

St Petersburg
Mikhail B. Piotrovsky, Vladimir Matveev,
George Vilinbakhov, Anatoli Ivanov,
Adel Adamova, Yuri Miller, Natalya Venevtseva,
Marta Kryzhanovskaya, Mark Kramarovsky

Rotterdam
Hein Reedijk, Charlotte Huygens, Mark Hoos,
Fred Wartna

Venice
Feliciano Benvenuti †, Mons. Antonio Meneguolo,
Ettore Vio, Giuseppe Fioretti

Washington, D.C.
H.E. Joris Vos, Milo Cleveland Beach, Glenn Lowry,
Abolala Soudavar, Massumeh Farhad, Bruce Young

cat.no. 274 ▶

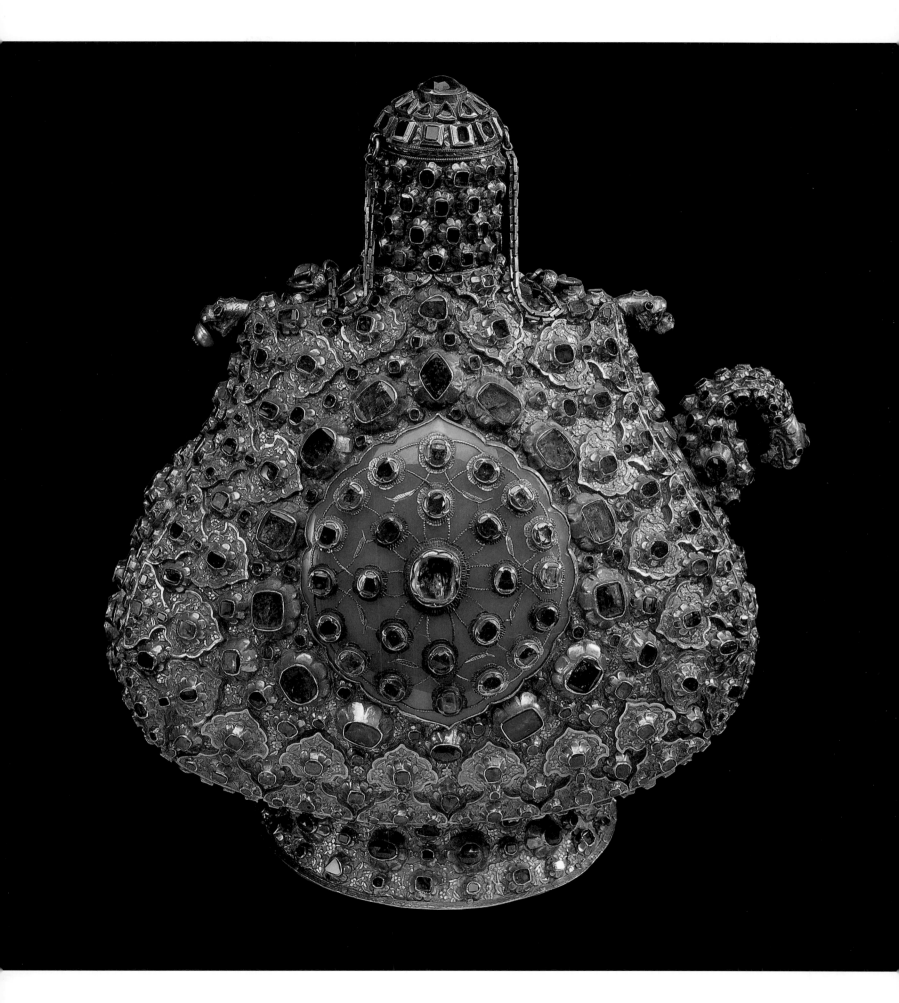

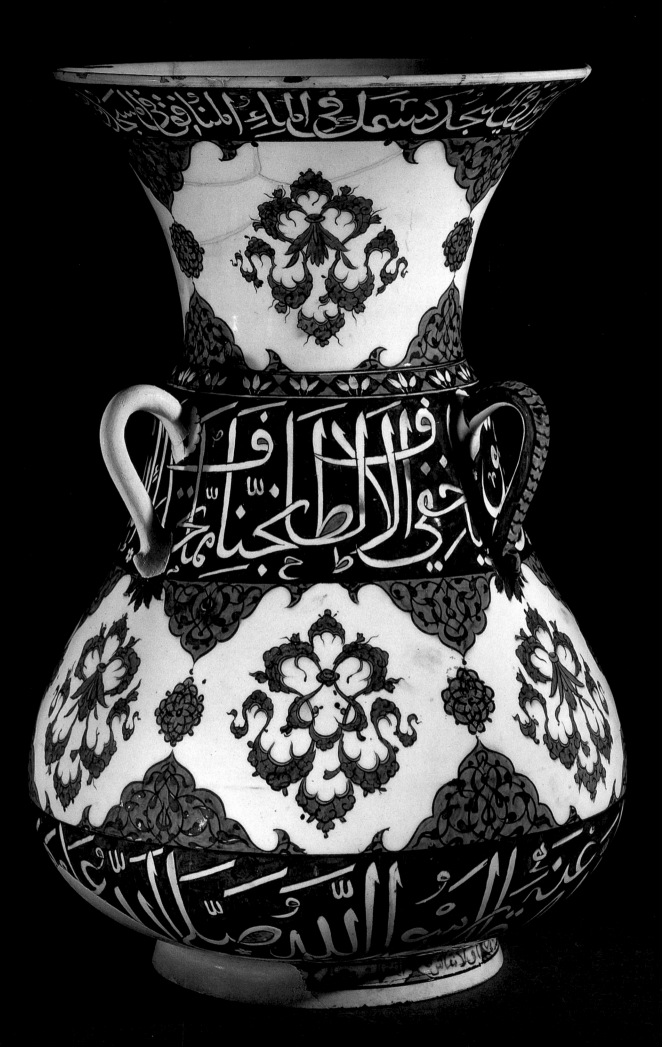

The Enigma of Islamic Art

The expression 'Islamic Art' is at once both simple and complicated. Generally speaking, it refers to the art made by people who profess the faith of Islam. But whether we can make a strict definition of such a thing as an artistic phenomenon has both raised, and continues to raise, serious doubts among researchers and writers. Some of them prefer to see more worldly origins for art, in terms of the culture from which it emerges. Others support the notion of the continuity of a specific 'national' culture which is determined by having a common language or territory.

So far so good. However, everyone will understand what we mean if we speak of 'the art of Islam' and even more so when we refer to 'the art of Islamic peoples.' This reflects the fact that in the art referred to with this term – in all its manifold and radiant forms – a number of characteristics that are fairly easy to recognize, repeatedly return.

There is a clear distinction between the objects made during the Islamic period and works by the same peoples from a pre-Islamic time. And the distinguishing characteristics provide a fairly clear division between art forms that arose contemporaneously in places where several religions were practised. Clearly, all this is highly relative. The roots of Islamic art in the pre-Islamic cultures of Iran, Central Asia, Egypt, China, India and other regions are well known and enthusiastically studied. However, ideas concerning these roots are regularly adjusted, often in accordance with prevailing Islamic politics and ideology. Traditions flow in and out of each other and give rise to new creations. This is an expression of the universal and synthetic nature of Islamic society which forms one worldwide community for all Muslims.

Not surprisingly, Islamic art and that of non-Muslims from the same region, has much in common. The exhibition shows several objects on loan that illustrate this fact clearly. Indeed, the unity often remains because in the course of time qualities emerge in one world which in fact characterize the other.

The characteristics of Islamic art are: abstract designs, a wealth of rich decoration, and a tendency to avoid of human or animal shapes. This may be summarized in one single and all-embracing expression: the language of Islamic art. Many of the details may or may not be immediately linked with the ideological foundations of the culture, or cultures, of Islamic peoples, through the religion. It is a double connection: Islam has determined the appearance of certain features, such as abstract design, and in their turn many of the features of art serve as unobtrusive and often hazy propaganda for the basic values of the Islamic way of life.

Nothing shows so clearly the unique nature of Islamic art as a comparison with the pre-Islamic heritage of Syria, Egypt and Iran. Because so much remains, it can easily be seen how within a short period an entirely new artistic language has developed. The origins of this language remain a mystery. The Islamic conquest certainly spread the cultural heritage of the Arabs through a large part of the world, but this fails to explain the radical changes and pluriform synthesis that came as a result. The one explanation of the enigma is, for the time being, to acknowledge the dynamism in the Islamic spirit which, passionate and forceful, found an aesthetic form which was both expressive and convincing.

◄ cat.no. 8

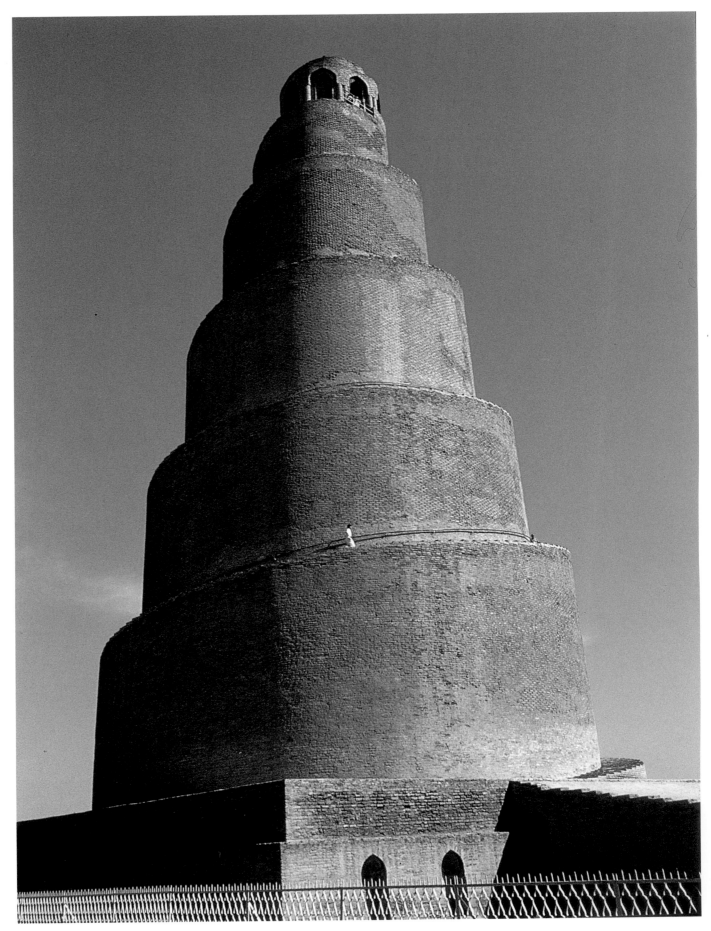

Ill. 1 Tower of the al-Mutawakkili Mosque, Samarra', built 842-852

1 *The World of Islam*

Islam is one of the three monotheistic religions which arose successively in what in Europe is called the Middle East. They were, in order, Judaism, Christianity and Islam and distinguished themselves from other great world religions in that they believed in only one God, the Creator of the world and all living things. This one God, is the same in the three religions but called differently by the name of Yahwe (Jehovah), God, and Allah. The three religions have a common history, in which the patriarch Abraham (Ibrahim in Islam) appears as a key figure. He was the first man to reject the then customary worship of idols. Indeed, he was even prepared to sacrifice his own son for his belief. This is why these three religions may be referred to as the 'Abrahamic' religions.

The holy scriptures of the three religions more or less follow each other chronologically in date of writing. The Hebrew Bible forms the Old Testament of the Christians who see in the prophecies concerning the Messiah, references to the life of Jesus Christ. Islam, in its turn, recognizes both the Tora of the Jews and the Gospels of the New Testament, but considers that both Jews and Christians have debased the original teachings about God, have turned to the worship of idols, and above all have distorted the idea that there is only one God. For Muslims, the Christian concept of the 'Son of God' and the Trinity (Father, Son and Holy Spirit) appear somewhat unsubtle. The Qur'an was given to Muhammad by Allah as the final definitive Word (in Arabic *qur'an* means a reading, or recitation) which comes forth from the eternal heavenly source.

Muhammad

The bearer of this 'third testament', the message of Allah, was the prophet Muhammad (*c*.570-632), the son of Abd-Allah from the mercantile city of Mecca. This city lies inland in the Arabian peninsula, along the ancient trading routes that criss-cross the deserts and oases of Arabia. According to the Qur'an, Allah

continually sent people, one after the other, prophets and messengers to warn the world, teaching about the way of righteousness and adjuring people to convert to faith in Him. Among these prophets were Moses and Jesus. However, the prophets were either murdered or – if they were received – their teachings were soon rejected and people continued to pursue their more bestial urges. Finally Allah 'sent' His last prophet, as a final warning. This is called 'the seal of the prophets'. For in the same way that a seal on a document confirms what it contains, so Allah confirmed the words of earlier prophets and now completed the text (nothing further may be added to it).

Muhammad, chosen by Allah to be His Prophet, summoned people to repent for the final time, gave them the laws by which to lead a righteous life, and proclaimed the original text of the holy scriptures. Thereafter there would be no way out. A terrible Judgment Day would arrive when the dead would arise from their graves to be judged for their deeds and either punished with Hell or rewarded with Heaven.

Muhammad was an ordinary man with a keen sense of the spiritual misery that was rife around him. He was forty when Allah began to speak to him, either directly or via the archangel Gabriel, and commanded him to go and preach Islam to people. This preaching implied among other things obedience to Allah and faith in his uniqueness and all-powerfulness. After some initial uncertainty both about himself and the nature of his holy inspiration, Muhammad began to preach with great conviction, proclaiming to his fellow countrymen what God had said to him.

These words, the direct messages from Allah to Muhammad intended for all people, are the source of the Qur'an. The holy text was first delivered orally and later recorded on parchment and paper. It became the cornerstone of Muslim spiritual life, basis for their rituals and – most important for us –

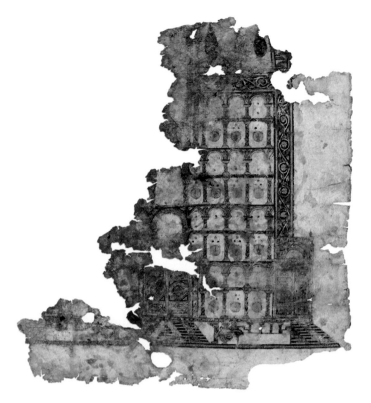

Cat.no. 36 front

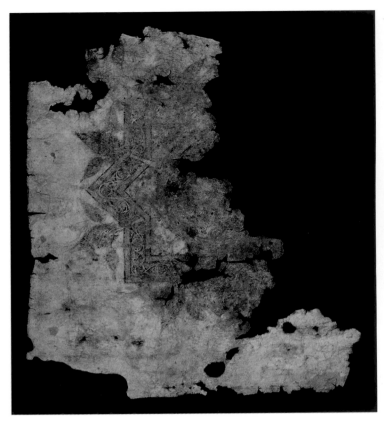

Cat.no. 36 back

the fundament for their artistic ideas and the source of their artistic creation.

Allah foretold the terrible Last Judgment Day and described the horrors of the end of the world, the suffering of sinners in Hell and the blessed nature of the gardens of Paradise. As illustration he recounted how prophets and peoples from the past had been judged for their lack of faith. He summoned people to turn aside from paths of wickedness and to convert to the true faith in the One who had created humankind and provided them with all things necessary.

Many of Muhammad's fellow-townsfolk rejected his preaching. They wanted to continue living as they had always done. Persecution forced Muhammad to flee from Mecca in 622 with a group of his supporters. He established himself further north in Yathrib where the local folk received him enthusiastically as their spiritual and political leader. The year and day when Muhammad moved, 16 September 622 is called the *Hegira* and was later taken to mark the beginning of the Muslim era. Shortly after this, Yathrib changed its name to *Medinat al-naabi*, meaning 'the city of the Prophet' and now known as Medina.

The Muslims spread their message with the word and with the sword. Followers of Muhammad waged war against Mecca, ending in the capitulation of the city and the destruction of all the idols that stood around the holy place of the Kaaba. The Kaaba itself, which contained – set in its northeastern wall – the Black Rock originally sent by Allah from heaven, became the centre of Muslim ritual and the place of remembrance. After the Great Flood, which destroyed the Kaaba, it was recreated by Abraham who came here to visit his son Ishmael (who is the forefather of the Arabs). The entire ritual of remembrance, called the *hajj*, is dedicated to the memory of Abraham, who wrestled with temptation and was even prepared to sacrifice his only son to God.

The *hajj* became incorporated into the basic rules of Islam and the Islamic way of life. Beside this, faithful Muslims believe that 'there is no god but Allah and Muhammad is His messenger.' Further, they must observe the holy month of Ramadan, must pray five times a day, either at home or in the mosque, and on Fridays they must participate in special community prayer which has a great symbolic value for the huge Islamic community spread across the globe. They

must also give alms to the poor and donate a portion of their possessions to the needy. The Qur'an consists of powerful texts discussing the main points of faith, episodes recounting histories of holy figures, and general prescriptions for a pure life. It has rules appertaining to inheritance law and the relationships within the family and the wider community, as well as the prohibition of games of chance, drinking alcoholic beverages, and eating pork.

The teaching of the Qur'an was directed towards the whole of humankind and prepared the way for the expansion of its sphere of influence. Under Muhammad, Islam conquered the entire Arabian peninsula. When in 632 he died, at the age of about 60, the political and spiritual authority passed to the caliphs (literally meaning 'follower' in Arabic). The first four caliphs, called the 'righteous leaders' established Mecca and Medina as their political centres for their community. They also held extensive military campaigns. The armies of Islam overcame a large portion of the Near and Middle East. Their neighbours were two powerful kingdoms, Byzantium and Sassanid Persia. The latter was in decline; gradually Iraq and the ancient Iranian territories fell under the caliphate, including Central Asia as far as the border with China and north India. Byzantium handed over Syria, Palestine and Egypt. Armies of fanatic warriors, inspired by the faith of Islam, penetrated the whole of north Africa, spreading westwards and north into Spain.

The Umayyads

Many of the great battles took place after the first 'righteous' caliphs had been succeeded by the Umayyad dynasty from Mecca. They moved their capital to Syria, choosing one of the oldest cities of the world: Damascus. A great burgeoning of new Islamic art and culture found place under the Umayyads, based on a system of spiritual and political instructions. Those who exercised this authority were the local population. They created highly impressive objects which became imbedded in the ancient artistic traditions of Syria, Egypt, Iraq and Persia. As a result, local artists made use of their indigenous traditions for the benefit and indeed the

Ill. 2 The Dome of the Rock, Jerusalem, completed 691

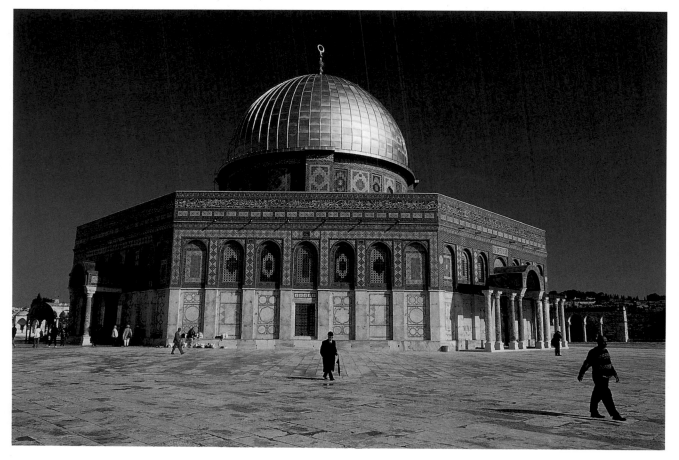

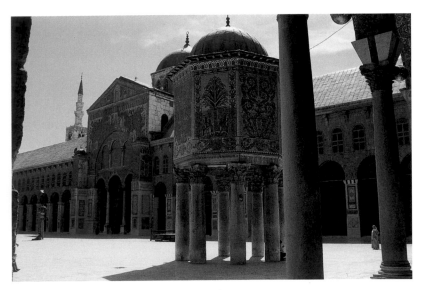

Ill. 3 The Umayyad Mosque, Damascus, built 706-714

glorious reputation of their new society. The old forms of decoration and luxuriance were turned into ways of glorifying Islam and its followers.

It should be noted here that the political system in the conquered territories was a model of gradual assimilation. Non-Muslims were allowed to retain their former religion but were heavily taxed. Gradually, most of the conquered peoples chose to follow the new faith. A clear illustration of this is given by two architectural monuments from the days of the Umayyad dynasty: the Dome of the Rock in Jerusalem (completed in 691, *see ill. 2*) and the Umayyad mosque in Damascus (built 706-714, *see ill. 3*). In the architectural methods and principles of these buildings, as well as the ornamental motifs and the mosaics, it is easy to find parallels in Christian architecture and Persian decorative art. In the Islamic world, however, monuments were created with an ideological aim, that of preaching the triumph of Islam. This embraced among other things the ties with ancient religious traditions, the abstract concept of 'God', and the descriptions of Paradise. This agenda dictated the style and artistic language in which flamboyant ornamentation and luxurious materials mix and merge with an almost iconoclastic asceticism.

The Umayyads continued to wage war and built a state in the which Byzantine brilliance was toned down by the traditions and practical wisdom of the Bedouin desert rulers. This period was full of civil wars between various groups who had tasted the sweets of power and didn't want to let go. One of the wars ended in 750 with the annihilation of the dynasty and the transition of the title of caliph to the Abbasid dynasty, whose claim to rule was based on close family ties with the Prophet – they were descendants of his uncle, Abbas ibn Abd al-Muttalib.

One Umayyad prince managed to escape the family massacre of 750 and founded his own Umayyad caliphate in the Spanish city of Córdova, assuming the title of Abdulrahman I. This marked the beginning of the inevitable decline of the united Islamic state, with the independent development of Islamic art in Spain. One aspect of this was that the Syrian-Byzantine tradition came into contact with the customs and tastes of barbarian Europe. The result was a sophisticated and elegant art with its own peculiar characteristics but which, with all its peculiarities was still part of mainstream Islamic art – abstract, decorative and extravagant.

The Abbasids

The Abbasids moved their capital to Iraq, the land of the Sassanids. In 762 they built a new city, their capital Bagdad, 'city of Peace', vibrant centre of a mighty empire. It was a huge city, with many palaces, mosques and bazaars. After a while the caliphs grew tired of it, and caliph al-Mutasim (870-892) built a new capital city about 80 kilometres north of Bagdad. It was called Surraman-raa ('happy is he who beholds') or Samarra'. It was a centre for study and scholarship, for bureaucrats and warriors, with palaces, hippodromes, gardens and mosques of enormous size. The famous Great Mosque of Samarra' (*see ill. 1*) was adorned with a spectacular minaret, which had a spiral pathway leading upwards to its summit. The palaces were beautified with striking wood carving and stucco. The style of this carving determined to a large extent the characteristics of the plant ornamentation from the Abbasid dynasty. The Abbasids, then a world power and coming from Persia, had a richer and more monumental manner of constructing their buildings, their metal or ceramic domestic objects, their weapons and their clothing, than did the Umayyads from Syria. But for both dynasties the spirit and the style were one and the same. Less exuberant but no less impressive, were the styles

of Islamic Spain and North Africa. The horseshoe-shaped arches and the combination of red and white lines in the architecture, the pale blue leaves with golden lettering of the Qur'an and the wealth of bone carving characterize the Spanish variation of this dominant artistic language (*ill. 4*).

The Saljuqs

In the course of the 9th century the Abbasid caliphate and its rulers were overthrown by a new military power. Turkish tribes of the Saljuq dynasty were the new major political force. Under them traditional rulers were placed on the throne, which was once again located in Bagdad. In the meantime the Islamic world had changed into a conglomerate of large and small kingdoms with a varying degree of mutual dependence. The Saljuqs followed a strictly orthodox form of Islam. Under their influence and protection a strong Islamic theology developed presenting the fundamental principles of Islamic dogma and of political organization.

Classical Islamic art gained its shape in particular in the 11th century. At that time in many ways all kinds of artistic customs were being circulated which for many centuries were to characterize Islamic art. What happened was that the taste of the Turkish steppes was overlaid upon the layers of Persian, Byzantine and Arabic art. The cupolas and minarets became more regular, while new standard designs came into vogue for decoration. Metalwork witnessed the appearance of brass inlaid with copper and silver, in which motifs are to be found from China and India.

The Fatimids

At the same time Egypt and part of north Africa were ruled by the Fatimid dynasty who were descended from Muhammad's daughter Fatima and his nephew 'Ali ibn Abi Talib. During an extended struggle for power they developed a complicated religious law containing many obscure principles and meanings which was only accessible for the initiated. Their stress on the inner significance of religion, on secret rituals and a secret system of propaganda gave a unique attraction to the teaching of the Fatimids, which was increased by the addition of a mystical 'sparkling' in their art. Many products of Fatimid art, such as illustrations on pottery, or motifs in mosques

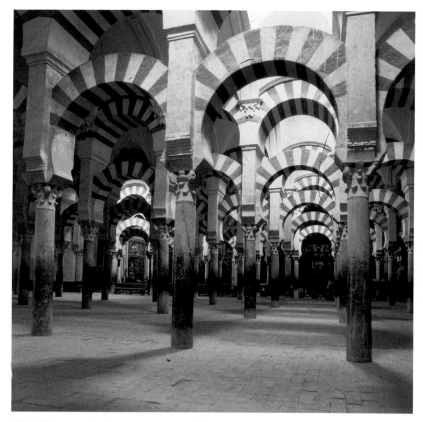

Iil. 4 The Mezquita (Great Mosque), Córdova, started 750

and palaces, are undeniably open to several interpretations. With its mysterious glowing colour and suggestive layers, rock-crystal was one of the most coveted materials.

The Fatimids were powerful rulers and would often make use of art to assert their position. They built the city of al-Qahira ('the Conqueror'), today Cairo, adorning it with mosques such as the al-Hakim in which grandeur goes hand in hand with the ever-present possibility for the individual to withdraw into contemplation and prayer. The immeasurable riches of the Fatimids were used in a demonstrative manner. The Fatimid caliphs organized huge processions in which countless gold objects, often utensils, would be borne along and revealed to the crowds, along with enormous bronze figures and candlesticks, together with lamps of rock-crystal and splendid garments embroidered with texts and motifs.

The Crusaders, the Ayyubids, and the Mamluks

In 1099 Jerusalem fell to the Crusaders. Palestine came under European feudal overlords whom the sophisticated Byzantines and Muslims considered to

be quite simply barbarians. Much of Europe's cultural development is thanks to the daily contact and the wars waged in the time of the Crusades. Furthermore, these wars and commercial ties helped create a kind of unity in the Near East, turning it into a general cultural terrain where both Christian and Islamic art was made in a like spirit and often with like materials. This exhibition shows some objects which, as far as their detail and motifs are concerned illustrate the enriching effect on Islamic art through these contacts.

The Fatimids were driven out of Egypt by the Kurdish Ayyubids, the dynasty of the famous Salandin. Following in the tracks of the Ayyubids, Egypt was ruled for several centuries by the Mamluk dynasty, originally slaves captured in war who, from being commanders of military units, became the rulers of the country. Under the Mamluks, who were both courageous warriors and excellent merchants in the Red Sea and Mediterranean areas, Egypt enjoyed a period of great prosperity. This is recorded in Cairo with a number of remarkable architectural monuments from the period, as well as exceptional glass lamps decorated with enamel, beautiful brass objects with an intricate overall design, and manuscripts of the Qur'an rich in stunningly vivid decoration.

The Great Mongols

At the same time, in the 13th century, the eastern part of the Islamic world was attacked by the Mongols under Jingghis Khan and his descendants. In 1258, the armies of Jingghis's grandson, Ögedei Khan, captured Bagdad after a bitter and bloody struggle. Syria was the only place where the Mamluks could offer resistance to the fierce Mongols. The Islamic culture suffered a severe blow; bloodthirsty massacres took place and countless people, including many artists were killed. Also, many palaces, mosques and libraries went up in flames. Gradually, however, the aggressors converted to Islam, became assimilated into the already centuries-old culture, and indeed became its guardians. There are many schools and styles in Islamic art that take their names from dynasties of Islamic rulers whose roots lay in Mongolia.

An exceptional place is occupied by the Timurid dynasty. Timur (known in the West as Tamurlane)

who claimed descent from Jingghis Khan, ruled in Central Asia in the 14th century. He was a great warlord and conquered Afghanistan, Iran, Iraq including Bagdad, Syria and Asia Minor. Timur moved his capital to Samarkand (now in Uzbekistan) which he made into one of the most splendid cities of the world. His descendants also made their contributions: thanks to them remarkable architectural monuments appeared, richly decorated with tiles bearing flower motifs, and graceful texts. The special school of miniature painting, the beautiful examples of elegant ceramics, and the weaponry, all bore the exceptional Timurid stamp.

The Ottomans

In 1453 Constantinople was captured by the forces of the Ottoman sultan Muhammad II. Gradually the Ottoman Turks took over the whole of Asia Minor, together with the Near and Middle East and the Balkans. For several centuries – into the 20th – the Ottoman empire was a power to be reckoned with in world politics. This vast kingdom revived the arts of Islam by developing further the traditions of the Mamluks from Egypt, Syria and Byzantium. Ideas in western Europe concerning Islamic culture and the daily life of Muslims stem largely from impressions gained about the Ottoman empire. The characteristic social patterns of this community, with their luxury and ceremony, find expression in the exuberance of its art: brocade robes and turbans, domestic ware, weapons and garments encrusted with precious stones and metals, the delicately decorated ceramic tiles and pottery with their blues and reds, not to forget the cult of the tulip in the Ottoman empire (*see cat.no. 274, p. 11*). After all, the tulip was born in Turkey and still possesses great symbolic value for Turks.

The Mughals

The merging of luxuriousness with the greatest refinement also characterizes the art from the period of the Mughals, rulers of India who claimed decent from Timur, or Tamurlaine. One of the wonders of the world, built in Mughal style, is India's Taj Mahal (*see ill. 5*), a mausoleum set up by shah Jahan in memory of his beloved wife, the beautiful Momtaz Mahal. The objects from the treasures of the Mughals, on show in this exhibition, glittering with precious

jewels, serve as symbols, as it were, for the later period of Islamic art. They were taken to Russia by the ambassador to the Persian government of Nadir Shah who in 1739 demolished the Mughal state and plundered the capital city of Delhi.

In the course of fourteen centuries dynasty followed dynasty. Each in turn ruled over part of the Islamic world and each had its own ethnic, political and cultural peculiarities. The political structure and the culture in the world of Islam changed from age to age. Clearly, the art of 9th century Egypt is totally different from that of Egypt in the 18th century. And equally clearly, the art of Muslims in 15th-century India varies markedly from that of Morocco in the same period. This will come as no surprise. However,

these vastly different historical periods and geographical regions – including China and Indonesia – share certain characteristics which may be recognized while being difficult to describe. The shared nature has many roots. but the chief of these is the inspiration based on Islamic traditions and ideas. This also made it possible for art to survive through various political and cultural scenarios.

The spiritual inspiration is not immediately obvious. For it lies not in the subject, but in the manner of artistic expression. It is unexpected, vital and alluring. This exhibition is designed to excite visitors, to introduce them to the outer beauty and the inner riches of the art of a religion still so little known to many i in the West.

Ill. 5 The Taj Mahal, Agra, built 1632-38

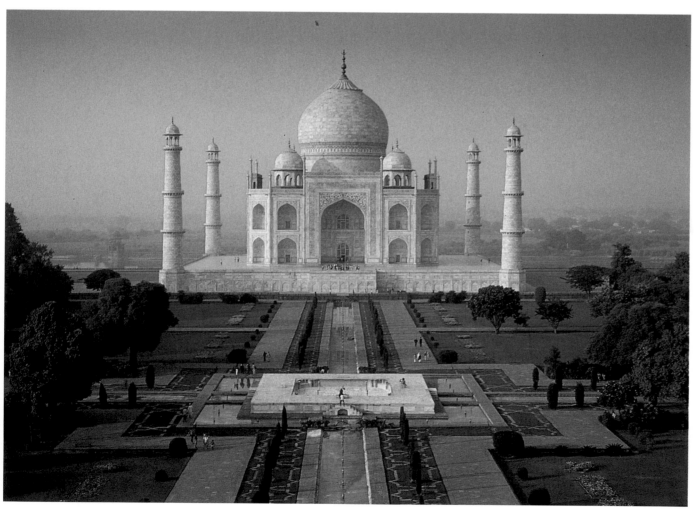

2 *Monotheism and Ornamentation*

Islam is a religion of an emphatic, almost exalted, monotheism. The entire message of the early preaching of the Qur'an was to abstain from idolatry. To worship a person or a god other than Allah, the Creator, was condemned by the Qur'an as the most terrible sin a person could commit, as a monstrous betrayal of the faith and traditions of one's ancestors, who believed in One Indivisible God. It should be noted here that the three world monotheistic religions – Judaism, Christianity and Islam – all originated from the same source in the Near East.

For Islam, monotheism was equivalent to knowledge about the religion of the earliest people – something that was often forgotten but continually revived by the prophets. The idea that belief in Allah isn't something new but rather the rebirth of an ancient religion, is of great importance in Islam, for it emphasizes the tradition stemming from Abraham which is also a central theme in Islam.

It is this total monotheism that arguably gave Islam the right to call itself 'a more advanced religion' than those of the patriarchs, since they deviated from the central concept of an unshakeable faith in one God. The One Indivisible God was held and still is in Islamic theology as both sublimely simple and endlessly complex, something both as intimately close as breathing and at the same time immeasurably distant.

The Qur'an begins with the *sura* (chapter) titled al-Fatiha, the Opening Chapter. In it the essence of Islam is so encapsulated that it became the most important text in Muslim prayers:

> In the name of God,
> Most Gracious, Most Merciful.
> Praise be to God,
> the Cherisher and Sustainer of the Worlds;
> Most Gracious, Most Merciful;
> Master of the Day of Judgment.
> Thee do we worship

> and Thine aid we seek.
> Show us the straight way,
> The way of those on whom
> Thou hast bestowed Thy Grace,
> Those whose (portion) is not wrath,
> And who go not astray.

The original formulation of monotheism is found in sura 112, *al-Ikhlas*, or 'Purity of Faith'. The text has become one of the most important elements in Islamic art. It is repeated in unending sequence in calligraphic script round objects, round buildings both spiritual and temporal, and on talismans (small pieces of paper bearing a text from the Qur'an which will ensure good luck). The opening of the sura reads:

> Say: He is God, the One and Only;
> God, the Eternal, Absolute;
> He begetteth not, nor is He begotten;
> And there is none like unto Him.

It is fairly evident that this precise formulation is a concrete rebuttal of both the Christian belief that God had a son, and the heathen Arabians who, while recognizing Allah, saw Him (God) as one among many gods.

Another passage in the Qur'an about Allah which has acquired the nature of a powerful citation with exorcising force, and is frequently used in Islamic calligraphic ornamentation, is the *aya* (verse) known as the Throne Verse (S.II:255):

> God! There is no god but He - the Living,
> the Self-subsisting, Eternal.
> No slumber can seize Him, nor sleep.
> His are all things in the heavens and in earth.
> Who is there can intercede in his presence,
> except As He permitteth?
> He knoweth what (appeareth to His creatures as)
> Before or After or Behind them.
> Nor shall they compass aught of His knowledge
> Except as He willeth.
> His throne doth extend over the heavens

and the earth, and He feeleth
No fatigue in guarding and preserving them.
For He is the Most High, the Supreme (in glory).

Images

With regard to this aya, we may refer to one of the problems that arise in connection with pure theology as also with questions of an artistic nature. Namely, the aya describes Allah seated upon a throne, and for some this raises the picture of an earthly emperor. Indeed, other parts of the Qur'an refer to the hands of Allah, or to His actions which may well suggest similar human comparisons. In Islamic theology of the classical period fierce arguments arose over the question as to what extent these anthropomorphic descriptions should be interpreted literally. The overriding opinion, which was generally accepted, was to interpret these words metaphorically, to see the images as symbolic, and of a literary nature. In theological terms they are expressions which make comprehensible for the lay person concepts of a profound philosophical content. This kind of many-layered and therefore enriching understanding of the text of the Qur'an and of theological ideas is typical for Islam. It is also customary for the Muslim to discover in everyday shapes and objects deeper meanings and layers, and indeed to find fuller meaning in the actions of daily life.

The Qur'an contains other passages which refer more or less directly to making likenesses or images. In Paradise, the just, or righteous, behold God face to face. This led to lengthy controversies: can a man behold God, and if so, what does he see? Does God have a face?

Symbolic explanations offered a means of solving the contradictions between concrete physical words and abstract concepts. It is not possible to describe God's Being in human language, nevertheless these words represent a means whereby the believer may approach the Divine Presence. The many aspects of God's Nature are described in episodes from the holy scriptures and hymns of praise to the glory and majesty of Allah. The power of His Might and Will are also apparent in the commandments, the debates with unbelievers, and the terrifying prophecies concerning the Day of Judgment. There are many

descriptions, having the nature of a written formula, which in different ways attest to the nature of Allah, such as 'Allah is the Greatest, Allah is the All-Knowing, we all return to Allah.' The repetition of this type of formula became an important element both in Muslim prayer and in daily conversation and such expressions became the source of calligraphic decoration.

Allah's names

One particular way of describing God was to list his names. The Qur'an lists 99 names for Allah. They are written out in many ornamental decorations, on special talismans and magic rolls, on sheets of manuscript and decorative plates and dishes. The names refer to the many aspects of Allah's character. Here follows a list from the Qur'an giving His names

God is He, than Whom there is no other god;
Who knows (all things) both secret and open;
He, Most Gracious, Most Merciful.
God is He, than Whom there is no other god;
The Sovereign, the Holy One
The Source of Peace (and Perfection),
The Guardian of Faith
The Preserver of Safety
The Exalted in Might
The Irresistible, the Supreme:
Glory to God (High is He)
Above the partners they attribute to Him.
He is God the Creator,
the Evolver,
the Bestower of Forms (or Colours).
To him belong the most beautiful names:
Whatever is in the heavens and on earth
Doth declare His Praises and His Glory.
And He is the Exalted in Might, the Wise.
(S. 59:22-24)

The most important names here are those which occur at the opening of every Islamic text, 'In the name of God, most Gracious, most Merciful.' Second only to the statement of faith, this formula is the most frequently found in Islamic texts. With the help of a complete understanding of the mercy and goodness of Allah, Islam managed to solve one of the major points of debate in this and many other religions. Namely, if the Only God has created humankind and if as all-powerful God He can determine human action and

Cat.no. 32 Carpet containing the word Allah repeated

behaviour, how then can humankind be responsible for their actions? Many are the Islamic and Christian writings on the question of free will and predestination, trying to explain what appears a highly contradictory riddle. Variations appear in these writings, granting people different degrees of free will and responsibility. However, a general summing up of the attitude of Islam is that choices must be made within the limitations imposed by the will of Allah, that people must obey His will, hoping for His mercy – which the faithful are sure to find; the only question is where, when, and in which world.

To repeat the name of Allah is an act of piety. In this Islam is very different from Judaism, which considers the name of God too holy to be spoken. Only variant forms of His name may be said, such as Jehovah, or

He may be called Hashem, meaning 'the Name'. Different too is Christianity, which adheres to the commandment 'Thou shalt not take the name of the Lord Thy God in vain' (Ex. 20: 7) and teaches that the name of God is holy and should be treated with great respect. In Islam, however, the rule is: the more the holiest name, Allah, as well as His other names, are spoken and repeated, the better. To repeat them either silently or aloud forms the basis of prayer and of the mystics' trance. Their repetition is one of the ways of attaining truth and of manifesting dedication to God.

Abstract ornamentation

With this, we have come close to the world of visual art. For the basic nature of ornamentation in Islamic art is formed from the repetition of certain artistic

25

elements. This is one of the chief – if not *the* chief – areas of development belonging to Islamic art. It is in essence an abstract art and this is undoubtedly related to the understanding of God's nature. The attempt is made not only with words that describe Him, but also with art and abstract ornamentation, to speak of that which is essentially abstract. To recount tales of the invisible. The ornamentation, the motif, is continually repeated, teaching in a restrained but persistent and subtle manner, how to nourish certain feelings that are derived from the many representations of Allah as the one, indivisible and immeasurably good Creator.

The idea of the abstract Allah, high above all else, became the main element in the inner world of every Muslim and also contributed to a feeling of inner pride: in Islam that has been preserved as an essential and holy aspect of life, something which they claim has been lost in Judaism and Christianity. Muslims emphasize the fact that they have not succumbed to the temptation to worship strange idols; they have preserved and continue to preserve the purity of monotheism. Undoubtedly, this is the primary element of not only the intellectual but also the emotional world of the Muslim. In some way or another, it had to manifest itself in their works of art.

The power of the arts to transmit this Islamic message was well understood. From the start, Islam paid due heed to artistic representations of its victories, its supremacy and its grandeur. That huge masterpiece, the Dome of the Rock (*see ill. 2, p. 17*) was a combination of the reconstruction of Solomon's Temple in Jerusalem, the creation of a house surmounting the grave of Jesus Christ, and the proclamation of the triumph of Islam over the Christians and the Zoroastrians, followers of the Persian prophet Zarathustra (or Zoroaster) who lived circa 1000 BC. The artistic style of the decoration follows the Islamic thought: there is luxuriant ornamentation without the use of concrete (human or animal) images. The Umayyad mosque in Damascus (*see ill. 3, p. 18*), the famous mosques of Kairouan (now Tunisia) and Córdova (*see ill. 4, p. 19*) – all these formed the conquerors' triumphant affirmations of faith. With their elaborate beauty they were intended to amaze and delight. And it wasn't long before this luxurious decoration gained its own agenda. Ornamental decoration

formed a natural successor to the pre-Islamic traditions. Like the new religion, the decor was pruned of excessive tendrils and reformed into something that was purely Islamic.

In Islam, every part of life is holy. An essential difference between Islam and Christianity is that the former does not divide life into the temporal and the spiritual. Every element in a Muslim's life has a religious significance and is judged by comparing it with the standards and principles of their religion. Every work of art is assessed according to a religious world view. And on the other hand, religious and political practice requires an artistic formulation. There was a social 'decree' which, unlike analogous decrees in the Christian world, was not essential to the religious history but was so, in the way that it symbolized and represented abstract truths. The first of these concerned the existence of *one* God 'without whom there is no God, and to whom there is none equal.' Ornamentation, which by its very nature is endless, was a perfect vehicle to illustrate this and became the favourite means for expressing the Islamic attitude to life.

It is important to note here that in medieval Islamic literature there are no discourses to be found on the relation between art and religion. Furthermore, it seems probable that in the majority of cases people scarcely considered that the artist was free to choose the tenor of a work of art in a religious context. Undoubtedly, internal factors of psychology and the spiritual standards that the artists held, would play a role here. They would elicit a reaction from the community which would recognize the style applied as belonging to them, and thus acceptable.

Ornamentation became the most characteristic artistic genre, gaining enormous significance and attaining a high level of refinement. Ornamentation can be classified into three major types: calligraphy, plant (that is, arabesque) and geometric. One of the things these three forms have in common is that they contain artistic references to and reminders of the divine Being.

Calligraphy

Before long, calligraphy became the foremost artistic signature of Islamic art. Arabic script is in itself graceful and elegant. Since the letters of its alphabet may be written in various ways it presented many opportunities which the Islamic masters multiplied time and again. Often, it is difficult to read a text in calligraphy. Thus its primary function is purely decorative – it delights the eye, it absorbs the viewer into an endless river of rhythmical lines gliding in and out of each other and opening out into works of refined ornamentation. In this highly complex dance of shapes, which is typical for all Islamic decoration, there is a ceaseless movement which began with a primal act of Allah and is one of the ways of manifesting His Being to this world.

The decorative nature of Arabic script forms the basis for an elaborate system of handwritten styles, varying from exuberant and monumental to one so delicate it resembles strokes of air. The ancient Arabic scripts, which were used when people first copied out the Qur'an, were amalgamated into one script called Kufic (*see cat.no. 56, p. 48*), after the city of al-Kufa which the Arabs had founded in Iraq. This was a monumental script with strongly delineated vertical bands of letters and severe horizontals. Dots in various colours indicated groups of letters and vowels. Generally black or dark-brown ink was used on a pale yellow parchment or paper. In the Maghreb region a type of Qur'an was prevalent called 'Kairouan', in which the text was written in gold letters on a dark blue background. The golden lettering was commonly used to illuminate titles and as filling on ornamental word divisions in the form of palmettes, rosettes and patterned disc-shapes. The Kufic script incorporated the possibilities for both great dignity of shape and elaborate decoration. The ends of letters could be developed by calligraphers into tendrils of plants; the top of the vertical stroke could be shaped like a plant or even a human figure. The letters themselves could indicate direction, adding a sense of rhythm and change.

The Kufic script is by its very nature both monumental and exuberant which is probably why it was the most commonly used, especially for the solemn lists in the Qur'an and when decorating huge buildings. Its formal severity was remarkably appropriate for inscriptions on Arabian coins, which were decorated purely with texts declaring Islamic dogma and stressing the supremacy of the ruler who had ordered this particular coin to be minted. In the field of applied art the elegant Kufic script would be used in carving, inlay and painted decoration. At a fairly early stage two variations of the script developed. The eastern variant was more refined and ebullient than the classical Kufic; indeed, its joyful letters seem to skip along the page. The western variant (from the Maghreb and Spain) retained the strong sobriety of form and had dignified loops and angled links between letters. Eventually this style developed into the *Maghribi* script.

The Kufic script was and is used for the most formal purposes. However, from the 9th century cursive Arabic scripts also developed, many of these attaining a monumental and ornamental form. Several reforms introduced a great advance in the development of script, one of these being the introduction of pointing for consonants and vowels. This brought a system not only into the meaning of the letters but also into the filling-in of the space between the thicks and thins of the letters. Furthermore, a system of constructing the letters was established, making the script uniformly geometric. A basic module would be selected, such as a lozenge shape, formed by the diagonal stroke of the Arab reed pen, called a *qalam*, which was the favourite instrument of the calligrapher. A fixed number of these lozenges (five or seven) determined the height of the letter *alif*, which in turn determined the diameter of a circle. This system was created by Ali ibn Muqla (d. 940), a politician who served as vizier under three Abbasid caliphs, and was also a most talented and inventive calligrapher. Many was the time when he landed up in gaol, and on one occasion his right hand was chopped off, but he simply went on with his left – producing more beautiful calligraphy than anyone else. A system developed known as *al-khati al-mansub*, meaning proportional script.

Continuing the work of Ibn Muqla several famous pupils of his, among them Ibn al-Bawwab (d. 1022) developed and used new scripts. These Arabian calligraphers, whose name and patronymic has been

27

preserved for posterity, are among the best-known creators of Islamic art. The makers of other genres may well be known to us (many of them inscribed their name on their work) but are now less famous. The next 'star' in the calligraphic firmament was to be Yaqut al-Musta'simi (d. 1298). He survived the plundering of Bagdad by the Mongols, when thousands of manuscripts were destroyed. One piece that also survived is a delightful miniature showing Yaqut serenely concentrated in his work of producing beautiful calligraphy while all around him in the city of Bagdad the battle raged.

The calligraphers invented and developed various scripts, some of which remained in fashion for many centuries. Others disappeared together with their creator. Generally, the number of basic scripts is confined to six, known as *al-aklma as-sitta*, meaning the 'six feathers' or handwritings. They consist of three pairs of cursive script; first, the large rounded *thuluth* with its smaller variant, the *naskh*. The latter has become the major standard used when copying texts and forms the basis for printed Arabic script. Second, there is the slightly elongated, solid-looking *muhaqqaq* and its smaller variant, the elegant *rayhani*. Finally there is the script called *tawqi* with its smaller variant, the *riqa*. The former is a passionate script with expressly curving letters which often transform into the intricate delicacy of the second, which today is the most commonly used in Arabic handwritten texts.

The world of the Persians had a strong impact on the standard scripts and led to their sloping more sideways, becoming more elegant and more curling. A sheet of Persian manuscript is utterly different from an Arabic one – there is more flowing movement, often with exuberant patterns. The Persian script seems to curl along across the sand leaving its greatful traces.

The Persians, and after them the Turks, had the habit of making a distinction between the type of calligraphy used for the main text and that of another body of text interwoven with it. Thus separate sheets would be written, bearing – in different handwriting – citations from the Qur'an and sayings of the prophet Muhammad. Particularly popular were sheets with a list of the names of God (*al-asthma al-khusna*) and descriptions of the appearance of the Prophet (*shamail*). In the Ottoman world a gentle, rounded script became widespread (*naskh, thuluth*). The calligraphers, who already enjoyed high social status, gained even greater prestige and the most famous of them, such as Seyh Hamdullah (d. 1520) or Ahmed Karakhisari (d. 1556) were among the most acclaimed people of their society.

A major step in the development of elaborate manuscripts were the *tughras* of the Ottoman sultans. The name and title of the sultan was embedded in an intricate pattern in which the loops and lines of many letters danced and intertwined. In this way a sign would develop bearing clearly distinguishable lines and details making it possible to decipher the monogram of the sultan without reading the text. The written word flowed and merged into the decorative icons that were characteristic for the Turkish families and which are still often to be found in Islamic culture. Thus these tughras demonstrate in many ways the development of ornamentation in Arabic script. The word became almost completely transformed into a symbolic motif (*see also cat.no. 304*).

Parallel with this, virtuosic methods developed of producing mirror-image ornamental manuscripts, and above all texts that took the shape of objects such as lamps, books, birds, a seated figure, or a boat. This form of artistic gymnastics is both interesting and remarkable, but to a great extent breaks with the essence of the calligraphic ornamental tradition.

In a way, calligraphic ornamentation see-saws between a beautifully produced text and a beautiful motif as framework. The seamless link between these two aims lies – in various ways – at the basis of all such ornamentation. It is almost everywhere to be found, as in pious texts and in the writings describing the One Indivisible God. This decides the ideological significance of the ornamentation. Generally, calligraphers would inscribe on objects and buildings the essential, specifically monotheistic citations from the Qur'an. The names of God were a frequent subject. The various blessings formed another category, such as the wish 'May Allah grant the bearer of this happiness, prosperity, enlightenment,

success' and so forth. All the virtuous combinations derive from Allah, which is why on objects and ornament they are always associated with Allah. They are a reference to His almighty power and the fact that He alone, out of His great compassion, can grant true welfare to humankind. The name of Allah and His sovereign power served as protection for art objects or buildings, and their owners. Furthermore, we find – chiefly
on domestic pottery such as beakers and dishes (in imitation of Chinese porcelain) various wise sayings. Allah could not be named here, but the selection of lauded qualities would always be consistent with the Islamic rules of conduct. Finally, writing on objects of applied art, especially those coming from the regions of post-11th-century Persia, would often take the form of poetry. Generally, these would be mystic verses, instilling people anew with an awareness of the all-pervading being of Allah.

In this way we see that the content of calligraphic ornamentation was always a highly conscious witness to monotheism, a 'story' about Allah, dressed as an appealing and visually attractive motif. The calligraphic texts, especially those in Kufic, always require of their reader a certain amount of preparation, not to mention considerable concentrated effort. This results in a feeling of pleasure and satisfaction when the result is achieved and the reader understands the text. The feeling of satisfaction with an effort rewarded is to a certain extent related to the processes of penetrating more profoundly into an understanding of God, of movement in His direction, of reading the Qur'an and reciting the prayers aloud. It is this connection that gives calligraphic ornamentation its exceptional significance.

There is yet another exceptional quality in calligraphy that reflects a religious notion. Arabic writing has the appearance of an unending flow of line, a linked pattern of letters, many-shaped and ever-moving. It projects the concept of continuity, of endlessness, of pluriformity. These contribute in no small measure to the attempt to imagine God.

The arabesque
The second type of ornamentation is the plant motif, or arabesque, an unbroken curling and waving line

derived from the intricate rhythmic undulations of the vine tendril. Not surprisingly, this motif was born in the Mediterranean countries, where the vine grows plentifully. As motif it was very popular in Roman and Byzantine art, frequently found in their mosaics. The Arabs would often have seen this motif, both before and after the Islamic conquests in these countries. In itself it was an attractive design and it contained no idolatrous images. The Arabs soon adopted it and developed it in an imitable manner, whereby it became one of the most distinctive marks of Arabic ornamentation. Indeed, this is the source of the word 'arabesque' in Europe for this looping and twirling decoration.

The curling movement of the vine tendrils is enriched and interrupted in a rhythmical fashion by the leaves and fruit of the plant. They may – and indeed should – vary greatly. The space between the fundamental flowing lines is filled in with twirls, plant shapes and their elements, and vases and animals. Gradually, the aspect that became characteristic for Islam – that all the empty spaces should be filled in – became compulsory. This is generally done by using an interwoven plant motif on a small scale, which does not obscure the basic rhythm but in fact enhances it. The tendril motif is characteristic of the earliest Islamic art, from the time of the Umayyad dynasty (661-750). Under the Abbasids (750-1258) it developed further and since then has become an essential feature in all Islamic periods and throughout the Islamic world. The motif varies in different ways but always retains the unbroken rhythm of an exuberant living plant, while with virtuosic imagination the empty spaces between the tendrils are given flamboyant filling.

One of the earliest and most remarkable examples of this type of ornamentation can be seen in the sculpted decoration on the walls of the Umayyad castle of Mshatta in Jordan, where plant-like shapes curl in all directions. These curls sprout into vases with plants in them or figures representing real or imaginary animals. The surface is a network of fine motifs linked together by a few geometric shapes.

An interesting example of the development of the arabesque is provided by the sculpted panels in the

Abbasid capital of Samarra' (Iraq), a city that was only granted a brief existence. Extensive archeological excavations in this once large metropolis, that became neglected and abandoned, have produced large quantities of material. Among other things this distinguished three types of plant ornamentation which were found carved out of or applied onto a certain type of stucco. The first style has curled vine leaves on a branch either produced in one straight line or on a curve. In the second type the vine leaves cannot be recognized any longer; the motif itself is flatter and more geometric. In the third, plant shapes can be detected, growing into forms that interweave through each other, occasionally interrupted by circles and curls. These are no longer recognizable, but nevertheless make a definite impression of growth and fluidity.

The examples from Samarra' are no more than an apt illustration of the qualities and of a particular inner evolution of plant ornamentation as this was to be found throughout the Islamic world, and then with regard to objects made from certain materials such as stone, wood, metal and pottery. All these retain and bestow the delight aroused by the internal movement of plant shapes. The shapes become increasingly abstract. However, the evolution here is far from straightforward. A splendid example of plant decoration is provided by the Iznik pottery of the Ottoman empire, in which the depictions of plants are totally realistic while retaining all the charm and essential nature of ornamentation.

The arabesque has two inner meanings. Both delight the eye, and both hint at general spiritual representations and basic beliefs. The first of these is the most profound. It expresses the eternal movement and multiplicity of form; the latter coincides with the understanding of Allah and is to be found in every ornamentation that repeats itself endlessly. The second meaning is more concrete: it is pride in and love for the world which Allah has created for people. The Qur'an frequently mentions the plant and animal world as lavish evidence of Allah's affection for humankind, who may enjoy this marvellous creation. The grape and the curling vine represent in part this affection for His people. The ornamentation is a reminder, in a manner of

speaking, of the philosophical and concrete being of the godhead. And in conclusion: the beauty and the peaceful aspect of a garden filled with fruit is a pointer to the Qur'anic descriptions of the gardens of Paradise.

Thus the plant ornamentation gives rise to the same kind of delight as that which the Qur'an arouses in the righteous person. In this way, it alludes to the manner in which people should rejoice in the existence of Allah and His deeds.

Geometric ornamentation

Moreover, in every plant ornamentation there are elements or indeed large parts present, containing ornamentation of the third type: geometric. The straight lines, triangles and lozenge shapes, the circles and rosettes add structure to the curling arabesque and the calligraphic text. Indeed, they allude, as it were, to the stern will of God in the midst of a feast of swirling forms. At the same time, however, the geometric elements bring with them their own specific ornamentation. It has become yet another aspect of the artistic language and an important means of expressing cardinal aspects associated with the divine.

Even Kufic script, with its geometric elements, already possesses a certain rhythm of movement, but this is linear. However, an attempt to create an element of depth can be discerned on paper and on a stone. A rosette is depicted which symbolizes the sun, suspended in unfathomable space. The manuscripts on which the Qur'an was written were the first flat surfaces to be given an impression of depth, through the effect of the geometric lines. Polygons, squares, octagons and stars formed from triangles were at first the framework for calligraphic texts and plant ornaments, but quickly became the chief motif. In this sense it is the 'carpet' pages of the Qur'an that are the most remarkable. They are to be found from the 11th century on. The complete title page is filled with geometric patterns enclosing elegant inscriptions and extravagant plant shapes, often obscured by the wealth of pattern. Sometimes they can only be detected after concentrated inspection, and sometimes they are quite simply not there. The entire surface is coloured with geometric patterns which,

▲ cat.no. 93 and ▼ cat.no. 92

because they are drawn in layers upon each other, create an unexpected effect of depth. This can be seen particularly well on the title pages of Mamluk Qur'ans. There are countless geometric illusions. They offer different impressions seen from different angles and (most important) create a three-dimensional space in which they continually criss-cross and intercept.

An absolutely breathtaking way in which geometric ornamentation is implemented can be found in the architectural 'stalactites', arches carved in stone with the fragility of finest lace which together somewhat resemble a beeswax honeycomb. These stalactites formed an important aspect of Islamic architecture in buildings and domes. In both cases they create the illusions of the vaulted sky, attracting and bemusing the eye of mankind, yet at the same time allowing

people to glimpse the vastness of the unending. This is the illimitable, the more so because it presents an aspect of Allah.

Possibly, geometric ornamentation is the nearest people come to expressing the abstract concept of Allah, for it suggests a wealth of ideas. The lines and shapes flowing into each other fill the entire surface of an Islamic work of art. Five, six and eight-pointed stars, lozenges and rectangles live a life of their own as well as combining with inscriptions and arabesques. Most remarkable is the effect of geometric ornamentation when inlaid with various kinds of wood and ivory. The geometric patterns on wooden *minbars* (pulpit shaped like a staircase) and balconies are a significant aspect of the overall design in a mosque.

31

The abstract implications of the geometric forms are further stressed by the symbolic and magic meanings of geometric shapes. The Star of Solomon (Suleyman), the Star of David (Daoud) and other signs were used as talismans. The profound meaning successfully went hand in hand with the simple, so that the artistic content of the ornamentation matched the state of mind of the people who made use of it. By means of the ornamentation they experienced divine perceptions and perceived in it, to some extent, a reflection of God. In a way, ornamentation and particularly calligraphy, acted like an icon, playing the role of negotiator between this world and the next, creating a window beyond which there was a vast space. And in that space God is present in all His majesty.

It goes without saying that we cannot speak of the 'iconic' significance of ornamentation or of Islamic art in general, without referring to the art of the religion itself, that is, the manuscripts of the Qur'an or the decorations of mosques and mausoleums. Indeed, it holds for all the other works of art, that we can only understand them completely when we have an idea of how the religious and philosophical implications of ornamentation – dressed in a fine aesthetic robe – are part of the story. But that 'part' actually often means 'a great extent'. Indeed, it should be said that in Islamic society there is no official distinction between the temporal and the spiritual; for Muslims, every aspect of life is connected with their religion. This means that every Islamic work of art contains a reference to the overall immanence and deeply-felt indivisibility of God. And that indication would undoubtedly also have been visible to medieval Muslims, even though they would certainly have experienced it in a very different way.

Allah cannot be seen and even attempts to reveal Him come to nothing. But Allah may be spoken of, as the Qur'an does. Allah may be felt, as the mystics feel Him. The abstract art of Islam relates with artistic means a story about Allah, the eternal Creator of everything that is. And this helps people along the way to experiencing his presence, to perceiving the ineffable beauty of His majesty and mercy.

³ *Iconoclasm*

It is well known that Islam forbids the representation of living creatures in the form of pictures, sculptures and so forth. However, there are many such representations in Islamic art, both of animals and people. But these are never used for religious purposes and are generally completely secondary to the ornamentation. Indeed, they are often elements of the decoration and as such are subject to the rules governing this. In Islam the pictures of living creatures may not be used as exegesis or propaganda. The sacred history of the Muslims may only be told in words. Thus it is accurate to state that Islamic art is in essence abstract and not figurative. In the previous chapter this has been discussed in some detail.

Seen in this way, Islamic art may best be described as iconoclastic, that is, non-figurative. Iconoclasm is an essential aspect of monotheism, whose greatest enemy is the worship of idols. Representations of gods, saints, monarchs or pop stars is an immediate precondition for their worship. In Judaism there is a commandment against making images, although from time to time these may be found in their art, such as the frescoes of the synagogue of Dura Europos in Syria (now in The National Museum of Damascus). In Christian Byzantium, at the same period in which Islamic art began to develop (8th and 9th century), iconoclastic tendencies could be observed. Indeed, this period has earned the name 'Iconoclastic'. It is not impossible that this arose out of the need to distinguish itself from Islam which claimed to be the best guardian of the original purity of Abraham's religion. Icons were smashed and frescoes were whitewashed over or destroyed. In their place the Byzantine world erected symbolic crosses, fishes and other mystical symbols, or sumptuous decorations.

Few examples of Christian art remain from the Byzantine Iconoclastic period. They are sometimes assessed with a sideways glance at Islamic art objects from the same period, such as the mosaics in the Dome of the Rock in Jerusalem (*see ill. 2, p. 17*).

Furthermore, almost nothing has survived from the period before the Iconoclastic Controversy. However, the few objects that have been preserved help us in understanding the feelings of the iconoclastic warriors and the Muslims. Byzantine painted ikons achieved an astonishing virtuosity in representing people and figures, producing pictures that were almost lifelike in their realism. For example, the eyes appeared to look at you and were moist, the wounds gushed blood, and so forth. The illusion of reality was impressively convincing. It was as if people were trying to usurp the prerogative of the Lord and Creator. It is hardly surprising then that those who believed with deep conviction in the One Indivisible Intangible God, and for whom the Christian concept of the Trinity (three Gods in One) was an abomination, saw with horror the images associated with religion. For them, these were not only blasphemous, they presented a dangerous threat. They were a blatant and appalling temptation and had to be attacked.

Idolatry

The prophet Muhammad condemned with heart and soul all that he saw to be idolatrous. To crowd out Allah with other deities, beings of the same sort, or divine sons and daughters, was anathema to him for it represented the deepest betrayal of God's Indivisibility. In Muhammad's day people often made representations of gods in the form of idols, and these were placed in the Kaaba in Mecca. Believers approached these idols with their prayers, requests, and on some occasions, protests. What this in fact amounted to was a form of polytheism. In many ways Muhammad's struggle was one against idolatry. The most significant demonstration of his victory was his triumphant return to Mecca when he solemnly destroyed the idols in the Kaaba.

Collections of legends recounting Muhammad's sayings (the *Hadith*) provide many examples of how he consistently demanded the destruction of pictures in the homes of Mecca and Medina, since in them he

Cat.no. 188 The heads of the birds have been hacked off by an 'iconoclast'.

saw the danger of idolatry. There is a famous saying by him that at the Last Judgment a curse will fall upon the *musavvirs*, that is, people who make large images and pictures. They will be told: 'Like God, you have created beings (figures), so like God, breathe life into them.' Together with the stern prohibitions, cases are also cited in which Muhammad permitted a piece of pictured fabric to be kept in the home, provided it was torn and not used for idolatrous purposes but rather for something like cushions which people didn't treat in a 'respectful' manner.

Gradually the representations were suppressed until they were no longer seen as a dangerous temptation for Muslims. This led to a beautifully written legend. One of the Prophet's most pious supporters, his uncle Idi 'Abbas, once saw a person making an image. He laid his hand upon the man's head and repeated the words of the Prophet, that the fires of hell would be the lot of sculptors. Then he added, 'If you really must do this, carve out a tree, or something which has no soul.' These words admirably express the essence of the earliest period of Islamic art – the transference of the creative artistic inspiration to another sphere than that of Christian art. The suggestion of Muhammad's uncle was taken almost literally. That this was so is illustrated by the trees that dominate in the mosaics of the Dome of the Rock

in Jerusalem (*see ill. 2, p. 17*), the Umayyad mosque in Damascus (*see ill. 3, p. 18*) and the baths in the palace of Kirba al-Mafjar, near Jericho on the west bank of the Jordan.

Influenced by monotheistic inspiration, the abstract art of ornamentation was given a kind of social mandate and became the main formula of artistic creation and the chief method for expressing the ideas that were currently active in society.

The art of the elite

At the same time, this didn't mean the complete rejection of visual art as a means of creating aesthetic pleasure. In the art of the Umayyads we find, together with the non-pictorial mosaics of the mosques, frescoes in the reception rooms and baths of the castles of Qasr Amra in Jordan and Qasr al-Hayr al-Gharbi near Palmyra in Syria, and relief carving in the palace of Khirba al-Mafjar (see above). Clearly, images were permitted in places with a recreational function where they offered no religious threat. Thus pictures became associated with the everyday life of the ruling class, with the culture of splendid banquets, lavish festivities and sumptuous luxury. In this light, the finds from the Abbasid capital of Samarra' (Iraq) are highly characteristic. The remains of a palace were excavated there, used almost exclusively for entertainment of the caliph and his followers. Here pictures were found showing female dancers, and shards from an earthenware wine jar had illustrations of a monk.

A fine example of the link between the visual nature on the one hand and riches and luxury on the other, are the miniatures found in books. Illustrations first appear in Islamic books only when they have a practical necessity, such as treatises on the stars, writings on medicinal plants, and 'do-it-yourself' handbooks on how to construct ingenious apparatus to entertain party-goers (*see cat.no. 85*). Books about animals and plants, and collections of fables (such as the 13th-century Kalila and Dimna from Iraq) could also be illustrated with no problem. In the 11th century a school for illustration of artistic products was founded in Iraq. The entire, quite considerable repertoire of illustrative miniatures derives from a small quantity of basically non-religious art objects.

The chief of these were the *Makamat* (Sayings) of al-Hariri (1054-1122). The literary genre of which they form a part is highly individualized and is important for an understanding of Islamic culture. In principle these stories have much in common with picaresque novels: the storyteller encounters the main character, the trickster Abu Zaid in various places and observes how in different ways he cajoles people to part from their money. This essentially popular literature is written in a highly vivid rhythmical prose and saturated with the most unusual vocabulary and complicated allusions. It contains many verses, as is common in Arabic literature, which come across as somewhat trivial in contrast to the weighty prose. The beauty and subtle humour of these works can only be appreciated by those with considerable education and even they need to have a commentary and dictionary. Because of its refinement and virtuosity, reminiscent of Islamic ornamentation, the *Makamat* became the literature of the educated and wealthy. Sumptuous manuscripts were produced for them, containing brilliant miniatures showing scenes from daily life which today provide us with a combination of elegant composition, colouring and draughtsmanship, giving exclusive information about the customs of the medieval Muslim.

Illustrations were created for a situation in which they were non-threatening (to monotheism) and became part of a certain lifestyle. This wasn't a conscious process. In Islamic society the spiritual and the temporal gradually became separated, despite all the theory to the contrary. This happened first in the realm of learning where the distinction was connected with the power-sharing between the caliphs, who represented spiritual authority, and the sultans who saw power as the prerogative of the (physically) strongest.

After the Mongolian conquests the traditions of book illumination flourished in the Persian section of the Islamic world. Miniature illustrations framing handwritten texts became one of the major cultural phenomena, a means of reflecting Iran's artistic past. In Persian miniatures an illustration became almost ornamental, or abstract, and developed into one of the characteristics of Islamic art. The books, however, remained luxury items because it required so much

effort to make them and were only accessible to a limited range of people.

The representation of living creatures

For the masses, who were the main supporters of religious fanaticism and who had both the intention and pretension of being strictly pure, to draw pictures and make representations remained wicked. In this group it wasn't long before there was a complete prohibition against the representation of living creatures. This was confirmed by the sentences of the theologian and severe judge, Ibn Taymiyn (1263-1328). He strove against idolatry in all aspects of life for it seemed to him as if this pernicious phenomenon once again had the world in its vice, threatening the very foundations of Islam. From time to time the conviction that idols were unacceptable and dangerous became a major topic of importance in the Muslim world. It is an issue which reappears regularly, and will certainly do so again.

In the Petersburg manuscript of the *Makamat* every figure in the miniature illustrations has its head cleanly cut off. This was how a religious Muslim ensured that these figures weren't worshipped as idols. But before censoring him too strongly, we should be thankful that he only cut out the heads – in this way the rest of the manuscript has been preserved. After all, he might simply have burnt the whole thing.

Meanwhile, in the world of the middle class, illustrations of people were accepted provided they formed part of the ornamentation and conformed to the canon and the rhythm – that is, didn't draw too much attention to themselves individually. Initially the ornamentation also contained animals, subsequently the figures of horsemen appeared (huntsmen), imperial courtiers, musicians and singers. Scenes from the life of aristocrats merged fluidly into a general ornamental illustration of the world, as created by God. A major aspect of the ornamentation were furthermore the illustrations with magical significance, drawings of the zodiac and heavenly constellations made on ceramic objects, bronze ewers and boxes and silver beakers. Like the benedictory inscriptions they were intended to grant the ruler

eternal fame. The small human figures found on pottery, especially Persian and Fatimid Egyptian, were in a sense part of the ornamental language, comparable with the vine leaves in an arabesque. Nevertheless they have many artistic characteristics of their own that provide us with the possibility of categorizing and studying them as artistic products in their own right. In doing this we can consider closely the way people both accepted and rejected the doctrine.

It was the application of the law in daily life and with it the invulnerability to religious temptation that made possible the development of an independent three-dimensional Islamic art. In this we find different types of ewers, incense burners, fruit dishes, candlesticks and suchlike that adorned the festive tables of wealthy Muslims. We can only guess at how these feasts would actually have been. However, it would appear that figures of creatures such as eagles, ducks, and game birds, lions, cows being devoured by leopards, horses, roosters, deer and stone griffins were intended to add a lively touch to the banquet scene. Rich and intricate motifs were carved out or inlaid. And often two-dimensional images flowed together with arabesques across the surfaces of huge platters, jugs and buckets.

Whoever wishes to may refute the hypothesis concerning the prohibition by Islam against making images, if they produce examples similar to the ones just mentioned. However, the exceptions confirm the general rule. Islamic art is iconoclastic. It doesn't permit any image in the realm of religious art, so that in many different ways the dogma of the indivisibility of God is maintained in the face of the temptations introduced by idols. Where images of people or animals are found they play a subsidiary role either as an aspect of a strongly developed ornamentation or serving the limited areas of scholarship and everyday life.

The profound aesthetic feeling that is connected with the monotheistic conviction, is one of the chief spiritual cornerstones of the art of Islam.

4 *Art for Everyday Life*

Almost everything that goes by the name of Islamic art (with the exception of architecture) has a link with what in Europe is classified as Applied Art, that is, objects used in everyday life. In the previous chapter we saw how the religion didn't tolerate any form of image in its propaganda programme. It created delight with the impressive and elegant architectural shapes such as domes, intricate mazes of pillars, endless rows of arches, richly alternating with niches and carving. The walls of the mosque were covered in compact or isolated carved patterns consisting of rosettes, shells and polygonal compositions with arabesques. Carved inscriptions encircled the base of the dome.

In religious buildings the walls were covered with mosaics, glittering mysteriously in the light of many lamps. They would also be decorated – at first partially and later completely – with tiles and flower motifs in marble. These acted as a reinforcement of the chief ornamentation which was inscriptions in praise of Allah and elaborate and extravagant curls and whorls of plants, creating with their shapes and patterns a remarkable impression of depth. The two main items in the interior of the mosque are articles of applied art: lamps hung in abundance in the arches and the niches, while carpets glowing with coloured patterns covered the floor. The carpets are in the first place used for prayer: they show the picture of a niche with a lamp hanging in it. Sometimes the mosque contains huge candlesticks or torchstands which are carried in processions.

The interior of a mausoleum resembles that of a mosque, except that it also contains tombs with their inscriptions and decorations. Palaces and ordinary houses., like mosques and mausoleums, are sparsely furnished and have richly decorated walls.

There are two other items used to decorate the Islamic home, which may or may not have a religious purpose: these are water and the garden. In the mosque water has a ritual function: before praying people have to perform a ritual washing of hands and feet. In the palaces and larger houses we find basins, small channels and pools of water which, together with flowers, plants and shady trees create shadow and companionable coolness and in their own way provide an extension of the ornamentation that decorates the walls.

In such a setting, beauty and utility were combined, and produced a vast number of monuments to Islamic art. Almost all the objects that are discussed here, both the comparatively everyday and the world-famous pieces that represent the most intricate master-work, were intended to be seen from close quarters or indeed to be handled. Without this, it is impossible to gain a true understanding of the beauty of Islamic art. The objects ask to be felt, held up to the light and gently revolved while their admirer attempts to decipher the inscription, or to make out the details of the decoration, the shapes, the intricate arabesques and elaborate flourishes of letters, an animal peering through the foliage. This is the secret of the delight that is created by viewing Islamic art. And indeed not only delight, for the applied art of Islam contains references and reminders of a life that transcends the everyday.

Gold and silver

Let us begin with gold and silver. It is generally held that the Qur'an condemns the use of gold in daily life as being too luxurious. Indeed, the Qur'an criticizes vast riches and luxurious living but nowhere does it explicitly condemn gold. In fact, as is the case with many things that are unacceptable in this earthly life, the righteous believer once in Paradise will bathe in the heavenly variations of those very things which on earth were forbidden. And in this list we find, as well as 'wine that makes not drunken', precious metals and jewels.

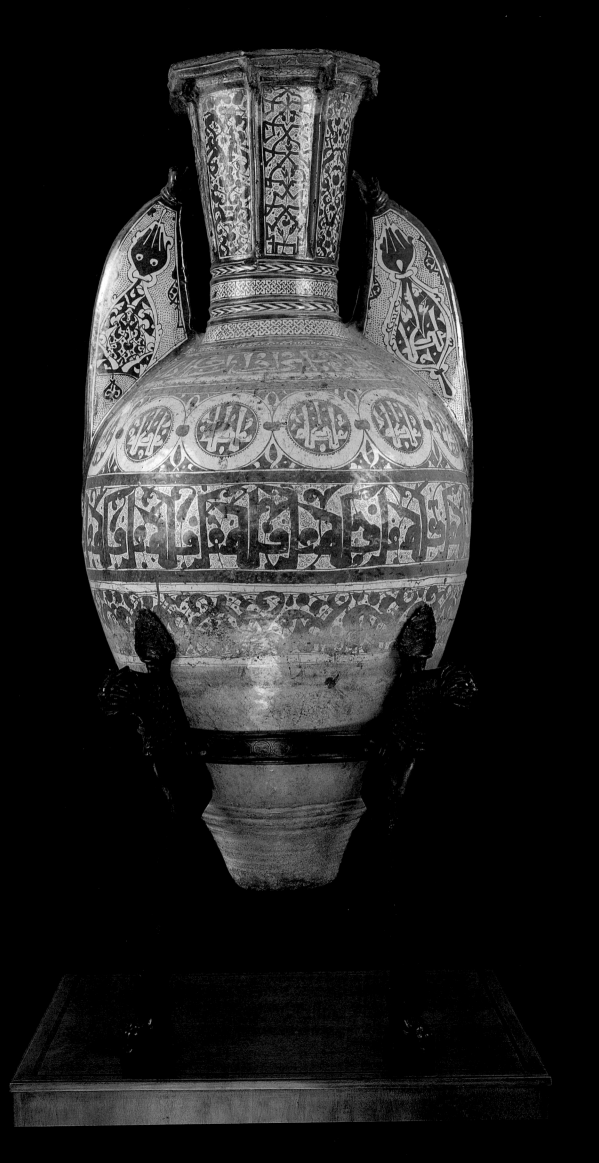

Objects made from precious metal and jewels have only survived in small quantities for they were often melted down. Early Islamic gold (meal) services are thought to be a development from Sasanid objects and became gradually more intricate and elaborate. Gold goblets and beakers would be presented as gifts and guarded in treasure houses. In most cases, early examples of such objects no longer survive, but in museums the world over we can find a large number of objects from more recent periods, from the Safavids (ruled in Iran 1501-1730), Mughals and Ottomans. Many types of domestic goods were made from gold to enhance festive celebrations. Gold jewellery proves eternally popular. Of particular interest is the gold jewellery for women with filigree and ball decoration, dating from the time of the Fatimids. In the days of the Safavids and Mughals it became fashionable to enhance the jewellery and domestic ware with precious stones such as rubies and emeralds. The glittering of precious stones is a well-known image favoured by the mystics, one element of that holy ecstasy experienced as a person approaches the presence of God. Even when precious stones were used to decorate daggers and swords, their glittering retained an added, unconscious message relating to the riches of Paradise, where their luminous colour is a reflection of the divine Light.

Silver, with its soft sheen, was a favourite material among jewellers in both the Near and Middle East. Artists from Sasanid Iran and Byzantium, the most notable predecessors and inspirers of Islamic art, created wondrous objects. Silver beakers, for which the Sasanid empire was famous, were copied in the Muslim world. These beakers are the earliest objects to be decorated with the iconography of the imperial feast, which developed into one of the main set themes in Islamic art. The beakers themselves were used at banquets. The famous Arab poet Abu Nuwas (c.756-c.810) has left poems describing how the frothy wine bubbles in the beaker and from that froth arise warrior figures who are etched upon the base. Both the wine and the human figures were forbidden, but were certainly to be found in the world of the nobility. Art often flourished on the borderland of freethinking. More and more plants and wild animals

appeared decorating silver services, on the platters used for serving fruit, on exquisite gifts and as general decoration. Often silver coins would be collected inside a silver beaker. Small beakers bearing the image of the ruler would be made to commemorate a specific occasion. Silver was an easy material to work with and an excellent surface on which to engrave inscriptions. These are to be found, together with plant and animal decorations, on trays and various types of carafe and vessels for scented water.

Gold and silver coins should also be listed among the works of art. On classical examples only the inscription appears, containing a couple of *ayas* from the Qur'an, written in the strong harmonious Kufic script. These would be clear and easily decipherable admonitions, formulas emphasizing the importance of monotheism and the mission of the Prophet. The date and place of production would also be given, and sometimes the ruler's name. Horizontal inscriptions would be written inside a small circle, usually at the centre but sometimes on the edge. Clearly, as well as being symbols of the ruler's power (the official function of such coins) these objects also served as talismans because of their pious inscriptions. And it is presumably partly for this reason that before long coins became part of women's jewellery throughout the Islamic world, although undoubtedly just as important was the recognition of their aesthetic quality.

Inlaid bronze
The glorious glittering of gold and silver was without doubt not only a reflection of their preciousness but also of the world to come, of the overwhelming beauty of the Divine Presence. As such it found an echo in the objects of art made out of other materials. Bronze items formed the most important artistic production of the Islamic world. Different bronze alloys, sometimes brass and sometimes copper, were used to make beakers, large trays, ewers to hold water for washing the hands, and incense burners, candlesticks, large containers for washing hands and feet, and inkpots for scribes. The surface of domestic ware was elaborately decorated with inlay. Fine copper, silver or gold wires were inserted into narrow

◀ cat.no. 150

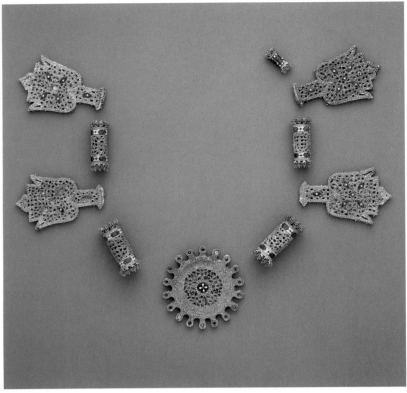

Cat.no. 271

were produced. Although made from relatively simple materials the objects became no less costly than those of silver or gold. Even today, these ceramic works, with their various types of glaze and strewn with illustrations in many colours, still amaze and delight the eye. The Islamic world has given us a wide range of ceramic masterpieces of many kinds. In the 9th century a beautiful type of pottery with a white glaze was produced in Samarkand (Transoxiana, now Uzbekistan) and Nishapur (Khorasan, now Iran); it clearly imitated – and not without success – the exquisite porcelain of China. Across the white background flow circles of sober black or dark brown Kufic script (*cat.no. 23*). The message of these texts is often Chinese in nature – wise sayings about the value of such virtues as patience, studiousness, gentleness and so on. In the centre will be an elegant vignette containing a blessing for the owner of the object.

grooves. Calligraphic and plant designs were used in ornamentation which pictured animals, astrological signs, tableaux and banquets, or showed hunting and battle scenes. The amazing delicacy of the artisanry turned many of these pieces into the most precious works of art. The most exquisite of them were just as costly as silver objects. In the bronze works from Iran and Central Asia we detect the rich traditions of China and India, while the bronze inlays from Syria and Egypt achieved a remarkable degree of refinement. Bronze domestic ware is among the most well-known product of Islamic art, striking examples being the so-called Bobrinsky Bucket in The Hermitage (*cat.no. 114*), the Baptistère of Saint Louis from The Louvre, and the Vescovali Vase from The British Museum. Such objects contain a wealth of miniature illustrations that teach us details about the daily life of the medieval Muslim. They also illustrate generally-held concepts about life on earth and in heaven whereby everything is subservient to the will of Allah.

Ceramics

The divine sheen is also an aspect of Islamic ceramics. Just as in the manufacture of metal objects, so here too articles of high quality and extreme complexity

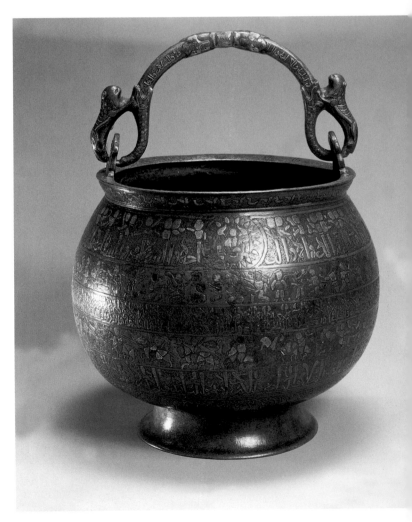

Cat.no. 114

Another famous type of ceramics, first developed in Iran, is the lustreware in which a metallic sheen is produced on the surface after firing and combining with sulphuric acid, copper and silver. There are various ways of decorating this lustreware with ornamentation and illustration, and often it carries lines from Persian poetry in cursive script. Sometimes it was produced in the form of large vases, bearing relief illustrations showing animals and mounted polo players, as on the large vase from The Hermitage (*cat.no. 149*). A masterpiece in this genre is the Fortuny Vase (*see cat.no. 150, p. 38*) made in Granada and wondrously decorated with mysterious plant ornamentation and Arabic inscriptions in various scripts ranging from a sturdy Kufic to an elegant Spanish Arabic. Lustreware was extremely popular in Islamic Spain and remained so after the expulsion of Muslims from the country, when production was further developed under Spanish and Italian masters. A fair number of famous pieces of this type of ware came from north Africa. Of particular note here are the Egyptian dishes from the 11th century, the period of the Fatimid dynasty. With their sobriety and precise illustrations, charming pictures of musicians, dancers and animals both real and fabled, they are a wonder and delight.

The technique of enamelling (*minai*) gave rise to an unexpectedly delicate type of ceramic ware. Their lyrical light blue colour fits perfectly the content of the illustrations: langourous maidens with moon-shaped faces, elaborately refined young men, verses from poetry and suchlike.

The Ottoman period gave the world the glorious Iznik pottery. These dishes and vases have the most exquisite decoration, painted wreaths of flowers and plants in blues and reds often appearing almost to have a three-dimensional quality.

Ceramic tiles are an exceptional and most important category. Used to adorn both the inside and outside of buildings, as in Samarkand, Isfahan (Iran) and Karbala' (Iraq), they bear a wealth of motifs and inscriptions. They brought a distinctive character to the architectonic decoration found in the eastern part of the Islamic world. Typical for these tiles is a light blue colour and a predominating vegetal decoration,

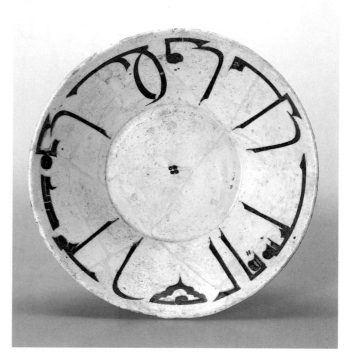

Cat.no. 23

together with inscriptions. In Spain and north Africa ceramic tiles were also produced, darker, many coloured and more geometric in ornamentation.

Ceramic decoration in its various forms gradually began to predominate in Muslim artistic work in the 13th and 14th century. It is indisputably a magnificent expression of some of the fundamental aims of Islamic art: to bring balm to the sight, to presage coolness and rest in the desert.

Rock crystal

Nowadays, when there is so much manmade crystal on the market, it is sometimes difficult for us to imagine the enormous value that objects of rock crystal possess. To begin with, it was necessary to find large crystals of this rare stone. This done, craftsmen carved out jugs or other objects with thin sides, and decorated them with motifs. Crystal is extremely hard and therefore extremely breakable. Thus services made from rock crystal are rare and very valuable. The crusaders from Europe knew this very well. They perceived such objects as the most costly of prizes and brought them home, often offering them to a church. Indeed, the finest examples of carved rock crystal from Islamic countries are often to be found in west European church treasuries.

The light is broken in a wondrous manner by rock-crystal objects and they seem to hold it nestling in their centre. They bring a mysterious glow to natural light as if it shines from another world. A rock-crystal lamp suggests an intangible fire and when liquids are poured into a rock-crystal jug they change into something inscrutable and unfathomable. Some of the crusaders perceived this as a reference to the Cup of the Holy Grail. The exalted character of the material gave rise to a legend that recounted how Muhammad lay buried in a crystal tomb that hung in the air. These stories transmit some of the excitement the Europeans must have felt on seeing the creations of Islamic artists. And they reveal to a large extent that the Europeans and the Muslims had the same ideas about the beauty and value of rock-crystal objects.

In the Islamic world view, light is a major element. This is even more so for the *sufis*, the Islamic mystics who held that people can approach closer to God and can attain a state of ecstasy if they lead a pious life and follow certain rules and rituals. They often describe a strong sense of the presence of God as a sensation of light, piercing through the darkness of the everyday world. In this connection they point to the famous verse from the Qur'an, the *aya* of light ('ayat al-nur') which speaks expressly of this light (S. 24:35):

> God is the Light of the heavens and the earth
> The parable of His Light is as if there were a niche
> And within it a lamp:
> The lamp enclosed in glass
> The glass as it were a brilliant star
> Lit from a blessed Tree
> An Olive, neither of the East
> Nor of the West,
> Whose oil is well-nigh luminous
> though fire scarce touched it:
> Light upon Light!
> God doth guide whom He will
> To His Light:
> God doth set forth parables for men:
> And God doth know all things.

Light as a symbol for Allah was one of the central elements of Islamic art. The expression 'mishkat al-nur' (a niche where there is light) became widespread and found its way into the titles of mystic texts. In the mosque there is an actual niche containing a light, called a *mihrab* which points the direction of the Black Stone of the Kaaba in Mecca. Towards this stone all Muslims turn in prayer, wherever they may be in the world. The symbolic light in the niche is provided by a lamp that is generally hung in the mihrab. This concrete light forms a concrete illustration of the verse (aya) cited above. Another reference to light is found in the prayer rug which generally shows a picture of a niche with a hanging lamp. There is often a vase of flowers beneath this, as an allusion to the gardens of Paradise. The whole picture has a double message: the mihrab in the mosque guides the believer into the ritual of prayer, and at the same time leads through the doorway of this world, into Paradise beyond.

Glass

The play with light is a characteristic of the glass objects for which the Islamic world is justly famous. These include remarkable pieces of cut glass made in imitation of rock-crystal, and blown glass with graceful arabesques, sometimes adorned with inscriptions. Even more widespread were the various types of painted glass whose surface would be covered with colourful figures and motifs in enamel and made into beakers and goblets of varying size. But the most typical Islamic glass objects are the large oil lamps. These are the lamps pictured on prayer rugs, the kind that hang in every niche of the mosque. The lamps, that have a definite religious-mystical significance, are considered to be a sign of wealth and piety. Moreover they would be presented not only to mosques, but also as gifts to private persons.

In Syria and Egypt under the Mamluks remarkable lamps were produced. They were large pieces of glass with a wide uncovered neck. Across the base, usually in blue enamel, colourful inscriptions would announce the name of the donor or the recipient, set amid a luxuriant branching plant motif. It is not uncommon, especially on lamps, to find heraldic devices from the 11th to the 13th century referring to the rank at court of the person in question – the

Cat.no. 246 ▶

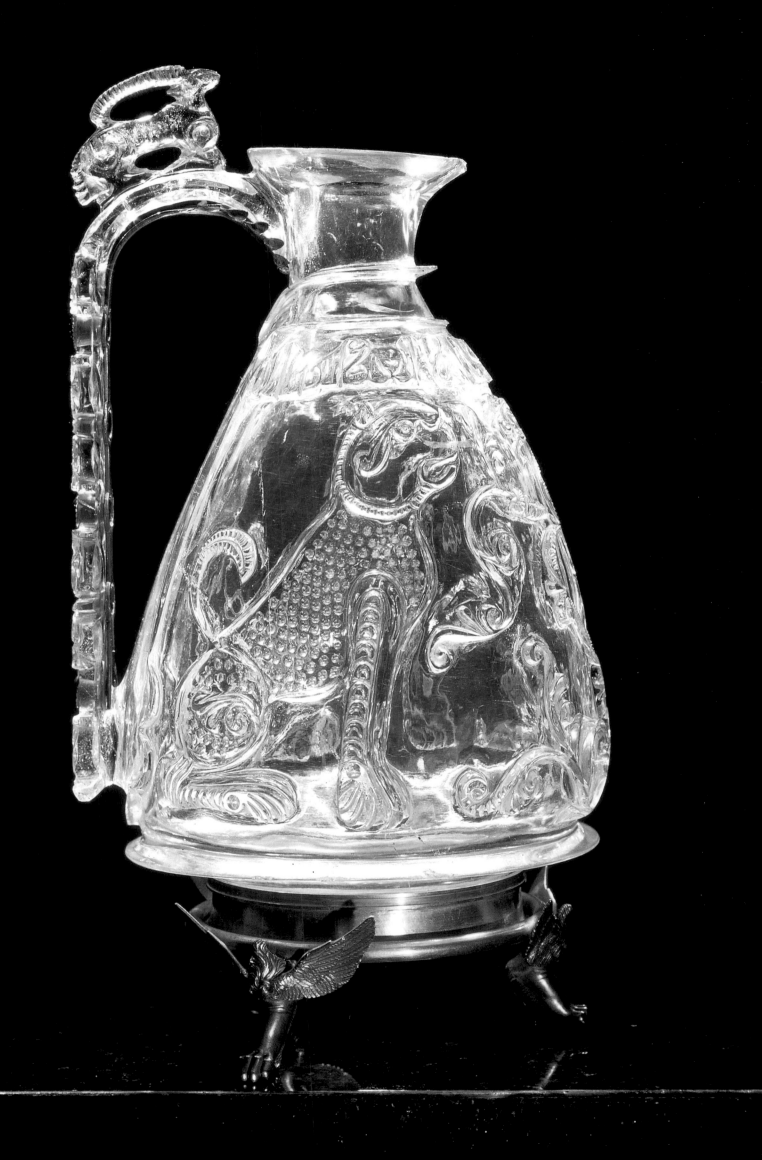

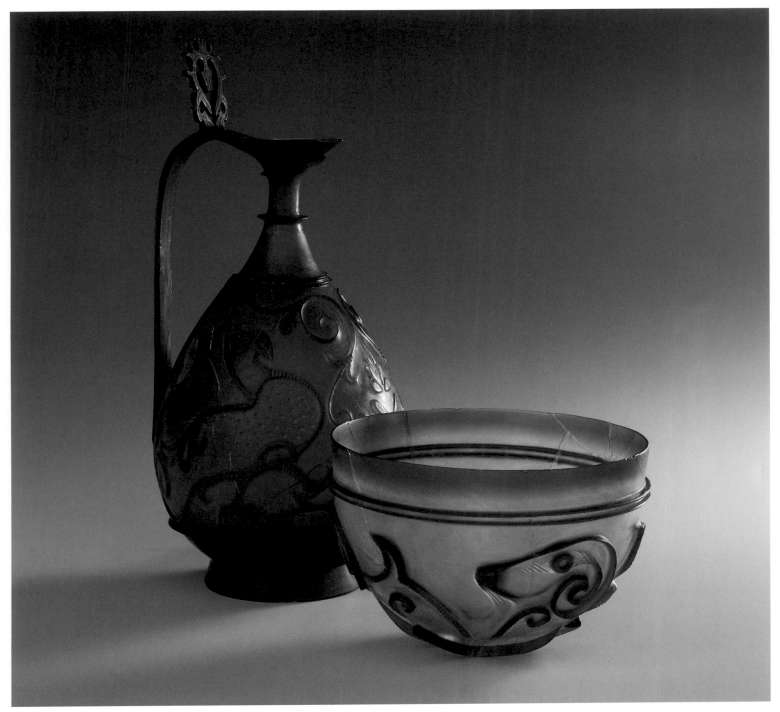

Cat.no. 171 (r.) and cat.no. 172 (l.)

sultan's shield-bearer, cupbearer, and suchlike.

An unusual type of domestic ware was the container for scented water or for incense. Some of these, decorated with fine fretwork and enamelling, would be used as receptacles and others – especially those with a long narrow neck – were used for dispersing rose-water (*cat.no. 168*). Pleasing fragrances played an important part in the daily life of Muslims and became part of their artistic world together with such

natural phenomena as gardens, flowers, fountains and song-birds.

Carpets and textiles
No product of Islamic art is so characteristic or so common as carpets. They are to be found in homes of every social level and in buildings of every type, whether they be mosques or palaces. They cover the floor, they give structure to the entire life of the Muslim, from birth to grave. The carpet is the surface

upon which they play, pray, eat, sleep, and converse with friends. Different patterns and techniques in carpets provide convincing illustration of the ever-changing marriage of unity and diversity in the Muslim world.

The figurative world of the carpet is vast. The main distinguishing features of all carpets – be they Persian, Turkish, Caucasian, Maghribi or other – are the different combinations of plant and geometric motifs. For example, the plant motifs may become more geometric, and the geometric motifs may sprout curls and twirls. Often the geometric pattern derives from a symbolism from pre-Islamic times or from specific districts in the Islamic world. Plant ornamentation may have varying degrees of abstraction. It is some-times extremely complex, forming part of an overall rhythm, but then again, especially in Persian carpets, there are recognizable plants, mingling in a luxuriant flowerbed and creating the appearance of a garden (*see cat.no. 192, p. 47*). In some cases there is appro-priate staffage in these gardens – peacefully grazing animals, or wild creatures prowling after the unsus-pecting ones. The next step is the appearance of the huntsmen, in their turn attacking both the wild lion and the peaceful antelope. The so-called garden carpets contain schematic pictures of not only trees but also rivers and ponds (sometimes with fish). All these things might be presented in a highly stylized manner, so much so as to become almost unrecognizable.

In contrast, the prayer rugs mentioned above show an almost realistic picture of part of the mosque, while at the same time providing a symbolic represen-tation of certain 'doorways' into the presence of God. The carpets contain almost all the artistic principles of Islamic art and almost its entire iconographic reper-toire. To a large extent they may be seen as the classic example of how to answer the question: 'What is Islamic Art?'

Islamic weavings have given the world a large number of most beautiful works of art, of two types. The ancient Sasanid tradition was continued in luxurious weavings, mainly from silk. The flam-boyance and extravagance of the designs on these fabrics make the intricate carpet motifs pale by comparison. Textiles triumphant with huge plant and flower compositions, vast 'heraldic' shapes of lions, eagles and elephants, and richly filled medal-lions were the undeniable symbols of wealth and power. They were more valuable than gold or silver and formed an admirable gift for princely rulers. In the late Middle Ages the designs became more complex and the embroidered textiles would often be illustrated with thematic pictures, for example scenes from the 12th-century Persian poem *Layla and Majnun* by Nizami Ghandjavi, or the figures of people dancing and making merry. These textiles would often be made into garments with a severe design and elegant noble inscriptions of benedictions, and they recalled the royal workshops where the textile had been produced. The weavings from 11th- and 12th-century Syria and Egypt are possibly the best-known. They are called *tiraz* (from the Persain word for embroidery) and were made in special state work-shops. The name of the workshop and often the date, would be mentioned on the *tiraz* in the same way as on coins. And like coins, the *tiraz* served to demon-strate the power of a ruler. It was a special privilege of power to grant the right and means to produce works of art at the cost of the state. These works were then presented to warriors who had distinguished themselves in battle, to scholars and to poets.

Patronage and the marketplace
Court patronage, in some cases state commissions, was an important aspect of the social structure sup-porting artistic production. Attached to the largest courts there would be entire districts where artisans lived, working for the rulers. The patrons of art were rulers and functionaries of all levels. The system was maintained partly through the custom of donating gifts. Those in a higher position rewarded those below them who in then returned the gesture by honouring their superiors with other gifts.

Many gifts and beautiful objects were presented to the mosques and institutions dedicated to God. Islamic society supported the custom of *awqaf* (plural of *waqf*), donating possessions for pious ends. In many cases a waqf would be a beautifully decorated manuscript, a silver-inlaid bronze candlestick or torchstand, or a lectern for the Qur'an made from wood and ivory. The ornamental inscriptions

decorating such objects preserve for posterity the names of both the donors and the recipients. And not infrequently the artist would confidently announce his own name, placing it in a prominent position. The Islamic artisans occupied a secure position in the hierarchy of urban life where the focal point was formed by the marketplace, serving both the aristocracy and all layers of municipal society.

In addition, objects were produced for the free market. Some of these were articles on which the benedictory inscription contained no name. In some cases the name was added later to a work that was finished. Thanks to the huge demand for applied art objects there were bodies (like guilds) of artists, headed by the calligraphers who were given the greatest respect and honour. In the production of an object tasks became separated – a different craftsman would, for example, make the inlay on a work, or decorate a piece that had been produced by another group of craftsmen.

Medieval and post-medieval Islamic society was highly urbanized. The city was the place where the aristocracy was always present and was a comprehensive centre for trades and crafts. Consequently there was considerable social mobility, an absence of sharply delimited lines between social classes and a comparatively large middle class. With respect to art this could be seen in the fact that a great deal of art production was directed towards an extremely wide range of the public with their associated broad spectrum of tastes.

This didn't mean there was no elitist art. It certainly existed, open-minded and extremely luxurious, to be found only at the most sophisticated courts. This explains the existence of illuminated manuscripts, frivolous frescoes and opulent garments. However, much of this sumptuous work has a more accessible equivalent. The general stylistic principles were the same whether work was produced for palace or market place. The basic elements of the artistic language did not change. Indeed – the upper middle class, consisting of wealthy and socially active merchants – would often fill their homes with the same sumptuous objects as the nobility. A good example of this is the Bobrinsky Bucket *(cat.no. 114)*.

The nature of the images it contains, the aristocratic banquet with the riders playing at polo, certainly suggests a noble client. The object is, however, produced as a gift for an important tradesman. The convergence of tastes from differing social classes, the mutual expansion of taste, had the result that many of the art objects were suitable for a cultural middle class, somewhere between the nobility and the uneducated masses. This 'democratic' aspect of medieval Islamic society should be remembered when we are considering Islamic art. Even with all their sumptuousness and costliness the examples that we know of present us with a wide cross-section of culture. The artistic language that they spoke was understood by many.

All domestic ware was subjected to a common artistic style. This appeared in the most everyday objects since in principle even the most luxurious of these was intended for everyday use.

By handling and using these objects people encountered and came to recognize their beauty so that gradually, the message that the artist had implicitly instilled in his work, was transmitted to those who acquired it. At the highest level, this meant that the quality of the work was increasingly appreciated by the viewer or user the more they handled the object or looked at it. The next stage was the layer of inscriptions which were read – often not without difficulty. There followed more profound experiences, when the patterns and their rhythm aroused certain feelings flowing from the Islamic view of life. Like all medieval art, that of Islam was saturated with deeper meanings. However, these were seldom expressed in concrete images, as in Christianity. They could be understood because they made reference to certain fixed ideas and feelings about the unfathomable God whom people could approach, and to the delight in the divine creation, and to the blessed realms of Paradise that would be reached at the end of the world after the Day of Judgment.

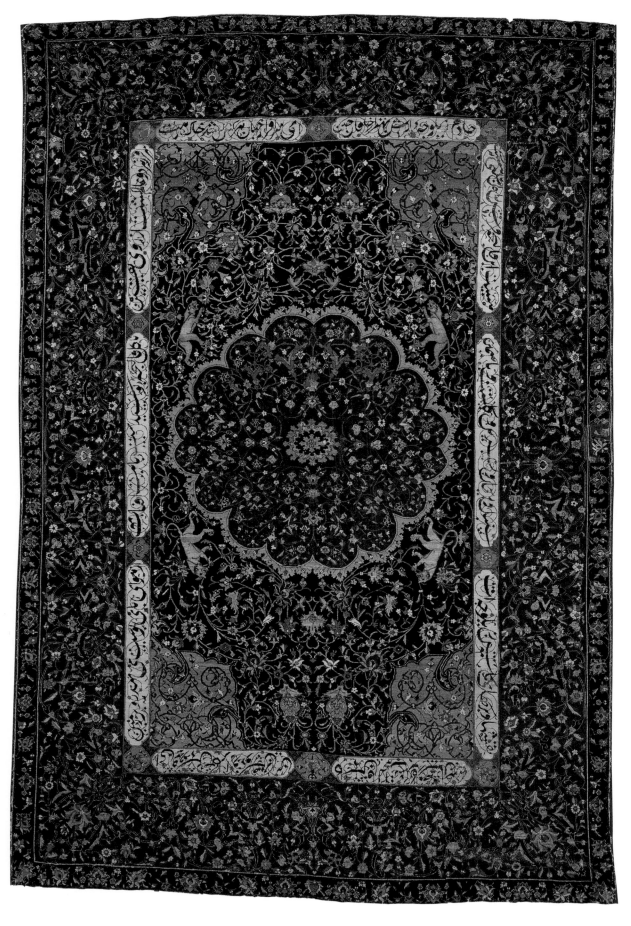

Cat.no. 192

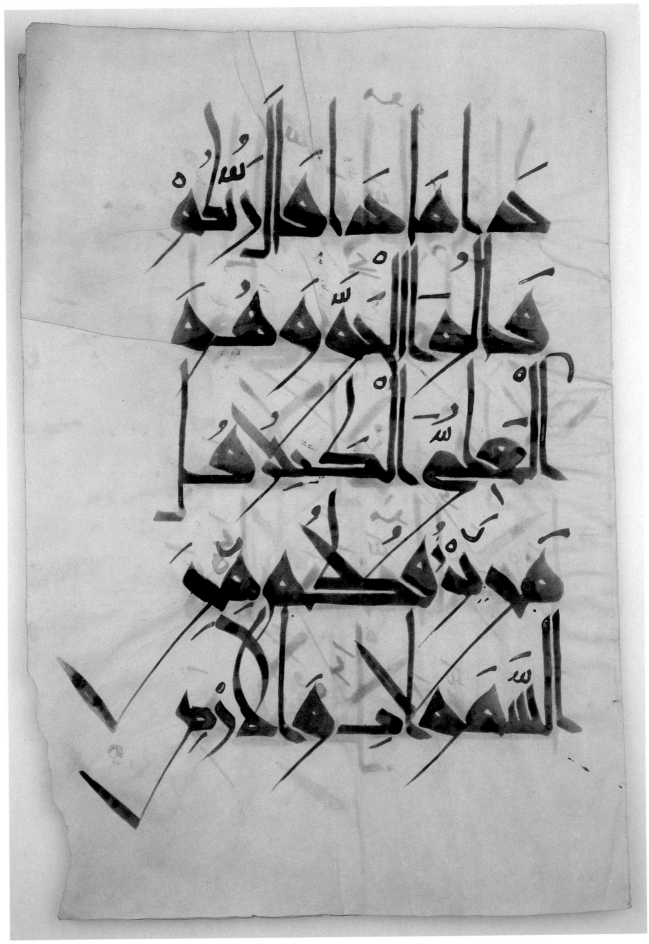

Cat.no. 56

⁵ *The Qur'an as source of all inspiration*

The Qur'an is the source of inspiration for everything a Muslim does and feels. This holy book comprises ideas and principles out of which Islamic society has developed its laws, rules of conduct and system of values.

The Qur'an contains no direct statements concerning either art or the artistic process. However, the text itself is of great artistic value and quite clearly contains the sources and examples of which much Islamic art, not only the literary, makes abundant use.

To Muslims, the Qur'an is Allah's greatest miracle, given to His Prophet and by him to all humankind. The language of the Qur'an is that in which Allah spoke to Muhammad. What God revealed to Muhammad by means of his messenger the angel Gabriel (Arabic Jibril or Jibra'il) was passed on by the Prophet to his followers in the form of sermons. Initially these were stored in the memory and delivered orally, to be later committed to paper. In this way the material, earthly version was created of the Holy Word which is a divine phenomenon existing in heaven.

It goes without saying that the language of God, as we should call the text of the Qur'an, is by definition beautiful. In Islamic religious literature there is a distinct category of essays that concentrates on analyzing the stylistic and linguistic beauty of the Qur'an and posits that it is inimitable. For the book is indeed unique, containing as it does sermons that were created in a state of ecstatic inspiration, taking the form of rhythmically shaped prose.

As artistic product the Qur'an is unique in Arabic literature, in which it has no equivalent, either from before or after the call of Muhammad. The text can neither be repeated nor imitated. Indeed, to imitate it would be considered a grave sin.

However, the Qur'an has special stylistic and artistic features which influenced the development of Islamic art. The text of the Qur'an is richly and almost excessively 'decorated'. It is highly ornamental with its many repetitions and various associations, either immediate or secondary. On the whole the text lacks a narrative flow and is moreover often interrupted by emphatic statements or emotional passages. All this is in keeping with Islamic ornamentation. However, the Qur'an is even more passionate and emotional – it is an ecstatic text, streaming in an uninterrupted flow from the mouth of the Prophet. Here it should be noted that this ecstatic quality is apparent not only in the early *suras* (where there is an emotional tension connected with the prophecies concerning Judgment Day and the terrible doom that will ensue) but also in the later chapters (which present the laws and rules governing daily life).

The verses (*ayas*) of the Qur'an are clear in their substance and always well rounded off. They may be moved from one part of the text to another without losing their meaning. Throughout the text of the Qur'an there are comparable or even identical formulae which combine to give the effect of a specific semantic and artistic background. We do well to remember in this context that the repetition of the name of Allah and of blessings is held in Islam to be a devout and pious act.

Repetition is a characteristic feature of qur'anic prose. It serves both to honour God (in the nature of a prayer), to emphasize a certain message, and to embellish the text. The repetitions have their own rhythm which may change in different places in the holy scriptures.

The embellishing words do not always hold an immediate meaning. In many ecstatic, finely-worded sentences we find expressions that are almost impossible to understand, and newly-coined words. The Qur'an often gives a special explanation of these. This element of incomprehensibility increases the

incantatory effect of many sentences. A great many of these were used later as talismans, as a protection against misfortunes and the Evil Eye. Another factor that makes the text mysterious are the incomprehensible mixture of letters at the beginning of many suras, such as *'alif lam ra'* (15th sura). There are many theories regarding their original intent. At all events, for the majority of Muslims they were obscure, but God's Word and as such holy. Thus they were inscribed on objects such as weapons.

The structure

In general, a qur'anic text is specific and strongly constructed. The basic unit is called an *aya* (meaning 'wonder') and is a more or less separate verse, but written with the appearance of prose. In fact, they are not actual verses, since the text of the Qur'an isn't a poem. And although it is chanted aloud in a sing-song fashion, it is certainly not a song. In fact, it may be said of the entire Qur'an that it reminds you of many things, but is never quite the same as anything else.

The text of the Qur'an, sent from heaven to earth, was first committed to memory by certain people and then written down. It was a disorganized text, without a definite beginning, middle or end. People set it down in a harmonious and highly formalized structure. Single ayas were placed together in a separate sura. Critics may however place question marks beside the manner in which this was done. All the suras, whether they be long or short, contain a selection of fundamental sermon devices. For example, there is always a narrative element, exhortations, exorcisms, explanations and 'hymns'. In each sura almost all the chief ideas in the holy writing appear and are always, albeit often in a most unexpected way, linked with each other. Thus one sura resembles a Qur'an in miniature.

Every sura begins (there is one exception, sura 9) with a formula reminding people of Allah's sovereign power and goodness, 'In the name of God, Most Gracious, Most Merciful.' In Arabic this is known as the *basmala*. Every sura has its own name, most of them appearing somewhat strange and esoteric, such as 'The Cow' (2nd sura), 'The Spider' (29th), 'The Elephant' (105th), 'The Smoke' (44th), 'The Sand Dunes' (46th), or 'The Adoration' (32nd, officially

called 'The Prostration') and 'The One Wrapped Up' (74th). In most cases such a word is characteristic of that sura. On closer examination it appears to be in no way coincidental, for it defines the subject that connects the entire sura. For example, the second and longest sura is defined with the Arabic word for 'cow'. It is in this sura that the story is told about how the Children of Israel tried to avoid the obligation laid upon them by Moses to make an offering to God. They embroiled the prophet in a lengthy discussion concerning the question as to exactly what sort of cow should be sacrificed (2:67(63)-71(66)). This is the central story, with a good many additions and sidetracks all indicating and illustrating how the Jews rejected the law of Moses just as they did that of Muhammad, without really knowing much about it.

The suras appear in the Qur'an according to the number of their ayas, starting with the longest, but with the single exception of the first sura. Thus the earliest suras appear at the end, the words with which Muhammad began his preaching – emotional sermons in which the Prophet warned his listeners of the approaching end of the world. The emotional tension in the text of the Qur'an gradually increases as it continues while the chronology appears to be going backwards. This is arbitrary, but acceptable in holy writings, which both may and must contain a great many contradictions that allow the reader to comprehend the central idea in a more complex manner.

Another apparent contradiction characteristic both for the Qur'an and Islamic culture in general is the existence of several versions of the text all of which are recognized as being equally valid. The first written Qur'ans consisted of words inscribed only with consonants. When Arabic began to add the pointing indicating vowels, it became apparent that there were many possible readings and interpretations of the words. Although the variations were often small, they could alter the meaning considerably. After lengthy discussion, seven 'canonical' versions of the Qur'an were selected, each reading treated as equally correct. It is astonishing that this acceptance of different versions is connected with the general principle of the unity of Islam in all its forms. Here we find, in fact, the same happy conjunction of contradictions as we see in the heterogeneous Islamic art.

Monotheism

The content of the Qur'an is on the one hand diverse, also as regards style, while on the other hand it is extremely compact in its central ideas. The most important of these is the concept of monotheism: there is only one God. Neither the Jews nor the Christians appear to honour this basic concept. The Muslims, the true believers, should not allow anything to distract them from fulfilling the obligation to demonstrate their love for God and to fill their thoughts with Him.

The story of humankind, created by God, is set out in the Qur'an as if it were a river, an arabesque, cycles of civilization. Each successive generation appeared according to the will of God. Generation after generation, human pride overcame piety and the prophets were not believed. As punishment people were all destroyed. The Qur'an recounts these historical narratives in a highly summary manner, as a reference to well-known events. Such stories cannot be visually illustrated. The course of world history is determined by two major acts of Allah. The first is His creation of the world and people; the second will take place on the Day of Judgment: the dead will rise again, judgement will be pronounced, and history will come to an end.

Reward and punishment

The next basic idea is that all people are divided into two categories: those who go to Hell and those who enter Paradise. The description in the Qur'an of punishment and reward is perfectly clear. This is discussed more fully in Chapter 7.

Rules of conduct

A considerable quantity of the contents of the Qur'an is dedicated to the third basic idea: rules of conduct. Belief in Allah and the mission of His Prophet, pilgrimage, prayer, fasting and mercifulness lead to the bliss of Paradise. The acts that are forbidden include adultery, usury, gambling, drunkenness, and eating pork. Laws are set out dealing with property inheritance, honest trading, distribution of wealth and general social intercourse. Such subjects proved even less inspiring to the illustrators than did the historical narratives, although the linguistic style of these mundane themes remains both ecstatic and ornamental.

The entire qur'anic preaching consists of short formulae, allusions and comments. Indeed, it is through its commentary that the Qur'an achieves its unity. The commentaries are an aid to believers, helping them to understand the often gnomic utterances. Indeed, the believer gains an added and enriched understanding from interplay of formulae and commentary. This is why the confrontation with a short qur'anic text immediately gives rise to all kinds of possible meanings and associations, in a way similar to how a few letters on a computer screen may call up an entire document and related references. In this way the text becomes steeped in meaning, far more so than would at first glance appear.

Layers of meaning

Another characteristic that increases the meaning of the text is its many-layered nature. Behind a sentence, a statement, a narrative or a description there are often several layers of meaning. Often, the texts in the Qur'an appear very concrete, not to say earthy. There is frequent use of jargon and demotic language, of the sort used by the tradesmen of Mecca, expressions like 'a poor deal', 'a business bonus' or 'a rip-off'. But on another level these refer to the value of the true faith and the fate of the unbeliever.

There are many descriptions famous for their vividness. Images of hell and paradise astonish with their concrete detail. We often have the feeling we are being recounted something that was actually seen, as in the story of Joseph (Yusuf) that tells how he was rescued from the well (S. 12:19), or in the description of the flood that was sent when Saba' turned against God, and the dam burst (S. 34:15(14)-17(16)).

The text becomes all the more convincing when it appears to be an eye-witness account, and the story becomes more immediate and dramatic. But always, the deeper significance of the narrative returns, especially since concrete images don't serve an artistic purpose but rather are used to reveal a more profound content.

There are several places in the Qur'an where God is described as a person, where it is said that people are made in His image, or where mention is made for example of His hands or the throne upon which He

sits. These anthropomorphic metaphors in no way diminish the greatness of Allah but indeed act as a ladder that leads up to Him. They are intended as the first rung in the ascent towards the knowledge of the complex and lofty being of God. More is to follow, and step by step knowledge of God increases. Each step, or layer of knowledge, is expressed in a brief and simple description. An understanding of the text may remain limited to one layer or rung, but equally may extend to cover a larger area, more steps of the ladder.

Concrete descriptions of the deeds of the just and of those who worship many gods, naturalistic descriptions of Paradise and Hell, scenes from the Day of Judgment – all these open the door onto the profound religious-philosophical nature of history and help to understand better the underlying reason for, as well as the nature and the essence of, Hell and Paradise.

The short passages merge into one whole but still remain independent. Indeed, this is one of the most striking artistic features of the Qur'an. The separate ayas and the complete suras each have their own demarcations, they are sections in their own right. In a similar way, it is completely permissible to chant passages from the Qur'an – or read aloud in a singing manner – in various different ways.

All the separate elements, however, with all their individuality, flow together into one endless stream. The different elements may be placed randomly above, below or linked to each other. The same thing happens in the ornamental art of Islam; it has a mission to present the fundamental feelings and apprehensions that are taught by the Qur'an. Naturally, the Qur'an has many other individual characteristics which people need to be well aware of before they begin to study it. This chapter has only dealt with those features that found an echo, sometimes an expression, in Islamic art – that is, strict monotheism as the ideological cornerstone for artistic creation; a mingling and melting together of seeming nonchalance with ebullient expressiveness; countless variations on one 'canon'; continuous mingling of separate elements to form one whole; and finally, its many-layered nature creating an arena in which many elements appear to contradict each other or indeed actually do, whereby the texts acquire a magical tone.

One of the Qur'an's main 'aesthetic' lessons is the holy meaning of the Word, which is a direct intermediary between God and people. Other art forms make use of the Word, but are of a secondary nature. This explains the absence of figurative art. In this context written script and calligraphy obtain a distinctive religious and artistic value as being the most suitable means for the direct transference of the Word. This explains the desubstantiated nature of Islamic art and architecture, for it consists of an unending stream of ornamentation that embodies the divine and formless Word.

6 *The language of Islamic art*

Art has a language of its own. It arises out of the feelings and experiences that affect people the whole world over. At the same time, however, many aspects of art can only be appreciated when they have become familiar, or have been studied. We can divide art into many different components. The way in which art gives shapes to things makes it into an active force providing people with types of aesthetic information that they gradually imbibe. The efforts of the scholarly who devote themselves to the study of art are in most cases attempts to understand what a particular form of art is talking about. Scholars search for the key to translate this transference of the language of one culture to that of another.

We can speak in a comparatively serious and scientific way about the language of art. It is also possible to use the expression 'language of art' in a metaphorical and somewhat hazy manner, as is generally the case in discussions about art. But we can also apply the whole complex apparatus of modern linguistic and semiotic definitions, approaching art as we would a written text. Between these extremes lies another way – that uses the 'language of culture', a combination of formal analysis with contextual understanding of those elements which play an active role in works of art. Using this method, studies have for some time now been made of, in particular, medieval cultures including that of Islam. On analogy with the analysis of language, for the purposes of clarity these studies define several groups, or categories. The division into categories of 'types of art expression' is made on the basis of the presence of certain elements, at various levels of creation and perception. In this chapter the particular characteristics of Islamic art will be listed, while providing a classification of this art into (language) groups that makes it as comprehensible as possible.

Artistic language consists of a way of expressing the things people feel and understand about the world. When we analyze this language we perceive that people make a model of the world which they imbue with meaning, and then transfer this meaning to others. For outsiders it is appreciably easier to decode an artistic language because they do this using concepts which are not immediately recognizable to someone immersed in the language (who has spoken it, as it were, from birth). However, if the 'native speakers' study the language more carefully they will become aware of much that they had taken for granted, and in the description of this possibly discover aspects that are both unexpected and inspiring.

Basic materials
The language of art is to a great extent determined by the basic materials from which the artistic production is made. In a way, these resemble the individual sounds (phonemes) of a spoken language. Islamic art consists of objects made from gold, silver, bronze and similar metal alloys, ivory, pottery (glazed and unglazed), rock-crystal and glass, enamel, parchment, paper, leather, stone, brick, ceramic tiles and wood. Another aspect of these basic materials are the methods of decoration, including carving – with high or low relief, writing or drawing with paint, or mounted fittings. Finally, in this category we should mention the colours used: gold for the sun, blue for the sky, green for the garden and Paradise, red for precious stones.

The 'lexical' level
Developing from these basic materials – keeping the linguistic image – come 'words'. These fall into another category, a 'dictionary' or lexicon which includes different types of elements acting as motifs or illustrations. In the first place these are 'signs of the heavens' such as rosettes symbolizing the sun, many types of star shape, polygons piled one upon the other, lozenge shapes, the symbols of the zodiac signs (possibly used in a figurative manner) and astrological signs and astronomical phenomena. In the second place there are the 'signs of the garden', including palmettes, vine tendrils, trees, bushes and

bouquets of flowers in vases, animals both wild and domestic, and dragons. In the third place come the human figures, such as the ruler on his throne, courtiers, warriors, mounted polo players, musicians, both male and female singers and dancers, and wine pourers. Many of the figures are astrological signs. Finally, there are the 'signs of stones', or the symbols of precious stones. These take the form of ornamental ovals, diamonds, pearl-drops and crystals.

In calligraphy too, we find various categories of artistic elements which are inherent to the aesthetics of the Arabic script. We may, for example, distinguish between elements that claim attention through their flamboyancy, such as looping letters (almost arabesques), letters that run sharply upwards with their vertical tails, letters that transform themselves into plant motifs – leaves, branches and fruit, or into human figures, and finally the letters that are difficult to recognize, being half ornamental geometric shapes and half Kufic script.

We also find separate artistic elements in Islamic architecture. Here we may distinguish the following groups: the court, the central section of the mosque or palace, the garden, the wall (with or without decoration), the tower (or the minaret), the decorated doorway at an entrance, the large niche (*iwan*) and the pillars. There were different types of pillars, combinations of slender and thick pillars, and a fusion of pillars into galleries with one or two levels, creating the effect of a kind of 'pillared woodland'. One particular architectural element, highly characteristic for Islamic art, were the so-called stalactites (*muqarnas*) resembling arches filled with wondrous dripping stone endlessly repeated and thereby creating the effect of an infinitely intricate honeycomb. The gardens were laid out with various combinations of types of plant – bushes, trees, and flowers set in a scheme of pools and streams. An important visual element was the reflections in the water of buildings and plants. The twitter of birds and the sound of their wings in flight formed an inextricable part of this, as did the scent of various flowers and the incense that wafted into the air from place to place.

The 'morphological' level

The above may be seen as the lexical level, containing the basic elements. The next level is the morphological (incorporating new variant forms as when a word declines, while retaining its root). Here we may distinguish several recurring, complex compositions. The first are the arabesques: these may be formed by the unending branches of the vine, that string onto one necklace as it were the leaves and bunches of grapes, the tendrils and the isolated fruit. Second come the geometric sections of the space, such as a rectangular page, part of a wall, a dome rising into the sky, or craving in a niche. Polygons piled upon each other, lozenges and star-shapes, often created as it were by chance, flow together into one space that is forever changing in size because it is affected by the interaction of neighbouring geometric elements.

Close to this we find the third type, the medallions. These are closed areas that are crammed full of large and small (often plant) ornamentation. The background of these areas often contains many patterns but equally well may be completely empty. In this category we should also mention circular inscriptions in which letters resembling arabesques entice into their presence a quantity of plant and geometric motifs. And finally, we list an important and deviant type: this will be a tableau such as a banquet, a dance, a musical performance, a hunting scene, a duel, polo played by horsemen, the game of backgammon, or an 'epos' which would be an intricate presentation of astrological signs such as a certain's person's horoscope.

'Syntax'

The above-mentioned, as well as other combinations of elements may all be seen as conforming to certain principles which may be placed under the heading 'syntax'. By far the most important of these principles is that the elements in question should be ornamental. A large emphasis is placed on the express repetition of elements (for example, the repetition of the name of Allah). Here too should be listed the endlessly on-flowing uncompleted nature of the composition, even when it is not abstract.

Three aspects of the syntax should be mentioned. The first is the movement of the (lexical) elements in various directions. The movements shift in arabesques making a line across the horizontal surface, inter-

rupted by the delicate motifs of each curl. In purely geometric compositions the movement explores the depth – the space expands and the ornamentation is absorbed into it The continuity of the movement is emphasized by separate accented figures, such as the cliffs against which the waves of the ornamentation beat. A similar role is played by medallions of figures representing wild animals in a plant-filled jungle.

The second aspect is the use of surface area, that may be seen as a 'game'. Sometimes this surface is entirely filled with subtle patterns, often subdivided into the main pattern, a smaller one and a still smaller one. In other cases sections are left empty in order to create a contrast. This can be seen in particular on medallions in books, on silver flatware and services, and on carpets. The most extreme form can be found in the sobriety of the facades of Islamic buildings, both public and – even more so – private. This creates a sharp contrast with the luxuriousness and the accent on aesthetic pleasure which is to be found in the interiors.

The third striking aspect is the combination of abstract and highly concrete elements side by side. For ex-ample, there are realistic bunches of grapes and carafes within arabesques. The illusion is created that these objects can actually be touched and held and reference is made to wine as the symbol of mystical intoxication arising from the love for God. This produces a complex of meanings and implications which are to be found in all the elements and com-po- sitions connected with the language of Islamic art.

Levels of knowledge
Continuing with the linguistic analogy, we may also make use of the linguistic term of the ' describer' – as opposed to the 'described'. Here we are primarily concerned with perception. Select at random any monument of Islamic art or architecture – these last-mentioned may be apparent at various levels. The lowest level is the ordinary everyday perception of the object, of an attractive motif or a detail that is recognized. The highest level is that of the theological or indeed, what should be called the mystical, as a way of approaching nearer to God or of demon-strating one's love for Him. Translated into terms of the 'described', Islamic poets have written many

verses about wine and profane love, poetry of supreme beauty describing human feelings and situations. However, seen at a higher level, these poems are an attempt to describe the intoxicated ecstasy of the mystic and to recount the love of God. Earthly elements were thus used as symbolic of and as references to, divine inspiration, and indeed as a means of merging into and becoming part of the divine world.

The applied art of Islam also contains allusions to and evidence of an indirect link with other, higher levels of knowledge. These may be the signs and reflections of pious thoughts, of supernatural forces which bring good luck (talismans) and divine favour, and finally of the world in which God reveals to people an aspect of His Divine Being. In some cases the allusion almost goes undetected. In others, the secondary meaning is obvious – indeed, almost self-evident, as in the magic content of certain inscriptions and motifs. The presence of a second, third or even fourth layer of meaning in objects of applied art bestowed a more profound value on daily life; it became transformed (in complete agreement with the Islamic belief in the indivisibility of the earthly and the heavenly) into an intimation of something more sublime. And at the same time the link between the describer and the described became more complex since the 'described' might well contain several dimensions.

The entire system of Islamic art was an extension and reflection of the suggestions of ideas found in the Qur'an. The many confirmations and reaffirmations of basic formulae converted this into more than mere knowledge – it became part of people's unconscious. This widened the audience of believers considerably. The basic ideas – expressed in patterns and decoration – were accessible to everyone, according to the level of their education and spiritual development. Every-day objects could become the vehicle for spiritual understanding or exercise, such as meditation. In this way Islamic teaching and art offer the believer the possibility of solving questions that have arisen through historical changes.

There are two ideas in Islamic art that occur repeat-edly at various levels with varying degrees of clarity and directness, both of them clamping art securely to

religion. The first idea is that of the reality of God. Art contains many allusions to the image of God, which people cannot apprehend. It nevertheless provides the aesthetic possibility of referring to His Being as the very essence of beauty and goodness, and the promise that meeting with Him will be something indescribably sublime. The second idea is that of a Paradise to come, created for the just to inhabit, a place of peace and plenitude. Almost all Islamic art is a reminder of this. Beautiful objects, exquisite buildings serve not only to delight the Muslim in this world; they are a promise of grace to come. They are the hopeful confirmation that the religion of Islam is the one true faith.

7 *Paradise – the major theme of Islamic art*

The Qur'an was revealed to people to warn them against the coming Day of Judgment. The early suras are filled with emotional and vivid descriptions of the end of the world, the pangs of hell and the pleasures of paradise. It will be a day of doom and terror,

> *When the Sky is rent asunder*
> *And hearkens to (the Command of) its Lord –*
> *And it must needs (do so);*
> *And when the Earth is flattened out,*
> *And casts forth what is within it.*
> *And becomes (clean) empty,*
> *And hearkens to (the Command of) its Lord –*
> *And it must needs (do so)*
> *(Then will come home the full Reality)*
> (S. 84:1-5)

The book describes how the dead will arise from their graves:

> *When the Sky is cleft asunder;*
> *When the Stars are scattered;*
> *When the Oceans are suffered to burst forth;*
> *And when the Graves are turned upside down; –*
> *(Then) shall each soul know*
> *What it hath sent forward*
> *And what it hath kept back.*
> (S. 82:1-5)

And, more extensively:

> *When the sun (with its spacious light) is folded up;*
> *When the stars fall, losing their lustre;*
> *When the mountains vanish (like a mirage);*
> *When the she-camels, ten months with young,*
> *Are left untended;*
> *When the wild beasts are herded together*
> *(In human habitations);*
> *When the oceans boil over with a swell;*
> *When the souls are sorted out*
> *(Being joined, like with like);*
> *When the female (infant), buried alive,*
> *Is questioned –*
> *For what crime she was killed;*
> *When the Scrolls are laid open;*

> *When the World on High is unveiled;*
> *When the Blazing Fire*
> *Is kindled to fierce heat;*
> *And when the Garden is brought near; –*
> *Then shall each soul know*
> *What it has put forward.*

Or again:

> *Verily, the Day of Sorting Out*
> *Is a thing appointed, –*
> *The Day that the Trumpet*
> *Shall be sounded, and ye*
> *Shall come forth in crowds;*
> *And the heavens shall be opened*
> *As if there were doors,*
> *And the mountains shall vanish*
> *As if they were a mirage.*
> (S. 78:17-20)

These are the dramatic descriptions of the end of the world, the Islamic Apocalypse. It is arguable that the whole of the Qur'an is a sermon prophesying the end of time, and offering a prescription for how to prepare for this end. For people are presented with a choice. One possibility is direful:

> *Therefore do I warn you*
> *Of a Fire blazing fiercely;*
> *None shall reach it*
> *But those most unfortunate ones*
> *Who give the lie to Truth*
> *And turn their backs.*
> (S. 92:14-16)

> *And the Wicked –*
> *They will be in the Fire,*
> *Which they will enter*
> *On the Day of Judgment*
> *And they will not be able*
> *To keep away therefrom.*
> (S. 82:14-16)

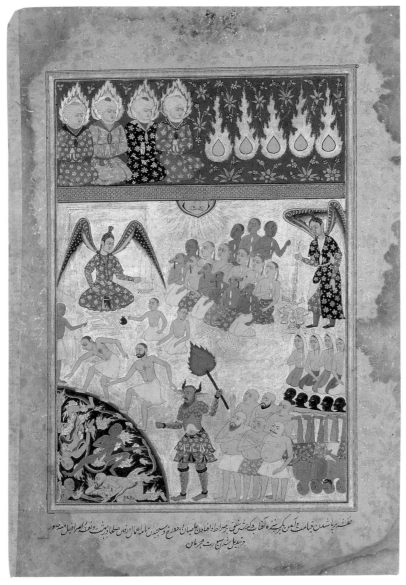

Cat.no. 239A

But never will he be near
Swallowing it down his throat;
Death will come to him
From every quarter, yet
He will not die: and
In front of him will be
A chastisement unrelenting.
(S.14:16-17)

The Companions of the Left Hand –
What will be the Companions of the Left Hand?
(They will be) in the midst
Of a fierce Blast of Fire
And in Boiling Water,
And in the shades of Black Smoke:
Nothing (will there be)
To refresh nor to please:
For that they were wont
To be indulged, before that
In wealth (and luxury),
And persisted obstinately
In wickedness supreme!
And they used to say,
What! When we die
And become dust and bones
Shall we then indeed
Be raised up again? –
(We) and our fathers of old?'
Say: Yea, those of old
And those of later times,
All will certainly be
Gathered together for the meeting
Appointed for a Day well-known.
Then will ye truly –
O ye that do wrong,
And treat Truth as Falsehood! –
Ye will surely taste
Of the Tree of Zaqqum. [the Cursed Tree]
Then will ye fill
Your insides therewith
And drink Boiling Water
On top of it
Indeed, ye shall drink
Like diseased camels
Raging with thirst!
Such will be their entertainment
On the Day of Requital!
(S. 56:41-56)

Some faces, that Day
Will be humiliated,
Labouring (hard), weary, –
The while they enter the Blazing Fire, –
The while they are given to drink
Of a boiling hot spring,
No food will there be for them
But a bitter Dhari [a bitter, vile-smelling plant]
Which will neither nourish
Nor satisfy hunger.
(S. 88:2-7)

Or again:

In front of such a one
Is Hell, and he is given
For drink, boiling fetid water.
In gulps will he drink it

Is that the better entertainment
Or the Tree of Zaqqum?
For we have truly made it (as)
a trial for the wrong-doers.
For it is a tree
That springs out of the bottom of Hell-fire:
The shoots of its fruit-stalks
Are like the heads of devils:
Truly they will eat thereof
And fill their bellies therewith.
Then on top of that
They will be given a mixture
Made of boiling water.
Then shall their return
Be to the (Blazing) Fire.
(S. 37:62-68)

Those who reject Our Signs, We shall soon
Cast into the Fire:
As often as their skins are roasted through,
We shall change them for fresh skins,
That they may taste the penalty:
For God is Exalted in Power, and Wise.
(S. 4:56)

The horrors of the inevitable catastrophe and possible punishment are intended to shake people out of their apathy and force them to listen to Allah. The preaching of Muhammad, as we know, had a tremendous impact but didn't lead to a mass conversion. A handful of followers grew into an active community when the inhabitants of Yathrib (Medina) started to believe in Allah. Their motives were mixed: partly spiritual, partly political. After Muhammad had convinced the people of Mecca of the power of his system of belief, there followed a mass conversion. But it took time before the conquered countries would become Islamic. The inhabitants of those districts didn't convert to Islam out of fear, but because of a social system which held advantages for the converts. Those who did not accept the new faith were forced to fulfil certain (considerable) obligations. This proved a more effective method of winning people over than holding up the threat of a direful massacre or the pangs of hell-fire.

Punishment or bliss

From the very start the sermons, together with the story of the punishments and terrible tortures, spoke of the blissful lot which lay in store for true believers. On the whole, descriptions of Hell and Paradise balance each other in the Qur'an. Both are spiced with unambiguous language intended to arouse the listener. The images used are highly realistic and comprehensible for every Arab. However, it should be said that the image of Paradise in the Qur'an is extremely detailed, and diffuses a sense of delight. A picture is drawn of a shadowy garden, where the righteous recline on soft beds, feasting in the presence of beautiful virgins. Naturally, a description of this sort only projects a superficial understanding. Concrete, sensitive images were an expression of a deeper spiritual ecstasy which would be expressed in terms that the simplest listener could understand. Furthermore, this demonstrates the many ways in which the Qur'an may be understood. Depending on the apprehension of the listener, the image of Paradise found its response in the soul of the desert Bedouin or the fierce warrior (both commander and foot soldier), the philosopher, the theologian and the mystic. The practical element of the sermon proved highly adaptable in supporting the general aim, that of convincing and converting, which had developed in the earliest phases of Islam.

The pictures of Paradise in the Qur'an are so vivid that some oriental scholars have suggested that Muhammad was inspired by the mosaics he had seen in Christian churches. This seems most improbable, but the style of the Qur'an incorporates comparably sensuous images.

But God will deliver them
From the evil of that Day
And will shed over them a Light
Of Beauty and a (blissful) Joy.
And because they were patient and constant
He will reward them with a Garden
And (garments of) silk.
Reclining in the (Garden) on raised thrones
They will see there neither the sun's (excessive heat)
Not the moon's (excessive cold).
And the shades of the (Garden)
Will come low over them,
And the bunches (of fruit) there
Will hang low in humility.

And amongst them will be passed round
Vessels of silver and goblets of crystal.
Crystal-clear, made of silver:
They will determine the measure thereof
(According to their wishes).
And they will be given
To drink there of a Cup
(Of wine) mixed with Zanjabil [ginger]
A fountain there called Salsabil ['Seek the Way'].
And round about them will (serve) youths
Of perpetual freshness:
If thou seest them, thou wouldst think them
Scattered Pearls.
And when thou lookest,
It is there thou wilt see
A Bliss, and a Realm Magnificent.
Upon them will be Green Garments
Of fine silk and heavy brocade
And they will be adorned
With Bracelets of silver;
And their Lord will give to them to drink
Of a Wine Pure and Holy.
Verily, this is a Reward for you
And your Endeavour is accepted and recognized.
(S. 76:11-22)

Or the passage:

These will be those nearest to God:
In Gardens of Bliss.
A number of people from those of old,
And a few from those of later times.
(They will be) on Thrones
Encrusted (with gold and precious stones),
Reclining on them, facing each other.
Round about them will (serve)
Youths of perpetual (freshness),
With goblets, (shining) beakers
And cups (filled) out of
Clear-flowing fountains:
No after-ache will they receive therefrom,
Not will they suffer intoxication.
And with fruits, any that they may select:
And the flesh of fowls, any that they may desire.
And (there will be female) Companions
With beautiful, big, and lustrous eyes, –
Like unto Pearls, well-guarded.
A Reward for the Deeds of their past (Life).
No frivolity will they hear therein

Nor any taint of ill,
Only the saying, "Peace! Peace!"
The Companions of the Right Hand –
What will be the Companions of the Right Hand?
They will be among lote-trees without thorns,
Among Talh trees [possibly a kind of Acacia]
With flowers (or fruits) piled one above another, –
In shade long-extended, by water flowing constantly,
And fruit in abundance.
Whose season is not limited, nor (supply) forbidden,
And on Thrones (of Dignity) raised high.
We have created (their Companions)
Of special creation
And made them (virgin-pure and undefiled), –
Beloved (by nature), equal in age, –
For the Companions of the Right Hand.
A (goodly) number from those of old,
And a (goodly) number from those of later times.
(S. 56:11-39)

And again:

But for such as fear
The time when they will
Stand before their Lord,
There will be two Gardens –
Then which of the favours
Of your Lord will ye deny? –
In them (each) will be
Two Springs flowing (free);
Then which of the favours
Of your Lord will ye deny? –
In them will be Fruits
Of every kind, two and two.
Then which of the favours
Of your Lord will ye deny? –
They will recline on Carpets
Whose inner linings will be
Of rich brocade: the Fruit
Of the Gardens will be
Near (and easy of reach).
Then which of the favours
Of your Lord will ye deny?
In them will be (Maidens)
Chaste, restraining their glances,
Whom no man or Jinn
Before them has touched; –
Then which of the favours
Of your Lord will ye deny? –

Like unto rubies and coral.
Then which of the favours
Of your Lord will ye deny?
Is there any Reward
For Good – other than Good?
Then which of the favours
Of your Lord will ye deny?

And beside these two,
There are two other Gardens, –
Then which of the favours
Of your Lord will ye deny? –
Dark-green in colour
(From plentiful watering).
Then which of the favours
Of your Lord will ye deny?
In them (each) will be
Two Springs pouring forth water
In continuous abundance:
Then which of the favours
Of your Lord will ye deny?
In them will be Fruits
And dates and pomegranates:
Then which of the favours
Of your Lord will ye deny?
In them will be
Fair (Companions), good and beautiful; –
Then which of the favours
Of your Lord will ye deny?
Companions restrained (as to
Their glances), in (goodly) pavilions; –
Then which of the favours
Of your Lord will ye deny? –
Whom no man of Jinn
Before them has touched; –
Then which of the favours
Of your Lord will ye deny? –
Reclining on green Cushions
And rich Carpets of beauty.
Then which of the favours
Of your Lord will ye deny?
Blessed be the Name of thy Lord,
Full of Majesty, Bounty and Honour.
(S. 55:46-78)

There are also shorter descriptions that are less formal:

Here is a Parable of the Garden

which the righteous are promised:
In it are rivers of water incorruptible;
Rivers of milk
Of which the taste never changes;
rivers of wine, a joy
To those who drink;
And rivers of honey pure and clear.
In it there are for them
All kinds of fruits;
And Grace from their Lord.
(Can those in such Bliss)
Be compared to such as
Shall dwell for ever
In the Fire, and be given
To drink, boiling water
So that it cuts up
Their bowels (to pieces)?
(S. 47:15-16)

And again:

But those who believe
And do deeds of righteousness,
We shall soon admit to Gardens,
With rivers flowing beneath, –
Their eternal home:
Therein shall they have
Companions pure and holy:
We shall admit them
To shades, cool and ever deepening.
(S. 4:57)

Or:

(Other) faces that Day will be joyful
Pleased with their Striving, –
In a Garden on high,
Where they shall hear
No (word) of vanity:
Therein will be
A bubbling spring:
Therein will be Thrones
(Of dignity), raised on high,
Goblets placed (ready),
And cushions set in rows,
And rich carpets (all) spread out.
(S. 88:8-16)

And finally:

Truly the Righteous will be in Bliss:

On Thrones (of Dignity)
Will they command a sight
(Of all things):
Thou wilt recognize in their Faces
The beaming brightness of Bliss.
Their thirst will be slaked
With Pure Wine sealed:
The seal thereof will be Musk: and for this
Let those aspire, who have aspirations.
With it will be (given)
A mixture of Tasnim:
A spring, from (the waters)
Whereof drink those nearest to God.
(S. 83:22-28)

Gardens

Generally speaking, the picture of Paradise is given in concrete and detailed terms. It consists in the first place of gardens (Paradise itself is called in Islam *djanna*, which literally means garden(s)). Shadowy trees grew there, bearing at the same time both blossom and fruit that hung low ready to be plucked. Trees that generally had thorns now had smooth barks. Scattered around were acacias, palms and pomegranate trees. Through the gardens flowed broad rivers and bubbled limpid brooks: names are given to them, such as Kafur and Salsabil. There was water that never became fetid, sometimes spiced with a plant such as ginger. Furthermore there were streams of milk that never became rancid, purest honey and finally wine that didn't make people drunken.

In the cool shade of the gardens the righteous will enjoy eternal bliss. They will recline on soft beds, propped upon brocade-covered cushions. Cushions are scattered all around and tents are set up. Moving gracefully about are beautiful maidens with lovely eyes. The righteous are clothed in rich garments of green brocade with silver jewellery. They are served their drinks by lovely boys who are forever young. They bear goblets of silver and crystal, fruits of all kinds and game birds. They drink water, honey, milk and wine of a good vintage 'and sealed with musk'. There is no bickering, nor frivolous talk in these gardens; only such words are head as 'Peace, peace'.

In the descriptions there are incidental comparisons with precious and semi-precious stones such as pearls, rubies and rock-crystal. The colour green predominates – the colour of the garden and of the sumptuous garments worn by the blessed, while red gleams through in the rubies and the pomegranates.

The description is that of a dweller in the desert – what can afford greater joy than reaching shade and water after the long day's heat? The images are vivid and almost tangible, we feel the coolness, we slake our thirst. Clearly, these are pictures to appeal to the people of the desert countries of the Near and Middle East.

At the same time as being down-to-earth, the description is also mysterious. Somewhere in these paradisal gardens lies the source of the holy text of the Qur'an, somewhere there grows the Tree of Life. There are constant references to the presence of Allah. Also, there is a mysterious element in the fact that some words and names of waters and drinks found in the Qur'an were unknown to the Arabs before Muhammad. The hermetic associations are further increased with the introduction of new and incomprehensible words that give the Qur'an its special rhythm and particular charm. Nor should it be forgotten that behind everyday words there are other, less immediate, meanings and associations.

Behind the concrete, realistic images of the Qur'an there lurks a more profound meaning. Contentment and delight, the rewards of the righteous, appear at first sight to be merely physical. In fact, they represent the bliss of God's grace, that full spiritual tranquillity, the joy of approaching into the presence of God. For this is – beneath the realistic representations and just as in the poetry of the mystics – the essence of Paradise.

The bliss of Paradise

We find a similar deeper meaning when reading the descriptions of the blessed in Paradise. There they have their fill of those things that were forbidden in this world. They drink wine, they enjoy unrestricted carnal pleasures, they are surrounded by objects of luxury. All this, however, also has a symbolic level: it is to show that in Paradise the righteous are recompensed for their pious lives, for the self-imposed

restrictions of this world. In fact, the joys of Paradise are spiritual ones. Only they cannot be described except in material terms and using images of earthly objects.

Islamic theology has probed deeply into the question of paradisal pleasure. Scholars have not only alluded to the possibility, they have indeed stressed the fact that the qur'anic ayas are ambiguous. They have shown indisputably that behind the physical images there are references to intellectual and spiritual delights. Debates have also arisen in the context of Paradise over the qur'anic expression 'the person of Allah'. Some hold that the greatest joy for the righteous in Paradise will be to behold God (face to face). Others, however, fiercely refute the notion that God can be seen in this way, while still others support the opinion that God can be seen, but then 'without form or being'. In general terms it is agreed that in Paradise people approach into the presence of God and perceive Him to a certain degree.

All the qur'anic images with their many explanations have become part of the general and psychological mental scenario of the broad mass of the population. The picture of Paradise gradually became the main topic of sermons. In speaking of Paradise, comparisons were made with beautiful objects from daily life which served as symbols for something more profound and complex. Earthly beauty was a reflection of the splendour of Paradise.

This explains why Islamic art, both the religious and the secular, has chosen Paradise as the most important theme that can be represented or referred to. This was partly made possible because of the prohibition against making pictures of holy personages, partly also because of the general precept to think, speak, and make with only Allah in one's mind. Paradise is, after all, both what God has promised to the righteous and also the place where He dwells, where He is closest to humankind.

The first Islamic religious works of art to proclaim loudly the victory of the new religion were mosaics (see the Dome of the Rock in Jerusalem, *ill. 2, p. 17* and the Umayyad mosque in Damascus, *ill. 3, p.18*): they illustrate gardens that are filled with verdure and opulence. Clearly, these are the gardens of Paradise. It should be pointed out, however, that in some Damascus mosaics as well as rivers and trees there are pictures of many noteworthy buildings. It is quite possible that here we have one of the later (post-qur'anic) impressions of Paradise imagined as a city, comparable to the Christian representations in that period of the city of Jerusalem.

The entrance to Paradise

The mihrab with its lamp shedding holy light bears a reference to entrance into Paradise, often taking the form of pictures of trees and vases of flowers. This iconography was adopted for prayer rugs with a similar function. Indeed, all carpets, whether or not with a religious purpose, serve as more or less formalised representations of the garden – which in the first place is the Garden of Paradise. The carpets often contain pictures of streams and rivers, fountains and lakes as if they had arisen from a description in the Qur'an of the waters of Paradise.

Finally, there were also the earthly gardens, which occupy an extremely important place in the Islamic aesthetic system, being a reflection of the heavenly ones. In Granada, the famous gardens were given the name *Djannat al-arifin*, meaning 'gardens of those who know the truth', which in one explanation is a reference to the inhabitants of Paradise. Also, the park around the mausoleum of Taj Mahal was consciously planned to suggest the gardens of Paradise, as is apparent not only from the ground plan but also from inscriptions on the buildings which bear citations from the qur'anic descriptions of Paradise.

Every plant decoration referred to some extent to the gardens of Paradise. Thus the walls of the Ottoman mosques are covered with tiles bearing many distinct plant motifs. This is a faithful analogy with the very first monumental buildings of Islam.

Luxury items, too, referred to the delights to come – they were but pale reflections and suggestions of the life in Paradise. A hierarchical line developed: the splendour and luxuriousness of the paradisal life was expressed in the first place by objects of gold and silver; then followed bronze and ceramics; finally

came lustreware, that gave a clear reflection and had the gleam of metal. This sheen was a constant reminder of light, God's primary attribute, and was embodied symbolically in lamps and everything that glittered and gleamed.

Beautiful objects made from rock crystal, silver beakers and other domestic ware were even some of the items found in the qur'anic description of Paradise. These too symbolized the future union with God, as did Sufic verses in which intoxication with wine or love represented mystic radiance. And the banquet scenes so frequently encountered in Islamic art, with pictures of musicians and dancers may simply be explained as visions presaging the feasts of Paradise or symbols of spiritual blessedness expressed in a human language (as in the Qur'an).

This kind of deeper meaning , often not entirely precise and nowhere explained more fully, gave an impression of mystery, of something beautiful that was holy and welcome. Almost all Islamic art in some way or another tells a story about Paradise, alludes to it, refers to it.

In Europe and the Near East, medieval art was always strongly influenced by religion. Indeed, it was dedicated to religion. In Islamic art, unlike its Christian counterpart, this was not so evident: it had no statues representing living forms, it had no Stations of the Cross, no pictures of martyred saints or holy ascetics. Islamic art at first glance appears non-religious. That is, however, by definition impossible, since in Islam no distinction is made between the earthly and the heavenly life. This attitude underlies Islam's history, and its social and cultural life (although gradually a wave of deviations did arise).

A careful investigation reveals the true nature of Islamic art. It doesn't force itself upon the viewer, but calmly and steadfastly bears witness to two things: God and Paradise. Put another way, it speaks of the dogma of the One Indivisible God and the blessedness of life after this world, that are the chief treasures of

the Muslim. Islamic art doesn't illustrate the Qur'an but offers an abstract artistic account of its chief ideas.

This account is not only attractive, it is also cheerful. Islamic religious buildings are intended to create warmth from the inside outwards, to offer delight to the believer. Abstract references to God are magnified, are made amazingly intricate, but they do not scare off or overwhelm. The pictures of Paradise, or the descriptions of it, recount in a simple manner the blessed state which will be the reward of the righteous. Islam entices people with the promise of goodness, with the excitement of insight and a revivifying outlook. The pictures of Hell, that occupy a secondary place in the Qur'an, are less realistic than those of Paradise.

Christian art, Islamic art

Finally, a word of comparison between Islamic art and Christian art. The main difference between the two lies in their approach. In Christian art the emphasis falls on the forgiveness of sins, the suffering of the Son of God that should be deeply felt by every Christian. God, embodied in His church, is a terrible god and forces His servants to be humble. The greatest means of making sinners toe the line is the fear of Hell. Man is born sinful.

In essence, the two religions, Islam and Christianity, are not dissimilar. Like Islam, Christianity promises people heavenly bliss. And Christian ritual and Christian art bring to those who truly believe an overwhelming sense of joy. But the approaches, the methods of the two, are quite different. While Christian art tries to convince the believer by emphasizing the suffering (of Christ), Islamic art attempts to uplift the believer with the promise of bliss.

We should not forget, however, that at one time or another, both make use of these two approaches. Islamic art and the art of the Christian tradition are after all two branches of the same tree.

The word *mosque* means literally 'the place where men kneel down'. The mosque is a place for praying. On Fridays and festivals this is done communally, while on other days people pray individually. Beside this, the mosque is a meeting place and a teaching centre for Islamic learning.

The very first mosque was in the courtyard of Muhammad's house in Medina. A great many mosques – though certainly not all of them – have an inner courtyard containing a fountain for the ritual washing which precedes the act of prayer. Some also have a garden. Adjoining this is a covered section for prayer, which will contain a *mihrab*, or prayer niche, often richly decorated. This points to the black stone of the *Kaaba* in Mecca, and thereby shows the direction in which to face when praying. The mihrab symbolizes the gateway into the very presence of God and thus into Paradise. A second holy attribute of the mosque is the *minbar*, an elaborately decorated pulpit which has the shape of a throne.

Normally a lamp is hung in the mihrab, whose light symbolizes the presence of Allah.

The floor in the mosque is covered with carpets, upon which men kneel in prayer. These prayer carpets generally have a woven decoration showing a niche containing a lamp and sometimes a vase of flowers. This symbolizes the garden of Paradise which the righteous will enter when they leave this world and join the other world of God.

Mosques are usually beautifully decorated, both on the inside and outside. Almost all the large mosques have one or two minarets, which are towers from which believers are summoned to daily prayer. Generally, the interiors of houses of prayer are decorated with texts from the Qur'an written in calligraphy, particularly the chief statement, or creed, of Islam, 'There is no God but Allah and Muhammad is his prophet.' The decorative nature of Arabic script is utilized to the full. Graceful ornamental arabesques and geometric patterns are very popular; they delight the eye of the beholder and are a promise of the visual beauty of Paradise.

J.V.

The mosque

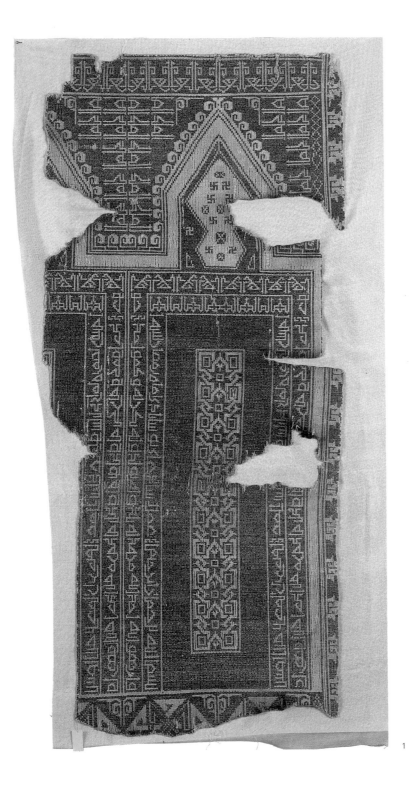

1

Fragment of a carpet

Signed by the craftsman 'Ali Nushabadi

Iran, 14th century

Cotton ◆ Length 104.5 cm, width 46 cm

The State Hermitage Museum, St Petersburg,

inv.no. IR-2253

Provenance: unknown; purchased in 1985

Literature: Kuwait 1990, no. 61

This is a fragment of a large prayer rug with a repeating design of niches, of a type usually called *saf*. The technique of manufacturing such carpets, known as *zilu*, employed from early times: such carpets are mentioned in a 10th-century source. The design covers both sides: it is difficult to distinguish front from back. The Friday mosque in Yazd (Iran) has a carpet produced using the same technique, with essentially the same colour scheme plus a little red. This is dated Rabi'II AH 808 (October 1405), along with the artisan's name, 'Ali Baidak ibn Hajji Maibudi (?).

The letter forms of the inscriptions on the Hermitage fragment suggest it was woven in the first half of the 14th century, making it the oldest known Iranian Islamic carpet.

The upper part of the carpet bears a decorative Kufic inscriptional register, which may be interpreted as a mirror image stylization of the word:
 Glory.

Below, in the spandrel areas around the arches, another word is repeated, also in Kufic script:
 Power.

An inverted horizontal band across the area just below the top of the niches, repeats the same inscriptional motif from the upper part of the carpet, below this there is another register of epigraphic ornament.

The vertical perimeters to each of the central fields bear two registers with Kufic inscriptions. To the left, furthest from the centre, is a Qur'anic inscription (Sura 112, al-Ikhlas, 'Sincere Belief'), which is repeated in mirror image on the right. Next to the central field on the left is the inscription (also in mirror image on the opposite side):
 In the name of God, the Merciful, the Compassionate. Work of Ustad 'Ali Nushabadi, in the month of Ramadan of the year.

It is unfortunate that the inscription does not give the year in which this carpet was made. The artisan's *nisba* has no diacritical dots, and the reading, 'Nushabadi', is only the most probable. Although settlements called Nushabad can be found in various parts of Iran, there is no indication which of these is referred to here.

No known sources can provide information on a craftsman named 'Ali Nushabadi.

A.I.

2

Prayer rug

Mughal India, circa 1630–40

Silk warp, weft and pile ✦ Length 152 cm, width 98 cm

The Nasser D. Khalili Collection of Islamic Art, London, inv.no. TXT 93

Literature: Martin, 1908, p. 93, fig. 217; Walker 1997, pp. 88–95

The design of a small but outstanding group of Mughal carpets is dominated by a single, large flowering plant, presented as though growing in an arched niche. At least two such carpets were made using the same cartoon as this one, while a third, fragmentary example has engaged colonnettes on either side of the main field, reinforcing the illusion of an architectural niche. The similarities in design are not matched by consistency in the materials and technical quality of this sub-group. Other examples have silk or cotton warps and wefts and are knotted in wool of varying quality, whereas this carpet has silk warps and wefts and is finely knotted in silk.

From this Daniel Walker has concluded that carpets of varying quality were produced in the same general period using the same cartoons, which runs counter to the notion that lower quality indicates work of a later date.

The central composition shows a flowering double poppy flanked by two tiny tulips beneath a pointed bracketed arch. The spandrels of the arch are filled with a vine bearing double poppies, while there is a flowering lotus vine in the main border. The guard stripes are of stepped lozenges. The rich crimson characteristic of Mughal carpets of this period is absent, but the colour scheme of this piece is clearly related to that of the main fields of other carpets in this sub-group.

M.R.

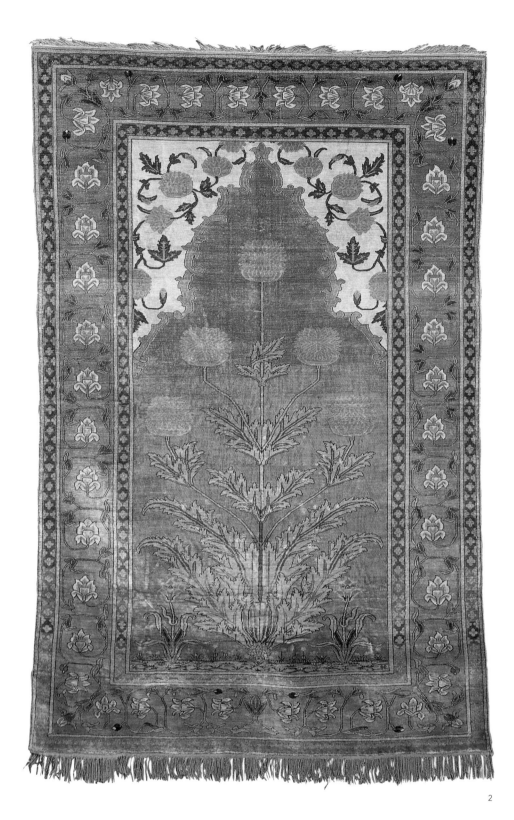

2

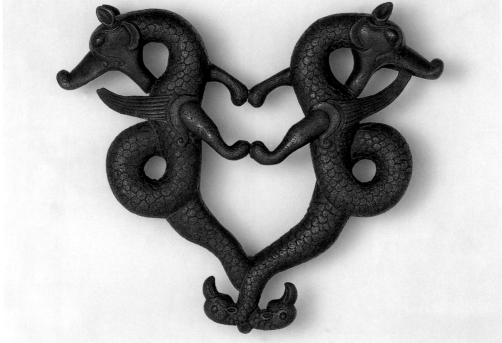

3

3

Pair of door handles

Jazira (now southeast Turkey), early 13th century

Copper alloy, cast ◆ Height 33.7 cm (1), 33.5 cm (2);
width: 39.5 cm (1), 40.5 cm (2)

The Nasser D. Khalili Collection of Islamic Art,
London, inv.nos. MTW 1407, MTW 1428

Literature: *Berlin 1971, no. 14; Hill 1974,*

pp. 194–195, 274; Louisiana Revy, 1987, nos 95, 96;
Khalili Collection 1993, p. 36; Copenhagen 1996,
nos. 71, 72 and 90; Maddison - Savage-Smith 1997,
no. 120, pp. 206–209

The door handles are in the form of addorsed
winged dragons, their scaly bodies knotted
and terminating in gryphons' heads. They
have no hind legs. The dragons' heads,

which seem to be engulfing the tips of their
wings, are severely modelled, with ears,
bulbous eyes and snouts, though their teeth
are not shown. Their feet are stylized and
show no sign of claws.

These impressive, monumental figural
sculptures have sometimes been described as
door knockers. Although other such dragons
have a lion's head between them, the three
great loops to secure them to a door would
have made them immovable. However, they
were not intended for use as handles, and
they show very little wear. Mosque doors in
the Jazira, Syria and Egypt of the 12th–14th
centuries frequently sport such 'handles'.
But they are often as much as nine feet from
the ground and must have been for show
only.

The closest parallel to this pair of dragons is
from the Great Mosque at Cizre (Jazirat Ibn
'Umar) in southeast Turkey, on the Syrian
border (Copenhagen, David Foundation,
no. 38/1973), though this is significantly
smaller, 27.5 cm in height. A dragon knocker
in Berlin of similar height (27.3 cm; no. I.
2242), has markedly fussier decoration,
with teeth, decorated 'manes', claws, and
indications of fur on the legs. The scales have
a central dot, and the gryphons' heads have
a more developed wattle. The dragons in
al-Jazari's well-known illustration of the
knocker he cast for the Urtuqid palace at
Diyarbakir (Topkapi Palace Library, A.3472,
folios 169 a–b) are confronted, not addorsed,
nor are their tails knotted.

These disparities show that there was a
fashion for dragon handles, or knockers, of
various sizes and physical characteristics in
early 13th century Jazira. Also noteworthy
is a series of cast brass or bronze knockers,
some of them evidently from the same
workshop which manufactured a headpiece
for an astronomical instrument in the Khalili
Collection, using palmettes or half palmettes
in more or less 'post-Samarra' style, in which

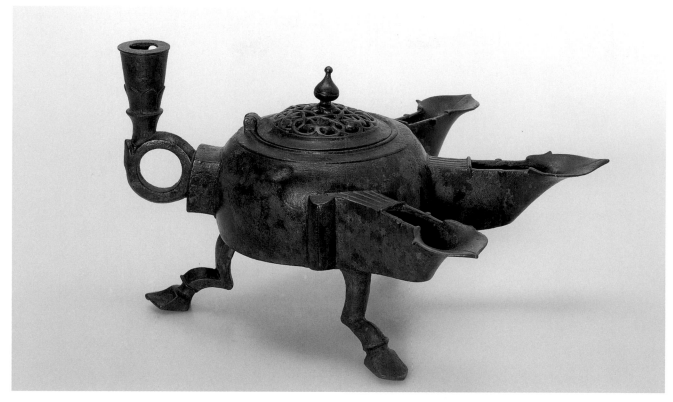

4

the figural allusions are clearly identifiable but the creatures have been reduced to bosses or scrolls. From the analogies they show with stucco and woodwork from the period of Badr al-Din Lu'lu' (d. AD 1259) at Mosul (today Iraq) they have also been attributed to the Jazira. The closest of these to the dragon group are in the David Collection (nos 2/1993, 21/1993 and 1/1994) but there are two others in a Kuwaiti private collection .

The knotted tails of the dragons may be an allusion to a pseudo-planet, Jawzahr, known in the West as *Caput et Cauda Draconis*, which was invoked by Muslim astronomers to explain eclipses of the moon.In mediaeval astronomy, however, knotted serpents were also an emblem of the constellation Hygeia (*Sanitas et duo dracones perplexi*) and may show the persistence of the serpents of Aesculapius in the eastern Hellenistic world. In Iraq and the Jazira they also decorated the gates of cities or fortresses, like the Talisman Gate (*Bab al-Tilasm*) at Baghdad (1221; no longer extant), the Aleppo Gate at

Diyarbakir (AH 589/AD 1183–84) and the Citadel of Aleppo (AH 606/AD 1209–10).

M.R.

4

Large oil lamp

Iran or Anatolia, 12th century
Quaternary alloy, piece-cast, with openwork decoration • Height 19.4 cm
The Nasser D. Khalili Collection of Islamic Art, London, inv.no. MTW 1293
Literature: unpublished

The flat-bottomed, three-spouted lamp stands on three legs with faceted hoof-like feet, with a candlestick surmounting the ring handle. The lid is hinged and has a cast vase-shaped finial. The openwork decoration of the lid suggests that the oil or tallow in the lamp contained scented substances which when burned might offset the smell of burning.

The central spout faces straight forward, but the side spouts, which curve gracefully

outward reach directly above the widely splayed legs and convey the impression that they are galloping away. The elegant leaf-like contours of the spouts, like the openwork hexagon interlace of the lid with its acanthus-like palmettes, may suggest a provenance from western Asia, perhaps 12th-century Anatolia or northern Syria.

M.R.

5
—

Candlestick

Signed by Ibn Jaldak 'the engraver'

Probably Amida (now Diyarbakir, southeast Turkey),

AH 622/AD 1225

Hammered brass, incised and inlaid with silver ◆

Height 34 cm, diameter 37 cm

Museum of Fine Arts, Boston, Edward Jackson

Holmes Collection, inv.no. 57.148

Literature: Rice 1949, no. 561, pp. 334-341; Rice

1957, p. 283-326; Baer 1983, p. 27-28; 32. See also:

Rice 1953, pp. 61-79

Inscription, main band, base of neck:

'Work of Abu Bakr son of al-Hajji Jaldak,
apprentice of Ahmad son of 'Umar son of
Kamil, known as al-Dhaki the engraver of
Mosul, in the year 622 [AD 1225]. Long life to
its owner'

Inscription, outer raised rim of candlestick
base:

'Lasting might and growing success and ?? and
ascending luck
and God's blessings in eternity and rising luck
and helping destiny and sweeping victory and
enduring good fortune and perfect integrity
and…[damaged area]…and wide authority
and lasting life
to its owner.'

Graffito, inner rim of candlestick base:

'The Vestiary of [al-Malik] al-Ma'sud'

Graffito, outside of candlestick base, above a
pictorial medallion:

'For a lady [under the supervision] of 'Afif al-
Muzaffari'

An important group of thirteenth-century
silver-inlaid brass objects is associated with
Mosul. While only one of these, the master-
ful Blacas ewer in The British Museum,
has an inscription stating that it was made
in Mosul, numerous others bear signatures
of artists using the sobriquet 'al-Mawsili'.
The second oldest dated object with such a

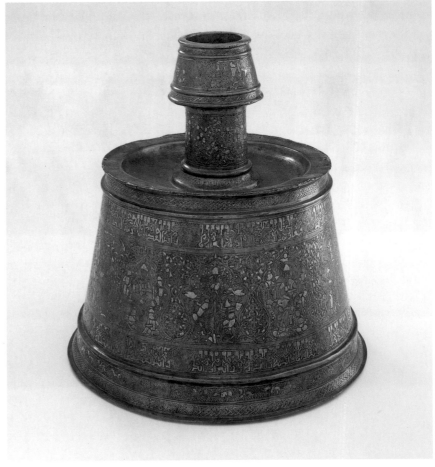

5

signature (the oldest is a modest box, with-
out figural scenes, in the Benaki Museum,
Athens), this candlestick was made by one
Ibn Jaldak, apprentice to Ahmad al-Dhaki
al-Mawsili, in 1225.

The candlestick is notable for its decoration,
which includes two styles of script, abstract
and animated interlaces, and scenes of
human activity. In eleven arched compart-
ments around the base, Ibn Jaldak has
depicted seated rulers, hunters, and gar-
deners; probably using contemporary book
painting as his model, he has provided a
glimpse into the different social strata of
his day.

Two graffiti – inscriptions not original to
the candlestick – suggest where it was made
and what happened to it. The al-Ma'sud
mentioned in the earlier graffito (hidden
inside the candlestick base) was probably the

last Urtuqid sultan of Amida; it seems more
likely that Ibn Jaldak made the candlestick
there than in Mosul itself. After the Urtuqid
dynasty fell in 1231, the deposed sultan
eventually took refuge with al-Malik al-
Muzaffar of Hamah (in Syria), and Ibn
Jaldak's candlestick probably passed to a
woman in al-Muzaffar's harem, of which
a eunuch named 'Afif was in charge.

J.B. *(with research assistance of Persis Berlekamp)*

6

Candlestick

Iraq, AH 717/AD 1317-18

Brass, inlaid with silver and gold ◆ Height 53 cm,
diameter of the base 41 cm

Benaki Museum, Athens, inv.no. 13038

*Literature: Alexandria 1925, pl. 13; Devonshire 1925,
pl. 1c, p. 99-100; Devonshire 1928, p. 195; Combe
1930, pp. 51-54; Wiet, p. 9, No 16; Macridy 1937,
p. 141; Philon 1980, fig. 113, p. 29*

This brass candlestick is inlaid with silver
and gold although a considerable quantity
of these metals has been removed. It is
decorated with inscriptions in the cursive
script typical of the period.

On the rim of the candle holder:

*The work of the master Ali, son of Umar, son of
Ibrahim al-Shankari (?) al-Mawsili, and that
was in the year 717 of the Prophet's hijra.*

Around the candle holder:

*I preserve the fire and its constant glow. Dress
me in yellow garments. I am never present in
an assembly without giving the night the
appearance of day.*

In the medallions, which were originally
decorated with Z-shaped patterns, an incised
inscription:

*This candlestick was endowed to the sanctuary
of the Prophet by Mirjan Aqa.*

The band around the neck is inscribed with
part of the Qur'an (II: 255):

*God! There is no god but He – the Living,
the Self-subsisting, Eternal.
No slumber can seize Him, nor sleep.
His are all things in the heavens and in earth.
Who is there can intercede in His presence,
except As He permitteth?
He knoweth what
(appeareth to His creatures as)
Before or After or Behind them.*

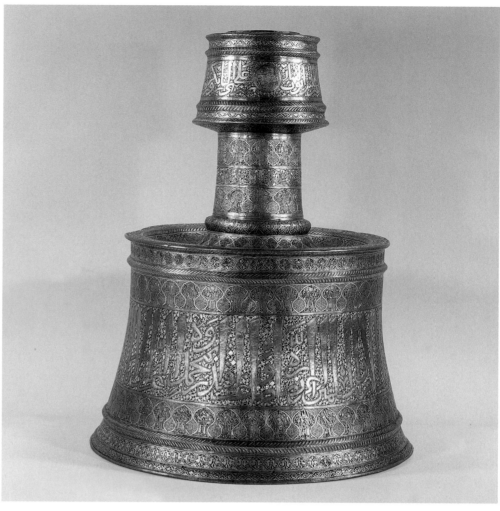

6

The inscription around the edge of the
shoulder:

*I preserve the fire and its constant glow. Dress
me in yellow garments. I am never present in
an assembly without giving the night the
appearance of day. For its owner the glory and
prosperity will last and long life for infinite
days. Glory and victory and prosperity and
grace and luck and splendour and excellence
and generosity and forbearance and learning
are the things for which you are exalted, that
the Arabs and Persians are embarrassed to
describe you. What is created is very little beside
you, seeing that your qualities are for them the
principles of existence while the (other) people
have disappeared.*

Around the body:

*Glory to our Lord, the possessing king, the
learned, the just, the fortified (by God), the
triumphant, the victorious, the holy warrior,
the protector of frontiers, the defender, the
support of Islam and Muslims. May God glorify
his adherents and multiply his power,
through Muhammad and his family.*

Inside the candlestick:

*This most luminous candlestick was endowed
by Mirjan of the Sultan, to the sanctuary of the
Prophet and The curse of God be upon the one
who changes it or attacks it or takes possession
of it. It is flogging in the open and before all.*

Furthermore, the candlestick is decorated
with standing figures on a geometric
background, the twelve signs of the zodiac,
bands with pairs of birds and dense foliage.
Although the candlestick is dedicated to an
unnamed sultan, the titles of the sovereign
around the body suggest this may have been

Shams al-Din-Salih, the Urtuqid Sultan of Mardin (southeast Turkey) who reigned between AH 712-765/AD 1312-1363-4. At a later date Mirjan Aga presented the candlestick to the Sanctuary of the Prophet in Mecca after attempting to remove some of the human figures from the decoration. Mirjan Aga (d. AH 755 / AD 1374) was a slave of Sultan Uljaytu and twice governor of Baghdad.

M.M.

7

Candlestick

Signed by the craftsman Ruh ad-Din Tahir

Iran, Muharram AH 725 (December-January 1324-25)

Bronze (or brass), silver ◆ Height 47.8 cm

The State Hermitage Museum, St Petersburg, inv.no. IR-1980

Provenance: transferred in 1966 from Bakhchisaray History and Architecture Museum (Crimea)

Literature: Kuwait 1990, no. 50

The shape of this candlestick is typical of 14th-century Iranian metalwork. However, it is inlaid only with silver, in a period when it was a more common practice to inlay with both gold and silver. The only living creatures represented are birds.

The candle holder bears the artisan's name:
The work of Ruh ad-Din Tahir,

as well as a probable *Hadith*:
The Prophet said, peace be upon him...

The base of the candlestick bears an inscription in large thuluth script:
Glory to our master, sultan of the sultans of the Arabs and the non-Arabs, holder of the power of life and death over the peoples, the just, the warrior for the faith.

This inscription is of a standardized type and is to be encountered on many 14th-century

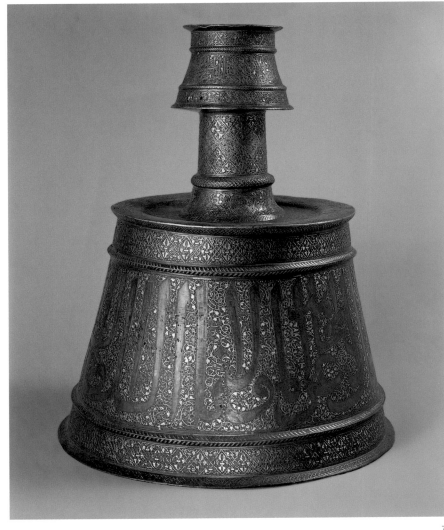

7

Iranian bronzes; as with many of these, the sultan's name is not mentioned.

The most important inscription is placed in six cartouches on the shoulders of the candlestick. This has been damaged and now we can read the contents of only four cartouches. The language is Arabic, written in *naskh* script:

At the beginning, there is a Persian word – 'work doing', executed with a tool different from that used for the rest of the legible part of the inscription (two cartouches cannot be deciphered and in addition, the owner's *nisba* has been changed).

Thus, the beginning remains unclear. Perhaps, the second word was: 'two

candlesticks', the further text being unproblematic:
...the highest master, king of viziers, saviour (benefactor) of the Hajj and the two Holy Shrines (i.e. Mecca and Medina), 'Imad ad-Dunya wa'd-Din Muhammad Falaki, may his victory be strengthened and his success multiplied...in Muharram, [of the] Hijra year 725.

Regretfully, we have not found this man's name in historical sources, impeding the solution to many problems connected with this piece.

A.I.

8

Mosque lamp

Signed by Musli

Ottoman Turkey (Iznik), Jumada AH 956 (June 1549)

Ceramic, stonepaste body, underglaze decoration, transparent colourless glaze ♦ Height 38.1 cm, diameter 24.9 cm

The British Museum, London, inv.no. 1887 5-16 1

Provenance: Gift of C. Drury Fortnum

Literature: Drury Fortnum 1869, pp. 387-397; Hobson 1932, fig. 100; Lane 1957, fig. 38; Rogers - Ward 1988, p. 148, no. 48; Atasoy - Raby 1989, no. 355; Carswell 1998, fig. 39

This symbolic mosque lamp is the key document for the study of Iznik pottery. The inscription around the footring includes the date, the name of the designer and a dedication to the local saint of Iznik, Esrefzadeh Rumi. The majestic *thuluth* inscriptions around the lip, neck and lower body are Qur'anic verses. According to the donor of the lamp, it was found in the Mosque of Omar in Jerusalem in 1865 and subsequently given to him by the friend who found it. Scholars have deduced that the lamp was produced as part of the refurbishment of the Dome of the Rock, instigated by Sultan Süleyman the Magnificent in the mid-16th century.

The repeating cloud-bands on a white ground, the black arabesques on turquoise in lobed semi-medallions and the narrow band of tulip buds recur in several Iznik objects otherwise notable for their size and decorative clarity, and help to date those objects to the mid 16th century. The lamp was made at a time when polychrome glazes were beginning to replace the blue and white and blue, turquoise and white palette of early 16th-century Iznik wares. The sober, measured ornament of the lamp accord with its intended use in one of the holiest buildings in Islam.

SH.C.

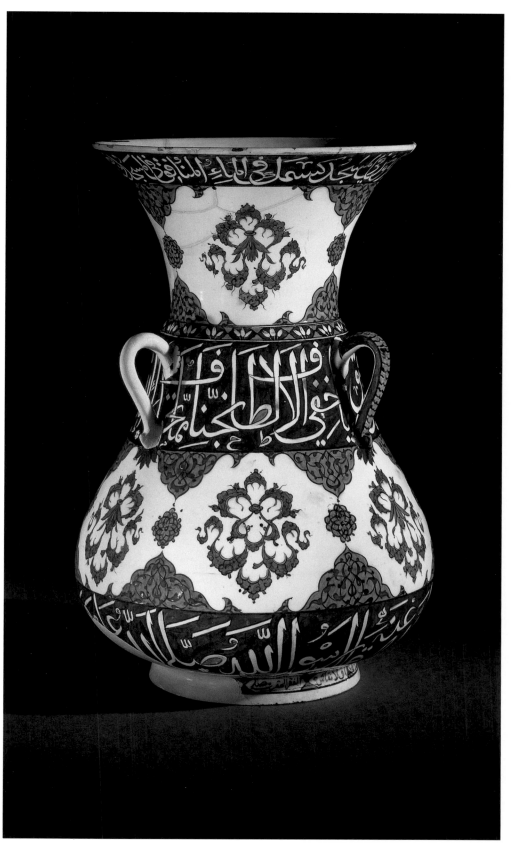

8

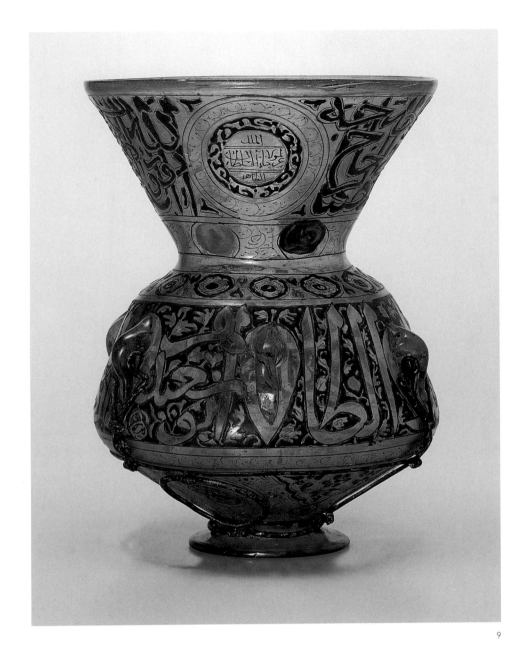

9

And within it a lamp:
The lamp enclosed in glass

The inscription is interrupted by three large medallions enclosing calligraphic blazons:
Glory to our lord the sultan al-Malik al-Zahir.

The main decoration on the body is a wide calligraphic frieze, also in Mamluk *thuluth* script, outlined in red and reserved on a dark blue ground:
Glory to our lord the sultan al-Malik al-Zahir Abu Sa'id, may God grant him victory.

The inscriptions indicate that the lamp was commissioned by al-Malik al-Zahir Sayf al-Din Abu Sa'id Barquq. He was the first in the line of *Burji* Mamluk sultans and ruled twice, between 1382–1389 and 1390–1399. It is possible that this lamp was intended for the *madrasah* he built in Cairo in 1384–86.

Gaston Wiet recorded 35 intact mosque lamps, and a group of fragments from several others, bearing the name of Barquq. Many share the same decorative schemes seen on this example.

M.R.

9

Mosque lamp

Egypt, circa 1385
Transparent, bubbly glass with a greyish tinge, blown, with trailed-on handles; opaque red, blue, green and yellow enamels and gilding; later gilded metal attachments; the base a modern restoration ✦
Height 33 cm, diameter 25 cm (maximum)
The Nasser D. Khalili Collection of Islamic Art, London, inv.no. GLS 572
Literature: *Wiet 1929, pp. 174–179, nos. 128–163, pls. LXIII–LXXXVIII; Galerie d'Orléans 1991; Khalili Collection 1993, pp. 54–55*

The lamp, which carries the name and blazons of the Mamluk sultan Barquq, has a wide, funnel-shaped neck with a thickened, rounded rim. The straight walls of the body flare out from the sloping shoulder before tapering sharply towards the base; six suspension loops are trailed on to the body.

The dark blue inscription on the neck, in Mamluk *thuluth* script, outlined in red on a gilded ground, consists of the opening part of *Ayat al-Nur* ('The Verse of Light', XXIV: 35):
God is the Light of the heavens and the earth The parable of His Light is as if there were a niche

10

Mosque lamp

Syria or Egypt, 1346-47

Glass, enamel ♦ Height 36.2 cm

The State Hermitage Museum, St Petersburg, inv.no. EG-883

Provenance: transferred in 1885 from the A.P. Bazilevsky Collection, Paris

Literature: Pevzner 1958-II, ed. XII, pp. 94-87

Inscriptions on the neck and body ('High-principled, noble, greatest [servant] of the lord our sultan al-Malik al-Muzaffar, son of the late sultan al-Malik an-Nasir') indicate that this lamp was made for the Mamluk sultan al-Muzaffara Hadji, who ruled for no longer than 15 months in 1346 and 1347.

A.I.

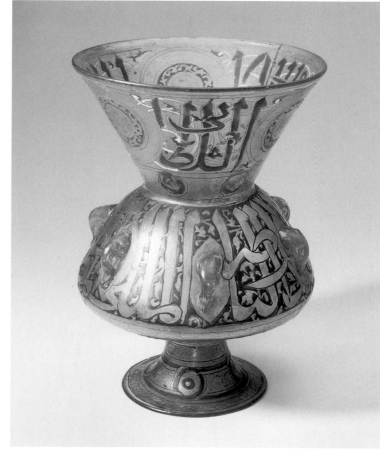

11

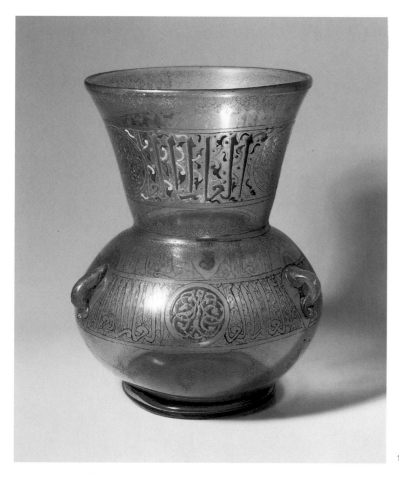

10

11

Mosque lamp

Syria or Egypt, 15th century

Glass, enamel ♦ Height 30.7 cm

The State Hermitage Museum, St Petersburg, inv.no. VG-17

Provenance: transferred in 1924 from the Museum of the former Baron A.N. Stieglitz School of Technical Drawing

Literature: unpublished

The same title *al-Alim*, 'the omniscient' is repeated over the neck and body. There is no mention of the individual who commissioned this piece.

A.I.

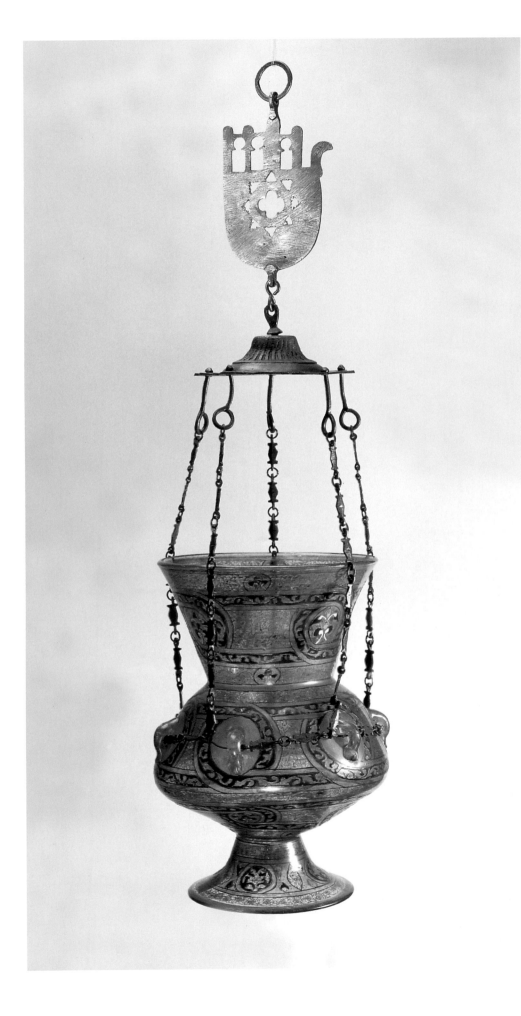

12

Mosque lamp with pendant

Syria or Egypt, 15th century

Glass, enamel ◆ Height of lamp 32 cm

The State Hermitage Museum, St Petersburg,
inv.nos. EG-493 (lamp), EG-937 (pendant)

Provenance: the lamp was acquired in 1924 from
the E.V. Shuvalova Collection, the pendant was
brought from Egypt in 1898 by V.G. Bock

Literature: Turku 1995, no. 76

The pendant on this lamp is probably older
than the lamp itself. They were brought
together in The Hermitage.

A.I.

Once in their lives Muslims, provided they have the means and are fit, should make a pilgrimage to the city of Mecca. The pilgrim undertakes this journey, called a *hajj*, including a visit to the holy places mentioned in connection with the prophets Ibrahim (Abraham) and Muhammad. Mecca is the birthplace of Muhammad and the city where he began preaching in about 610. In 630, when the prophet gained control of the city, he purified the ancient temple complex from its idolatrous images and dedicated it to Allah.

The holiest object in Mecca is the *Kaaba*, a rectangular building which Muslims all over the world turn to face when praying. According to Islamic tradition the Kaaba was built by Adam, the first prophet. Later on, Ibrahim and his son Isma'iel (Ishmael), who is the forefather of all Arabs, are said to have rebuilt it after the fall. Set in one corner of the Kaaba is the Black Stone, which Allah once sent down out of heaven.

The Kaaba, which has one door, is covered with a black cloth called the *Kiswa*. The Kiswa, replaced each year, has a band beautifully embroidered in gold and silver thread with the creed and verses from the Qur'an.

The holy shrine stands empty. But inside a few gold and silver lamps burn, symbolizing the presence of God.

J.V.

Pilgrimages

13

Pilgrim's flask

Syria (Damascus), 13th-14th century

Earthenware ◆ Height 23.5 cm

National Museum of Syria, Ministry of Culture,
General Directorate for Antiquities and Museums,
Syrian Arab Republic (Damascus), inv.no. 918-A

Provenance: Damascus

Flasks such as these were used by travellers
or to store water. The vessel can be sus-
pended from one of the handles. The
porous clay body kept the water cool.

The flask has a thickset disc-shaped body
made with a mould and a broad base; there
are two handles attached to the neck and
shoulder. The lip is broad and simple. The
decorations comprise stylized floral and
geometric motifs surrounding two circular
cartouches which both contain a sword.
These are the emblems of 'the man who
is responsible for weapons'.

M. AL M.

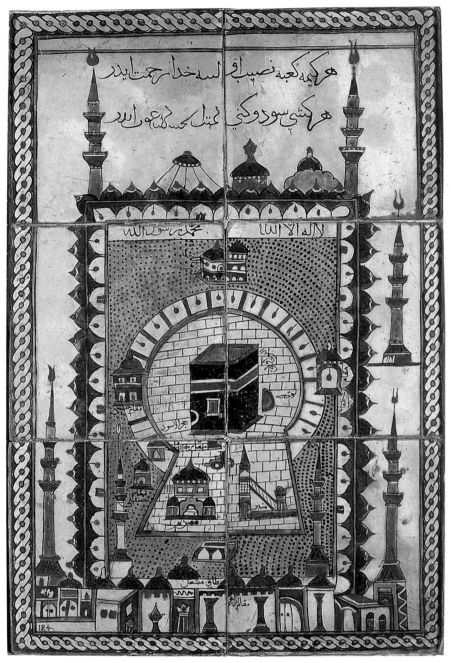

14

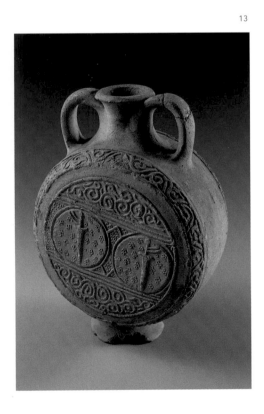

13

14

Panel of six tiles

Turkey (Iznik), 17th century

Earthenware, glazed ◆ Height 73 cm, width 49.5 cm

Benaki Museum, Athens, inv.no. 124

*Literature: Alexandria 1925, pl. 24; Philon 1980,
fig. 9, p. 15*

This panel consists of six square tiles with
polychrome decoration under a transparent
glaze. The panel depicts a map of the Holy
Sanctuary of the Great Mosque (Masjid
al-Haram) at Mecca with the Kaaba in the
centre. The rectangular courtyard is sur-
rounded by five minarets and other build-
ings. Inside the arched courtyard the Kaaba
is depicted in the centre surrounded by dif-
ferent buildings and sites which are ident-
ified by their names. On the top and between
the two minarets are two lines of Turkish
inscription in cursive script. Within the

courtyard there are another two inscriptions in Arabic:

There is no god but God and
Muhammad is the Messenger of God.

All Muslims turn in the direction of the Kaaba to pray and every Muslim must visit the Kaaba at least once in his lifetime. Tiles such as this had a votive or commemorative function and were produced at Iznik in the 17th century.

M.M.

15

Tile

Ottoman Empire, AH 1118/AD 1706

Earthenware, glazed ✦ Height 31.5 cm, width 31 cm

Benaki Museum, Athens, inv.no. 125

Literature: unpublished

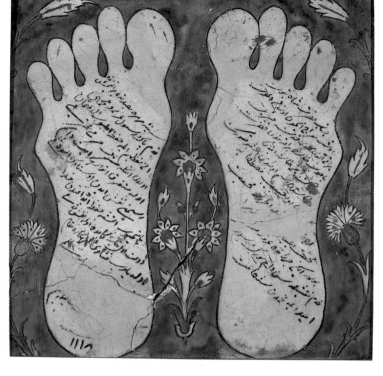

15

This rectangular tile has polychrome decoration under a transparent glaze, depicting a pair of footprints amidst flowers arranged symmetrically on a green background. The footprints contain Turkish inscriptions and the date AH 1118/AD 1706.

Footprints of holy figures are revered in Islam, as in other religions. A small building beside the Kaaba houses a stone which is believed to bear the footprint of Abraham (Ibrahim).

The footprints on this tile, however, refer to those left by the Prophet before his miraculous night journey to heaven. This site was later marked by the Dome of the Rock in Jerusalem.

M.M. (J.V.)

16

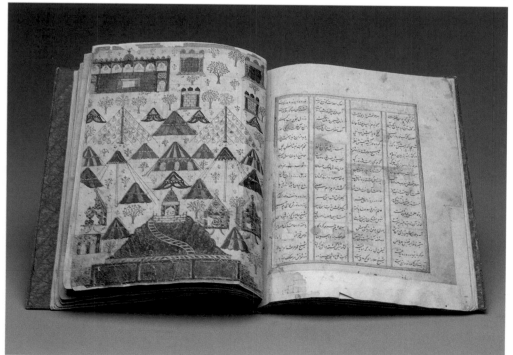

16

Muhyi al-Din Lari. Futuh al-Haramayn (poetical description of Mecca and Medina)

Copied by the calligrapher Vasi al-Harawi

Mecca, AH 970/AH 1562-63

Gouache, paper

25 leaves, the final leaf is a leather binding ✦ Height 25 cm, width 17.5 cm

The State Hermitage Museum, St Petersburg, inv.no. VR-941

Provenance: unknown; acquired in 1939

Literatuur: Adamova 1996, p. 358, no. 11

The manuscript contains 13 miniatures depicting the Muslims pilgrimages.

A.A.

17

Three charts of pilgrimage sites

Probably the Hijaz (today Saudi-Arabia),

17th or 18th century

Ink, gold, silver and watercolours on

cream laid paper ◆ Length approximately 64.6 cm,

width between 41.9 cm and 47.5 cm

The Nasser D. Khalili Collection of Islamic Art,

London, inv.nos. MSS 745.3, MSS 745.1, MSS 745.2

Literature: Tanindi 1983, pp. 401–437; Rogers - Ward

1988, nos. 36, 43a–b; Rogers 1992, pp. 228–255;

Copenhagen 1996, no. 38

These depictions of the Holy Places of the Hijaz form part of a very ancient and very conservative tradition. Although the details may change with each rendition, the basic schemes remain constant over long periods. The view is always from the north, and the monuments are invariably shown partly in elevation and partly in bird's-eye view, at an angle of about 60 degrees. The images of the Masjid al-Haram (the mosque that contains

the Kaaba) in Mecca and the Haram al-Nabawi (Mosque of the Prophet) in Medina can be traced back as far as the 12th century, but many more survive from later centuries, appearing on a variety of objects. One stimulus was the growth of proxy pilgrimages. Members of Muslim imperial families, who were not able to perform the *hajj* themselves for political reasons, paid others to go in their stead, and attestations in scroll form were issued by the authorities in the Hijaz to show that the pilgrimage had been properly conducted. The most splendid surviving example, although incomplete, is the scroll attesting to the proxy pilgrimage performed in AH 951/AD 1545 on behalf of Prince Mehmed, a son of Sultan Süleyman the Magnificent who had died in 1543 (Istanbul, Topkapi Palace Library, ms.H.1812). The same conventions were adopted for illustrations of literary works on the Holy Places, such as Muhyi Lari's *Futuh al-Haramayn* (*see cat.no. 16*), which the author dedicated to the Sultan of Gujarat (now west India) in 1506, and which was much copied in 16th-century Persia, Turkey and India. The conventions were also applied in views of other shrines, notably those at Najaf and Karbala' in Iraq, which are so represented in a scroll acquired by the Danish traveller Carsten Niebuhr at Karbala' in 1765 (Copenhagen, National Museum, EEA.1). Comparable views of the same shrines seem to have existed much earlier, as they occur in the Mecmu'a-i Menâzil prepared by Matrakçi Nasuh in 1537 (Istanbul University Library, ms.T.5964).

As in the case of *cat.no. 18*, the three illustrations in this group may be the work of an Indian draughtsman working in the Hijaz. This would certainly account for the fanciful Indian-style domes that adorn many of the buildings, and for the inscriptions in Persian, the literary language of many Indian Muslims in the past. The diagrams were drawn on large sheets of paper (composite in the case of *folio a*) using a rule and compass, with some freehand drawing. They were then

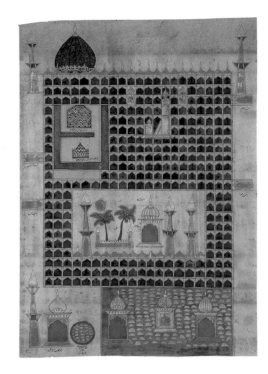

17C

painted in colours, silver and gold, and glosses were added in black ink.

17A

Stations of the pilgrimage outside Mecca (MSS 745.3)

The chart represents the area to the east of Mecca where the greater part of the hajj ceremonies took place. The underlying scheme is identical to *cat.no. 18, folio a*, but the effect is lighter and more obviously Indian, due to the colours used, and the more fanciful rendition of both the buildings and the five mountains. The three main stations on the ritual journey from Mecca to the plain of 'Arafat are represented by the Mosque of Mina (centre), the smaller Mosque of al-Muzdalifa above it, and the Mount of Mercy on the plain of 'Arafat itself (top left). These are complemented by depictions of six other features. The Mosque of the Prophet Adam is shown at the top, with Mount Thawr to its right, and Mount Abu Qubays below that. In the bottom right corner are cemeteries, one of which contains the Tomb of Khadija al-Kubra, while Mount

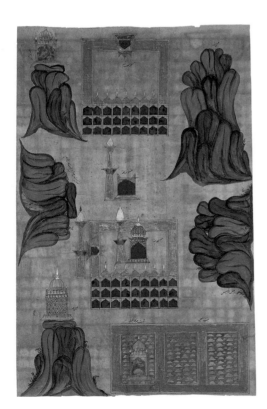

17A

Nur to its left is crowned by an Indian-style pavilion. Above it is the Jabal al-Kabsh, 'the place of the sacrifice of Ishmael – Peace be upon him!' This gloss is a reference to the sacrifice of Abraham, when the patriarch's willingness to sacrifice his son Ishmael was rewarded by God, who sent an angel with a ram to be slaughtered in his son's place.

17B

The Masjid al-Haram at Mecca (MSS 745.1)

Literature: Vernoit 1997, no. 14, p. 34

The monuments are elegantly depicted, though the buildings in the courtyard and the minarets have inauthentic onion domes. Similarly, the arcades, which were vaulted in Ottoman works of the later 16th century under Selim II and Murad III and would have had hemispherical domes of the Ottoman type, are here shown with bracketed domes of an Indian type. The Kaaba is represented in the same manner as in *cat.no. 18, folio b*, but omitting the waterspout. The building is covered with a black curtain, the *Kiswa (see cat.no. 19)*, while the horizontal yellow band stands for the girdle or *Hizam (see cat.no. 20)*, and the red and gold square, labelled 'Door of the Kaaba', marks the location of the *Sitara (see cat.no. 21)*. The buildings in the courtyard include stations for the imams belonging to each of the four schools (*Madhhab*) of Islamic law (*Shari'a*). That at the top (south) belonged to the Malikis, that on the right (east) to the Hanafis, and that shown at an angle in the bottom left (north-west) to the Hanbalis. The Shafi'is used the building covering the Well of Zamzam, which is distinguished by a large silver and red medallion, representing the well itself.

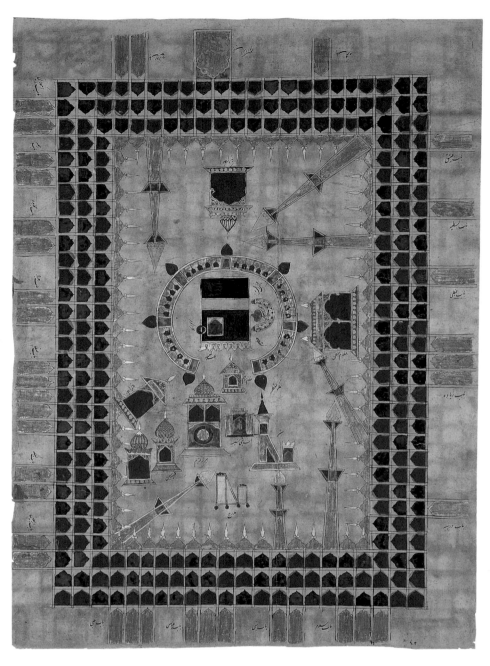

17B

17C

The Haram al-Nabawi in Medina (MSS 745.2)

Literature: Vernoit, no. 14, p. 35

This chart shows the Haram al-Nabawi, or Mosque of the Prophet. This was constructed on the site of the Prophet's house and contains his tomb, which is marked by the Green Dome in the top left corner. (It is shown as deep-blue, with green scrolls).

Below it is the cenotaph of the Prophet with its characteristic zigzag cover, and below that the cenotaph of the Prophet's daughter, Fatima. To the right, amidst the domed arcades shown in bird's-eye view, stand a minbar (pulpit) between two *mihrabs*, one labelled as the Hanafi mihrab, the other as the mihrab of the Prophet. The courtyard of the mosque contains the Tomb of Zaynab, a well and two palm trees, while the cemetery below contains a number of monumental tombs. That on the right is identified

81

as containing the graves of 'Abbas (Muhammad's uncle, and founder of the Abbasid Caliphate), Imam Hasan (son of Fatima and Imam 'Ali ibn Abi Talib, and 'Ali's successor as Imam) and two other Shi'i imams, Muhammad Baqir (the Fifth Imam, 677-733) and Ja'far al-Sadiq (the Sixth Imam, 702-765). To its left stands the tomb of Malik (circa 712-795), the founder of the Maliki school of law, and that of the Caliph 'Uthman (d. 656). To the left, outside the cemetery, is the tomb of Amir Hamza (a figure from the *Hadith*, the legends about the Prophet's life).

M.R.

18

Three charts of pilgrimage sites

Probably the Hijaz (today Saudi-Arabia),
18th or 19th century
Ink, burnished silver and watercolours, probably
tempera, on dark-cream laid paper ◆ Length
approximately 62.5 cm, width between 41.7 cm
and 44 cm
The Nasser D. Khalili Collection of Islamic Art,
London, inv. nos. MSS 745.4, MSS 745.5, MSS 745.7
Literature: Vernoit 1997, pp. 27–38

These three charts, like *cat.no. 17*, come from a set that was probably prepared for sale during the *hajj*, the great annual pilgrimage performed in Mecca and its environs. There was a longstanding tradition of purchasing such items as souvenirs of the pilgrimage, which every pious Muslim hoped to complete at least once in a lifetime. The pilgrimage to Mecca was usually combined with a visit to other holy sites in the region, including the Tomb of the Prophet in Medina, which was also shown in such sets of charts (*see cat.no. 17, folio c*). This group is unusual in that it also features a view of Jerusalem, which was the third holiest city for Muslims and was included in some itineraries.

18A

The three charts were created by gluing two sheets of paper together along one side; the diagrams and other images were executed in silver, a brown wash, red, green and black, with north at the bottom of the chart. Captions were added in Persian, and the use of this language indicates that, as in the case of *cat.no. 17*, both the producers of these images and their intended customers were from the eastern half of the Islamic world, probably from India. During his illicit visit to Mecca in 1853, Richard Burton noted Indian painters who produced depictions of the holy shrines, their works being a 'mixture of ground plan and elevation, drawn with pen and ink, and brightened with the most vivid colours'.

18A

Stations of the pilgrimage outside Mecca (MSS 745.4)

The pilgrimage sites and other features of the area immediately to the east of Mecca are shown as schematically rendered buildings and cemeteries (the three rectangular areas

in the bottom right) and five stylized mountains. Mount Abu Qubays, which protrudes into the chart from the right edge, marks the eastern limit of the city. To the east is the mosque at the pilgrimage site of Mina, which has arcades running along one side. Above is the tower and small mosque at al-Muzdalifa, and above this, in the top left corner, is the Mount of Mercy in the plain of 'Arafat, by which the central rite of the hajj took place. The hill is shown surmounted by the domed Qubbat Umm Salama, which is no longer extant. The large building at the top of the chart is 'the Mosque of Father Adam', who according to Islamic tradition was buried in this area; the mountain shown below the Mount of Mercy is described as the site of the sacrifice of Abraham (*compare cat.no. 17, folio a*).

18B

The Masjid al-Haram in Mecca (MSS 745.5)

The Masjid al-Haram in Mecca is the vast enclosure within which stands the Kaaba,

18C

the unifying focus of the Muslim world. This small, cube-shaped building is believed to have been built by Abraham but has been reconstructed many times since, always incorporating the holy Black Stone in its eastern corner. The Kaaba is shown in the centre of the diagram, covered with a black and gold curtain and displaying three features that are labelled. They are the 'Door of the Kaaba' and the 'Most Felicitous Stone', both shown in red, and the golden 'Water-spout of Mercy', protruding from the roof at its western angle. The semicircular wall called the *Hatim* is shown immediately to the west of the Kaaba; within it lie the graves of Abraham's son Ishmael and his mother Hagar. Around the Kaaba and the Hatim runs the circular walkway called the *Mataf*; ten other small structures are indicated in more or less their correct locations within the courtyard. Around the courtyard runs a colonnade roofed with domes, which are shown projecting into the courtyard, as are seven minarets. The blank margins beyond the colonnade clearly represent the outer walls of the building, since they are pierced by its many gates.

18C

The Haram al-Sharif in Jerusalem (MSS 745.7)

The Haram al-Sharif, or Temple Mount, in Jerusalem is depicted in much the same style, but with fewer, larger buildings, as one would expect. The two main structures are represented in an emblematic manner. The Dome of the Rock, identified as the 'Throne of the Lord of the Worlds', is the domed building to the north, emblazoned with the footprints of the Prophet, while the flat-roofed Masjid al-Aqsa is shown with its *minbar* (pulpit) in one arch and a silver roundel representing the Well of the Leaf in the other. The set of scales between the two buildings are conceptual rather than real: they are the scales on which souls will be

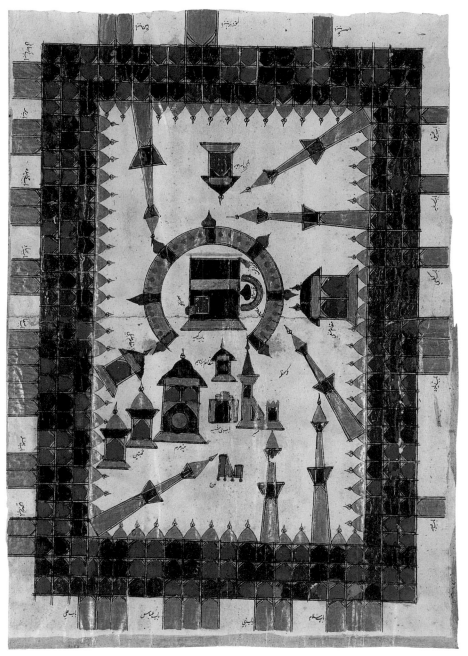

18B

weighed on the Day of Judgement, and they indicate that the Haram al-Sharif is the place where the assembly on the Last Day will take place (*see cat.no. 239, folio 10b*).

M.R.

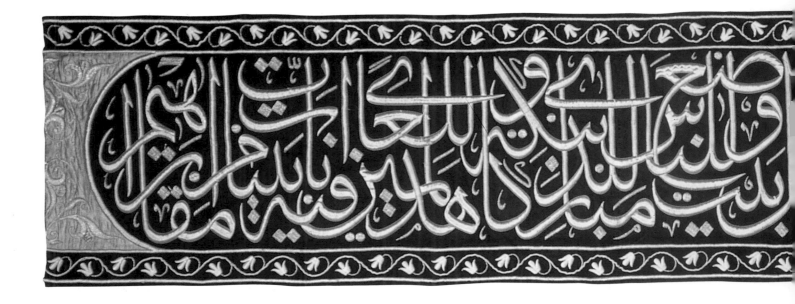

19

Fragment of the Kiswa

Cairo, 19th century

Silk, lampas weave with a satin ground and tabby

pattern ✦ Height 160 cm, width 88 cm

The Nasser D. Khalili Collection of Islamic Art,

London, inv.no. TXT 38

Literature: Vernoit 1997, pp. 26–27, no. 8

The *Kiswa*, or Veil, was the outer covering of
the Kaaba in Mecca. It is renewed annually,
and in the Ottoman period the new trap-
pings for the Kaaba were brought with the
pilgrimage caravan that came from Egypt
towards the close of the Muslim lunar year.
In the course of this process the previous
year's Kiswa was taken down and cut up,
and the pieces distributed among the pious.
The self-patterned black textile bears a
design of zigzag bands with alternating
inscriptions. Every other band contains
the *Shahada*, the Muslim profession of faith,
written in the *thuluth* style of script. The first
half of the text, *La ilah illa Allah* ('There is no
god but God'), occupies the rising sections of

the band and is composed so that the word
Allah appears at the apex. The second half,
Muhammad rasul Allah ('Muhammad is the
Messenger of God'), occupies the falling
sections, but it is written sideways, so that
the word *Allah* again appears at the 'top'.
The inscription in the intervening bands
consists of the word *Allah* in a larger size of
script, again set in the apex of the zigzags.
It is flanked by the phrase, *jalla jalalahu*
('May His glory be glorified!'), written in
positive in the rising sections and in reverse,
in so-called mirror script, in the falling
sections.

The outer covering of the Kaaba also in-
cluded the *Hizam* (*see cat.no. 20*) and the
Sitara (*see cat.no. 21*).

M.R.

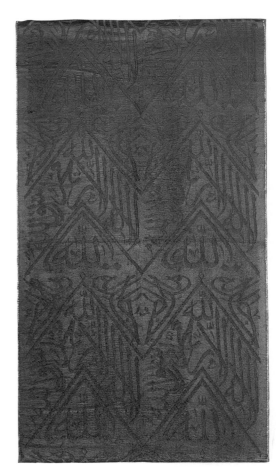

19

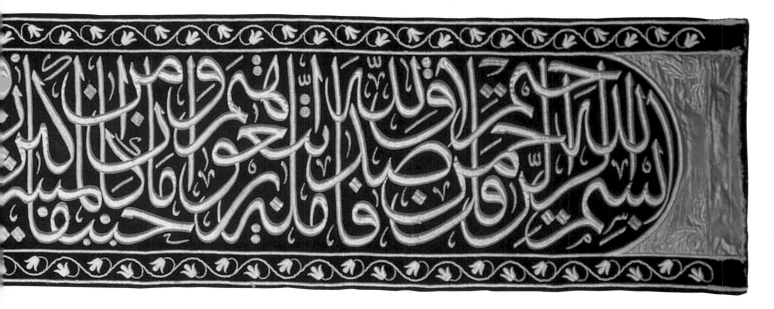

20

20

Panel from the Hizam

Cairo, 19th century

Black and gold satin, the main elements of the

decoration embroidered in gold and silver thread

over padding, the smaller motifs embroidered in fine

flattened gold and silver wire ✦ Height 590 cm,

width 90 cm

The Nasser D. Khalili Collection of Islamic Art,

London, inv.no. TXT 39a

Literature: *Vernoit 1997, pp. 28–29, no. 9*

The *Hizam* is part of the elaborate textile
covering for the Kaaba in Mecca that is
renewed every year during the pilgrimage
season. It is the belt-like band that engirdles
the upper part of the building; by this date it
took the form of eight calligraphic panels,
two to a side. This section is emblazoned
with a magnificent inscription in the *thuluth*
style, executed in gold embroidery over
padding, with the diacritical dots, vowel
signs and other aids to pronunciation em-
broidered in gold wire. The text consists
of the *basmala* ('In the name of God, the

Merciful, the Compassionate'), followed
by a quotation from the Qur'an (III: 95–97):
> Say:
> 'God speaketh the Truth:
> follow the religion of Abraham,
> the sane in faith;
> he was not of the Pagans
> The first House appointed for men
> was that at Bakka: full of blessing and
> of guidance for all kinds of beings:
> in it are Signs Manifest:
> the Station of Abraham.'

M.R.

21

Sitara

Mecca, after 1985

Black satin, embroidered in gold and

silver thread ✦ Height 256 cm, width 136 cm

The Nasser D. Khalili Collection of Islamic Art,

London, inv.no. TXT 154

Literature: *Vernoit 1997, pp. 27–33*

The *Sitara* is the curtain that covers the door
of the Kaaba. Like the rest of the Kaaba's
external covering, it is replaced every year
during the *hajj*. For many centuries these
textiles were brought from Egypt, where
they were made. This custom was associated
with the status of the Mamluk and then the
Ottoman rulers of Egypt as suzerains of the
Hijaz, the region where Mecca is located;
this was expressed in their title of Servant
of the Two Noble Sanctuaries. In 1924,
however, King 'Abd al-'Aziz of the Al Sa'ud
dynasty conquered the Hijaz. 'Abd al-'Aziz
transferred production of the Kiswa and
other textiles associated with the Kaaba to
Mecca. This example was made in Mecca

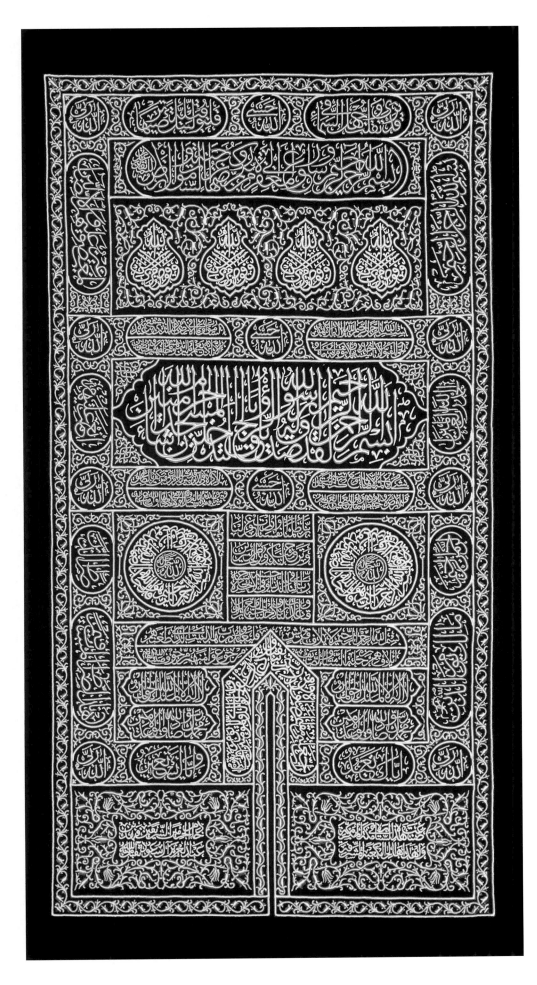

under the patronage of King Fahd, who ascended the throne in 1985, information contained in the silver inscription at the base of the curtain.

Moving production to Mecca did not entail great alternations to the design of the Sitara, which continued to be made of black satin lavishly embroidered in gold and silver thread with a complex pattern of panels, roundels and other devices inscribed with apposite Qur'anic quotations and prayers. The main inscription in silver, for example, consists of the basmala and a quotation from verse 27 of *Surat al-Fath* ('Victory'; XLVIII):

> *In the name of God,*
> *the Merciful, the Compassionate.*
> *Truly did God fulfil the vision for His Apostle:*
> *Ye shall enter the Sacred Mosque,*
> *if God wills,*
> *with minds secure.*

M.R.

19

The Word

For Muslims, the words that God spoke to the prophet Muhammad are sacred. The Qur'an, which contains all the revelations to the prophet, is literally the Word of God which descended from heaven to earth. This endows the Qur'an with a sacred nature.

This exalted nature soon led to a special religious and artistic value being attached to the written word. Indeed, calligraphy, or beautiful handwriting, was the most suitable method for transmitting the Word. In the Islamic world the calligrapher is the most highly revered of all artists.

Allah revealed His words to the angel Gabriel (in Arabic Jibril or Jibra'il) in the Arabic language. This is why Arabic script has a special significance for all Muslims. It is to be found on garments, on domestic objects, on valuable items and on both worldly and religious buildings. It offers a spiritual, protective power, and brings good luck.

Arabic script is highly decorative. Down the centuries Arab masters have developed handwritings that range from the delicately refined to the hugely monumental.

The most sober and dignified form is Kufic script which takes its name from the city of Kufa in southern Iraq, in the Middle Ages a major centre of Islam. This handwriting is the one most often used, on account of its formal dignity and elegance, particularly for decorating large buildings and works of art.

From the 9th century on cursive scripts were used. Some of them are so graceful and virtuosic that they appear made more with the intention of delighting the sight than actually to be read.

J.V.

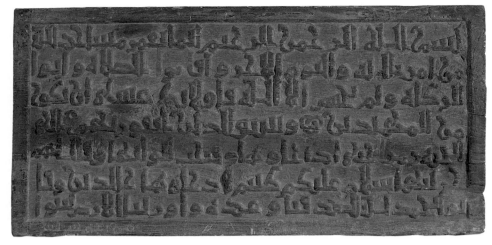

22

would have been coloured; there are a few traces of paint on the frame and the background to the text.

M.M.

23

Bowl

Iran (Nishapur), 11th century
Earthenware, slip-painted under a transparent glaze ◆ Height 7.2 cm, diameter 25.1 cm
The Nasser D. Khalili Collection of Islamic Art, London, inv.no. POT 1492
Literature: Ghouchani 1986, pls 27, 41, 55, 68, 101, 126 and 139; Grube 1994, no. 66, p. 77; see also p. 76

22

Carved panel

Fatimid Egypt, 11th century
Wood, carved ◆ Length 55 cm, height 27 cm
Benaki Museum, Athens, inv.no. 9136
Literature: unpublished

A Fatimid wooden panel from the door of a mosque carved with a seven-line inscription with two verses from the Qur'an, IX: 18:

In the name of God,
the Merciful, the Compassionate,
Only he shall inhabit God's places of worship
who believes in God and the Last Day, and
performs the prayer, and pays the alms,
and fears
none but God alone; it may be that those will
be among the guided.

and XXXIX: 73, 74:

Then those that fear their Lord shall be driven
in companies
into Paradise, till, when they have come
thither, and its gates
are opened, and its keepers will say to them,
"Peace be upon you
Well you have fared; enter in, to dwell forever."
And they shall say, "Praise belongs to God,
who has been true
in His promise to us, and has bequeathed upon
us the earth…

The inscriptions are in simple ornamental Kufic script and separated by a simplified rosette. Certain letters such as *mim* and *nun* discreetly decorate the text by occasionally extending above the line at the end of a word, as do the vertical intertwining elements of the *lam-alif*. Originally the panel

The bowl is decorated with a fine Kufic inscription, painted in a purplish black slip.

Generosity is a disposition of the dwellers of Paradise. He Said.

23

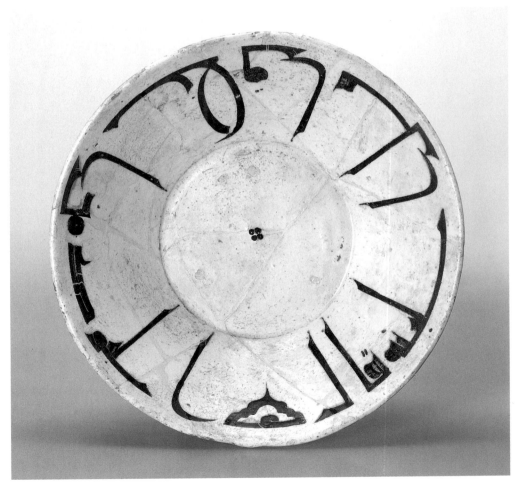

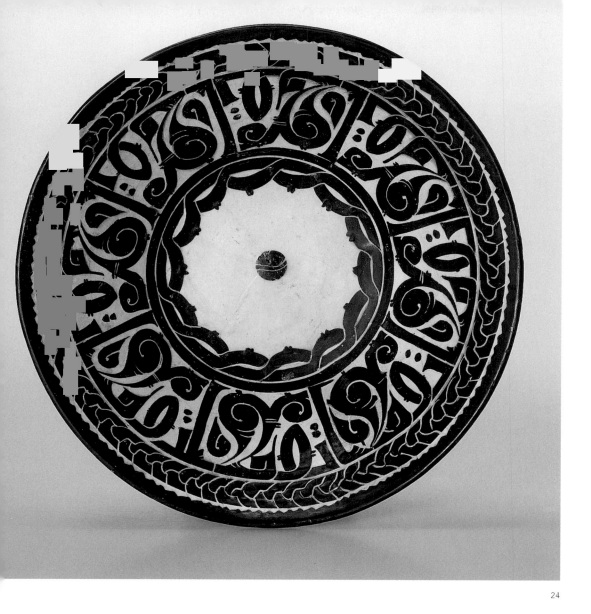

24

25

Bowl

Transoxiana (central Asia), 11th century

Earthenware, glazed

Diameter 24.5 cm

The State Hermitage Museum, St Petersburg,

inv.no. CA-7013

Provenance: transferred in 1931 from

L.V. Puzillo's collection

Literature: Shishkina 1979, p. 10, 50, tab. X, 3;

Kuwait 1990, no. 13

This bowl of reddish clay has been painted
with colored slips over a red engobe and
covered with a colourless transparent glaze.
The four medallions contain similar, highly
stylized, Arabic inscriptions. A comparison
with inscriptions on other vessels supports
the theory that the craftsman repeated
the word 'Piety' several times, in a highly
simplified form. The style is typical of late
10th- and early 11th-century Samarkand
(Afrasiyab); the script itself suggests the
11th century, the beginning of the
Karakhanid dynasty.

B.M.

This inscription seems to have been popular
on this ware, as it is found – sometimes with
minor variations – on 35 recorded objects.

The script is datable by manuscript parallels
to the 11th century. The appearance of
having been written with a pen is entirely
misleading since the slip is far too thick:
instead the potter would have used a knife
to sharpen up the contours, a technique
requiring considerable skill.

M.R.

24

Bowl

Central Asia, Afrasiyab (old Samarkand), 11th century

Earthenware, slip-painted under a transparent glaze ♦

Height 8 cm, diameter 28 cm

The Nasser D. Khalili Collection of Islamic Art,

London, inv.no. POT 1204

Literature: Grube 1994, no. 68, p. 79. See also:

Bolshakov 1958, pp. 21–38, pl. VII a–b

The decoration of the bowl, in a heavy black
slip, consists of a herringbone motif scratched
in the slip below the rim, a bold band of flori-
ated pseudo-Kufic with repeating letter forms
on the sides and a plaited band round the
central well. Two pieces collected by Vyatkin
at Afrasiyab, with similar illegible inscrip-
tions, have been dated to the 11th century;
one is virtually identical to the present piece.

M.R.

25

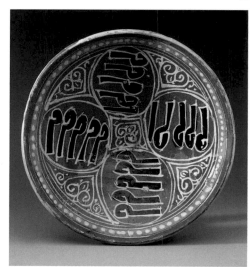

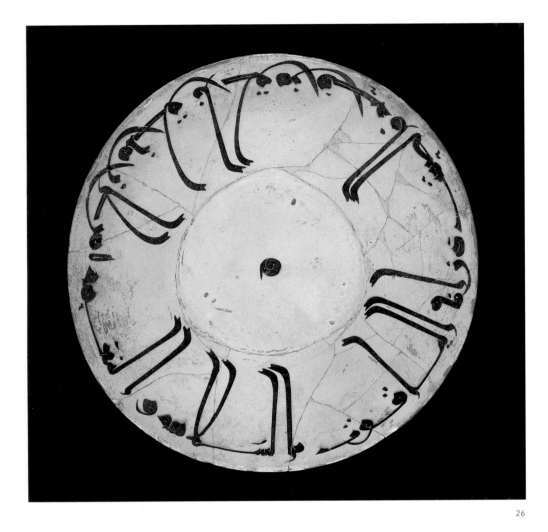

26

many other media, the visual impact of the Samanid epigraphic wares most resembles that of writing on paper and *tiraz* textiles. Moreover, when the inscriptions are written around the inner rim of a bowl, they maximise the rhythmic possibilities of the circular form.

SH.C.

27

Inkwell

Iran, 12th century

Bronze (or brass), silver, copper • Height 10.5 cm

The State Hermitage Museum, St Petersburg, inv.no. IR-1533

Provenance: transferred in 1925 from The State Academy of Material Cultural History

(N.I. Veselovsky Collection)

Literature: Mayer 1959, p. 61; London 1976-I, no. 180; Ferrier 1989, p. 175, fig. 8-9; Kuwait 1990, no. 29

Literacy was widespread in the Muslim world, so there are a large number of objects connected with writing. Most numerous are inkwells and pencases made of various materials. By the 12th century in Iran cylindrical inkwells had appeared with lids attached using strings that ran through loops on the sides and were tied to the body.

This richly-decorated example comes from the Hermitage collection; its surface is covered with abstract ornament, representations of animals and Arabic inscriptions.

The inscription on top of the lid, in *naskh* script, reads:

> *Glory and prosperity and power, and perfection, and endurance and happiness, and... and generosity, and praise, and perpetuity to its owner.*

The inscription on the side of the lid, in Kufic script, reads:

26

Bowl

Iran or central Asia, circa 1000

Ceramic, buff body, white and manganese slip, transparent, colourless glaze • Diameter 34.6 cm

The British Museum, London, inv.no. 1958 12-18 1

Provenance: purchase

Literature: Ghouchani 1986, p. 292, no. 136

Bowls, dishes, and other vessels covered with white slip and inscribed with Arabic sayings in manganese were produced in large numbers during the Samanid period; they have been excavated at Nishapur in Iran (Khorasan) and Afrasiyab, the pre-Mongol mound of Samarkand in Transoxiana, now Uzbekistan. The inscriptions tend to be pithy sayings, such as the one on this bowl:

> *He who speaks, his speech is silver, but silence is a ruby. With good health and prosperity.*

According to 'Abdallah Ghouchani, this saying is attributable to Imam 'Ali. Given the marked stylistic variety of Samanid ceramics, it has been suggested that the black and white and red and black and white epigraphic wares appealed to an Arabic-speaking clientele, either the educated urban elite or Arabs living in the far northeastern reaches of the Muslim world.

The style of Kufic script used on this bowl is slightly freer than that found on the most severe Samanid epigraphic wares. As a result the rising, vertical letters such as *lam* and *alif* curve to the left before terminating in a fork. These curving verticals may mark a stage between the squared, simple Kufic found on some Samanid bowls and the development of the forked terminals into foliate devices. While such letter forms have parallels in

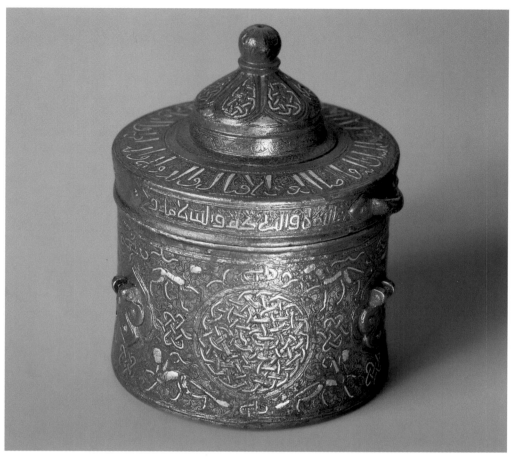

27 ▲

With good fortune, and blessing, and well-being, and completeness, and generosity, and gratitude, and obedience and beneficence to its owner.

A further inscription inside the inkwell, in *naskh* script, reads:

Glory and prosperity, and power, and well-being, and endurance, and perpetuity to its owner.

A.I.

28

Inkwell

Khorasan (Herat), early 13th century
Quaternary alloy, cast; silver and copper inlay, with finely chased detail ◆ Height 11.1 cm, diameter 10 cm
The Nasser D. Khalili Collection of Islamic Art, London, inv.no. MTW 1466
Literature: unpublished. See also: Copenhagen 1996, no. 81, pp. 122–123; Hartner 1973–74, p. 121; Baer 1983, fig. 212. pp. 261–262

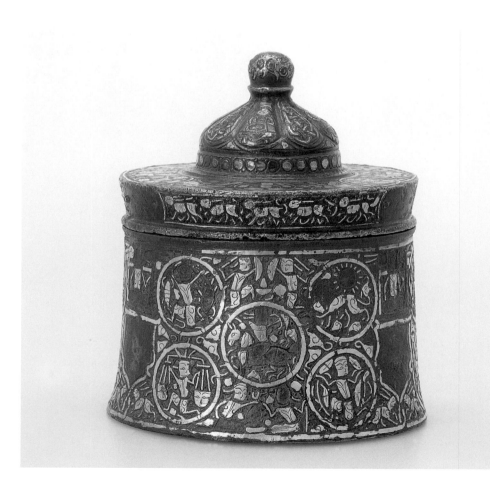

▼ 28

The inkwell has a tapering cylindrical body and a lid with an eight-faceted dome surmounted by a globular knob. The entire external surface, including the underside of both the base and the lid, is covered with silver- and copper-inlaid decoration.

The facets of the dome alternate seated figures with knotted interlaces; traces of three animals, separated by copper-inlaid dots, can still be seen on the knob. Round the dome, mounted figures with falcons or stylized wild beasts alternate with seated drinkers in roundels, all on a punch-dotted ground. On the sides of the lid are processing hare-like quadrupeds, while on the underside are six six-petalled rosettes in silver and copper.

The decoration of the body is much richer and is of silver alone. Round the inset collar is a frieze of quails. Its inner rim has a frieze of hare-like quadrupeds and dogs marchant, with a border of small circles. The sides have

central roundels with mounted hunters, and vignettes of courtly pursuits above and below. The vignettes are flanked by twin registers of zodiac signs with their planetary domiciles. Between these groups are narrow panels with an enthroned figure above, confronted hares below and blank lobed cartouches in the middle. On the base is a large roundel with a sunburst surround showing a mounted hunter and a frieze, broken by three blank pointed ovals for optional feet, of winged monsters marchant, with bird-headed or hare-headed tails and the heads of ducks, lions or bearded men. Hartner has suggested an astronomical explanation for the prominence of hares and hares' heads in Khorasani silver-inlaid vessels circa 1200. At that time, in latitude 30°–40°, the constellation Lepus below Orion's feet rose simultaneously with Gemini.

The blank lobed panels on the sides of the body correspond to blanks on the sides of the lid. These were originally fitted with loops (*compare cat.no. 29*) through which a cradle – used to carry the vessel without spilling the ink – was secured. The differences in workmanship between lid and body, however, suggest that they may in fact be from two different vessels of similar dimensions.

This is not improbable. In the David Collection (no. 6/1972), for example, is the base of a virtually identical inkwell, inlaid in copper as well as silver, and another was published by Eva Baer. Both use knotted interlace and punch-dotted ground, features present on the lid of the Khalili inkwell but absent from the decoration on its body.

M.R.

29

Inkwell

West Iran or Jazira (now southeast Turkey),
early 13th century
Quaternary alloy, cast, engraved and inlaid with silver,
copper and black paste ◆ Height: 10.1 cm,
diameter 8.3 cm
The Nasser D. Khalili Collection of Islamic Art,
London, inv.no. MTW 1474
*Literature: unpublished. See also: Allan 1982-II, no. 9,
pp. 66–69; Baer 1983, fig. 89. p. 110*

The sides of the inkwell have an all-over pattern of eight-petalled rosettes set in a chain interlace. The design is interrupted by three lobed plaques to which hinged loops were once attached: all but one are missing. Underneath it bears a central interlace roundel with three sections of palmette scroll separated by blank pointed ovals for optional feet.

The lid has a central dome of six facets, alternately decorated with interlace designs and six-petal rosettes. The dome is surmounted by a knop finial and surrounded by a band of benedictory inscription in *naskh* script, broken by three eight-petalled rosettes:

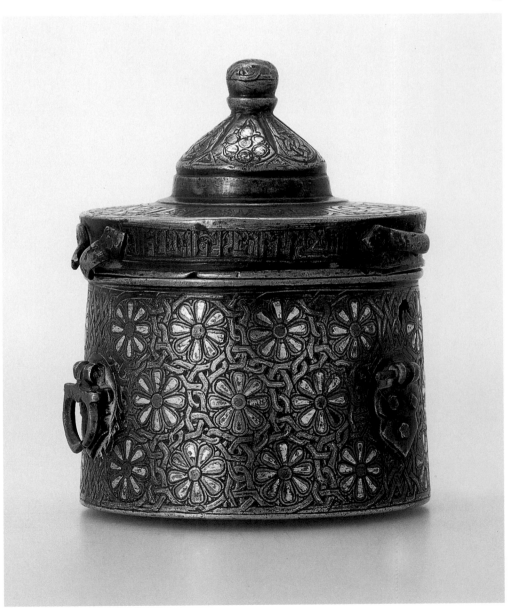

29

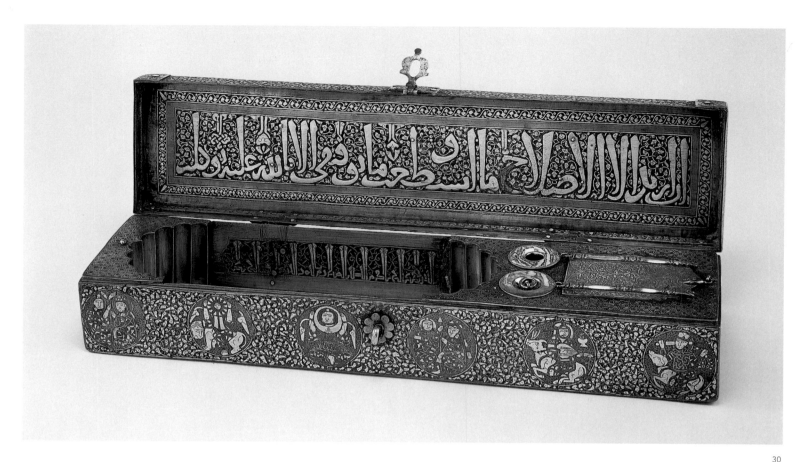

30

Glory, and prosperity, and wealth,
and happiness, and wellbeing, and abundance,
and grace (?), and support.

The edge of the lid has a silver-inlaid Kufic inscription, also benedictory:

With good fortune, and blessing, and wealth,
and joy, and well-being, and happiness (?),
and gratitude, and support (?), and affection
(?) and.

Underneath the lid bears half palmette scrolls broken by three six-petalled rosettes.

The decoration on the sides is not known from any other inkwell, but it is very close to that of a footed cup, probably from western Iran, now in the Bargello Museum in Florence. Closer still is the decoration on an early 14th-century candlestick in the Nuhad es-Said Collection, which James Allan has compared to designs on 13th- and early 14th-century buildings in Anatolia.

M.R.

30

Pen box

Mosul (north Iraq), 1230-50
Brass, inlaid with silver and copper ◆ Length 36.8 cm
The British Museum, London, inv.no. OA 1884. 7-4.85
Provenance: given to The British Museum by
Augustus Wollaston Franks in 1884
Literature: Lane-Poole 1886 p. 184 no. 12; Barrett
1949, figs. 14 & 15; Ward 1993 cover and fig. 62;
Blurton 1997 no. 247

The rectangular pen box has a long section for pens, with smaller containers at one end for ink, sand (for blotting the ink) and threads (for cleaning the reed pens).

All the interior and exterior surfaces of the pen box are finely engraved and inlaid with silver and copper in a style associated with the city of Mosul in the 13th century. The inlaid brass vessels produced there were highly esteemed by local noblemen and were sometimes given to neighbouring rulers as diplomatic gifts.

The inside of the lid is filled with a magnificent inscription:

I desire only to set things right
so far as I am able.
My succour is only with God; in Him
I have put my trust
(Qur'an XI: 88)

The sides of the pen box are decorated with twelve roundels containing personifications of the planets in their day or night houses. From the right end of the front: Mars in Aries (a warrior holding a sword and severed head riding a ram), Venus in Taurus (a female lute player riding a bull), Mercury in Gemini (two figures holding a staff), the Moon in Cancer (a figure holding a crescent), the Sun in Leo (a figure with the face of the sun riding a lion), Mercury in Virgo (a female figure holding ears of corn and a male figure), Venus in Libra (a female lute player beneath some scales), Mars in Scorpio (a warrior holding a sword and a scorpion), Jupiter in Sagittarius (a centaur turning to shoot a man), Saturn in Capricorn (a man

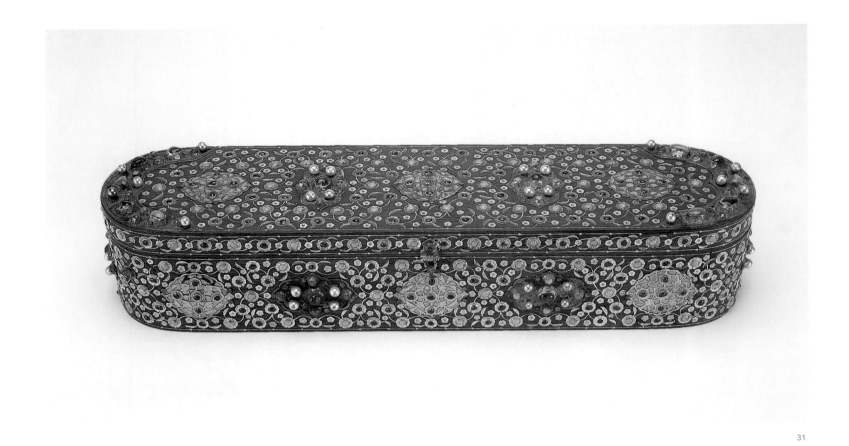

31

with a pick axe riding an ibex), Saturn in Aquarius (a figure drawing water from a well), Jupiter in Pisces (a man seated between three fish).

R.W.

31

Jewelled pen case

Ottoman Empire, late 16th-early 17th century

Ebony, gold, turquoise, rubies, pearls, mother-of-pearl • Length 33 cm, width 8 cm, height 7 cm

Topkapi Palace Museum, Istanbul, inv.no. 2/2110

Literature: Atasoy - Artan 1992, p. 153

Turquoise, rubies, pearls, mother-of-pearl and gold enrich this ebony pen case which was used during ceremonies by the sultan or one of his representatives.

E.B. - S.M.

32

32

Silk textile

Perhaps north Africa, 18th century

Silk, plain weave with the pattern carried on

additional wefts ◆ Length 158 cm, width 130 cm

The Nasser D. Khalili Collection of Islamic Art,

London, inv.no. TXT 222

Literature: unpublished

This large panel of indigo-blue silk is
decorated with an all-over pattern in white
which consists simply of the word *Allah*

('God') repeated in a plain *naskh* script.
The pattern is almost a visual representation
of the ritual of *dhikr* ('remembrance') as
practised by certain Sufi orders, who attempt
to release themselves from involvement with
this world by repetition of the name of God.

M.R.

33

Batik cloth

Java, early 20th century

Cotton cloth, resist dyed ◆ Length 230 cm,

width 81 cm

The Nasser D. Khalili Collection of Islamic Art,

London, inv.no. TXT 104

Literature: Vernoit 1997, pp. 58–59, no. 30

Traditional Javanese dress incorporated a
number of untailored rectangular cloths,
usually decorated in the batik technique of

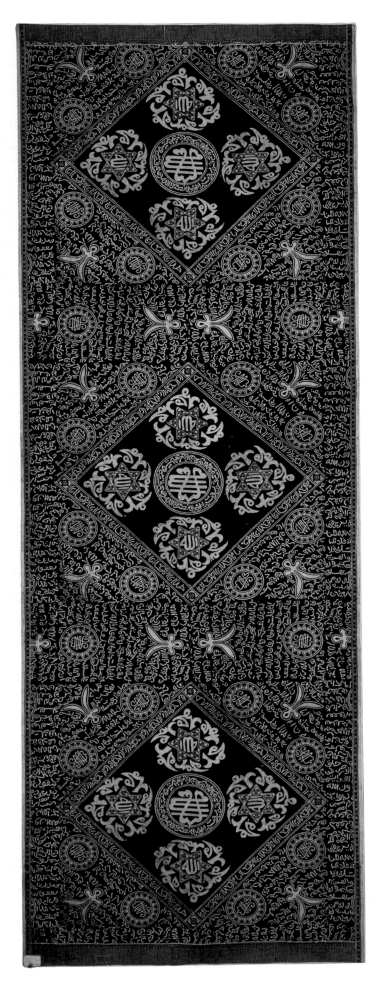

resist dyeing. This example has been identified as a *selendang*, a shawl usually draped around the head or upper half of the body. The sacred character of the inscriptions, in which the name of God plays a central role, indicates that it was not for everyday use, and may have been part of a wedding outfit.

The background is dyed dark blue, and the reserved design is divided into three compartments. Each compartment contains a large square rotated 90 degrees, with a plain ground. At the centre of the square is a roundel containing the name *Allah*, written in an elongated script, with the final stroke of the last letter (the *ha'*) drawn out to form an ornamental flourish. The roundel is bordered by a quotation from the Qur'an (Sura LXI, verse 13) repeated twice:

> *Help from God and a nigh victory.*
> *So give thou good tidings to the Believers!*

The name *Allah* within a six-pointed star, surrounded by the name *Muhammad* repeated six times, is disposed in the four corners of the square, which has a border formed from a repeat of the phrase *la ilah illa Allah* ('There is no god but God') from the *shahada*, the Muslim creed, written so that is readable from the reverse side of the cloth. The triangular corners of each compartment and the framing bands are decorated in the same manner: the ground is sown with further medallions containing a stylized rendering of the name *Allah*, and representations of Dhu'l-Faqar, the two-pointed sword of Imam 'Ali. Between these motifs are Qur'anic verses, some readable on the recto and some on the verso.

M.R.

33

The Qur'an

For Muslims, the holy book the Qur'an (in Arabic the word *qur'an* means 'the reading aloud') is the greatest wonder that Allah has bestowed upon humankind. What God revealed to Muhammad was handed on by the prophet in his sermons. According to some traditions these were already written down in his lifetime, but others state that this only occurred later under the first Islamic caliphs.

The Qur'an is divided into 114 chapters, called *suras*. These always bear a name that is derived from the contents of the sura itself and generally occurs only in that chapter, such as the word Cow (Sura 2), Spider (29), Smoke (44), Sand Dunes (46) and Elephant (105).

Each sura is divided into verses, called *ayas*. The number of ayas in a sura determines more or less their order of appearance in the Qur'an. The longest, which has 286 verses, stands at the beginning of the book, while the shortest, having a mere three verses, concludes the writing. The very first sura which has seven verses forms an exception to this. In ordering the suras matters of chronology were ignored and as a result the earliest suras are placed at the end of the Qur'an.

The Qur'an is a holy book and over the centuries Islamic masters have spared neither time nor effort in producing beautiful copies. To do this was considered to be an act of piety.

J.V.

34

Marble fragment

Qasr al-Hayr al-Gharbi (central Syria), 8th century
Ink on marble ✦ Height 15.5, width 9.5 cm
National Museum of Syria, Ministry of Culture,
General Directorate for Antiquities and Museums,
Syrian Arab Republic (Damascus), inv.no. 17981-A
Provenance: excavation of Qasr al-Hayr al-Gharbi

Marble fragments were found during exca-
vations in the palace of Qasr al-Hayr al-
Gharbi. Many of these were inscribed in
both Arabic (Kufic script) and Syriac.

This fragment bears the black-ink inscription:
In the name of God, the Merciful,
the Compassionate

This is the *basmala* (the laudation) which
begins 113 of the Qur'an's 114 *suras*.

Below this are the Arabic letters *alif lam mim
ra* which appear at the beginning of Sura 13,
al-Ra'd ('Thunder'; beneath these are *ta sin*,
the two letters which begin Sura 27, al-Nami
('The Ant').

M. AL M.

35-53

Early Qur'an manuscripts found in the Great Mosque of Sanaa (Yemen)

Literature: Moritz 1938; Pretzl 1938, pp. 249-274;
Grohmann, pp. 213-231; Déroche 1983; Puin 1985,
pp. 9-17; Bothmer 1986, pp. 22-33; Bothmer 1987-I,
pp. 177-180, pl. 185-187; Bothmer 1987-II, pp. 4-20;
Déroche 1988, pp. 20-29; Bothmer 1989, pp. 45-67;
Dreibholz 1991, pp. 299-313; Déroche 1992-I;
Déroche 1992-II; Puin 1986, pp. 107-111; Rezvan
1998, pp. 13-54; Bothmer 1999, pp. 40-46; Puin
1999, pp. 37-40; Bothmer (in prep.-I); Bothmer (in
prep.-II)

In 1973, restoration work in the Great
Mosque of Sanaa was the first major cultural
activity undertaken by the government of
the recently established Republic of Yemen.
This was an important statement which
acknowledged the relevance of the past.
When the western wall had to be recon-

34

structed, a pile of old, torn fragments of written material was found between the roof and ceiling. Since 1980, a German-Yemeni team has been working on this find, concentrating on early parchment material, nearly all of which proved to be fragmented Qur'an manuscripts.

The sheer quantity of these fragments – some 14,000 from more than 900 manuscripts – has revealed developments which were previously unknown. This has made it possible to ascertain which of the manuscripts were locally produced and which came from elsewhere. Accounts regarding the establishment of the 'canonical' version of the Qur'an can now be checked against contemporary manuscripts which, incidentally, seem to agree with Islamic tradition. Changes in orthography reported in early sources are confirmed by later corrections made to satisfy modified rules. More than a hundred illuminated manuscripts with bright, colourful ornamentation represent artistic traditions which preceded the severe style of Abbasid illuminations that rely on gold.

Examination of the manuscripts has led to greater understanding of the energy which calligraphers, painters and *ulama* (theologists) devoted to studying the meaning of God's word so that this could be committed to writing and visually presented in the most effective manner.

H.C.B.

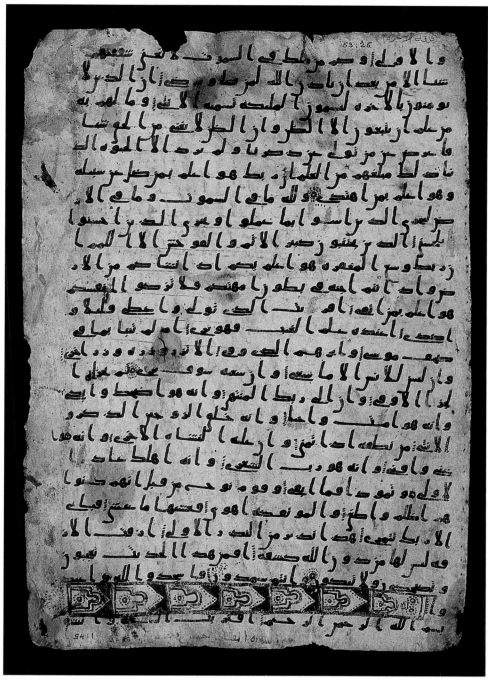

35

35

Page from a Hijazi Qur'an manuscript

Surat al-Nagm ('The Star'; LIII: 25-end) and Surat al-Qamar ('The Moon'; LIV: 1)

Arabia (Medina?), 1st half 8th century

Ink and gouache on vellum • Height 40.9 cm, width 29,4 cm

Dar al-Makhtutat, Sanaa, inv.no. 01-28.1

This page, in *Hijazi* script, represents the earliest phase of Qur'anic design. Typical features are the folio's modest proportions and the varying numbers of lines per page (this page has 26 lines, the reverse 28). However, clear definition both of the text area and of the distance between the lines of script has produced a uniform appearance which is not common in Hijazi manuscripts. Hijazi script, which is closely related to the earliest cursive scripts known from papyri, was written in thin, even lines. Here it is unusually controlled. Diacritical marks are frequent.

The ends of verses are marked by vertical lines of dots; after every tenth verse there are red circles surrounded by dotted circles. The illuminated bands separating the Suras generally comprise a sequence of simple motifs with an internal direction.

H.C.B.

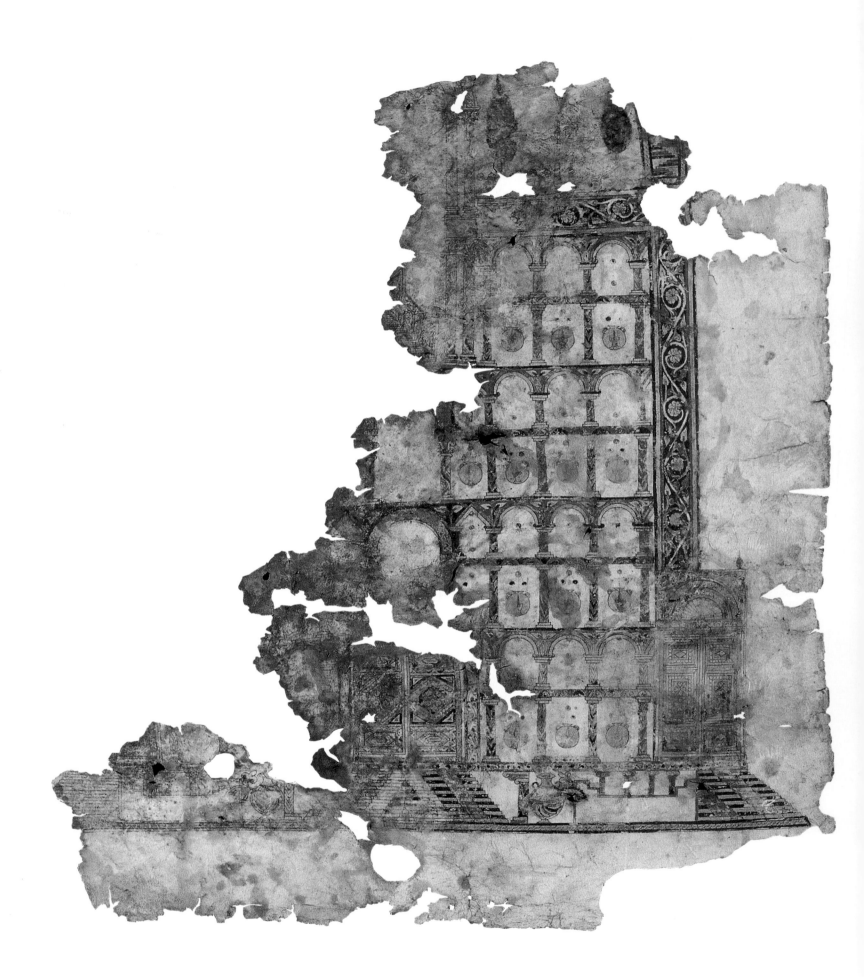

36

36-41

Six leaves from a monumental Qur'an manuscript

Syria (Damascus?), around 710-715

Ink, gouache, gold and, rarely, silver on vellum ◆

Original dimensions: height at least 51 cm,

width 47 cm

Dar al-Makhtutat,Sanaa, inv.no. 20-33.1

These pages come from one of the most splendid Qur'ans ever made. Originally the manuscript comprised some 520 folios. Almost square in format this Qur'an occupies a middle ground between the vertical format of early *Hijazi* manuscripts (which it reflects in the text area) and the horizontal codices which were soon to follow for some two centuries. There are 20 lines to each page, except when sura dividers are required or some shorter *suras* are given a page to themselves, leaving space for wide frames.

At present this is the earliest known manuscript in Kufic script. The calligraphy is superb and derives its dignity from the impact of the vertical and horizontal strokes on the articulation of individual characters and groups of characters. The closest parallel can be found in the mosaic inscription on the Dome of the Rock in Jerusalem. Thanks to the wide cut of his pen the calligrapher was able to draw lines that range from hair-fine to bold and broad. He used dashes as line fillers to keep the pages in register.

The rich illumination comprises full-page images, sura dividers and frames. The repertory of ornamental motifs is late classical; the refined technique suggests the manuscript was produced in a place with a long tradition of book making. Certain features of the manuscript and the iconography intimate that this work was made for a member of the Umayyad family; historical circumstances suggest that caliph al-Walid himself may have commissioned it. However, carbon dating points to a slightly earlier date.

H.C.B.

36

Frontispiece and architectural image

Height 41 cm, width 37.1 cm

Unlike any other Qur'an manuscript this work opens with a group of full-page images: a representation of Paradise based on a 'cosmogram', a classical motif combining an octagon and a circle and, on the reverse, a mosque. The following page also depicts a mosque; on the reverse the text begins with the first *sura*. If the image had not occupied the same leaf as the text, its association with a Qur'an context would have been unlikely. The images themselves suggest royal provenance. The cosmogram motif was used as a frontispiece in a Byzantine manuscript produced circa AD 512 for an imperial princess, Juliana Anicia. Here, however, it has been enhanced by the repetition of the inner octagon in the eight-pointed star, the ornamental enrichment of the symbol and the luxuriant growth of the trees employed as a metaphor for the surpassing of earthly experience.

The mosque does not portray a specific building but rather a type of mosque as does the image on the following leaf. This type of mosque was first employed under the Umayyad caliph al-Walid, in the Great Mosque of Damascus. The painter has used an unusual combination of floor plan and elevation to show the main features of the building, such as the three sections of the prayer hall, two-storeys high, which run parallel to the *qibla* wall, and the axial space which cuts across these sections, leading from the main gate to the *mihrab*. Important details – the *minbar* in front of the mihrab, the mosque lamps suspended on long chains, the ablution facilities between the monumental flights of steps, even the minaret (top left) with its inside staircase – are depicted with a great fluency which testifies to a long pictorial tradition, now lost, which must have preceded this work.

Both the type of mosque shown here and the courtyard version on the opposite page are closely connected with al-Walid's architectural projects. The courtyard type was employed for the Haram al-Nabawi, the Mosque of the Prophet at Medina, and when the Great Mosque of Sanaa was expanded. These fragments of manuscript were found in the Great Mosque of Sanaa; the codex was apparently sent there soon after its completion. Although these depictions of mosques are obviously related to al-Walid's building programme, their exact role in this programme is as yet unclear.

H.C.B.

37

Surat al-Baqara
(*'The Cow'; II: 39-43*)

Height 29.7 cm, width 43.6 cm

Decorative frames were only used on a few
pages at the beginning of the manuscript
and on a few towards the end. The first *sura*
and the beginning of the second sura are
distinguished by wide frames; these are
followed by three pairs of pages with narrow
frames around the text area (as shown here).
After nearly a thousand pages without frames,
these reappear on the reverse of *cat.no. 41*.
Five pairs of pages with narrow frames and
three with wide frames, decorated with
increasingly rich ornamentation, make the
end of the codex only slightly less spectacular
than its beginning.

Where possible vertical letters are grouped
parallel to the frame, even inside the text
area. There are Byzantine counterparts to
the decorations in the frame.

H.C.B.

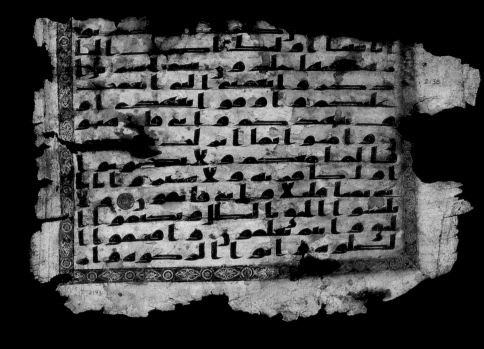

37

38

Surat al-Mulk (*'The Kingdom';*
LXVII: 21-end)

Height 38.2 cm, width 44 cm

Despite the mutilation this page is beautifully
balanced and the text evenly distributed.
The line register is less rigid than on *cat.no. 37*.
Small dashes are used as line fillers, indicating
that this manuscript was produced before the
proverbial flexibility of Arabic script had been
recognized and exploited.

The *sura* divider, with its scroll incorporating
palmette motifs and grapes, features orna-
mentation that figures prominently in
Umayyad art.

H.C.B.

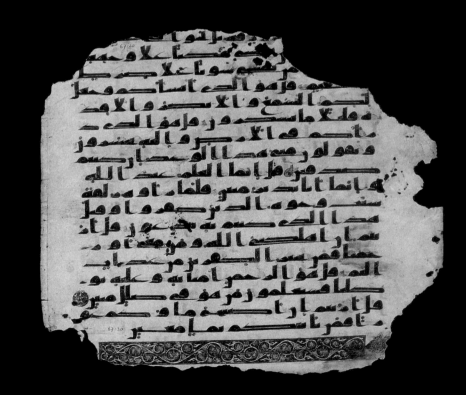

38

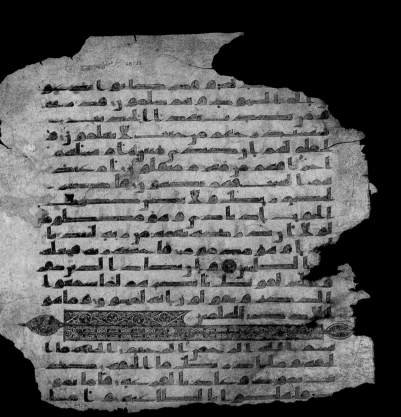

39

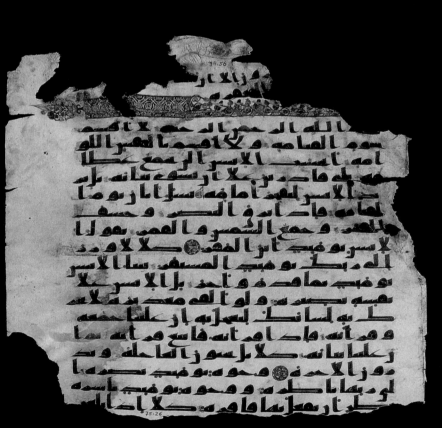

40

39

***Surat al-Qalam** ('The Pen'; LXVIII: 43-end) **and Surat al-Haqqa** ('The Indubitable'; LXIX: 1-6)*

Height 42.3 cm, width 44.2 cm

One of the illuminator's artistic problems was choosing a form for the *sura* divider in a stepped field. Here there are two parallel bands of ornament, one largely geometrical, the other a scroll echoing the first. Another correspondence emerges where the curve of the upper band meets the final letter of the sura ending. The sura dividers are wider than the text area, with *ansae*, or end motifs, protruding into the margins.

H.C.B.

40

***Surat al-Muddaththir** ('Shrouded '; LXXIV: 56-end) **and Surat al-Qiyama** ('The Resurrection'; LXXV: 1-26)*

Height 39.9 cm, width 43.6 cm

This *sura* divider contrasts geometrical and floral ornamentation in another way. The framed section to the left extends into scrolls with golden leaves and alternating grapes and pomegranates against the pale vellum background.

There are different kinds of verse stop: a series of fine lines after every verse, the golden letter *ha'* (*ha'* = 5) after every fifth verse, and circles enclosing a gold letter, denoting the appropriate numerical value, after every tenth verse. The golden *has* have obviously been added at a later date. There is barely room for the single verse stops which are highly visible. Although the calligrapher did leave space for the circle markers after every tenth verse, their present appearance dates from an early modification which replaced the original rosettes with letters. The sura headings written in gold over the

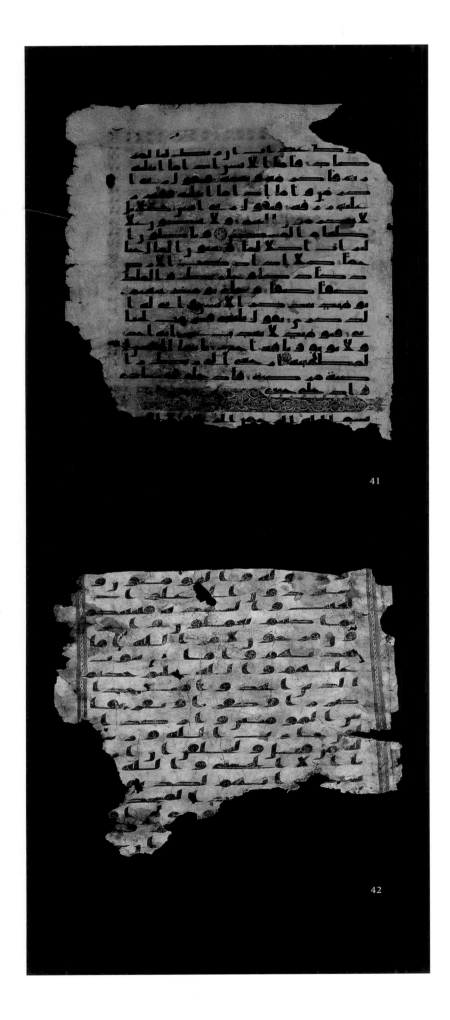

41

42

ornamental bands were probably added at the same time.

The small red dots which seem to swirl over the page are vowel marks.

H.C.B.

41

***Surat al-Fajr,** ('The Dawn'; LXXXIX: 13-end) **and Surat al-Balad** ('The Land'; XC: 1)*

Height 43.5 cm, wicth 42.7 cm

This page still gives a good impression of the codex's generous layout, with wide margins enclosing the sacred text.

The *sura* divider differs greatly from the two previous examples, deriving its effect from the deep blue (lapis lazuli) ground on which the scrolls unfurl, and from the contrast between this blue and the red frame.

The manuscript was hidden for centuries between the roof and ceiling of the Great Mosque of Sanaa. This has caused some of the parchment to become slightly translucent, allowing the frame on the reverse to show through a little.

H.C.B.

42
―――

Page of a Qur'an manuscript
Surat al-Tauba (*'Repentance'*, IX: 105-108)

Yemen (Sanaa?), 8th century

Ink and gouache on vellum • Height 29.2 cm,

width 35.5 cm

Dar al-Makhtutat, Sanaa, inv.no. 01-29.2

Among the Qur'ans found in Sanaa, there
are fragments of two manuscripts which
resemble the monumental codex from Syria
(*cat.nos. 36-41*). Their similarities in size,
proportion, number of lines, script and
illumination suggest that the Syrian codex
may have served as a model.

This fragment comes from one of these
manuscripts. Its calligraphy reflects that of
the Syrian manuscript in quality rather than
features; fluent beauty has replaced severity.
The letters are spaciously distributed, with
'less ink to the page'; they are not as firm
and the curves are more flexible. Once
connected individual letters tend to blend
with their neighbours, as in the final two
letters of 'Allah'. Diacritical marks are
sparsely distributed. There are no vowel
marks.

H.C.B.

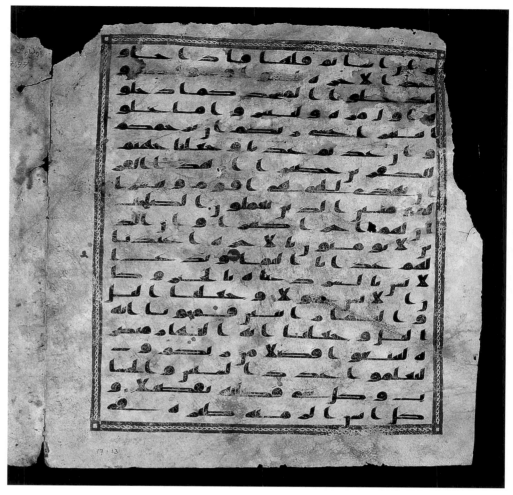

43

43
―――

Double leaf from a Kufic Qur'an
manuscript
Surat al-Isra (*'The Night Journey'*; XVII: 7-13 and 97-102)

Yemen (Sanaa?), 8th century

Ink and gouache on vellum • Height 40.4 cm,

width (of both leaves) 78.8 cm

Dar al-Makhtutat, Sanaa, inv.no. 01-29.2

There are just a few instances of narrow
frames in the Syrian codex (*see cat.no. 37*).
Here they appear on every page, with only
minor variations. The other decorative
elements, the *sura* dividers, are also fairly
simple. Certain features, however, such as
the scroll with grapes and the unframed
stepped sura divider with uncurling tendrils
reflect their Syrian model. The relative
simplicity of the decoration may indicate

limited artistic skill on the part of the illumi-
nator, or a conscious decision to refrain
from ostentatious splendour, prompted by
humility in the face of the Word of God or
lack of a royal patron. Nevertheless, this
double page does evince a certain grandeur.

There are stops after every verse and every
tenth verse, containing letters appropriate to
the number.

H.C.B.

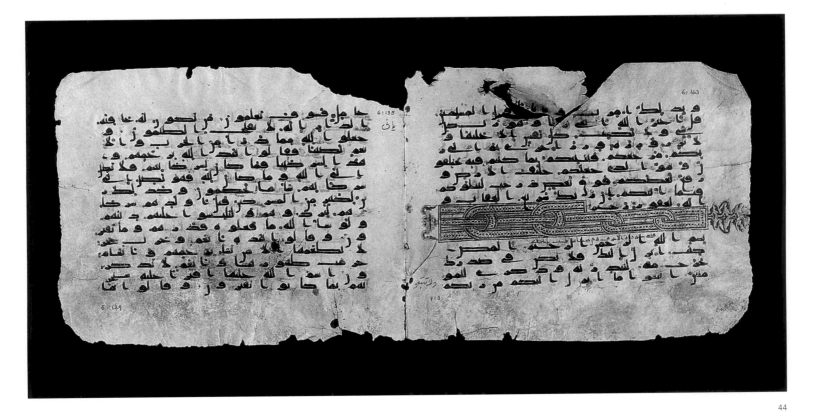

44

44
———

*Double leaf from a Kufic Qur'an
manuscript
Surat al-An'am ('Cattle'; VI: 135-
139) and Surat al-A'raf
('The Battlements'; VII: 1-3)*

Yemen (Sanaa), 9th century

Ink and gouache on vellum ◆ Height 23.7 cm,

width (both leaves) 59.1 cm

Dar al-Makhtutat, Sanaa, inv.no. 15-23.1

These two pages could not be viewed to-
gether when the manuscript was intact.
The clearly defined text areas are freely
filled with a beautiful, flexible script without
diacritical marks but fully vocalized.

The *sura* divider makes unusual use of the
stepped field: a systematic pattern achieves
added impact through a break in the
pattern. *Ansae* extend into both margins;
their appearance varies according to the
space available. A motif by the fold is
common, but is never used in the outer
margin.

This manuscript was produced in a period
when it was not yet considered necessary to
include the sura name and number of verses
inside the sura divider. This information was
added underneath, possibly at a later date.

H.C.B.

45
———

*Page from a Kufic Qur'an
manuscript
Surat Yunus ('Jonah'; X: 27-34)*

Yemen (Sanaa), 9th century

Ink and gouache on vellum ◆ Height 22.1 cm,

width 31.1 cm

Dar al-Makhtutat, Sanaa, inv.no. 17-25.1

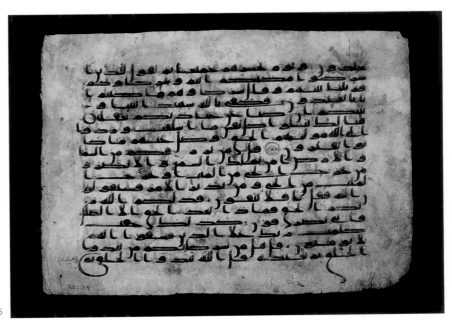

45

This splendid page of calligraphy is both balanced and full of movement. Many of the Qur'an manuscripts found in Sanaa have been written in this script, suggesting that this may have been what al-Hamdani, a companion of the Third Imam, Husayn, was referring to over a thousand years ago when he mentioned a special script used in Sanaa.

Certain details reveal the calligrapher's playful ingenuity. At the end of line 5, for example, he turns the final letter *nun* into a near circle resembling a verse stop; this is indeed the end of a verse. In the last line the tails of the two final *qafs* swing boldly while the others, within the text area, undulate unobtrusively.

H.C.B.

46

Page from a Kufic Qur'an manuscript

Surat al-'Ankabut ('The Spider'; XXIX: 8-15)

Yemen (Sanaa), 9th century

Ink and gouache on vellum ◆ Height 19.3 cm, width 27.7 cm

Dar al-Makhtutat, Sanaa, inv.no. 17-25.1

Dashes are used as line fillers in order to create a clearly defined text area. Normally these dashes appear at the end of lines; here they are found at the beginning where the calligrapher left some space to avoid colliding with letters descending from above. This script seems more self-assured in its execution than the script on *cat.no. 45*.

There are few diacritical marks but many vowel signs, most in red and some in green, indicating the *hamza* (diacritical marks). The stops after every verse are minute; the stops after every ten verses are large circles containing green and red quatrefoils.

H.C.B.

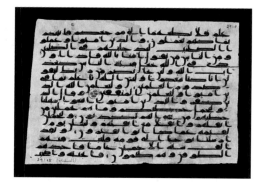

46

47

Page from a Kufic Qur'an manuscript

Surat Luqman ('Lokman'; XXXI: 32-end) and Surat al-Sajda ('Prostration'; XXXII: 1-4)

Yemen (Sanaa), 9th century

Ink and gouache on vellum ◆ Height 18.2 cm, width 26.5 cm

Dar al-Makhtutat, Sanaa, inv.no. 17-25.1

This script is very close to that on *cat.no. 46* but also shares features with *cat.no. 45*, such as the swinging tail of the final *qaf* and the figurative formulation of words underlined by their final letter, a retroflex *ya* (for example, three lines above the *sura* divider).

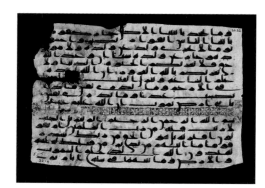

47

The sura divider combines an ornamental band of squares with a field containing a 'subscription', the name and verse number of the preceding sura. This is the earliest kind of sura designation; such subscriptions would soon make way for headings. The *ansae* at either end of the sura divider are quite distinctive.

The margins have been carefully removed by a parchment hunter in search of material to make amulets.

H.C.B.

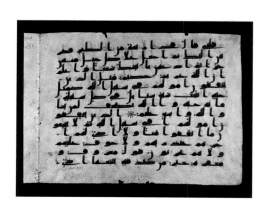

48

48

Double leaf from a Kufic Qur'an manuscript

Surat al-Baqara ('The Cow'; II: 254-256 and 260-263)

Yemen (Sanaa), 8th-9th century

Ink and gouache on vellum ◆ Height 29.6 cm, width (both leaves) 79.3 cm

Dar al-Makhtutat, Sanaa, inv.no. 13-33.1

Soon after 750, during the early Abbasid period, some changes occurred in the conventions surrounding book production. These included a switch to horizontal format, possibly in order to distinguish Qur'an manuscripts from Christian writings, and an increased use of gold in illumination.

These pages come from the largest of the horizontal Qur'an manuscripts produced in

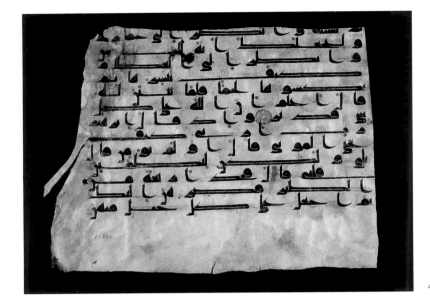

49

Page from a Kufic Qur'an manuscript
Surat al-Anbiya
('The Prophets'; XXI: 18-22)

Near East (Egypt?), 9th century

Ink, gouache and gold on vellum ◆ Height 40.3 cm, width 45.6 cm

Dar al-Makhtutat, Sanaa, inv.no. 13-38.1

The verse stops in this manuscript are very different from the others shown here. After every verse there is a triangle of six gold circles with accentuated centres; after every tenth verse a circle enclosing the verse number as a gold word is surrounded by overlapping circles marked by either a red or green dot.

At the beginning of the fifth line there is a gap to prevent the first letter from colliding with the word above which extends well below its line. Elsewhere such gaps are filled with a dash which is missing here.

H.C.B.

Yemen. The script is strong and clear; vertical letters extend far above and below the lines while horizontal letters preserve the balance. In some instances the connecting line between two letters is elongated although dashes still serve as line fillers.

Sura dividers incorporate the sura heading and number of verses. The illumination employs bright colours in combinations which indicate a workshop preference.

H.C.B.

carefully calculated, as is the position of the few diacritical marks. Red dots mark the vowels, green dots the *hamza*.

No pages have been preserved intact. However, the margins must have been very large, measuring up to 9.5 cm for the outer margin and 8.9 cm for the upper margin.

H.C.B.

49

Page from a Kufic Qur'an manuscript
Surat al-Baqara ('The Cow'; II: 159-160)

Near East (Egypt?), 9th century

Ink, gouache and gold on vellum ◆ Height 32.8 cm, width 43.9 cm

Dar al-Makhtutat, Sanaa, inv.no. 13-38.1

This page comes from a monumental codex with highly ambitious calligraphy and double-page illumination marking the breaks between the different sections (*ajza'*). The calligraphy is powerful and vigorous; some of the horizontal letters are more than 12 cm long. The connection between the letters is

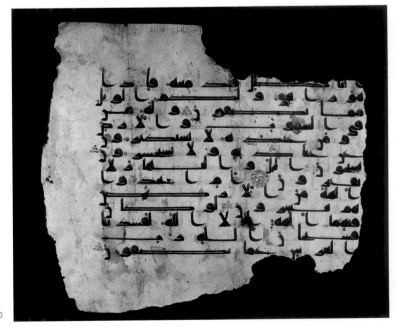

50

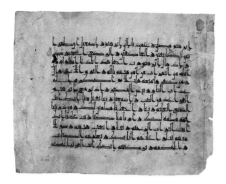

51

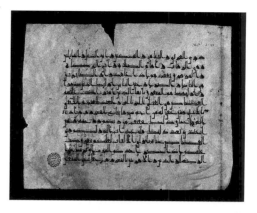

52

52

Page from an 'Eastern Kufic' Qur'an manuscript ('New Style') Surat al-Baqara *('The Cow'; II: 177-180)*

Near East, 10th century

Ink and colours on vellum ◆ Height 34 cm,

width 42.9 cm

Dar al-Makhtutat, Sanaa, inv.no. 12-29.1

Althoug the script appears slightly stiff, its ornamental quality is strong and most evident in 'figures' such as the *lam-alif*, for example in the centre of the third line from the end: in the final line *lam-alif* appears in 'normal' script.

A typical feature of non-Yemeni manuscripts is the method of marking the end of every tenth verse: twice in the text area and once in the margin by a more elaborate ornament with the number in words. Here, both types of stop have been added later.

This folio and its companion, *cat.no. 46*, are among the few manuscripts found in Sanaa which possibly retain their original, impressive dimensions.

H.C.B.

53

Double leaf from a Kufi Qur'an manuscript Surat al-Ma'ida *('The Table'; V: 41-47 and 61-68)*

Near East, 9th - 10th century

Ink and colour on vellum ◆ Height 6.2 cm,

width (both leaves) 20.2 cm

Dar al-Makhtutat, Sanaa, inv.no. 13-8.1

Unlike most of the early manuscripts exhibited here, this small work does not pretend to reflect the rank of its owner or donor, or to represent a specific theological position or tradition. Manuscripts such as this were cheap pocket editions, as can be gathered from the poor quality of the vellum. They were designed to be carried about and act as a memory aid, for their owner probably knew their contents by heart. Like amulets, small Qur'ans were also regarded as a charm against evil.

The script is written with a pointed pen, thereby abandoning many of its characteristic features. It is tempting to describe this script as cursive, a forerunner of Qur'anic scripts of the future which would predominate after the introduction of paper.

H.C.B.

51

Page from an 'Eastern Kufic' Qur'an manuscript ('New Style') Surat al-Baqara, *('The Cow'; II: 125-129)*

Near East, 10th century

Ink and colour on vellum ◆ Height 34.2 cm,

width 42.9 cm

Dar al-Makhtutat, Sanaa, inv.no. 12-29.1

This script differs greatly from standard Kufic. It appeared during the 10th century and was adopted for Qur'anic calligraphy somewhat later. The most splendid examples of such script can be found in vertical-format paper manuscripts from the 5th and 6th centuries AH (11th and 12th centuries AD). Its characteristic angularity has been achieved through the sophisticated transformation of most letters. Articulation of the majority of letter tops and many letter ends recalls the `foliated Kufic' of monumental inscriptions.

Although diacritical marks are absent, the text is almost fully vocalized. Originally there were no verse stops. One such mark has been added, at the end of the fifth verse.

H.C.B.

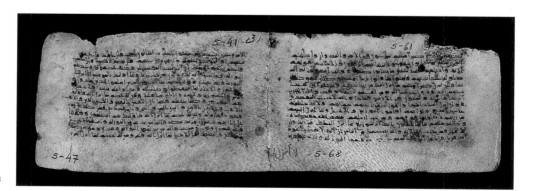

53

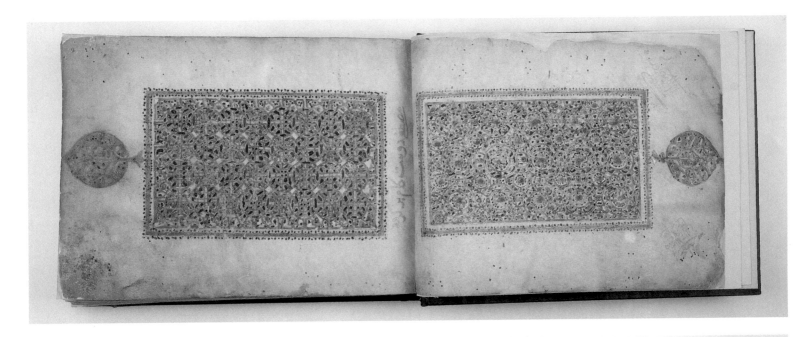

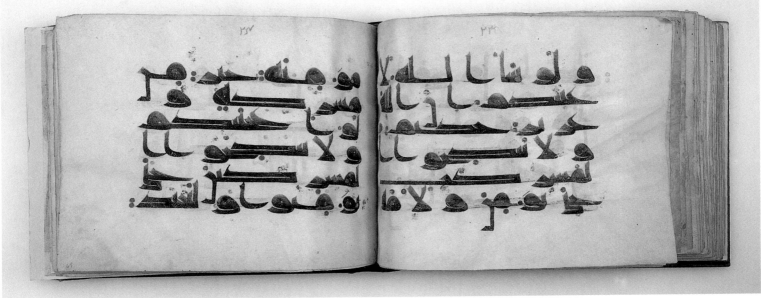

54

Qur'an section

Abbasid caliphate, circa 900

Ink, watercolours and gold on vellum; modern
binding ✦ 99 folios, 20.6 x 28.2 cm, text area
10.4 x 19.2 cm

The Nasser D. Khalili Collection of Islamic Art,
London, inv.no. QUR 372

Literature: Déroche 1992-II, pp. 72–76, no. 24

Over the course of Islamic history the
Qur'anic text was often copied in 30
separately bound sections known as *juz'*

(plural *ajza'*), one for each day of the month
(*compare cat.nos. 49, 59, 60 and 61*). This early
example contains the second of the 30 ajza'.
Like most fine Qur'an manuscripts of the
8th–10th centuries, it was written on vellum
leaves whose width is greater than their
length. The script used is Kufic of a type
(Déroche's D.II) that has been dated to the
later 9th century, and the vowels are
indicated by a system of red dots. Each page
bears six lines of text, except the first two
and the last two (*folios 2b–3a and 97b–98a*),
which have four lines surrounded by gold
frames. These are preceded and followed by

a pair of illuminated double spreads (*folios
1b–2a and 97b–98a*). The four pages all have
different designs of interlacing polygons or
circles enclosed in gold frames edged with
rows of coloured dots. Each of the eight
decorative frames in the manuscript has a
hasp motif, not quite joined to it by a short
stem, in the outer margin.

M.R.

55

55

Quire from a Qur'an section

Palermo, AH 372/AD 982–983

Ink, watercolours and gold on vellum;
modern binding ◆ 10 folios, 17.6 x 25 cm,
text area 9.5 x 16 cm

The Nasser D. Khalili Collection of Islamic Art,
London, inv.no. QUR 261

Literature: Déroche 1992-II, pp. 146–151, no. 81

As this example shows, the type of Kufic
script seen in *cat.no. 54* went out of use for
Qur'an production during the 10th century,
being supplanted in some cases by a formal
version of the normal copyhand of the
period (Déroche's NS.III). Other material
from this Qur'an manuscript has been
preserved in Istanbul (Nuruosmaniye
Library, ms.23), and an inscription on it
(*folio 1b*) states that it was written in 'the city
of Sicily', that is, Palermo, in AH 372/AD
982–983. At this time Sicily formed part of
the Fatimid caliphate; this is the only Qur'an
manuscript known for certain to have been
produced in a Fatimid centre.

A concession to tradition is the absence of
diacritics to distinguish letters with the same
basic shape, although the vocalization and

other aids to pronunciation have been
provided, using a combination of coloured
dots and the system of symbols of different
shapes still in use today. Other features of
earlier Qur'an production have been pre-
served, including the use of vellum, the
oblong format, and the use of inscriptions
in gold Kufic script as *sura* headings. This
fragment consists of a complete quire; it
shows that the manuscript was composed
of gatherings of five bifolia (quinions),
which was also traditional.

The manuscript was written in 17 lines
of dense script that is clear and regularly
composed, although there are no traces of
ruling. Verse stops are rosette-like motifs
in gold and colours; there are more complex
decorative stops for every fifth and tenth
verse. Other textual divisions and points
at which the reader had to perform a pros-
tration (*sajda*) are marked in the margins by
inscriptions in bold Kufic within ornamental
devices.

M.R.

56

Bifolium (quinion) from a copy of the Qur'an

Probably Tunisia, early 11th century

Ink, watercolours and gold on vellum ◆ Each folio
45 x 30 cm, minimum length of each line 19 cm,
interlinear spacing 6.5 cm

The Nasser D. Khalili Collection of Islamic Art,
London, inv.no. KFQ 94

Literature: Lings 1976, pl. 10

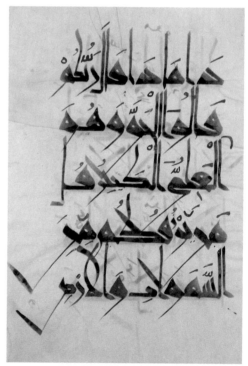

56

This monumental bifolium comes from the centre of a gathering, as it bears a continuous text, beginning in the middle of verse 23 of the *sura* 'Sheba' (XXXIV) and ending in the middle of verse 28. Each page has five lines of a swash Kufic script written in a brownish-black ink. The ascenders are tall, without serifs (*tarwisa*), and some terminations are exaggeratedly angular. The *haraka* (vowel mark) is in red, and other textual signs in blue and deep green. On folio 2a there is a marginal ornament in the form of an extended lozenge, in ink and gold, with green dots.

The script is very close indeed to that of the Qur'an manuscript known as the Mushaf al-Hadina, which was commissioned by the former nurse of the Zirid (Maghribi dynasty 973-1135) ruler al-Mu'izz ibn Badis and was written, perhaps at Kairouan, by 'Ali ibn Ahmad al-Warraq in AH 410/AD 1019-20 (Kairouan, Ibrahim ibn al-Aghlab Museum). Nothing is known, however, of the copyist's origins, and the letter forms seem to originate from Qur'ans of similar date from Mesopotamia and Iran.

M.R.

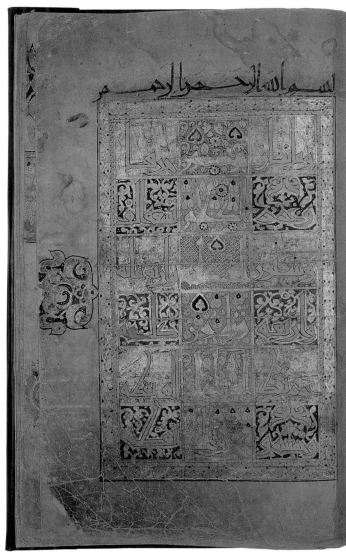

57

Leaves from a Qur'an section

Iran, later 11th century
Ink, watercolours and gold on thick, cream laid paper; modern binding ◆ 10 folios, 36.5 x 23.8 cm, text area 27.2 x 18 cm
The Nasser D. Khalili Collection of Islamic Art, London, inv.no. QUR 89
Literature: Lings 1976, pl. 11; Déroche 1992-II, pp. 156–165, no. 84

These leaves come from the first volume of a large copy of the Qur'an prepared in seven parts (*asba'*, singular *sub'*), an alternative to the division into thirty *ajza'* seen in *cat.no. 54*.

They consist of one illuminated page, the left-hand half of a double spread and text from the *Surat al-Fatiha* and *Surat al-Baqara* (I; II, 1–7, 13–19, 54–74). Another 112 leaves from the same manuscript are also preserved in the Khalili Collection, and this material may be dated by its close relationship in terms of script to a Qur'an section in the library of the Astan-i Quds-i Rizavi in Mashhad (ms.4316). This was copied and illuminated by 'Uthman ibn Husayn-i Warraq in AH 466/AD 1073–74.

The illuminated page has a chessboard pattern of three columns of six squares, each containing one or two words from a list of

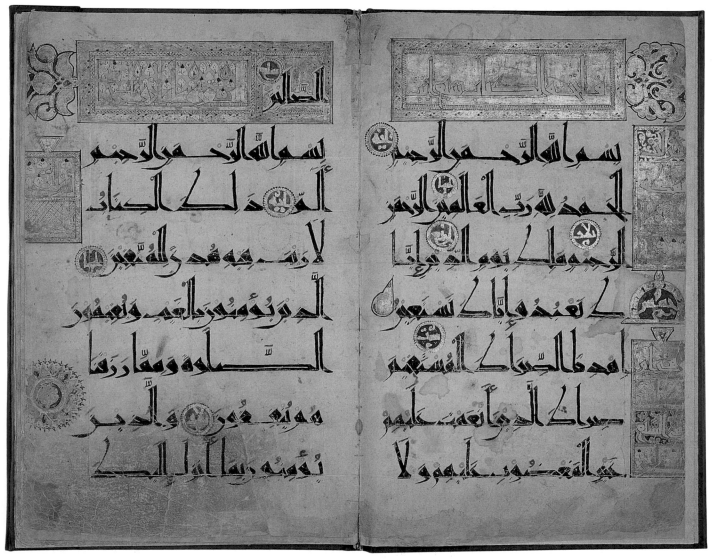

57

the components of the Qur'an: '… and the number of words is 69,434. The number of diacritical points is 1,025,000.' The text in the first and third columns is in white on gold or gold and blue grounds ornamented with palmette scrolls, while the text in the second column is in gold on grounds hatched in red or brown and set with palmette and rosette devices. There is also an elaborate palmette-based 'hasp' in the middle of the outer margin.

The same type of palmette device accompanies the illuminated sura headings on folios 2b–3a, as part of the elaborate decoration of these pages. In the margins there are three rectangular panels, two with *ansae*, and two medallions, one marking the end of Sura I, verse 5. Within the text the verse stops consist of small medallions in gold and colours, each inscribed with the number of verses. The exception is Sura I, verse 5, which is punctuated by a gold letter *ha'*. The same pattern of verse stops and marginal devices marking each fifth and tenth verse is repeated through the rest of the manuscript.

The text was written in eight lines of a Kufic-style script, with the vocalization and other aids to pronunciation given in their modern forms but in colours that reflect the old system of red, green, blue and yellow dots.

Variations in both the calligraphy and the illumination suggest the participation of at least two craftsmen in the production of the manuscript.

M.R.

113

58

Copy of the Qur'an

Valencia, AH 596/AD 1199–1200

Ink, watercolours and gold on vellum; modern

binding • 122 folios, 17 x 16 cm, text area

11.5 x 11.9 cm

The Nasser D. Khalili Collection of Islamic Art,

London, inv.no. QUR 318

Literature: James 1992-I, pp. 86–95, no. 20

This manuscript was copied in the diminutive Andalusi script, with 25 lines to the page. The text concludes with a detailed colophon written in gold *naskh*, which tells us that it was produced in the city of Valencia in AH 596 by a scribe called Yusuf ibn 'Abd Allah ibn 'Abd al-Wahid ibn Yusuf ibn Khaldun and that the patron was Ahmad ibn Muhammad ibn 'Abd al-Rahman ibn Biyatush al-Makhzumi. Biyatush is evidently a form of the Latin Beatus.

The form of this manuscript is typical of a class of single-volume Qur'an manuscript produced in Muslim Spain in the 12th century; it is the last in a series of seven published examples that were produced in Valencia between 1160 and 1200. This indicates that the city was an important centre of manuscript production during the second period of Muslim rule in the city, between 1102 and 1238.

The homogeneity of this group of manuscripts is demonstrated by the design of the illuminated frontispiece, only one half of which survives (*folio 1a*). It consists of a four-part pattern of knotted interlace surrounded by borders of denser strapwork; a similar design was used in another Valencia Qur'an, dated 1168 (Tunis, National Library, ms.Ahmadiyya 13,727). The headings of Suras I and II, arranged one above the other on *folio 1b*, are set in illuminated panels, but the remainder were written in gold, in a form of Kufic script. Each is accompanied by a marginal palmette, now trimmed; there are

marginal medallions marking the division of the text into 120 sections – both *hizbs* and *half-hizbs*.

M.R.

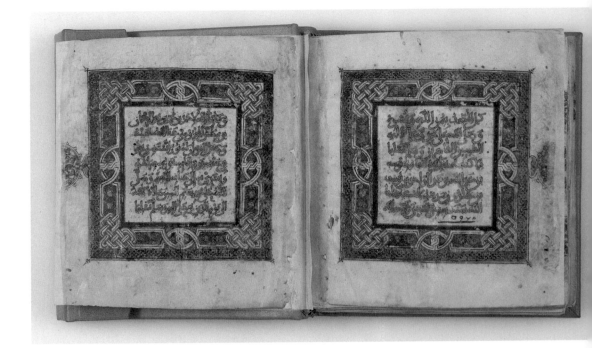

58

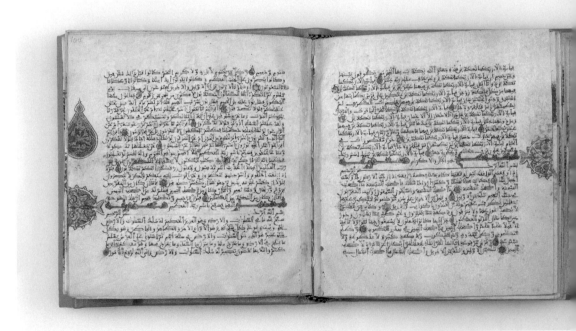

59

Qur'an section

Iran (perhaps Azerbaijan), circa 1175–1225

Ink, watercolours and gold on well-polished cream

laid paper; later binding • 92 folios, 39.2 x 32.4 cm,

text area 25.6 x 19 cm

The Nasser D. Khalili Collection of Islamic Art,

London, inv.no. QUR 87

Literature: Arberry 1967, pp. 22–23, no. 67; Paris

1987, no. 30; James 1992-I, pp. 34–39, no. 5

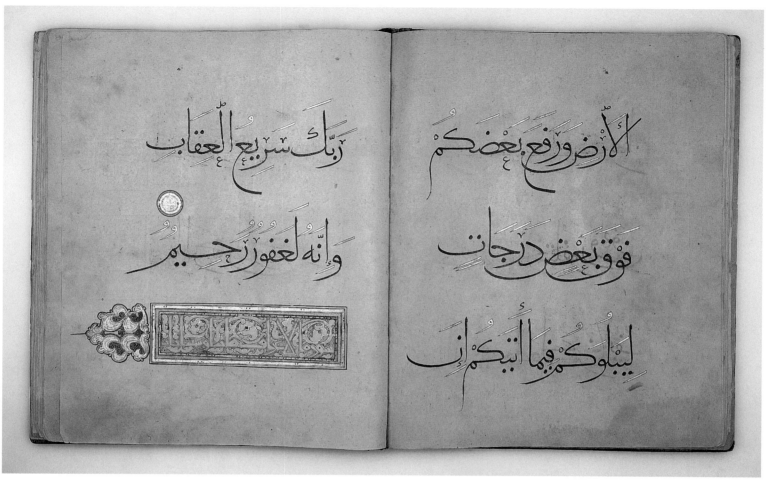

59

This imposing manuscript is the eighth volume from a set of *ajza'*, each of which contains one-thirtieth of the Qur'anic text (*compare cat.nos. 49, 54, 60 and 61*). Another *juz'*, the seventh, is in the Chester Beatty Library in Dublin (ms.1487), and a third is reported as being in the National Library in Tehran. Although this material is undated, it is related in terms of both its script and its illumination to a copy of the Qur'an in seven parts dedicated to Abu'l-Qasim Harun ibn 'Ali ibn Zafar, the vizier of the *atabeg* Özbeg, who ruled Azerbaijan between 1210 and 1225. The first volume of this manuscript, which was written in five lines to the page and has Persian interlinear glosses, is preserved in Paris (Bibliothèque Nationale de France, ms. Supplément persan 1610). On that basis this Qur'anic manuscript may be taken as an example of a type that was produced in Iran before the Mongol invasions of the 1220s to 1250s; it can therefore be dated to the late 12th or early 13th century.

The main text, written in three lines to the page, is in a stately form of the *muhaqqaq* script, in black. The diacritic dots are also in black, while the vocalization is in gold outlined in black; other aids to pronunciation are in blue. On the opening pages (*folios 1b, 2a*) there are only two lines of script set on illuminated grounds surrounded by strapwork frames. The frames also enclose pairs of panels, above and below the text, which are filled with a striking form of knotted chain motif and the title in Kufic script over palmette scrolls, all in gold on gold grounds. Attached to the frames are a pair of 'hasp' motifs formed of symmetrical arrangements of gold palmette scrolls, which are filled with diminutive scrollwork in white on blue and black grounds.

A similar 'hasp' accompanies the *sura* heading on *folio 38a*, which consists of the title and verse count written in white Kufic within an illuminated panel. Other decorative features are the verse stops, which follow the count of Basra, an unusual choice, and a series of rectangular panels containing statistical information, which were in the margins at the beginning of the manuscript and inscribed in gold *naskh* script.

M.R.

115

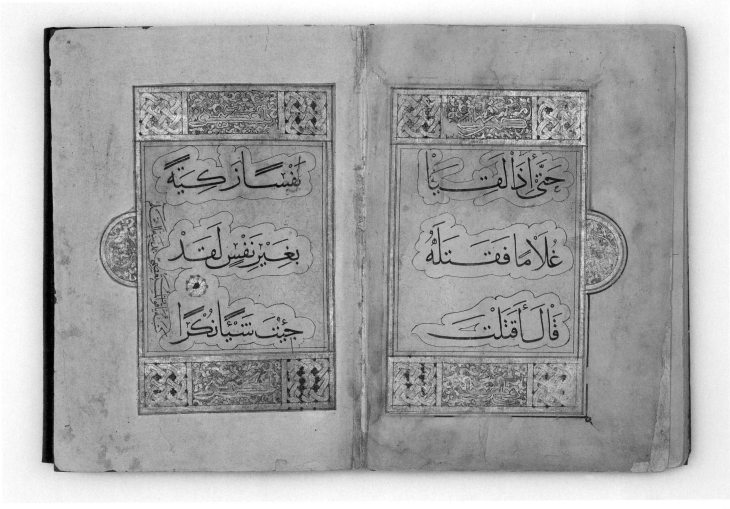

60

Qur'an section

Probably Baghdad, AH 681/AD 1282–83

Ink, watercolours and gold on deep-cream laid

paper; later binding ✦ 58 folios, 24.5 x 17 cm,

text area 19.2 x 11.5 cm

The Nasser D. Khalili Collection of Islamic Art,

London, inv.no. QUR 29

Literature: Tanindi 1986, pp. 140–152; James 1992-I,

pp. 58–67, no. 11

Yaqut al-Musta'simi (d. 1298) is one of the
most important figures in the history of
Islamic calligraphy; this manuscript is one
of the very few pieces bearing his signature
that can be accepted without hesitation as
a genuine example of his work. Yaqut is
traditionally regarded as the third great
calligrapher in the school founded by 'Ali Ibn

Muqla (d. 940) in the 10th century; it was he
who gave the repertory of calligraphic styles
known as the Six Pens their canonical form.
His refined version of the Six Pens was in use
in many parts of the Islamic world in the
14th–17th centuries.

This manuscript, which contains part 15 of
a Qur'an prepared in 30 *ajza'* (*compare
cat.no. 54*), has a colophon written down
the left-hand side of the page on folio 58a,
stating that it was written by Yaqut in
Baghdad in AH 681. Parts 2 and 12 of the
same Qur'an are in Istanbul (Topkapi Palace
Library, mss EH 227, 226), and part 8 is in
Dublin (Chester Beatty Library, ms.1452).
The colophon of part 2 is a later addition,
perhaps by another famous calligrapher,
Ahmed Karahisari (d. 1556), but that of
part 8 is clearly genuine and justifies the

colophon of part 15, despite its unorthodox
placing. The other three parts have all been
substantially refurbished, so the illumination
of part 15 is also an important document for
illumination at Baghdad under Mongol rule.

The frontispiece (*folio 1a*), executed in gold,
black, white, blue and red, is somewhat
comparable to the work of Muhammad ibn
Aybak al-Baghdadi, the outstanding illumi-
nator of the early 14th century, although it
is markedly simpler, owing to its smaller
format.

M.R.

116

61

Qur'an section

Beijing, China, AH 804/AD 1401

Ink, watercolours and gold on a smooth, cream laid
paper made in three layers; bound in boards faced
with leather tooled in blind and gilt and lined with
turquoise cotton ◆ 56 folios, 24.5 x 17.5 cm, ruled
text area 15.8 x 10.8 cm

The Nasser D. Khalili Collection of Islamic Art,
London, inv.no. QUR 974

Literature: Bayani 1999, pp. 12–17, no. 1

This book contains the 29th part (*juz'*) of
a Qur'an bound in 30 parts (*compare
cat.no. 54*). It was copied and illuminated
by Hajji Rashad ibn 'Ali al-Sini 'in the Great
Mosque of the city of Khanbaliq, one of
the cities of China', and completed on
30 Muharram 804, equivalent to 9 October
1401. Khanbaliq was the Mongol name for
the Yuan capital, renamed Beijing in 1421.
The city's Great Mosque, remodelled in
1427, is now known as the Niu Jie Si
('The Mosque on Ox Street').

This manuscript is a comparatively early
specimen of a type of Qur'an manuscript
produced by the Huihui, or Chinese
Muslims, under the Ming and Qing
dynasties. The ancestors of most Chinese
Muslims had been brought from eastern
Iran during the Mongol invasions of the
13th century; Chinese Qur'an production
reflects these origins. The text of this
example was copied in the *muhaqqaq* script,
with five lines to the page. *Sura* headings are
in red in a Chinese version of the *riqa'* script,
and marginal ornaments and verse stops are
in gold, red and blue. Mistakes, where de-
tected by the reviser, were papered over and
rewritten.

The most conspicuous of the illuminated
pages is the frontispiece (*folio 2a*), which has
a central roundel inscribed with the *isti'adha*
('I seek refuge in God from Satan the
accursed') in a rounded script ingeniously

61

combined with Chinese cloud-scrolls. The
leather binding, which may be somewhat
later, bears a medallion with the *basmala*
('In the name of God, the Merciful, the
Compassionate') in similar script on a tooled
and gilded ground.

M.R.

62

Copy of the Qur'an

Iran (Shiraz or Qazvin), AH 959/AD 1552

Ink, watercolours and gold on polished, buff laid
paper; contemporary binding ◆ 203 folios,
42.7 x 30 cm, ruled text area 23.5 x 15.9 cm

The Nasser D. Khalili Collection of Islamic Art,
London, inv.no. QUR 729

Literature: Falk 1985, no. 66; James 1992-II, no. 43

This large and magnificently decorated
Qur'an is a product of one of the high points
of book production in Iran. Neither the
scribe's nor the patron's name is given, but
the large size and magnificent illumination
must indicate a special commission, perhaps
from the Safavid Shah Tahmasp himself.
The manuscript later passed into the imperial
Mughal library, for *folio 1a* bears a partially

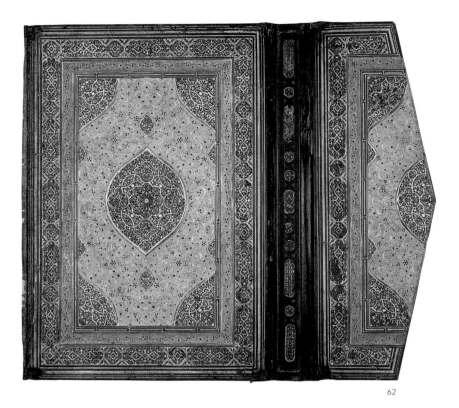

62

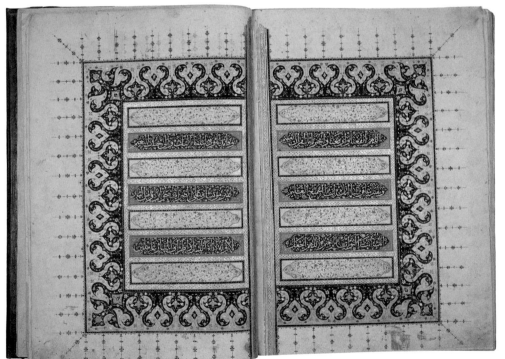

62

is mainly in gold and blue and makes conspicuous use of chinoiserie cloud scrolls in various patterns. The second sura, *al-Baqara* ('The Cow', *folio 2b*), begins with a splendid head-piece. In the main body of the manuscript the text area on each page is subdivided by rulings into five horizontal compartments. Three are filled with the first, middle and last lines of text, each written in the larger *muhaqqaq* style, while two larger compartments each contain seven lines of *naskh* script. The panels containing the lines of naskh are narrower, and four vertical compartments fill the remaining space within the ruled text area.

The Qur'an ends with a prayer, the *Du'a-i Khatim*, to be recited on completing the reading of the whole text (*folios 200b–201a*), and a *falnama* giving instructions on how to use the manuscript for divination, the latter written in fine *nasta'liq* (*folios 201b–203a*). Both sections are decorated with illumination of the same quality as in the rest of the manuscript. This high standard is also matched by the binding, which is of black morocco, with all-over stamped and gilded ornament. The rectangular field contains a central medallion with pendants; the border is formed of a row of cartouches that are alternately filled with Hadith texts and chinoiserie cloud-scrolls. The leather doublures also have stamped and gilded decoration, while the centre- and corner-pieces and the border of cartouches are of fine gilt filigree.

There is a similarly illuminated Qur'an of almost identical dimensions in the Chester Beatty Library in Dublin (ms.1558).

M.R.

erased inscription in Shah Jahan's own hand; on folio 203b there are librarians' notes and impressions of the seals of several Mughal court officials, possibly eunuchs in the service of the *zanana*, the women's quarters.

The manuscript opens (*folios 1b–2a*) with a sumptuous setting for the first *sura*, *al-Fatiha* ('The Opening'), which includes a border containing *Hadith*, that is, sayings attributed to the Prophet Muhammad. The illumination

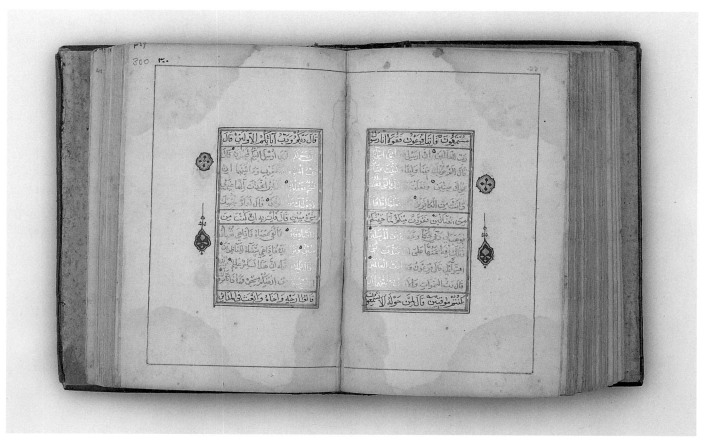

63

Copy of the Qur'an

Probably Saray-i Amanat Khan near Lahore
(India, now in Pakistan), AH 1050/AD 1640–41
Gold and colours on smooth, cream laid paper,
lightly burnished; contemporary leather binding with
stamped decoration and paper doublures
512 folios, 13.9 x 9 cm, ruled text area 7 x 4 cm
The Nasser D. Khalili Collection of Islamic Art,
London, inv.no. QUR 614
Literature: Bayani 1999, pp. 178–182, no. 58

The colophon of this manuscript, on folio
512a, is in the name of 'Abd al-Haqq Amanat
Khan Shirazi and states that it was copied
in AH 1050. Amanat Khan was a court
official of the Mughal emperors and the man
responsible for the design of the great *thuluth*
inscriptions on the Taj Mahal in Agra; this is
the only one of his works on paper that has
so far been published.

Amanat Khan was born in Shiraz in Iran and
followed his brother, Shukrallah Afzal Khan
Shirazi, to the Mughal court, where Afzal
Khan ultimately became Shah Jahan's chief
minister. Amanat Khan evidently made his
career on his achievements, receiving a series
of promotions within the ranks of senior
office-holders during the 1630s. Among the
positions he held was head of the imperial
library, but he is most famous as a calligra-
pher. He designed the inscription for the
main gateway of the tomb of the Emperor
Akbar at Sikandra (completed AH 1022/
AD 1613–14); on the death of Shah Jahan's
beloved wife Mumtaz Mahal, he also
designed the inscriptions for the Taj Mahal
(completion dates AH 1046/AD 1637–38 and
AH 1048/AD 1638–39), though he left Agra
before the inscriptions of the gatehouses
were executed. On his brother's death in
1639 he retired to a village near Lahore
where he built a great *caravanserai*, the
Saray-i Amanat Khan, for which he also

designed the main inscription (completed
AH 1050/AD 1640–41). He died shortly
afterwards.

The present Qur'an was evidently written
while the calligrapher was in retirement at
the Saray-i Amanat Khan. The hand is not
especially distinguished, perhaps because of
his advanced age, or perhaps because he was
more used to working on a large scale.
There are 11 lines of *naskh* to the page,
written in blue, gold and orange and
arranged within ruled compartments. The
sura headings are in naskh of similar size,
in blue or orange. The first pages of text
(folios 1b–3a) each have three short lines
of gold naskh set within 'clouds' reserved
in a hatched ground and surrounded by
panels illuminated mainly in gold and blue.
This work is distinctly archaic in appearance,
being reminiscent of Aqqoyunlu and
Ottoman ornament of the late 15th century.

M.R.

119

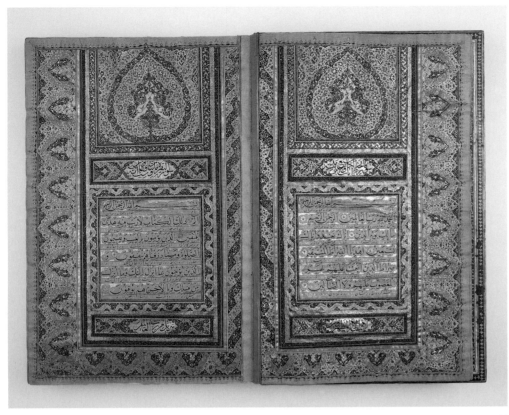

64

The binding is also a remarkable example of its type. The outer covers, which are not exactly identical, have a rich composition of birds and flowers, with a border of roses on a gold ground. The doublures also differ slightly, having a central composition of an iris on a skilfully executed imitation tortoise-shell ground, with borders of Qur'anic inscriptions in naskh.

M.R.

64

Copy of the Qur'an

Iran (Shiraz), mid-19th century

Ink, gouache and gold on firm, cream laid paper, highly polished; contemporary lacquer binding ◆ 289 folios, 36 x 23.5 cm, ruled text area 24.9 x 13.5 cm

The Nasser D. Khalili Collection of Islamic Art, London, inv.no. QUR 914

Literature: Khalili 1996, pp. 206–210, no. 156; Vernoit 1997, pp. 20–21, no. 4

Although the main text of this manuscript is anonymous, it is equipped with interlinear glosses and a marginal commentary; the latter completed on 25 Sha'ban 1272 (1 May 1856) and signed by Mahmud ibn Visal Shirazi, whose pen-name, Hakim ('doctor'), alluded to the fact that he was a physician by profession. He died of cholera in AH 1274 (1857–58). In addition, the fine lacquer covers were signed by the celebrated painter Lutf 'Ali Khan Shirazi and dated AH 1269 (1852–53). Hakim's father, the poet Visal

(d. 1846), and his sons are known to have cooperated with Lutf 'Ali Khan on a number of projects sponsored by the leading figures in 19th-century Shiraz; it must have been in that context that this fine Qur'an was produced.

The illumination, in gouache and gold, begins with three double pages of progressive sumptuousness: firstly, an index of *sura* headings set within a lattice design; secondly, prayer cartouches in green and gold on a blue ground overlaid with dense gilt scroll-work; and thirdly, the *Surat al-Fatiha* ('The Opening') and the beginning of the *Surat al-Baqara* ('The Cow'), with zigzag and crenel-lation borders and magnificent head-pieces containing a floral plume. The main text was written in black *naskh*, 14 lines to the page, and the interlinear glosses are in red *nasta'liq*, while the marginal commentary is in black nasta'liq. The textual divisions were also recorded in black nasta'liq, within marginal medallions.

65

Copy of the Qur'an

Indonesia, 18th or 19th century

Ink and watercolours on a crisp, cream European laid
paper, barely burnished; modern binding ✦ 425 folios,
31.5 x 21.5 cm, ruled text area 21 x 11 cm

The Nasser D. Khalili Collection of Islamic Art,
London, inv.no. QUR 133

Literature: Vernoit 1997, no. 31; Bayani 1999, no. 4

This manuscript is an example of Qur'an
production in southeast Asia, the region
known in medieval Muslim sources as Bilad
al-Jawa, the 'Lands of Java'. The text was
written in 14 lines of a script close to Middle
Eastern *naskh* but with a pronounced
forward slope, which is traditionally called
Jawi. Sura headings are in red, and verse
stops are in yellow. The fine illumination,
in yellow, red, black and white, is mainly
concentrated on the opening, middle and
final pages (*folios 1b–2a, 280a–209a and
416b–417a*), the last being very similar to
folios 1b–2a, but with the central fields left
blank. The frames are highly distinctive,
with elegant finials and marginal projections.

M.R.

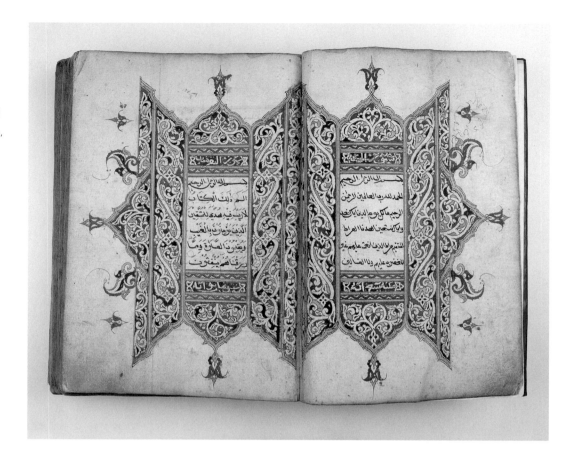

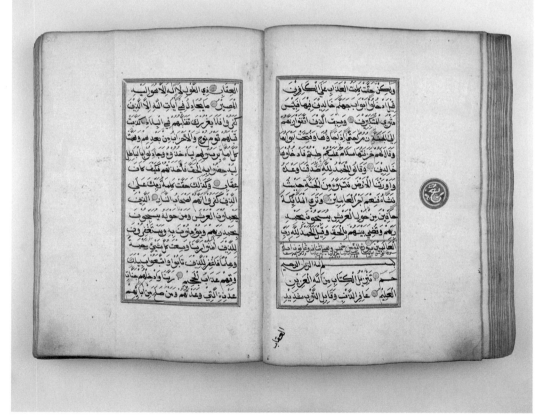

66

66

Case for a Qur'an manuscript

Central Russia (Kasimov)

AH 10[0]2 /AD 1593-94

Silver, turquoise, lapis lazuli ◆ 11.3 x 8.3 x 3.5 cm

The State Hermitage Museum, St Petersburg,
inv.no. VZ-279

Provenance: transferred in 1930 from the Academy
of Sciences, Asiatic Museum

*Literature: Fraehn 1822-I, part VIII, pp. 497-522;
Fraehn 1822-II, pp. 1-26; Dorn 1846, pp. 6, 28, 133,
169; Velyaminov-Zernov 1863-1864, part I, tab. III,
part II, pp. 113-121; Shishkin 1891, p. 30; Kuwait
1990, no. 109*

This Qur'an case, designed to be attached to
a belt, was made for Uraz Muhammad Khan,
one of the rulers of the Kasimov Khanate (in
the Ryazan district along the Oka river, its
centre at Kasimov), which existed from the
mid 15th century until 1681. This state was
ruled by different Tatar princes as vassals of
Moscow's Czars. The first of these rulers was
Qasim, who gave his name to the former
town of Gorodets and the entire princedom.
He was succeeded by unrelated rulers of
varying origins.

One of these was Uraz Muhammad (1592-
1610), for whom this case was made. The
case later came into the possession of Yakov
Bryus, a nobleman during the reign of Peter
the Great.

The case is richly decorated with inscriptions.
Those on the lid, in two cartouches, read:

> *In the name of God, the Merciful,
> the Compassionate, [in the] year 102.*

The date is somewhat problematic, because
the case is only inscribed '102'. Uraz
Muhammad became lord of Kasimov on
15 Ramadan 1000 (25 June 1592), and was
murdered in Kaluga at the end of 1610 (AH
1019). So the date could be either AH 1002
/AD 1593-94, or AH 1012/AD 1603-04.

Although the latter date has been preferred
by other authors, there is clearly no figure '1'
in front of the '2': AH 1002/AD 1593-94 is
therefore more probable.

The cartouches on three sides, on the front
(with the exception of two smaller round
medallions) and the border of the central
medallions on the back are inscribed with
verse 255 from *Sura* 2 of the Qur'an,
renowned as the Throne Verse with
additional words at the end:

> *Oh, God! O, Muhammad! Oh, 'Ali!*

Two small medallions on the front contain
Arabic verses, in a metre called *rejaz*, pre-
ceeded by the *basmala* ('In the name of
God, the Merciful, the Compassionate').
The inscriptions are continued in four round
medallions on the back (in *naskh* script):

> *Call on 'Ali, the revealer of miracles, You will
> find him a help for your griefs. Every concern
> and despair will disappear according to your
> prophecy, Oh, Muhammad, by your patronage,
> Oh 'Ali, Oh 'Ali!*

Added at the end is:

> *By Your mercy, oh, Most Compassionate among
> the compassionate!*

The central part of the medallion in the
middle of the back encloses a naskh in-
scription with the name and genealogy of
Uraz Muhammad

> *Urus Khan fathered Quyruchuk Khan, [who]
> fathered Buraq Khan, [who] fathered Janibek
> Khan, [who] fathered Yadik Khan, [who]
> fathered Shigway Khan, [who] fathered
> Undan Sultan, [who] fathered Uraz
> Muhammad Khan.*

The inscription is highly unusual, beginning
with the ancestor Urus Khan, and ending
with the latest descendant, Uraz Muhammad;
usually, the order is reversed. The names are
linked by the word 'ibn' which can be read
as 'son'. Although the suffix 'his' is absent, the
likely meaning is 'his son [is]' or 'fathered'.

There is a further inscription (in *thuluth* script) on a blank background on the lapis lazuli seal set on the lid. Researchers have managed to decipher only the first line (*misra*) of this Persian *bayt* (stanza). The metre is *hazaj,* which is not observed in the second *misra*:

Oh Dust-Muhammad, Shah-Muhammad's son, You have received eternal happiness from the blood of the time.

The script and the background date this seal to late 15th- or early 16th-century Iran. Unfortunately, there is no information in literary sources concerning its original owner.

A.I.

67

Qur'an stand (rahlah)

Mughal India, 17th century

Monolithic grey jade, carved ◆

Height: 26.2 cm, width 13.8 cm

The Nasser D. Khalili Collection of Islamic Art, London, inv.no. MXD 117

Literature: unpublished

The *rahlah,* which consists of two inter-locking leaves, is carved from a single piece of jade. The upper half of each leaf is in the shape of a lobed ogival arch, carved in relief with a stylized lotus plant.

The scalloped inner edge of the feet creates an arched opening in the lower half. The spandrels are decorated with lotus sprays, their sinuous stems standing in stark contrast to the symmetrical arrangement of the plant above.

M.R.

67

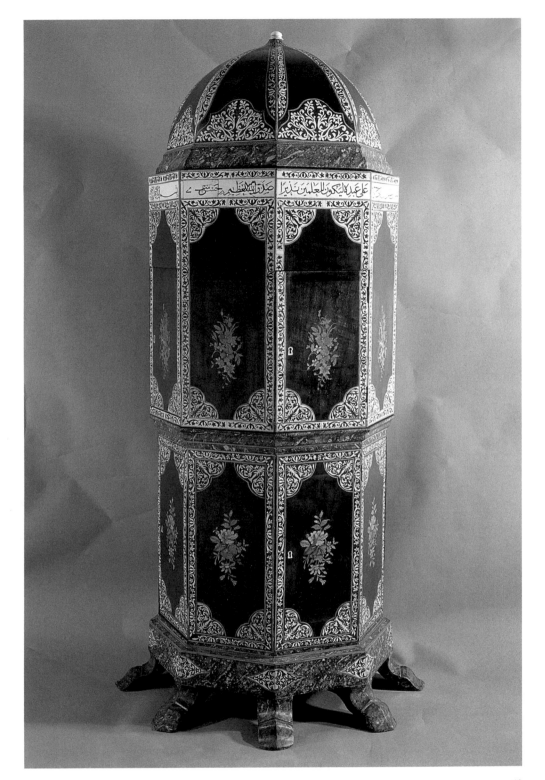

Kursi, a chest to hold the Qur'an

Turkey, 18th-19th century

Wood, inlaid with ebony and other wood sorts,
tortoiseshell and ivory; marbled paper ◆

Height 168 cm

Institut du Monde Arabe, Paris, inv.no. AI 84-21

Provenance: The Ph. Masson Collection (n.d.)

Literature: unpublished

This *kursi*, a chest to hold the Qur'an, con-
sists of two sections. Its octagonal shape is
reminiscent of the architecture of a mosque.
The lower section rests on eight lion feet,
while the upper section is dome shaped.
This dome is made from marbled paper with
ribs of ivory, and also surmounted with
ivory. Both sections have four doors and
are elaborately decorated with abstract orna-
ments, animal and plant shapes. The panels,
adorned with bouquets of flowers, may come
from an earlier piece of furniture, possibly
17th century.

The luxurious calligraphy on the cornice –
which is made from marbled paper known as
tortoiseshell paper – is inscribed on marbled
paper and can be recognized as a 19th-
century Turkish variant of *thuluth* script.
The text consists of two verses from the 25th
sura of the Qur'an, which is titled Al-Furqan
('Salvation'). The sequel to the text is no
longer legible.

*In the Name of God, the Merciful,
the Compassionate*

*Blessed be He
who has sent down the Salvation upon
His servant, that he may be a warner to all
beings;
to whom belong the Kingdom of the heavens
and the earth; and He has not taken
to Him a son, and He has no associate
in the Kingdom; and He created everything
then He ordained it very exactly.*
B.A.

68

For many Muslims, the world of the spirit was palpably present, and some strove for a mystical union with the divine. The followers of this mystic path in Islam are called *sufis*. The sufi wishes to concentrate on his way of life undisturbed by any earthly distraction and is thus generally celibate and ascetic.

According to certain important writings from the 10th to the 13th century the practice of the mystic was compared with making a journey to God. The mystic path would begin with a purification process: he must learn self-control and how to tame his moods and passions. He must take up against his rebellious self, as it were a holy war (a *jihad*) in honour of God. When he continued down this road he would achieve an experience of God of such intensity that it would seem as if he himself were annihilated and had been absorbed into the divine Being. In this state of ecstasy or trance he would experience oneness with God. After his journey into mystical realms he would return to this world and devote his life to his fellow men.

From the 12th century onward various mystic orders arose. Each one preached its own way of journeying down the mystic road. Most of these orders had a sheikh as their spiritual teacher, who generally assumed his authority from his ancestors. The founders of the orders were often revered as saints. The same was true for members of the order whose religious insight and exceptional piety excelled that of their master.

These many orders were largely distinguished by their different rites and practices. Some, for example, emphasized the holiness of silence and self-control, while others would dance wildly, sing and cry, or castigate themselves. The orders also differed in their lifestyles. Sometimes men would live together in a cloister, while sometimes the monks would wander begging from place to place (for example, the *dervishes*).

Down the centuries the mystic element in Islam has made a strong remark on Muslim society. It gave a concrete form to the life of devotion and ritual.

J.V.

Islamic mysticism

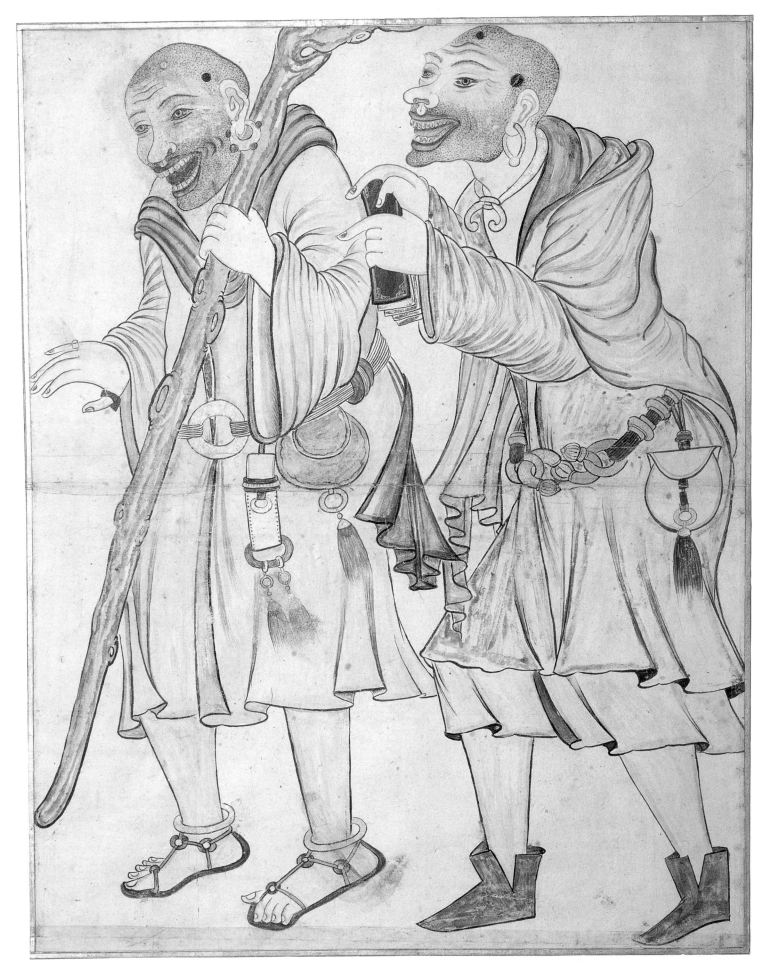

69

69

Two wandering dervishes

Iran (probably Tabriz), later 15th century
Brush drawing in ink, watercolour, gouache and gold
on smooth, off-white, lightly burnished paper,
apparently laid, backed on to fine card ◆
Height 48.6, width 37.5 cm
The Nasser D. Khalili Collection of Islamic Art,
London, inv.no. MSS 619
Literature: Grube 1972, no .225, pl. XLVIII

The figure on the right has a gold belt with
an S-shaped fastener from which hangs a
purse with a tassel. He wears a gold torque
and gold earrings and carries a book in *safina*
('boat-shaped') format, which was popular
for Persian and Turkish verse anthologies in
the later 15th century and 16th century.
He wears ankle boots, while the figure on
the left wears sandals. This second figure
has a tasseled purse and a two-tasseled bag
(perhaps for the book), also hanging from his
belt. He holds a wooden club in his left hand;
on his right hand he wears a ring on his little
finger and an archer's ring on his thumb.
He wears gold anklets and a studded earring.
Both have stubbly faces and shaven heads,
with two brand marks, one above the left ear
and one near the crown of the head.

Despite their garments and ornaments, which
do not exactly suggest material poverty, these
figures have been identified as wandering
dervishes (*qalandars*). In fact, the drawing is
a version of a Chinese genre of the Yuan
period and shows *lohans*, Buddhist holy men,
although some of their attributes may have
been thoughtlessly copied. There is a com-
parable study in New York (Metropolitan
Museum of Art, Rogers Fund, 68.48), also
after a Yuan original. Earlier attributions of
such work, including a group of markedly
chinoiserie paintings in Istanbul (Topkapi
Palace Library, H.2153), were to early 15th-
century central Asia, but now Tabriz in the
later 15th century is favoured.

M.R.

70

Dervish

Iran, early 17th century
The miniature is enclosed in mounts of yellow, blue
and pink with gold floral ornaments, backed on dark
violet card. On the reverse are faint impressions of
three rectangular stamps; one of these is also
impressed on the front of the miniature entitled
'The monkey on the bear', Hermitage inv.no. VR-948
Paper, gouache, gold ◆ Size 14.8 x 7.9 cm, album
page 27 x 19 cm
The State Hermitage Museum, St Petersburg,
inv.no VR-953
Provenance: unknown
Literature: Adamova 1996, no. 16

Against a background characteristic of the
Isfahan school in the early 17th century
(gold silhouettes of plants and clouds), a
man is depicted leaning slightly forward as
if addressing an invisible interlocutor. He
wears a short shirt and a long yellow scarf
wound around his entire body. His headgear
is striking: a tall hat of complex shape
fastened beneath the chin.

The figure portrayed was formerly assumed
to be a buffoon or a professional dancer
(*raqqas*), a theory based on folk dancers'
clothing in 16th-century miniatures.
However, material has subsequently
emerged which suggests that this early
17th-century miniature, and two other
miniatures, does not depict a dancer but
a *dervish*. A dervish is an Islamic mystic,
generally a member of a mystic order.

A miniature in the Keir Collection in London
shows the same figure in mirror image,
although the Keir figure has a beard and his
clothing is somewhat different: the hat is the
same but made of leopard skin, the kaftan
cut the same but from a tiger skin. This
supports the conclusion that the Keir figure
is a dervish as dervishes always wore robes
made from animal skin. Since the Keir
miniature and this work are so similar (even

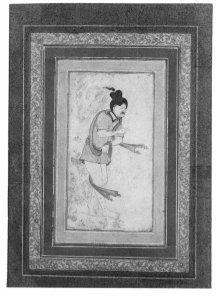

70

the dimensions are the same), the figure
portrayed here should be similarly inter-
preted. The miniature was painted by an
artist of the Deccan school (central/south
India) who worked from an Iranian proto-
type. The Persian inscription (which is
possibly later) identifies the figure as 'The
blessed Shams-i Tabriz'. This undoubtedly
refers to the dervish Shamseddin Tabrizi,
a friend of the poet Jalal-ad-din Rumi who
took the name Shams as a pseudonym after
the dervish was treacherously murdered.

In this miniature there are red and white
spots on the figure's hands and legs. Many
miniatures from the 16th and 17th centuries
depict dervishes with burns on their body,
demonstrating their contempt for pain.

A.A.

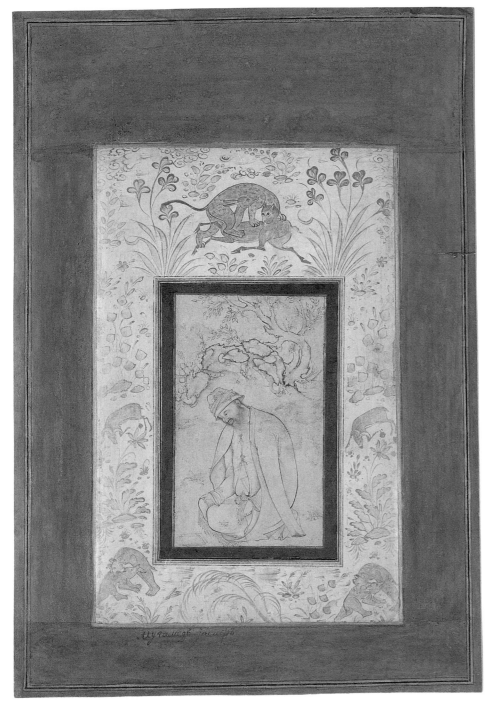

71

18th century ('Muɜamed Josuf' also appears in Russian on the card passe-partout). There is every reason to include this drawing in the oeuvre of Muhammad Yusuf: the high horizon, the three-dimensional treatment of the rocks, coloured pink and light blue, the tree with a fat crooked trunk, even the use of black and red Indian ink and the character of the lines support this attribution.

The portrayal of Sufis and dervishes is one of the most popular themes found in art of the Isfahan School. This drawing by Muhammad Yusuf obeys the conventions that applied to this subject.

A.A.

71

Dervish holding a rosary

Muhammed Yusuf

Iran, mid 17th century

The drawing is enclosed in a plain dark brown mount and yellowish ground painted in liquid gold with depictions of animals against a landscape background, backed on brown-coloured card

Paper, Indian ink, watercolour ◆ Size of drawing

13.3 x 7.8 cm, size with painted frames

25.5 x 16.1 cm, card base 36.5 x 25 cm

The State Hermitage Museum, St Petersburg,

inv.no. VR-740/XXV

Provenance: unknown

Literature: Adamova 1996, no. 22

The note on the *dervish*'s left knee 'this was drawn by Muhammad Yusuf' is not a signature but an attribution added in the

72

Kashkul (begging bowl for a dervish)

Signed by the craftsman Hajji `Abbas

Iran, AH 1207/AD 1792-93

Steel, gold ◆ Diameter 27 cm

The State Hermitage Museum, St Petersburg,

inv.no. VS-804

Provenance: unknown; purchased in 1925

Literature: Kuwait 1990, no. 118; Allan 1994; Turku 1995, no. 164; Loukonine - Ivanov 1996, no. 253

This bowl resembles a coconut in shape; indeed some *kashkuls* are made of coconut shell. Great skill was required to produce such an object in steel. More of these steel bowls are known, all inscribed with the name Hajji 'Abbas.

Unfortunately this signature is not accompanied by a date. Neither does the name of the craftsman appear in other sources. The type of decoration indicates that this was applied in the late 18th or early 19th century.

Every object made by this craftsman is of major importance, not only for greater understanding of his life and work but also

to the overall history of such items. This kashkul is dated AH 1207/AD 1792-93; the decoration appears to concur with this date. Ascribing this work to the 17th century as some journals have done is therefore questionable.

James Allen, however, has established that Hajji 'Abbas worked in Isfahan in the late 19th and early 20th century, where he died in AH 1380 (1960-61). This topples the above theory and implies that the date and/or the name of Hajji Abbas has been falsely inscribed on the bowl.

There are two inscriptions in *naskh* script on top of the bowl. The first is a fragment from the 'Gulistan' by Sa'di (a *misra'*, in *hazaj* metre):

The purpose is [the] track [in our life] that we leave

The other inscription is the craftsman's signature:
 work of Hajji 'Abbas.

There are six medallions on the sides of the kashkul, each containing the same exclamation:
 May it be pleasing!

There are also larger cartouches with Persian verses in a metre called *muzari*, plus the date in *nasta'liq* script:
 Wondrously beautiful kashkul, full of gold and ornaments [on] steel,
 See, it is as fine as precious stone!

Everyone who has drunk a handful of the water, says:
'It is a thousand times better than water from Heaven or Kawthar!'
Through the work of a skilled craftsman Has [this kashkul] been made,
'Abbas is a celebrity in seven regions of earth, 1207.
A.I.

72

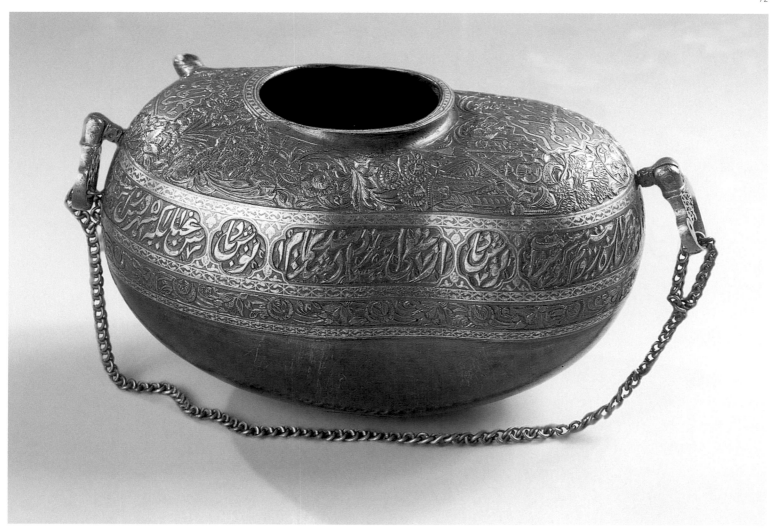

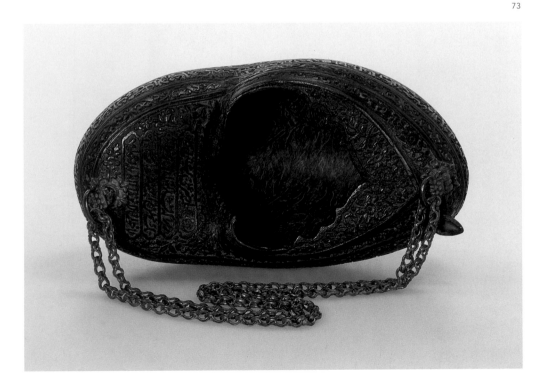

73

Kashkul (begging bowl for a dervish)

Iran, 19th century

Coco-de-mer, carved; silver chain and fittings ✦

13.5 x 28 x 14 cm

The Nasser D. Khalili Collection of Islamic Art,

London, inv.no. MXD 256

Literature: Vernoit 1997, pp. 42–43, no. 19

The *kashkul* consists of one half of a coco-de-mer (*Lodoicea maláivica, Lodoicea Seychellarum*), a nut famous for its medicinal, especially aphrodisiac, properties, Although native to the Seychelles and cultivated in the Maldives, it is cast up on all the shores of the Indian Ocean and occasionally as far as the Persian Gulf and Zanzibar. The vessel is carved with the *Ayat al-Kursi* ('Verse of the Throne', Sura II, verse 255) and Arabic and Persian verses.

Partly because of its alleged properties, the coco-de-mer accumulated legends all over south and southeast Asia. In later Safavid Iran its fantastic sea-voyages came to be seen as a metaphor for the *dervish*'s spiritual search. Hence it was an appropriate choice of material for a dervish's begging bowl. Boat-shaped begging bowls are known earlier in Iran and may derive from alms bowls of similar shape (*nefs*) in mediaeval Europe.

M.R.

73

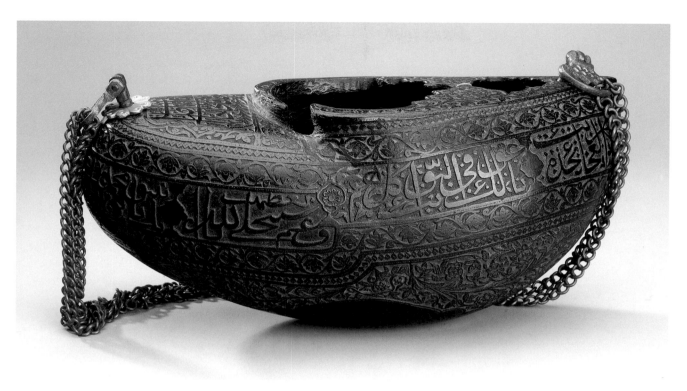

74

74

Kashkul (begging bowl for a dervish)

Iran, 19th century

Coconut shell ✦ 31 x 11.2 cm, height 14.5 cm

The State Hermitage Museum, St Petersburg,

inv.no. VR-1074

Literature: unpublished

The walls are decorated with floral motifs
and Arabic inscriptions.

A.A.

75

Kashkul (begging bowl for a dervish)

Iran, 19th century

Coconut shell, carving ✦ 16 x 28 cm; height 15.5 cm

The State Hermitage Museum, St Petersburg,

inv.no. VR-1077

Provenance: transferred in 1923 from the State

Museum Fund

Literature: Turku 1985, no. 180

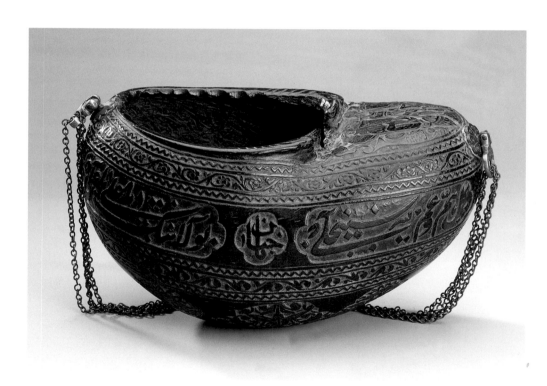

75

The walls of this *kashkul* are decorated
with carved floral ornaments and Arabic
inscriptions. *Dervishes* are depicted on the
uppermost section; one is smoking a *qalian*.

A.A.

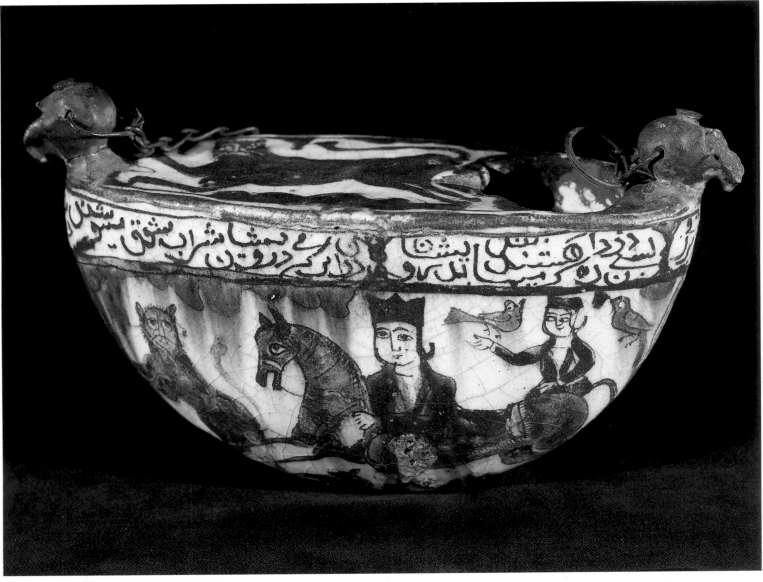

76

76

Kashkul (begging bowl for a dervish)

Iran, 19e eeuw

Faience, glaze-painted with blue, brown and black

paint ◆ Height 12 cm, length: 22.5 cm

The State Hermitage Museum, St Petersburg,

inv.no. VT-2707

Provenance: acquired in 1988 as a gift from the I.N.

Popov and T.B. Aleksandrovsky Collection

Literature: Adamova 1996, supp., no. 41

The walls of this *kashkul* are decorated with hunting scenes and inscriptions in Persian which allude to wine drinking by *dervishes*.

A.A.

The palace

In medieval Islamic society, cultural and economic life was carried out to a large extent in and around the palace of the ruler. Surrounding the courts of great rulers there would be large districts where artists and artisans lived, who worked on commission. These craftsfolk, often members of guilds, produced their goods not only for the rulers but also for merchants, courtiers and officials. This was partly because of the system of presenting gifts, which prevailed. Those in a high position presented gifts to those occupying lower positions, who in turn offered gifts back again.

In Islam there is no strict division between the spiritual and the earthly. Each aspect of the life of a Muslim, whether he be lord or lowly servant, has a religious significance and may be compared with the standards of the faith. The same is true of art.

One of the early *Hadith*, that is, a traditional saying of Muhammad or one of the earliest examplerary Muslims, runs as follows: 'Truly, God is beauty and loves that which is beautiful'. Seen in this way, it was the important task of art to act as a reflection of the glory of heaven. Princes, in their turn, and all who were sufficiently wealthy to do so, would surround themselves with beautiful objects, perceiving it as an act of devotion to support the arts and to beautify their palaces. The most precious materials were employed – gold and silver were not only a manifestation of worldly wealth but also of the beauty of God. Since the use of gold and silver utensils was explicitly forbidden by Islamic tradition, bronze and later copper items, became popular, pronding a gleeming and acceptable alternative. Bronze and copperware attached such superb variety and complexity that they were considered no less inferior than their precious metal counterparts. Carpets and costly textiles, the most characteristic and widespread examples of Islamic art, are a reminder of the Paradise to come, where the righteous will behold God. The function of art was to seduce the eye, to amaze and delight, thus bearing witness to the glory of God.

Another haddith condemns the use of figures in art, fearing lest it tempt people to the worship of idols. Because of this, Islamic art developed into a form of expression which is dominated by the abstract shape. Ornamentation became the most characteristic artistic genre. It grew to have great significance and achieved a high degree of refinement. The three most important examples of ornamentation are: calligraphy, plant and flower motifs (such as the arabesque), and geometric patterns in which repetition is an artistic feature. All these elements have an ideological meaning. In the case of the calligraphic decoration the citations are often from the Qur'an and the name of Allah frequently occurs. The plant ornamentation is a reminder of God the Creator's tender affection for His people. The geometric patterns often have a magic and symbolic meaning.

Despite the prohibition against representing living creatures, in practice we see many examples of figurative Islamic art. We find this in particular in the art made for a decidedly elite circle. For example, the festive meals of wealthy Muslims would rejoice in elaborate metal services perhaps inlaid with creatures from the zodiac, or jugs and candlesticks in the shape of animals. At the most luxurious courts manuscripts were produced illuminated with miniatures in which human figures appear, illustrating literary or scientific texts. In such learned and indeed private circles people felt they were immune from danger of idolatry.

J.V.

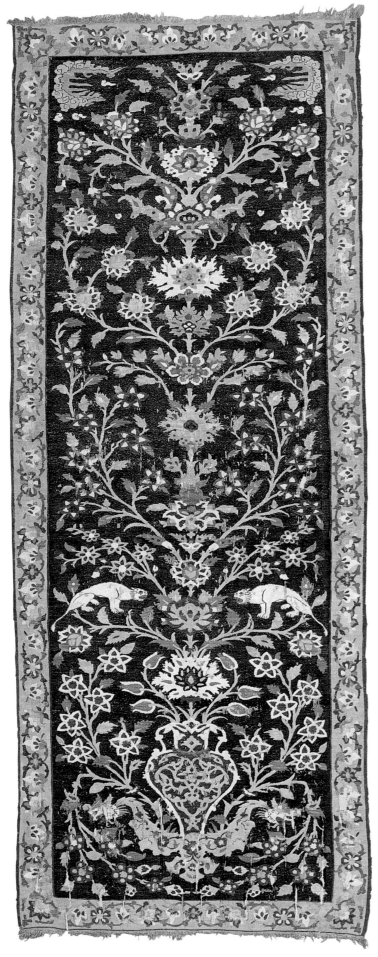

77

Carpet

Turkey or Iran, 16th century

Silk, slit-tapestry weave ✦ Height 212 cm, width 84 cm

The Nasser D. Khalili Collection of Islamic Art,

London, inv.no. TXT 189

Literature: Murich 1979, fig. 1

The main field is entirely filled with a design
incorporating a number of chinoiserie
elements. The dominant motifs are sprays
of flowers, which branch out from a vertical
stem dressed with fantastic composite
blossoms. This floral 'tree' grows from an
ornate vase which rests on a curious device
set with a pair of phoenix heads; it is in-
habited by a pair of snarling felines. The
upper corners of the field are filled with a
pair of chinoiserie clouds, while the lower
corners are filled with sprays of flowers that
rise from the phoenix-headed device; the
sprays have been 'broken' to fit into the
corners. An Ottoman note is provided by
the six tulip heads that rise directly from
the vase.

The design and fine workmanship are
reminiscent of the so-called Palace kilims
that have come to light in a number of
mosques in Turkey. These include the Great
Mosque at Divrigi (northeast Turkey),
restored by Sultan Süleyman the Magnificent
in 1523-33, and the Esrefoglu mosque at
Beysehir (central-south Turkey), which was
restored in AH 982/AD 1574-75. The Palace
kilims tend, though, to have all-over designs
rather than a principal composition.

A kilim of this type now in the Bayerisches
Armeemuseum in Ingolstadt (A.1855) was
captured from the tent of the Ottoman grand
vizier Kara Mustafa Pasha at the relief of
Vienna in 1683.

M.R.

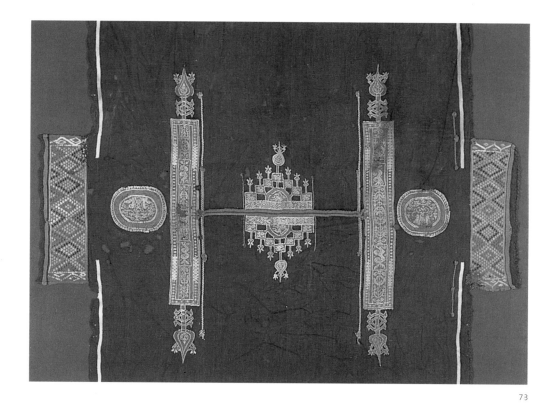

73

78

Tunic

Upper Egypt, 8th or 9th century

Wool, with areas of ornament in tapestry weave ◆
Height 223 cm, width 108 cm

The Nasser D. Khalili Collection of Islamic Art,
London, inv.no. TXT 1

Literature: unpublished

This tunic of dark-blue wool probably sur-
vived because it was used as a shroud and
buried in the parched earth of Egypt. In cut
and technique it belongs to the traditions
established in the Roman period, but the
style of decoration suggests that such 'Coptic'
textiles were also produced in the early
Islamic period.

There is a slit for the neck running at right
angles to the warp, and extensions on either
side to form short sleeves; the piece only
required sewing along the sides to make it
into a tunic. The areas of ornament, woven
in mauve, pink, ivory, yellow and blue wool,
include panels with horses at the collar and
the nape of the neck, the shoulder bands

with sea monsters and roundels with human
figures. The shoulder bands also have hasp-
like appendages very similar to the marginal
ornaments placed beside *sura* headings in
early Abbasid Qur'an illumination.

M.R.

79

Chasuble

Iran, 16th century (fabric); Russia,
17th century (shoulders)

Silk, silver thread ◆ Length 136 cm

The State Hermitage Museum, St Petersburg,
inv.no. IR-2327

Provenance: transferred in 1930 from the
State Historical Museum

*Literature: Maastricht 1994, no. 26;
Loukonine - Ivanov 1996, no. 182*

Precious old fabrics were traditionally popu-
lar with the Russian clergy who used them
to make liturgical vestments, regardless of
the scenes depicted. This chasuble has in-
corporated a piece of fabric which shows
Majnun in the desert, surrounded by wild
animals (*see cat.no. 87*), a theme taken from
the writings of the great Persian poet Nizami
Ganjavi.

The chasuble comes from the collection of
Russian textile collector P.I. Shchukin who
specialized in textiles produced by both
Iranian weavers and Russian embroiderers.

A.I.

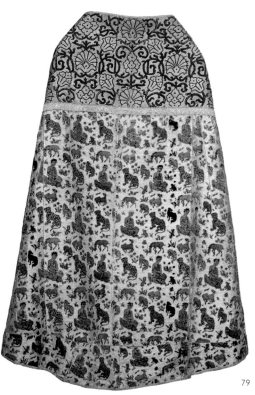

79

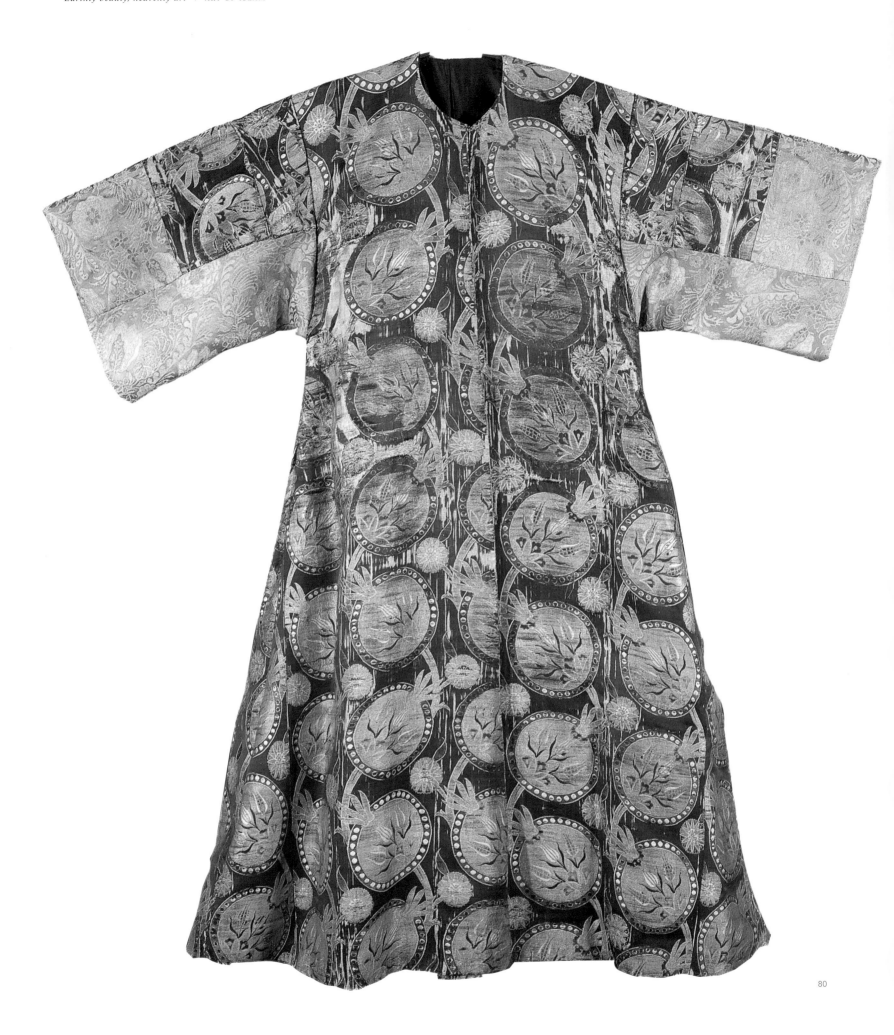

80

Silk kaftan

Bursa or Istanbul, circa 1550

Length 134 cm, width with sleeves 126 cm

Benaki Museum, Athens, inv.no. 3900

Literature: Öz 1951, pl. CVIII; Mackie 1980, fig. 204;

Frankfort 1985, part II, 259, no. 5/6

This kaftan is cut with straight flaring skirts from a crimson silk fabric of lampas weave brocaded with gilt metallic thread. The loom width of the fabric is woven with four undulating vertical stems which bear round stylized pomegranates and small rosettes. Diminutive tulips adorn the pomegranates which are delineated with a white pearl border on a blue ground, curiously reminiscent of medieval silks. Louise Mackie dates this kaftan to the mid 16th century, a date which fits well with a group of Iznik dishes also decorated with pomegranate motifs. Other fabrics woven with larger vertical stems bearing pomegranates are ascribed to the second half of the 16th century or the early 17th century (for example, an Osman II kaftan). The short sleeves have been repaired with a later fabric.

A.B.

81

Child's kaftan

Ottoman Empire, late 16th century

Silk brocade ✦ Length 76.5 cm

Topkapi Palace Museum, Istanbul, inv.no. 13/267

Literature: Öz 1951, pl. XLI; Altay 1974, pp. 14-15;

Altay 1979, p. 31; Delibas - Tezcan, II / 41

This collarless kaftan with short sleeves has a front opening and slit pockets in the sides. It is made of *kemha*, silk brocade, decorated with two vertical stems that curve and overlap. These bear narcissi, tulips, roses and serrated leaves which bend and intersect the stems. The motifs are embroidered in white and blue on a ruby-red ground.

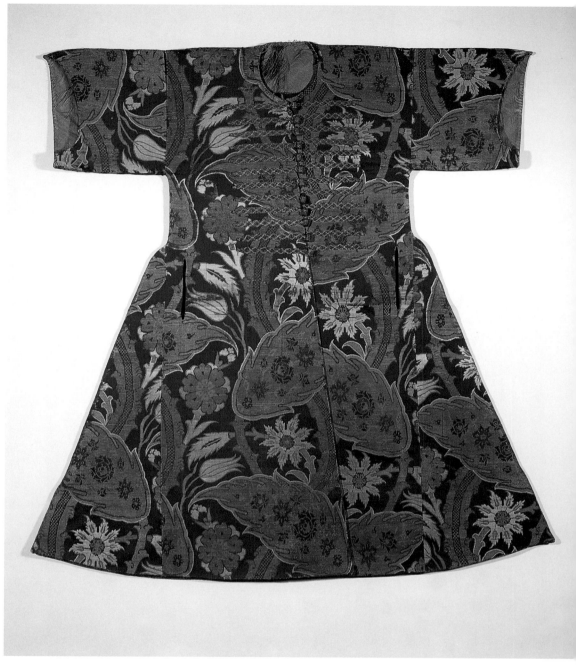

81

Textile designs with vertical stems or branches were popular in the second half of the 16th century and the early 17th century. They were used for various purposes. This kaftan is lined with ruby-red silk edged with green.

The museum archives record that this kaftan belonged to Sultan Ahmed I who ruled from 1603 to 1617.

E.B. - S.M.

82

Velvet saddle cloth

Istanbul, late 16th century

Height 185 cm, width 129.5 cm

Benaki Museum, Athens, inv.no. 3784

Literature: Devonshire 1928, 190, fig. a; Benaki
Museum 1974, 14; London 1976-I, 386, no. 645;
Delivorrias 1980, 48, fig. 38; Philon 1980-I, 50, no.
256; Mackie 1980, 357, fig.. 208; Frankfort 1985, 365,
no. 11/25a, pl. XXX; Alexander 1996, part II, fig. 141;
Fotopoulos - Delivorrias 1998, 30

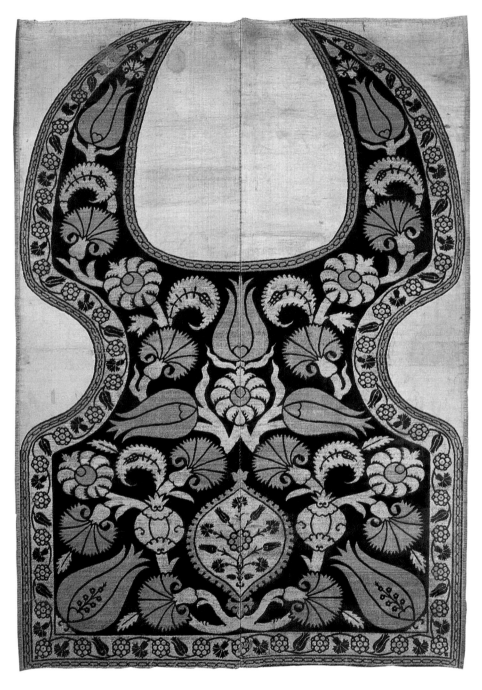

82

This saddle cloth is made from two lengths
of fabric sewn down the centre and woven
with a mirror-image design on either side.
A characteristic Ottoman flora of tulips and
carnations with pomegranates and serrated
leaves proliferates from a central ogival
cartouche; this is brocaded with metallic
threads on a maroon ground. The cloth
is bordered by a loop pattern and a band
containing a scroll with tulips and car-
nations. This exceptionally fine textile
contains almost no repeat patterns in the
weave. It must have been commissioned by
a high-ranking official and used, if ever, at
official parades.

A.B.

83

Panel from a tent

Probably Fatehpur Sikri (India), later 16th century

Silk lampas ♦ Height 151 cm, width 182 cm

The Nasser D. Khalili Collection of Islamic Art,
London, inv.no. TXT (IND) 17

Literature: Brand - Lowry 1985, pp. 108–109, fig. 70;
McLean 1994, pp. 79–83; Skelton 1998, p. 162 and
pl. 27

This impressive textile is a product of the
Mughal imperial workshops in the reign of
the Emperor Akbar (r. 1556–1605). It shows
a princess standing under a lobed arch with a
beaded border. She is depicted in profile, her
head surrounded by a nimbus; she wears a
yellow *jama* trimmed with green and a green
jabot, and holds two rods, one pointing up
and one down.

The piece is a *qanat*, a panel from a tent;
it may have formed part of a monumental
series of courtly types. A companion panel
in the Los Angeles County Museum of Art
(73.5.702) shows a male courtier holding a
wine cup. This figure is in Persian costume,
and the image is doubtless, as Robert Skelton
has argued, after a Mughal or Deccani copy
of a portrait of the Qazvin school (Iran).
The princess on the panel shown here wears
Indian dress; the contrast of Indian and
Persian types is presumably deliberate.

M.R.

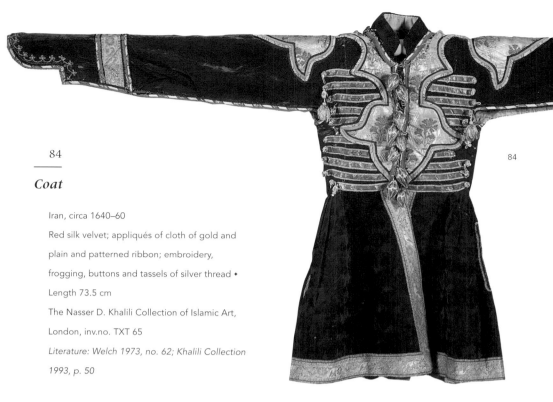

84

Coat

Iran, circa 1640–60

Red silk velvet; appliqués of cloth of gold and
plain and patterned ribbon; embroidery,
frogging, buttons and tassels of silver thread ◆
Length 73.5 cm

The Nasser D. Khalili Collection of Islamic Art,
London, inv.no. TXT 65

*Literature: Welch 1973, no. 62; Khalili Collection
1993, p. 50*

84

The cut of this red velvet coat is very similar
to those depicted in Safavid paintings of the
mid 17th century. In Shaykh 'Abbasi's *Shah
'Abbas II and the Mughal Ambassador* of
AH 1074 (1663–64) (ex-Mahboubian Col-
lection), for example, a coat of this cut, and
with heavy frogging, is worn by the Shah
himself. The most dramatic feature of this
object is its 'cloud collar' ornament, which
was made by applying cloth of gold over
the velvet. Although such ornaments are
not shown in depictions of Iranian costume
from this period, the cloth of gold is clearly
a product of 17th-century Iran, as is the
brocade ribbon that runs along the hem and
around the wrists.

'Cloud collar' ornaments were a popular
fashion at the Timurid courts in the 15th
century, but these earlier examples were
smaller and had more elaborately bracketed
contours. Here the design extends almost
down to the waist and along the arms as four
large palmette motifs. The cloth of gold used
is semé with a floral sprig in green and pink,
and the wide brocade ribbon at the wrists
and along the hem has a repeat pattern of
small two birds perched between two large
blossoms on an undulating scroll. These
elements are edged with narrow ribbon of
varying types, and there is silver frogging on
the chest. The remaining decoration was
worked in silver thread. The frogging is
matched by the conical buttons in the centre
and by the large tassels at either end, of
which only two survive. There is a modest
amount of embroidery along the cuffs.

M.R.

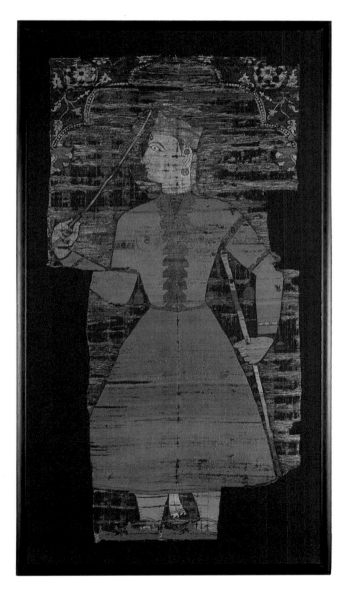

83

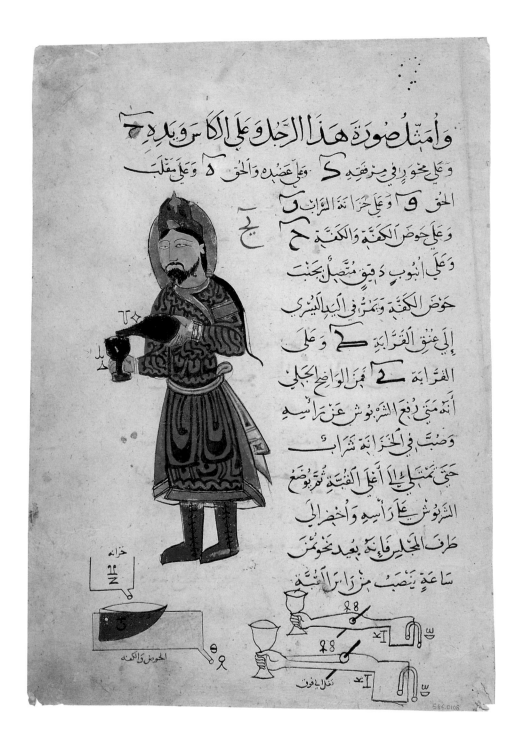

85

Picture of a mechanical device for pouring a drink

From a copy of the Kitab fi ma'rifat al-hiyal al-handasiyya of Badi'uzzaman b. al-Razzaz al-Jazari made for the treasury of Amir Nasruddin Muhammad Egypt, AH Safar 755 (February-March 1354)
Opaque watercolour, ink, gold on paper ◆
Page: height 39.8 cm, width 27.5 cm
Arthur M. Sackler Gallery, Smithsonian Institution, Washington, D.C.; Purchase, Smithsonian

Unrestricted Trust Funds, Smithsonian Collections Acquisition Program, and Dr. Arthur M. Sackler; inv.no. S86.0108
Literature: Lowry - Nemazee 1988, no. 6

The *Kitab fi ma'rifat al-hiyal al-handasiyya* (Book of Knowledge of Ingenious Mechanical Devices), popularly called the *Automata*, is devoted to the explanation and construction of fifty mechanical devices, or automatons. Divided into chapters and sections, each part of the book describes the various

functions and components necessary for their construction. This page is from the section of the manuscript that discusses the construction of vessels and figures suitable for drinking sessions. According to the text, the automaton depicted here is to be used for entertainment at formal gatherings. When the man's cap is removed, wine is poured into a reservoir in his head. The cap is then replaced and the automaton brought before the guests. After several minutes the liquid, flowing through a series of concealed tubes, begins to fill the goblet held in the figure's left hand, entertaining those assembled. The detailed drawings at the bottom of the page describe the construction of various components of the device.

G.L.

86-88

Two miniatures and an ornamental composition from the manuscript 'Khamsa' by Nizami Ganjavi

Calligraphy by Mahmud for Sultan Shakhrukh Herat, (Iran, now Afghanistan), AH 835/AD 1431 ◆
Size without binding 23.7 x 13.7 cm
The State Hermitage Museum, St Petersburg, inv.no. VR-1000
Transferred in 1924 from the Museum of the former Baron A.N. Stieglitz School of Technical Drawing
Literature: Dyakonov 1940, pp. 275-286; Robinson 1958, pp. 12-13; Pugachenkova 1963, pp. 201-204; Leningrad 1967; Akimushkin - Ivanov 1968, pp. 9-10, 35; Samarkand 1969; London 1976-II; Dokhudoyeva 1978, pp. 149-151; Grube 1979, pp. 152-154; Titley 1984; Lentz - Lowry 1989, no. 38; Adamova 1992, pp. 95-101; Adamova 1996, p. 96

The *Khamsa* (Quintet) by the renowned Iranian poet Nizami Ganjavi (1141-1209) comprises five poems: 'The treasury of mysteries', 'Khusraw and Shirin', 'The Story of Layla and Majnun', 'The Seven Beauties' and 'Book of Alexander the Great' which is divided into two parts, 'Sharaf-Nameh' and 'Iqbal-Nameh'. There are numerous manu-

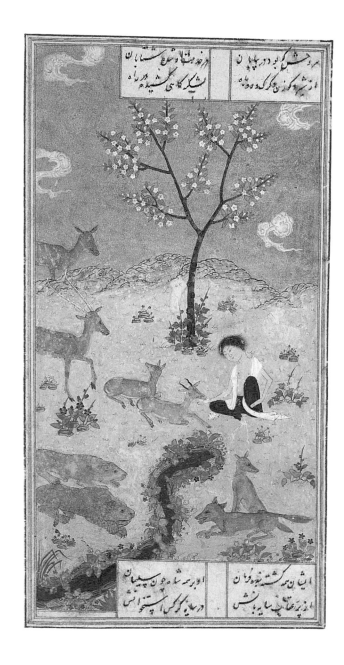

scripts of these poems, richly decorated with illustrations and ornaments. This loose-leaved specimen from The Hermitage is one of the finest.

A.I.

86

Ornamental design

Decoration for the poem 'The Story of Layla and Majnun' Page: (1/39)

Literature: Dyakonov 1940, pp. 275-286, tab. 1; Lentz - Lowry 1989, no. 38; Adamova 1996, no. 1/30

On the title page to every poem is a medallion (*shams*) with the title. Each medallion is an exquisite work of ornamental art in its own right. The beginning of every poem is marked with a small decorated frontispiece (*unvan*).

This page is particularly interesting as an ornamental design has been painted in the position usually reserved for a miniature.

A.A.

87

Majnun in the desert, surrounded by wild animals

Miniature for the poem 'The Story of Layla and Majnun'

Page 200A

Literature: Sakisian 1929, fig. 83; Enderlein 1976, fig. 15; Ivanov 1979-II, no. 10; Adamova 1996, no. 1/22

In 'The Story of Layla and Majnun', the most famous poem from the poet Nizami's *Khamsa*, Majnun gives his heart entirely to Layla, with a devotion which made him a hero of

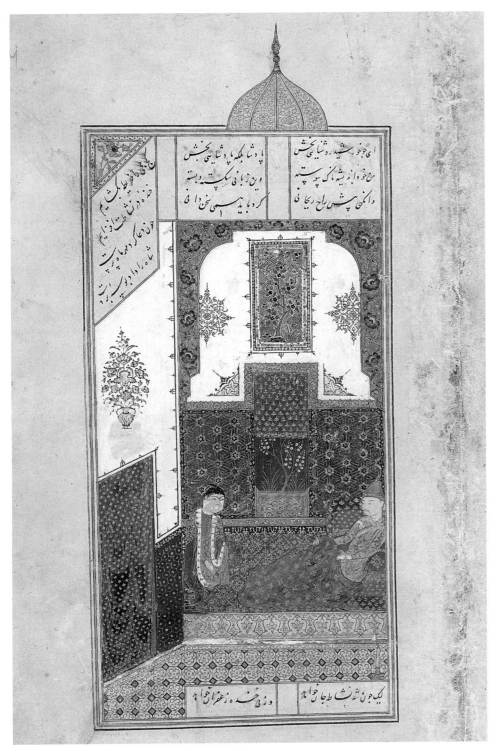

88

Bahram Gur in the Sandal wood Palace

Miniature accompanying the poem 'Haft Paykar'
(The Seven Beauties); Page 304
Literature: Ivanov 1979, no. 13; Adamova 1996, no. 1/34

The poem 'Haft Paykar' recounts how Bahram Gur, the 5th-century Sassanid emperor of Persia, married the daughters of seven *padishahs* (emperors) of seven different countries. For each one of these beautiful damsels the architect Shideh designed a palace in a different colour, corresponding to the colours of the seven planets.

Each day of the week Bahram Gur would visit one of his seven wives: on Saturday – the day of Saturn – he went to the Indian princess in her black palace; on Sunday – the day of the sun – to the Byzantine princess in her golden palace; on Monday – the day of the moon – to the princess of Khorezm in her green palace; on Tuesday (the day of Mars) to the Slavic princess in her red palace; on Wednesday – the day of Mercury – to the Maghrebian princess in her blue palace; on Thursday – the day of Jupiter – to the Chinese princess in her brown (sandalwood) palace; and on Friday to the princess of Iran in her white palace. On each occasion the emperor went clothed in the colour of the palace he was visiting.
The miniature here belongs with the chapter relating the Thursday visit to the Chinese princess. the face of the princess has been painted over. Bahram Gur's face has been remodelled, like the texts.

A.A.

the Sufis (Islamic mystics). Following established tradition, reflected in two 'Anthologies' from Shiraz (1410-11 and 1420), Majnun is depicted surrounded by animals. He is stroking a gazelle whose eyes remind him of Layla's eyes, as the poem repeatedly mentions. The accompanying lines of text describe how all the wild animals – lions, deer, wolves and foxes – defer to Majnun; he is their emperor, the equal of Suleyman, as described in Sura 27 of the Qur'an.

A.A.

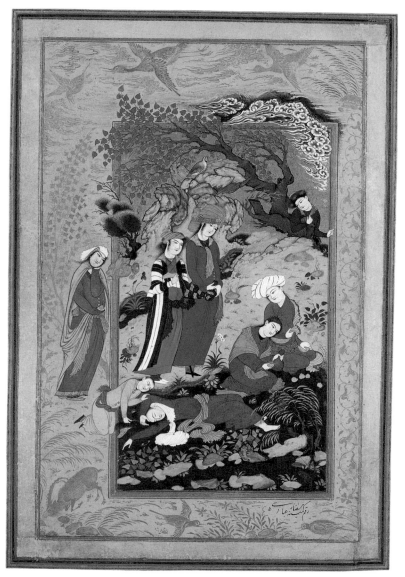 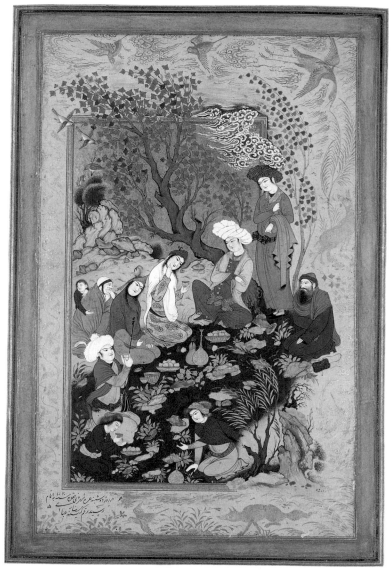

89

89

Feast in the open air

Rizah-i-'Abbasi

Iran, AH 1020/AD 1612

The composition comprises two miniatures, both
enclosed in a yellow frame and backed on pink card.
On the reverse of both are imprints of a rectangular
Persian stamp with the date 1171 (1758-59)
Paper, gouache, gold ◆ Right half 26 x 16.7 cm,
left half 26.2 x 16.5 cm
The State Hermitage Museum, St Petersburg,
inv.no. VR-740/I and VR-740/XVIII
Provenance: unknown
Literature: Izmaylova 1960-II, pp. 50; Stchoukine
1964, pl. XXXVIII-XXXIX; Akimushkin - Ivanov 1968,

tab. 59-60; Veymarn 1974, fig. 183-184; Robinson
1982, fig. 35; Stockholm 1985, p. 171, no. 54, p. 173;
Adamova 1996, no. 15

Both halves of this composition have been
signed by the artist, on painted areas at the
base. On the right this reads:

*He is [God]. Completed on Monday I zu-l-
k'ada of the year 1020. Work by the humble
Rizah-i 'Abbasi*

(see Akimushkin - Ivanov 1968, p. 38, which
reveals that the day of the week and the date
do not match: I zu-l-k'ada 1020 fell on a
Thursday, not a Monday).

On the left the inscription reads:
Work by the humble Rizah-i 'Abbasi

On the right half of the composition, on the
card at the base, is a Russian inscription:
*on Hegira (Hijra) 1020 this was painted by
Raza Abbasov.*

This composition with many figures, folded
into two pages, obeys the conventions
governing subject and treatment for folded
frontispieces which were used to decorate
sumptuous manuscripts. The painting shows
a regal youth and his retinue holding a feast
in the open air. This theme was particularly
popular in late 16th-century painting. The

143

elements on the two pages are perfectly balanced. The foreground scenes form a unity with the decorative background painting which includes clouds, trees and animals.

Presumably these two pages originally served as a frontispiece for an album or manuscript which has not been preserved. In which case the central figure could be the person who commissioned the work. Most of the characters present at the feast – musicians, servants, youths seated or standing, a comatose man (lying foreground right) being coddled by a servant – are generally found in many pictures of feasts. However, the scene is unusual in its inclusion of a woman with child.

Apparently the miniature was not completed and was subsequently 'touched up'. It is not inconceivable that the orange lines used to model the faces are a later addition. Extreme magnification reveals that the musicians' arms have been overdrawn with the same orange colour, while orange of a different shade appears to have been used under this in the original drawing. This overdrawing is clearly visible on the face of the tambourine player who is shown in profile. Some details – the stones and plants in the foreground, the servants' arms (and the lower edge of the miniature) – have not been overdrawn at all.

A.A.

90

90

Reclining youth

Iran, between 1700 and 1735

The miniature is enclosed in two frames, one pink, one yellow, both decorated with a gold plant motif, and backed on green card with a gold floral motif

Paper, gouache, gold ◆ Size 9.8 x 18.8 cm, album page 20 x 30.8 cm

The State Hermitage Museum, St Petersburg, inv.no. VR-706

Provenance: transferred in 1924 from the Museum of the former Baron A.N. Stieglitz School of Technical Drawing (previously A.A. Polovtsov Collection)

Literature: Ivanov 1959, no. 8; Robinson - Falk - Sims 1976, no. 45, no. 112; Adamova 1996, no. 17

The robe and the dagger stuck in his girdle indicate that this figure is a young man, despite his extremely feminine face. He is resting, reclining on brocade cushions in an easy, relaxed posture. Everything in this unsigned miniature is based on contrasts. The plastic modelling of the youth's form contrasts with the flat, roughly painted background. Even the colours seem to clash (the youth's vivid orange robe, the light yellow curtains with gold fringes, the narrow lilac scarf, the dark violet edge to the cushion).

A coloured background with gold surround is not common. It was chiefly used in miniatures from the late 16th or early 17th century. Daggers of this shape encrusted with precious stones are also depicted in a number of other miniatures from this period.

The absence of light and shadow in the artist's rendering of body and face dates this miniature to the first 35 years of the 17th century.

A.A.

91

Shah Jahan watching an elephant fight

North India, circa 1640–1645

Ink, gouache and gold on paper, mounted as an album page on thin board, within a border of paper dyed a light-tan colour and margins of gold-sprinkled cream paper ◆ Folio 50.4 x 35 cm, painting 33.5 x 20.5 cm

The Nasser D. Khalili Collection of Islamic Art, London, inv.no. MSS 900

Literature: Leach 1998, pp. 110–115, no. 31

This painting belongs to a great cycle of illustrations of events in the reign of the Mughal emperor Shah Jahan (1628–57). Many of the images were incorporated into a copy of the *Padshahnama*, an account of the reign by 'Abd al-Hamid Lahawri, which was destined for the imperial library. This manuscript, which is one of the supreme of Mughal art, passed to the ruling family of Awadh, and then to the Royal Library at Windsor Castle in England, where it is now preserved. Other images from the cycle, including this example, were mounted as album pages and are now dispersed.

In this scene Shah Jahan is shown watching an elephant fight from the audience window (*jharoka-i darshan*) in the Red Fort at Agra. To either side of him are princes, probably Dara Shikoh and Shah Shoja *(see cat.no. 238)*: their strictly formal representation in profile renders them distant from the principal scene in the foreground. Below, against the walls of the fort, are two groups of officials, many of them clearly identifiable, standing on the roof of a white marble loggia. In front of this building are groups of officials and petitioners, also showing little interest in the fight before them.

Among the courtiers standing on the loggia is the Persian ambassador Muhammad 'Ali Beg (in a white turban on the far left), while one of the two dark-skinned men in the crowd below (above the elephant on the right), has been identified as a Deccani called I'timad Khan, who was welcomed at the Mughal court as a defector from Bijapur. Leach has observed that the simultaneous presence of these two men in the scene links it to the brief description in the Padshahnama of events on 23 October 1632, Shah Jahan's lunar birthday. Nevertheless, the painting seems to have been executed as much as a decade after the event, since one of the figures on the loggia (the man seventh from the right, who is wearing an orange turban and green *jama*) has been identified as a portrayal of Shayasta Khan as he looked in the 1640s.

M.R.

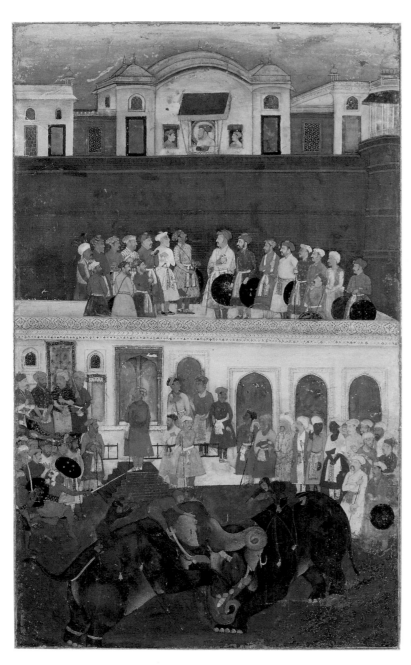

91

92

Fragment of a figurine

Qasr al-Hayr al-Gharbi (Central Syria), 8th century
Plaster ◆ Height 12.5 cm, width 9 cm
National Museum of Syria, Ministry of Culture,
General Directorate for Antiquities and Museums,
Syrian Arab Republic (Damascus), inv.no. 32485-A
Provenance: excavation of Qasr al-Hayr al-Gharbi

A large number of figurines and sculptured reliefs have been found in the palace of Qasr al-Hayr al-Gharbi. These were used to decorate the interior, the facade and the porches. Subjects include human figures, animals and motifs from nature.

92

Part of a frame

Qasr al-Hayr al-Gharbi (central Syria), 8th century
Stucco ◆ Height 75 cm, length 10 cm, width 10 cm
National Museum of Syria, Ministry of Culture,
General Directorate for Antiquities and Museums,
Syrian Arab Republic (Damascus), inv.no. 32484-A
Provenance: excavation of Qasr al-Hayr al-Gharbi

Some 80 km to the southwest of Palmyra in Syria lies Qasr al-Hayr al-Gharbi, one of the many palaces built by the Umayyad caliphs and princes in the Badiyat Ash-Sham desert which lies in both Syria and Jordan.

Qasr al-Hayr al-Gharbi represents one of the earliest schools in Islamic architectural history. The stucco decorations are rich, varied and exuberant. Natural motifs in the decoration of a window arch are always offset by geometric elements on the sills and vice versa.

This piece is part of a frame for a door or window. It is remarkable for its geometric decoration which comprises a simple pattern of interlacing rectangles.

M. AL M.

93

Part of a frame

Qasr al-Hayr al-Gharbi (Central Syria), 8th century
Stucco ◆ Height 88 cm, length 28 cm, width 14 cm
National Museum of Syria, Ministry of Culture,
General Directorate for Antiquities and Museums,
Syrian Arab Republic (Damascus), inv.no. 31773-A
Provenance: excavation of Qasr al-Hayr al Gharbi

During excavations in the palace of Qasr al-Hayr al-Gharbi thousands of pieces of plasterwork were found. These had been used to decorate doors and windows. No two pieces were the same in size, shape and design, even pieces from the same chamber. All the decorations are based on the interplay of natural and geometric motifs. This is regarded as one of the earliest types of decoration to distinguish Islamic art from other art traditions.

This fragment is part of a frame for a door or window. The design clearly shows the interaction of natural motifs such as flowers and leaves and geometric forms such as semicircles. The spaces inside these semicircles are filled with a selection of leaves.

M. AL M.

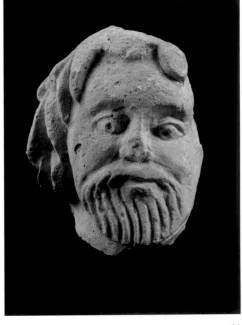

94

This head is part of a figurine, with long hair curling from right to left across the forehead, a beard and a moustache. The smiling face has large eyes looking to the right. The nose has been broken off.

M. AL M.

93

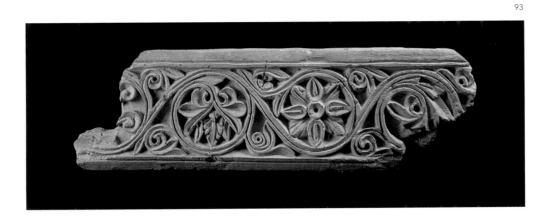

95

Fragment of a figurine

Qasr al-Hayr al-Gharbi (Central Syria), 8th century

Plaster ✦ Height 37 cm, length 22 cm, width 8 cm

National Museum of Syria, Ministry of Culture,

General Directorate for Antiquities and Museums,

Syrian Arab Republic (Damascus), inv.no. 31772-A

Provenance: excavation of Qasr al-Hayr al-Gharbi

Like ‹CAT.NO. 94› this fragment was found in the palace of Qasr al-Hayr al-Gharbi.

This is the lowest part of a figure of a man with a loosely hanging robe secured around his thighs. The figure seems to be moving to the right. The shape of his legs is revealed through the folds in the cloth. This statue may have formed part of the decorations in the section of the palace interior overlooking the inner courtyard.

M. AL M.

96

95

96

Fragment of a fresco with a woman's face

Qasr al-Hayr al-Gharbi (Central Syria), AD 727

Paint on plaster ✦ Height 42 cm, width 41 cm

National Museum of Syria, Ministry of Culture,

General Directorate for Antiquities and Museums,

Syrian Arab Republic (Damascus), inv.no. 32486-A

Provenance: excavation of Qasr al-Hayr al-Gharbi

Frescos of varying sizes, depicting diverse themes, have also been found in the palace of Qasr al-Hayr al-Gharbi, in the reception halls on the ground floor and the caliph's chamber on the first floor.

This fragment, part of a fresco representing two people face to face, shows a woman's head with an elegant transparent veil whose folds reach to her shoulders. A little of her black hair hangs over her face. She is wearing costly earrings.

The woman is encircled by stylized floral and geometric motifs. She seems to be one of the palace ladies.

M. AL M.

97

This fragment, from palace B, was discovered in 1950. It forms part of a window frame. The vine branch decoration has been constrained into geometric forms. Lines have been applied to the leaves to produce a shadow effect.

This piece is extremely important as it allows comparison of decorations from the Umayyad and Abbasid periods.

M. AL M.

97

Relief

Ar-Raqqa (northeast Syria), AD 835
Stucco ♦ Height 80 cm, width 36 cm, depth 8.5 cm
National Museum of Syria, Ministry of Culture,
General Directorate for Antiquities and Museums,
Syrian Arab Republic (Damascus), inv.no. 32487-A
Provenance: excavation of Ar-Raqqa

The city of Ar-Raqqa lies on the east bank of the Euphrates, where the great river is joined by a tributary, the Balikh. Ar-Raqqa reached its heyday during the Abbasid period (750-1258). In 1949-56 and 1990-98 a number of archaeological expeditions revealed four palaces, designated A, B, C and D.

98

Capital

Ar-Raqqa (northeast Syria), 9th century
Marble ♦ Height 27.5 cm, sides of top square 30.5 cm
National Museum of Syria, Ministry of Culture,
General Directorate for Antiquities and Museums,
Syrian Arab Republic (Damascus), inv.no. 9557-A
Provenance: excavation of Ar-Raqqa

During the Abbasid period many types of decoration emerged. This capital is carved with motifs from nature, recalling art of the Umayyad period. The lower section is round and decorated with a kind of braid. The central section comprises stylized leaves while the upper section is square, edged with a braided band and a field of stylized vine branches. The capital originally formed part of a column on the first floor of one of the palaces in Ar-Raqqa: the capitals on ground-floor columns were generally larger.

M. AL M.

99

Jar and stand (kilga)

Fatimid Egypt, late 11th-12th century
Marble ♦ Jar: height 55 cm, rim diameter 18 cm;
stand: height 33 cm, length 48 cm, width 32 cm
Benaki Museum, Athens, inv.nos. 10833-10834
*Literature: Knauer 1980, figs. 15 and 34; Philon 1980,
fig. 4, p. 15*

98

The jar stand is richly decorated and bears a Kufic inscription around the rim of the basin:
Perfect blessing and grace and perpetual glory and perpetual happiness and perpetual good fortune

It rests on four fluted feet separated by pointed arches. The sides are ornamented with *muqarnas* and figure-of-eight motifs. The front diagonal niches support seated nude figures with raised arms; on the front is a pair of feline heads carved in the round. The back is decorated with a stylized leaf.

148

99

100

This type of jar stand, known as a *kilga*, would normally support an unglazed porous earthenware jar through which water would filter into the protruding basin. However, this particular jar has been carved from a single block of marble and cannot perform this function. It may have served as a water container in the courtyard of a house or mosque.

M.M.

100
———

Jar and stand (kilga)

Fatimid Egypt, 11th-12th century

Marble stand and alabaster (?) jar ✦ Jar: height 50cm, rim diameter 23 cm; stand: height 36 cm, length 50 cm, width 33 cm

Benaki Museum, Athens, inv.nos. 10831-10832

Literature: Knauer 1980, fig. 19, p. 78; Philon 1980, fig. 3, p. 15

The marble jar stand known as a *kilga* rests on four fluted feet separated by pointed arches. The decoration is relatively plain with feline heads on the front and a mask on either side. The four diagonal niches and the back feature the outline of a lobed leaf. The fluted jar with two handles is not the original for the stand. The upper part is decorated with medallions bearing ornaments that are too damaged to be identified with certainty: possibly floral motifs or human figures. The hole in the lower part of the jar allowed water to run into the basin through a pouring device.

M.M.

149

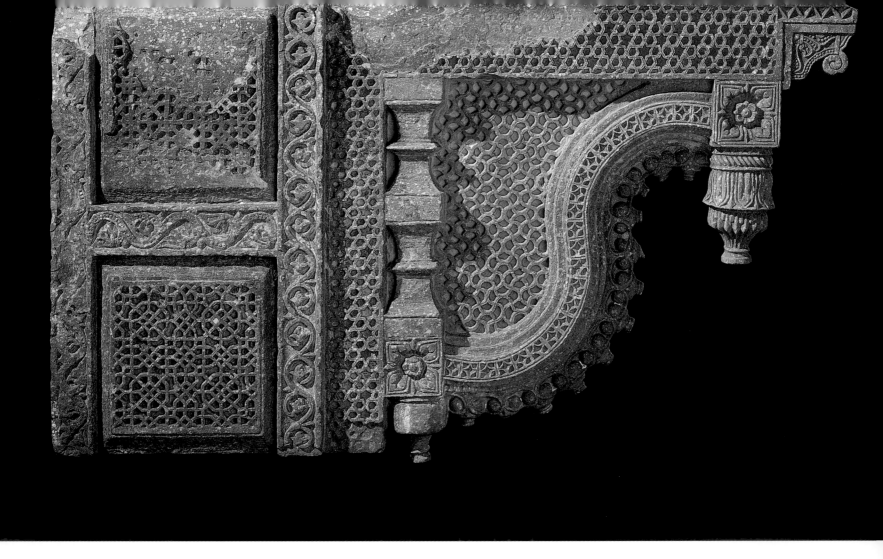

101

Pair of brackets

North India (perhaps Agra), Sultanate period
(early 16th century)
Mottled pink sandstone, carved ◆ Height 134.5 cm,
width 79.5 (average)
The Nasser D. Khalili Collection of Islamic Art,
London, inv.no. MXD 266 a, b
Literature: unpublished

The brackets are carved, on one side only,
with panels of interlacing strapwork motifs
between borders of undulating scrolls.
The inner edges of the brackets are in the
form of a stylized water monster (*makara*).
M.R.

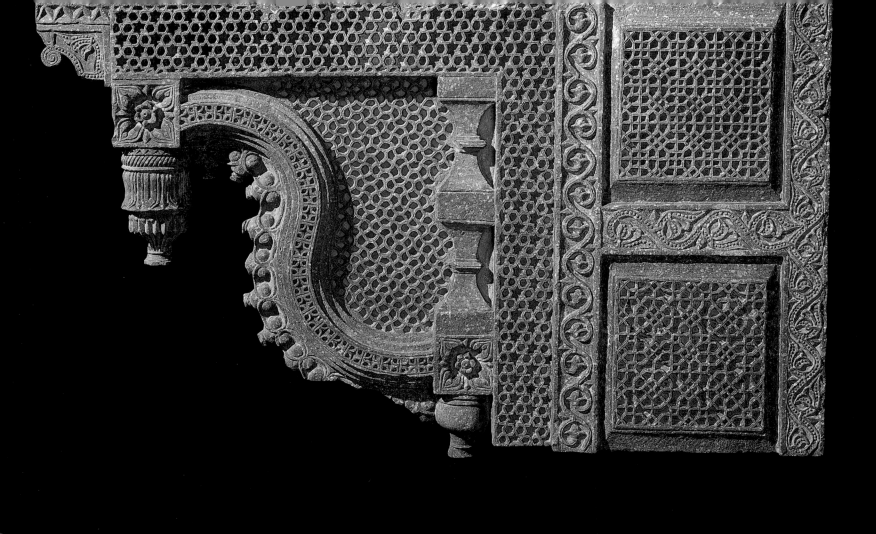

102

Jali

North India, later 16th century

Pink sandstone, carved and pierced ◆

Height 134.5 cm, width 100.5 cm

The Nasser D. Khalili Collection of Islamic Art,

London, inv.no. MXD 267

Literature: unpublished. See also: Smith 1985, pl. LII

The double-sided *jali* is deeply carved with
bold intersecting ogival tracery over fine
strapwork of concentric octagons and
elongated hexagons. The border is of
stepped lozenges. Parallel screens exist at
Fatehpur Sikri in Uttar Pradesh.

M.R.

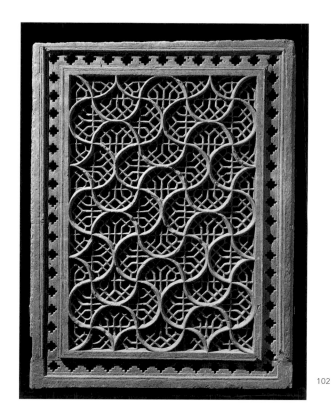

102

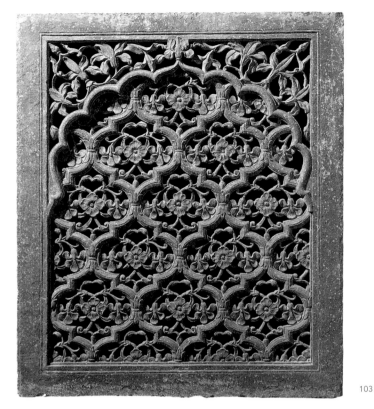

103

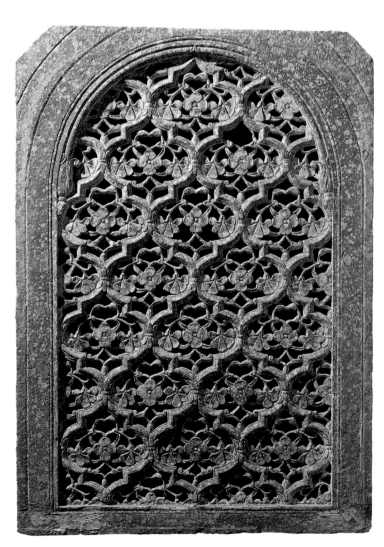

104

103

Jali

Agra, Shah Jahan period (1630–1640)

Mottled pink sandstone, carved and pierced ◆

Height 124 cm, width 105 cm

The Nasser D. Khalili Collection of Islamic Art,

London, inv.no. MXD 260

Literature: unpubl shed

The design of this double-sided rectangular
jali consists of a lobed arch with iris and
lotus finials. It is filled with a finely profiled,
stepped ogival lattice enclosing four-petalled
flowers and stems flanked by irises. The deep
carving is equally elaborate on both sides of
the screen (*compare cat.no. 104*).

M.R.

104

Jali

Bhurtpore, orig nally from the Red Fort at Agra,

Shah Jahan period (1630–1640)

Mottled pink sandstone, carved and pierced ◆

Height 158.5 cm, width 111.2 cm

The Nasser D. Khalili Collection of Islamic Art,

London, inv.no. MXD 261

Literature: unpublished

The rounded arch, which has been slightly
cut down, is filled with a squashed stepped
ogival lattice enclosing four-petalled flowers
and stems flanked by irises. The filler motifs
are very similar to those on (*cat.no. 103*), and
the work is equally refined on both sides of
the screen.

In 1761, Agra was sacked by the Jat Raja of
Bhurtpore. The city was looted and many of
its treasures, including *jalis*, were taken to
Bhurtpore. The corners of this jali have been
cut down, suggesting that it may have been
reused in another building.

M.R.

105

Pair of doors

Iraq (Baghdad), mid 8th century

Wood, carved • Height 2.55 m, width 1.23 m

Benaki Museum, Athens, inv.no. 9121

Literature: Pauty 1931, pp. 77-81; Shafi'i 1952, pl. 1;

London 1976-II, fig. 660, p. 391;

Philon 1980, fig. 21, p. 54

A pair of doors with carved decoration,
found in a tomb near Baghdad. The main
design, which is repeated four times, com-
prises a tree motif amidst dense naturalistic
foliage and under a lobed arch. The centre
of each panel bears a geometric design with
a star within a circle and a stylized vine
scroll. Four smaller panels at the top and
base contain three medallions separated by
rosettes. This unique pair of doors displays
a variety of decorative elements which
combine to produce a rich and sumptuous
effect. The combination of elements has been
carefully planned to juxtapose various motifs
and degrees of naturalism in an organized
manner. All these elements can be found in
later Umayyad art, at Qasr al-Hayr al-Gharbi
(Syria) and Mshatta (Jordan), along with
classical and Sasanian influences. They are
also related to motifs associated with Abbasid
ornamentation.

M.M.

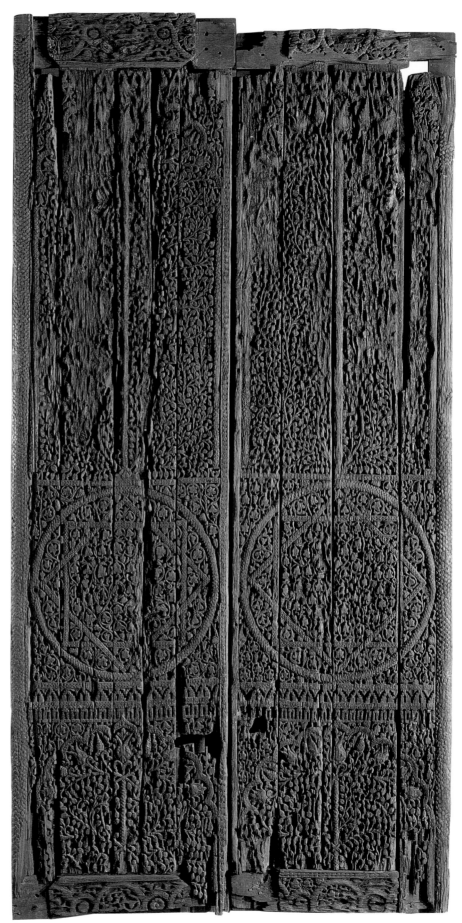

105

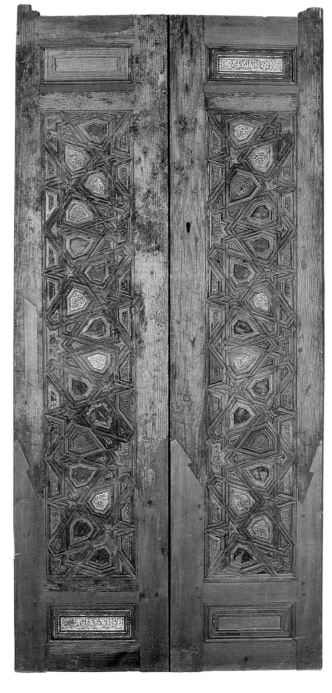

106

Door

Iraq (Samarra'), 9th century

Wood, carved ◆ Height 2.39 m, width 55 cm

Benaki Museum, Athens, inv.no. 9128

Literature: Creswell 1969, vol. II, p. 238, fig. 56d;
Philon 1980, fig. 74, p. 24; Anglade 1988, p. 20,
fig. 5c

A door leaf with three identical inset
decorative panels. Each panel is carved in
the bevelled style with a composition of two
superimposed stylized motifs: a large fan-
shaped lotus flanked by two half palmettes
and an inverted five-lobed palmette flanked
by two scrolling leaves. Two sphere motifs
feature at the base of the lotus. There is a
keyhole between the first and second panel.
The decoration is of the highest quality and
represents Samarra' C style at its finest.
Marble panels with identical decoration were
found in the throne room of the Jausaq al-
Khaqani palace in Samarra'. This door, to-
gether with two other door panels in the
Benaki Museum, was found in a rock-cut
sepulchre at Takrit, just north of Samarra',
used for the interment of Assyrian
Christians.

M.M.

107

Pair of doors

Egypt, 14th century

Wood and ivory ♦ Height 197 cm, width 90 cm

Benaki Museum, Athens, inv.no. 9281

Literature: Philon 1980, fig. 114, p. 29

This pair of doors comprises a symmetrical geometric frame for small ivory or wooden polygonal panels. Each panel is decorated with intricate arabesque designs. The two surviving rectangular panels at the top and base of the doors bear inscriptions in cursive script against the background of a scrolled stem:

Praise to God, from the highest to the lowest

and

Daughters of Kings rise through your generosity

Such inscriptions are commonly found on doors from Coptic churches. This method of panel-based construction was popular in the Islamic world from the 12th century. The technique allows wood to expand and contract according to variations in temperature and humidity. During the Mamluk period ivory and costly wood such as ebony were commonly used.

M.M.

108

Doors

Marrakesh (Morocco), 18th century

Painted cedarwood, iron fittings ♦ Height 350 cm, width 192 cm, depth 23 cm; height of doorstep 40 cm; height of towers 45 cm

Museum voor Volkenkunde Rotterdam, inv.no. 68168

Literature: Rotterdam 1993-1996, pp. 22-23

The reception rooms of palaces and wealthy homes in the major cities of Morocco are notable for their magnificent carved and decorated wooden doors. During the brief but cold winters these large doors are kept closed and people use a smaller entrance. In the lower section of these doors two layers of wood have been used to create a perspective effect. In the first layer the outline of two *mihrabs*, or prayer niches, has been carved out; the rim is decorated with wood carving. The deepest layer has been carved with flower patterns which echo the designs on the upper section of the doors, on a smaller scale. The doors are crowned with two richly decorated towers surmounted by green roof tiles.

108

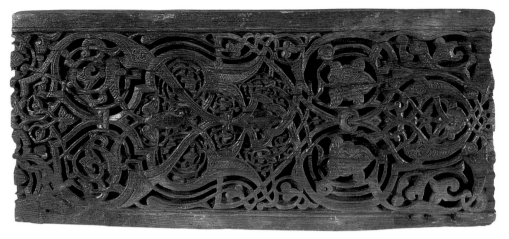

109

109

Carved panel

Egypt, 13th century

Wood, carved ♦ Length 63 cm, height 28 cm

Benaki Museum, Athens, inv.no. 9244

Literature: Alexandria 1925, pl. 2; Devonshire 1928,

pl. II c,d, p. 196; Philon 1980, fig. 166, p. 36

A wooden panel with a complex symmetrical arabesque design carved in two levels of relief, with incised detailing in the floral motifs and beaded outlines. The reverse of the panel is decorated with a carved shell niche painted light blue. This piece of woodwork was probably reused during the 13th century, a not uncommon practice, especially in periods when wood was scarce. The arabesque was a popular surface decoration for wood from the 12th century onwards. Designs became increasingly complex and refined.

M.M.

110

Tray

Syria (?), 8th-9th century

Bronze (or brass) ♦ Diameter 68.5 cm

The State Hermitage Museum, St Petersburg,

inv.no. KZ-5762

Provenance: transferred in 1925 from The State

Academy of Material Cultural History (A.A. Bobrinsky

Collection)

Literature: Orbeli - Trever 1935, tab. 67; Marshak

1978, pp. 29-31, 38, 41, 42, 44, 46-48, fig. 3, 14;

Marschak 1986, pp. 294-295, fig. 200, 205; Kuwait

1990, no. 4

A standing goddess wearing a *corona muralis* is depicted in the centre of the tray. She is probably the patroness of a city. In the early Middle Ages such representations had a purely secular function as a symbol of a city.

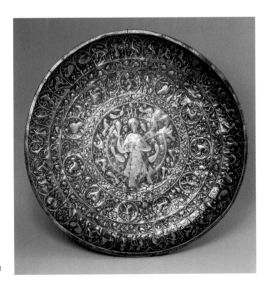

110

The goddess is accompanied by four peacocks. Other motifs are placed in three concentric circles. From the inner circle outwards, these comprise: running animals, medallions containing representations of a vase, hunters, animals and birds and an arcade with mostly seasonal images, such as reapers, grape collectors, dancers etc. The spaces between the medallions and between the bands of representations are filled with vines.

This tray belongs to a series whose earliest designs followed Byzantine iconography, while the last were strongly Iranized. Their evolution evidently reflected the development of early Islamic culture, with the Byzantine-Hellenistic traditions of Egypt and especially Syria prevailing in Umayyad times and those of Sasanian Iran dominating under the Abbasids. This tray is one of the most highly stylized and one of the last to preserve Classical motifs.

B.M.

111

Plate

Iran (or Afghanistan), early 11th century

Silver ♦ Diameter 10.3 cm

The State Hermitage Museum, St Petersburg,

inv.no. S-499

Provenance: acquired in 1951. Found in Yamalo-

Nenets National District (northeastern European

Russia)

Literature: Trever 1960, pp. 256-270; Kuwait 1990,

no. 19

This plate is decorated with a representation of a king sitting on his throne between two servants, each of whom has a horned cap of the kind usually worn by Ghaznavid courtiers during the 11th and 12th century. The Ghaznavids were an Islamic dynasty descended from a Turkish warlord or prisoner of war. They ruled over Afghanistan and the Punjab (962-1186) from their base in the Afghan city of Ghazna. This silver

Sagittarius, which is replaced by a harpy. They are arranged in groups of three, with a quadripartite medallion between them. Above is a band with a benedictory inscription in Kufic, broken by interlacing medallions:

With good fortune, and blessing, and wealth, and honour, and gratitude, and intercession, and contentment, and abundance, and wealth and comfort.

A second inscription in *naskh* script decorates the lower part of the body, while a third is engraved in three cartouches on the underside of the base:

Glory, and prosperity, and wealth, and happiness, and well-being, and intercession, and contentment, and care, and good health, and abundance, and duration, and comfort, and everlasting perpetuity to its owner.

Glory, and prosperity, and wealth, and happiness, and well-being, and comfort, and care, and intercession, to its owner.

The band decorating the edge of the lid balances that on the lower part of the body. It is similar in content and in style, and has the same background of spiral palmette scrolls reserved on a ring-matted ground:

Glory, and prosperity, and wealth, and happiness, and well-being, and intercession, and contentment, and care, and duration to its owner.

The flat top of the lid bears further benedictory inscriptions in both naskh and Kufic scripts, inlaid or engraved, some interrupted by roundels enclosing crescent-shaped motifs. These are arranged around a handsome finial in the form of a pointed dome surmounted by a stylized Buddhist lotus and a hawk or dove. The inscriptions on the lid, starting from the innermost band, read:

With good fortune, and blessing, and wealth, and honour, and abundance, and duration, and perpetuity to its owner.

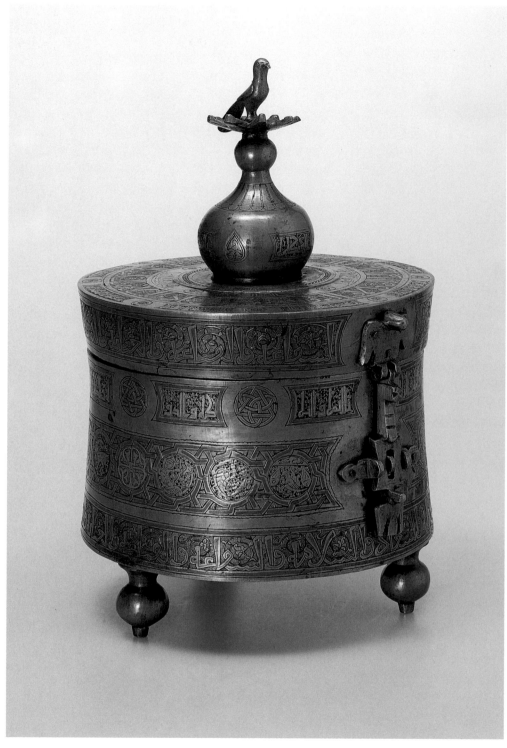

116

Glory, and prosperity, and wealth, and happiness, and well-being, and intercession, and contentment, and care, and duration, and abundance, and perpetuity to its owner.

With good fortune, and blessing, and wealth, and joy, and happiness, and honour, and permanence, and … and well being, and

compassion, and grace, and good health, and good health, and … and compassion.

The hinge and hasp of the casket are also cast; they are fixed to plaques in the form of eagles displayed, while the tip of the hasp is similar in form.

M.R.

161

117
—

Casket

Khorasan, later 12th century

Brass or quaternary alloy, piece-cast; engraved,
ring-matted and inlaid with copper ◆ Height 41.7 cm,
diameter 22.8 cm

The Nasser D. Khalili Collection of Islamic Art,
London, inv.no. MTW 1106

Literature: unpublished

The cylindrical casket stands on three
knobbed feet. Its slightly tapering body is
decorated with a series of roundels with
interlacing contours enclosing the signs
of the zodiac. These are more or less
conventionally represented, although
Capricorn, Aries, Leo and Taurus are all
shown winged. This is bordered above by
two panels, each with the same benedictory
inscription in a cursive script, *'with good
fortune, and wealth, and well-being'*. Below are
Kufic panels repeating the word *bi'l-yumn*
('with good fortune'), separated by roundels
with split palmettes. The copper-inlaid
decoration on the underside of the base
consists of an interlacing roundel at the
centre, surrounded by three panels, each
enclosing the word 'wealth'.

The flat lid carries similar benedictory
inscriptions. At the centre is an openwork
dome, surmounted by two knobs. The upper
knob is also openwork, and is crowned with
a stylized peacock perched on a lotus rosette.
The inside of the lid bears a central quadri-
partite medallion framed by a band of
undulating scrollwork.

Like *(cat.no. 116)*, the hinge and hasp
are cast; however, the hinge attachment
is a bird-headed human, while the hasp
attachment is probably an eagle displayed,
the tips of its wings terminating in birds'
heads.

M.R.

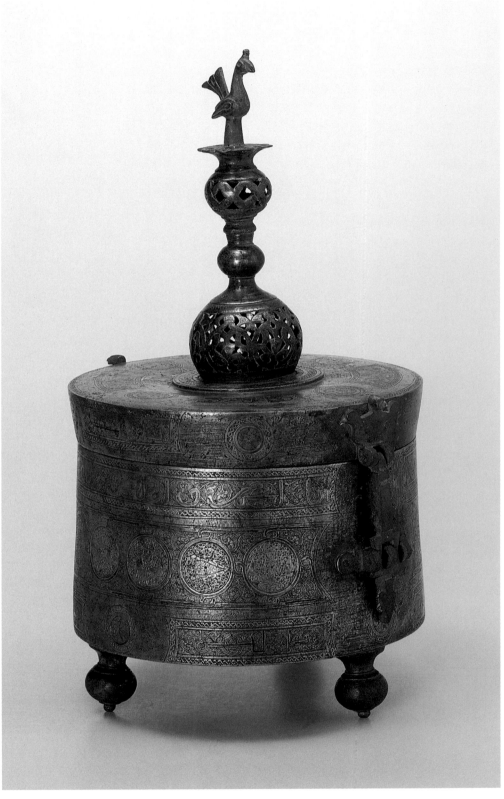

117

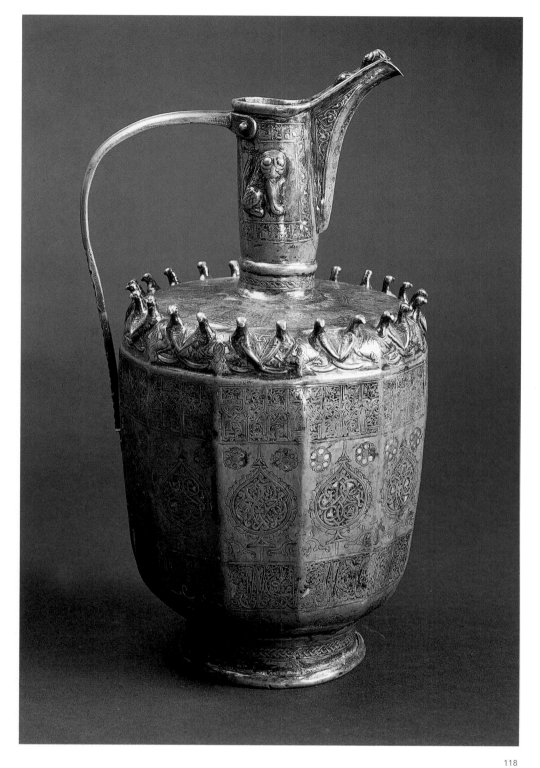

Herat workshops of the late 12th to early 13th century. This conclusion is supported by Persian verses inscribed on one such ewer in the Museum of Georgia, in Tbilisi which is dated AH 577/AD 1181-82), and inscribed with the name of the artisan, Mahmud ibn Muhammad al-Herevi, who recorded that such jugs were made in Herat.

All these ewers are richly decorated in silver and copper inlay, with floral ornaments, frequent human figures and Arabic inscriptions; the necks usually bear lion figures in relief.

The inscriptions are as follows:
a) around the neck, in Kufic script:
 favour,
 happiness,
 entirety
 peace;

b) on the shoulders (in *naskh* or *thuluth* script):
 Glory and prosperity, and wealth, and happiness, and health, and favour, potency, and power, and divine support, and assistance, and perpetuity to its owner.

c) around the upper part of the body, (in Kufic script, the upper ends of the letters being interwoven):
 With good fortune and blessing, and wealth, and honour, and resurrection, and intercession ... and potency, and power, and gratitude ... and endurance, and entirety, and perpetuity to its owner.

d) around the lower part of the body, in naskh or thuluth script:
 Glory and prosperity, and wealth, and happiness, and health, and intercession, and resurrection, and kind-heartedness, and mercy, and favour, and contentment, and honour, and entirety, and success and perpetuity to its owner.

A.I.

118

118

Ewer

Iran, 12th-early 13th century
Bronze (or brass), silver ✦ Height 36.5 cm
The State Hermitage Museum, St Petersburg, inv.no. IR-1468
Provenance: transferred in 1925 from the State

Academy of Material Cultural History (A.A. Bobrinsky Collection)
Literature: Munich 1912, part II, tab. 141; Kühnel 1925-I, fig. 112; Pijoan 1949, fig. 244; Moscow 1957; Dyakonova 1962, no. 36; Kuwait 1990, no. 35

This ewer belongs to a large group of similarly shaped objects which can be linked to

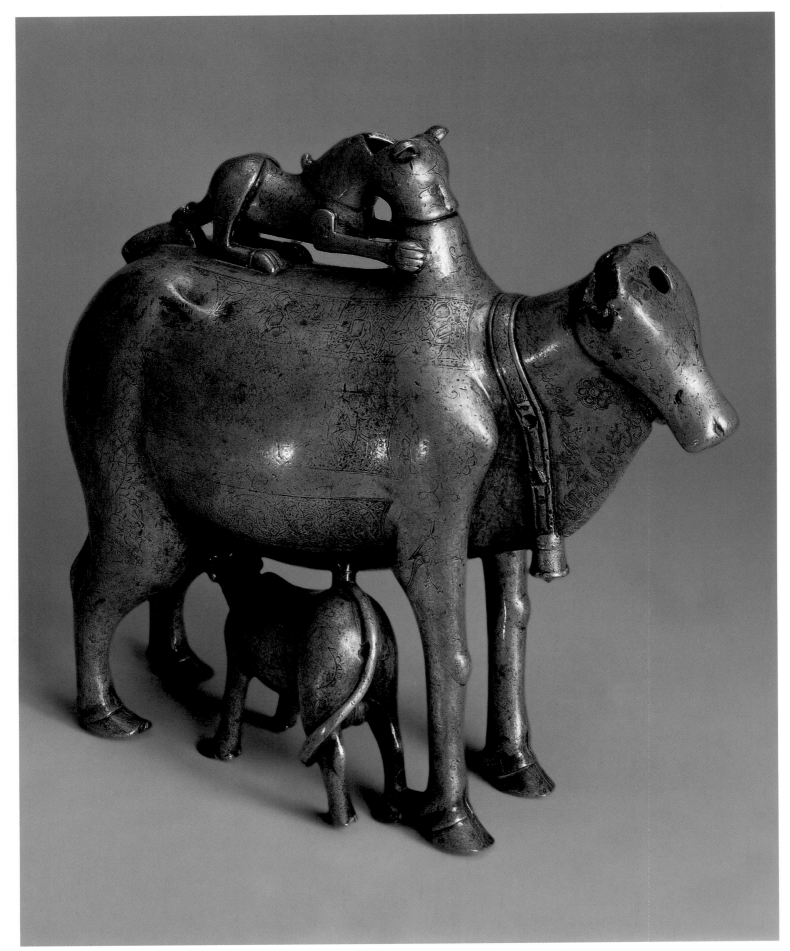

119

119

Water jug (aquamanile)

Signed by the craftsman 'Ali ibn Muhammad ibn
Abu-l-Qasim

Iran, Muharram AH 603 (August–September 1206)

Bronze (or brass), silver ◆ Height 35 cm

The State Hermitage Museum, St Petersburg,
inv.no. AZ-225

Provenance: acquired in 1929 from the State
Antiquarian Shop

*Literature: Dyakonov 1939, pp. 45-51; Mayer 1959,
p. 36; Gyuzalyan 1968, pp. 102-105; Kuwait 1990,
no. 39*

This famous aquamanile, once richly
decorated with silver inlay, is probably
the last known in the series of theriomorphic
vessels to which it belongs. The casting of
such a complex composition was obviously
considered a difficult task, since the artist
stresses in his inscription that the entire
piece was cast simultaneously. The inscrip-
tion is in Persian, with a few Arabic phrases,
which is rare for bronze objects of the period.

The inscription is placed on the cow's neck
and head:

> *This cow and the calf and the lion were all
> three cast simultaneously with the assistance of
> God, the Just, the Almighty, thanks to the
> action (i.e. order) of Ruzbeh ibn Afridun [ibn]
> Burzin. Blessing to its Shah Burzin ibn
> Afridun [ibn] Burzin. Work of 'Ali ibn
> Muhammad ibn Abu-l Qasim annaqqash in
> Muharram, 603.*

The first publications which considered this
water jug stated that it was made somewhere
in Shirvan (northern Azerbaijan). However,
during the last fifty years no other bronze
vessel of the late 12th or early 13th century
has come to light which can be associated
with Shirvan, suggesting that there was no
school of copper manufacture in this region
during the period.

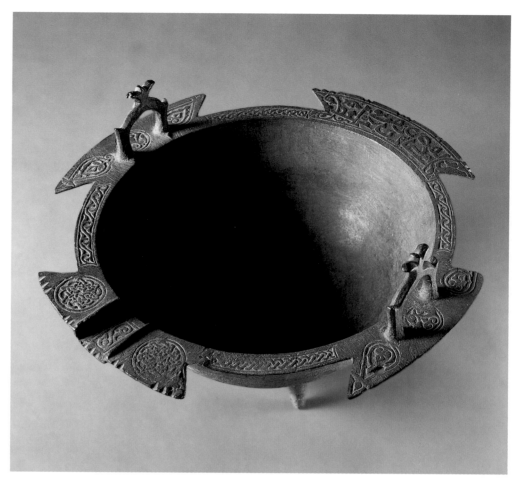

120

The ornamentation links this water jug to
Khorasani bronzes of the late 12th and early
13th century.

A.I.

120

Cauldron

Signed by the craftsman Bu Bak‿ Mahmud

Iran, 12th century

Bronze (or brass) ◆ Height 29 cm, diameter 53 cm

The State Hermitage Museum, St Petersburg,
inv.no. TP-207

Provenance: transferred in 1925 from The State
Academy of Material Cultural History

This cauldron by the artisan Mahmud al-
Qazvini is remarkable in a large group of
similar objects for its huge size.

Vessels such as this were extremely popular
in central Asia where they were used at
open-air banquets.

A.I.

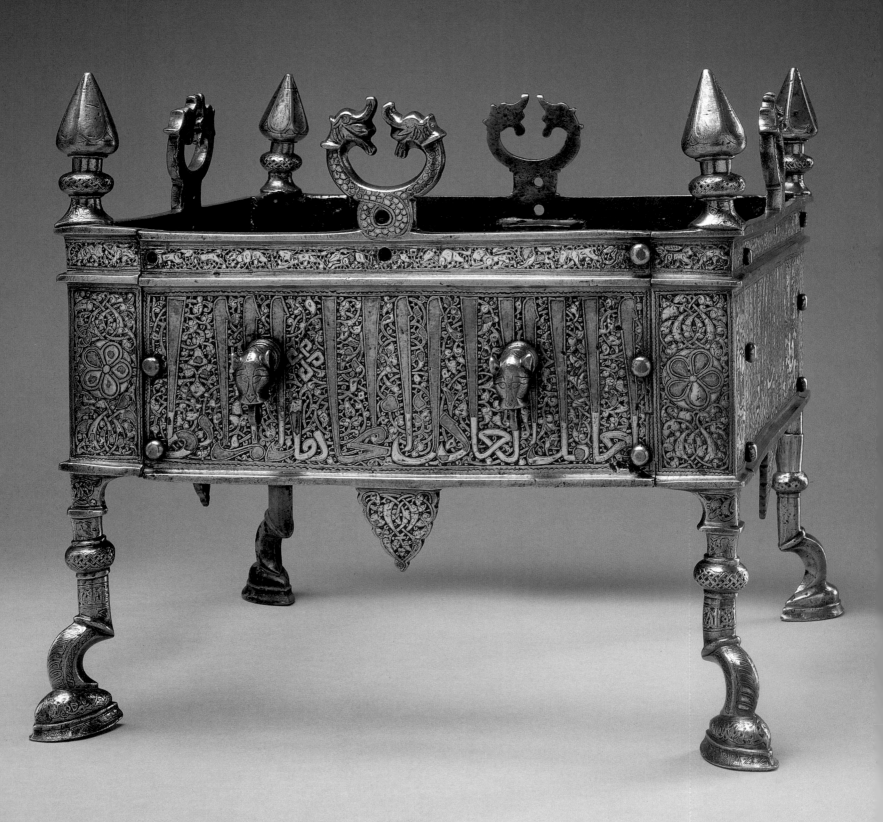

121

Brazier

Egypt (Cairo), 2nd half 13th century
Brass inlaid with silver and bitumen ✦ Length (of each side) 34.0 cm, max. height 34.6 cm
The Metropolitan Museum of Art, New York, inv.no. 91.1.540; Edward C. Moore Collection, Bequest of Edward C. Moore, 1891. Made for the Rasulid sultan of Yemen, al-Muzaffar Shams al-Din Yusuf (r. 1250-1295)
Literature: Porter 1987, pp. 232–53, fig. p. 255. New York 1987, p. 55; Mexico City 1994, pp. 204–05

Braziers served a dual purpose, as portable heaters and also grills. A flat pan, now missing, would have held the charcoal. Following the pattern of other domestic metalware made during the period, this unique, elegant, monumental, and probably ceremonial brazier is one of the best examples of early Mamluk silver-inlaid metalwork to survive.

The object, perfectly square, is composed of four panels bolted to four corner sections, each cast with a finial and a leg (two legs are modern replacements). Each rectangular panel was cast with two confronted dragon's heads at the top and a lobed pendant at the base. The pairs of lion's heads that protrude from two of the panels are probably later replacements of originals. Apart from their decorative role, the dragon's and lion's heads are functional: the dragon's heads and the holes beneath them may have been used to hold grilling skewers; the rings protruding from the lion's mouths were probably meant to hold handles. Each panel is decorated with a large band of honorific titles in *thuluth* script, set against an intricate vegetal background, dedicated to the Rasulid sultan al-Muzaffar, who may have been the recipient of this gift from the Mamluk sultan. The inscription reads:

Glory to our master, the sultan, the wise, the ruler, the just, the fighter [of the faith], the warden [of Islam], the mighty, the victorious,

sultan of Islam and of the Muslims, subduer of the insurgents and the rebels, the sultan al-Malik al-Muzaffar Yusuf [to him].

The Rasulid dynasty of Yemen (1228–1454) was a prosperous one. The country was an important trade crossroads with connections to India, the Arabian peninsula, and Africa and had strong cultural and commercial ties to the Mamluk sultanate of Egypt and Syria.

The corner pieces are decorated on each side with the Rasulid emblem, a five-petalled rosette, against a field of floral scrolls. Running above the main inscription is a narrow band of coursing animals, typical of Mamluk iconography. Eulogies in Kufic script surround the two original legs.

S.C.

122

Rectangular casket

Jazira (now southeast Turkey), 1st half 13th century
Sheet brass, with remains of substantial inlay in silver; the sides are held together by brass c ips; the hinge mounts and the fastening hasp are so dered to the sheet metal ✦ 20.3 x 19.5 x 15.8 cm
The Nasser D. Khalili Collection of Islamic Art, London, inv.no. MTW 850
Literature: Hill 1974, pp. 199-201, 274; Cologne 1983, pp. 96-97; Maddison 1985, pp. 141-157; Christie's 1989-II, lot no. 526; Khalili Collection 1993, p.40; Copenhagen 1996, no. 82, p. 123; Maddison - Savage-Smith 1997, no. 344, pp. 390-391.

The casket has a gabled lid, and rests on four knob feet. The lid has four dials and knobs, the remains of a combination lock, and a loop for suspension. The lavish silver inlay must have been dazzling in its pristine state; even now enough remains for the ambitious decorative programme to be descried. In addition to the 16-letter dials of the lock, the lid bears a lobed medallion of a prince

122A

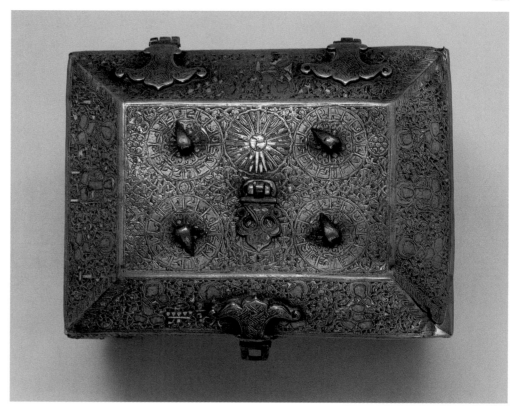

enthroned, below a sun medallion. The short sides of the gable show an enthroned prince flanked by musicians or cup bearers; the long sides bear a pair of musicians between the hinges and two pairs of musicians, one with a tray of beakers between them, on the front.

Around the base of the lid is a benedictory inscription in *naskh* script broken by six-petalled rosettes:

> *Perpetual glory, and safe life, and increasing prosperity, and rising diligence, and immediate good fortune, and helpful destiny, and effective authority, and … and … well-being …*

The narrow sides on the casket show drinkers or musicians in the arcs of intersecting circles, with an enthroned prince and attendants, all drinking, at the centre. This central medallion is flanked by smaller lobed medallions, each with a cross-legged seated figure bearing a crescent moon. The

rear panel has a central lobed medallion of a drinking prince with attendants and two figures playing backgammon in front. This is flanked above by musicians in small roundels and below by even smaller roundels of cross-legged seated figures bearing crescent moons. Below all these medallions are lobed arches with standing figures, hands clasped or arms folded, with attributes of Christian priests or deacons.

The front panel has two quatrefoil medallions of mounted figures, one a lancer and one a falconer, each with small medallions of cross-legged seated figures bearing crescent moons above and below. Between the quatrefoils is a standing Christian figure with cross and book rest. The ground is a uniform mass of vigorously spiralling split-palmette scrolls and six- or eight-petalled rosettes.

The remains of the combination lock associate it with the lock with 16-letter dials

illustrated in al-Jazari's *Kitab fi Ma'rifat al-Hiyal al-Handasiyyah* (Topkapi Palace Library A.3472). Two other specimens of this type are known, one on a similar casket in a private collection in New York, and another on an ivory casket, made in the eastern Mediterranean, or possibly Palermo, circa 1200, and now in the treasury of St Servatius, Maastricht. The letters on the dials of these three locks are all in *abjad* order. They are a simplified form of two late 12th-century Persian combination locks, in Copenhagen (David Collection, no. 1.1984) and Boston (Museum of Fine Arts, no. 55.1113).

M.R.

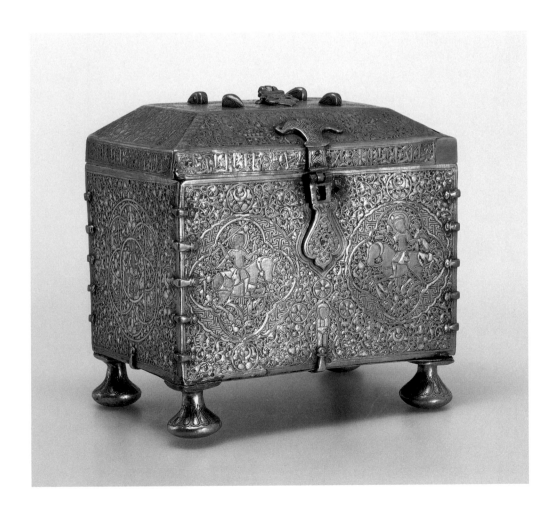

122 B

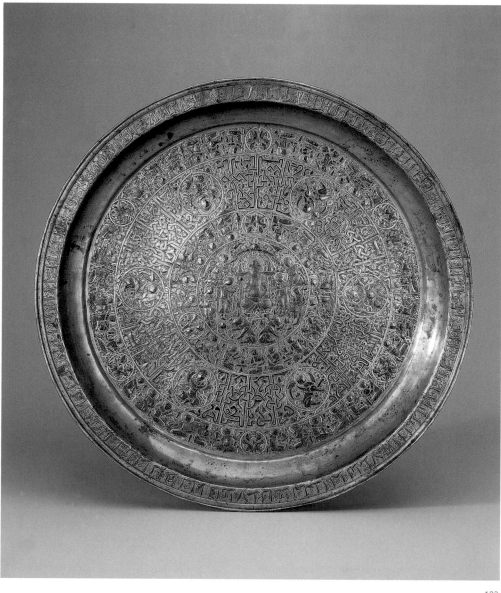

increasing goodness, great success, rising fortune, lasting power, quiet good ...life, fulfilled action
(the inscription is repeated almost in full).

The broad inscriptional band in the tray's interior is indecipherable owing to its extreme stylization.
Also, small drums (or tambourines) in the hands of musicians are engraved with the word:
tambourine.

The outside base is inscribed with two names of later owners:
Muhammad
and
hoja Raykhan.
A.I.

123

123

Tray

Iraq, 1st half 13th century

Bronze (or brass), silver • Diameter 44 cm

The State Hermitage Museum, St Petersburg,

inv.no. IR-1455

Provenance: transferred in 1925 from the State

Academy of Material Cultural History

(A.A. Bobrinsky Collection)

Literature: *Munich 1912, II, tab.153; Voronikhina 1961, p. 67*

This tray is decorated with Arabic inscriptions, representations of musicians and drinkers and an enthroned ruler surrounded by servants. The scene with the ruler is similar to certain miniatures of the Mesopotamian School, which links the tray to Iraq. The style of the figures and other ornamental aspects shows the influence of 12th-early 13th century Khorasani metal-work.

The inscription around the rim, in *naskh* script, reads:
Lasting glory and increasing prosperity, actual destiny, long life, eternal favour, increasing goodness, great success, rising fortune, lasting power..., the one following the order given to its owner(?). Lasting glory, increasing prosperity, actual destiny, long life, eternal favour,

124

Tray

Syria, mid-13th century

Bronze (or brass), silver • Diameter 43.1 cm

The State Hermitage Museum, St Petersburg,

inv.no. CA-14238

Provenance: unknown, bought in 1898

Literature: *St Petersburg 1901, p. 89, fig. 157; Munich 1912, part II, tab. 153. Yakubovsky 1938, pp. 209-216, tab. 23-27; Baer 1989, p. 10, fig. 23, 25-36; Kuwait 1990, no. 41*

This tray is inlaid with silver, which is fairly well preserved. The decorations include an Arabic inscription, representations of animals and floral ornament. However, the main distinguishing feature of this tray are Christian saints in twelve separate niches. Such objects, which combine Muslim and Christian artistic styles, were produced in 13th-century Syria, where Muslims and Christians were neighbours.

The inscription reads:
Lasting glory and increasing prosperity, and continuing wealth, and sublime peace, [and]

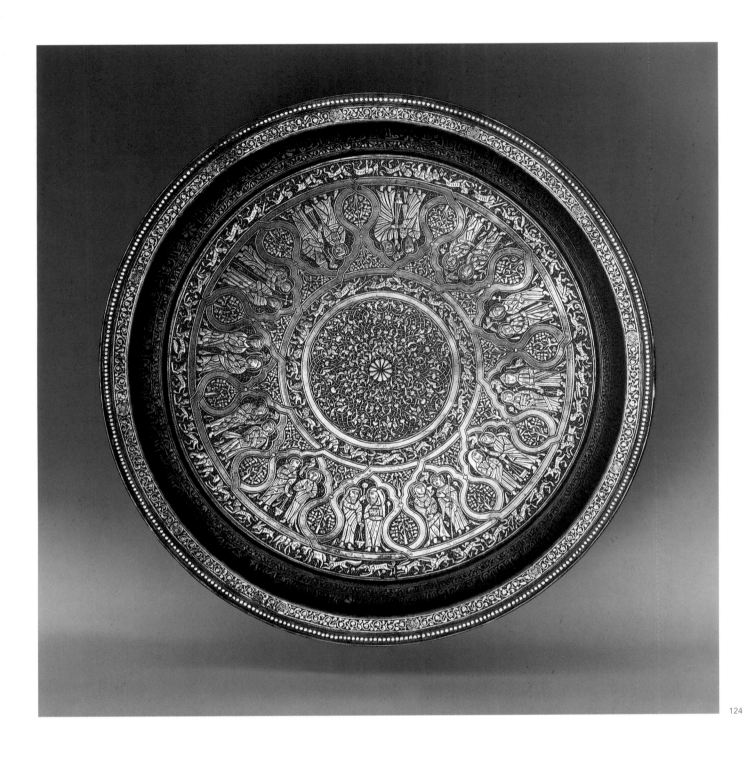

124

rising fortune, and actual destiny, and effective authority, and good luck, and full honour, and total happiness, ..., and sufficient sufficiency, and total favour, and rising fortune, and increasing goodness, and glory, and gratitude, and praise, and generosity, and beneficence, and success, ... of the Heaven over you, and glory, and prosperity, and perpetuity to you, oh lord high with dignity, and fortune, and luck, and happiness [and] high position.

A.I.

125

Spherical incense burner

Made for Badr al-Din Baysari
Syria, 1277-79
Brass inlaid with silver • Diameter 18.4 cm
The British Museum, London, inv.no. OA
1878.12.30.682
Provenance: Given to The British Museum
by John Henderson in 1878
Literature : Lane-Poole 1886 pp. 174-7 and fig. 81;

Barrett 1949, fig. 22, London 1976 no. 210; Ward 1991 figs 12 & 17; Ward 1993 fig. 87

The incense would have been placed inside a small saucer suspended from a series of metal rings or gimbals within the incense burner, allowing the saucer to remain upright and the contents secure even when the vessel was rolled across the floor. The loop at the top of the incense burner is a later addition.

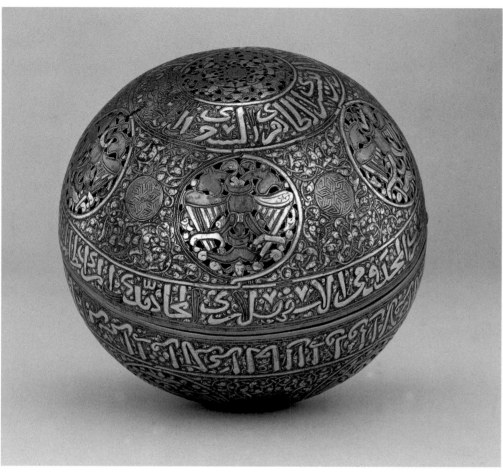

The double-headed eagle was a popular motif in Syria, northern Iraq and Anatolia during the 13th century. Although it undoubtedly had imperial significance and featured on coins and at the entrances to palaces, it was also used as a decorative motif on metal and pottery vessels.

R.W.

126

Lidded box

Egypt, 1st quarter 14th century

Bronze (or brass), gold, silver, niello ♦

Height (box) 4 cm, diameter 10.5 cm

The State Hermitage Museum, St Petersburg, inv.no. EG-765 a,b

Provenance: unknown

Literature: Moscow 1957; Dyakonova 1962, no. 59; Kuwait 1990, no. 57

125

126

Inscription bands around the incense burner read:

> *One of the things made for the honourable authority, the lofty, the lordly, the great amir, the revered, the masterful, the chief of the armies, the holy warrior, the defender, the protector of frontiers, the fortified by God, the triumphant, the victorious, al-Badri Badr al-Din Baysari al-Zahiri al-Sa'idi al-Shamsi.*

Badr al-Din Baysari was a well known Mamluk *amir* (local ruler) of the 13th century. Confidante of Sultan Baybars, he became immensely wealthy and powerful and was famed for his extravagance. This incense burner may well have been destined for his palace in Cairo, which was one of the most magnificent in the city. The title al-Sa'idi is a sign of Baysari's allegiance to Sultan al-Malik al-Sa'id Baraka Khan (1277-79) and so the vessel is likely to have been made during his reign.

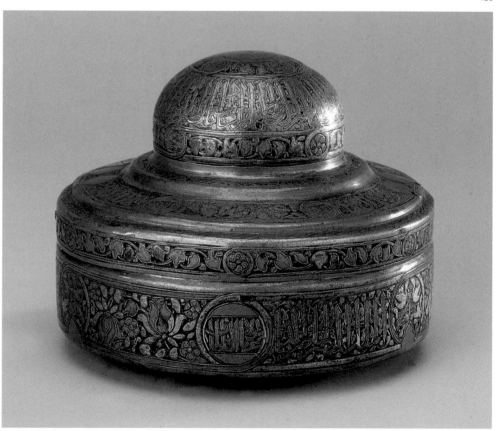

171

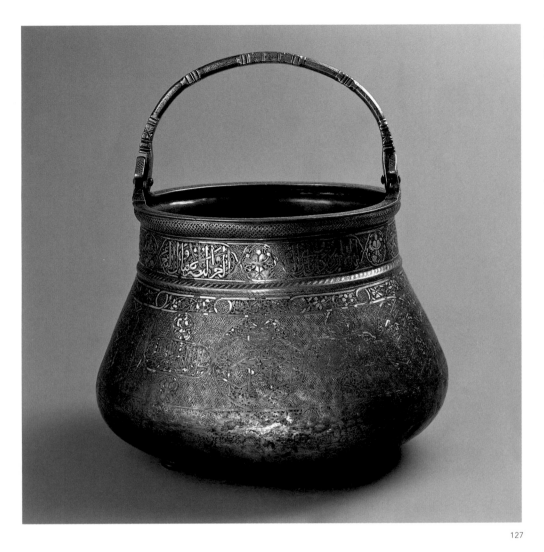

127

Each of the incriptions in the three round medallions along the box's lower side, in naskh script, reads:

Glory to our lord the sultan.

N.V.

127

Bucket

Signed by the craftsman Muhammad Shah ash-Shirazi

Iran, AH 733/AD 1333

Bronze (or brass), gold, silver ◆ Height 48.7 cm

The State Hermitage Museum, St Petersburg,

inv.no. IR-1484

Provenance: transferred in 1925 from the Museum of

the former Baron A.N. Stieglitz School of Technical

Drawing

Literature: Kühnel 1925-II, pl. 56; Persian Art 1939,

pl. 1363 B; Gyuzalyan 1963, pp. 174-178; Kuwait

1990, no. 51

This bucket is one of the most important pieces of 14th-century Iranian art as it records the exact date when it was made, as well as the names of the artisan and owner. However, nothing is known of these people from other sources. Since the artisan's *nisba* was 'Shirazi', and the sultan's title contained the expression '....the heir to Solomon's kingdom...', (the latter often met in the inscriptions from the province of Fars), the bucket can be linked to the south of Iran, most probably to Shiraz. This attribution is reinforced by the artist's description of himself as a 'slave' of the *amir* Mahmud Inju, who ruled the region during this period.

The inscription around the upper rim in *naskh* script reads:

*Following the order of the master, the greatest
sahib, honor and order of Iran, decoration of
the state, peace and faith, amir Siyavush ar-
Rida'i, [may God] strengthen his following
[and] his rule. The work of the weak slave,
Muhammad Shah ash-Shirazi, the smallest
among the slaves of the great amir, Khusraw of
horizons, amir Sharaf ad-Din Mahmud Inju,*

This box is decorated with Arabic inscriptions containing the name of a Mamluk Sultan, al-Malik an-Nasir Muhammad ibn Qala'un (who ruled in the late 13th and early 14th century), which confirms dating of this piece to the early 14th century. Both the box and its lid are decorated with a fine and elaborate ornamentation of lotuses, flying ducks, and Arabic inscriptions of a sort usual in Mamluk art of the period. The design, created in gold, silver and niello inlay, achieves a visual richness which attests to the artisan's skill. The inscription on the dome of the lid, in *thuluth* script, reads:

*Glory to our lord the sultan, victorious king,
knowledgeable, just assistant of the peace and
the faith, Muhammad, son of the king al-
Mansur Qala'un, as-Salihi, (i.e. formerly in
the service of as-Salih Najm ad-Din) may his
victory be magnified.*

The inscription along the periphery of the shoulder area of the lid, in *naskh* script, reads:

*Glory to our lord, victorious king,
assistant of peace and faith,
Muhammad son of Qala'un, may his victory
be magnified.*

Each of the inscriptions in three round medallions on the shoulder of the lid, in naskh script, reads:

Victorious king.

The inscription in the cartouches along the box's lower side, in thuluth script, reads:

*Glory to our lord the sultan, victorious king,
assistant of peace and faith, Muhammad ibn
Qala'un, may his victory be magnified.*

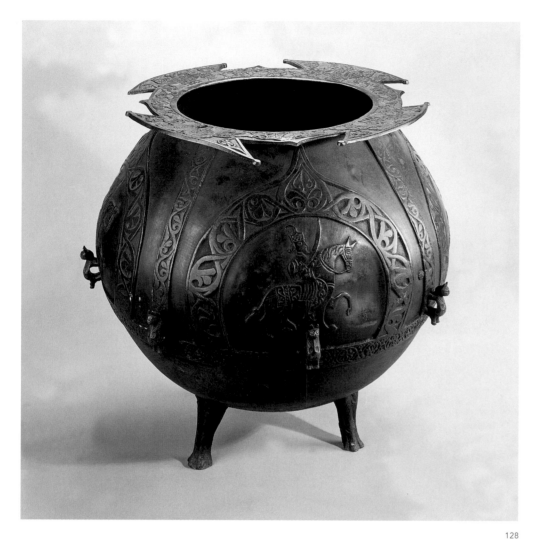

128

Cauldron

Dagestan, 2nd half 14th century

Bronze (or brass) ✦ Height 66 cm, diameter 66.5 cm

The State Hermitage Museum, St Petersburg, inv.no. TP-175

Provenance: transferred in 1924 from the former Museum of Baron A.N. Stieglitz School of Technical Drawing

Literature: *Orbeli 1938-II, pp. 300-326. tab. 47-50; Mammayev 1987, pp. 101-127, fig. 6; Kuwait 1990, no. 72*

Cauldrons of this type, displaying a wide range of decoration, come from Dagestan.

Certain elements in its construction, such as the exaggerated horizontal rim, hint at a connexion with cauldrons made in Kubachi (western Dagestan). Nevertheless, both the floral ornament and distinctive shape – which is of the so-called 'closed type'– suggest another centre, probably in close contact with Kubachi.

This particular example might be attributed to Zarkan, a village of chain-mail makers, mentioned by Arab geographers, thought to have been situated west of Kubachi. The dating for this piece is indicated by the floral ornamentation's resemblance to that on the stone tympanum in the Museum of History in the Dagestani capital Makhachkala, which is dated AH 807/AD 1404-05.

A.I.

may God multiply his justice, in the year 733. May the world be as you wish it, and Heaven be your friend. May the Creator of the world be your protector.

The inscription in the cartouches on the upper part of the body in *thuluth* script reads:

Glory and success, and prosperity, and favour, and fortune, and excellence, [and] generosity, and learning, and discernment, through which victory is achieved...

The inscription in the cartouches on the middle part of the body in thuluth script reads:

In the days of the rule of the greatest sultan, holder of the power of life and death over the peoples, master of the sultans of the Arabs and the non-Arabs, the heir to Solomon's kingdom, the Alexander of [his] time, assisted from above

in his victories over enemies, God's shadow on the earth, suppressor of faithlessness and paganism, [may God] make his kingdom eternal and perpetuate his rule, his well-being, and his sultanship.

A.I.

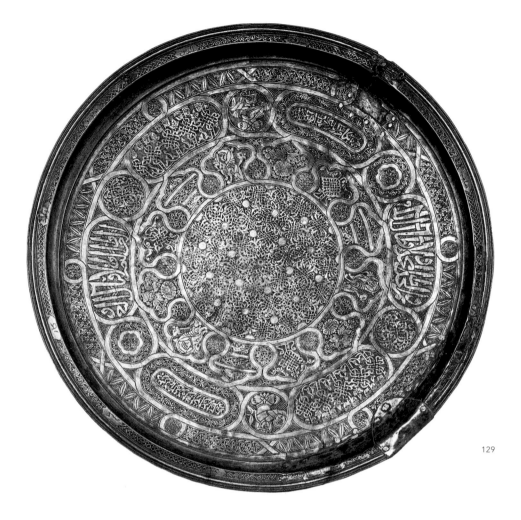

129

and fortune, and splendour, and excellence, [and] generosity;

The Persian verses in naskh script in the smaller compartments in the bottom of the tray are written in a metre called *mutaqarib* and read:

May the world be your friend as heaven wishes, may the Creator of the world be your Protector. [You], the well-wisher of the thousandfold happiness, place in the front of your lord [like] a tray [your] gratitude [for] the good deed.

A.I.

129

Tray

Iran, late 14th century

Copper ◆ Diameter 70 cm

The State Hermitage Museum, St Petersburg, inv.no. IR-2170

Transferred in 1925 from the State Academy of Material Cultural History (A. A. Bobrinsky Collection)

Literature: Ivanov 1967, pp. 94-104; Kuwait 1990, no. 73

From the 14th century copper was used on a large scale in the manufacture of household utensils in the Middle East, starting in Iran. Previously bronze or brass had dominated. Bronze was not entirely dispensed with, however, and considerable amounts of bronze metalwork were still produced. Over the decades, copper vessel production increased, especially in Iran. These vessels were usually tinned.

This large tray represents a rare example of 14th-century copperwork which in many respects resembles decoration on bronze or brass pieces.

A 14th-century dating is also supported by the figural decoration as depictions of animate creatures had disappeared from metalwork by the 15th century.

The inscription in reserved compartments around the perimeter, in *naskh* script, reads:

The owner and proprietor of this is Sharaf ad-Din ibn Yusuf, may the end of his endeavors be successful...

(the end is illegible).

The Arabic inscription in the larger compartments in the bottom of the tray (in *thuluth* script with some *diwani* script elements) reads:

Glory and victory, and prosperity, and favour,

130

Bowl

Iran, AH 811/AD 1408-09

Copper, tin ◆ Diameter 23.9 cm

The State Hermitage Museum, St Petersburg, inv.no. IR-2173

Provenance: transferred in 1890 from the Archaeological Commission

Literature: Ivanov 1960-I, pp. 41-44; Kuwait 1990, no. 75

The decorative style of this bowl, with its net-like covering of curvilinear geometric compartments, floral and inscriptional ornament, was an innovation which appeared on Iranian copper objects in the mid 14th century. Despite the richness of decoration, this type is more modest than bronzes inlaid with gold and silver, which were more usual in the 14th and early 15th centuries. Such copper objects were generally tinned.

The inscriptions on this object feature a precise date of manufacture as well as three different *ghazals* (love poems) by Hafiz. Specialist literature has expressed the opinion that the date should be read as AH911/ AD 1505-06, a theory which is supported by the ornamentation which is close to that of copper objects from the early 16th century.

However the figure '8' can be clearly seen. Moreover virtually nothing is known about the evolution of ornamental style on metal objects of the 14th and 15th centuries. Certain elements in the decoration of this piece clearly follow conventions applied in the first half of the 15th century. The inscribed date cannot, therefore, be rejected out of hand.

Another surprising element in the decoration of this bowl is the style of the inscription in the second exterior register, which resembles what is called *nasta'liq*, or 'hanging', script. Although this style developed in manuscripts in the 14th century, it only became widespread on Iranian metal objects in the second half of the 16th century. So the bowl stands outside the mainstream of development in this respect as well. Further study is obviously required.

One inscription in the cartouches inside the rim of the bowl (in Arabic in *thuluth* script) gives the owner's name and the date:

> Its owner and proprietor is Imam Quli K...
> 811.

The five other cartouches contain Hafiz' verses (in Persian, in *muzari* metre and *thuluth* script):

> It is morning. Oh, cup bearer,
> fill this bowl with wine!
> Skies revolve quickly, so be quick!
> Before this mortal world is destroyed,
> Destroy (i.e. intoxicate) us with a bowl
> of red wine!
> If you are looking for pleasure,
> forget about sleep!

The Persian inscription in thuluth script along the outside rim (in *mujtas* metre) reads:

> You will then be able to see the mystery of Jams
> bowl,
> When you make the ashes of the inn your eye's
> paint,
> Do not be without wine and musicians,
> because under the dome of the skies

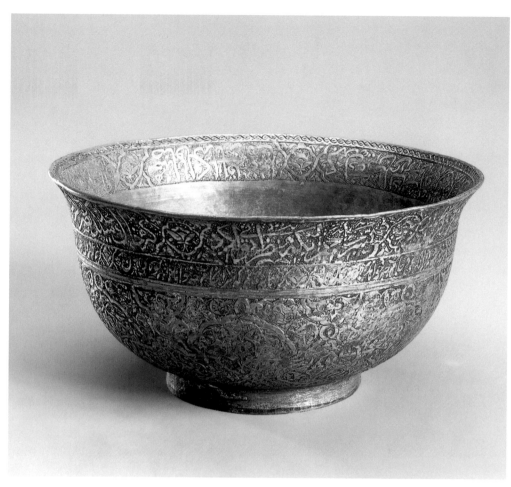

130

> You will be able to send the grief
> away from your heart with this song.
> As long as you are wishing for your
> lover's mouth and the edge of the bowl,
> Do not pretend you can do anything.

The Persian inscription in nasta'liq script in the second register on the exterior (in ramal metre) reads:

> What is better than the thought of wine and
> bowl,
> As long as we do not see the end.
> For how long can a heart grieve about
> the lack of remaining days? Do say: Let
> the heart perish together with days
> [and] what else? Drink wine, do not
> bother or listen to the sermons of buffoons.
> How can you trust the word of anybody?

A.I.

131

Jug

Signed by the craftsman Javanbakht ibn Husain

Iran, late 15th century

Bronze (or brass), gold, silver ◆ Height 12.7 cm

The State Hermitage Museum, St Petersburg,

inv.no. IR-2044

Provenance: transferred in 1923

by the State Museum Fund

Literature: Kuwait 1990, no. 80

The place of manufacture for such jugs was not determined with certainty until the 1960s. Among other theories, they were believed to have been made in Venice by Iranian artisans. However, various studies proved that the jugs were made in the east Iranian province of Khorasan (possibly in Herat) in the late l5th to early 16th century. The jugs were usually inlaid with gold and

131

132

Lamp

Iran, AH 987/AD 1579-1580

Bronze (or brass) ▪ Height 40.7 cm

The State Hermitage Museum, St Petersburg,

inv.no. IR-2203

Provenance: Transferred in 1925 from the State

Academy of Material Cultural History

(A.A. Bobrinsky Collection)

Literature: Ivanov 1960-II, pp. 337-345; Kuwait 1990,

no. 87; Bloom - Elair 1997, p. 408, fig. 222

In the 1540s a new type of lamp appeared in Iran, a combination of lamp and torch whose upper part (the reservoir) could be carried separately on a stick or set on its base; inside the house. Later, many of these lamp-torches were turned into candlesticks (with the torch inverted upside down into the base). This explains why specialist literature considered these objects candlesticks for many years.

This example from the Hermitage is precisely dated, with the owner's name and the date incised on both the reservoir and the base:

Its owner is Hajji Chelebi, 987.

The torch reservoir is also inscribed with verses by Katibi Turshizi, in *nasta'liq* script:

That night when the moon of your
face became the lamp of our solitude,
The candle melted [for it] could not
bear the heat of our being together.
The moment when you throw away the
cover off your moon-like face,
Will be the sunrise of our happiness!

The verses on the upper part of the base are an extract from Sa'di's 'Bustan', in *mutaqarib* metre, in nasta'liq script:

I remember one night, when my eyes
were not sleeping,
I heard a moth tell the candle:
I am in love [and] I am to die in
flames,
Why should you weep and get
burned?

silver, decorated with floral ornament and Persian verses, the latter often written by famous poets.

The cartouches on the neck and body of this piece contain an extract from a *ghazal* (love poem) by a known poet-mystic from the first half of the 15th century, Qasim-i Anvar Tabrizi. It is written in *naskh* script, in the meter called *mujtas*:

When the reflection of the place with the
morning of the eternity dawned,
The friend's beauty became clear in all atoms of
the Universe.
The door to the treasury of mercy had been
locked by wisdom,
But with our happiness coming it opened.
The pot full of eternal wine had been always
pure,
But in the bowl of our hearts the wine became
the purest,
The legend of my friend reached the bazaar of
all created ones,

The Doomsday came, unheard of before!
A thousand holy souls were the victims of the
Arab's shah
(ie. The Prophet Muhammad peace be upon
him).
So Kasimi's joy became total due to his love to
him.

The artisan's signature is on the base of the jug (in a *thuluth*-like script):

Work of the slave Javanbakht ibn Husain.

A.I.

The first zigzag register on the central part of the lamp is inscribed in nasta'liq script with verses by Hairati Tuni in *mujtas* metre:

> When my heart [is full of] love
> towards my ideals, which burns my
> soul,
> My love burns me every moment with
> another stamp.
> I am like a moth near a candle.
> As soon as I move ahead, my wings
> and my feathering get burned.

The second curved register on the central part of the body is inscribed in nasta'liq script with verses by Ahli Shirazi (the author identified by A.S. Melikyan-Shirvani) in *hazaj* metre:

> Thanks to you, I see the lamp of
> generous people lit,
> I see all wise hearts turned to you.
> You are the good of the world, may
> hair on your head never grow less,
> Because I see the world as a parasite
> on your hair's end.

The third zigzag register on the central part is inscribed with the same verses by Hairati Tuni as the first zigzag register. The base repeats the verses by Katibi Turshizi on the torch reservoir.

A.I.

132

133

Candlestick

Iran, 1st half 17th century

Bronze (or brass) ✦ Height 26.5 cm

The State Hermitage Museum, St Petersburg, inv.no. IR-2270

Provenance: collection of the Counts Stroganov, year of acquisition unknown

Literature: Persian Art 1939, part VI, 1377B; Grube 1974, pp. 233-269, fig. 100; Kuwait 1990, no. 108

This group of candlesticks with bell-like bases and candle holders in the form of dragons' heads and necks (twisted about each other) poses a number of problems for the art historian. Although the candle holders are identical, with scale-pattern ornament, the bases vary: some have no ornamentation at all, others are variously decorated.

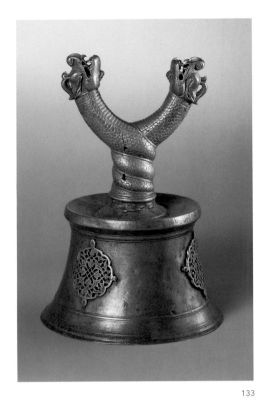

133

made in the early 17th century, an attribution based on a study of its features. The dragonesque candle-holder is of the same metal and could have been made at the same time, although this has not been confirmed.

A.I.

134

Magic medicine bowl

Iran, 17th century
High-tin bronze, cast and spun, engraved decoration inlaid with a white paste ◆ Height 17.3 cm, diameter 45.2 cm
The Nasser D. Khalili Collection of Islamic Art, London, inv.no. MTW 1444
Literature: Maddison - Savage-Smith 1997, no. 32, pp. 93–95

and invocations in Arabic and Persian and Qur'anic texts in an elegant *naskh* script. Between these are numerical magic squares which are not, however, entirely error-free, and grammatological talismanic squares.

The inscriptions include an invocation against demons (*min kull shaytan*) and the Persian and Arabic titles of a Sufi shaykh, although his *tariqa* (Sufi order) is not identifiable.

M.R.

Some of the bases can be dated, through study of their ornament, to the late 15th century; the majority were made later. Around 15 years ago, a candlestick from the David Collection (in Copenhagen) with a scale pattern covering both dragons and base was discussed in a publication. This unity of decoration supported the theory that the piece should be considered a fully preserved original from late 14th-century Iran although the base is of a slightly different shape.

The existence of candlesticks with similar ornamentation on both the base and candle holder raises the question of why this tradition was not continued, and why the decoration of base and candle holder diverge in other examples. The bases were apparently made at various later periods, for candle holders in the form of dragons, most of which were probably from the 15th century. However it is not clear why the original bases had disappeared and hard to believe that they were intentionally destroyed. These questions have yet to be resolved. The base of the Hermitage candlestick was

The inside of the bowl is engraved with an eight-lobed medallion at the centre with concentric surrounds of circles, lobed squares and oblong cartouches, all filled with prayers

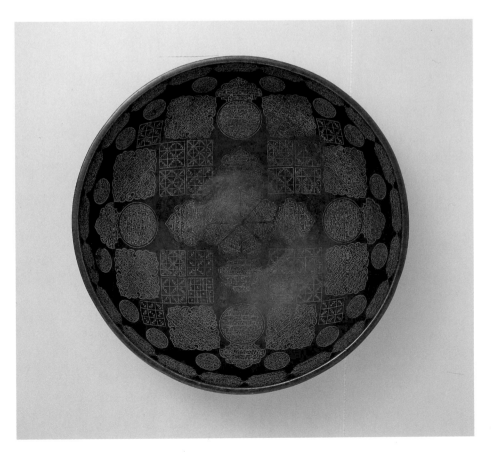

134

135

Celestial globe

India, perhaps Lahore (now in Pakistan), AH 1074/
AD 1663-64

The globe is brass, cast by the lost-wax process,
engraved, and inlaid with silver ◆ Inner diameter
of stand 25.4 cm; height of stand 20.8 cm

The Nasser D. Khalili Collection of Islamic Art,
London, inv.no. SCI 45

Literature: Savage-Smith 1985, no. 29; Westerham
1985, no. 69; Maddison - Savage-Smith 1997,
pp. 168-175, 234-235, no. 134

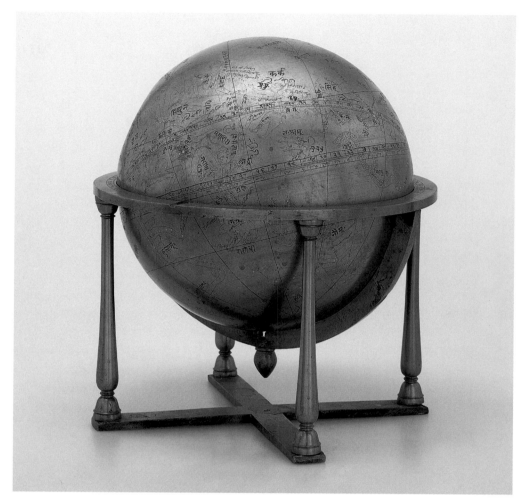

135

This globe was made by a prominent
17th-century instrument maker, Muhammad
Salih Tatavi, who was responsible for at
least one other globe and three astrolabes.
Muhammad Salih's Persianized nisba, Tatavi,
marks him as a native of the city of Thattha
in Sind, but the highly specialized production
technique he employed suggests that he
worked in the metalworking and instrument-
making centre of Lahore. It is also possible
that during the period when this object was
made, his workshop had followed the
Mughal court to Delhi.

In the Islamic tradition, which continued
Hellenistic and Roman practice, the heavens
were interpreted as a hollow revolving
sphere that enclosed the Earth. On globes of
this type, the sphere is shown as though the
observer were looking down from above;
the constellations are therefore represented
in reverse of what is seen from Earth. On
this globe, as on all Islamic specimens, the
human figures used for certain constellations
are depicted facing outwards, towards the
observer, rather than facing inwards, as on
examples from Christian Europe. The globe's
Islamic character is further demonstrated
by the presence of numerous inscriptions
in Arabic, which were engraved at the time
the piece was made. These include the
names of the 48 Classical constellations
engraved on its surface, and some of the
1018 stars marked by silver points, which are
graduated in size to indicate the magnitude
of the star in question. The other features
shown are the North and South Poles, the
celestial equator, the two tropics (the circles
marking the maximum declination of the
sun north and south of the equator), the
ecliptic (the path of the sun through the
fixed stars as it appears from Earth), and
six great circles at right angles to the ecliptic,
for measuring the latitude of stars.

It would once have been possible to use the
globe as an analogue computing device for
solving various astronomical, astrological
and time-keeping problems. For this purpose
the globe had to be enclosed in an apparatus
which incorporated meridian and horizon
rings, allowing it to be oriented so that
readings could be taken for a particular
location. The positions of the stars changed
over time, however, and the markings on a
celestial globe lost their validity after 50
years. The instrument's loss of scientific
precision did not end its useful life, as it
could still be used as a star map. In 1767
(or perhaps 1802), more than 110 years
after this celestial globe was made, it was re-
engraved with Sanskrit captions by a Hindu
astronomer called Nandaraya. The meridian
and horizon rings were no longer strictly
necessary. They and the original stand have
been lost, while the present support is a later
replacement.

M.R.

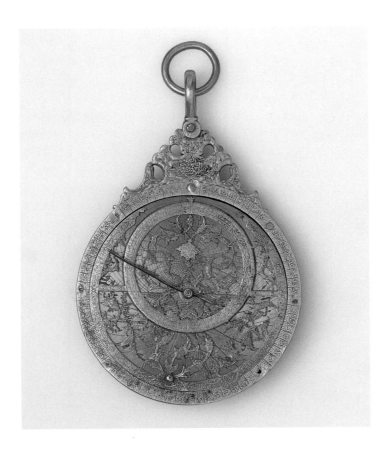

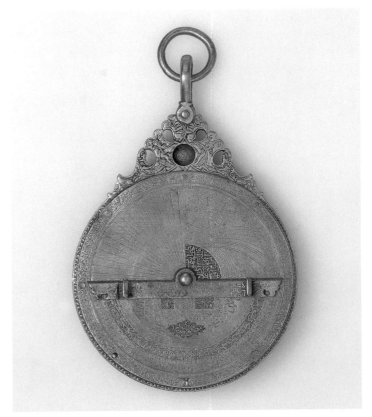

136

136

Planispheric astrolabe

Iran, probably Isfahan, AH 1060/AD 1650

Brass, sheet and cast, cut and engraved ◆

Diameter 11.4 cm, height 14.6 cm, excluding shackle

and ring; maximum thickness of mater 0.7 cm

The Nasser D. Khalili Collection of Islamic Art,

London, inv.no. SCI 161

Literature: Maddison - Savage-Smith 1997, no. 144

Despite its very different shape, the classical
origins and theoretical bases of the plani-
spheric astrolabe, as well as the practical
purposes to which the instrument was put,
were very similar to those of the celestial
globe (*see cat.no. 135*). The astrolabe took
on a new lease of life with the advent of
Islam, as the correct performance of Muslim
ritual requires all communities of believers,
wherever they may be, to know the direc-
tion of the Kaaba in Mecca and the precise
times for the five daily prayers. For more
than a millennium after the *Hijra* (the year

of the Prophet's move to Medina, in 622),
these calculations were most frequently
made using astronomical instruments such
as this. At the same time, the Hellenistic
tradition of star-lore remained vigorous,
at least in Iran and India, and astrolabes
were part of the standard equipment of
the astrologer.

The astrolabe contains a circular web-like
star map, called the rete in Europe and the
'ankabut, or 'spider', in the Islamic world.
This is the planispheric element, being the
projection on to a plane of part of the
celestial sphere as seen from above: the
centre is the North Pole, and the rim is the
Tropic of Capricorn. On this example 44 of
the brighter stars are marked by the tips of
foliate pointers. The rete sits snugly within
the rimmed body of the instrument (the
mater), which is fitted with a bracket and
ring. Through the ring passed the cord used
to suspend the astrolabe during observations
of the sun or stars, which were accomplished

by means of the *alidade*, the sighting vane on
the back. When the vane was aligned so that
sunlight passed directly through the holes in
both ends, or a star could be seen through
these holes, the altitude of the sun or star
could be read off a scale marked along the
edge of the instrument. This information
could then be interpreted by reference to
one of the set of plates engraved for different
latitudes that were kept in the mater,
beneath the rete. All these elements – rete,
mater, alidade and plates – were kept to-
gether by the pin that passed through the
hole in the centre of each, and which was
secured by a wedge called the horse.

The astrolabe was made by the instrument
maker Muhammad Mahdi al-Yazdi, who
worked between 1649 and 1663; his father
and uncle were also instrument makers.
The piece is superbly engraved with a mass
of technical information, which is supple-
mented by Qur'anic quotations and Persian
verses. The latter include the chronogram:

I asked a quick-witted man the date of it. He said, It is Alexander's mirror and the cup in which one can see the world.

When the values of the letters are added together, they produce the date AH 1060.

M.R.

137

Lustre-painted bowl

Fatimid Egypt, 11th century

Earthenware, glazed • Diameter 20.4 cm

Benaki Museum, Athens, inv.no. 11119

Literature: Sourdel 1968, afb. 143; Philon 1980-I, afb. 87, p. 25; Philon 1980-II, afb. 467, p. 221; Paris 1998, afb. 37, p. 112; Vienna 1998, afb. 54, p. 105

A Fatimid bowl decorated with lustre painting over an opaque white glaze, and on the reverse with lustre circles and strokes. The surface of the bowl is treated as a canvas with no divisions and depicts a leopard and its keeper in reserve. It belongs to a group of Fatimid lustre-painted ceramics decorated with court activities and genre scenes in a semi-realistic style. The keeper reaches out

137

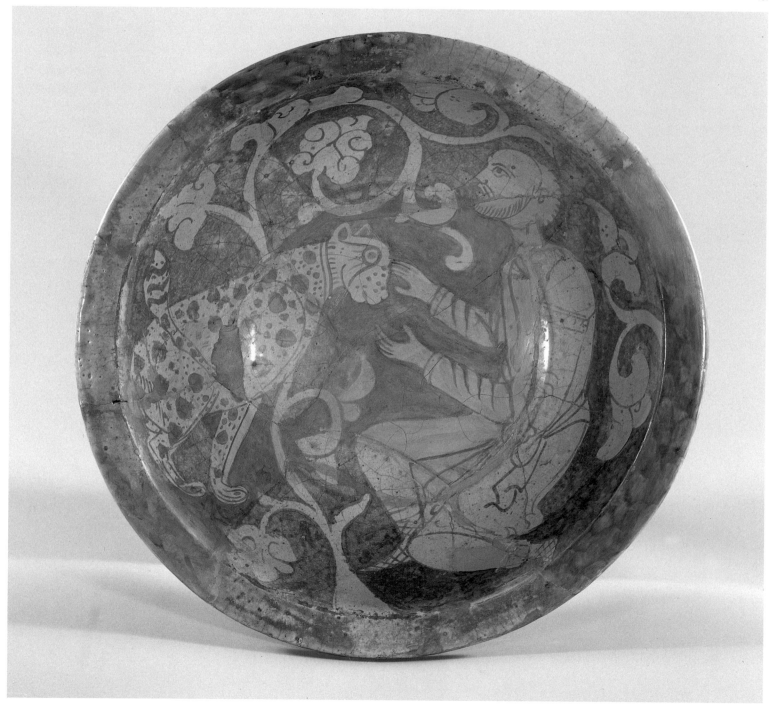

138

138

Large bowl

Nishapur, or possibly Afrasiyab (old Samarkand),
circa 1000

Earthenware, slip-painted under a transparent glaze ✦
Height 10.8 cm, diameter 36.5 cm

The Nasser D. Khalili Collection of Islamic Art,
London, inv.no. FOT 99

*Literature: Soustiel 1985, pl. 29; Sotheby's 1986, lot
no. 99; Grube 1994, no. 36, pp. 46, 48*

The decoration of the large bowl, painted in
olive-green and reddish slips, depicts an
enthroned prince. His tresses are curled at
the ends. Although his crown has stylized
Sasanian wings there is very little trace of the
corymbos: a veil appears to hang from this to
the shoulders. His gown, with a lozenge
diaper, is open almost to the waist; the skirt
has a bolder teardrop pattern. A belt with
tongue-like appendages is schematically
indicated. On his left hand a bird is perched.

139

to the animal creating a rapport between the
two figures and some degree of movement.
The details are carefully painted, particularly
the man's costume and face, while the
animal's skin is dotted with spots of varying
size. A swirling palmette tree is used as an
effective background for the scene. During
the Fatimid period leopards were a status
symbol, owned by the court and used in
hunting.

M.M.

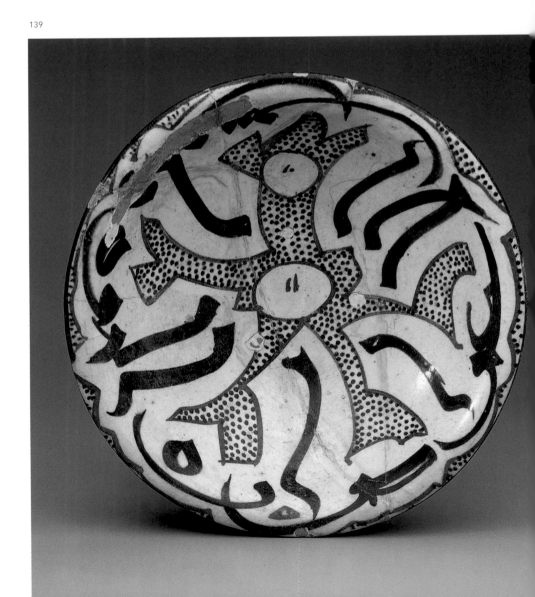

To his left is a dachshund trailing a palmette and biting a leaf; to his right is a small feline or rabbit and a legless bird. The costume is not markedly central Asian and its Sasanian elements are more characteristic of the Buyid (945-1041) revival in western Iran.

The densely dotted background panels, like the choice of slip colours and the figure's physiognomy, suggest a Mesopotamian Abbasid lustre original. There is also a somewhat similar pseudo-lustre dish with a *Zahhak* figure in the J.-P. Croisier Collection in Geneva. The dotting, however, is also highly reminiscent of the ring-matting of high-tin bronze vessels (*compare cat.no. 112*); it is probable that both Abbasid monochrome lustre wares and their Nishapur imitations owe much of their decoration to this source.

M.R.

139

Bowl

Transoxiana (central Asia), 10th century

Earthenware, glazed ✦ Diameter 17.4 cm

The State Hermitage Museum, St Petersburg, inv.no. CA-7194

Provenance: transferred in 1936 from the D. Yusupov Collection

Literature: Bolshakov 1963, p. 48, tab. VI g; Kuwait 1990, no. 7

This vessel is made of reddish clay and covered with a white engobe on both interior and exterior. The blackish-brown slip painting is covered with a transparent colourless glaze. The inscription exemplifies a style employed in ceramics found both at Afrasiyab (old Samarkand) and Nishapur, and is one of several distinct styles on these Samanid wares (the Samanids ruled from 819 to 999).

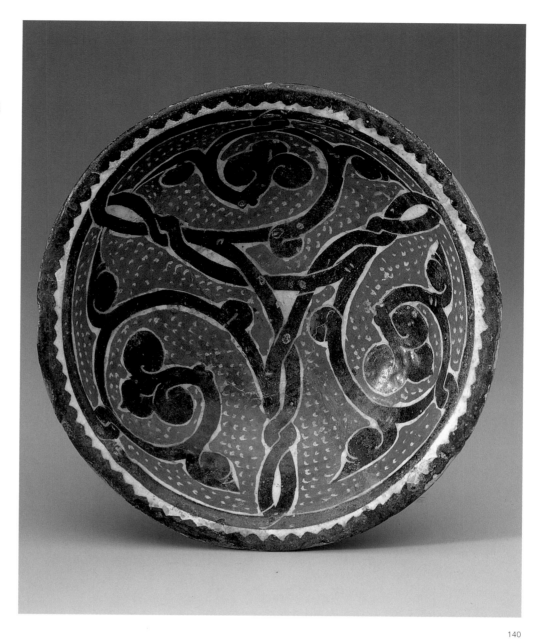

140

The circular inscription reads:

Generosity is the guarantee of honour.

This text, known in more complete versions, is one of those most frequently seen on Samanid earthenware. The dotted background, with outlined spaces around the letters, follows the decorative tradition of metal items.

B.M.

140

Bowl

Transoxiana (central Asia), 10th century

Earthenware, glazed ✦ Diameter 13 cm

The State Hermitage Museum, St Petersburg, inv.no. CA-7074

Provenance: transferred in 1931 from L.V. Puzillo's collection

Literature: Shishkina 1979, p. 11, 57, tab. II, 109; Kuwait 1990, no. 6

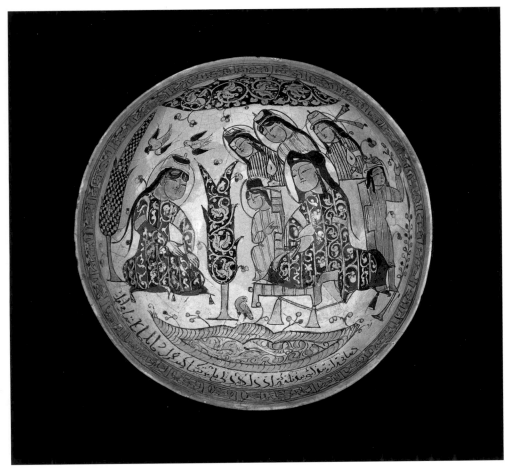

141

The British Museum piece. In addition to his *minai* wares, lustrewares signed by Abu Zayd suggest that he was the driving force in the luxury ceramic workshop at Kashan in the late 12th century. Since both minai and lustre wares require two firings, Abu Zayd's bowls required a high level of technical proficiency which he must have helped to perfect. However, perhaps his greater contribution was to the development of the pictorial style of minai wares, which so closely reflects that of miniature painting, and then to the emergence of the distinctive Kashan lustre style with myriad designs incised through the lustre glaze.

The iconography of this bowl and others in the group generally adhere to the medieval Iranian repertoire of courtly scenes: hunting, feasting, and enthronements. However, the fact that all the bowls date to Muharram suggests that they had a special purpose connected with the New Year. The month of Muharram is particularly important to Shiites because the martyrdom of Imam Husayn occurred at Karbala' on the 10th of the month (the *ashura*) in AH 61, a date commemorated annually. Kashan, the probable source of the Muharram bowls, had a reputation as a centre of Shiism and the bowls with their sad verses may have been used or displayed at this time. On the other hand, the imagery of The British Museum bowl, with its smiling figures, pool and bird in the foreground and floating canopy above, does not seem to relate in any way to the Battle of Karbala' and may have more to do with the traditional Persian New Year, which occurs on March 21st and is a time of family celebration, than with the Muslim New Year of Muharram.

SH.C.

This bowl of reddish clay is covered with white engobe on both interior and exterior. The painting inside is blackish-brown on a red background, in which there are sgraffito dots reaching to the white engobe. The painting, in coloured slip, is covered with a transparent colourless glaze. The bowl may be considered a typical example of Afrasiyab ceramics, Afrasiyab now being the name used to denote the remains of pre-Mongol Samarkand.

Afrasiyab ceramics from the time of the Samanids (819-999) strongly resemble those from Nishapur (Khorasan) of the same period.

B.M.

141

Bowl

Signed by Abu Zayd
Iran, dated Muharram AH 583 (March-April 1187)
Ceramic, buff body, inglaze and overglaze
decoration, transparent, colourless glaze ◆
Diameter 21.1 cm
The British Museum, London, inv.no. 1945 10-17 261
Provenance: Oscar Raphael Bequest
Literature: Persian Art 1939, pl. 688; Watson 1985, fig. 51, pp. 70, 79, 84

This bowl, in which an enthroned figure surrounded by attendants converses with a figure seated on a cushion, is one of a group of five bowls dated to the month of Muharram, the first month of the Muslim calendar, in the years AH 582/AD 1186 and AH 583/AD 1187. All five bowls in the group have been attributed to the master potter Abu Zayd on the basis of his signature on

142

Bowl

Iran, late 12th –13th century

Composite body, stained and overglaze painted and
gilded ✦ Max. diameter 19.7 cm, height 8.9 cm

The Metropolitan Museum of Art, New York,
inv.no. 57.61.16. Henry G. Leberthon Collection,
gift of Mr. and Mrs. A. Wallace Chauncey, 1957

*Literature: Islamic Pottery 1983, cat.no. 19;
New York 1987, pp. 36–37*

Twelfth-century Iranian potters developed
a technique known as *minai* (literally,
'enameled'). Stable colours were stain-
painted in a lead glaze that was rendered
opaque by the addition of tin. After the first
firing, less stable colours were applied over
the glaze and the object was fired again at a
lower temperature. This technique enabled
the artist to paint in a greater variety of
colours (it was also known as *haft aurang*,
or 'seven colours') with complete control,
lending a miniature-like quality to the design
and creating a unique and complex style of
painting on pottery. Minai painters usually
preferred figural designs, as opposed to the
more common vegetal ones of other ceramic
products. Many objects – bowls, cups, jugs,
and bottles – illustrate scenes from the
Iranian national epic, the *Shahnama* ('The
Book of Kings'), written in Persian by the
poet Firdausi at the end of the tenth century.
The style of these figures echoes that of those
illustrating contemporary manuscripts of
which very little has survived. Thus minai
ware serves to increase our knowledge of
painting in Iran in the early medieval period.

Minai ware has an off-white background
under the translucent glaze over which the
figures are painted, but a limited number
of extant pieces have a pale blue glaze,
such as this example, which represents one
of the most accomplished objects in this
small group. A traditional scene of courtly
entertainment is represented here.

A female lute player figures prominently in
the centre; two footed trays stacked with
fruit symbolize food refreshment; and
courtiers literally surround the musician in a
well-balanced composition that follows the
profile of the bowl. Inscriptions on one of the
two fruit bowls and below the rim (both on
the interior and the exterior) wish
happiness, power, and well-being to the
owner.

 S.C.

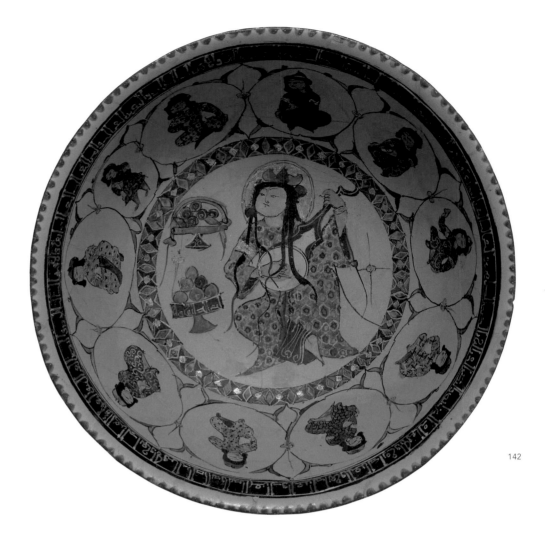

142

185

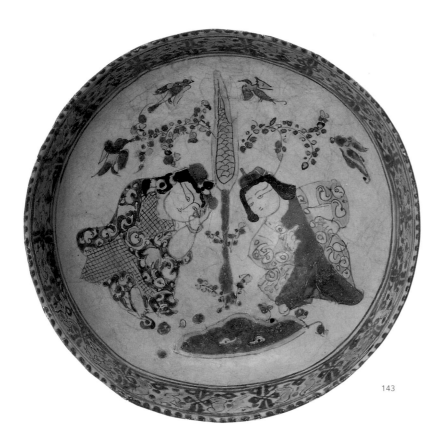

143

Bowl

Persia, late 12th-early 13th century

Earthenware, glazed (minai ware) ◆ Diameter 19.3 cm

Benaki Museum, Athens, inv.no. 715

Literature: Macriay 1937, p. 158; Benaki Museum 1972, fig. 65, p. 17

This bowl is decorated with polychrome enamels in the *minai* technique over a turquoise glaze; on the reverse is a black inscription in cursive script. In the centre a ruler is depicted seated on a throne with a high back; to the sides five horsemen alternate with five stylized trees. Each tree is flanked by two falcons except the tree above the ruler's head which is flanked by two harpies. The branches of the trees are

143

Footed bowl

Iran, circa 1200

Fritware, painted in cobalt under an opaque white glaze, and over-painted in black, red and turquoise (minai ware) ◆ Height 9 cm, diameter 21.7 cm

The Nasser D. Khalili Collection of Islamic Art, London, inv.no. POT 12

Literature: Grube 1994, no. 229, pp. 210, 334

The bowl is underglaze painted in cobalt and overglaze in red, turquoise and black enamels with two seated princely figures, a schematic landscape, flying birds and a pond with two fish. The inscription on the inner rim is pseudo-Kufic, doubtless based on a repetition of the word *al-'izz* ('Glory'). The inscription on the outer rim makes no sense.

M.R.

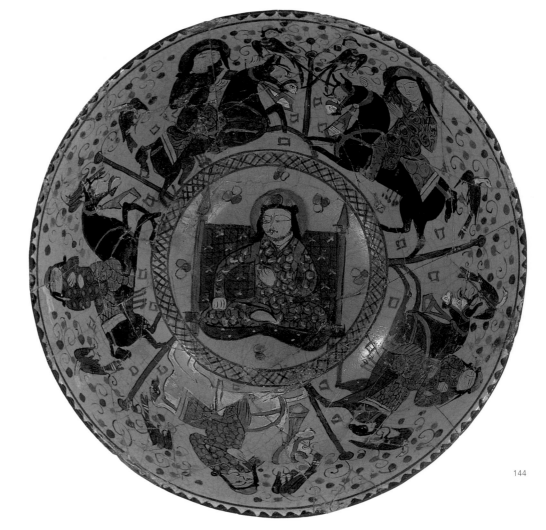

144

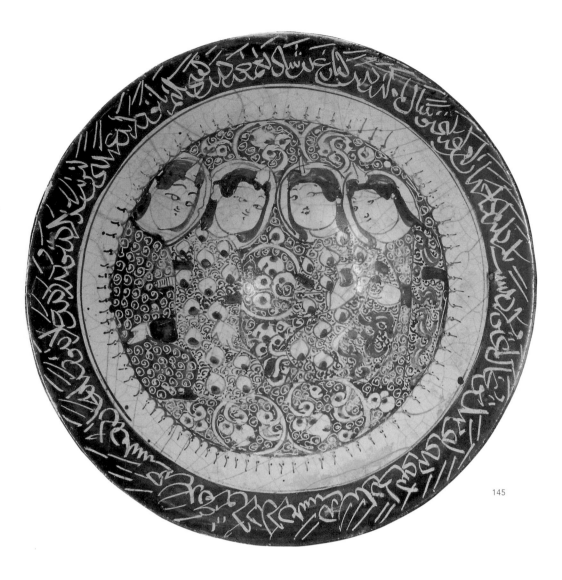

145

145

Dish

Iran (Kashan), early 13th century

Fritware, painted in chocolate lustre over an opaque

white glaze ◆ Height 6.8 cm, diameter 22.9 cm

The Nasser D. Khalili Collection of Islamic Art,

London, inv.no. POT 491

Literature: Grube 1994, no. 268, pp. 238, 334

The shallow dish is conical and stands on a low foot. At the centre are four figures while the rim has a vigorous inscription with Persian verses written in *naskh* script. The exterior has a series of large, heart-shaped palmettes.

The figures may be interpreted as two couples and suggest that the content of the verse inscription may be mutual reproaches on the pangs of unrequited love.

> *Oh you, whose will it is to hurt me*
> *for years and months,*
> *You are free from me and glad at my anguish,*
> *You vowed not to break your promise again,*
> *It is I who have caused this breach.*
> *Oh beloved, through you many*
> *have come to life,*
> *From grief over you, many hearts*
> *and eyes have bled.*
> *You are like and idol in hardness of heart,*
> *out of utter helplessness,*
> *Your equal has become the dust of your feet.*
> *May the Creator of the world protect [the*
> *owner of this vessel, wherever he may be].*

M.R.

depicted with fine lines and red and blue dots. During the twelfth and thirteenth centuries Iranians developed this technique of enamel decoration for luxury ceramics, thereby extending their palette. The general style of decoration resembles miniature painting of the period; even the subject matter often comprises themes from literature or court scenes and activities.

M.M.

Double-shelled ewer

Iran (Kashan), early 13th century
Fritware, painted in black under a turquoise glaze
with cobalt staining at the mouth ◆ Height 28.2 cm
The Nasser D. Khalili Collection of Islamic Art,
London, inv.no. POT 773
*Literature: Lane 1953, pl. 83B; Grube 1994, no. 211,
p. 195; see also no. 212, pp. 196–197*

The body is of double-shell construction,
with a solid inner wall and a pierced outer
one. This has boldly spiralling arabesques
with dotted outlines, while the neck has
hexagonal reticulations. The slender
spout and inner face of the rim have half
palmettes, and on the base is a spray of
Kashan 'water-weed'. The glaze has pooled
thickly around the low footring.

The ewer belongs to a small group of vessels
with openwork outer shells. These include
the 'Macy jug' in the Metropolitan Museum
of Art, New York (no. 32.52.1), which is
dated AH 612/AD 1215–16, and a very
similar, but undated, jug in the Khalili
Collection.

M.R.

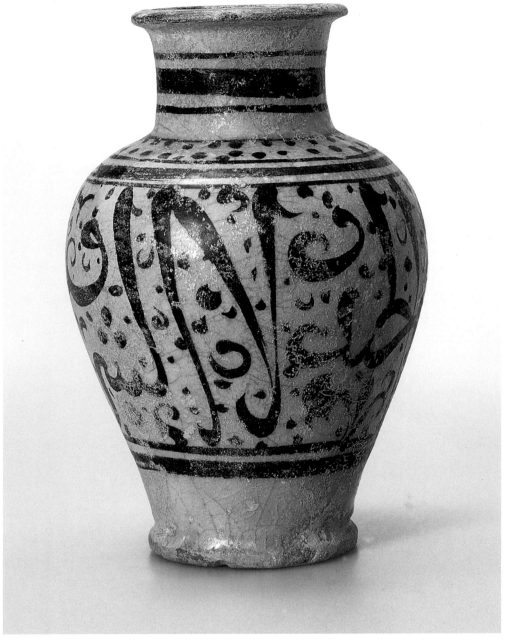

146

Jar

Syria, 1200–1250
Fritware, painted in black under a transparent
greenish glaze with light turquoise staining ◆
Height 25.2 cm
The Nasser D. Khalili Collection of Islamic Art,
London, inv.no. POT 2
Literature: Grube 1994, no. 337, pp. 292–293, 336

The jar has a collar neck and a slightly
everted rim. The body bears an elegantly
written inscription on a dotted ground.
The inscription reads:

> *Piety is the driving force of soldiers, not drink
> or time.*

M.R.

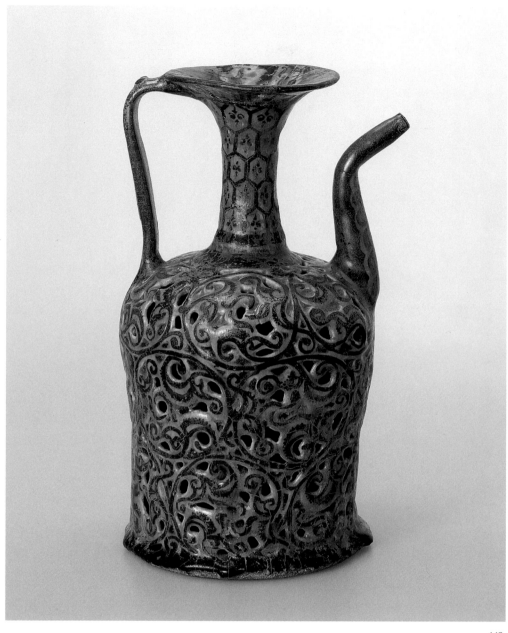

147

bearing the name Tughril, namely, Tughril I (AH 429–455/AD 1038–63), Tughril II (AH 526–529/AD 1132–34) and Tughril III (AH 571–590/AD 1176–95). What is more, there is no known portrait tradition for any member of the dynasty, and the costume shows no affinities with the traditional representations of Turkic rulers.

The function of the figure is not known, but one possibility is that it was made as one of a set of pieces used in a board game such as *pachisi* or chess. If this is the case, a literary reference from later in the Seljuk period may provide a clue. In his account of the reign of Sultan Tughril II, the historian Rawandi gives a long description of how to defeat one's enemies on the battlefield, declaring that: 'Like a chess player, one has to observe the enemy's move as well as one's own.' As the date AH 538/AD 1143–44 falls within the reign of Tughril's brother and successor,

148

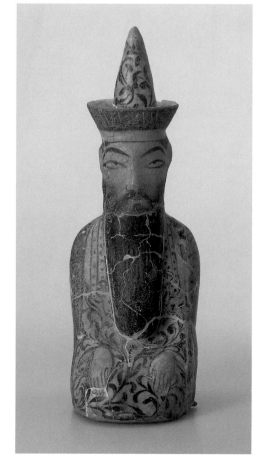

148

Figure of 'Sultan Tughril'

Iran (Kashan), later 13th century

Fritware, painted in black under a transparent glaze stained turquoise and cobalt ◆ Height 40.5 cm

The Nasser D. Khalili Collection of Islamic Art, London, inv.no. POT 1310

Literature: Rawandi 1921, pp. 208, 217; Khalili Collection 1993, p. 69

The heavily bearded male figure wears a conical hat with upturned brim, and is seated cross-legged with his hands on his knees.

Over his shoulders is a cloak decorated, like the hat, with 'water weed' motifs. On the brim of the hat, in reserve, is an inscription in *naskh* script referring to Sultan Tughril, and bearing the date AH 538/AD 1143–44.

Our Lord Tughril the Sultan, the Learned, the Just [in the] year thirty eight five hundred [sic].

The date AH 538/AD 1143–44 does not refer to the date of manufacture, as the piece can be attributed to the later 13th century on stylistic grounds. Nor does it fall within the reign of any of the three great Seljuk sultans

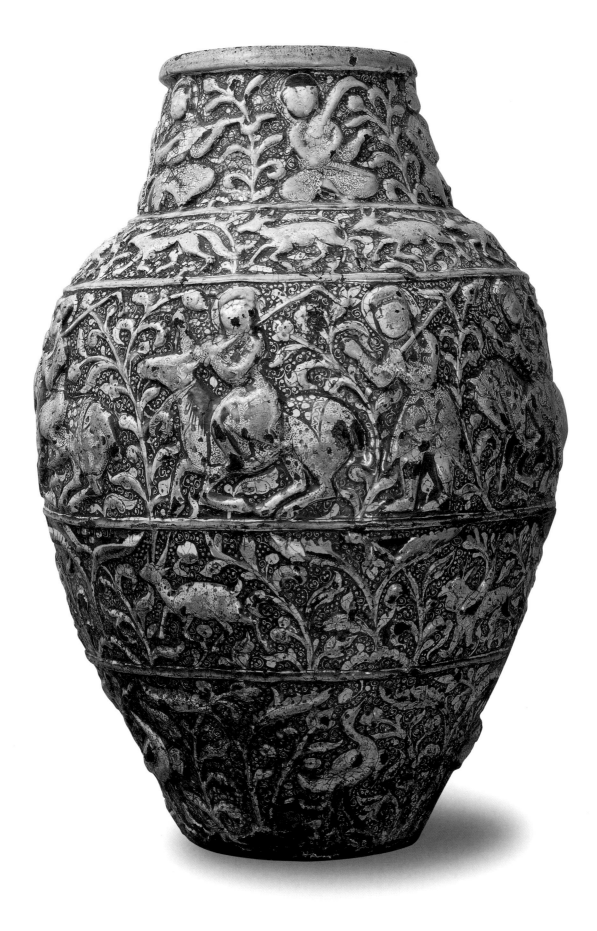

Sultan Mas'ud (AH 529–547/AD 1134–52), and as the two brothers engaged in a bloody struggle for the throne, it may be that Mas'ud had a monumental chess set made to commemorate these events, and his ultimate victory. Indeed, there is a Persian inscription on the figure's cloak that has not been fully deciphered, and it ends with the phrase, 'your heart on waves of blood', which would fit these circumstances. This figure may therefore be a 13th-century copy of one of the pieces in this hypothetical set.

M.R.

149

Large vase

Iran, mid 13th century

Faience ✦ Height 80 cm

The State Hermitage Museum, St Petersburg, inv.no. IR-1595

Provenance: transferred in 1885 from the A.P. Bazilevsky Collection, Paris.

Literature: Loukonine - Ivanov 1996, no. 138

In the mid 13th century Iranian potters were working at such a high level they were able to produce this magnificent large vase. Its size and ornamentation sets it apart from all other ceramics.

The vase is decorated with five bands, the broadest of which, around the belly, shows polo players on horseback. On the topmost band, around the neck, figures playing musical instruments are depicted. The three other bands are filled with animals and probably symbolize hunting. The vase as a whole is a eulogy on the pleasures of life.

In places the white/gold lustre glaze is flecked with blue. This may have been caused by a maker's error, or a deliberate addition to the glaze, in order to diminish the extravagant and luxurious character of this monumental vase.

A.I.

150

Alhambra vase

Granada, early 14th century

Faience ✦ Height 117 cm

The Hermitage, St Petersburg, inv.no. F-317

Provenance: acquired in 1885 from the A.P. Bazilevsky Collection, Paris

Literature: New York 1992, No. 111

The Alhambra vases are unquestionably some of the finest examples of ceramics produced in Spain under the Nasrid dynasty (1246-1492). Although traditional in form, their large size and unwieldy contours meant they were probably decorative rather than functional.

This magnificent vase, in exceptionally good condition, is one of the few examples of this monumental pottery to survive. It is known as the Fortuny Vase, after the painter who discovered and purchased it in 1871 from the El Salar church in the province of Granada. The vase had stood in the church for centuries, supporting a holy water basin. In 1875 Fortuny sold the vase to the Russian collector A.P. Bazilevsky whose collection was acquired by the Romanovs in 1885.

The decorative scheme is based on a series of horizontal bands. The two most important are in the centre; both contain inscriptions. These are bordered above and below by zones with arabesques. The upper of the two bands comprises a design of contiguous circles, each containing the word 'pleasure'. The lower band repeats the word 'health' in the Kufic script of Granada. The handles display the hand of Fatima, daughter of the Prophet Muhammad, above a 'sleeve' in the form of a schematically rendered Tree of Life. One of the handles is decorated with arabesques while the other incorporates an epigraphic motif which can be read as 'blessing'.

Similar Alhambra vases can be found in the Instituto de Valencia de Don Juan in Madrid, the Carthusian monastery in Jérez de la Frontera and the Galleria Regionale della Sicilia in Palermo.

J.V.

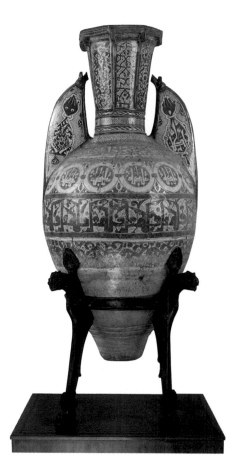

150

191

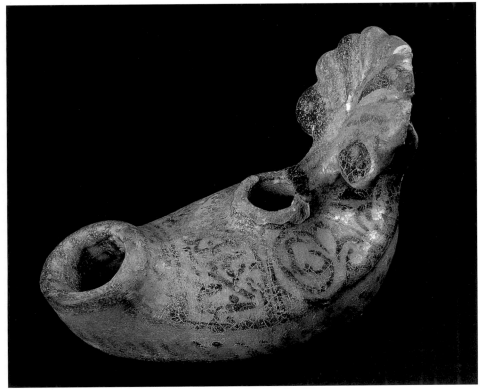

151

Lamp

Syria (Damascus), 13th-14th century

Ceramic ◆ Height 11 cm, length 15 cm

National Museum of Syria, Ministry of Culture,

General Directorate for Antiquities and Museums,

Syrian Arab Republic (Damascus), inv.no. 20891-A

Provenance: Damascus

This ceramic lamp has a spiral-shaped body,
two openings - one for the oil, the other for
the wick - and a pierced handle decorated
with a palm leaf. It is ornamented with
stylized floral and geometric motifs, plus
an inscription:

Favour to the owner

The decorations are black and blue on
a beige base under transparent glaze.

Ceramic objects such as this were generally
made under the Mamluks who ruled Syria
from 1260 to 1516.

M. AL M.

152

Dish

Syria, 14th century

Ceramic ◆ Diameter 27 cm, height 7 cm

National Museum of Syria, Ministry of Culture,

General Directorate for Antiquities and Museums,

Syrian Arab Republic (Damascus), inv.no. 19061-A

Provenance: Ar-Raqqa (northeast Syria)

Many cities in the Islamic world were famed
for their ceramics. These included Kashan
(Iran), Samarra' (Iraq), Ar-Raqqa and
Damascus (both in Syria). Ceramics with
black decorations under transparent blue
enamel were know as 'Raqqa ware' and
became widespread in the 14th century.

This dish has a central decoration of geo-
metric forms with stylized floral motifs,
surrounded by bands of geometric
decoration.

The rim is also ornamented with geometric
elements, plus an epigraphic inscription in
naskh script. All the decorations are black,
under a layer of transparent blue enamel.

M. AL M.

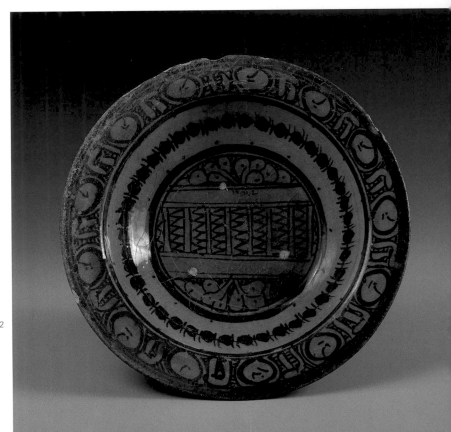

152

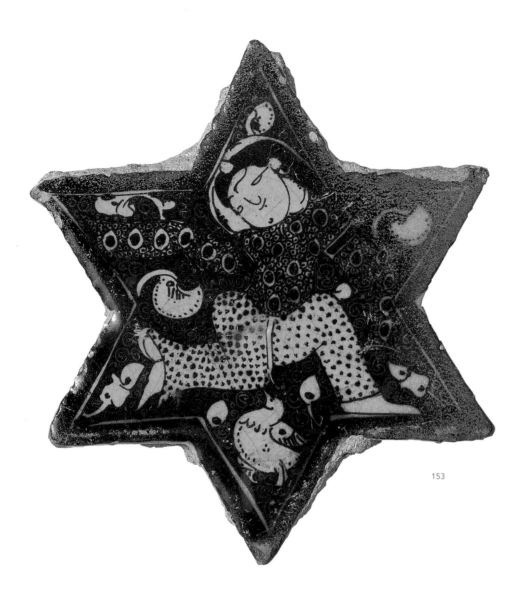

153

154

Tile

Iran, 13th century

Faience, enamel ◆ Diameter 10.3 cm

The State Hermitage Museum, St Petersburg,

inv.no. IR-1188

Provenance: transferred in 1925 from the Museum

of the former Baron A.N. Stieglitz School of

Technical Drawing

Literature: Kuwait 1990, no. 46

The shape of this tile is not the usual star,
but an octagon. It is a fairly rare type,
since it is painted with overglaze enamel,
a technique which is known to have been
used in the 13th century for painting vessels
(*compare cat.nos. 141-144*), but which was not
usually thought suitable for tile decoration.

A.I.

153

Tile

Iran, Kashan, early 13th century

Fritware, painted in chocolate lustre bleeding ruby

over an opaque white glaze ◆ Diam: 14.9 cm

The Nasser D. Khalili Collection of Islamic Art,

London, inv.no. POT 1477

Literature: unpublished

The six-pointed star tile shows a moon-
faced dancer, barefoot with spotted trousers
and a long-sleeved tunic above her waist
pulled aside by her gestures. The tile is
also decorated with a fat chicken and half
palmettes in reserve.

The tile would have been combined with
hexagonal tiles, doubtless in contrasting
colours, to achieve all-over tessellation.

M.R.

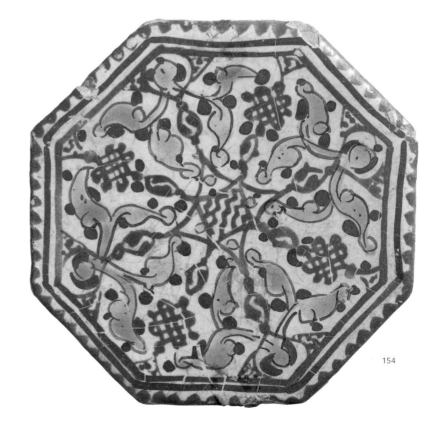

154

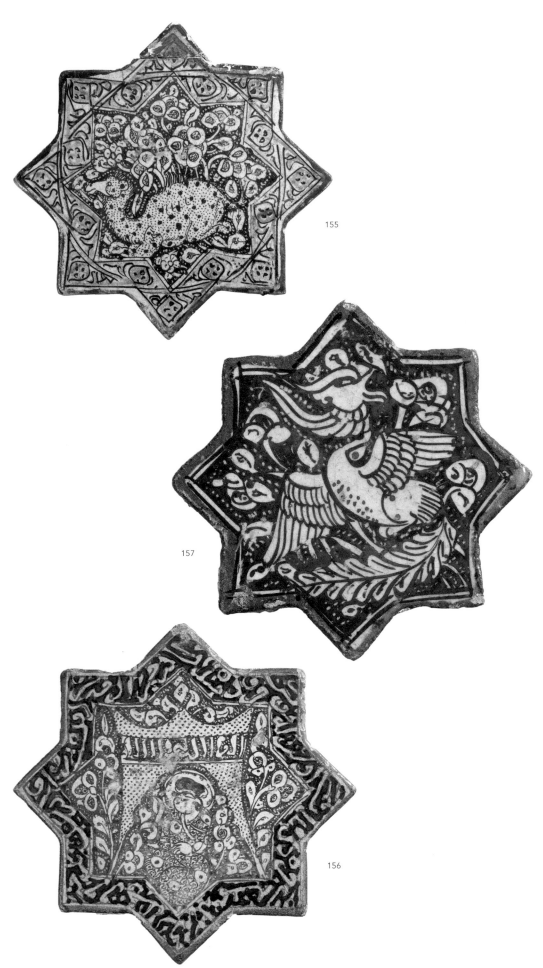

155

157

156

155

Tile

Iran, 2nd half 13th century

Faience, lustre, cobalt ◆ Hoogte 21 cm,
breedte 21 cm

The State Hermitage Museum, St Petersburg,
inv.no. IR-1275

Provenance: unknown; bought in 1936

Literature: Kuwait 1990, no. 47

This tile is similar in technique to the
example described above (*see cat.no. 154*),
although it has no inscription along the edge.
The ornamentation supports attribution to
late 13th-century Iran.

A.I.

156

Tile

Iran, 2nd half 13th century

Faience, lustre, cobalt ◆ Height 20.5 cm,
width 20.5 cm

The State Hermitage Museum, St Petersburg,
inv.no. IR-1179

Provenance: transferred in 1925 from the Museum
of the former Baron A.N. Stieglitz School of
Technical Drawing

Literature: Kuwait 1990, no. 44

In 13th-century Iran buildings were often
adorned with eight-pointed star tiles. The
tiles themselves were decorated in various
techniques, with Persian inscriptions running
around the edges, often verses by well-
known poets.

This tile is painted in overglaze lustre.
The verses inscribed along its edge are still
undeciphered. However, such inscriptions,
in large letters over a blue background, are
typical of the late 13th century.

A.I.

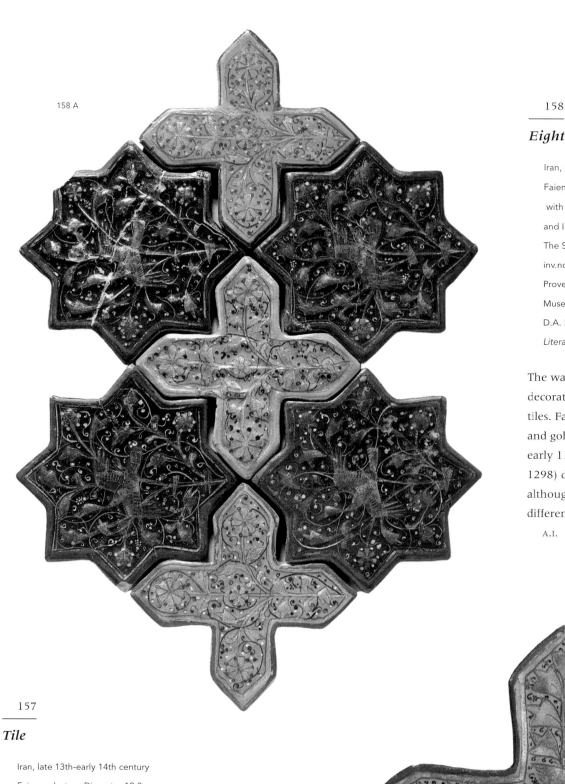

158 A

Eight tiles

Iran, early 14th century

Faience ◆ Each tile: height 15 cm, width 15 cm,
with the exception of IR-1296 (14.5 x 14.5 cm)
and IR-1298 (20 x 19.6 cm)

The State Hermitage Museum, St Petersburg,
inv.nos. IR-1291-1298

Provenance: transferred in 1932 from the State
Museum Fund (five tiles are marked 'ex-libris
D.A. Benckendorff')

Literature: unpublished

The walls of various buildings were
decorated with such stellate and cruciform
tiles. Faience objects with dark-blue glaze
and gold inscriptions are typical products of
early 11th-century Iran. The largest tile (IR-
1298) did not originally belong to this series,
although its inscriptions are technically no
different from those on the other tiles.

A.I.

157

Tile

Iran, late 13th-early 14th century

Faience, lustre ◆ Diameter 12.2 cm

The State Hermitage Museum, St Petersburg,
inv.no. IR-1186

Provenance: transferred in 1925 from the
Museum of the former Baron A.N. Stieglitz
School of Technical Drawing

Literature: Kuwait 1990, no. 45

This small tile, with its stylized represen-
tation of a bird, is painted with lustre and
may be regarded as typical of late 13th-or
early 14th-century manufacture.

A.I.

158 B

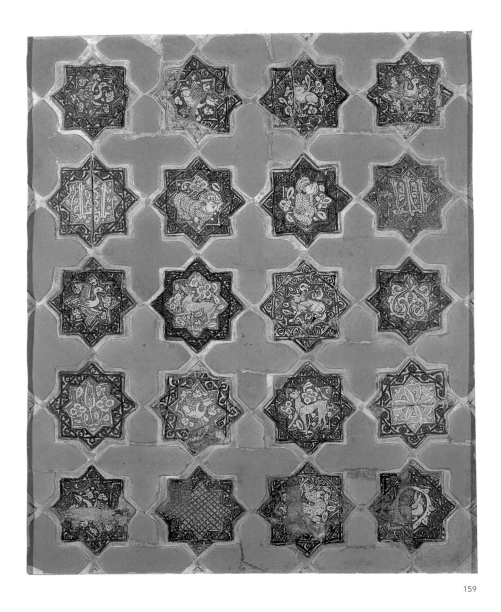

commissions. Unlike the mosque lamp, however, the interior and exterior decoration exuberantly combines green and blue saz leaves (*see cat.no 162*), lotus blossoms, prunus, carnations, hyacinths and purple tulips with arabesque medallions. Atasoy and Raby have noted that this basin's less restrained decoration is the result of its intended use in a secular setting. Certainly many of the motifs present on the basin recur on Iznik dishes, jugs and bottles of the 1550's which would have been employed domestically. The basins' function, however, is debatable. J.M. Rogers has proposed that the Turkish description of 'foot basins' may refer to objects such as these in which the Ottoman royalty soaked or washed their feet, rather than simply deep bowls on high foot rings.

SH.C.

159 160

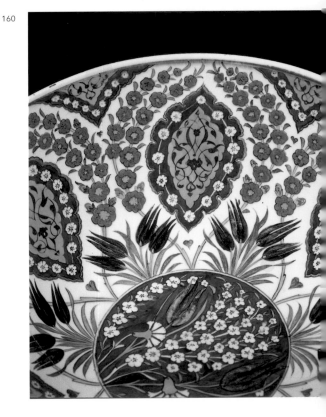

159

Tile panel

Iran, early 14th century

Faience ◆ Height 69.5, width 5 cm

The State Hermitage Museum, St Petersburg,

inv.nos. IR-1390-1419, IR-1621-1665

Provenance: transferred in 1925 from the Museum of

the former Baron A.N. Stieglitz School of Technical

Drawing

Literature: unpublished

Tile panels of this type, bearing represen-
tations of living creatures, inscriptions or
ornaments, were used to decorate large
surfaces on the walls of secular buildings.

A.I.

160

Footed basin

Turkey, 1545-50

Ceramic, stonepaste body, underglaze decoration,

transparent colourless glaze ◆ Height 27.3 cm,

rim diameter 42 cm, foot diameter 19.6 cm

The British Museum, London, inv.no. 1983.66

Provenance: Godman Collection

Literature: Lane 1957, fig. 37; Atasoy - Raby 1989,

no. 358; Carswell 1998), fig. 45

This large and impressive basin on a high,
flaring foot has been attributed to Musli,
the designer of the mosque lamp dated
AH 956/AD 1549 (*see cat.no. 8*). Its size and
decoration leave little question that this
and two related basins were imperial

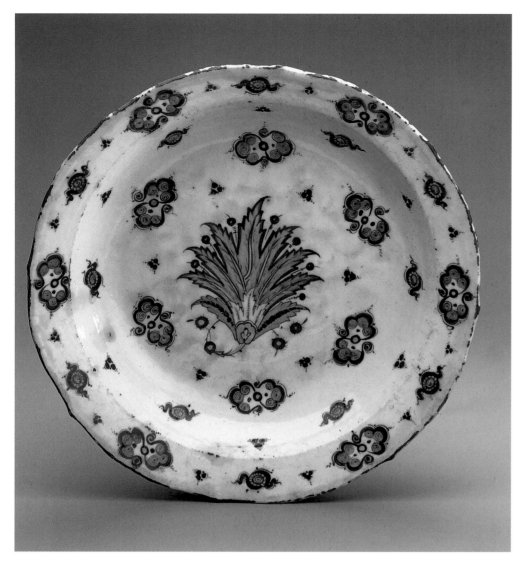

161

162

Plate

Ottoman Turkey (Iznik), 2nd half 16th century

Fritware, glazed ◆ Height 29 cm

Benaki Museum, Athens, inv.no. 27

Literature: unpublished

An Iznik plate ornamented with flowers over a white slip under a transparent glaze. The centre is decorated with a serrated leaf known as a *saz* leaf, red roses, a tulip and blue garden flowers, all of which rise from a central leafy tuft. Around the rim is a stylized wave-and-rock design. The reverse is decorated with small blue leaves alternating with small blue circles. This is a typical plate from the second half of the 16th century with a vivid palette and asymmetric design dominated by the saz leaf in the centre. The leaf is surrounded by swirling flower stems which convey a sense of movement.

M.M.

162

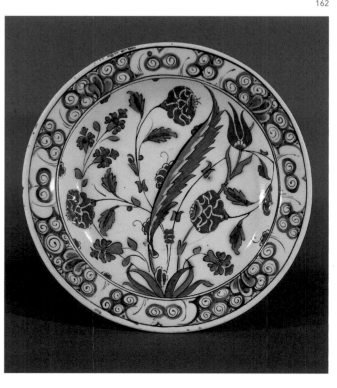

161

Dish

Turkey (Iznik), mid 16th century

Faience ◆ Diameter 38 cm

The State Hermitage Museum, St Petersburg, inv.no. T-35

Provenance: transferred in 1925 from the Museum of the former Baron A.N. Stieglitz Technical Drawing School

Literature: Kverfeldt 1947, tab. XXIV; Miller 1972, p. 40; Kuwait 1990, no. 85

In shape, colours and ornamentation, this dish is typical of Iznik 16th-century faience pieces.

A.I.

197

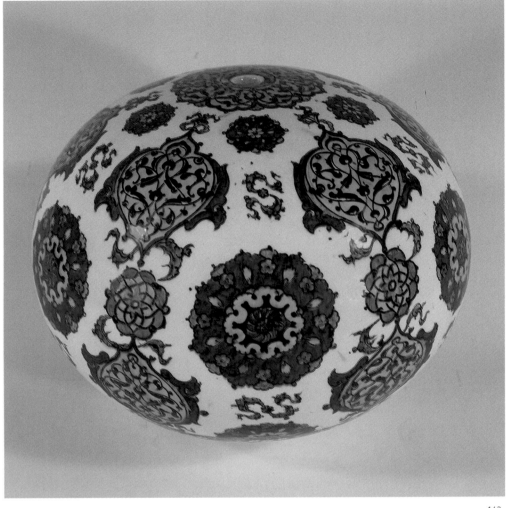

163

164

Jug

Turkey (Iznik), final quarter 16th century

Fritware (quartz, clay, and glaze frit), with colors

painted on white slip under clear glaze ◆

Height 23.5 cm, diameter 14.6 cm

Museum of Fine Arts, Boston, Gift of

George W. Wales, inv.no. 85.482

Literature: Unpublished. See also: Atasoy - Raby

1989; Paquin 1992, pp. 104-119

After 1550, the chromatic range of Iznik
ceramics expanded to include an emerald
green and a thickly applied, brilliant red
that stood up in relief. The colourful tiles
and tablewares of this period were most
often decorated with stylized flowers but in
some cases featured animals, boats, or
abstract forms.

Although they have been termed lips,
waves, or clouds, the motifs on this jug are
probably excerpted from a more complex
design known as *çintamani*. Consisting of
paired, wavy lines combined with trios of

163

Hanging ornament

Turkey (Iznik), mid 16th century

Fritware, glazed ◆ Height 23 cm

Benaki Museum, Athens, inv.no. 9

Literature: Macridy 1937, p. 136; Lane 1957-II;

Frankfort 1985, fig. 2/16, p. 145; Atasoy - Raby,

fig. 263, p. 142; Carswell 1998, fig. 42, p. 67

A hanging ornament from a mosque,
decorated with turquoise cartouches, a
fine black arabesque design, rosettes, large
and small circular stylized flowers and
cloud bands below a band divided into
cartouches with small flowers alternating
with manganese brown flowers. This
ornament was intended to be viewed from
below so the top is undecorated and has
three large spur marks. Although the overall

decoration of the sphere is relatively austere
and restrained in comparison with the
elaborate floral designs on Iznik ware of
the same period, certain details such as the
floral motifs date it to the mid 16th century.
The decoration is similar to that on a mosque
lamp in The British Museum dated 1549
(*see cat.no. 8*), so this ornament may be a
product of the same workshop.

M.M.

164

balls, the origins of çintamani seem to lie in
both Buddhist jewel imagery and the spots
and stripes of leopard and tiger skins that
clothed the Iranian epic hero, Rustam.
With possible apotropaic connotations and
uncontestable visual power, çintamani
became a decorative staple of 16th-century
Ottoman art; the items which it decorated
ranged from kaftans and carpets to inlaid
furniture. After 1550, Iznik artists likewise
featured the çintamani design on their
tiles and wares, or used its elements – in
particular the paired stripes – as independent
motifs.

J.B.

165

Jug

Turkey (Iznik), final quarter 16th century

Fritware (quartz, clay, and glaze frit), with colours

painted on white slip under clear glaze ✦

Height 21.4 cm, diameter 13.3 cm

Museum of Fine Arts, Boston, Gift of

George W. Wales, inv.no. 85.481

Literature: unpublished. See also: Atasoy - Raby 1989

From the latter part of the 16th into the
17th century, Iznik tankards, bottles, dishes,
and jugs were often decorated with fleets
of *dhow*-like, lateen-rigged boats, their
triangular sails typically sporting jaunty blue
stripes.

Irregular red and green motifs between
the boats on this jug represent islands;
on slightly earlier Iznik wares of the same
type, the intervening shapes are larger, with
discernable rocky contours and, on at least
one tankard, trees and towers.

J.B.

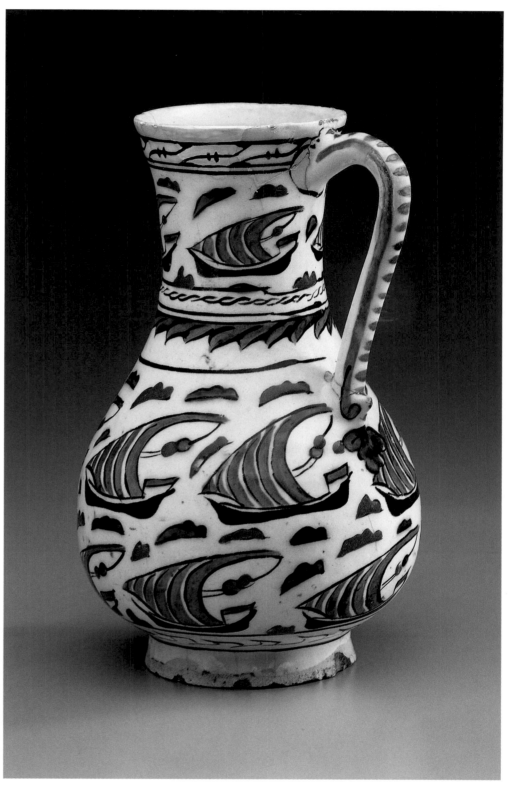

165

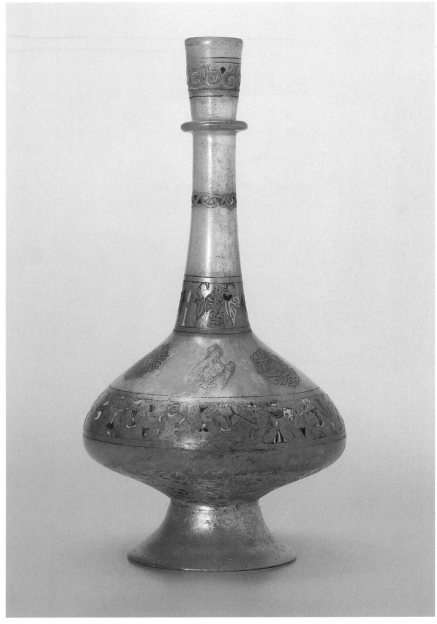

166

Middle Ages. On the belly is a frieze of drinkers and musicians with cups and flasks, three of which are similar in shape to the present vessel, of ruby wine, on a gold ground with enamelled details.

Comparable 'Christian' figures also appear on a pilgrim flask in Vienna (Dom- und Diözesan-Museum L.6), presented to the Cathedral of St. Stephen by the Archduke Rudolph IV and datable *circa* 1310, and on a drinking horn now in the Hermitage, St Petersburg (*see cat.no. 167*). They are not, however, so similar as to demonstrate that the three vessels are all from the same workshop.

M.R.

168

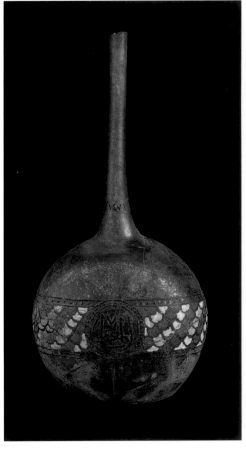

166

Flask

Syria-Palestine, circa 1280–1310

Colourless glass, with silvery-white iridescence inside and out; blown, tooled and enamelled in opaque white, red, blue, green and yellow on gold, with contours finely drawn in brownish red ✦

Height 34.5 cm

The Nasser D. Khalili Collection of Islamic Art, London, inv.no. GLS 350

Literature: unpublished. See also: Kuba-Hauk 1987, pp. 23–24 and figs 16–26

The pyriform flask stands on a high flaring foot which retains a pontil-scar, which marks the place where the piece was removed from the glassblower's stick. The rim has a gilt edge and flares slightly above the flange on the tall neck. The neck is decorated below the rim with a frieze of palmettes in white, with a guilloche band below that. At the base of the neck is a frieze of 'Christian' figures with Western European coiffures and coloured shawls or stoles. On the shoulder, seven-pointed star interlaces alternate with pelicans, the widely used symbol of Christ the Redeemer in the Western European

167

Drinking horn in silver mount

Syria, 14th century (glass); Germany (?), 1551 (frame).

Glass, enamel, silver, gilt ◆ Height 29.5 cm

The State Hermitage Museum, St Petersburg,

inv.no. VZ-827

Provenance: transferred in 1860 from

Peter the Great's Cabinet of Curiosities

Literature: St Petersburg 1998, no. 68

This glass horn with its Arabic inscription
and pictures of Christian saints was made,
presumably for a Christian client, in 14th-
century Syria. The Arabic inscription does
not refer directly to Islam.

What journeys this drinking horn under-
went before the 16th century are not
known. By this point it had arrived in the
Baltic states of Latvia and Lithuania, which
then bordered on lands belonging to the
Ottoman Empire. It is possible that one
of the last knights of the Teutonic Order
drank from this horn in celebration of a
final victory. To judge from the inscriptions
the silver-gilt mount was commissioned in
1551 by Bruno von Drolshagen. In view of
the style and technique, it was probably
made in Germany. The figures of the saints
and the divine supreme power presiding
over the world are unmistakably Christian
elements, which reinforce the symbolism
of the glass horn.

A.I.

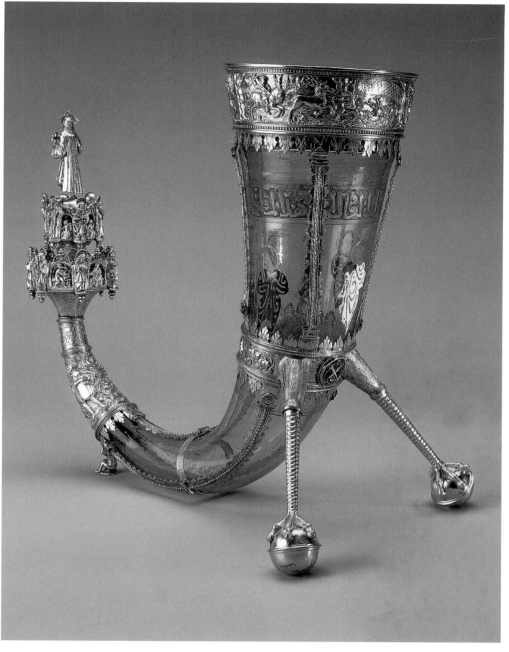

167

168

Qumqum
(bottle with narrow neck)

Syria (Aleppo), 13th-14th century

Glass ◆ Height 18.5 cm

National Museum of Syria, Ministry of Culture,

General Directorate for Antiquities and Museums,

Syrian Arab Republic (Damascus), inv.no. 9090-A

Provenance: Aleppo

This bulbous glass bottle with a long narrow
neck, known as a *qumqum*, is decorated with
a band of scale-like ornamentation. In the
centre of this band are two circles with
inscriptions. The first reads:

The greatest.

The second:

Glory to our Lord.

These indicate that the bottle once belonged
to a prince or ruler. The decorations are
executed in green, white and dark-blue
enamel. Such bottles were generally used
for perfume.

M. AL M

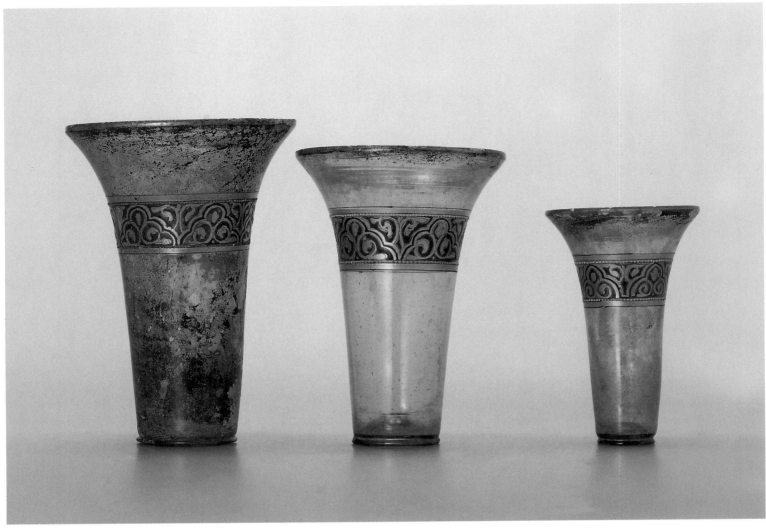

169

169

Three beakers

Syria-Egypt, circa 1300

Transparent, rather bubbly glass with a yellowish-brown tinge, blown and decorated in thickly applied red, blue and white enamels and gold ◆

Height 18 cm, diameter 12.7 cm (GLS 578a)/

Height 15.8 cm, diameter 11.4 cm (GLS 578b)/

Height 12.5 cm, diameter 8.4 cm (GLS 578c)

The Nasser D. Khalili Collection of Islamic Art, London, inv.nos. GLS 578 a–c

Literature: Cambridge 1978, no. 132a; Lucerne 1981, no. 631; Khalili Collection 1993, p. 54

The three beakers come from a stacking set. They are trumpet-shaped and the small pad base has a domed kick with a pontil-scar

(see cat.no. 166). The decoration consists of a single frieze of scrolling palmettes, with bands of white dots and of gilt above and below. There are traces of gilding at the rim and, on the second largest, round the base pad.

A beaker with identical decoration, probably the second smallest of the original group of four, is in Kuwait (Al-Sabah Collection, no. K97g); another, but of rather squatter form, was also sold at Sotheby's, London (sale of 12 October, 1981, lot no. 75). A fragmentary beaker with similar decoration is in Cambridge (Fitzwilliam Museum, C.I.C. 1940).

M.R.

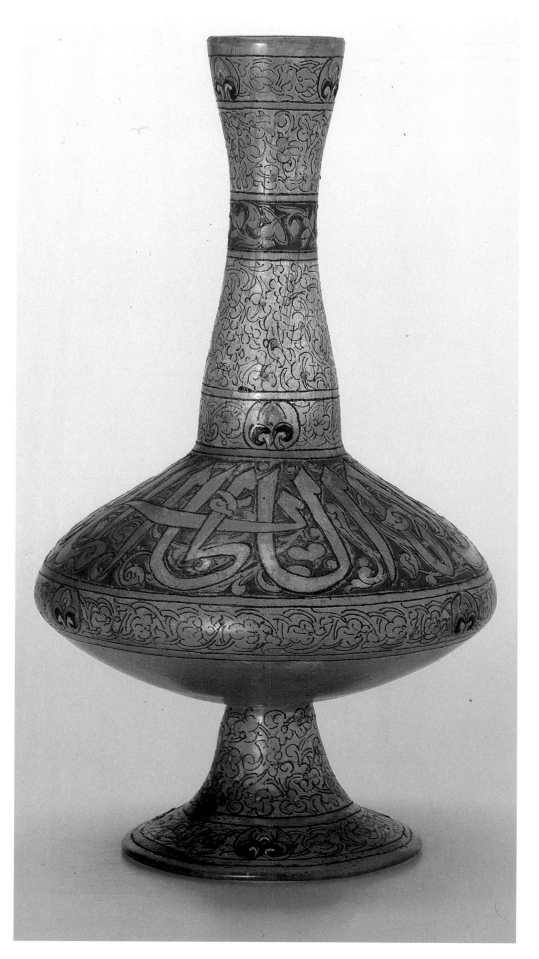

170

Flask

Egypt, circa 1300-1350

Slightly brownish bubbly glass, blown and tooled;
with opaque red, white, blue, green and yellow
enamels ◆ Height 28.4 cm

The Nasser D. Khalili Collection of Islamic Art,
London, inv.no. GLS 172

*Literature: Atil 1975, no. 74, p. 138; Christie's 1988,
lot no. 357*

The flask has a depressed globular body,
tapering neck flaring at the rim and a high
flaring foot. There is no pontil-scar: the foot
was made separately and joined to the body.

The neck bears bands of dense vine scroll
in red between bands with fleurs de lis at
the rim and the base. The shoulders have
an inscription showing traces of gilding,
in reserve on a ground of spiral scrolls:

*Glory to our Lord the Sultan, the king, the
learned, the just.*

The foot bears more vine scrolls, enhanced
with enamelled dots and a border with fleurs
de lis.

A much larger and more highly decorated
flask in Washington, D.C. (Freer Gallery of
Art, no. 34.20), but with a fleur de lis on
the neck, bears the name of the fifth Rasulid
Imam of the Yemen, Sayf al-Din 'Ali
(r. 1322–63). The lack of a ruler's name
on the present piece may reflect the
Rasulids' somewhat ambiguous status in
Mamluk eyes.

M.R.

170

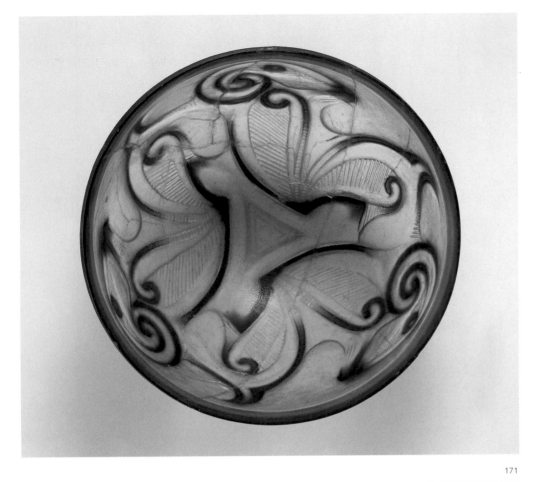

171

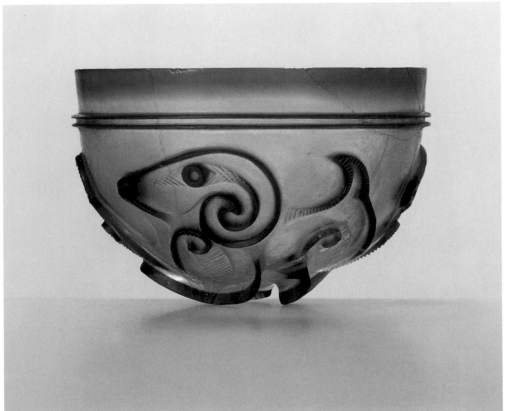

171

Cup or bowl

Probably Fatimid Egypt, circa 1000

Deep blue glass over a colourless matrix, mould-
blown, lathe-turned and relief-cut (cameo technique)

Height 6.8 cm, diameter 9.9 cm

The Nasser D. Khalili Collection of Islamic Art,
London, inv.no. GLS 550

Literature: Wiet 1930, no. 90; Cairo 1969, no. 159;
London 1976-I, no. 130; Khalili Collection 1993, p. 56

This is probably the most important piece
of Islamic cameo-cut glass in existence. The
colourless matrix was first blown in a mould,
after which it was dipped in a layer of blue
glass. The bold design was created by cutting
away most of both layers to leave the pattern
standing in relief, to a depth of 1 cm in
places.

The bowl is decorated below the rim with a
double ridge and then with a whirling design
of three ibexes round a central triangle.
A circular depression in the middle of the
triangle marks the point where the vessel
was evidently turned on the lathe. Some
contours are rouletted, and other details are
hatched. The treatment strongly recalls the
post-Samarra style as it was adapted, for
example, for Fatimid woodwork. Somewhat
comparable is a fragmentary cameo-cut cup
or bowl in the Islamic Museum in Cairo
(no. 2463), though that has rather more
in common with Fatimid rock-crystals of
circa 1000.

M.R.

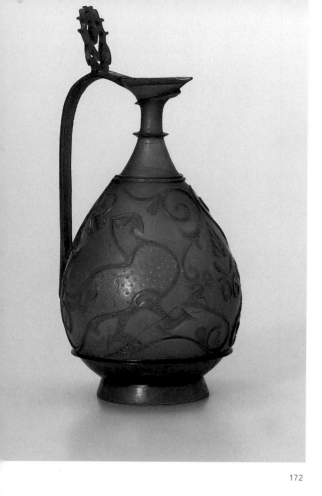

172

172

Small ewer

Probably Fatimid Egypt, circa 1000
Deep blue glass, mould-blown, with linear-, chip-
and relief-cut decoration ◆ Height 18.5 cm
The Nasser D. Khalili Collection of Islamic Art,
London, inv.no. GLS 551
*Literature: London 1976-I, no. 130; Khalili Collection
1993, p. 56; Contadini 1998, figs. 15, 16 and pl. 7*

The shape of the ewer is very close to a series
of rock-crystal ewers associated with Fatimid
Egypt, even to the everted pointed oval
mouth and the flanges below it, although
the neck in this example is markedly narrow
and elongated.

The body has two confronted pouting birds
of prey separated by a palmette tree enclosed
within s-scrolls. The bodies of the birds are
filled with small circular depressions, similar
to those found on a cameo-cut cup in Cairo
(Islamic Museum, no. 2463). The relief-cut
outlines are partly rouletted. The strap
handle has cut decoration and an openwork

thumb-rest or finial. The foot has a central
circular depression underneath.

M.R.

173

Ewer

Egypt, or Iran, circa 1000
Aubergine glass, mould-blown, with relief-cut and
openwork decoration; the thumb-rest and sections of
the handle are restorations ◆ Height 25.2 cm
The Nasser D. Khalili Collection of Islamic Art,
London, inv.no. GLS 589
*Literature: unpublished. See also: Contadini 1998,
figs. 19, 20*

The short-necked pyriform ewer has an
everted pointed oval mouth, a flaring foot
and a carved openwork handle with vertical
finial. There are two angular flanges below
the rim. The centre of the base is recessed
and the pontil scar (*see cat.no. 166*) has largely
been drilled away. The shape may be com-
pared to a cameo-decorated ewer in the
Corning Museum of Glass (no. 85.1.1), and
a fragmentary relief-cut ewer in the Victoria
and Albert Museum (the so-called 'Buckley
ewer', C.126-1936).

The body bears confronted ibexes, their
heads turned backwards. Their great spiral
horns are surmounted by a central triangular
spike. Between them is a Tree of Life, with
wheel-cut details, composed of confronted
tendrils with arrow-shaped half-palmettes.
The contours are mostly rouletted.

M.R

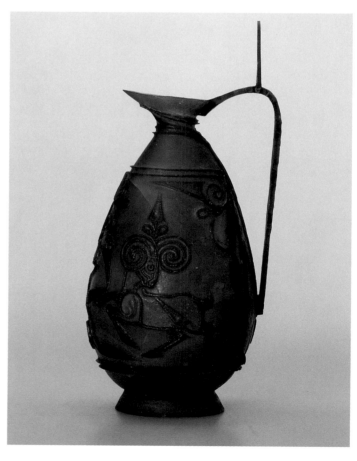

173

205

174

Large bowl

Egypt or Iran, circa 1000
Pinkish glass over a colourless matrix, mould-blown
and relief-cut (cameo technique) • Height 8.3 cm,
diameter 19.5 cm
The Nasser D. Khalili Collection of Islamic Art,
London, inv.no. GLS 585
*Literature: Flury 1920, Tafel XV; Khalili Collection
1993, p. 53*

The is the largest known piece of Islamic
cameo-cut glass. Its walls are exceptionally
thin, being no more than 0.1 mm in places,
and although broken and repaired, it has
survived almost complete.

The bowl has rounded sides and a profiled,
slightly everted rim; the low foot has been
lathe-turned. The exterior bears a benedic-
tory inscription,

*Blessing, and good fortune, and good fortune
(?), and grace, and joy, and happiness, and
well-being, and long life to its owner.*

Below the inscription are scrolling
compositions made up of double and
reversed curves, with lozenges between.

The inscription is in floriated Kufic script.
Some letters have fan-like engraving, others
stylized palmettes, and ascenders terminate
in horizontal half palmettes: the swan-like
appearance of some of the letter forms may
be deliberate. No parallels for the style of the
inscription are known on glass, but letters
with fan-shaped terminals, albeit much less
exaggerated, can be seen in a carved wooden
inscription of the first half of the 11th
century, in the Maqsura of Sidi Oqba in
Kairouan (Tunisia).

M.R.

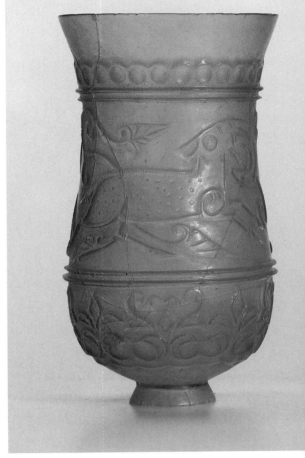

175

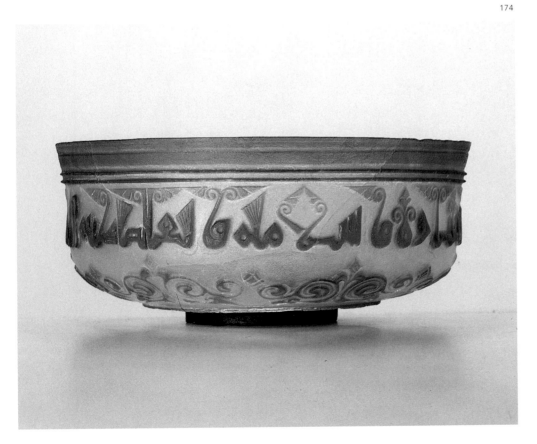

174

175

Beaker

Iran (?), circa 1000
Yellowish-brown glass, mould-blown and relief-cut
Height 13.4 cm, diameter 13.4 cm
The Nasser D. Khalili Collection of Islamic Art,
London, inv.no. GLS 351
Literature: unpublished

The tulip-shaped beaker rests on a low
footring which has been applied and ground
down. The main band of decoration is of
two running ibexes, their heads turned
backwards, with rouletted outlines and
incised dots on the body, on a ground of
rather stiff palmettes. Below this, on the
swelling base, are running stylized palmettes,
some with bird-headed terminations. Below
the rim is a band of concave discs.

M.R.

In the ancient Islamic legal code, systematized in *shari'a*, the decoration of a tomb or grave is prohibited. It was permitted to mark a grave with a stone or a piece of wood, but not to give the name of the buried person. Nevertheless, there is a long tradition of decorating graves with carved stone, often with verses from the Qur'an and even the name of the dead person, and a list of his or her good deeds. Mausoleums were sometimes erected for high-placed officials and Islamic saints, despite the commandment that graves should stand open under the sky. The most renowned of these grave monuments are the Taj Mahal in Agra (India) and the Dead City of the Mamluks in Cairo.

Just as inside a mosque, a mausoleum generally contains a *mihrab*, a prayer niche, as sign of the gateway to Paradise. There will also be a lamp, symbolizing the presence of God. Verses from the Qur'an, written in calligraphy, together with the statement of faith 'There is no God but Allah and Muhammad is His Prophet' decorate the walls. At the centre of the mausoleum stands an impressive tomb, decorated with patterns and writing.

Generally, mausoleums are set in a garden, a reference to the Paradise that awaits the righteous Muslim after death.

J.V.

The mausoleum

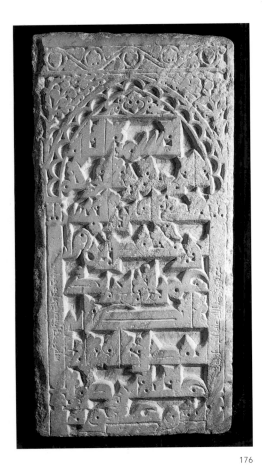

176

177

Funerary stele

Egypt (?), AH 252/AD 866

Marble ◆ Height 92 cm, width 55 cm

Benaki Museum, Athens, inv.no. 10771

Literature: Cairo 1932, no. 472

A funeral stele carved in low relief with
a sixteen-line inscription in floriated
Kufic script which mentions the name of
al-Husain, son of Yusuf, son of Yazid, son
of al-Garrah al-Khurasani and the date
AH 252. The text is evenly distributed
over the surface and decorated with half
palmettes.

Although Islamic tradition (*Hadith*) prohibits
the embellishment of graves, this prohibition
is widely disregarded in Islamic societies,
particularly Shiite ones where it is common
custom to mark a place of burial with a
funerary stele. Some stelae are inscribed
with beautiful calligraphy and are remark-
able works of sculpture.

M.M.

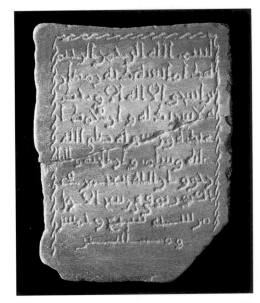

178

176

Funerary stele

Egypt, AH 249/AD 863

Marble ◆ Height 100 cm, width 50 cm

Benaki Museum, Athens, inv.no. 10770

Literature: Cairo 1932, no. 495; Macridy 1937, p. 116

This funerary stele is carved in high relief
with a nine-line inscription in foliated Kufic
script which mentions the name of al-
Hassan, son of Hafs, son of Yazid al-Tai and
the date AH 247. The text is set under a
pointed, cusped arch that rests on two
columns with capitals in the form of two
stylized leaves. The upper part of the stele
is decorated with leafy branches and an
undulating stem with five-lobed leaves
alternating with half leaves. In the Islamic
Museum in Cairo there are several funeral
stelae with similar decorations surrounding
text, dating from approximately the same
period.

M.M.

177

178

Funerary stele

Egypt, AH 257/AD 871

Marble ◆ Height 42 cm, width 31 cm

Benaki Museum, Athens, inv.no. 10775

Literature: Cairo 1932, no. 617

A funerary stele carved with a ten-line Kufic
inscription inside a rope pattern around
three sides. The text mentions the name of
Ramadan, son of Ishaq and the month Rabi
al-awal 257 (871 AD). The text on such
stelae from the early periods follows a
standard formula which begins with the
basmala ('In the name of God, the Merciful,
the Compassionate') and includes the name
of the deceased, confirmation of his faith
through quotations from the Qur'an,
blessings and eulogies, and the month and
year of death. The rope pattern is a frequent
device, especially on stelae found in Egypt.

M.M.

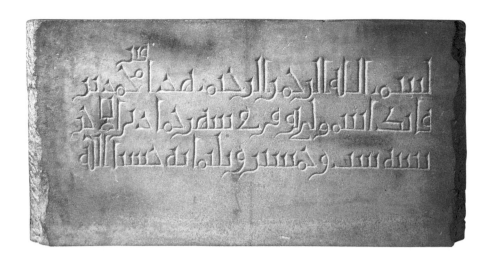

179

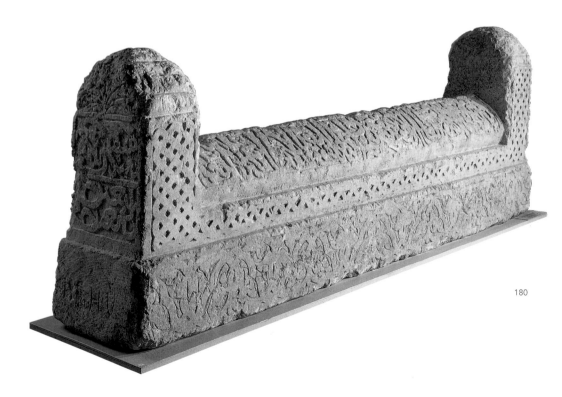

180

180

Gravestone

Khanate of the Golden Horde (Solkhat,
now Staryy Krym in the Crimea), AH 776/AD 1374-75
Sandstone ✦ 80 x 45 x 216 cm
The State Hermitage Museum, St Petersburg
Provenance: brought back in 1981 from Staryy Krym
by The Hermitage Expedition
Literature: Akchokrakly 1927

The form of this stone is characteristic of
gravestones from Solkhat which date from
the late 13th or 14th century. The inscrip-
tions are in a Turkic language, *Çagatay*.
They have not, however, been completely
deciphered. Some of the inscriptions
comprise verses; at the end a specific
alamdar or standard bearer is mentioned.

A.I

179

Panel from a cenotaph

Made for the grave of Muhammad
b. Fatik al-Ashmuli
Egypt (Cairo), AH 356/AD 967
Marble ✦ Height 45 cm, length 76 cm,
thickness 5.3 cm
The British Museum, London,
inv.no. OA 1975 4-15, 1
Provenance: Acquired by The British Museum
in 1975 from the Brooke Sewell Fund
Literature: Phillips 1995 no. 7.48

Rectangular marble panel carved with
ornamental Arabic inscriptions in Kufic
script. The panel would have been at the
head of a four-sided open cenotaph placed
around the grave of the deceased. The
inscription on the exterior is carved in high
relief and consists of the beginning of the
basmala ('In the name of God, the Merciful,
the Compassionate'); it would have
introduced a verse from the Qur'an which
continued on the exterior surface of the
three missing panels. The inscription on the
interior is incised into the stone; it again
begins with the *basmala* then gives the name
of the deceased, Muhammad b. Fatik
Ashmuli and the date of his death in the
month of Jumada II 356 AH (967 AD).

Similar panels in the Islamic Museum and
the Gayer Anderson Museum in Cairo
confirm that there was an active school of
stone carvers producing open cenotaphs in
this style for the citizens of Fatimid Cairo in
the 10th century.

R.W.

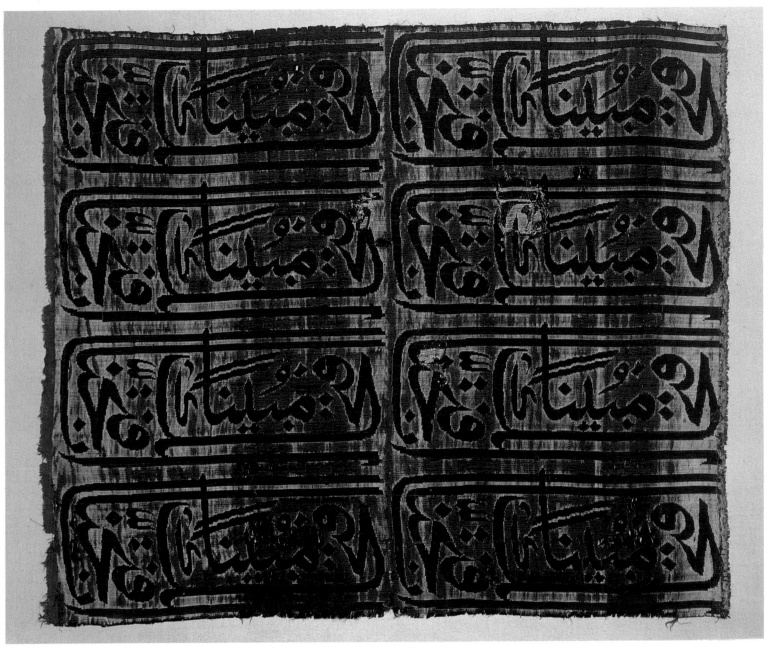

181

181

Silk textile

Iran, early 18th century

Silk, of weft-faced compound tabby weave ◆

Height 40 cm, width 35 cm

The Nasser D. Khalili Collection of Islamic Art,

London, inv.no. TXT 74

Literature: Welch 1979, no. 64

This crimson silk is decorated with eight repeats of a calligraphic design in which the letters were manipulated to create the semblance of a cartouche. The script is in the *thuluth* style, and the text employed is a Qur'anic quotation, being the first verse of the *Surat al-Fath* ('Victory'; XLVIII): *inna fatahna laka fathan mubinan* ('Surely We have given thee a manifest victory.'). The words *inna fatahna* and *laka fathan* are similar in form, and they have been arranged at either end of the 'cartouche' to suggest a mirror image, while the word *mubinan* ('manifest') takes the centre.

A similar textile in the Musée Historique des Tissus in Lyons bears the date AH 1123/AD 1711-12; it has been suggested that they are sections from tomb covers.

M.R.

182

Incense burner

Syria, 8th-9th century

Quaternary alloy, piece-cast, with openwork
and surface engraving ◆ Height 26.6 cm

The Nasser D. Khalili Collection of Islamic Art,
London, inv.no. MTW 1044

Literature: unpublished. See also: Atil 1975, no. 8;
Allan 1986, pp. 25–34

The cylindrical base of the incense burner
rests on three feet and its cover is in the form
of a quadripartite domical vault, surmounted
by a stylized eight-petalled lotus with drop-
like tips. The divisions between the segments
of the vault are clearly marked.

The openwork decoration of both the base,
which is surmounted by stepped crenel-
lations, and the handle is an arcade of
rounded arches with prominent imposts,
alternating with rectangular openings.
The 'drum' of the domical vault bears lightly
engraved acanthus fronds, the segments of
the vault having openwork lozenge diapers
with acanthus borders and toppings. The
classicising motifs strongly recall both the
Åby incense-burner in Denmark and the
monumental incense burner in the Freer
Gallery of Art in Washington, D.C.(52.1),
though these are treated in more three-
dimensional fashion, which seems to relate
them to early Islamic Egypt with its strong
Coptic tradition. Here the treatment may
point to Syria in the same period (8th-9th
century).

M.R.

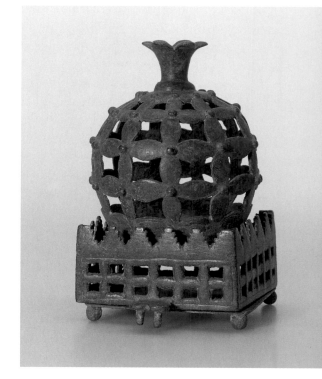

183

182

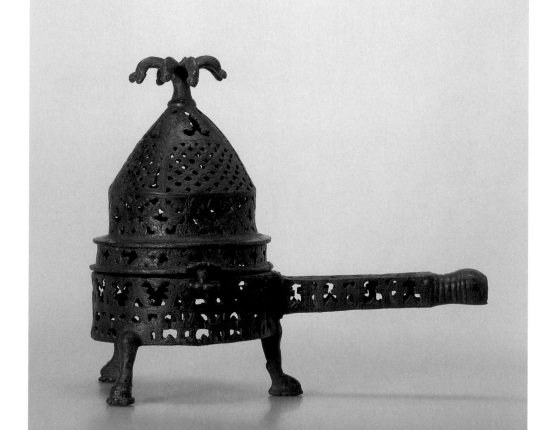

183

Small incense burner

Iran, 10th-11th century

Quaternary alloy, piece-cast ◆ Height 14.5 cm

The Nasser D. Khalili Collection of Islamic Art,
London, inv.no. MTW 1065

Literature: unpublished. See also: Folsach 1990,
p. 191; Allan 1986, p.32, fig. 23

The incense burner has a square base, with
a spherical dome and lotus finial in the form
of a pomegranate riveted to it. The dome
resembles a lattice of metal strips held to-
gether by rivets – a similar method of con-
struction can be seen on a brazier in the
Copenhagen (David Collection, no. 64/
1979). The body has small oblongs executed
in openwork and is surmounted by stepped
crenellations. The base is hinged, doubtless
to allow the insertion of a separate coal-box.
A hasp with two prongs must have served
to attach a handle which would have
simultaneously held the base in place.

This is an ingenious version of the standard
domed incense burner surmounted by a

211

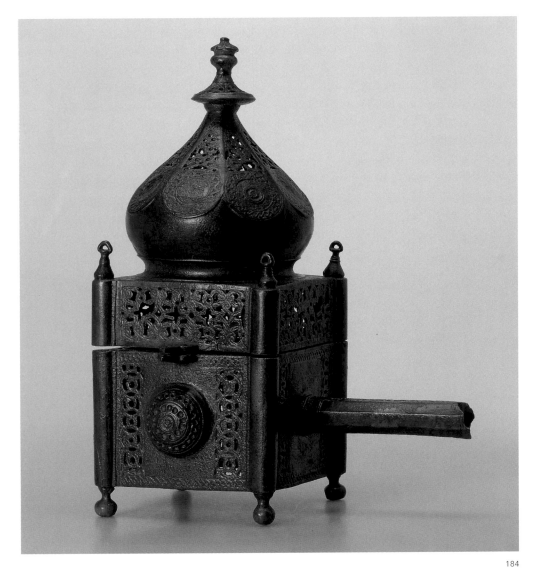

184

central rounded bosses with chip-cut decoration of small circles – reminiscent of the chip-cut decoration of high-tin bronzes of 11th-12th century Khorasan. The hinged lid has side panels of openwork interlace, while the eight-faceted pointed dome has further openwork, with circular medallions below. Inside, the base of the coal-box with chamfered sides is filled by a circular medallion with concentric bands of ring and dot ornament and small chip-cut circles. The dome is surmounted by a finial on a base of openwork palmettes.

Technically and decoratively, the piece is transitional between the high-tin bronzes of 11th-12th century Khorasan and the more elaborate cast and engraved brasses of the later 12th century. The faceted dome, misleadingly Mughal Indian in its form, is, for its period, sheer fantasy, and the relation of this group of incense burners to actual domes therefore quite distant.

M.R.

185

Lamp

Signed by the craftsman 'Izz ad-Din ibn Taj ad-Din Isfahani

Transoxiana (central Asia), early 15th century

Bronze (or brass) ✦ Height 70 cm

The State Hermitage Museum, St Petersburg, inv.no. SA-15932

Provenance: transferred in 1935 from the mausoleum of hoja Ahmad Yasavi in Turkestan

Literature: Yakubovsky 1939, pp. 277-285; Mayer 1959, pp. 52-53, 103; Ivanov 1981, pp. 68-84; Kuwait 1990, no. 74

A new type of lamp appeared in the 14th century, with an oblate spheroidal reservoir fixed on a tube attached to a special base (sometimes even to a candlestick base). Usually, such lamps were not as large as this example, and they are occasionally mistaken for candlesticks, despite the fact

lotus and recalling a Buddhist stupa which, to judge from a Hellenistic lotus incense burner illustrated by James Allan, is an adaptation of a pre-Islamic type.

M.R.

184

Incense burner

Khurasan, 12th century

Quaternary alloy, piece-cast, with openwork and surface engraving; the partially openwork handle is broken at the tip, and the top of the finial of the dome also seems to be missing ✦ Height 38 cm

The Nasser D. Khalili Collection of Islamic Art, London, inv.no. MTW 1417

Literature: unpublished

The form is architectural, with rounded corner buttresses rising from the knobbed feet and terminating in vase-shaped finials with stylized crescent tops. The sides have openwork panels of overlapping circles and engraved plaited bands above and below and

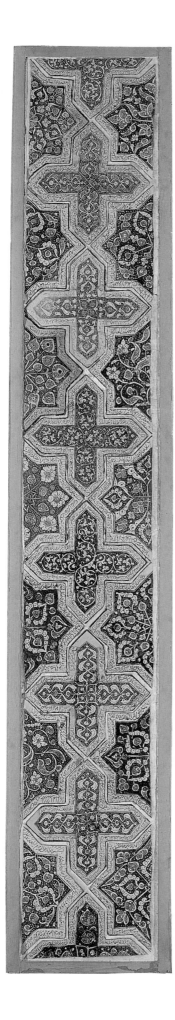
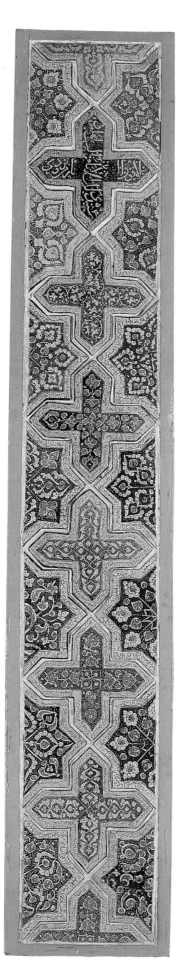

187

Two tile panels

Iran, AH 660-661/AD 1262-63

Faience ✦ Height 226 cm, width 32 cm

The Hermitage, St Petersburg, inv.nos. IR-1097-1118

and IR-1119-1140

Provenance: transferred in 1925 from the Museum of

the former Baron A.N. Stieglitz School of Technical

Drawing

Literature: unpublished

These tiles come from the same series as
cat.no. 186. Tiles from this series are found in
major museums throughout the world. The
inscriptions are also various suras from the
Qur'an.

A.I.

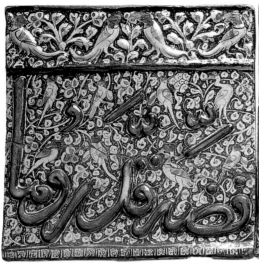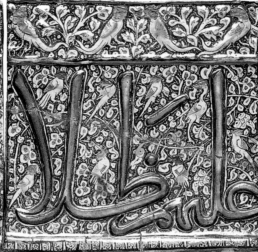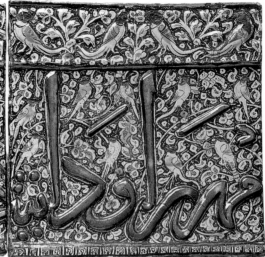

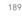
188

188

Three large tiles from a frieze

Iran, 13th century

Faience ✦ 37 x 36 cm); 36.5 x 36 cm; 37 x 36.5 cm

The State Hermitage Museum, St Petersburg,

inv.nos. IR-1363-1365

Provenance: transferred in 1925 from the Museum of

the former Baron A.N. Stieglitz School of Technical

Drawing.

Literature: unpublished

These tiles were intended for a frieze, or
as part of a frame around a *mihrab*. The
inscriptions are fragments from the 13th,
14th (IR-1363-1364) and 16th (IR-1365)
verse of Sura LXXVI (al-Insan, "Man"). The
heads of the birds have been conspicuously
hacked off by a fanatic 'iconoclast'.

A.I.

189

Three tiles

Iran, early 14th century

Faience ✦ Height 27 cm, width 26.5 cm

State Museum The Hermitage, St Petersburg,

inv.nos. IR-1346-1348

Provenance: transferred in 1925 from the Museum of

the former Baron A.N. Stieglitz Technical Drawing

School

Literature: unpublished

These three tiles are part of an exceptionally
long frieze, which may be deduced from
the fact that the inscriptions are taken from
various *suras* from the Qur'an. Tile number
IR-1346 is inscribed with Sura XLVIII
(al-Fath, 'Victory'), *aya* (verse) 29; IR-1347
has Sura XLVIII, aya 38, while IR-1348 is
inscribed with Sura II (al-Baqara, 'The
Cow'), aya 255, the famous Throne Verse.

A.I.

189

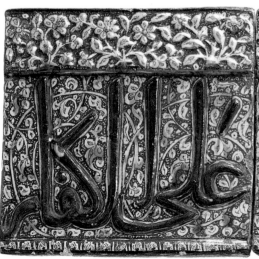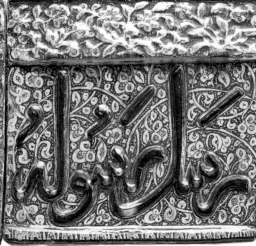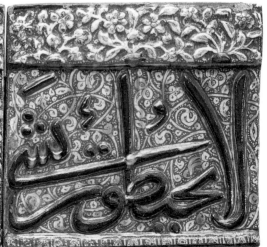

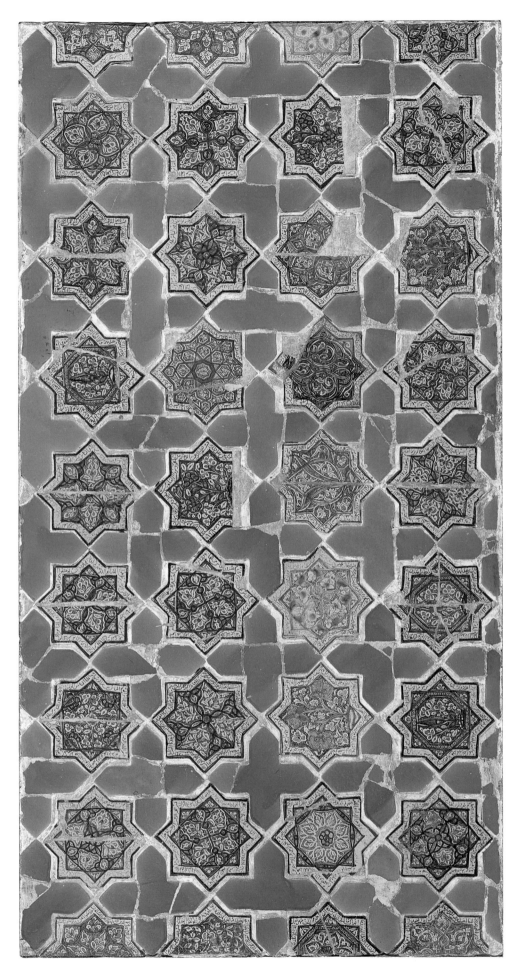

190

Tile panel

Iran, AH 683-684/AD 1284-86

Faience ♦ Height 179 cm, width 92.5 cm

The State Hermitage Museum, St Petersburg,

inv.nos. IR-233-287

Provenance: transferred in 1929 from the Museum of

the former Baron A.N. Stieglitz School of Technical

Drawing

Literature: Krachovskaya, pp. 124-128, tab. IV; Turku

1995, no. 213

This panel decorated the mausoleum of
Sheik Pir Husayn Rawanan in the north
of Azerbaijan. The tiles were made in Iran
between 1284 and 1286, according to the
dates on some of them. The stellate tiles are
adorned with inscriptions from the Qur'an
and, in two cases, Persian verses.

A.I.

190

191

Five tiles from a frieze

Iran, early 14th century

Faience • Measurements of each tile: 38.5 x 19.5 cm

State Museum The Hermitage, St Petersburg,

inv.nos. IR 1278-1282

Provenance: transferred in 1923 from the Sate

Museum Fund

Literature: Turku 1995, no. 86

These tiles formed part of the decoration in
a frieze. It is not known in what kind of
building they were placed. The inscriptions
are fragments from *aya* (verse) 286 from the
second *sura* titled al-Baqara, or 'The Cow'.

 A.I.

218

The Arabic word for Paradise, *djanna*, also means 'garden'. Indeed, in the Qur'an the description of Paradise is of a luxuriant green garden where trees offer delightful shade, and whose branches bear at the same time sweet-scented blossom and plentiful ripe fruit. In this garden stream rivers of water, milk, honey, and wine – which doesn't make men drunk. Enrobed in costly garments, the righteous lie upon couches, enjoying endless feasts in the presence of beautiful virgins. Handsome boys, forever young, serve them from silver and crystal bowls and wash them from beakers of ginger-scented water. There is no idle chit-chat – the only words heard are greetings and blessings.

Not surprisingly, for the dweller in the Arabian desert, such a vision was extremely attractive. Gradually the picture of Paradise became the most prominent theme in Islamic preaching.

Behind such a realistic and recognizable picture, the Qur'an packs many associations and suggestions. There is contentment, enjoyment and other blessed aspects of Paradise, which are promised to the righteous; these may appear to be purely physical but are in fact spiritual. They describe in earthly terms the joy of the blessed believers as they approach the divine presence.

Indeed, beautiful objects in everyday life served the same purpose. Like the descriptions of the heavenly gardens they represent aspects of a higher life. Earthly beauty is a reflection of that which is to be found in heaven.

This explains why Paradise is a major theme in Islamic art. Each ornamentation derived from a plant shape refers in its own way to the gardens of Paradise. Precious stones, costly objects made from rock crystal, gold and silver, bronze, glass, ceramics or textile are all a promise of the heavenly glory to be found in Paradise. Not least, the gardens of this world which in the Islamic culture are always laid out with care and devotion, are a promise and suggestion of the future union with God.

J.V.

Gardens and Paradise

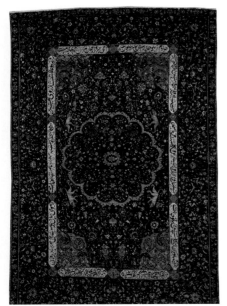

192

192

Carpet

Iran (perhaps Kashan), 16th century
Wool pile with metal thread on a silk foundation ◆
Height 248 cm, width 199 cm
The Nasser D. Khalili Collection of Islamic Art,
London, inv.no. TXT 220
Literature: Beattie 1987, pp.365-368;
Khalili Collection 1993, pp.48-49

The group of extraordinarily sophisticated
carpets to which this example belongs can be
dated on the basis of a celebrated matching
pair, now divided between the Victoria
and Albert Museum, London and the Los
Angeles County Museum of Art. Known as
the 'Ardabil' carpets, they were both signed
as 'the work of Maqsud-i Kashani' and dated
AH 942/AD 1535-36. The 'Ardabil' carpets
are outstanding for their technical quality
and their enormous dimensions (the London
carpet now measures 10.51 x 5.35 m), but
their unprecedented size clearly placed a
burden upon the design resources of the
workshop that produced them, and their
overall layout is not entirely satisfactory.
This carpet is much smaller, but the design
is perfectly matched to the scale.

The main composition consists of a large,
lobed central medallion with a red ground
and four green corner-pieces of 'cloud-collar'
form, which are extended on the long sides
of the main field by yellow half palmettes.
This composition is framed by a band con-
taining treacly Persian verses in a series of
ivory cartouches, and there is a wide red
inner border and a narrow black outer
border. The main field is also black and is
covered with lush chinoiserie lotus scrolls
inhabited by four lions in silver thread. The
central medallion is filled with an overlay of
two types of spiralling scrollwork, organized
around a central rosette motif: a more
restrained form of polychrome lotus scroll
and feathery palmette scrolls in two colours.
Similar patterns fill the corner-pieces and the
inner border, while the outer border has a
repeating lotus-scroll pattern.

The counterpoint between the different
layers of scrollwork is perhaps not as well-
handled as on the 'Ardabil' carpets, but the
curving lines of the *nasta'liq* hand used for
the inscription are certainly as well rendered.
The verses contain grandiose references to
floor coverings decorated with floral
patterns:

> *O you who have had the blossom-filled*
> *meadow of the highest heaven spread out in*
> *your path, the rose garden of your carpet is the*
> *envy of the picture gallery of China!*
> *The patterns and leaves in the garden of your*
> *carpet show the hyacinth, the basil, the wild*
> *and the garden rose and the jasmine.*
> *This carpet is spread out on the path of a king*
> *so sublime that the servant who carries his mat*
> *is better than the Emperor of China!*
> *O you who are exalted in the world! Even those*
> *who have been dust on your path are exalted*
> *in both worlds for sure.*
> *The sun has kissed your feet with the flowers*
> *on the carpet; out of a desire to kiss them he*
> *places his face on the ground.*

M.R.

193

Carpet with pictorial design

Lahore (northern India, today Pakistan), late
16th or early 17th century
Wool pile on cotton foundation ◆ Length 833 cm,
width 289.5 cm
The Metropolitan Museum of Art, New York,
inv.no. 17.190.858. Gift of J. Pierpont Morgan, 1917.
Ex-collection Lady Sackville, Knole Park, Kent
Literature: Sarre - Trenkwald 1926-29, vol. 2, p. 25,
pl. 55; Dimand - Mailey 1973, no. 54, pp. 119-20,
129, fig. 128; Gans-Ruedin 1984, pp. 82-83, pl. 83;
Brand - Lowry 1985, pp. 111-13, fig.12; Walker 1997,
cat. no. 4, pp. 40, 42-44, 164, figs. 33-34

During the reign of Akbar (1555-56), carpet
factories were established in the Mughal
cities of Lahore, Agra, and Fatehpur Sikri
(today Uttar Pradesh, India), beginning a
craft tradition that continues to be vital to
this day. The impetus for the weaving of
knotted-pile carpets on an imperial level
probably came with the introduction of
weavers from Iran in Akbar's time. Many
descriptions by European travelers to the
Mughal courts, as well as Mughal records,
describe the wealth of textiles and carpets
that were used to decorate and furnish
imperial Mughal palaces, tents, and garden
pavilions.

Pictorial carpets from 16th-century Iran hint
at the origin of the design on this splendid
carpet. Scenes of animals in combat or
hunting were probably adapted for patterns
on carpets from Persian miniature paintings,
indicating that court artists must have been
instrumental in supplying designs or patterns
for the production of woven fabrics. This
composition clearly illustrates a combination
of Persian and Indian concepts. A formal
Persian landscape inhabited by mythical
beasts, birds, and hunted and hunting
animals pulses with the life and vigor of
Mughal inspiration. Delicate trees placed on
rocks and flowers echo Persian style, con-
trasting vividly with the sturdy Indian palm

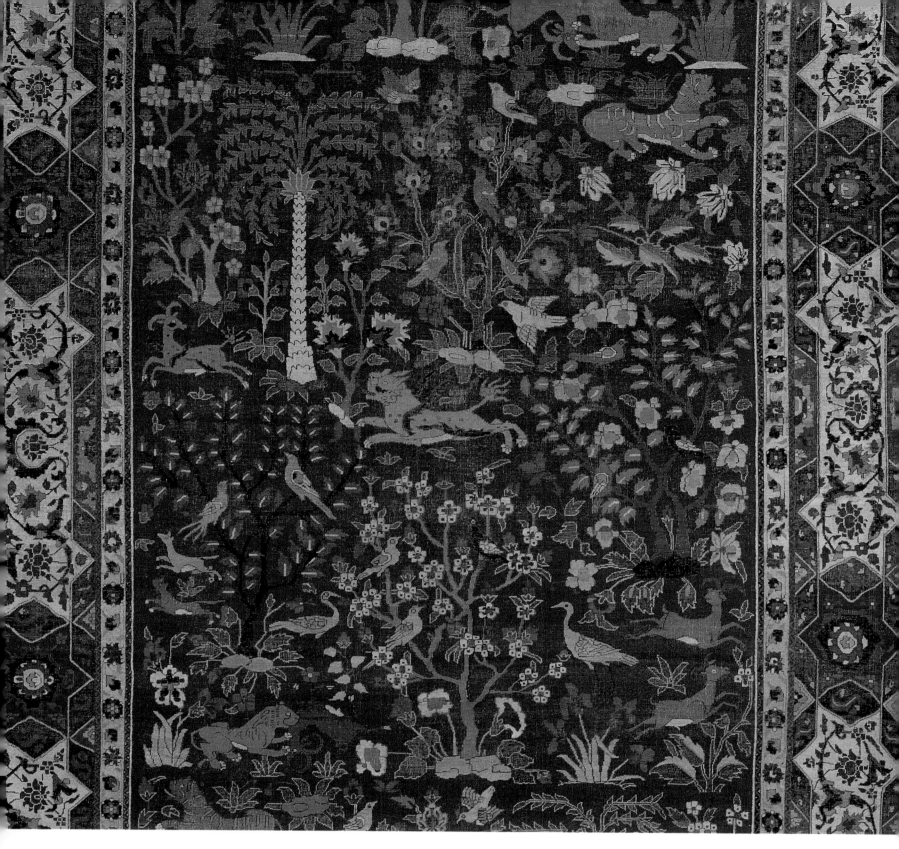

193

tree and naturalistic portrayal of birds and animals.

The field design consists of a single pattern unit repeated vertically 2 3/4 times, each time reversed (follow the placement of the palm tree). It is interesting to consider that the use of a pattern repeat saves time and labor in the production of loom-woven textiles but not in pile carpets (except in the preparation of a smaller cartoon), which are knotted by hand. The use of pattern repeats in pile carpets thus represents an aesthetic choice and suggests a close relationship between the carpet and textile workshops.

D.W.

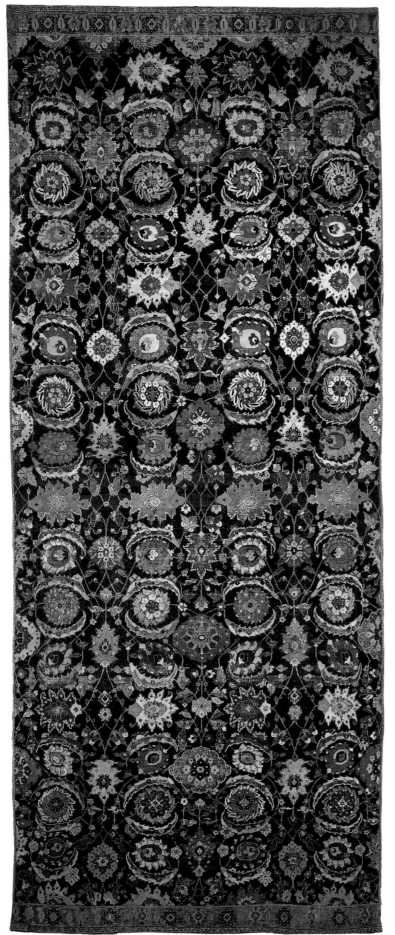

194

Carpet

Iran (perhaps Kirman), 17th century

Wool warp, weft and pile ◆ Length 591 cm,

width 244 cm

The Nasser D. Khalili Collection of Islamic Art,

London, inv.no. TXT 191

Literature: Eskenazi 1982, pl. 25; Bode-Kühnel 1984,

fig. 88

One class of Safavid carpets has an all-over
pattern of scrollwork in the main field.
The designs employed are varied, but they
often incorporate the two types of scrollwork
that were standard in this period: palmette
scrolls, which were sometimes so thick that
they take on the form of 'arabesque' strap-
work (*see cat.no. 195*), and sinuous vines
bearing composite lotus blossoms and
rosettes and feathery, sickle-like leaves.

In the group to which this carpet belongs,
however, only the latter were used, and the
pattern has been transformed by increasing
the size of some of the floral elements and
leaves and reducing the scrollwork linking
them to an almost geometric net. In the
process, the complex structure of the pat-
tern has been obscured, and the enormous
blossoms give the impression of being ar-
ranged in orderly rows. The effect is very
striking indeed, not least because the bright
colours employed for the flowers and leaves
are set against a dark navy ground.

The basic module of the pattern is arranged
in staggered rows, but it is so large that
there are only three complete repeats: two
modules appear side by side in one half of
the carpet, while only one appears in the
other half, flanked by two half modules.
As a result, the pattern of the whole carpet
is symmetrical along the longer axis only, but
each half is symmetrical along a transverse
axis.

194

The only borders are at the narrow ends, and they have a lotus-and-rosette vine pattern on a red ground.

M.R.

195

Carpet

Iran (perhaps Isfahan), 1st half 17th century
Wool warp, weft and pile ✦ Length 823 cm,
width 317 cm
The Nasser D. Khalili Collection of Islamic Art,
London, inv.no. TXT 176
Literature: unpublished

The deep-red ground of the carpet is over-laid with a net of fine scrollwork set with fantastic composite blossoms and leaves, which is overlaid in turn with a dominant 'arabesque' strapwork pattern. The 'arabesques' are composed of undulating palmette scrolls which form four parallel chains. The scrolls are worked in contrasting colours and are themselves overlaid with fine floral chains. The borders have an undulating vine set with chinoiserie lotus flowers and half palmettes on a dark ground.

M.R.

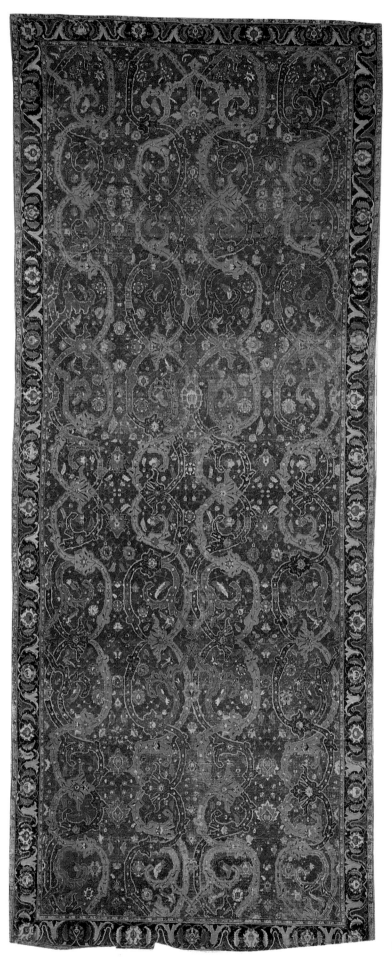

195

196

Cloth fragment

Egypt, 12th-14th century

Linen, embroidery ◆ Height 99 cm, width 56 cm

The State Hermitage Museum, St Petersburg, inv.no. EG-661

Provenance: brought from Egypt by V.G. Bock in 1897

Literature: Pevzner 1958, p. 61; Izmaylova 1960-I, p. 36; Kuwait 1990, no. 38

A rectangular fragment of bleached linen textile, embroidered in black thread. Geometric figures of roosters are placed in staggered rows over the whole field, while along the left edge there is a vertical border consisting of two stripes enclosing oblique diagonals constructed from squares and rhomboids.

Since all details of the ornamentation in these lines, as well as the forms of the roosters, are similar in shape and size, it is certain that stencils were used in this design.

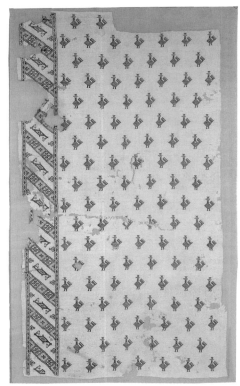

196

Carpet

Iran, 1st half 17th century

Silk, silver thread ◆ Height 141 cm, width 203 cm

The State Hermitage Museum, St Petersburg, inv.no. VT-1547

Provenance: unknown; acquired in 1933

Literature: Loukonine - Ivanov 1996, no. 234

The first silk carpets of this type examined by researchers were decorated with the arms of the king of Poland. Hence their designation 'Polish carpets'. It was not until the 1930s that these carpets were actually proved to have come from Iran.

A.I.

The composition of the design, the stencils, the geometric ornamentation, the embroidery technique and the quality of the fabric, led Pevzner to attribute this textile to the 14th or 15th century, ie., to the period when the production of linen textiles flourished in Egypt.

Both linen and silk textiles, designed with printed drawings, or decorated with stencils or block printing, were produced in Egypt during the 13th and 14th centuries. It seems likely that the linen textiles were made for the larger markets of the well-to-do population, while the silk ones were produced for the courts of sultans.

N.V.

198

Fabric fragment

Iran, 3rd quarter 16th century

Silk ◆ Height 46.5 cm, width 26.5 cm

The State Hermitage Museum, St Petersburg, inv.no. VT-1010

Provenance: transferred in 1925 from the Museum of the former Baron A.N. Stieglitz School of Technical Drawing

Literature: Kverfeldt 1940, pp. 263-272, tab. II; Pirverdyan 1969, pp. 39-42; Kuwait 1990, no. 84

Iran has always been famous for its silk fabrics, but the vast majority of those which have survived date from the 16th to the 17th centuries, the period of Safavid rule, when a wide range of art manufactures flourished.

This fragment of silk fabric, with its representation of different scenes, is one of the finest objects in the Hermitage collection. Other fragments of the same piece are preserved in various other museum collections. Certain details of the clothes worn by people depicted in the design indicate a date of manufacture in the third quarter of the 16th century.

A.I.

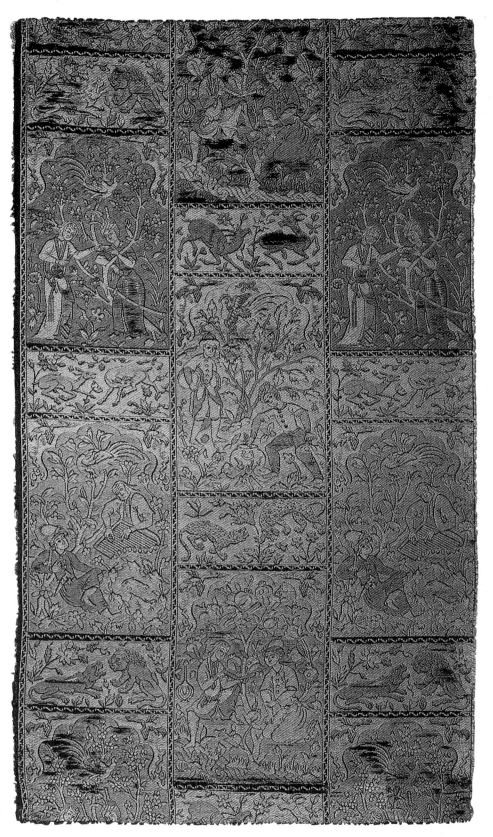

198

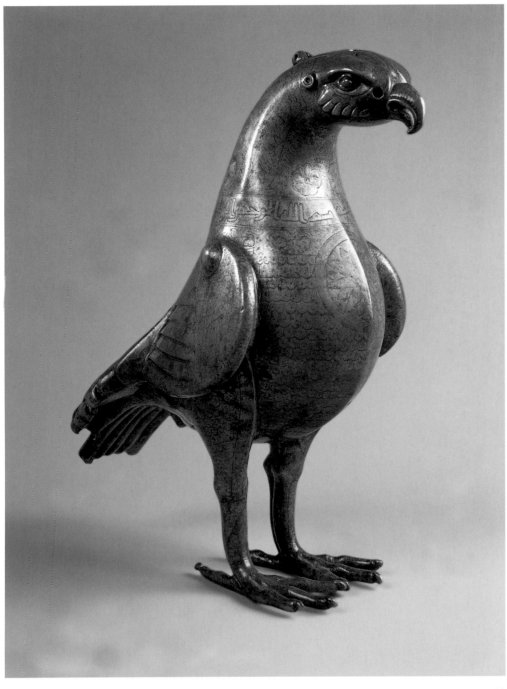

199

This remarkable zoomorphic aquamanile, bearing remains of silver and copper inlay, is the oldest firmly dated bronze item from the Islamic period. It was most probably used as a vessel for water.

The neck bears an Arabic inscription written in simple Kufic:

In the name of God the Merciful the Compassionate, Blessing/from/God. [This is] from among that which was by Suleiman in the town of...? [in] the year 180.

This date was first read as AH 180 by Gyuzalyan in 1949 (and not by Rice in 1959); the reading is now accepted as beyond question.

The piece's place of origin is more complicated. In 1959, Rice suggested the reading 'Madinat al-Fazz', a quarter in Nishapur. In 1973, Melikyan Shirvani read it as 'the town Kashan' in Iran, or as 'the town Kasan', in central Asia. Regretfully, all these readings involve different interpretations of the letter forms, none of which correspond to the actual inscription.

However, the art of inlaying metalwork did not begin to spread over eastern Iran (the province of Khorasan) before the 11th century, and over central Asia before the late 12th century, although the first bronze (or brass) items with inlay appeared in the late Sasanian periods (7th century) and were plentiful during the Umayyad (661-750) and early Abbasid (8th-early 9th century) periods.

Given the inlay on the figure, its origin should be sought somewhere to the west of Iran, most probably in Iraq, which was the centre of the Caliphate in the 8th century. However, the exact place (or even the general region) where such objects were manufactured remains unknown.

A.I.

199

Aquamanile in the form of a bird

Signed by the craftsman Suleyman

Iraq (?), AH 180/AD 796-797

Bronze (or brass), silver, copper ◆ Height 38 cm

The State Hermitage Museum, St Petersburg, inv.no. IR-1567

Provenance: transferred in 1939 from the Checheno-Ingush Museum, Groznyy

Literature: Gyuzalyan 1949, pp. 129-130; Mayer 1959, pp. 85, 92 (for the full bibliography and the reading of the town's name after D.S. Rice see ibid.); Sourdel-Thomine - Spuler 1973, Taf. XVI, p. 187 (with A.S. Melikyan Shirvani's annotation containing his reading of the name of the town); Kuwait 1990, no. 1; Ward 1993, p. 46, pl. 31; Bloom - Blair 1997, p. 122, fig. 67

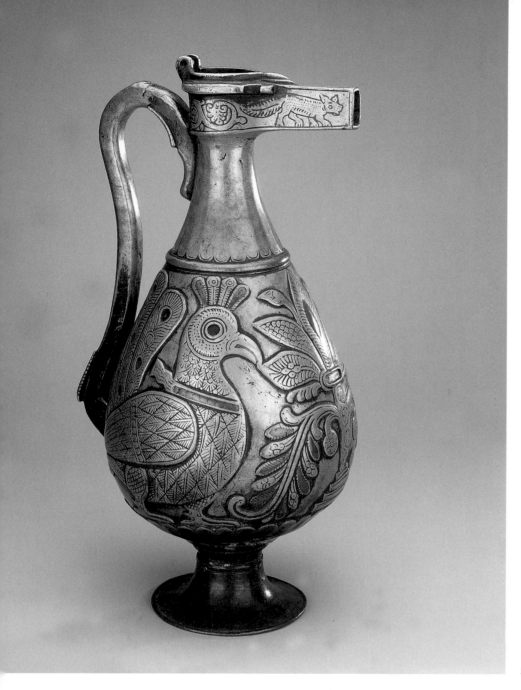

200

Ewer

Iraq, 8th- 9th century

Bronze (or brass) ♦ Height 40.5 cm

The State Hermitage Museum, St Petersburg, inv.no. KZ-5755

Provenance: transferred in 1925 from

The State Academy of Material Cultural History

(A.A. Bobrinsky's collection)

Literature: Munich 1912, part II, tab. 132;

Orbeli - Trever 1935, tab. 75; Marshak 1972,

pp. 80-81, 89, fig. 16; Kuwait 1990, no. 3

This piece belongs to the group which includes bird-shaped aquamaniles (*see cat.no. 199*). The features displayed by this group comprise an almost spherical body, a high cylindrical neck with its 'cut' rim, a spout in the form of a bird and the handle with an almost circular upper section and a vertical lower part.

Such vessels can be dated to the 8th to 9th centuries.

The floral decoration on the body of the famous bronze ewer in the Georgian Museum resembles the ornamentation on

200

Ewer

Iraq, 8th-9th century

Bronze (or brass), copper ♦ Height 39.2 cm

The State Hermitage Museum, St Petersburg, inv.no. KZ-5753

Provenance: transferred in 1925 from

the State Academy of Material Cultural History

(A.A. Bobrinsky Collection)

Literature: Munich 1912, part II, tab. 128; Orbeli - Trever 1935, tab. 72; Marshak 1972, pp. 81-84, fig. 11,4; Kuwait 1990, no. 2

The ewer is decorated with two peacocks flanking a palm tree, a fox and some vine scrolls to the side of the spout and on the

upper part of the neck. The handle is shaped like a question mark, with animal heads where it meets the body. The lower part of the neck and of the body are fluted. The decorations employ copper inlay. The ewer's form resembles that of Sasanian gold and silver specimens. However, the spout is closed from above and the lip projects from the side, indicating a later date for manufacture. Vessels of similar shape were produced until the 11th and 12th centuries. The shape, decorative motifs and ornamental details suggest Byzantine influence. The palm tree positioned on steps resembles the Christian 'Tree of Life', the Cross and a Zoroastrian fire altar.

B.M.

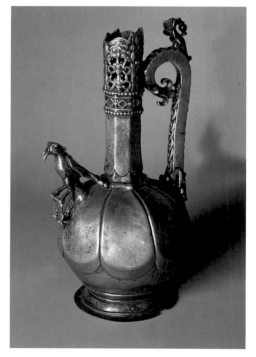

201

this ewer's neck and body. The inscription on the body states that the piece was made in Basra, so it is reasonable to assume that this ewer comes from Iraq.

B.M.

202

Incense burner

Iran, 11th century

Bronze (or brass), silver, copper ◆ Height 45 cm

The State Hermitage Museum, St Petersburg, inv.no. IR-1565

Provenance: unknown

Literature: *Orbeli 1938-I, pp. 293-300, tab. 53-54; Dyakonov 1947, pp. 163, 166, 175; Mayer 1959, p. 37; Stockholm 1985, p. 129, no. 5; Kuwait 1990, no. 18*

Open work incense burners in feline shape were widespread in 11th- to 12th-century Iran, often being inlaid with silver and copper. This example, which is most probably a lynx, has been richly decorated with Arabic inscriptions in Kufic script. The creature's breast bears a name:(?)

Ali ibn Muhammad al-Taji(?).

It is not known whether this is the name of its owner or the artisan.

Both the neck and body have narrow bands bearing Kufic inscriptions, with good wishes that begin thus:

…with good fortune, and blessing…

The last word, as usual, refers to the object's owner. The script, together with the ornament, point to the 11th century as the date of manufacture for this object.

A.I.

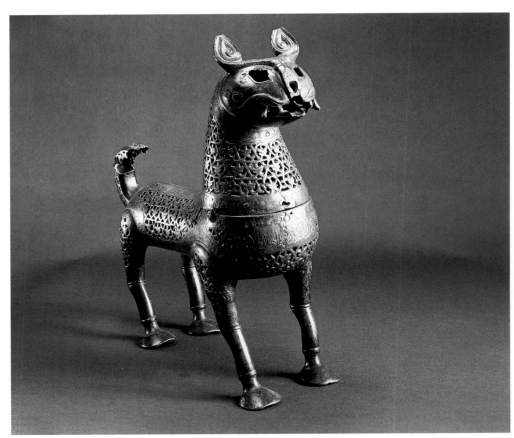

202

203

Pouring vessel

Khorasan, 12th century

Quaternary alloy, cast, engraved and inlaid with silver

Height 22.8 cm

The Nasser D. Khalili Collection of Islamic Art, London, inv.no. MTW 1430

Literature: *unpublished*

The vessel is in the form of a stylized long-necked bird, with a plump body and a stubby tail, standing on a rectangular base. The plumage of the wings is delicately executed. The back bears undulating scrolls and the breast a benedictory inscription in *naskh* script with elongated ascenders, reading:

Glory and Prosperity.

The tapering neck, which has a filter at its base, has a foliate medallion between bands of benedictory inscription at the rim and base. The former is in naskh script and reads:

Glory

and the latter, in Kufic:

With good fortune and blessing.

Two small lugs on the neck may indicate that it was completed with a detachable half-cylinder. The base of the vessel, which is open, was evidently plugged with a stopper, now missing.

M.R.

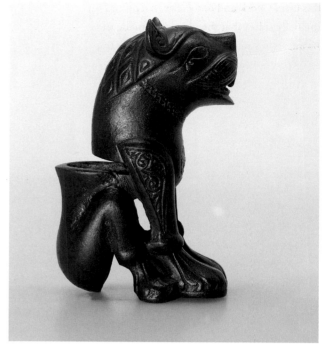

204

204

Squatting lion

Iran, 12th–13th century

Quaternary alloy, cast ◆ Height 13 cm

The Nasser D. Khalili Collection of Islamic Art,

London, inv.no. MTW 916

Literature: unpublished. See also: Allan 1982-II,

pp. 100-101, nos. 173-175

The cast detail is of high quality: the ears
have half palmettes; the mane is a lozenge
diaper with almond-shaped bosses; the

forelegs bear almond-shaped medallions
with split-palmette filling, bangles and
exaggerated claws. Around the neck is an
engraved chain or fillet reminiscent of a
leash. The circular hole in the rump may
be a casting flaw.

The slit and the flat projection in the lion's
back indicate that it was a support for some
horizontal object, such as a large tray. Such
support fittings, in the form of standing lions,
were excavated in Nishapur in Khorasan.

M.R.

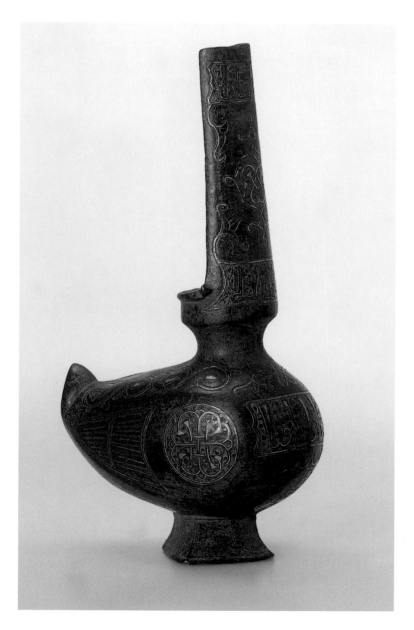

203

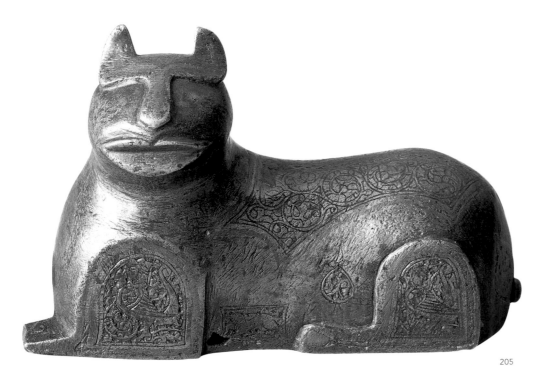

205

Incense burner

Khorasan, 12th century

Quaternary alloy, cast, with openwork and
engraved decoration ◆ Height 17 cm

The Nasser D. Khalili Collection of Islamic Art,
London, inv.no. MTW 100

Literature: Khalili Collection 1993, p. 72

The incense burner is in the form of a dove.
The body of the bird is covered with finely
engraved decoration. The plumage is
elegantly realized with a bold medallion
of seven roundels at the wing joints, and
a scale pattern at their tips and on the tail.
The back has a roundel on the head and a
panel between the wings, both filled with
palmette scrolls, as is the band encircling the
base of the neck. Holes pierced in the latter
allowed the incense smoke to escape.

The burner was filled through a rectangular
opening in the breast. Its flat cover is fitted
with a small loop handle.

M.R.

206

205

Figurine of a cat

Iran, 12th-early 13th century

Bronze (or brass), copper ◆ Height 8.8 cm,
Length 17 9 cm

The State Hermitage Museum, St Petersburg,
inv.no. IR-1433

Provenance: transferred in 1925 from
the State Academy of Material Cultural History
(A.A. Bobrinsky Collection)

*Literature: Munich 1912, part II, tab. 152;
Egyed 1955, II, p. 65, fig. 1; Kuwait 1990, no. 37*

The function of such figurines remains
obscure, although they were probably just
decorations. This piece is covered with
engraved ornamentation, inlaid with copper.
The style of these ornaments link it to other
pre-Mongol Khorasani bronzes.

A.I.

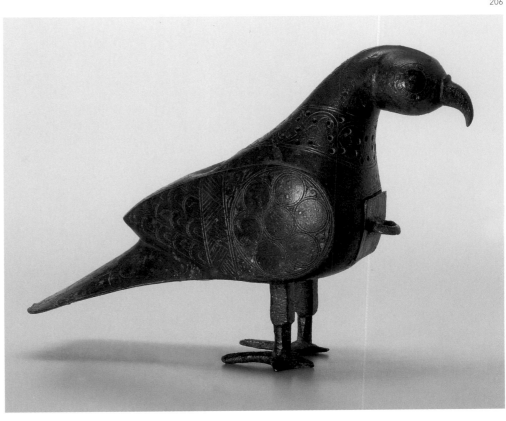

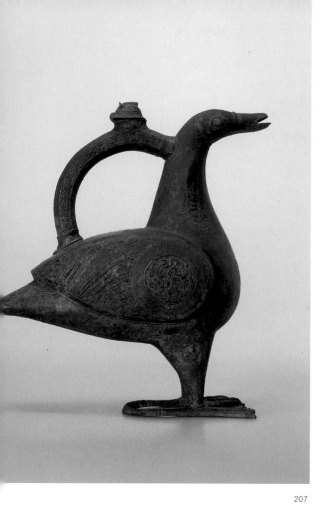

and is markedly more rectangular than a *mim*. There do not appear to be enough letters for an alternative reading of the *nisba* as *al-Marvazi*.

The engraved decoration includes the plumage, with interlace roundels at the wing joints, palmettes, a roundel with a deer on the breast, similar roundels on the sides of the neck and the thighs, and an almond-shaped medallion with a stylized peacock underneath the tail. The tail plumage is turned slightly, giving a vivid impression of movement from the back. The splayed webfeet are joined by a hoop, which makes a stand for the vessel.

M.R.

207

Aquamanile

Signed by Abu'l Qasim ibn Muhammad al-Haravi
Khorasan, 12th century
Quaternary alloy, piece-cast, with surface engraving and traces of a black compound; the eyes are inlaid with fragments of turquoise-glazed pottery ✦
Height 37 cm
The Nasser D. Khalili Collection of Islamic Art, London, inv.no. MTW 846
Literature: Khalili Collection 1993, p. 70

The aquamanile is in the form of a goose, its beak slightly agape. The hollow handle, which is soldered to the body, has a circular hole for filling the vessel, with a hinged lid in the form of a lion's mask.

On the back of the bird is a craftsman's signature in florid Kufic,
The work of Abu'l Qasim al-Haravi.

The letter *he* in *al-Haravi* has no horizontal stroke, although it reaches below the ductus

208

Incense burner

Khorasan, 12th century
Quaternary alloy, cast, with openwork and finely engraved decoration ✦ Height 24.2 cm
The Nasser D. Khalili Collection of Islamic Art, London, inv.no. MTW 412
Literature: unpublished. See also: Pope - Ackerman 1938–39, pl. 1298A

The incense burner is in the form of a lynx (*caracal*). The head, with its perked ears, its almond-shaped eyes terminating in a palmette, its flattened nose, moustaches, and toothy grin, is particularly well realized, as is the openwork decoration. The back of the neck has an elaborate four-fold knot pattern, and medallions filled with related interlace

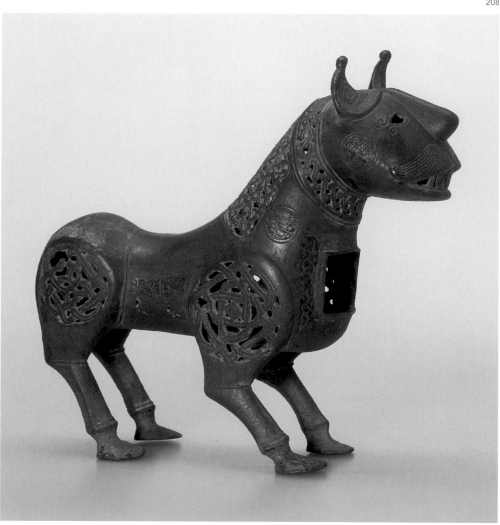

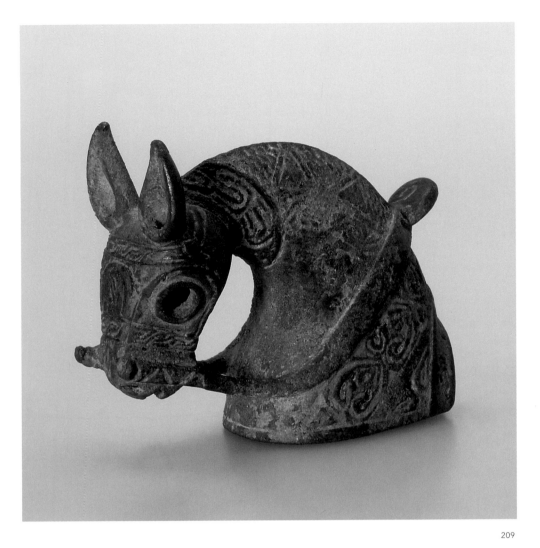

209

209

Cover of an incense burner

Khorasan, 12th century

Quaternary alloy, cast and engraved ◆ Height 6.6 cm

The Nasser D. Khalili Collection of Islamic Art,

London, inv.no. MTW 1339

Literature: unpublished

The cover, which comes from an incense burner of the type illustrated by *cat.no. 210*, is in the form of a horse's or mule's head. The large eyes may have been filled with turquoises or turquoise-glazed pottery *(compare cat.no. 207)*. Alternatively, they were meant to remain open, so that they and the mouth allowed the smell of the burning incense to escape. The forehead bears a stylized head ornament, the mane is elaborately plaited in v-shapes and the reins and bit are clearly indicated.

M.R.

210

Incense burner

Khorasan, 12th century

Quaternary alloy, cast, with openwork and incised decoration ◆ Height 26.8 cm, Length 23.2 cm

The Nasser D. Khalili Collection of Islamic Art,

London, inv.no. MTW 824

Literature: unpublished. See also: Kuwait, 1990, no. 18

designs decorate the front and hind legs at the haunches; a plaited band encircles the neck.

The incense burner bears additional engraved decoration, all once inlaid with a black compound, only traces of which remain. This includes four roundels filled with an 'eternal-knot' on the cheeks and either side of the neck, two panels with Kufic inscriptions, perhaps benedictory, on the flanks, and a plaited band framing the rectangular opening in the chest. All but the latter are missing from a very similar piece, once in the Demotte Collection.

Unlike *cat.no. 210*, this burner was filled

through the opening in the chest. This would have been fitted originally with a cover like that seen in *cat.no. 206*. Traces on the rump suggest that a tail was once attached, but this too is now missing.

M.R.

Incense burners in the form of birds *(compare cat.no. 206)* and beasts, both real and mythical, were especially popular in 12th- and 13th-century Iran, none more so, perhaps, than those in the shape of lions or other felines. These range in size from the monumental, (Metropolitan Museum of Art, no. 51.56, dated AD 1182), to the large (The State Hermitage Museum, IR-1565, also in this exhibition, *cat.no. 202*) and smaller examples like this one, which is in the form of a saddled lion.

The head, which is raised as if in greeting, is amusingly realized, with a wide grin, flaring nostrils and ridged eyebrows *(compare cat.no. 204)*. The eye-holes are four-lobed. The tail, for realism, is hinged, as is, for purely practical reasons, the protome, which opened to allow coals and incense to be inserted: presumably, the vessel was carried on a tray.

An unusual feature of this incense burner is the saddle on the lion's back. The saddle, which is clearly represented complete with an engraved saddle cloth, may be a purely whimsical addition, for lions are not

generally ridden, either in Islamic iconography, except by Sufi mystics like Ahmad-i Jam *(compare cat.no. 239, folio 17b)*, or anywhere else.

M.R.

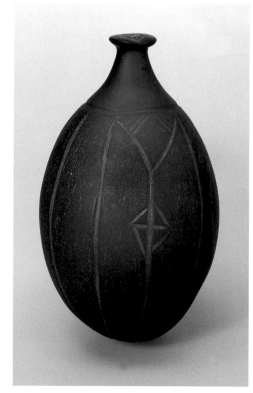

210

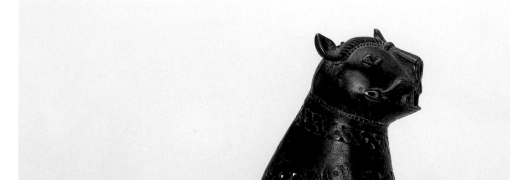

211

211

Bottle

Iran or Mesopotamia, 5th-7th century
Deep green glass, blown, tooled, wheel-cut
and polished ✦ Height 35 cm
The Nasser D. Khalili Collection of Islamic Art,
London, inv.no. GLS 384
*Literature: unpublished. See also: Whitcomb 1985,
fig. 58z*

The thick-walled bottle is in the shape of a watermelon. The thickened rim has been tooled and, while the vessel was still hot, has been indented to form a pouring spout. The melon-like appearance is enhanced by wheel-cut vertical grooves. Remarkably, the bottle is so cracked that it feels like a watermelon.

Related rims and necks have come to light at Jerash (today Jordan) and at Qasr-i Abu Nasr (near Shiraz, Iran) in 5th–7th century contexts, though no exact parallels in size or shape are known.

M.R.

212

212

Flask

Iran or Mesopotamia, 8th-9th century
Pale bluish-green glass, blown and pattern-moulded
Height 38.1 cm, diameter 3 cm
The Nasser D. Khalili Collection of Islamic Art,
London, inv no. GLS 256
Literature: unpublished. See also: Whitcomb 1985,
fig. 59e, pl. 43; Tait 1991, no. 140, p. 116

The tube-like flask has a smooth rim and
rounded base which retains the pontil scar.
It is decorated with pattern-moulded spiral
flutes.

Sherds of comparable vessels, though with
cut rather than moulded decoration, have
been found at Nineveh (Mesopotamia) and
at Qasr-i Abu Nasr (Iran). Their function
remains unclear. A fragmentary example in
The British Museum (WAA, no. 91498A),
also with facet-cut decoration, is described
as a scent or unguent container. Suggestions
that these vessels may have been used for
scrolls or for writing implements, however,
are somewhat implausible.

M.R.

213

Bowl

Iran (Nishapur) 10e-11e eeuw
Earthenware, slip-painted under a colourless glaze;
broken and repaired, with small areas of restoration ✦
Height 6 cm, diameter 21 cm
The Nasser D. Khalili Collection of Islamic Art,
London, inv.no. POT 763
Literatuur: Grube 1994, no. 9, p. 88

The bowl is decorated with two birds, their
feet apart as if on perches. Their bodies each
bear the word *barakah* ('blessing').

M.R.

213

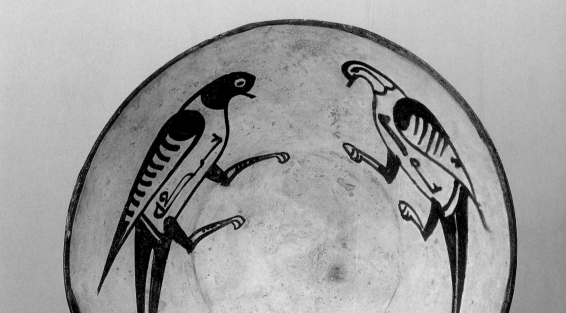

234

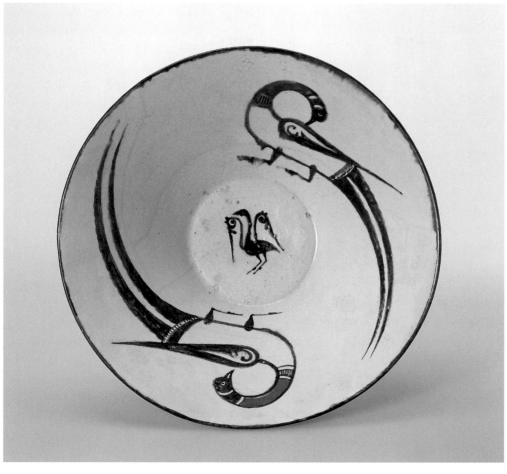

214

215

Pot

Transoxiana (central Asia), 10th century

Earthenware, glazed ◆ Height 29 cm

The State Hermitage Museum, St Petersburg,
inv.no. CA-13204

Provenance: acquired in 1906 from

the A. Polovtsev Collection

*Literature: Dushanbe 1980, fig. 93; Kuwait 1990,
no. 9*

This pear-shaped pot, the neck of which has
been lost, is made from reddish clay and
covered with a layer of white clay. The
brown, red and olive-green strokes painted
on it are covered with a yellowish transpa-
rent glaze. The colours of the paint strokes
are somewhat reminiscent of the poly-
chrome lustrework of 9th-century Iraq.
However, this type of decoration is Samanid,
in the style of Khorasan and Transoxiana,
not that of Iraq. Since lustreware was not
produced in central Asia as early as the
Samanid period (819-999), this piece must

215

214

Large bowl

Iran (Nishapur), 11th century

Earthenware, slip-painted under a transparent glaze

◆ Height 16.3 cm, diameter 41 cm

The Nasser D. Khalili Collection of Islamic Art,
London, inv.no. POT 1623

Literature: Grube 1994, no. 80, pp. 88-89

The sides of the bowl are decorated by two
birds with forked tails. The birds' heads are
turned backwards. At the centre a smaller
bird with half-palmette wings may derive
from an animated inscription.

The birds are painted in a purplish-black slip
with a touch of ochre on a white ground
under a colourless glaze. The bowl is intact.

M.R.

be placed in the category of Samanid imitation lustreware of the 10th century.

This is one of the finest examples of Islamic ornamentation in which the expressive shapes of the birds are subtly arranged within a background filled with dots.

B.M.

216

Bowl

North Persia (perhaps Mazandaran area),
10th century
Eathenware, painted in white, purplish-black, yellow
and reddish slips under a colourless glaze ◆
❋Height 10.5 cm, diameter 23.7 cm
The Nasser D. Khalili Collection of Islamic Art,
London, inv.no. POT 305
Literature: Grube 1994, no. 111, p. 110

The deep-sided bowl belongs to a group of slip-painted wares with somewhat grotesque decoration of birds or animals associated with north Persian production centres.

The small tailless bird, with a crest and outstretched wings may be a stylized quail. It appears to be perching on rosettes.

M.R.

216

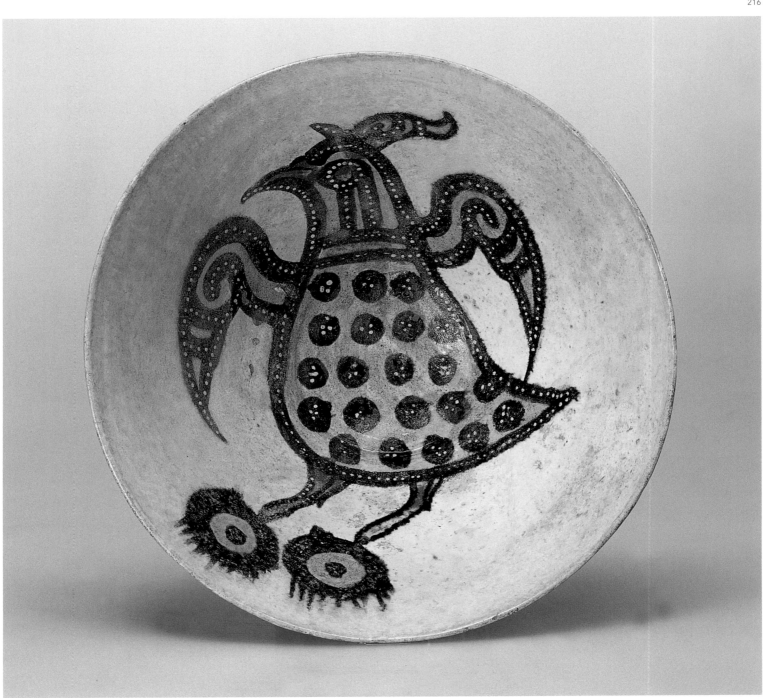

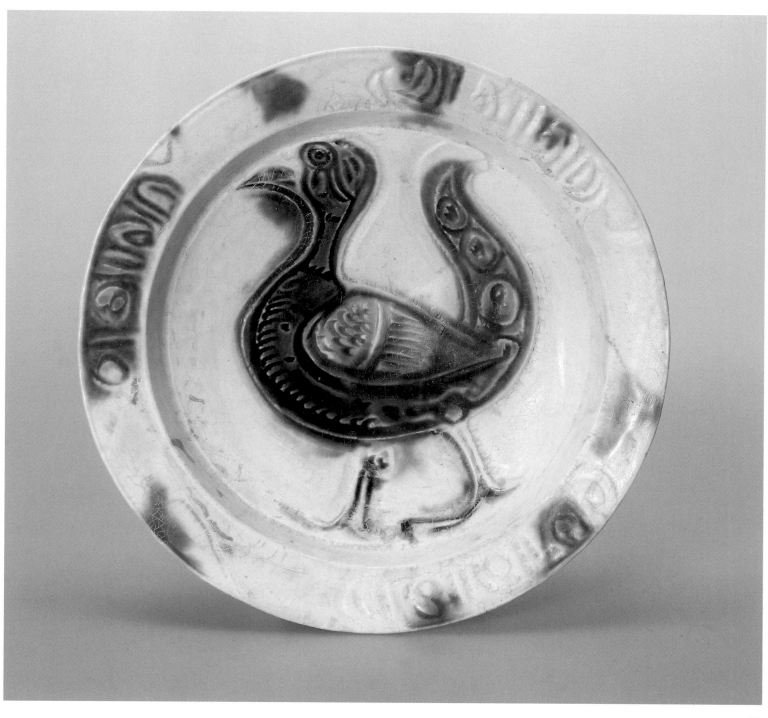

217

217

Dish

Syria, circa 1200

Fritware, with carved decoration under a slightly opacified white glaze, stained cobalt, manganese, yellow and green (*laqabi* ware) ✦ Height 6 cm, diameter 29.7 cm

The Nasser D. Khalili Collection of Islamic Art,

London, inv.no. POT 684

Literature: Grube 1994, no. 285, pp. 248, 250

The dish, which is exceptionally well preserved, is decorated with a brilliantly coloured, stylized peacock in the centre, and three bands of pseudo-inscription on the rim. The decoration is in the so-called *laqabi* technique, which combines carved

or champlevé designs with bright colours applied in the glaze. The carving prevented the colours from running into each other.

The shape of the dish, with its flat rim, carinated profile and low foot, is typical of lustre and carved (laqabi) 'Tall Minis' wares.

M.R.

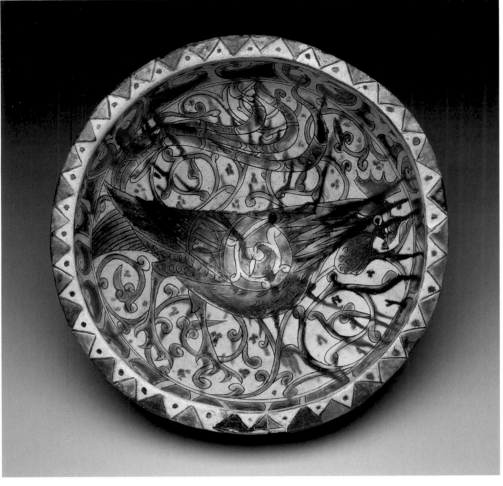

218

219

Large aquamanile or table fountain

Iran or Afghanistan, early 13th century
Fritware, painted in black under a transparent,
bright turquoise glaze, overglaze-painted in red
◆ Height 45.7 cm
The Nasser D. Khalili Collection of Islamic Art,
London, inv.no. POT 941
Literature: Khalili Collection 1993, pp. 70-71

The aquamanile is in the form of a stocky feline with a flattened face. The vessel is hollow, but closed at the neck. It is filled by a vertical pipe with narrow opening and a cup-shaped mouth over the rump, and can only be emptied through a narrow tube concealed below the extended tongue. To either side of the neck are shallow circular dishes, perhaps for sweetmeats.

The black underglaze-painted decoration is outlined in red, and covers the entire vessel, with the exception of the belly. It consists of finely drawn palmettes on the face, neck and back, a tasselled chain on the forehead, stripes on the legs and the curled tail, a

219

218

Bowl

Probably northwest Iran (so-called 'Aghkand'
pottery), 12th or early 13th century
Earthenware with incised (sgraffiato) decoration
and colours on white slip under clear glaze ◆
Height 13 cm, diameter 30.4 cm
Museum of Fine Arts, Boston, Edward Jackson
Holmes Collection, inv.no. 58.93
*Literature: Boston 1992, no. 217, p. 224. See also:
Persian Art 1939, part II, p. 1526-9 and part V,
pl. 607-611; Lane 1947, p. 25; Schnyder 1985;
Morgan 1994, p. 118-133*

A splendid rooster picks his way through a thicket of vines on this bowl, which exemplifies the incised, polychrome-painted wares known as 'Aghkand', after a village southeast of Tabriz where many such vessels were purportedly found. (Recent excavations have unearthed related ceramics in both Iranian and Russian Azerbaijan). While the *sgraffiato* technique may have been used as early as the 9th century in eastern Iran, in 12th-century Aghkand wares it performs a new, dual function, both outlining the design and serving to prevent, or at least impede, the coloured pigments – gold-brown, green, and blackish-purple – from running.

Although Aghkand vessels are sometimes decorated only with vegetal and abstract forms, the most imposing have interiors dominated by lively, large-scale animals – usually hares or birds – amid thick-stemmed vine scrolls. As if to keep the central exuberance in check, the rims of these bowls exhibit relatively austere geometric ornament such as the reciprocal triangles on this bowl.

M.R.

pseudo-inscription, or perhaps a simulation of fur, around a raised roundel with a moulded diaper design on the chest, petal motifs on the dishes; and palmette chains on the base of the pipe. Most of the decoration is now obscured by the heavy iridescence.

M.R.

220

Figurine in the form of a camel

Iran (Kashan), early 13th century
Fritware, painted in pinkish-olive lustre over an opaque white glaze ✦ Height 39.5 cm
The Nasser D. Khalili Collection of Islamic Art, London, inv.no. POT 857
Literature: *Anavian Collection 1976, no. 33;
Grube 1994, no. 267, pp. 236–237; see also no. 191, pp. 184–185*

The body of the camel is covered with lustre-painted floral and scroll designs, and its trappings and harness are indicated. The camel bears a flower vase of a type which was also made as a separate vessel. The decoration on the latter includes medallions with seated figures. The camel's body also has holes for flowers.

A small section of the rim was broken off during firing. The fragments can be seen attached to the lower part of the neck and the interior of the vase.

M.R.

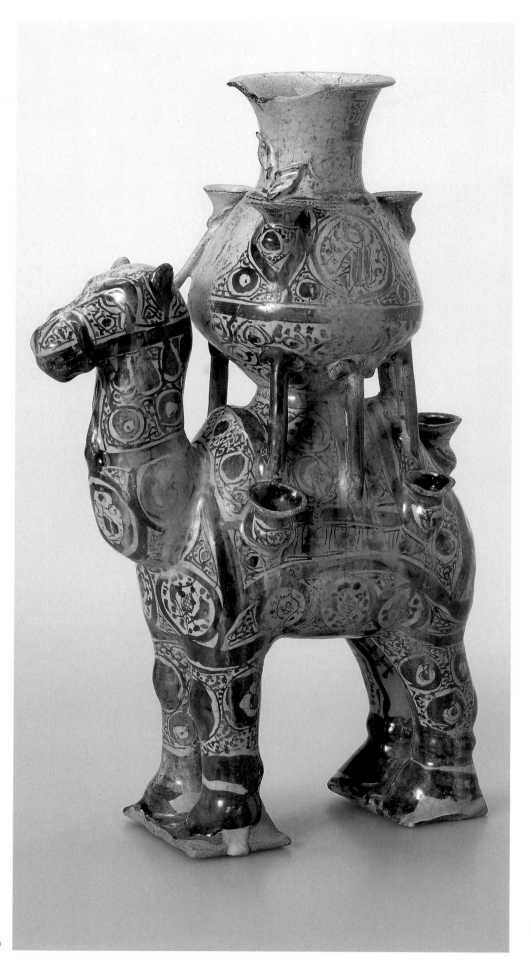

220

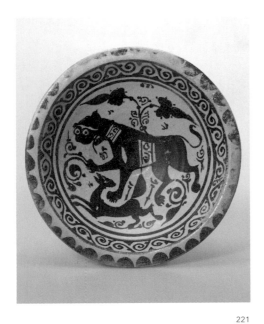

221

The bowl has rounded sides and an everted rim, and stands on a low foot articulated in a manner characteristic of Tall Minis ware. The inside is decorated with a lion and a small animal, a fox or a hare. The rim is festooned and the cavetto has an undulating scroll in reserve. The palmettes above the lion are characteristic of Egyptian Fatimid wares of the *Sa'd* type.

M.R.

221

Bowl

Syria, 12th century
Fritware, painted in chocolate lustre over a transparent glaze (so-called 'Tall Minis' ware) ◆ Height 10.5 cm, diameter 36 cm
The Nasser D. Khalili Collection of Islamic Art, London, inv.no. POT 1249
Literature: Grube 1994, no. 297, pp. 262–263

222

Straight-sided bowl

Syria, 12th century
Fritware, painted in yellowish-brown lustre with a coppery sheen bleeding ruby, over a transparent crazed glaze (so-called 'Tall Minis' ware)
◆ Height 10.7 cm, diameter 19.5 cm
The Nasser D. Khalili Collection of Islamic Art, London, inv.no. POT 1750
Literature: unpublished. See also: Grube 1994, no. 292–296, 306, pp. 260–261, 270

The bowl has straight sides, slightly everted at the rim, and a low foot. The shape is unusual, but other examples with a similar profile in the Khalili Collection are decorated with lustre, or bear carved flutes.

The exterior of the bowl has a frieze of quails with sprigs in their beaks and at their tails. Inside is a central eight-petalled rosette frieze and a band of floriated Kufic. The inscription is benedictory:

Perpetual glory, sovereignty, perpetual glory, sovereignty, perpetual glory.

M.R.

222

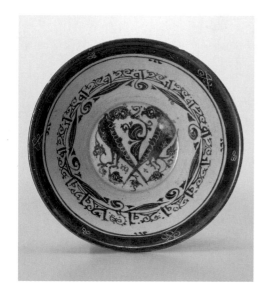

223

223

Bowl

Syria, later 12th century

Fritware, painted in olive-brown lustre with a coppery
sheen over a transparent glaze, crazed and pooling
pale green (so-called 'Tall Minis' ware) ◆
Height 8.2 cm, diameter 23 cm

The Nasser D. Khalili Collection of Islamic Art,
London, inv.no. POT 1749

Literature: unpublished

The bowl, with flaring sides and a slightly
everted rim, is finely potted. The centre has
addorsed birds with a foliate spray between
them. The details are incised in the lustre,
somewhat in the manner of Fatimid pottery
known as *Sa'd*. The sides have a pseudo-
Kufic inscription of repeating letter forms
with swags and curlicues below.

The exterior has two inscriptions. One
consists of a single word, probably *khass*
('private'). The second appears to be a
signature:

From the work of Ibn al-Hatif (?)

The bowl is in excellent condition: there is
a single iridized spot on the wing of the
righthand bird.

M.R.

224

Conical bowl

Iran (Kashan), early 13th century

Fritware, painted in olive lustre with a coppery sheen
over an opaque white glaze ◆ Height 8.4 cm,
diameter 18 cm

The Nasser D. Khalili Collection of Islamic Art,
London, inv.no. POT 1586

*Literature: Grube 1994, no. 273, pp. 241, 335;
Rogers 1994, pp. 24-31*

The bowl is in exceptionally fine condition.
Inside, at the centre, is a leopard pursuing
a long-horned goat through a schematic
landscape with a fish pond. This is followed
by a band with a Persian verse relating to the
pangs of love, written upside down in *naskh*
script:

*I talk of your tale every night with my heart,
I seek your scent from every morning breeze,
I wash my face with the blood of my heart for
the purpose*

*that my face may not be yellow the next day.
Blessing to its owner.*

At the rim is a benedictory Kufic inscription,
in reserve:

*Perpetual glory and prosperity, perpetual glory,
and triumphant victory, and durable glory,
and wealth, and happiness, and well-being,
and wealth, and happiness.*

Outside are more Persian verse inscriptions,
in reserve, above a frieze of stylized palmette
chains:

*Since the world is not permanent for any one,
Surely it is best that goodness is left to be
remembered,
Since the world is an inn, and we …
Perhaps you would not suffer a lot in it.
You said that in it [the world] …
… will pass in sorrow …*

M.R.

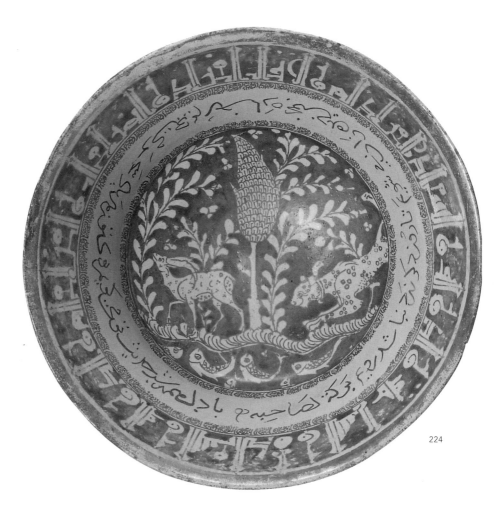

224

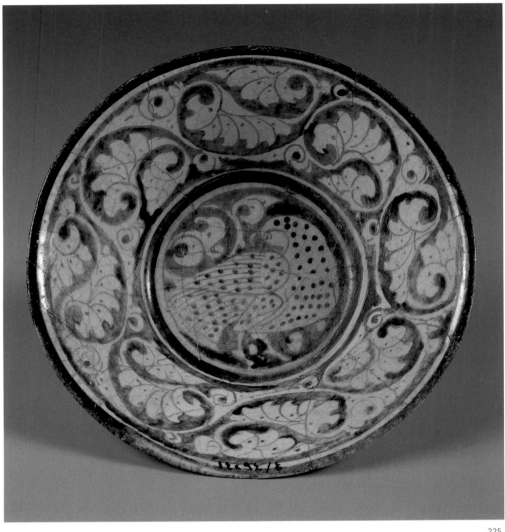

225

near Cairo. The colour has been achieved through the oxidation of metal, in particular silver.

The bowl is decorated with intertwining plant motifs around the sides and a dove-like bird surrounded by stylized floral patterns in the centre. The outer walls are adorned with the following text:

Honour, favour, happiness, peace and money to the owner.

M. AL M.

226

Bowl

Iran (Kashan, or perhaps Khorasan), 14th century

Fritware, painted in turquoise, manganese and black under a transparent glaze ◆ Height 9.7 cm, diameter 19.7 cm

The Nasser D. Khalili Collection of Islamic Art, London, inv.no. POT 1100

Literature: unpublished

226

225

Bowl

Iran, 13th-14th century

Ceramic ◆ Height 6 cm, diameter 15 cm

National Museum of Syria, Ministry of Culture, General Directorate for Antiquities and Museums, Syrian Arab Republic (Damascus), inv.no. 14294-A

Provenance: Iran

This small bowl represents one of the most sophisticated types of Islamic ceramic. The colours range from red-brown to golden-yellow with gold lustre. Such ware was known in Samarra during the 9th century from where its production subsequently spread to Ar-Raqqa (Syria), Persia and Fustat

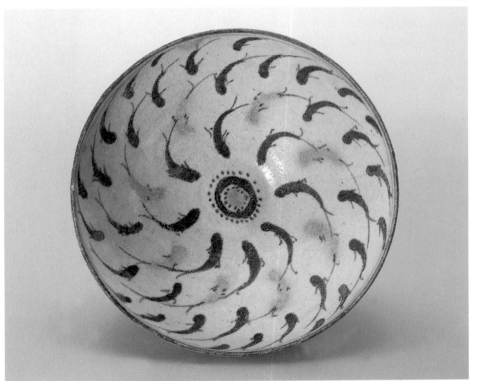

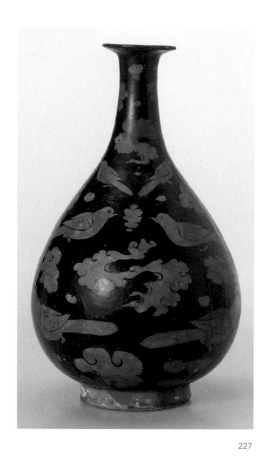

227

227

Flask

Iran, 15th-16th century

Fritware, painted in black under a transparent

turquoise glaze ◆ Height 35 cm

The Nasser D. Khalili Collection of Islamic Art,

London, inv.no. POT 1320

Literature: Khalili Collection 1993, p. 28

The pyriform flask has a narrow neck with an everted flattened rim, and a broad foot ring. It is rather heavily potted, and the footring has been ground flat. The decoration is of staggered rows of confronted birds and chinoiserie cloud-scrolls reserved on a black ground under the clear turquoise glaze.

The flask has been broken and repaired, with small areas of restoration.

M.R

228

Fish

Turkey (attributed to Istanbul), 2nd quarter 16th

century

Fritware, glazed (with later additions in red clay) ◆

Height 10.5 cm, length 26 cm

Benaki Museum, Athens, inv.no. 10

Literature: Grube 1966, fig. 11, p. 168;

Atasoy - Raby 1989, fig. 124, p. 106

The function of this object, a fish resting on three feet, is not clear. It may be a flask or a candlestick. The fish is decorated with blue designs over a white slip under a transparent glaze. Apart from the fish-scale pattern the body of the fish is decorated with flowers, leaves and another small fish on its back. Ceramic figurines are relatively rare in Islamic art, especially in the early Ottoman period. This suggests that the fish may have been specially commissioned or made for a non-Muslim client.

M.M.

The rounded bowl stands on a low foot. It is underglaze-painted in turquoise, manganese and black with concentric rings of fish swimming to the centre. The rings are staggered so that they create a whirling pattern. The contrast between the sharp colours and the rather runny, now iridized, turquoise is very pleasing. The exterior has radial black stripes.

The shape and the motifs are a development from early 13th-century Kashan blue and black wares, generally with rather sharper contours.

M.R.

228

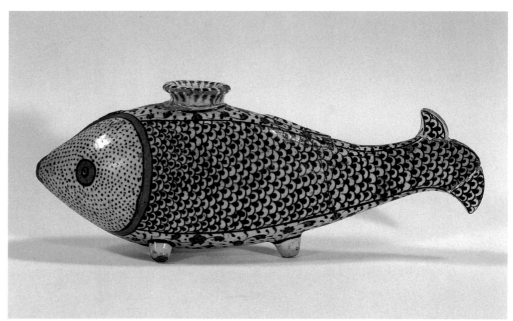

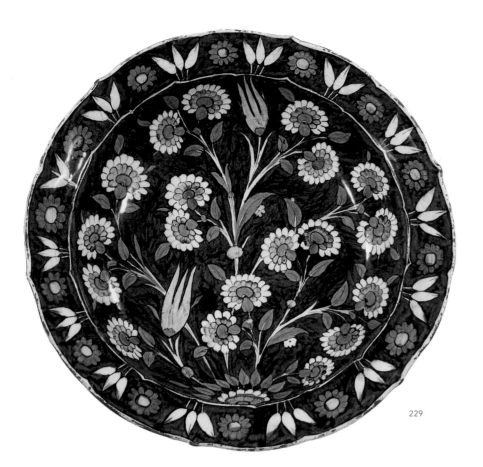

229

230

Dish

Iran, 16th century

Faience, painted with cobalt ◆ Diameter 35 cm

The State Hermitage Museum, St Petersburg,

inv.no. VG-2392

Provenance: unknown; acquired in 1949 by

The Hermitage Purchasing Committee

Literature: Golombek - Mason - Bailey 1996,

p. 120 and pl. 68 on p. 224

This deep dish with an outward flaring rim
on a ring-shaped foot is painted with cobalt
under transparent glaze. In the centre are
chinoiserie clouds and two fish, on the walls
blossoming branches. The rim is decorated
with a sinuous flowering shoot.

A.A.

230

229

Plate

Turkey (Iznik), mid 16th century

Fritware, glazed ◆ Diameter 37.5 cm

Benaki Museum, Athens, inv.no. 4

Literature: Migeon 1903, pl. 44; Koechlin - Migeon

1928, pl. XLII; Macridy 1937, p.138; Benaki Museum

1969, p. 4; Philon 1980-I, fig. 238, p. 47

This large Iznik plate with foliated rim is
decorated with flowers on a dark-blue ground
under a transparent glaze. The centre is
painted with a cluster of petalled flowers and
tulips springing from a single root in the
form of a half flower. Around the wavy rim
are groups of three small tulips alternating
with a blue flower. On the reverse are more
small blue flowers alternating with pairs of
leaves. This plate dates from the middle of
the 16th century and displays the floral style
inspired by indigenous flowers which was so
popular on Iznik pottery.

M.R.

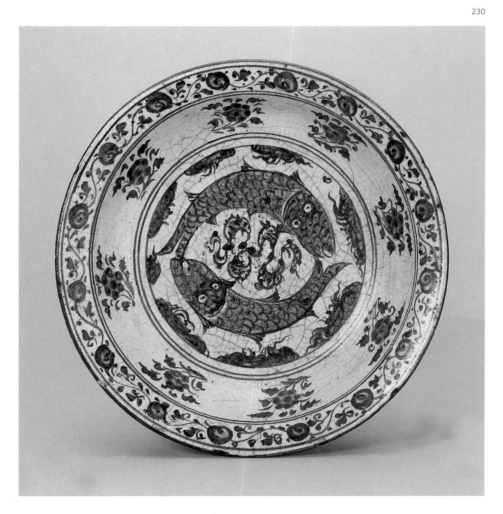

231

Dish

Iran, 16th century

Faience ♦ Diameter 37 cm

The State Hermitage Museum, St Petersburg,
inv.no. VG-732

Provenance: unknown; bought in 1929

Literature: Kuwait 1990, no. 81

Technical and stylistic peculiarities place
this dish in a group generally referred to as
'Kubachi ceramics', as the majority come
from Kubachi, a village high in the moun-
tains of Dagestan.

These pieces are predominately large, heavy
dishes of a soft, reddish, porous 'faience',
covered with a white engobe, over which
the decoration is painted, under a thin
transparent crackled glaze.

The ceramics known as 'Kubachi' in fact
include three separate groups of objects
differentiated by their painting style and
technique, all of which are believed by most
scholars to have been made in Iran, probably
Tabriz or other cities in the northwest part of
the country. The blue-and-white 'Kubachi'
type, like other Iranian ceramics, incorporate
ornamental elements which display strong
Chinese influence.

The two large birds among widely spaced
flowers and Chinese-type cloud motifs
exhibit the slightly blurred outlines typical
of the 'Kubachi' type to which the piece
belongs.

The exterior walls bear a register of curves
broken in several places by elongated leaves.

A.A.

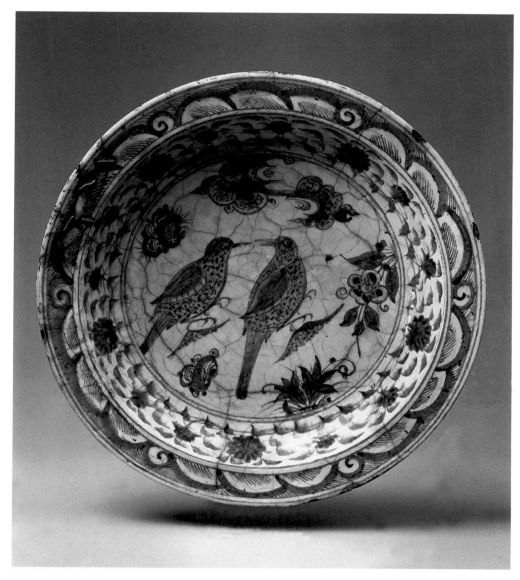

231

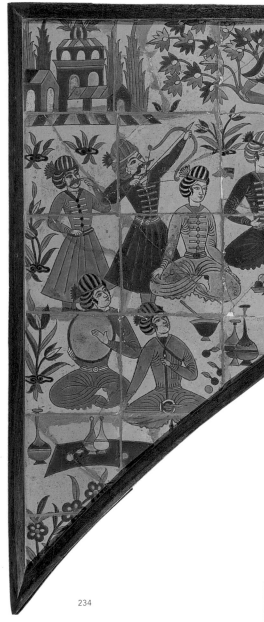

234

hunter aiming his gun at a running animal and a heron; on the other, there is a standing man dressed in the European fashion, carrying a slain animal over his shoulders, and a kneeling woman with a bowl in her hand. The same scenes, with minor

differences, can be seen on three more such bottles, in the Hermitage collection, the Chartoryjskie Museum in Cracow and the Victoria and Albert Museum, London.

Rapoport believes that this bottle can be attributed to Mashhad, one of the most important Iranian ceramics centres, in the period when cobalt-painted ceramics were produced, during the 16th and 17th centuries. The same view was taken by Lane regarding the bottle belonging to the Victoria and Albert Museum. A number of this piece's peculiarities are shared by others ascribed to Mashhad, such as the white body, the black outlines, the way the plants are represented and the flying birds in reserve against a cobalt background.

A.A.

232

232

Bottle

Iran, late 16th-early 17th century

Faience ✦ Height 36.3 cm

The State Hermitage Museum, St Petersburg, inv.no. VG-290

Provenance: transferred from the State Museum Fund, year unknown

Literature: Rapoport 1975, pp. 50-53; Stockholm 1985, p. 147, no. 6; Kuwait 1990, no. 100

This bottle is painted in cobalt stain with scenes reserved in white low relief. One of the sides is decorated with the figure of a

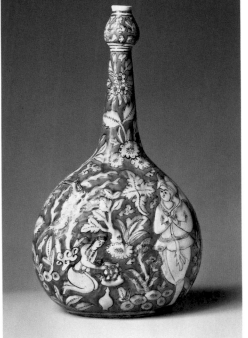

233

Panel of tiles

Iran, 2nd half 17th century

Faience ✦ Height 95.5, width 23.4 cm

The State Hermitage Museum, St Petersburg, inv.no. VG-1319

Provenance: unknown

Literature: Kuwait 1990, no. 106

This panel, consisting of four tiles bearing polychrome painting against a blue background, represents a standing man with outstretched arms, as if offering something to an invisible companion, lost due to the

233

234

incomplete state of the piece. This is a
fragment of a larger composition depicting,
perhaps, a feast in a garden. Such panels
composed of separate tiles were commonly
used in 17th-century Iran to decorate
houses.

A.A.

234

Two tile panels

Iran, late 17th century
Faience, glaze painting • Height 165 cm,
width 133 cm (VG-1279); height 168 cm,
width 135 cm (VG-1280)

The State Hermitage Museum, St Petersburg,
inv.nos. VG-1279, 1280
Provenance: transferred in 1925 from the Museum of
the former Baron A.N. Stieglitz School of Technical
Drawing
Literature: Connoisseur 1991

The painting, in glaze of various colours over
a white clay slip, represents a scene in a
garden. Merrymakers, musicians and an
archer are depicted against the background
of a pavilion in a park, cypresses and
blossoming trees and bushes.

A.A.

247

235

235

A prince enthroned surrounded by attendants

From an unidentified text

Iran (Herat), circa 1425-30

Opaque watercolour, ink, and gold on paper ♦

Page dimensions: height 21.7 cm, width 13.4 cm

Arthur M. Sackler Gallery, Smithsonian Institution,

Washington, D.C.; Purchase, Smithsonian

Unrestricted Trust Funds, Smithsonian Collections

Acquisition Program, and Dr. Arthur M. Sackler,

inv.nos. S86.0142, S86.0143

Literature: Lowry - Nemazee 1988, no. 46,

fig. on pp. 156-157

With its intense colours, carefully controlled lines, and elegant details, this image resonates with subtle rhythms and patterns. Although the manuscript from which the painting was removed has yet to be identified, the seated prince, with his round face and thin moustache, appears to be an idealized portrait of the Timurid prince Baysunghur (1399-1433). Devoid of any outward signs of emotion, the figures present a glacial facade typical of images found in paintings associated with Baysunghur's patronage.

G.L.

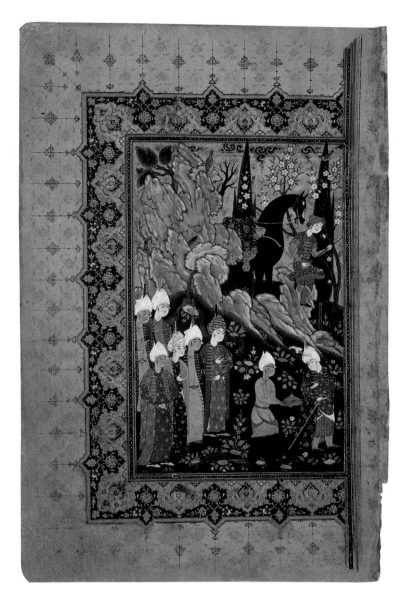
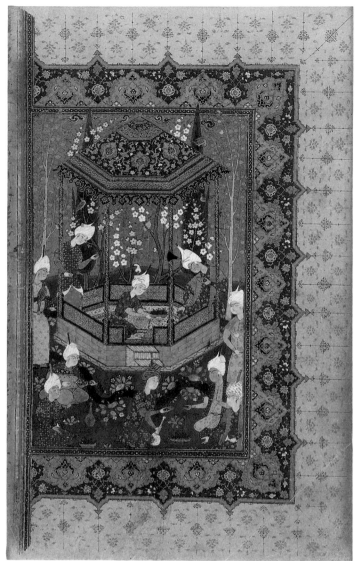

236

236

Court scene in a garden

Signed by 'Abdollah-e Mozahheb

Probably Mashhad, AH 989/AD 1581

Watercolour, ink, and gold on paper ◆

Page dimensions: height 24 cm, width 16 cm

The Art and History Trust; courtesy of the Arthur

M. Sackler Gallery, Smithsonian Institution,

Washington, D.C., inv.no. LTS 1995.2.94 (folio's Iv, 2r)

Literature: Robinson - Falk - Sims 1976, no. 24i;

Soudavar - Beach 1992, pp. 227-231

This manuscript was commissioned by Grand
Vizier Mirza Salman, possibly as a gift to his
brother-in-law – and Shah Muhammad's first
son – Hamzé Mirza (1566-86). In that time,
people commissioned such pieces to confirm
their high status. The young man to the right
of the pavilion could be the prince, while the
courtier holding a staff in the lower right
corner of the left page might well represent
Mirza Salman.

The manuscript, titled *Sefatol-'Asheqin*, is a
compendium of 15th-century poems about
love and devotion, and other works.

A.S. (J.V.)

237

Shah Shoja

Mughal India, circa 1620

Watercolour on paper ◆ Paper: height 36.7 cm,
width 249 cm, image: height 12.4 cm, width 7.2 cm
The Art and History Trust; courtesy of the
Arthur M. Sackler Gallery, Smithsonian Institution,
Washington D.C., inv.no. LTS 1995.2.98
Provenance: acquired from the Baron Maurice de
Rothschild Collection (year unknown)
Literature: Stchoukine 1935, pl. LXVII, fig. 2; Falk
1976, no. 111; Soudavar - Beach 1992, no. 129e,
p. 316-317

Shoja, the second son of Shah Jahan and
Mumtaz Mahal, the woman for whom the
Taj Mahal mausoleum was built, was born
on 23 June 1616. Jahangir, his grandfather
and Shah Jahan's predecessor on the Mughal
throne, recorded the event in his memoirs:
'On the eve of Sunday … there came from
the womb of the daughter of Asaf Khan …
a precious pearl into the world of being.
With joy and gladness at this great boon the
drums beat loudly, and the door of pleasure
and enjoyment was opened in the face of the
people. Without delay or reflection the name
of Shah Shaja'at (Shoja) came to my tongue.
I hope that his coming will be auspicious and
blessed to me and his father.'

This is far more enthusiastic than an earlier
statement by Jahangir noting the birth of the
elder prince, Dara Shokuh. Shoja actually
became his favourite grandson; from at least
his third year, he lived at his grandfather's
court. Jahangir also recorded an incident
that occurred when Shoja was two:
'[He was] attacked by a specially infantile
disease … and for a long time his senses left
him. Although many experienced people
devised many remedies, they were un-
profitable, and his insensibility took away
my senses. As visible remedies were hopeless
… [I] would give up hunting … If it were
possible that … God Almighty might give
him to me … I vowed to God that I thence

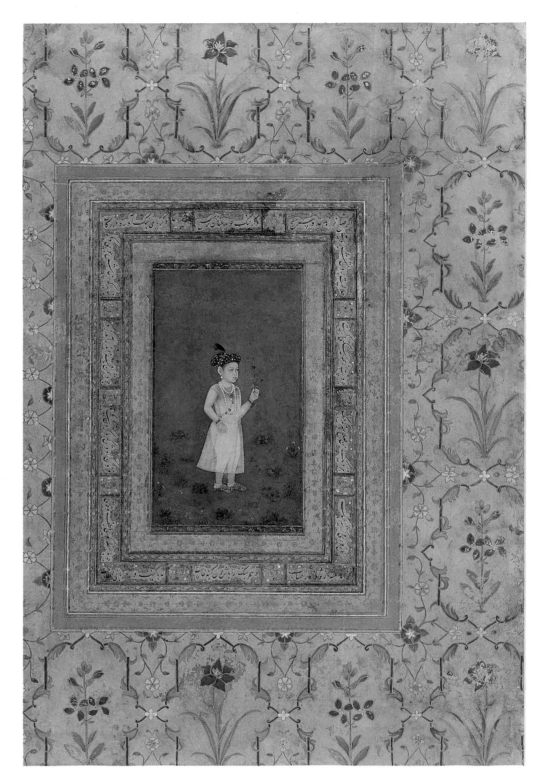

237

forward would not harm any living thing
with my own hand. By the Grace of Allah
his illness diminished.'

However, despite these good intentions,
Jahangir's memoirs continue to detail further
hunting expeditions and feats of marksman-

ships. Two year later, Shoja fell out of a
window of the palace at Agra, his fall broken
by a carpet laid near the riverbank, and the
following year he contracted another nearly
fatal illness. Jahangir discusses these events
too with great concern. His devotion to his
grandchild was clearly unusual. Shoja also

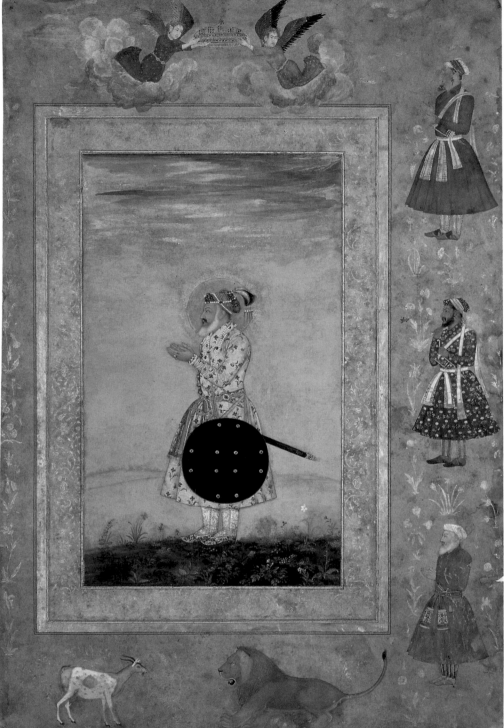

238

238

The elderly Shah Jahan

Mughal India, circa 1650

Watercolour on paper ◆ Page: height 36.9 cm,
width 25 cm, image: height 21.4, width 12.7 cm
The Art and History Trust; courtesy of the Arthur
M. Sackler Gallery, Smithsonian Institution,
Washington D.C., inv.no. LTS 1995.2.96
Provenance: acquired from the Baron Maurice
de Rothschild collection (year unknown)
*Literature: Stchoukine 1935, no. XIV, pl. LXX, fig. 8;
Falk 1976, no. 121; Soudavar - Beach 1992, no. 129d,
p. 315-316*

Around 1909, some 100 individual sheets
from a royal album appeared on the Paris
art market. Most dated from the mid 17th
century. The majority of the pictures were
portraits, a large number of which showed
the aged Shah Jahan. None portrayed any
of his successors. This suggests that the
album dates to between the years 1650 and
1660, the final decade of Shah Jahan's reign.

Many portraits of Shah Jahan, builder of the
Taj Mahal, are virtually identical. Early in his
reign, an official formula for royal portraits
replaced the spontaneity and immediacy
found earlier within the imperial portrait
tradition. During the reign of Jahangir
(1605-27), portraits emphasizing grandeur
and majesty became fashionable, many
stressing the unapproachable, godlike
character of the ruler. This aspect was
developed further by Shah Jahan's artists,
and the many images made for diplomatic
gifts or dispersal among the nobility clearly
proclaimed the emperor's might. Margin
designs continued this symbolism through
the use of angelic figures holding canopies
or emblems of rank, as well as images of a
lion and lamb – a symbolic representation
of peace. The spread of these images beyond
the Indian or Persian worlds is attested by
copies of similar portraits made by Rembrandt
in the mid 17th century.

M.C.B. (J.V.)

seems to be the only Mughal prince who was
regularly portrayed as a child by the imperial
artists.

As an adult Shoja was himself an important
patron of painters, and many illustrations
chronicle major events in his life. He joined
his brothers in rebellion against Shah Jahan,
who brought the country to the edge of
bankruptcy, with projects such as the Taj
Mahal. However, he was defeated by
imperial troops in 1658 and forced to flee
India. He never returned to his homeland.

M.C.B. (J.B.)

239

Eight pages from the Khalili Falnama

Probably Golconda, circa 1610–30

Ink, gouache, gold and silver on thick, deep-cream
laid paper, lightly burnished ◆ Folios approximately
41 x 28.4 cm, paintings 30.5 x 21 cm

The Nasser D. Khalili Collection of Islamic Art,
London, inv.no. MSS 979

Literature: Leach 1998, pp. 221–225, no. 65

This *Falnama*, or 'book of divination',
consists of a series of double openings, with
a large miniature on each right-hand page.
On the opposite page there are two Persian
texts. One written in an Indian variant of
the *thuluth* style provides a caption for the
painting, although the reference is some-
times oblique, while the second, written
in *nasta'liq*, draws a moral from the story
depicted in the image to give a good, bad or
variable fortune. The paintings could also
be viewed for their own sake, for which
purpose a second caption in Persian was
added beneath each scene at a later date.
In its current state the Khalili manuscript
has 35 double openings and is one of only
a small group of illustrated falnamas that
survive in something like their original form
(others are in the Topkapi Palace Library,
Istanbul). The published material suggests
that the form became popular in Persia in
the later 16th century and spread quickly
from there to Ottoman Turkey and to the
Qutb Shahi court at Golconda in southern
India, where this falnama was produced.
Pages from a dispersed volume, much larger
in format (59 x 44.5 cm), have often been
attributed to the Safavid Shah Tahmasp I
(r. 1524–1576), but they are not up to the
standard of his earlier commissions. It is
interesting to note, however, that one
illustration in the Khalili Falnama (folio 22b)
shows Shah Tahmasp leading his troops into
battle. At the very least, this illustrates the
close links between Safavid Persia and Qutb
Shahi Golconda.

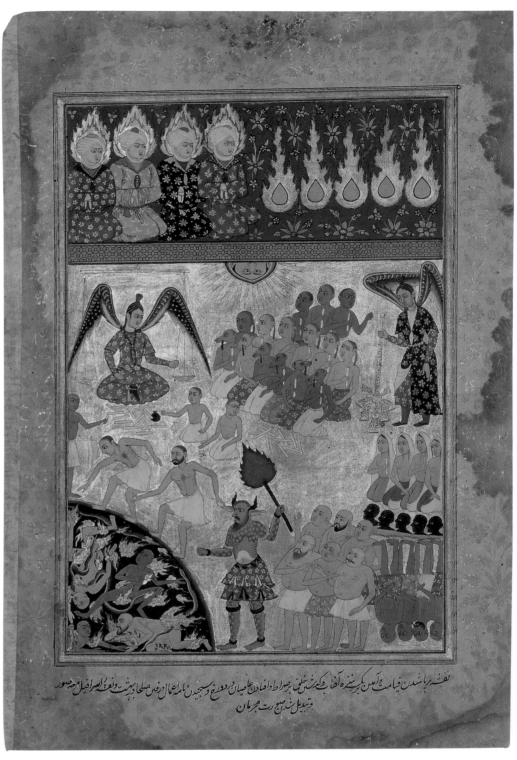

239A

239A

The Day of Judgement (folio 10b)

In the main scene the sun, represented by an
inverted human face, no longer moves
through its course, because Israfil (top right)
has blown his seven-branched trump, to
mark the end of Time. The recording angel
(top left) is weighing the deeds of men,
depicted as rolled-up scrolls (compare the
motto on cat.no. 276). To the right are
groups of humans and other creatures

awaiting their judgement. They include figures familiar from Islamic cosmographic literature, such as the six dog-headed men, the five black bodiless heads and the four representatives of the upside-down folk. Below, a group of six fat white men – perhaps denoting the vicious – is being led by a blue demon towards the Sirat al-Mustaqim, 'the strait and narrow path' across the pit of Hell, which must be traversed to enter Heaven. Two thin, hairy-chested men are making their way along the thin red line that represents this slender bridge, while below them the naked figures of the fallen are being tortured by flames and serpents. In the register at the top, the scene is surveyed impassively by four seated figures with flaming nimbuses, evidently prophets, and five incorporeal beings, also with nimbuses.

The fortune indicated by this scene is not as dire as one might fear. Tribulations must be expected, but those who perform good deeds and avoid temptation will enjoy eternal life in Paradise.

239B

Jesus raising the dead (folio 11b)

Jesus, shown mounted and with his face veiled, has raised the son of the old woman who crouches before him, giving thanks. According to the caption, the miracle has been performed to the wonderment of all present, including the monarch shown mounted, bottom left. The miracle, which recalls that of the centurion and his son in the New Testament (*Matthew 8: 5-13*), takes place amid ruins, and the presence of a pair

of owls and their nest in the top left corner make the source of this setting clear. It was taken from Nushirvan and the Owls, an illustration found in Safavid copies of Nizami's *Makhzan al-Asrar* ('The Treasury of Mysteries'), the first book of his *Khamsa* ('*Quintet*'; *see cat.nos. 86-88*).

The person who opened these pages is promised good luck in a whole range of circumstances, including making a journey or a marriage, recovery from illness, commercial transactions, moving house, weaning a child, and circumcision.

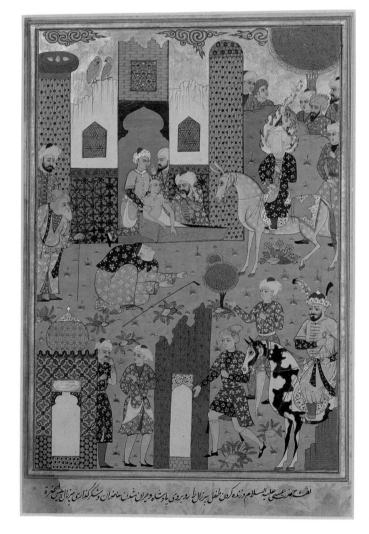

239B

239C

Muhammad's Night Journey (folio 12b)

Literature: Simpson 1997, pp.210–213; Leach 1998, no.65, p.226

The scene depicted is the *Mi'raj*, the miraculous night journey during which the Prophet Muhammad travelled to Jerusalem and ascended from there to the Throne of God. By the later 15th century the *Mi'raj* had become a standard illustration to the *Khamsa* of Nizami, but this depiction is closer to that in a manuscript of the *Haft Awrang* of Jami (Washington, DC, Freer Gallery of Art, 46.12, folio 275a), which was produced in Mashhad in eastern Iran about 1565, for the Safavid prince Ibrahim Mirza. It shows the Prophet mounted on the supernatural steed

Buraq, ascending from the Temple Mount in Jerusalem *(compare cat.no. 18, folio c)*. He is surrounded by angels bearing insignia and doing what the later caption describes as 'pouring light over him'.

Good fortune is promised in the text on the opposite page, where the caption in *thuluth* gives a Shiite gloss to the scene: 'The night when the Lord of the Two Mansions made the Ascent, he heard a voice coming from the Haram of the Lord (*the Temple Mount*). God spoke in 'Ali's graceful tones since the Prophet loved 'Ali's way of talking.'

239D

Ahmad-i Jam riding a lion (folio 17b)

Literature: Raby 1981, pp.160–163

Ahmad-i Jam was a celebrated Sufi master who lived between 1049 and 1141. His tomb became the centre of the town of Turbat-i Shaykh-i Jam in Khorasan, and the reverence in which he was held led to the accumulation of a large body of legend around the bare bones of his life story. Here he is shown riding a lion, using one serpent as reins and another as a whip. The Sufi sheikh riding a lion is a favourite *topos* among Sufi hagiographers, and this depiction of the miracle belongs to a genre with parallels in both Europe (for Samson) and China. In the caption in thuluth opposite we are

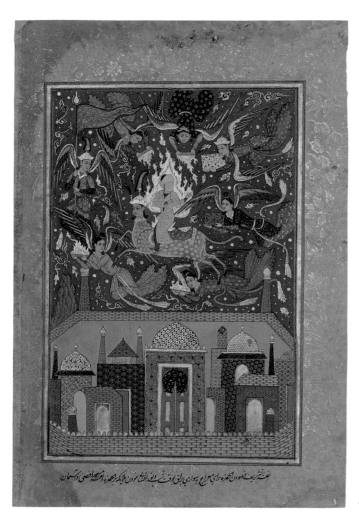

239C

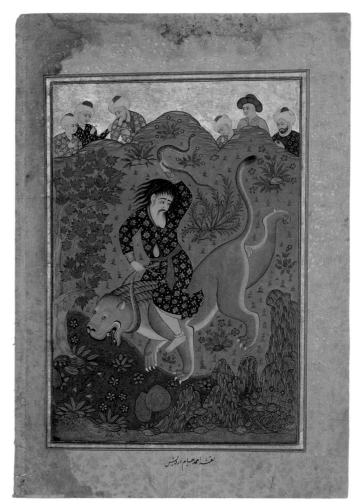

239D

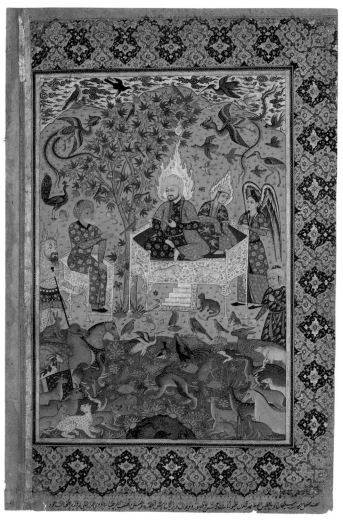

239E

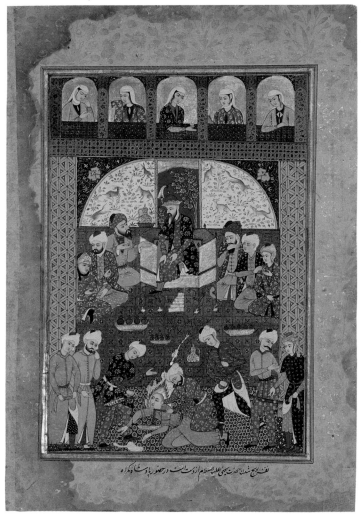

239F

told that, 'The great men of religion can ride on lions because they passed their time on earth more slowly than an ant.' Selecting the image of Ahmad-i Jam brought good luck.

239E

The court of King Solomon (folio 21b)

Literature: Bagci 1995, pp.101–111; Leach 1998, no.65, p.227

This composition is a worked-up version of a type of frontispiece illustration found in manuscripts produced in Shiraz in the mid 16th century. It shows Solomon (Suleyman) and Bilqis, the Queen of Sheba. seated on a golden throne decorated with couched

tigers and leaping gazelles. To the left sits Solomon's vizier Asaph; they are attended by a *peri*, a white demon and a human, representing the races under Solomon's command. Solomon's dominion over creation is further indicated by the mass of birds, animals and insects that surround the royal pair. Some are fabulous beasts, including two chinoiserie phoenixes and a *qilin*, and some are accurate representations of real creatures. One is the hoopoe, Solomon's messenger, who is perched on the throne at his right hand. Even the pond at the base of the picture is filled with animals – a fish, two terrapins, a crab and a snake. The omen inferred from the scene is a good one, although the subject needs to wear 'Solomon's armlet' for protection against the machinations of demons, peris and humans.

239F

The death of John the Baptist (folio 28b)

John the Baptist, known in the Islamic tradition as the prophet Yahya, is executed by the minions of Herod, here termed the 'misguided emperor'. The murder takes place in the foreground. John is depicted as a young man, whose prophetic status is indicated by a flaming nimbus. His turban has been knocked off, and his head is held over a dish while his throat is slit. Behind him, within a royal *iwan*, Herod sits enthroned, with his evil counsellors on either side, and the scene is watched from windows above the iwan by five ladies of the court, perhaps an echo of Salome's role. Indeed, this event was rarely represented in

255

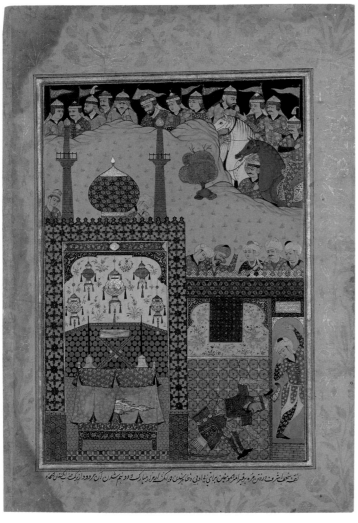

239G

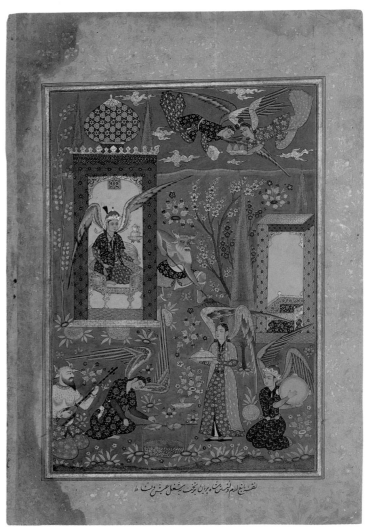

239H

Islamic miniature painting; its depiction here suggests some acquaintance (garbled) with the version in the New Testament.

The text of the accompanying exegesis does not refer to the episode displayed, repeating one associated with the Imam 'Ali.

239G

Murra miraculously cut in half (folio 29b)

The scene depicts a posthumous miracle of 'Ali ibn Abi Talib, who appears here in his role as the first Imam of the *Shiite* tradition. The Khalili Falnama contains a number of images with an explicitly Shiite content, and the link is greatly reinforced by the many Shiite references in the text (compare *folio 12b*). This is one sound reason for attributing the work to Golconda, the main centre of painting in 17th-century India that was under Shiite rule. The location is the tomb of 'Ali at Najaf in Iraq, to which one Murra ibn Qays has come in full armour to commit some act of desecration. He receives his just reward when two of the Imam's fingers,

surrounded by a flaming nimbus, emerge from the rich cloths covering his tomb, and Murra is miraculously cleft in two. The tomb servants show their amazement, as do the crowd on the horizon, who may be Murra's companions. Murra is not further identified, but he may have some association with the Banu Murra, an Arabian tribe of the time of the Prophet which, initially at least, ranged itself on the side of his enemies.

The omen derived from this image is a good one. However, as in the case of the Court of King Solomon (*see folio 21b*) good fortune could be assured only by wearing an amuletic armband.

239H

The Queen of the Peris enthroned in the garden of Iram (folio 30b)

Peris, assisted by a demon musician and a demon gardener, wait upon their Queen, who sits enthroned within a domed pavilion. Opposite her is a smaller pavilion containing an empty throne. The setting is identified as the Garden of Iram, the legendary garden of the pre-Islamic Himyaritic kings of Yemen, but the scene reads like a parody of the al fresco feasts of late 15th-century Timurid Herat.

The omen inferred is excellent, although the subject must always share his good fortune with the poor.

M.R.

240

Fragment of a carved panel

Egypt or Syria, 8th century

Ivory, carved ✦ Length 15 cm, height 7 cm

Benaki Museum, Athens, inv.no. 10411

Literatuur: Migeon 1927, part 1, fig. 146, p. 338;

Creswell 1939, pp. 29-42, pl. Va; Stern 1954, fig.

17, pp. 130-131; Creswell 1969, book I, part II,

fig. 683, p. 621; Kühnel 1971, no. 5, tab. II, p. 26;

Philon

1980-I, fig. 10, p. 16

This superb ivory plaque, carved in high relief, is decorated with a vine scroll with five-lobed leaves and bunches of grapes. The vine stalks curl symmetrically, creating circles around the leaves and the two birds whose heads are turned back to pluck the fruit. Outside the scroll are smaller leaves, a hare and another bird.

This fragment was part of a larger panel which was probably intended to decorate a piece of furniture. The missing part to the right was presumably decorated in a similar

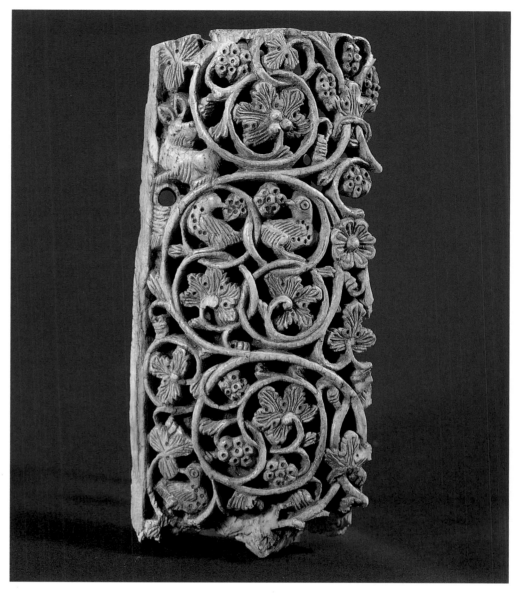

240

fashion, linked by a leaf motif alternating with a rosette. This plaque can be dated to the 8th century: its decoration compares with the late Umayyad (mid 8th century) decorative repertoire, such as the facade of the palace of Mshatta in Jordan, although there are also precedents in pre-Islamic vocabulary, particularly Coptic carving.

M.M.

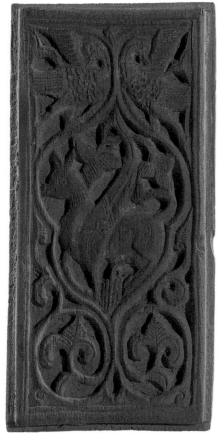

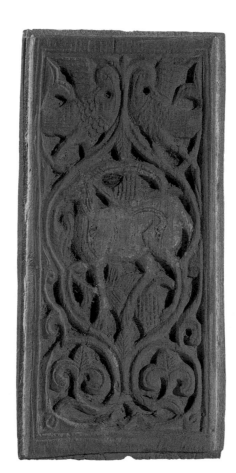

241A

241C

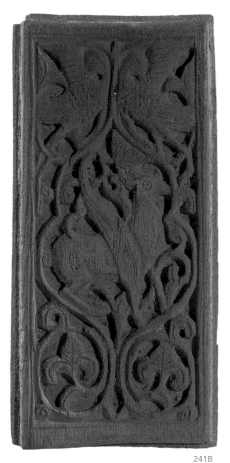

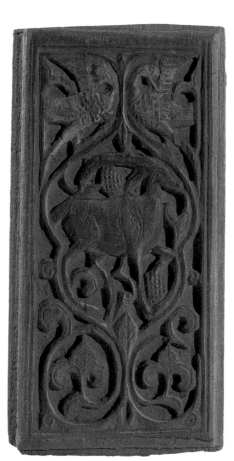

241B

241D

241

Four decorative panels

Fatimid Egypt, 11th century

Wood, carved ✦ Length 23 cm, width 11 cm (each)

Benaki Museum, Athens, inv. nos. 9168, 9169, 9170, 9171

Literature: Vienna 1998, fig. 16-19, p. 84

Two pairs of Fatimid decorative panels carved in high relief, the details obtained through incised lines. The panels are coloured in red; two bear traces of white. The composition on each panel comprises two addorsed birds with spread wings above a creature, either griffin or goat, amongst foliated stems which create a pear-shaped frame for the creature at their centre.

All the panels have extensions for fitting into a larger frame and probably decorated the same door or shutter. The ornamentation is typical of imagery from the Fatimid period in either an Islamic or Coptic context.

M.M.

242

Casket

South Italy, 11th century

Ivory, wood ✦ 33.6 x 18 x 16 cm

The State Hermitage Museum, St Petersburg, inv.no. EG-1244

Provenance: acquired in 1885 from the A. Bazilewsky Collection, Paris

Literature: Darcel - Basilewsky 1874, pp. 15-16, no. 51, pl. X; Kühnel 1971, pp. 64-65, tab. XXXVII-XXXVIII; Kuwait 1990, no. 23

Similar caskets, and carved elephant tusks, were produced in various Mediterranean regions in the 11th to 12th centuries.

The animals represented in the medallions on this casket (lions, antelopes, ibexes, roosters and fantastic beasts) resemble those depicted on the carved tusks. At the same

time, the stylization here is more pronounced than that on a casket in Berlin which was made earlier.

The large blank space left on the ivory plaques for the lock, hinges, and the animals' outlines, plus the arabesque framing and several other features, prompted Kühnel to suggest that the casket should be attributed to an Arab workshop of the 11th century.

Such caskets were probably used as reliquaries.

N.V.

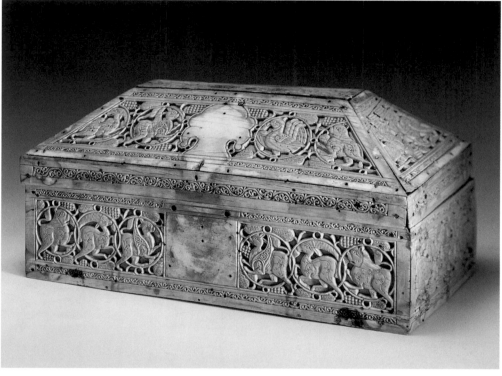

▲ 242

▼ 243

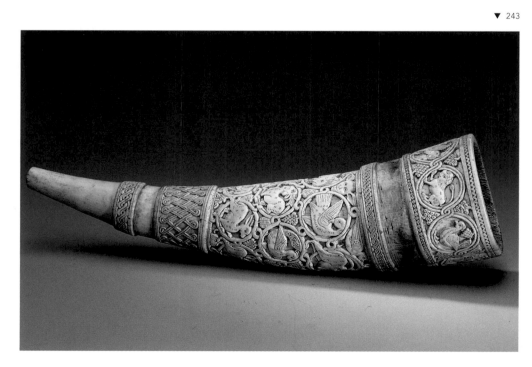

243

Horn

South Italy, 11th century

Ivory ◆ Length 47.5 cm

The State Hermitage Museum, St Petersburg, inv.no. B-5

Provenance: acquired in 1885 from the A.P. Basilewsky Collection, Paris (previously in the treasury of Saint-Frambourg Church in Senlis)

Literature: Darcel - Basilewsky 1874; Kube 1925, no. 44; Falke 1929, book IV, p. 514; Kühnel 1959, book I, pp. 37, 41; Kryzhanovskaya 1969, p. 153; Kühnel 1971, no. 64; Leningrad 1973, no. 130; Leningrad 1988, no. 3; Kuwait 1990, no. 26

Such carved ivory horns were produced in large quantities in various Mediterranean regions during the 11th to the 12th centuries. Among the representations carved on this one are fantastic beasts, as well as animals from warm climates, such as the antelope, lion, ibex and camel. The latter, however, has no humps and its image is not realistic. This could support the hypothesis put forward by Kühnel and several other researchers, who claim that this horn was made in an Italian or Byzantine workshop, where Islamic artists were employed. Originally, this horn was regarded as a 9th-century Byzantine object, until Kube attributed it to western Europe. Orbeli however suggested that its origin lies in Cilicia (southeast Turkey).

M.K.

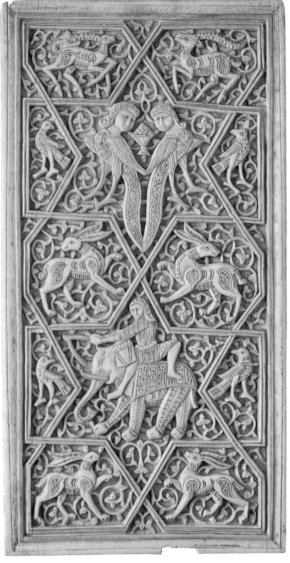

244

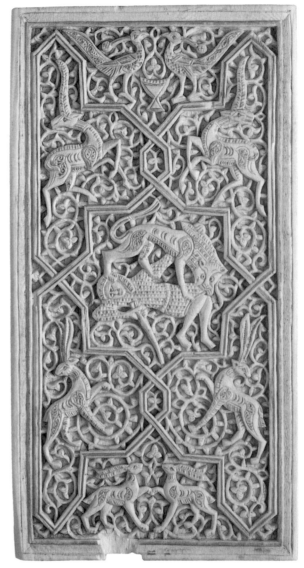

245

244

Plaque

Sicily, circa AD 1200

Carved ivory ◆ Length 24.7 cm, width 12.6 cm

The State Hermitage Museum, St Petersburg,

inv.no. EG-803

Provenance: acquired in 1885 from the A. Basilewsky

Collection, Paris

Literature: Kühnel 1971, pp. 80, tab. CVI; Kuwait

1990, no. 24

The ornamentation on this rectangular ivory
plaque is oriented vertically, the design being
carved in high relief.

The geometrically-organized composition, set

with decorative animal motifs within a back-
ground of tendril ornaments, resembles the
Fatimid style of carving, although these
features also compare with the style of
certain Spanish pieces.

Kühnel, who studied and compared this
plaque (and also *cat.no. 245*) with 'Mozarabic'
objects, and the Valencia casket, decorated
with hunting lions (dated circa 1050),
believed that it could have been made in
Sicily, no earlier than the late 12th century.

This plaque was probably the side panel
of a box.

N.V.

245

Plaque

Sicily, circa 1200

Carved ivory ◆ Length 24.6, width 12.7 cm

The State Hermitage Museum, St Petersburg,

inv.no. EG-804

Provenance: acquired in 1885 from the the

A. Basilewsky Collection, Paris

Literature: Kühnel 1971, pp. 80, tab. CVII; Kuwait

1990, no. 25

The ornamentation on this rectangular ivory
plaque is vertically oriented, the design being
carved in high relief.

Kühnel believed that this plaque, like *cat.no.244*, could have been made in Sicily, no earlier than the late 12th century. The collection at the Ravenna National Museum contains a fragment of an ivory plaque with an almost identical composition, the only difference being the mirror-image positioning of the warrior and the lion. This Kühnel also dates to the same period.

N.V.

concave disks. The forelegs are carved with overlapping scales; the tails are curled and terminate in palm leaves. The outside of the handle is decorated with half palmettes. The shoulder of the ewer bears the Kufic inscription:

the blessing of God on the iman al-'Aziz bi'llah

Imman al-'Aziz bi'llah was the fifth Fatimid caliph, who reigned from 975 until 996.

In 969 the Fatimids annexed Egypt to their existing North African territories. The ewer was made in Cairo. After the Turks pillaged the treasury of the caliph al-Mustansir in 1062, the fourth successor to al-'Aziz bi'llah, the ewer came on the market. Possibly this precious object came into possession of the Venetian Republic at this date.

J.V.

(based on a description by Daniel Alcouffe)

246

Ewer of caliph al-'Aziz bi'llah

Stonework: Fatimid, 975-976, metalwork:
16th century or later
Rock crystal, gold, enamel ◆ Height 23 cm,
width 12,5 cm
Procuratoria di San Marco, Venice, inv.no. 80
*Literature: Pasini 1885-1886, p. 93, pl. LII, fig. 118;
Molinier 1888, p. 38-40, no. 107; Lamm 1929-1930, I,
p. 192-193; II pl. 67, 1; Gallo 1967, p. 300, no. 85; p.
375, no. 29; Hahnloser 1971, pl. XCVIII-XCIX (with
bibliography); Alcouffe 1991, pp. 224-229; Bloom –
Blair 1997, p. 253, fig. 135, Vienna 1998, no. 106*

This magnificent ewer, a key piece in the identification of Egyptian Fatimid rock-crystal objects, is one of the the most famous hardstone vessels in the treasury of San Marco in Venice. The thin-walled ewer is entirely monolithic, cut from a single block of flawless crystal. The underside of the vessel, which is slightly convex, has a broken footring, which made the present gold mount necessary. The handle of the ewer, which is cut from the same piece of crystal as the body of the vessel, has a small sculpture of a crouched ibex as a finial. The relief decoration, enlivened by engraved detail, is of high quality. On the body it is sym-metrically conceived and well placed. Below the spout, arabesques terminating in palmettes and half palmettes spring from a three-lobed cartouche; the lions' heads are marked off by grooved collars from their bodies, which have an overall pattern of

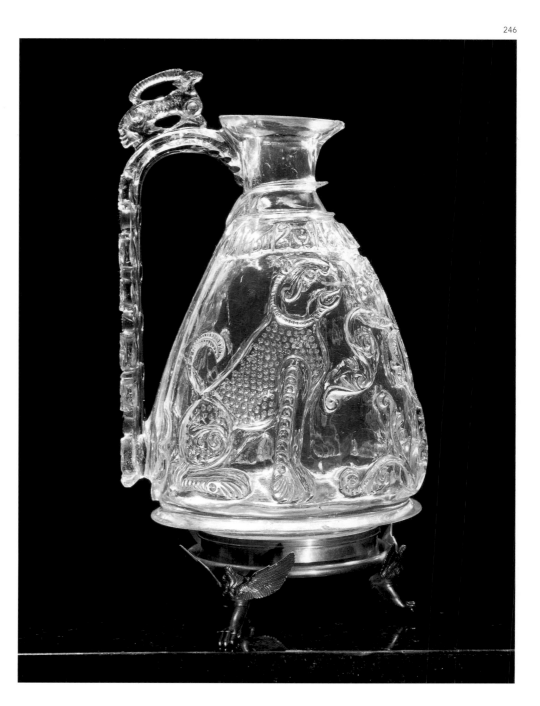

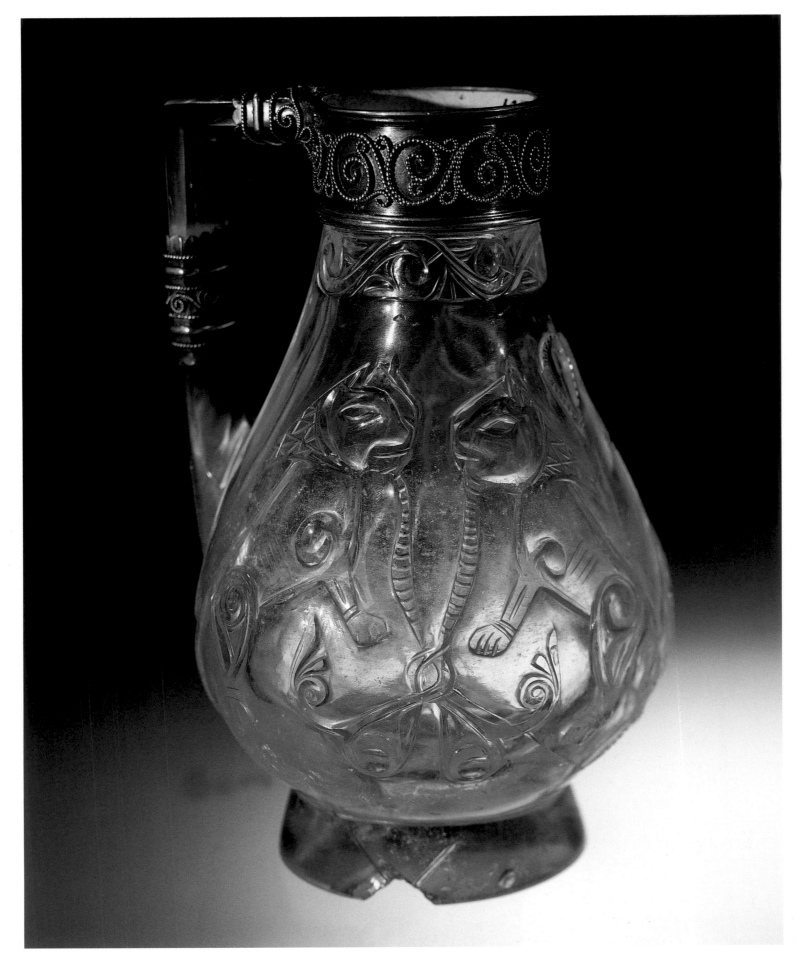

247

Ewer

Egypt, 10th-11th century, with 17th-century
Turkish additions

Rock crystal, gold, coloured stones ◆

Height 16.8 cm, diameter 5.9 cm

The State Hermitage Museum, St Petersburg,
inv.no. VZ-241

Provenance: unknown; acquired by the Department
of Jewellery before 1859

Literature: *Felkerzam 1915, p. 5; Miller 1978, p. 113,
fig. 6; Stockholm 1985, p. 119, no. 34; Kuwait 1990,
no. 16*

The body of this ewer was made of rock
crystal by Egyptian artisans in the 10th to
11th century, its entire surface being covered
with relief-cut geometrical and floral
ornaments.

The decoration of gold and coloured stones
set within a golden frame and fixed on the
body was usual in Turkish items of the mid-
17th century.

This ewer indicates that Egyptian rock-
crystal pieces were highly valued during
the Middle Ages, not only in western Europe
but also in the East where they received a
second life in the hands of the jewellers, and
found their way into royal treasuries.

N.V.

248

Ewer

Egypt, 10th century

Rock crystal, silver ◆ Height 19.8 cm

State Museum The Hermitage, St Petersburg,
inv.no. VZ-801

Provenance: acquired in 1911 from the G.S.
Stroganov Collection (gift of Princess Shcherbatova)

Literature: *Pennendreff 1961; Vienna 1998, no. 108*

Tradition has it that this ewer was found
under the altar in a ruined church in

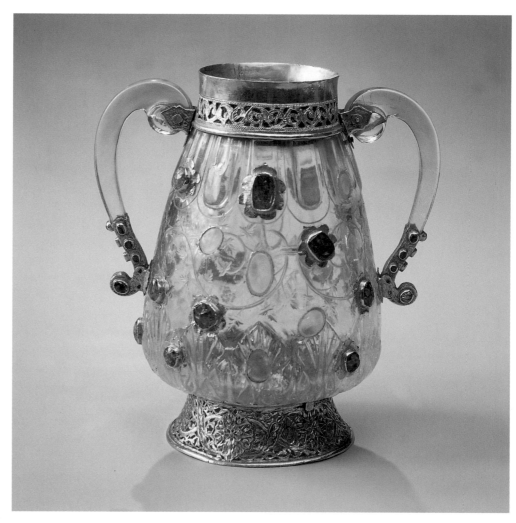

248

Cologne. Later it found its way into the
Stroganov Collection.

The pear-shaped belly has a wide opening
without a spout. The foot is relatively high,
and the handle is rectangular. There are
incised decorations representing two lions
facing each other below a frieze around the
neck, consisting of half palmettes. The
mouth of the neck is silver, of a much later
date, as are the two pieces of silver on the
handle. They are of European make.
The ewer is related to a large collection of
rock-crystal objects that were produced in
Egypt during the Fatimid dynasty (969-
1171). Similar decoration can be found, for
example, on the ewer of caliph al-'Aziz
bi'llah from the Treasury of San Marco
(see cat.no. 246).

A.I.

249

Vial

Egypt, 9th-10th century

Rock crystal ◆ Length 10 cm, Height 3.5 cm

The State Hermitage Museum, St Petersburg,
inv.no. CA-9993

Provenance: transferred in 1931 from The State
Academy of Material Cultural History

Literature: *Pugachenkova - Rempel 1966, fig. 215;
London 1976-I, no. 104; Kuwait 1990, no. 17*

Among the items made of rock crystal in
Egypt were vials in the shapes of animals:
several of these, in the form of recumbent
lions, have survived from the Fatimid period.
This fish-shaped vial is, however, unique in
the known repertory.

The cylindrical depression along the body is

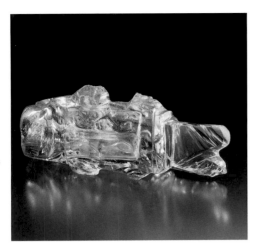

Both sides of the body are cut with ornamentation probably imitating scales, and a rectangular fin with two curves. Similar curves can be seen on other rock-crystal objects from the 9th century. The figure as a whole is rather crude: the head, body, fins and tail are merely suggested by lines.

N.V.

249

characteristic of smaller rock-crystal objects from the Tulunid (868-905) and Fatimid (969-1171) periods. The lower part of the body has been cut so that the fins, head and tail support the vial, thereby making it highly stable.

250

Lamp

Iraq (?), 10th century

Rock crystal ✦ 22 x 6.5 x 6.5 cm

The State Hermitage Museum, St Petersburg, inv.no. EG-938

Provenance: received in 1859 from the former Tatishchev Collection

Literature: St Petersburg 1902, no. 12, p. 332, part II.XXVII; Migeon 1927, part 11, p. 388, fig. 281; Lamm 1929-1930; Pennendreff 1961, p. 8; Stockholm 1985, p. 118, no. 33; Berlin 1989, p. 190, no. 290, p. 547, no. 4/10; Kuwait 1990, no. 15

This lamp is a fine example of 10th- to 11th-century rock-crystal work. Indeed, it seems to be the only rock-crystal lamp of that period which has been preserved. The high level of craftsmanship, the beauty of its decoration with floral motifs and the quality

250

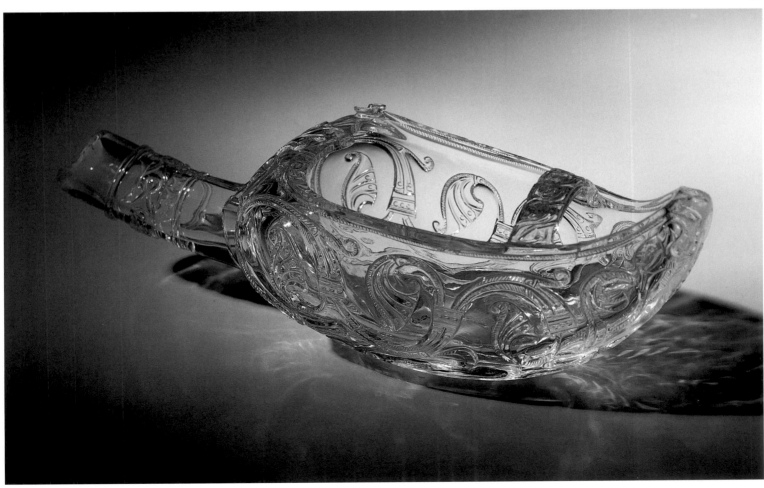

of the crystal itself all point to a court work-shop, whatever its place of origin. Written sources state that in the 10th to 11th centuries, Basra in Iraq, rather than Egypt, played the leading role in rock-crystal manufacture. This permitted Lamm, in 1930, to regard it as that of 10th- to 11th-century Iraqi artisans.

This lamp was brought to Europe during the Middle Ages along with other items of rock crystal. In 16th-century Italy, it was used as a bowl, having been decorated with figures of sea gods and animals. All these decorations were made of gold and enhanced with enamel.

N.V..

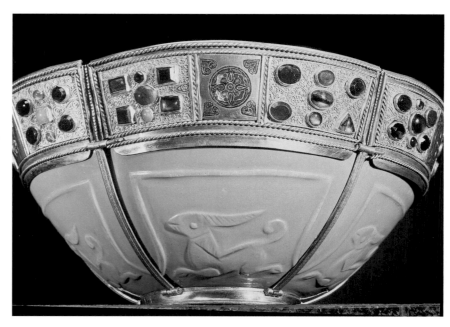

252

251

Square plaque

Egypt, 11th - 12th century

Rock crystal ◆ Height 6 cm, width 6 cm

Benaki Museum, Athens, inv.no. 9430

Literature: Lamm 1929-1930, pl. 76-77; Erdmann
1940, p. 133, fig. 16; Clairmont 1977, p. 104,
no. 354, pl. XXI i; Philon 1980-I, p. 23, no. 59;
Vienna 1998, 137, no. 111

The figure of an animal, possibly a camel, is carved in intaglio on this square plaque. The animal, which is depicted with a blossoming twig in its mouth, has a conspicuously

251

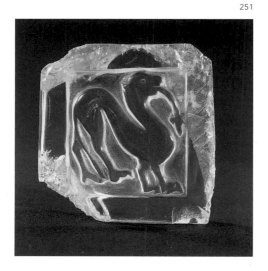

curved body, long hind legs and short ears. The plaque is badly chipped at the edges; its function is difficult to determine.

A.B.

252

Turquoise glass bowl

Glass: Iran or Iraq, 9th or 10th century . Enamel:
Byzantine, 11th century. Other metalwork: late 10th
and 15th century (?)

Glass, silver-gilt, gold cloisonné enamel, stones ◆
Height 6 cm, diameter 18.6 cm

Procuratoria di San Marco, Venice, inv.no. 140
(registered in the inventory of 1571 as no. 62)

Literature: Montfaucon 1702, p. 52; Monttraye 1727,
dl. 1, p. 72, pl. VII, VII bis.; Pasini 1885-1886, pp. 94-
98, no. 105, pl. XLVIII; Molinier 1888, pp. 40-41, 95-
96, no. 93; Lamm 1928, p. 63; Lamm 1929-1930, I,
pp. 144, 158-9; II, pl. 58/23 (with bibliography);
Lamm 1939, III, pp. 2597-2598; VI., pl. 1444A; Paris
1952, no. 73; Rome 1956, no. 486; Gallo 1967, pp.
206-212; 299, no. 62; 352, no. 70; 361, no. 199; 369-
370, no. 42; 397, no. 100; pl. 64, fig. 108-109 (with
bibliography); Hahnloser 1971, p. 101-104, no. 117;
pl. LXXXIX-XC; Charleston 1980, p. 68-73; Salderr
1967-1969, pp. 142-143; Kane 1991, pp. 224-229,
Bloom - Blair 1997, pp. 126-127, fig. 70

The technique of wheel-cutting, etching and polishing glass, found in both Roman and Sasanian periods, was adapted and perfected by the succeeding Islamic civilization, particularly in 9th and 10th-century Iraq and Iran, and was known by the late 10th century in Egypt. The Islamic artists found expression in a new repertory of shapes and designs. This opaque turquoise-glass lobed bowl is one of the best known of the relief-cut type, although it is unique in colour for this production. Generally, colourless glass was preferred at this time, though some undecorated turquoise glass fragments are known. The accomplished art of glass-cutting is one that follows the lapidary tradition in which the material is laboriously abraded to form the patterns. By this process, the relief design is seen on a smooth, usually polished ground, the patterns having been created by both high and counter-sunk relief. On the wall of this bowl is a lively file of running, stylized hares, one animal placed in each of the five lobes.

A low footring encloses an enigmatic inscription in a 9th-/10th-century type of Kufic script. It has been translated as 'Khorasan'. This cannot refer to the place of production, as Khorasan was a large undefined region in

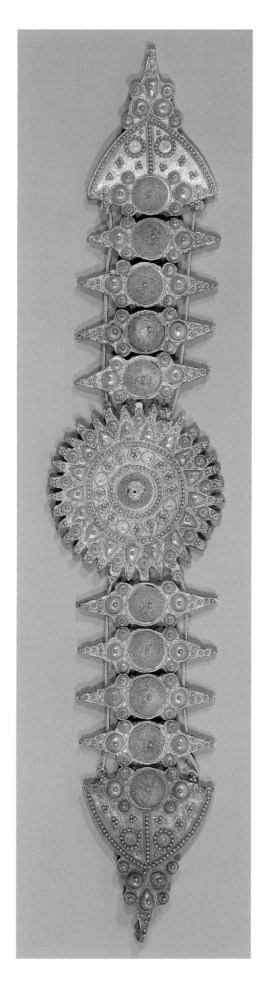

eastern Iran. However, the area was known for its turquoise production, and according to the literature, coloured glass was often accepted as being precious stone. If this bowl was made to simulate and be taken for turquoise it might be inferred that the word was added to support the deception. An explanation of its significance is still awaited.

The vessel is traditionally believed to have been presented by the Shah of Iran to the Venetian Republic in 1472.

J.V.

(*based on a description by Caroline Kane*)

253

Belt elements

Possibly Samarra', 10th century

Gold sheet decorated with granulation and twisted wire ◆ Diameter of central rosette 5.5 cm, length of bars 4 cm, width of finials 4 cm, length of finials 5 cm

Benaki Museum, Athens, inv.no. 1856

Literatuur: Segall 1938, 177, no. 280, pl. 55; Philon 1980-I, no. 48, Paris 1998, 136, no. 77; Vienna 1998, 125, no. 93

Comprising a central rosette, eight rhomboid bars and two finials, these fine, gold belt elements display a design largely composed of domes and granulation outlined by single, or double-twisted wire. Several features recall Iranian pieces, including the box construction with solid sheet on the back and the astonishing use of minute granulation which completely covers most of the domes. This latter feature appears on a pair of bracelets dated to the first half of the 11th century, and on a basket-type earring ascribed to Egypt or Syria in the late 10th to early 11th century. An early dating for this belt is supported by the conspicuous absence of openwork filigree and the decorative device of hemispherical and oval domes which seems to derive from Samarra'-type decoration.

A.B.

254

Ring

Fatimid Egypt, early 11th century

Gold sheet, gold-wire filigree and granulation ◆

Height 2.6 cm; bezel: 2.2 x 1.3 cm

The Nasser D. Khalili Collection of Islamic Art, London, inv.no. JLY 267

Literature: Wenzel 1993, no. 122, pp. 45, 48–49, 203

The ring, which is constructed of gold sheet, is of broad stirrup shape with cusped shoulders. The rectangular bezel is of granulated filigree openwork. The sides and shank have applied circles and arch shapes of thin twisted gold wire.

M.R.

255

Ring

Fatimid Egypt, 11th century

Gold sheet, gold wire filigree and granulation ◆

Height 2.7 cm; bezel: 2.3 x 1.2 cm

The Nasser D. Khalili Collection of Islamic Art, London, inv.no. JLY 1846

Literature: Wenzel 1993, no. 142, pp. 44, 52, 206

This is one of three rings of similar stirrup shape in the Khalili Collection (*compare cat.nos. 257 and 258*), and one of only 13 such rings known today.

The ring is in filigree and granulated openwork, the hoop with an inner lining of gold sheet. It has a high circular bezel surrounded by a figure-of-eight wire border. The shank and sides have roundels, ovoids and half palmettes.

M.R

▲ 254 ▲

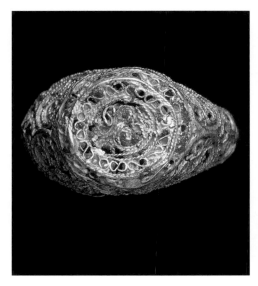

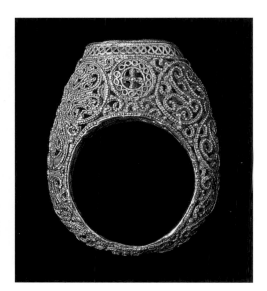

▲ 255 ▲

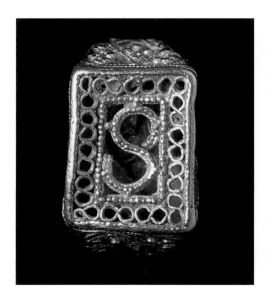

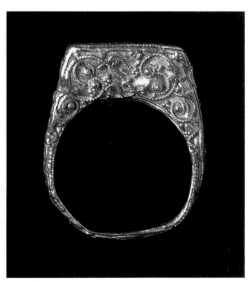

▲ 256 ▲

256

Ring

Fatimid Egypt, 10th or 11th century

Gold sheet, gold-wire filigree and granulaticn ✦

Height 2.1 cm; bezel: 1.7 x 1 cm

The Nasser D. Khalili Collection of Islamic Art,

London, inv.no. JLY 1861

Literature: Wenzel 1993, no. 124, pp. 45, 48–49, 203

The stirrup-shaped ring is of hollow box construction. The rectangular bezel is decorated with filigree and granulated openwork with an s-scroll within a border of figure-of-eight pattern. The shank and sides bear scroll designs in twisted-wire appliqués and granulation.

M.R.

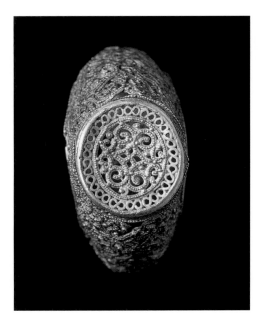

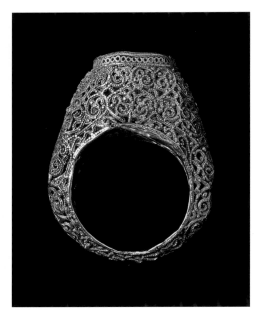

▲ 257 ▲

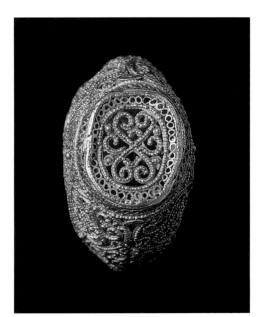

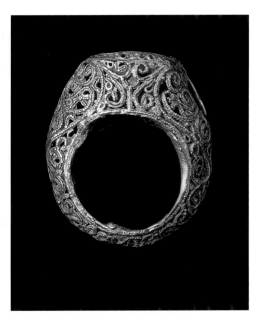

▲ 258 ▲

257

Ring

Fatimid Egypt, 11th century

Gold sheet, gold-wire filigree and granulation ✦

Height 3.1 cm; bezel: 2.5 x 1.2 cm

The Nasser D. Khalili Collection of Islamic Art,

London, inv.no. JLY 1878

Literature: Wenzel 1993, no. 617, p. 42

The high stirrup-shaped ring with an oval bezel is constructed in filigree and granulated openwork. The bezel has filigree scrollwork, while the sides and the shank have dense spiral scrolls. The gold sheet lining of the hoop has a pierced four-petalled rosette edged in filigree.

M.R.

258

Ring

Fatimid Egypt, 11th century

Gold sheet, gold-wire filigree and granulation ✦

Height: 2.9 cm; bezel: 2.3 x 1.2 cm

The Nasser D. Khalili Collection of Islamic Art,

London, inv.no. JLY 1847

Literature: Wenzel 1993, no. 141, pp. 44, 52, 206

The stirrup-shaped ring, in gold filigree and granulated openwork, has an oval bezel with two heart shapes, tip to tip. The shank and sides have medallions, those at the front and back filled with granulated crosses. The hoop is lined with gold sheet decorated under the bezel with a filigree rosette.

M.R

259

Two bracelets

Fatimid, Egypt or Syria, 11th century

Heavy gold sheet, hammered and chased, with

gold-wire filigree and granulation ✦

Diameter 9.2 cm and 8.8 cm, respectively

The Nasser D. Khalili Collection of Islamic Art,

London, inv. nos. JLY 1853, JLY 1854

Literature: unpublished. See also: Hasson 1987, pp.

59–60, and no. 74, p. 66; Atil 1990, no. 43, p. 143

The bracelets were shaped and decorated over a core, probably wax or bitumen, which still remains inside one of the rings. Their chased decoration consists of a design of open strapwork filled with scrollwork, rabbit-like animals, winged sphinxes and birds, some with intertwined necks. The 'clasp' at the front consists of two triangular panels bearing granulated filigree designs with central roundels of four-petalled flowers composed of heart-shaped palmettes, framed within a narrow band of figure-of-eight wire filigree.

The 'clasp' is non-functional and purely decorative. The draw-pin is soldered shut

and the bracelets are not fitted with the hinge seen on, for example, a bracelet in Jerusalem (L.A. Mayer Memorial Institute, inv.no. J46) or a pair in the al-Sabah Collection in Kuwait (LNS 7 J a–b), all of which are somewhat smaller in diameter than the Khalili bracelets.

M.R.

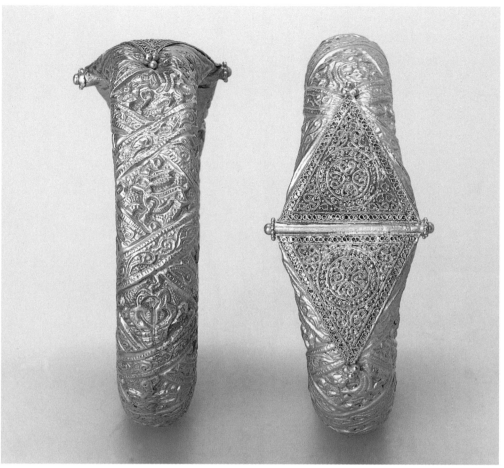

259

260

260

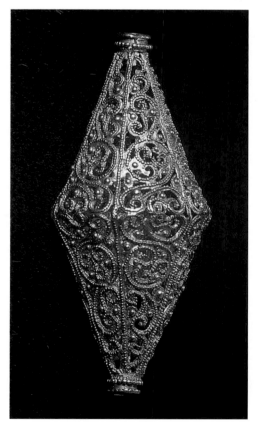

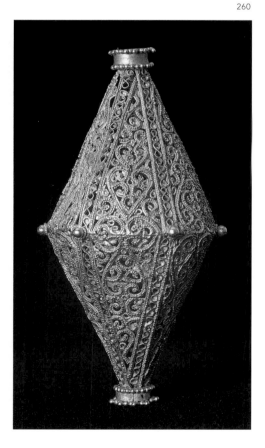

260

Bead

Fatimid, Syria or Egypt, 11th century

Strips of gold sheet, gold-wire and granulation ✦ Length 3.6 cm, diameter 1.6 cm (maximum)

The Nasser D. Khalili Collection of Islamic Art, London, inv.no. JLY 1852

Literature: unpublished. See also: Jenkins - Keene 1982, pp. 86–87 and no. 51d, p. 88

The biconical bead is constructed in granulated openwork. Each half is divided into six panels with scrollwork roundels and s-shaped volutes. The sheet collars are decorated with rows of granulation.

A slightly larger biconical bead with similar decoration is in the Metropolitan Museum of Art, New York (no. 1980.457).

M.R.

269

261

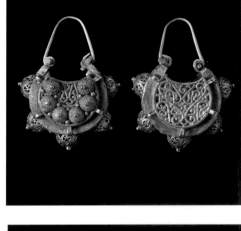

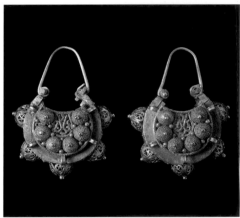

263

261

Two beads

Fatimid, perhaps Syria, 11th century

Gold sheet, wire and granulated openwork ◆ Diameter 2.7 cm

The Nasser D. Khalili Collection of Islamic Art, London, inv.no. JLY 1017

Literature: unpublished. See also: Jenkins - Keene 1982, pp. 86–87 and no. 51d, p. 88

The two large spherical beads are decorated with a finely granulated tracery of spiral scrolls. Their delicate structure is reinforced by the sheet gold tube that connects the two threading holes.

M.R.

262

Plaque

Egypt or Syria, 11th century

Gold sheet and strips, with plain and twisted gold-wire filigree ◆ Height 8.8 cm

The Nasser D. Khalili Collection of Islamic Art, London, inv.no. JLY 1286

Literature: Jenkins - Keene 1982, pp. 52-53; Sotheby's 1989, lot no. 334; Khalili Collection 1993, p. 57

The upper side of this plaque has scrolling designs and a large six-petalled rosette in wire filigree openwork; the back is of sheet gold. Although the filigree is supported by strips of gold sheet, these are placed so as to be invisible.

The lobed plaque retains two hinge elements on one side, and two circular loops behind for attachment, probably to a belt. The central heart-shaped depression was evidently a setting for a stone.

M.R.

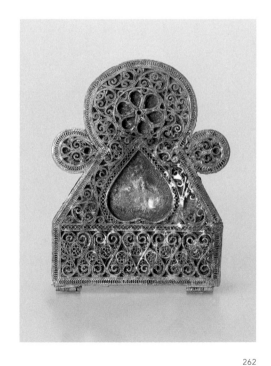

262

263

Pair of earrings

Fatimid, Syria or Egypt, 11th century

Gold sheet, wire and granulated openwork ◆ Height 4.1 cm, width 3.1 cm

The Nasser D. Khalili Collection of Islamic Art, London, inv.no. JLY 1725

Literature: unpublished. See also: Jenkins - Keene 1982, nos. pp. 84–85

The crescent-shaped earrings are of hollow box construction. Panels of granulated filigree on the front, back and sides are framed within strips of gold sheet. The front and sides also bear granulated and wire-filigree bosses.

The earrings were originally further decorated with pearls, strung through a series of small loops on the front and back.

M.R.

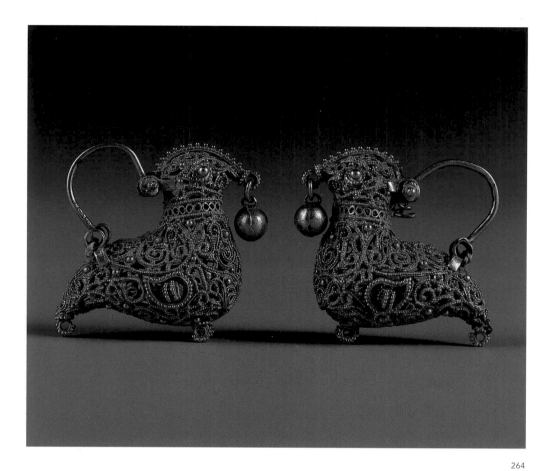

265

Bracelet

Ar-Raqqa (northeast Syria), 11th-12th century

Gold ✦ Diameter 13 cm, diameter at hinge 4.5 cm,
weight 200.33 g

National Museum of Syria, Ministry of Culture,
General Directorate for Antiquities and Museums,
Syrian Arab Republic (Damascus), inv.no. 2799-A
Provenance: Ar-Raqqa

This hollow bracelet is made of embossed
gold and is decorated with benedictory
inscriptions in Kufic script within a border
of stylized floral motifs. On one side the
inscription reads:

> *General glory / everlasting happiness / all
> prosperity / for the owner*

On the other side:

> *General prosperity, total bliss, enduring success*

264

The hinge, in the form of a disc, used to be
adorned with precious stones, all of which
are missing. The piece dates from the Fatimid
period (969-1171).

M. AL M.

264

A pair of earrings

Ar-Raqqa (northeast Syria), 12th century

Gold ✦ Length 3 cm, width 3 cm, weight 12.4 g
National Museum of Syria, Ministry of Culture,
General Directorate for Antiquities and Museums,
Syrian Arab Republic (Damascus), inv.no. 3052-A
Provenance: Ar-Raqqa

These earrings, in the form of a bird with a
ball in its beak, are hollow in construction.
They were suspended from the ear using the
hooks between the bird's head and its rump.

The earrings date from the Fatimid period
(969-1171).

M. AL M.

265

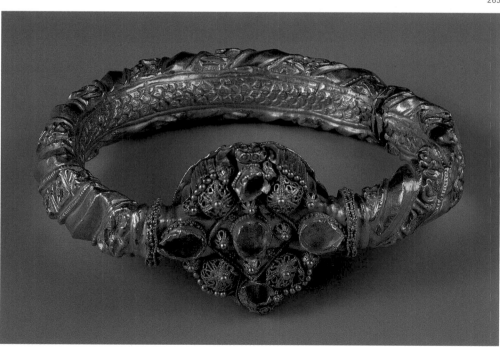

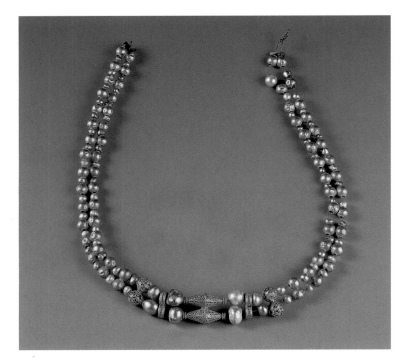

266

266

Necklace

Syria (Aleppo or Ar-Raqqa), 11th-12th century

Gold, pearls ◆ Length 32 cm, weight 17.725 g

National Museum of Syria, Ministry of Culture,

General Directorate for Antiquities and Museums,

Syrian Arab Republic (Damascus), inv.no. 3053-A

Provenance: Aleppo or Ar-Raqqa

This necklace comprises gold beads and
pearls; in the middle are larger pearls,
elongated forms, round beads and gold
circles.

M.AL.M.

267

Gold necklace

Egypt or Syria, 11th-13th century

Gold with filigree and granulation ◆ Length of

necklace without pendants 34.2 cm, length of

crescent-shaped pendant 2.7 cm, diameter of stellate

pendant 1.5 cm

Benaki Museum, Athens, inv.no. 1858

Literature: Segall 1938, no. 282, pl. 55; Philon 1980-I,

p. 21, no. 58; Vienna 1998, 128, no. 98

This necklace is composed of 16 teardrop
beads, 14 rosettes and two pendants which
were strung together in modern times. The
crescent-shaped pendant and the stellate
pendant – not originally part of the same
object – are similar to much Fatimid
jewellery of the 11th century, being of box
construction with openwork filigree and
granulation, incorporating s-curves made of
flat wire. The varying colours of the gold
alloy suggests the necklace elements are of
diverse manufacture. Each rosette is made
of two similar pieces soldered back-to-back;
the openwork section is made of s-curves
with a central hemisphere and crenellated
border of three grains. Similar crenellation is
found on jewellery ascribed to the 11th to
13th centuries. The teardrop beads are made
of sheet gold, decorated with filigree and
granulation that forms triangular facets

257

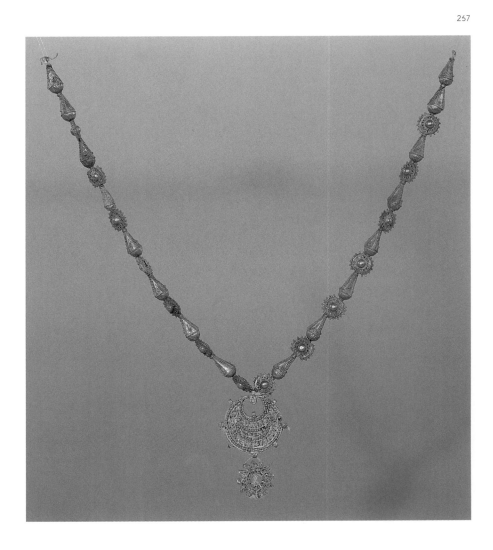

enclosing a single shot. One bead is different from the rest and decorated with a filigree scroll. These beads are similar in form and construction to two beads in the Metropolitan Museum of New York, of unknown origin but ascribed to the 11th or 12th centuries, and a number of beads in the Benaki Museum, also of unknown origin.

A.B.

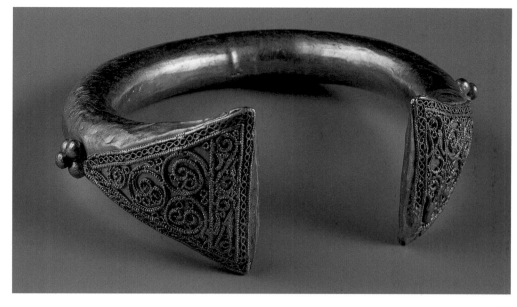

269

268

Pair of gold earrings

Spain, late 12th century

Gold ✦ Height 5.5 cm

Benaki Museum, Athens, inv.no. 1862

Literature: Segall 1938, fig. 285, pl. 57; London 1976-II, fig. 652, p. 388; Philon 1980-I, fig. 225, p. 46; Evans - Wixom 1997, fig. 279, p. 421

This pair of gold crescent-shaped earrings is ornamented with granulation and filigree. The upper edges terminate in trefoils; the area between is filled with a cursive inscription. The main decoration of two birds flanking a tree motif is contained within the crescent. The five triangular projections around the edges were probably hung with pearls or other precious stones. Crescent-

shaped earrings were also popular in the Fatimid period although the basic design had its origin in pre-Islamic times. These earrings are very similar to another pair in the Museum of Mallorca which were found in a jar with other jewelry and coins dated from the 12th century.

M.M.

269

Bracelet

Syria (Aleppo or Ar-Raqqa), 13th-14th century

Gold ✦ Diameter: 8 cm, weight 50.2 g

National Museum of Syria, Ministry of Culture, General Directorate for Antiquities and Museums, Syarian Arab Republic (Damascus), inv.no. 2795-A

Provenance: Aleppo or Ar-Raqqa

The ends of this cylindrical gold bracelet terminate in triangles which are decorated in gold wire with stylized floral and geometric motifs. Small balls adorn the junction of bracelet and triangles.

This piece was made during the Mamluk period (1260-1516).

M. AL M.

268

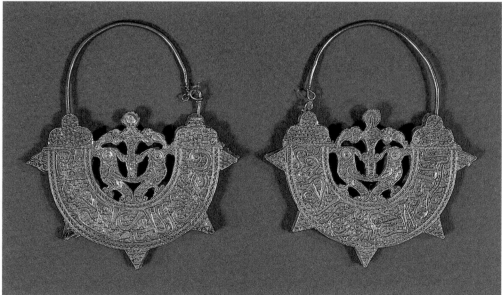

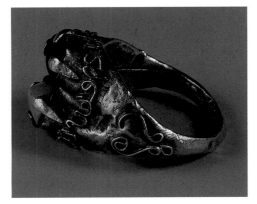

270

Ring

Syria (Aleppo), 13th-14th century

Gold ✦ Weight 3.395 g

National Museum of Syria, Ministry of Culture,
General Directorate for Antiquities and Museums,
Syrian Arab Republic (Damascus), inv.no. 1349-A

Provenance: Aleppo

This gold ring is set with two semi-precious
stones, a turquoise and a red silan, orna-
mented on both sides with gold wire in the
form of a stylized heart. There is also a text
in gold wire:

*Everlasting honour and favour for the owner,
and love*

This object dates from the Mamluk period
(1260-1516).

M. AL M.

271

Elements from a necklace

Granada, late 15th-16th century

Gold and cloisonné enamel

The Metropolitan Museum of Art, New York,
inv.no. 17.190.161a-j. Gift of J. Pierpont Morgan,
1917

*Literature: Rosenberg 1918, vol.3, pp. 154-55, figs.
277-280; Hildburgh, pp. 211-31, esp. 216-18; Dodds
1992, cat. no. 78, pp. 302-03 (ill.). See also: Osma y
Scull 1916, pp. 7-8 (ill.); Jenkins - Keene 1982, no. 52,
pp. 92-93; Levenson 1991, no. 55, pp. 172-73*

Ten elements of delicately crafted gold,
consisting of a medallion, four pendants
shaped like lotus flowers, four spool-like
beads, and a smaller tube (or tute), once
formed part of the same ensemble, a portion
of a treasure unearthed in Granada, Spain
before 1916. Given that all the elements can
be strung and are of precious material, they
are presumed to come from a necklace,
though the original arrangement, number of
components and range of materials are not
known. The work of a virtuoso goldsmith,
the surviving pieces combine filigree (in
which fine gold wire is used to create
openwork decoration), granulation (in
which tiny spheres of gold, individually
soldered, cluster together), and cloisonné
enamel (in which tiny particles of red, white
and green glass are fused to metal within
areas defined by gold wire).

The artistic heritage of these elements can
be seen in beads and pendants created and
preserved in Damascus. Yet these pieces are
irrevocably bound to the history of medieval
Spain, where they were excavated. On
the basis of common technique, the use of
enamel and appearance, they have been
attributed to the same workshop as a num-
ber of other pieces, including garniture for a
horse and a torah shield. The quality of the
goldsmith's work suggests a patron of the
highest level.

The large, circular medallion bears an overt
proclamation of the Christian context for
which it was created. Inscribed around the
perimeter of the circle are the words AVE
MARIA GRACIA PLENA, ('Hail Mary, full of
grace') the greeting of Gabriel to the Virgin
Mary when the archangel came to announce
that Mary would bear the Messiah. Recorded
in the Gospel of Luke, the angel's salutation
became one of the most frequently intoned
prayers of medieval Christianity.

B.B.

271

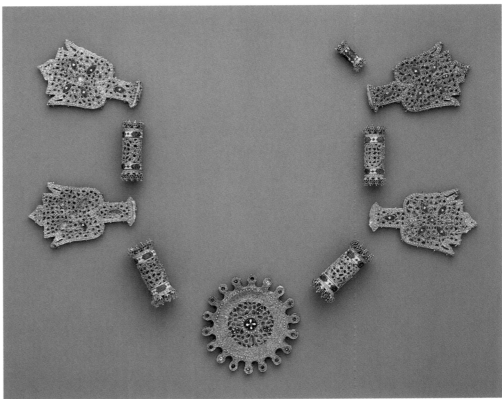

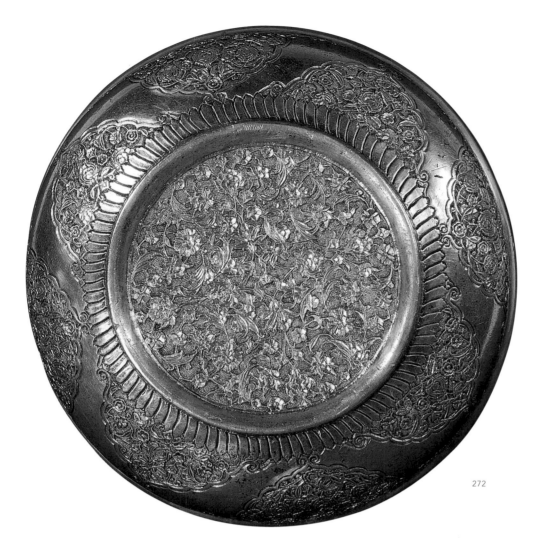

272

273

Parcel-gilt silver bowl

Ottoman Empire, 1481-1512

Parcel-gilt silver ◆ Diameter 12.5 cm, height 3 cm

Benaki Museum, Athens, inv.no. EA 909.

Literature: Ballian 1988-1989; Kürkman 1996, 123

This small hemispherical bowl is made of sheet silver with a facetted honeycomb cavetto resting on a row of embossed petal-like scallops. One of the cells is stamped with the *tughra* of Bayezid II which is also found on a bowl in the Freer Gallery of Art in Washington, D.C. A rivet in the centre shows where a disc was once attached. The underside is engraved with an interlacing design of elongated split leaves and small lotus palmettes on a ring-punched ground, radially arranged around a central flower, all enclosed by a band of overlapping leaves. Similar elongated leaves can be found in illuminations from as early as the last years of Mehmed the Conqueror's reign (died 1481), and on Iznik wares from circa 1480-1510. Bowls of this type evolved from late Gothic prototypes in Balkan countries; during the late 15th century they exercised considerable influence on the design of early Iznik ceramics.

A.B.

272

Silver-gilt bowl

Ottoman Empire, circa 1550

Silver gilt ◆ Diameter 15.5 cm, height 3.5 cm

Benaki Museum, Athens, inv.no. 13772

Literature: Borboudakis 1994, no. 93

This shallow bowl is made of sheet silver with a separate disc riveted to the centre. The ornamentation displays a variety of motifs and styles, which represent almost the entire repertory of Ottoman decoration in the mid 16th century. A split-leaf arabesque is engraved on the disc; the cavetto is engraved with interlaced quatrefoil medallions filled with split leaves and adorned with cloud bands at the interstices. The lobed half medallions on the outer walls and base are engraved with a *saz (see cat.no. 162)* and

rosette design. Broken stems around the perimeter of the base recall the painterly mannerism of the Sünnet Odasy panels, the Rüstem Pasha tiles and ceramic dishes from circa 1545-50. A guilloche pattern on the rim, a scroll with split leaves and lotus palmettes below, and waving petals at the base complete the decoration.

A.B.

273

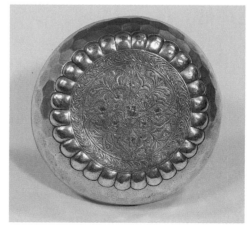

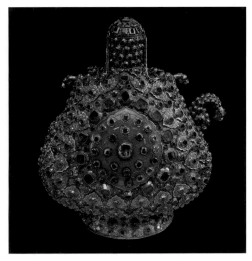

274

Ceremonial canteen (matara)

Ottoman Empire, 2nd half 16th century

Gold, jade, emeralds, rubies, pearls • Height 28 cm,
width 24 cm, depth 13 cm

Topkapi Palace Museum, Istanbul, inv.no. 2/3825

*Literature: Raby 1982, pp. 17-33, pl. 28; Çagman
1983, E.206; Çagman 1984, pp. 51-87, pl. 10;
Çagman 1987, pp. 85-91, pl. 1; Atil 1987, pp. 123-
125; Rogers-Köseoglu 1987, pl. 49; Atasoy - Artan
1992, p. 47; Ward 1993, p. 13, pl. 5; Bloom - Blair
1997, pp. 403-405, pl. 210*

This unusual *matara*, which was used to hold
the sultan's drinking water, has a flattened
bulbous body that tapers at the top, and a
round, slightly elevated foot. On the shoul-
ders are two dragon heads, one with a pearl
in its mouth, the other with an emerald;
between these are the neck and a gold mesh
handle. A short curved spout ending in a
dragon head is also attached to the body. The
canteen, of solid gold, is ornamented with
relief cartouches in the form of palmettes;
lobed medallions containing plaques of green
jade, decorated with emeralds and rubies in
gold floral mounts, adorn the centre of the
canteen front and back. The entire surface of
the object is encrusted with small blossom
and leaf motifs, plus emeralds and rubies in
raised petalled mounts.

The narrow sides of the matara are decorated
with medallions and a cypress tree motif;
the lowest medallion contains a small jade
plaque. The centre of the domed lid is set
with a large rose-cut ruby; the collar inserted
into the neck is engraved and decorated with
niello. The dragon holding the pearl is in-
scribed with the weight of the object '640
dirhem', and the word '*tecdid*', indicating that
the matara has been restored: the gold
decorations and settings must have been
repaired when this inscription was added.

Similar mataras can be seen in Ottoman
paintings from the 16th century; they were
carried by the *Çuhadar Aga*, the official
responsible for the sultan's clothing who
always accompanied the ruler, together with
the *Silahtar Aga* who carried the sultan's
sword. Paintings produced during the reigns
of Selim II (1566-1574) and Murad III
(1574-1595) often show such mataras which
were supervised by officials of the *Has Oda*,
the treasuries of Topkapi Palace.

The shape of this canteen has been derived
from central Asian leather prototypes such as
those found in the Pazyryk burial mounds in
the Altai mountains of southern Siberia.
A flask of the same shape, made of appli-
qued leather, was presented to the Austrian
Emperor Rudolf II in 1581 by Murad III.
Similar vessels are still used today by the
nomadic tribes of Anatolia.

E.B. - S.M.

275

Turban ornament

Ottoman Empire, mid 16th century

Gold, sapphires, turquoise, diamonds, rubies,
niello • Height 19.4 cm

Topkapi Palace Museum, Istanbul, inv.no. 2/2912

*Literature: Çagman 1983, E.84; Atil 1987, no. 83;
Rogers - Ward 1988, no. 61; Berlin 1988, no. 63; Paris
1990, no. 251; Sydney 1990, no. 101; Budapest 1994,
no. 50*

This ornament, in the form of a lobed half
medallion, is attached to the pin shaft with a
convex ring. On both sides of the medallion
and the ring delicate twigs have been
engraved on a niello ground; the ornament
is also encrusted with rubies and turquoise.
The centre of the ornament is set with

275

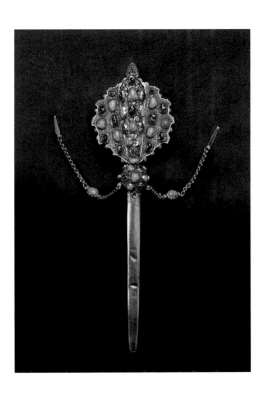

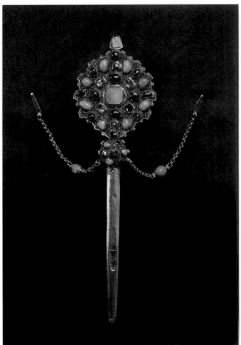

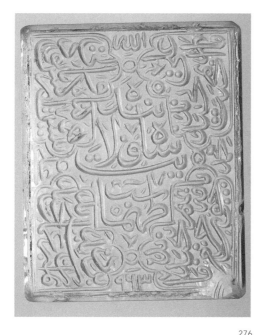

276

In Twelver Shiism (the dominant Shiite movement), the Persian term *shah-i-vilayat* ('King of Divine Amity') is an attribute exclusive to Imam 'Ali, and reflects his close personal relationship with God.

Beginning from the lower right-hand corner, the Persian verse reads:

> *When the list of my offences was rolled up and taken to be weighed on the balance of human deeds,*
> *my sins outstripped those of any other person, but I was forgiven, for the love of 'Ali.*

In addition, the names of Allah, Muhammad and 'Ali are written in the middle of the top, left- and right-hand sides, with the date 963 (AD 1555-56) along the bottom.

M.R.

The base and the domed lid are covered with sixteen emerald panels, carved with stylized cypress trees and acanthus borders, in a gold framework. The lid has a faceted diamond knop in a gold bezel.

The emeralds used, some 93 in total, are perfectly matched and were evidently cut from the same matrix, a Colombian stone. The underside is engraved with concentric floral designs enamelled emerald green.

M.R.

sapphires and diamonds. The gold feather socket on the back is decorated with bands of clouds in niello on gold. The techniques employed to decorate this turban ornament, in particular the combination of niello and gold, can also be found on a number of other objects from this period.

E.B. - S.M.

276

Seal of Shah Tahmasp

Iran, dated AH 963/AD 1555-56

Rock crystal, wheel-cut ✦ Height 3.1, width 2.4 cm

The Nasser D. Khalili Collection of Islamic Art,

London, inv.no. TLS 2714

Literatuur: Falk 1985, p. 102, no. 67

The rectangular seal is cut from flawless rock crystal. It is densely inscribed in a fine cursive script with the name of Shah Tahmasp, the second Safavid ruler of Iran (r. 1524-76), and four lines of Persian verse in the corners.

The name of Shah Tahmasp appears in the centre of the seal:

> *The slave of the king of Divine Amity, Tahmasp.*

277

Box (pandan)

Mughal India, Shah Jahan period, circa 1635

Gold sheet, carved emeralds, diamond, green

enamel ✦ Height 4 cm; diameter 5 cm

The Nasser D. Khalili Collection of Islamic Art,

London, inv.no. JLY 1857

Literature: Khalili Collection 1993, p. 58

277

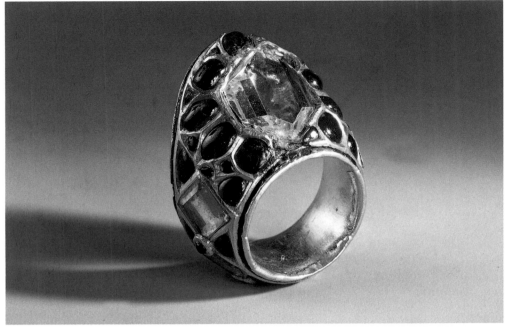

278

the mission were of Indian origin (including 14 elephants), which can be explained by the fact that Nadir Shah had captured Delhi in 1739, and had carried away the treasury of the Mughals. It was from there that he sent his mission to St Petersburg in October 1739. The journey therefore took two years.

A.I.

279

Bracelet

India, 17th century

Gold, precious stones, enamel ◆ Diameter 11.8 cm

The State Hermitage Museum, St Petersburg, inv.no. VZ-721

Provenance: brought in 1741 by Nadir Shah's mission

Literature: London 1931, N 314 B; Persian Art 1939, part VI, pl. 1436 B; London 1982, N 313; Ivanov - Lukonin - Smesova 1984, no. 91, fig. 143; Kuwait 1990, no. 95

In India, such bracelets were worn on the legs. This one can be divided into two halves. The outer surface is decorated with three diamonds, 547 rubies and 34 emeralds; the inside is decorated with champlevé enamel.

278

Archer's ring

India, 2nd quarter 17th century

Gold, precious stones ◆ Diameter 4 cm

The State Hermitage Museum, St Petersburg, inv.no. VZ-703

Provenance: brought in 1741 by Nadir Shah's mission

Literature: Ivanov 1972, pp. 25-29; Hermitage 1981, p. 95; Ivanov - Lukonin - Smesova 1984, no. 96, fig. 158-159; Kuwait 1990, no. 93

The form is typical of an archer's ring, which was designed to be worn on the thumb and protect the skin from bowstring damage.

This ring, an opulent example for a courtly milieu, is set with six diamonds, twenty-one rubies and fourteen emeralds. Its inner surface bears a Persian inscription:

Second Lord of the Auspicious [planetary] Conjunction.

This formula was part of the official titulature of Shah Jahan (r. 1628-1658), the third in the series of great Mughal emperors who ruled India in the 17th century. The well-established usage of this title on objects

made for Shah Jahan indicates that this piece was made for him personally.

The ring was brought to St Petersburg to the Russian court in 1741, 23 years before the Hermitage was founded, together with other gifts from Nadir Shah, who ruled Iran between 1736 and 1747 *(see also cat.nos. 279, 280, 282 and 288)*. All the gifts presented by

279

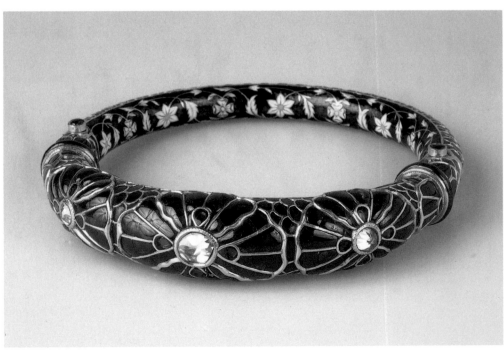

The 1741 mission brought two practically identical bracelets to St Petersburg; only the number of precious stones differed *(see also cat.nos. 278, 280, 282 and 288).*

A.I.

280

Ewer for rosewater

India, 17th century

Gold, silver, precious stones ◆ Height 26 cm

The State Hermitage Museum, St Petersburg, inv.no. VZ-701

Provenance: brought to Russia in 1741 by the delegation from Nadir Shah (gift to the Tsarina Elisabeth)

Literature: Ivanov - Lukonin - Smesova 1984, no. 105

This sumptuous ewer decorated with precious stones is a splendid example of the work of 17th-century Indian jewellers. A motif is engraved on the large emerald.

The highly functional form of this ewer was a characteristic design in all Islamic cultures where life was made more pleasant through the use of scented water.

A.I.

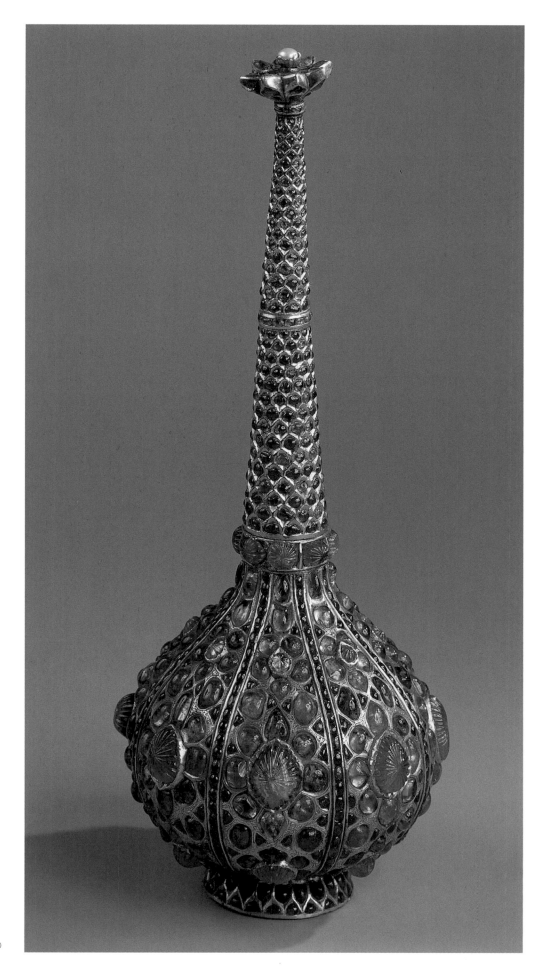

280

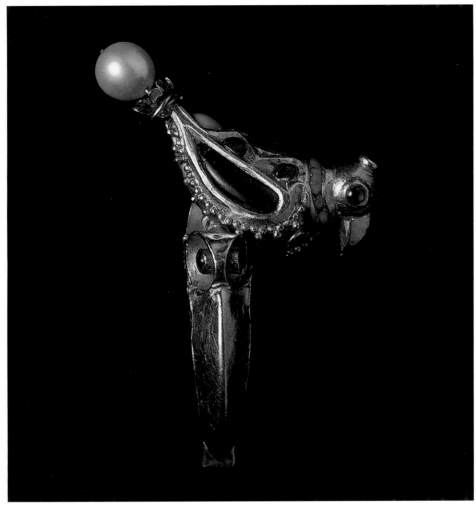

281

Turban ornament

India, 17th century

Nephrite (jade), precious and semi-precious stones ◆
Height 15.5 cm

The State Hermitage Museum, St Petersburg,
inv.no. VZ-444

Provenance: brought in 1741 by Nadir Shah's mission.
Transferred in 1886 from the Arsenal in Tsarskoye
Selo (today Pushkin, St Petersburg district)
*Literature: Gille 1835-1853, part I, pl. LXVII, no.8;
Kammerer 1869, p. 234, no. 264; Ivanov - Lukonin -
Smesova 1984, no. 92, fig. 150-151; Kuwait 1990,
no. 94*

Jewels such as this were called *jiqa* and worn
on a shah's or a sultan's turban as a sign of
dignity.
This ornament is decorated with six rubies,
one emerald, three beryls and seventeen
agates, the latter being of especially beautiful
quality. This jiqa was also among the gifts
brought to St Petersburg by Nadir Shah's
mission of 1741 (*see cat.nos. 278 - 280 and
288*).

A.I.

281

Ring

South India (perhaps Mysore), 17th century
Gold, cast and sheet, with wire and granules; set with
cabochon rubies, turquoises, New World emeralds,
and a pearl ◆ Height 4.3 cm, width 2.5 cm
The Nasser D. Khalili Collection of Islamic Art,
London, inv.no. JLY 1109
Literature: Wenzel 1993, cat. 493, pp. 154–155, 270

The bezel is in the form of a hawk, or a
parrot, on its perch. The technique suggests
late 17th-century Persian workmanship,
but the ring closely resembles the so-called
hawking ring of Tipu Sultan of Mysore
(r. 1782–1799) captured from him at the
battle of Seringapatam in 1792.

M.R.

282

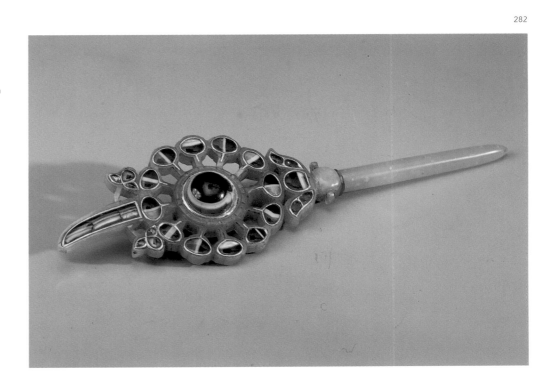

283

Pendant

Morocco, 17th century

Silver-gilt, pearls, precious stones ✦ Height 9 cm,
width 6.8 cm

Benaki Museum, Athens, inv.no. 2010

Literature: Segall 1938, fig. 378, p. 205

This fine silver-gilt pendant in the shape of
an eagle, decorated with openwork filigree,
is set with pearls, emeralds and rubies. The
eagle has spread wings and a silver crest on
its head. The filigree decoration on the body
of the eagle takes the form of a delicate
scroll. According to the museum's records
this pendant once belonged in the collection
of Prince Yasensky who was given the piece
by Tsarina Alexandra, wife of Tsar Nicholas II
of Russia.

M.M.

284

Dagger and scabbard

Iran, late 16th century (blade); Turkey, 17th century
(hilt and scabbard)

Steel, nephrite (jade), silver, gold, precious stones ✦
Blade length: 21.5 cm

The State Hermitage Museum, St Petersburg,
inv.no. OR-504

Provenance: acquired probably in 1924, from the
former Paskevich Collection

*Literature: Ivanov 1979-I, p. 66, no.7; Kuwait 1990,
no. 86*

A limited number of Iranian weapons have
survived from the 16th century, or earlier
periods. Since 16th-century pieces are
extremely rare, every item is of great
importance. As a result of this dearth,
weaponry from the 16th to 17th century
has not yet been adequately classified, and
researchers are still sorting the material.
Among the few pieces known is a group of
double-edged blades decorated with floral
ornaments and Persian verses. The majority

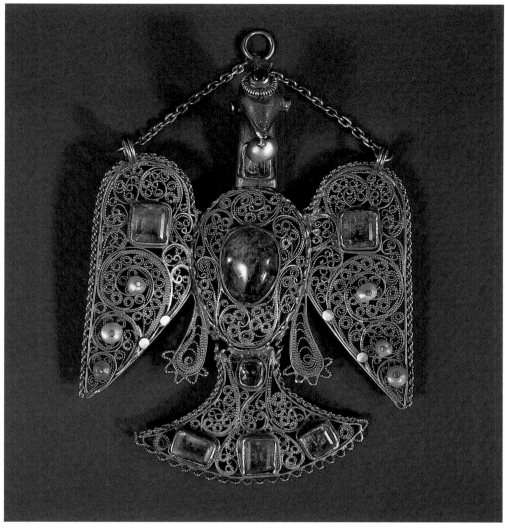

283

of these were made in Iran, in the late 16th
century, although their hilts and scabbards
were made much later in Turkey. The

Hermitage piece is a good representative of
this group, and has verses inscribed in
nasta'liq script:

284

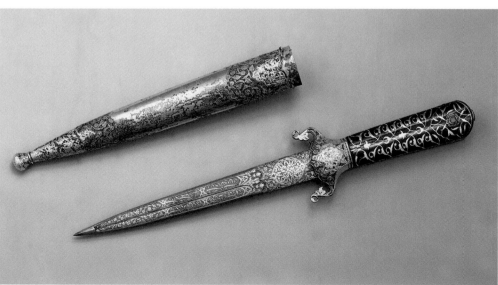

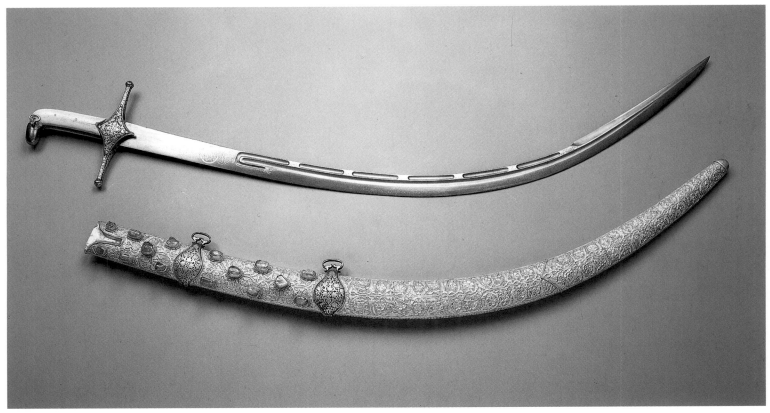

285

One side of the blade bears the following *rub'ayya* (four-part verse):

Every time your dagger spoke of revenge,
It confused time with its bloodshed.
The beauty and purity of its damask steel ornament
Made it like a willow leaf covered with dew.

On the other side is an incised line of verse by a little-known poet of the late 15th century, named Bayayzi Hisari' (in the metre known as *hazaj*):

Strike my chest with your dagger
several times,
Open several doors for pleasure in my
heart.

On the same side, there follows another *bayt* (stanza), also in hazaj metre:

Take out your dagger and get my
heart out,
So that you could see our heart among
the loving.
A.I.

285

Sword and scabbard

Signed by the craftsman Sultan-'Ali Misri
Blade: Syria (?), AH [1]023/AD 1614-15; hilt: Iran,
17th century; scabbard: central Asia (Khiva),
1st half 19th century
Steel, gold, ivory, precious stones ◆
Length in scabbard: 98 cm
The State Hermitage Museum, St Petersburg,
inv.no. OR-1847
Provenance: transferred in 1900 from the Palace
Administration in Peterhof (now Petrodvorets,
St Petersburg district), originally from the Khiva
treasury
Literature: Kuwait 1990, no. 115

This sword is composed of elements manufactured at different periods, a phemonenon frequently encountered.

The curved blade of pattern-welded steel is decorated with grooves along its back edge and inlaid with gold (floral) ornaments and

inscriptions. A large round medallion on the blade bears the artisan's signature and probably the date:

Work of Sultan-'Ali Misri 023.

The writing of the name ('Sultan' and "Ali' are joined), as well as the *nisba* which lacks the prefix *al*, suggest that the craftsman worked in Iran, probably in the 17th century: the numerals over the character *lam*, 023 may mean AH [1]023/AD 1614-15. However, this is difficult to prove as nothing is known of other examples of Sultan-'Ali Misri's works.

The strongly curved blade, widened at the end, does not resemble blades attributable to 17th-century Iran. This, together with the *nisba*, 'Misri' (meaning 'Egyptian'), makes it unlikely that the artisan was of Iranian origin. He may have been a Syro-Egyptian craftsman who came to work in Iran, or was born in a family of Syro-Egyptian artisans who had already settled there.

The presumed date, AH 1023/AD 1614-15, corresponds to the period when Shah 'Abbas I ruled in Iran (1587-1629); the second medallion of the blade bears his name:

A slave of the Shah of Holiness
(ie. of Imam Ali), *'Abbas.*

However, such inscriptions are to be encountered on a variety of blades, some of which are inscribed with false dates; the authenticity of this example has therefore to be independently established.

Two cartouches on the blade contain a Shiite Pious saying:

There is no stalwart but 'Ali; there is no sword but Dhu-l-Fiqar ('Ali's sword).

The shape of the quillon and the golden ornament on the hilt and scabbard fittings seem to be of Iranian origin, although not earlier than the 18th century.

The scabbard is covered in gold sheet repoussé work with large-scale floral ornament in a style seen in many items from the Khiva treasury, which were captured by Russian troops in 1873 and taken to St Petersburg. The two upper sections are also set with four beryls and eleven aquamarines.

A.I.

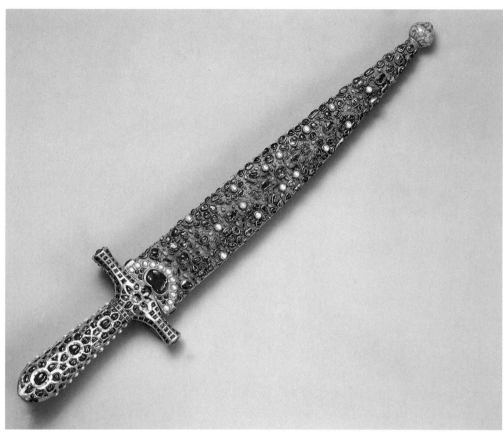

286

286

Dagger and scabbard

India, 17th century (blade, grip and locket);
Iran, late 17th century (scabbard)
Steel, gold, precious stones ◆
Length in scabbard: 39.7 cm
The State Hermitage Museum, St Petersburg,
inv.no. OR-452
Provenance: transferred in 1886 from the Arsenal in
Tsarskoye Selo (now Pushkin, St Petersburg district)
Literature: Kammerer 1869, tab. XX, no. 6; Ivanov -
Lukonin - Smesova 1984, no. 109, fig. 173-175;
Kuwait 1990, no. 112

This dagger was already in Peter the Great's Cabinet of Curiosities as early as the 1730s, although nothing is known of how it arrived in Russia.

The piece is of complex construction: the blade, grip and locket are evidently Indian, the precious stones set in deep cavities, whereas the scabbard – which is slightly too long for the blade – is decorated in a different fashion. The stone settings protude from the surface; the background between them has been worked to achieve a granulation effect. Some of the items in the State Armour Museum (in Moscow) with a similar background were brought from Iran in the 17th century. Thus it is likely that the scabbard was made in Iran.

A.I.

283

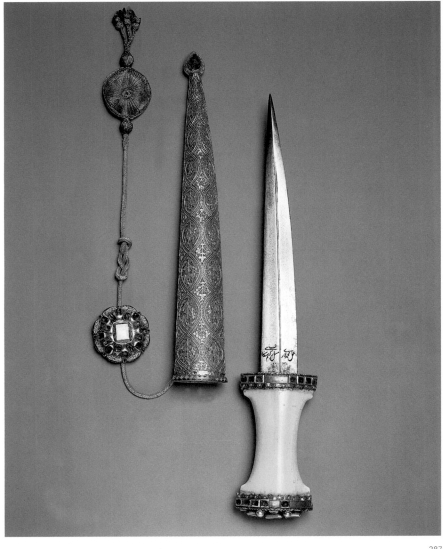

287

287

Dagger with sheath

Signed by the artisan Muhammad Lari

Iran AH 1031/AD 1621-22

Steel, gold, enamel, precious stones, emerald ◆
Length 42.8 cm

State Museum The Hermitage, St Petersburg,
inv.no. OR-448

Provenance: transferred in 1886 from the Arsenal in
Tsarskoye Selo (today Pushkin, district St Petersburg)

Literature: Ivanov - Lukonin - Smesova 1994, no. 53

This is a classic example of a 17th-century
Iranian dagger, its shape typical of the
period. The master craftsman Muhammad
Lari, active in the first quarter of the 17th
century, signed the piece as follows:

*Made by Muhammad Lari. With the blade I
widened the wound (or split). AH 1031.*

Later, in the second half of the 17th century,
the dagger was reworked, a common occurrence.. The chain is probably of a later date.
There is another dagger made by this craftsman, in the Moscow Armoury.

A.I.

288

Box with a tray

India, 17th century

Gold, enamel ◆ Diameter: 33 cm (tray), 15.2 cm (box)

The State Hermitage Museum, St Petersburg,
inv.nos. VZ-706, VZ-707

Provenance: brought in 1741 by Nadir Shah's mission

*Literature: London 1982, no. 327; Ivanov - Lukonin -
Smesova 1984, no. 99, fig. 163; Kuwait 1990, no. 96*

Both the tray and the box are octagonal
and made of gold covered with polychrome
champlevé enamels exemplifying the
extremely high level of 17th-century Indian
craftsmanship. This piece is particularly rare
as both tray and box have been

288

preserved together. The Hermitage has another octagonal gold tray, without the box.

Both pieces were brought to St Petersburg by Nadir Shah's mission in 1741 *(see cat.nos. 278-280, 282).*

A.I.

289

Tray and casket (pandan)

North India, circa 1700

Gold, engraved and enamelled in basse taille and cloisonné in translucent red and emerald green and opaque white ◆ Height 9.7 cm, diameter: 14.3 cm (casket), 31 cm (tray)

The Nasser D. Khalili Collection of Islamic Art, London, inv.no. JLY 1720a–b

Literature: Khalili Collection 1993, p. 58; Zebrowski 1997, pls. 30, 34, 35; pp. 53, 56, 59

The *pandan* and the tray are enamelled with poppy-like flowers, dwarf cypresses and acanthus fronds. The interior of the pandan and the underside of its base are enamelled emerald green over engraving with large lotus flowers and designs suggesting scales or plumage.

In style and workmanship these pieces, as well as cat.no. 290, are close to gifts, now in the Hermitage, St Petersburg, offered by an embassy from Nadir Shah to the Empress Elizabeth, which reached the Russian capital in 1741 *(see cat.nos. 278-280, 282 and 288).*

M.R.

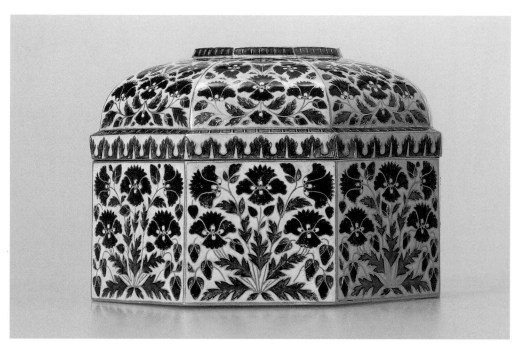

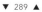
▼ 289 ▲

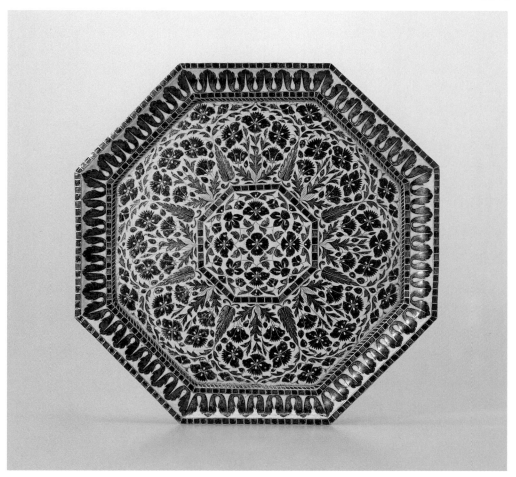

290

Spittoon

North India, circa 1700

Gold, engraved, and enamelled in basse taille in translucent red, emerald green, golden yellow and dark blue, and opaque bluish white ◆ Height 5.5 cm, diameter (rim) 11.1 cm

The Nasser D. Khalili Collection of Islamic Art, London, inv.no. JLY 1072

Literature: Khalili Collection 1993, pp. 60–61; Zebrowski 1997, pl. 37, pp. 58, 62

The spittoon has a depressed globular body on a lobed foot and a broad everted bracketed rim. The rim has eight petal-

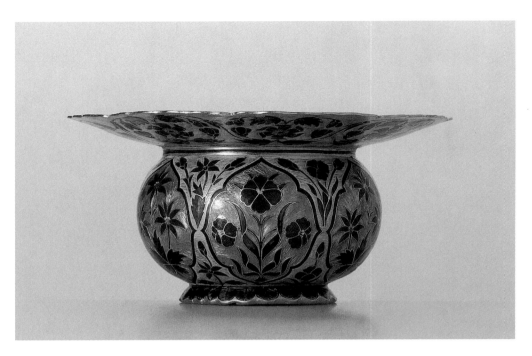

▼ 290 ▲

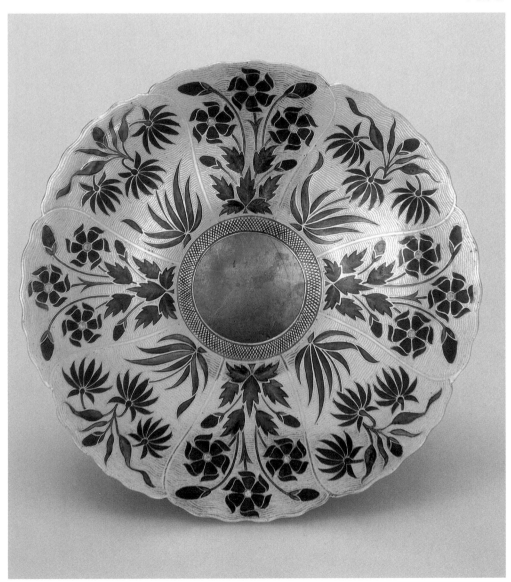

shaped compartments with alternating stylized poppies and Crown Imperials (*Fritillaria imperialis*); underneath it has an undulating floral scroll. On the body are flowers enamelled on a gold or a white ground. The underside of the foot is worked as a four-petalled lotus with emerald-green enamel over scale-like engraved ornament.

The treatment of the background, where opaque, bluish-white enamel has been applied in short, wave-like grooves, is unusual.

M.R.

286

291

Jewelled pendant

Ottoman Empire, Sultan Mustapha III period

(1754-74)

Emerald, gold, diamonds, pearls, rubies ♦

Length 19 cm; size of emerald 5 x 6.6 cm;

total length 45 cm

Topkapi Palace Museum, Istanbul, inv.no. 2/7618

Literature: Rogers - Köseoglu 1987, pl. 9

This pendant comprises an emerald cut as a hexagonal prism and a baroque jewelled gold mount inscribed with the name of Sultan Mustapha III (1757-74). The gold mount elements are set with small diamonds. Beneath the emerald hangs a small gold ornament set with rubies and a tassel made of 38 strings of seed pearls.

This pendant was originally intended for the tomb of the Prophet at Medina.

E.B. - S.M.

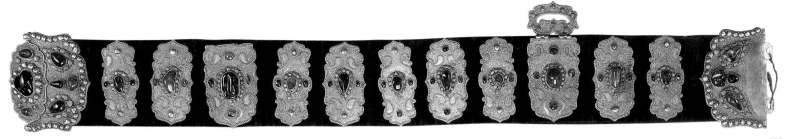

292

292

Belt

Ottoman Empire, early 18th century

Velvet, gold, turquoise, rubies, pearls and other

precious stones ◆ Length 110 cm, width 11.2 cm;

size of buckles 13 x 11.5 cm, 13 x 9 cm

Topkapi Palace Museum, Istanbul, inv.no. 2/677

Literature: unpublished

This belt comprises two large gold buckles
and 11 small gold plaques on dark-red vel-
vet. The gold elements are decorated with
twisted gold wire, large rubies, emeralds,
pearls and turquoise; the edges are delinea-
ted with a band of gold granulation.

Belts of this design adorned with filigree and
granulation were apparently first made in
the 18th century. However, the simple jewel
settings and cabochon stones recall early
16th-century Ottoman jewellery. This belt
is therefore an interesting example of
combined styles.

E.B. - S.M.

293

Two katars (push-daggers)

India, late 18th century

Steel, gold, turquoise ◆ Length 36.1 cm (OR-1196),

39 cm (OR-1180)

The State Hermitage Museum, St Petersburg,

inv.no. 1196

Provenance: transferred in 1885 from the Arsenal in

Tsarskoye Selo (now Pushkin, St Petersburg district)

(Count P. Saltykov Collection)

Literature: Kuwait 1990, no. 110, 111

Both daggers have a hilt made of steel,
decorated with stylized floral ornaments in
gold overlay. The smaller dagger has been
set with turquoise. The hilts are of pattern-
welded steel; on the smaller dagger this is
also decorated with a stylized floral orna-
ment overlaid with gold and set with
turquoise.

Y.M.

293

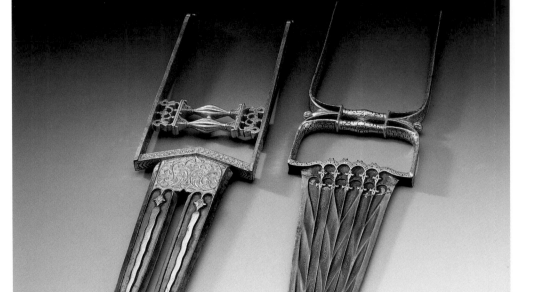

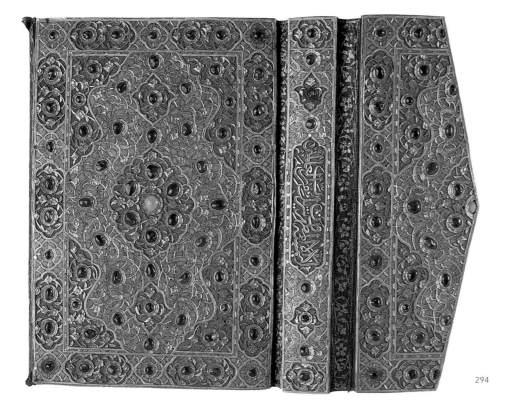

294

295

Reservoir for a qalian (waterpipe)

Iran, 1st half 19th century

Gold, enamel ◆ Height 20.2 cm

The State Hermitage Museum, St Petersburg,
inv.no. VZ-296

Provenance: transferred in 1927 from
the State Museum Fund

*Literature: Ivanov - Lukonin - Smesova 1994, no. 69;
Loukonine - Ivanov 1996, no. 275*

During the reign of Fath 'Ali Shah (1797-
1834, *see cat.no. 303*) gold objects decorated
with bright, multicoloured enamels became
widespread. These were showy items, initial-
ly made by jewellers at court. This reservoir,
which held water for a *qalian*, is a fine ex-
ample of such work. The connecting pipes
and top section for smoking tobacco have
been lost.

A.I.

294

Cover for a Qur'an

Ottoman Empire, 16th century

Gold, paper, leather, turquoise, rubies ◆

Height 14 cm, width 10 cm

Topkapi Palace Museum, Istanbul, inv.no. 2/2900

*Literature: Atasoy - Artan 1992, pl. 71; Bilirgen 1995,
pp. 385-395*

This Qur'an cover has a gold binding which
is decorated with an openwork floral pattern
and lavishly embellished with turquoise and
rubies. The spine is inscribed with a text
from the Qur'an.

E.B. - S.M.

295

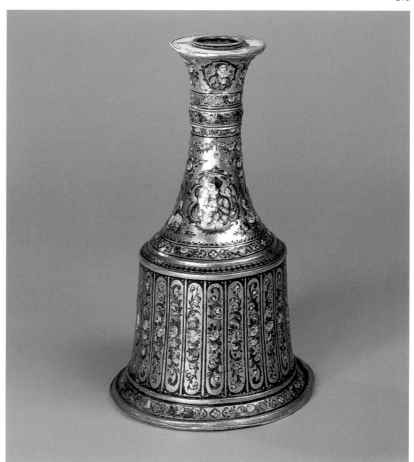

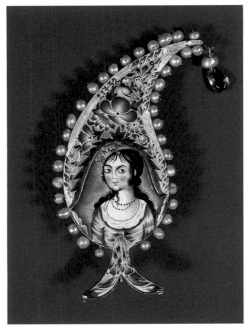

296

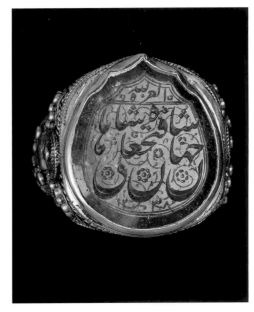

297

Signet ring of Fath 'Ali Shah

Iran, AH 1238/AD 1822–23
Siberian emerald, darkened with oil and set in gold
sheet with wire filigree, granulation and appliqués ◆
Height 2.7 cm, width 2.2 cm
The Nasser D. Khalili Collection of Islamic Art,
London, inv.no. JLY 1778
*Literature: Christie's 1989-I, lot no. 348; Wenzel 1993,
cat. 552, pp. 168-169, 280; Raby 1999, no. 133,
pp. 88–89*

The ring is set with a flat Siberian emerald
carved in fine *nasta'liq* script, on a ground
of delicate floral scrollwork,

*Glory belongs to God. The king of the kings
of the world, Fath 'Ali. 1238.*

In a recent study, Julian Raby has pointed
out that there can be little doubt that the seal
impression on a letter from Fath 'Ali Shah
(*see cat.no. 303*) to his Head Treasurer was
made using this signet ring. The personal
tone of the letter suggests that the Shah used
his signet ring on less official documents,
reserving the seal in the form of a *tabula
ansata* for royal orders.

The cusped oval shape of the seal seems to
have had some significance, as cartouches of
this shape are used to enclose the name and
titles of Fath 'Ali Shah on many of his early
portraits, including an enamelled miniature
in the Khalili Collection (inv.no. JLY 1231).

M.R.

▼ 297 ▲

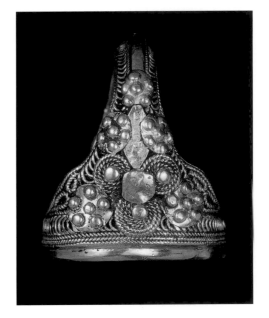

296

Turban ornament

Iran, Qajar period (19th century)
Gold, enamel painting, coloured glass, pearls ◆
Height 8.7 cm
Benaki Museum, Athens, inv.no. 21732
Literature: unpublished

A turban ornament in the form of a leaf
delineated by small pearls. The front is set
with coloured glass which simulates precious
stones such as rubies and emeralds. The
reverse is enamelled with the portrait of a
woman on a blue ground below colourful
flowers and a bird. The woman is delicately
painted with fine details in her face, hair and
costume. Enamel painting was a popular
decoration on Qajar jewellery from the
Safavid period (1501-1730) onwards,
imitating European miniatures of the 18th
century. Contemporary oil paintings reveal
the extensive use of such jewels at court. It
was quite usual for the front to be set with
stones, and enamelling applied to the back.

M.M.

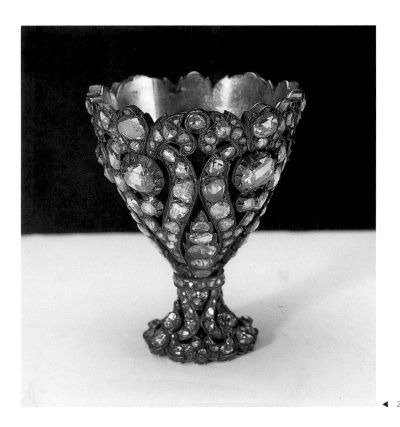

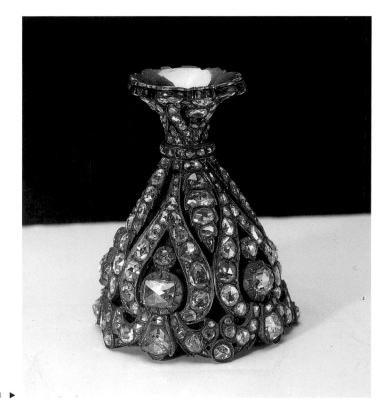

◀ 298 ▶

298

Two coffee cup holders

Ottoman Empire, 19th century

Gold, enamel, diamonds, silver ◆ Height 6 cm,
diameter 4 cm

Topkapi Palace Museum, Istanbul, inv.no. 2/2297,
2/2308

*Literature: Rogers - Köseoglu 1987, pl. 107;
Atasoy - Artan 1992, p. 256*

These two holders (*zarf*) for porcelain coffee
cups, from a set of 12, are enamelled and
encrusted with brilliants.

E.B. - S.M.

299

Sword with scabbard

Central Asia (Bukhara), final quarter 19th century

Steel, silver, precious stones, pearls ◆ Length 94 cm

The State Hermitage Museum, St Petersburg,
inv.no. OR-172

*Provenance: presented in 1889 to Tsar Alexander III
by a delegation from Bukhara*

The shape of this sword betrays the influence
of Russian (or European) weapons which
would subsequently become widespread in
Bukhara (now Uzbekistan) during the late
19th and early 20th century. The style of
decoration and the meticulous setting of the
stones, however, are characteristic of central
Asia in this period.

A.I.

299

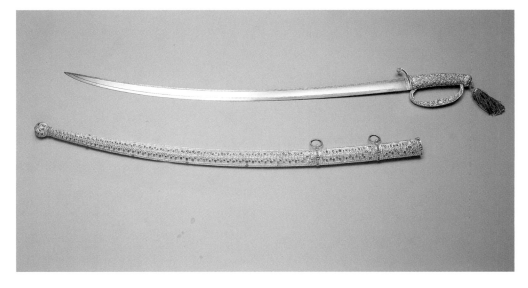

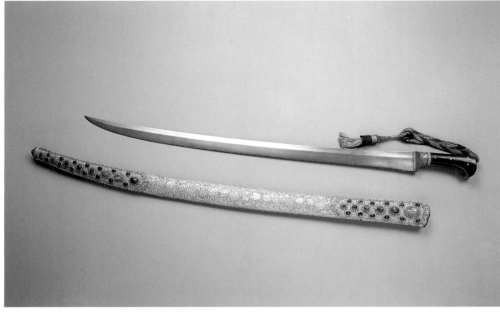

300

300

Sword and scabbard

Central Asia (Khiva Khanate), 19th century

Steel, gold, silver, precious stones, turquoise,

glass ✦ Length 79.3 cm

The State Hermitage Museum, St Petersburg,

inv.no. OR-102

Provenance: transferred as part of the looted treasury

of Khiva, after capture of the city in 1872

Literature: unpublished

The blade is typical of 19th-century central
Asian swords. The gilded scabbard, encrusted
with precious stones like fruit hanging from
a branch, indicates that this piece was made
by armourers from the Khanate of Khiva.

A.I.

301

Sabre and scabbard

Iran, early 19th century

Steel, gold, ivory, enamel, precious stones ✦

Length 99.5 cm

The State Hermitage Museum, St Petersburg,

inv.no. OR-22

Provenance: transferred in 1886 from the Arsenal in

Tsarskoje Selo (today Pushkin, district St Petersburg).

In 1836 a gift from the Tsarina to Nicholas I

Literature: Ivanov - Lukonin - Smesova 1984, no. 65

This sabre, which is encrusted with many

precious stones, is typical of the work of
armourers at the Iranian court during the
reign of Fath 'Ali Shah (1797-1834; *see cat.no.
303).* Such sabres were purely for ceremonial
purposes. They were a symbol of dignity and
station: a fitting gift from a ruler to a sub-
ordinate or a group of subjects to their ruler.

A.I.

302

Book rest

Iran, 17th century

Wood, paint finish ✦ Height 58 cm, width 20 cm

The State Hermitage Museum, St Petersburg,

inv.no. VR-184

Provenance: acquired in 1924 from the Stieglitz

Museum (formerly the P.V. Charkovsky Collection)

Literature: Veymarn 1974, fig. 216; Adamova 1996,

no. 37

On the outer surfaces of the book rest genre
scenes have been painted in bright colours
on a black background. These include girls
in a garden, a husband and wife, dervishes
in a garden and hunters on horseback. The
flat multi-coloured figures, stylized trees,
flowers, animals and birds form a rhythmic
and ornamental unity. The landscape com-
ponents are painted in brown, red and green;
the tree trunks, leaves and flowers are

301

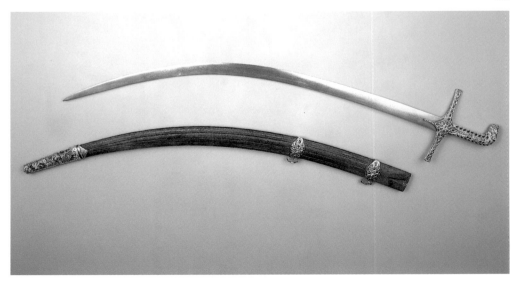

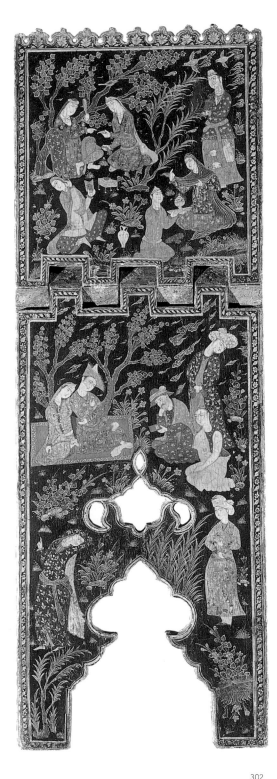

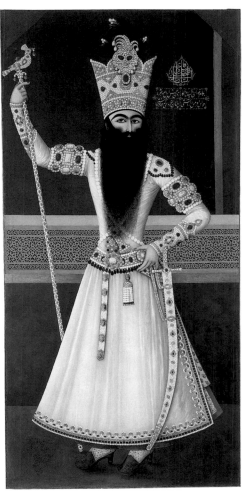

303

painted scenes are closely related in style to the works of Rizah-i 'Abbasi from the 17th century. Moreover the figures' clothing, especially the headgear – lavish turbans, pointed hats with wide brims trimmed with fur, a small ladies' hat – is typical of the 1630s and 1640s.

A.A.

303

Full-length portrait of Fath 'Ali Shah

Mihr 'Ali

Iran, AH 1224/AD 1809-10

Oil on linen ◆ Height 253, width 124 cm

The State Hermitage Museum, St Petersburg,

inv.no. VR-1107

Provenance: transferred in 1932 from the palace

museum of Gatchina (St Petersburg district)

Literature: Soltykoff 1853, p. 352; Adamova 1996,

no. 64

Fath 'Ali Shah, who ruled Persia from 1797 to 1834, is portrayed full-length against a dark background. In his right hand he holds a sceptre crowned with a hoopoe, the bird of Sultan Suleyman mentioned in the Qur'an (XXVII: 20). He wears a sumptuous official costume: a huge crown with three plumes of black heron feathers – a symbol of rank and dignity during the Qajar dynasty (1795-1925) – robes of yellow silk, a sabre, a girdle, *bozubands;* his sceptre is encrusted with pearls and precious stones. On the wall upper right behind the shah is an inscription in a medallion:

Sultan Fath 'Ali Shah Qajar

A rectangular cartouche under the medallion contains the following verses:

*According to thy will hast Thou, o Thou,
Serene Provider,
Created this illustrious monarch.
When Thou didst create this being,
Thou didst create him as he himself had
desired.*

In the corner lower left is written:

*This linen is a portrait of a padishah (sultan)
without equal, has in the light of clear
sanctified beams acquired qualities resembling
the sun, and has been assimilated without
[any] change in a series of portraits, executed
by the fortunate brush of the feeble slave Mihr
'Ali in 1224.*

Four portraits of Fath 'Ali Shah are known in which he is portrayed full-length; three of these were painted by Mihr 'Ali. This portrait is the first of the series. It may be assumed that Mihr 'Ali introduced this type of royal portrait.

Probably this painting of Fath 'Ali Shah from 1809 or 1810 once belonged in the collection of A.D. Saltykov who travelled through Iran in 1838. When Saltykov described the shah's

302

outlined in gold. This technique, which derives from 16th-century lacquer painting, heightens the decorative effect. Fanciful motifs on the inner surfaces of the book rest also form a rhythmic whole.

There is no date on the book rest but the

treasury in Tehran, he mentioned seeing amongst the other clothing a robe of yellow silk sown with pearls the size of peas. He added: 'I recognized the clothing in which Fath 'Ali Shah was portrayed larger than life in a painting which hangs in my home in Russia and was made by a Tehran artist.'

A.A.

304

Tughra of Sultan Mahmud II

Ottoman Empire, AH 122/AD 1808-09

Gold and black paint on cream-coloured paper ◆

28 x 34 cm

Topkapi Palace Museum, Istanbul, inv.no. G.Y.825

Literature: Çagman 1983, E.335

This *tughra*, the emblem with the sultan's monogram, was drawn for Sultan Mahmud II (1808-39) in black on cream-coloured paper by the renowned calligrapher Mustafa Rakim (1757-1826). The monogram has been copied upper right and combined with the word *adli*, the sultan's honorific, in an illuminated medallion.

The date and artist's signature have been inscribed in *thuluth* script in a number of registers lower left in a pear-shaped cartouche. The entire tughra is adorned with floral sprays and leaves; the squares in the corners are decorated in the style of the period. The panel is enclosed by black and gold bands; gold drawings and ornaments embellish the margins.

E.B. - S.M.

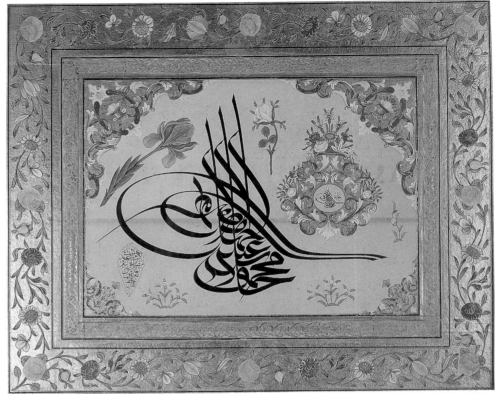

304

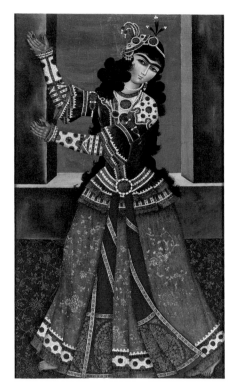

305

305

Female dancer with castanets

Iran, 1st quarter 19th century

Oil on linen ◆ Height 158 cm, width 90 cm

The State Hermitage Museum, St Petersburg,
inv.no. VR-1110

Provenance: transferred in 1932 from the palace
museum of Gatchina (St Petersburg district).

Literature: Adamova 1996, no. 66

For commentary see *cat.no. 306.*

306

Woman with rose

Iran, 1st quarter 19th century

Oil on linen ◆ Height 184 cm, width 94 cm

The State Hermitage Museum, St Petersburg,
inv.no. VR-1113

Provenance: transferred in 1932 from the Stieglitz
Museum (previously in the P.V. Charkovsky Collection)

*Literature: Borozdna 1821, pp. 120, 123; Adamova
1996, no. 67*

On the evidence of stylistic qualities this painting can be dated to the first decade of the 19th century. This dating is also confirmed by details in the clothing of both women which match descriptions by visitors to Iran at the beginning of the 19th century.

Borozdna, the secretary to the Russian embassy at the court of Fath 'Ali Shah, wrote: 'Before I had concluded my article on clothing, I began to fear that suspicion would arise amongst my esteemed readers with respect to the costume of Persian women, seeing that I had informed them myself how difficult it is to see these recluses. I must vindicate myself to them.

High-ranking ladies in Persia do not show themselves in public and live in seclusion in their harems. We have never obstructed these sacrosanct females, we have not been guilty of deception or attempts to penetrate to them; however, sometimes from the balconies of prominent Persian houses,

designated for our sojourn, our glances penetrated neighbouring houses, some swiftly and naturally, others with the aid of a spyglass. Old women with children on their arms appeared on balconies or behind windows without demur; young women and girls with veils were secluded behind them, standing or seated, and their heads could barely be seen. Several pictures and paintings also served to complete the description of costuming.'

Borozdna also wrote: '...in exceptionally wide pantaloons, of velvet or wool, and cotton for ordinary ladies, going down to the heels and covering almost all of the leg. A *pirokhan* (gown), of muslin, silk or cotton, extremely short and not reaching to the knees, is worn above the wide pantaloons and fastened from the top with a decorative button, and has an opening in the middle which extends beneath the bosom to reveal a portion of the body.'

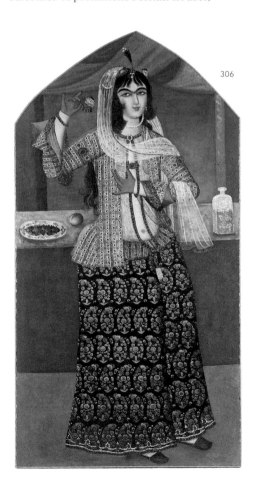

306

The woman with the rose wears a transparent pirokhan beneath a small jacket (*nimmaneh*) of typically Iranian striped fabric, with wide *shalvars* bearing a motif of repeated stylized betel palm leaves (*buta*). The female dancer's costume is richer and more complex: over the nimmaneh she wears a small brown jacket (*arkhaluq*), obviously of velvet, with short sleeves, secured around the elbows with *bozubands*. The *arkhaluq* is fastened around the waist with a massive belt; a red scarf with long fringes, printed with floral motifs, hangs from the little metal plate on the belt. The border of the wide pantaloons or skirt (the fabric appears to be European) is decorated with a pearl and emeralds which form a geometric pattern. Both women wear a small round hat, with side flaps, and a *jiqa (see cat.no. 282)* on the crown, stiffened with a string of pearls which hangs beneath the chin without touching it.

A.A.

295

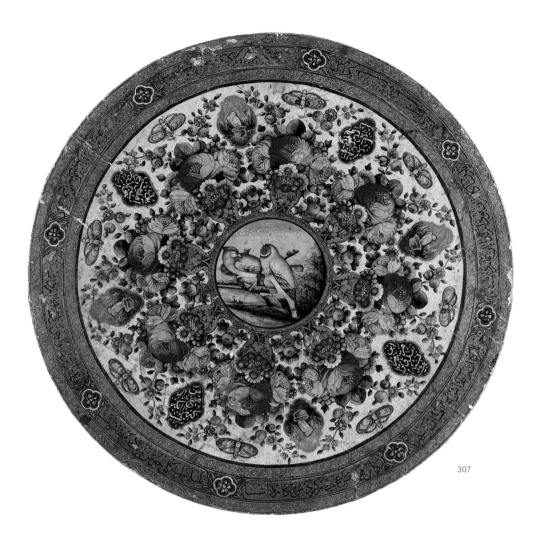

307

Each cartouche contains a prose verse from a *ghazal* (love poem) by the 14th-century poet Hafiz:

> *The nightingale held in his beak a petal from*
> *a rose and as well as beguiling song gave to*
> *that petal sad moans.*
> *I asked him: 'Wherefore these laments and*
> *pleas for deliverance, if you are fully one [with*
> *the rose]?' He said: 'I have been brought to this*
> *by the passion of one in love.'*
> *If the beloved did not come to sit with us, we*
> *had no reason to complain. You, beloved, were*
> *a free queen who did not descend to the poor*
> *rabble.*
> *Rise up, and let us lay our souls before the*
> *brush of that artist who disseminated all those*
> *dazzling motifs thanks to his artistic skill.*

Flowers and butterflies are painted on the support and feet.

The painting on the round table clearly displays the artist's ability to subject all elements to a decorative system: despite the complexity of the subject each component has been meticulously treated. Other objects decorated by the same artist show that he was capable of positioning similarly complicated compositions on both round and oblong forms, and in both medallions and cartouches. Bright colour combinations and accentuated contrasts between light and dark are characteristic features of this artist's work.

There is another piece by Abu-l Qasim al-Husayni al-Isfahani in The Hermitage collection, a picture frame from AH 1319/ AD 1901-02, inv.no. VR-1282. All four sides of this frame are decorated in the centre with landscapes with buildings and verses from the *ghazals* of Hafiz.

A.A.

307
———

Small table

Abu-l Qasim al-Husayni al-Isfahani
AH 1301/AD 1883-84
Wood, paint finish. On three legs, with a round top ◆
Diameter of top 52.5 cm, height 77 cm
The State Hermitage Museum, St Petersburg,
inv.no. VR-1281
Provenance: purchased in 1977 from M.V. Itina
Literature: Hafiz 1927, p. 21, no. 56; p. 87, no. 148;
Adamova 1996, no. 109

In the centre of the table top is a round medallion with a picture of two birds in a tree. Above the birds' heads is the artist's name and date, in white paint:

> *Made by Abu-l Qasim al-Husayni al-Isfahani.*
> *1301.*

Vases with bouquets of flowers, butterflies and eight cartouches are painted in concentric circles around the medallion. Four of the cartouches contain a quatrain attributed to Omar Khayyam (1048-1122), in white on black:

> *I do not know at all whether my creator*
> *inhabited blessed paradise or awful hell.*
> *But one thing I surely know: I have on the*
> *edge of the cornfield a beauty spot*
> *[on the cheek of a lovely woman],*
> *[her] lips*
> *and the lute in hand, and you [my creator]*
> *have only one paradise, and that is only your*
> *promise.*

Around the edge of the table are more cartouches (black on gold), alternating with small four-lobed ornamental medallions.

Bibliography

The following Qur'an was used for quotations:
Abdullah Yusuf Ali, *The Holy Qur'an. Text, Translation and Commentary*, Dar al-Liwaa Publishing, Saudi Arabia (n.d.)

Adamova 1992
A.T. Adamova, 'O probleme povtoreniya kompozitsii v persidskikh illyustrirovannykh rukopisyakh i v 'murakka", *Kultura Vostoka: problemy i pamyatniki. Kratkiye tezisy dokladov nauchnoy konferentsii*, St Petersburg 1992

Adamova 1996
A.T. Adamova, *Persidskaya zhivopis i risunok XV-XIX vekov v sobranii Ermitazha/Persian Paint and Drawing from the Hermitage*, exhibition catalogue, St Petersburg 1996

Akchokrakly 1927
O. Akchokrakly, 'Staro-Krymskye i Otuzskye nadpisi XIII-XV vv', *Izvestiya Tavricheskogo obshchestva istorii, arkheologii i etnografii*, Simferopol 1927

Akimushkin - Ivanov 1968
O.F. Akimushkin, A.A. Ivanov, *Persidskye miniatury XIV-XVII vv.*, Moscow 1968

Alcouffe 1991
D. Alcouffe; 'Kan van Kalief al-'Aziz bi'llah', *De Schatkamer van San Marco*, exhibition catalogue, De Nieuwe Kerk Amsterdam 1991 (before in a.o. Grand Palais, Paris, The British Museum, London and The Metropolitan Museum of Art, New York)

Alexander 1996
D. Alexander (ed.), *Furusiyya*, Riyadh 1996

Alexandria 1925
Les Amis de l'Art: Exposition d'Art Musulman, exhibition catalogue, Alexandria 1925

Allan 1982-I
J.W. Allan, *Nishapur: Metalwork of the Early Islamic Period*, New York 1982

Allan 1982-II
J.W. Allan, Islamic Metalwork. T*he Nuhad es-Said Collection*, London 1982

Allan 1986
J.W. Allan, *Metalwork of the Islamic World. The Aron Collection*, London 1986

Altay 1974
F. Altay, 'Türk Kumüslari', *Sanat Dünyamiz*, 1 (1974)

Altay 1979
F. Altay, *Kaftanlar*, Istanbul 1979

Anavian Collection 1976
Habib Anavian Collection, Iranian Art from the 8th to 19th Century, New York 1976

Atasoy - Artan 1992
N.Atasoy, T. Artan, *Splendors of the Sultans*, exhibition catalogue, Memphis 1992

Atasoy - Raby 1989
N. Atasoy, J. Raby, Iznik: *The Pottery of Ottoman Turkey*, London 1989

Atil 1973
E. Atil, *Ceramics from the World of Islam*, Washington, D.C. 1973

Atil 1975
E. Atil, *Art from the Arab world*, exhibiton catalogue Freer Gallery of Art, Washington, D.C. 1975

Atil 1987
The Age of Süleyman the Magnificent, exhibition catalogue National Gallery of Art, Washington, D.C. 1987

Atil 1990
E. Atil (ed.), *Islamic Art and Patronage: Treasures from Kuwait*, New York 1990

Baer 1983
E. Baer, *Metalwork in Medieval Islamic Art*, Albany, New York 1983

Baer 1989
Baer, *Ayyubid Metalwork with Christian images*, Leiden/New York 1989

Bagci 1995
S. Bagci, 'A new version of the Shirazi frontispiece miniatures. The Divan of Solomon', *Muqarnas*, XII (1995)

Ballian 1988-89
A. Ballian, 'Ekklesiastika Asemika apo ten Konstantinopouli kai o Ptriarchikos Thronos tou Ieremiou B', *Deltion Kentrou Mikrasiatikon Spoudon* 7 (Athens 1988/89)

Bayani 1999
M. Bayani et al., 'The Decorated Word', *The Nasser D. Khalili Collection of Islamic Art*, IV, Part One, London 1999

Benaki Museum 1969
Benaki Museum, *Pottery of Asia Minor*, Athens 1969

Benaki Museum 1972
Persian Art in the Benaki Museum, Athens 1972

Benaki Museum 1974
Benaki Museum, *Islamic Textiles*, Athens 1974

Berlin 1971

Museum für Islamische Kunst. Katalog 1971, Berlin 1971

Berlin 1988

Schätze aus der Topkapi serail, das Zeitalter Süleymans der Prachtigen, exhibition catalogue Staatliche Museum Preuzischer Kulturbesitz, Berlin 1998

Berlin 1989

Europa und der Orient 800-1900, Berlin 1989

Bilirgen 1995

E. Bilirgen, 'Osmanli Saray Hazinesindeki Murassa Kitap Kaplari, cüz Keseleri ve Cibentler Isiginda Osmanli Saray Kuyumculugu', 9. *Milletlerarasi Türk Sanatlan Kongresi*, I, p. 385-395, Ankara 1995

Bloom - Blair 1997

J. Bloom, S. Blair, *Islamic Arts*, London 1997

Blurton 1997

R. Blurton (ed.), *Beguiling Image*, India 1997

Bode - Kühnel 1984

W. von Bode, E. Kühnel, *Antique Rugs from the Near East*, transl. by Ch.G. Ellis, Ithaca, New York 1984

Bolshakov 1958

O.G. Bolshakov, 'Arabskye nadpisi na polivnoy keramike Sredney Azii XI-XII vv.', *Epigrafika Vostoka*, XII (1958)

Bolshakov 1963

O.G. Bolshakov, 'Arabskye nadpisi na polivnoy keramike Sredney Azii IX-XII vv.', *Aforisticheskye nadpisi*, edition XII, Moscow/Leningrad 1963

Borboudakis 1994

M. Borboudakis (ed.), *Pyles tou Mystiriou.Thesauroi tes Orthodoxes apo ten Ellada*, exhibition catalogue, Athens 1994

Borozdna 1821

Borozdna, *Kratkoye opisaniye puteshestviya rossiysko-imperatorskogo posolstva v Persiyu v 1817 g.*, St Petersburg 1821

Boston 1992

Museum of Fine Arts, Boston, Selected Masterpieces of Asian Art, exhibition catalogue, Boston 1992

Bothmer 1986

H.C. Graf von Bothmer, 'Frühislamische Koran-Illuminationen. Meisterwerke aus dem Handschriftenfund aus der Großen Moschee in Sanaa/Yemen', *Kunst & Antiquitäten* I/86, Munich 1986

Bothmer 1987-I

H.C. Graf von Bothmer, 'Meisterwerke islamischer Buchkunst: koranische Kalligraphie und Illumination im Handschriftenfund aus der Großen Moschee in Sanaa', in: W. Daum (ed.), *Jemen. 3000 Jahre Kunst und Kultur des glücklichen Arabien*, Innsbruck/Frankfort 1987

Bothmer 1987-II

H.C. Graf von Bothmer, 'Architekturbilder im Koran. Eine Prachthandschrift der Umayyadenzeit aus dem Yemen', *Pantheon*, XLV, Munich 1987

Bothmer 1987-I

H.C. Graf von Bothmer, 'Meisterwerke islamischer Buchkunst: koranische Kalligraphie und Illumination im Handschriftenfund aus der Großen Moschee in Sanaa', in:

W. Daum (ed.), *Jemen. 3000 Jahre Kunst und Kultur des glücklichen Arabien*, Innsbruck/Frankfort 1987

Bothmer 1987-II

H.C. Graf von Bothmer, 'Architekturbilder im Koran. Eine Prachthandschrift der Umayyadenzeit aus dem Yemen', *Pantheon*, XLV, Munich 1987

Bothmer 1989

H.C. Graf von Bothmer, 'Ein seltenes Beispiel für die ornamentale Verwendung der Schrift in frühen Koranhandschriften: Die Fragmentsgruppe Inv. Nr. 17-15.3 im 'Haus der Handschriften' in Sanaa, *Ars et Ecclesia. Festschrift für Franz J. Ronig zum 60. Geburtstag (=Veröffentlichungen des Bistumarchivs Trier, part 26)*, Trier 1989

Bothmer 1999

H.C. Graf von Bothmer, 'Die Anfänge der Koranschreibung: Kodikologische und kunsthistorische Beobachtungen an den Koranfragmenten in Sanaa (=Neue Wegen der Koranforschung III)', *Magazin Forschung* 1/1999, Universität des Saarlandes, Saarbrücken 1999

Bothmer (in prep.-I)

H.C. Graf von Bothmer, *Qu'ranic manuscripts from Sanaa: The problem of dating early Qu'rans, again* (in preparation)

Bothmer (in prep.-II)

H.C. Graf von Bothmer, *Koran-Illumination frühislamischer Zeit in Handschriftenfragmenten aus der Großen Moschee in Sanaa*, 2 pts. (in preparation)

Brand - Lowry 1985
Brand, G.D. Lowry (ed.), *Akbar's India: Art from the Mughal City of Victory*, exhibition catalogue, New York 1985

Budapest 1994
Kanuni Sultan Süleyman ve Çagi - Nagy Zsulejman Szultan es Kora, exhibition catalogue, Budapest 1994

Çagman 1983
F. Çagman, 'Osmanli Sanati', *Anadolu Medeniyetleri III*, exhibition catalogue, Istanbul 1983

Çagman 1984
F. Çagman, 'Serzergeran Mehmed Usta ve Eserleri', *Kemal Çiga Armagan*, Istanbul 1984

Çagman 1987
F. Çagman, 'Altin Tören Matarasi', *Topkapi Sarayi Müzesi Yillik 2*, Istanbul 1987

Cairo 1932
Repertoire chronologique d'épigraphie arabe, part II, Cairo 1932

Cairo 1969
Islamic Art in Egypt 969-1517, exhibition catalogue Semiramis Hotel, Cairo 1969

Cambridge 1978
Glass at the Fitzwilliam Museum, Cambridge 1978

Carswell 1998
J. Carswell, *Iznik Pottery*, London 1998

Charleston 1980
R.J. Charleston, *Masterpieces of glass: a world history from the Corning Museum of Glass* (Corning Museum of Glass Monograph), New York 1980

Christie's 1988
Christie's, London, 12 April 1988

Christie's 1989-I
Christie's, London, 11 April 1989

Christie's 1989-II
Christie's, London, 10 October 1989

Clairmont 1977
Chr. W. Clairmont, *Catalogue of Ancient and Islamic Glass*, Benaki Museum, Athens 1977

Cologne 1983
Ornamenta Ecclesiae. Kunst und Künstler der Romantik, exhibition catalogue Schnütgensmuseum, Cologne 1983

Connoisseur 1911
Connoisseur, Septembre (1911)

Contadini 1998
A. Contadini, *Fatimid Art at the Victoria and Albert Museum*, London 1998

Copenhagen 1996
Sultan, Shah and Great Mughal. The history and culture of the Islamic world, exhibition catalogue National Museum, Copenhagen 1996

Creswell 1939
K.A.C. Creswell, 'Coptic influences on early Moslem architecture', *Bulletin de la Société d'archéologie copte*, part 5, Cairo 1939

Creswell 1969
K.A.C. Creswell, *Early Muslim Architecture*, 2 pts., Oxford 1969

Darcel - Basilewsky 1874
A. Darcel, P. Basilewsky, *Collection Basilewsky. Catalogue raisonné*, Paris 1874

Delibas - Tezcan
S. Delibas, H. Tezcan, *The Topkapi Saray Museum. Costumes, Embroideries and other Textiles*, ed. by J.M. Rogers, Boston

Delivorrias 1980
Delivorrias, *Guide to the Benaki Museum*, Athens 1980

Déroche 1983
F. Déroche, 'Les manuscrits du Coran. Aux origines de la calligraphie coranique', *Bibliothèque Nationale, Catalogue des manuscrits arabes, Deuxième partie: Manuscrits musulmans*, I,1, Paris 1983

Déroche 1988
F. Déroche, 'Les origines de la calligraphie islamique/ The Origins of Islamic Calligraphy', *Islamic Calligraphy - Calligraphie islamique*, exhibition catalogue Musée d'art et d'histoire, Geneva 1988

Déroche 1992-I
F. Déroche, 'Les Manuscrits arabes datés du IIIe/Ixe siècle', *Revue des Études Islamiques*, 55-57, 1987-1989, Paris 1992

Déroche 1992-II
F. Déroche, *The Abbasid Tradition. Qur'ans of the 8th to the 10th centuries AD. (=The Nasser D. Khalili Collection of Islamic Art, vol. I)*, Oxford 1992

Devonshire 1925

R.L. Devonshire, 'An exhibition of Moslem Art in Alexandria', *Burlington Magazine*, 47 (1925)

Devonshire 1928

R.L. Devonshire, 'Some Moslem Objects in the Benachi Collection', *Burlington Magazine* (October 1928), vol. 53

Dimand - Mailey 1973

M.S. Dimand, J. Mailey, *Oriental Rugs in The Metropolitan Musem of Art*, New York 1973

Dodds 1992

J.D. Dodds (ed.), *Al-Andalus: The Art of Islamic Spain*, exhibition catalogue, New York 1992

Dokhudoyeva 1978

L.N. Dokhudoyeva, 'Nekotorye ikonograficheskye prototipy miniatur 'Khamse' Nizami 1431 g.', *Narody Azii i Afriki*, Leningrad 1978

Dorn 1846

B. Dorn, *Das Asiatische Museum der Kaiserlichen Akademie der Wissenschaften zu St. Petersburg*, St. Petersburg 1846

Dreibholz 1991

U. Dreibholz, 'Der Fund von Sanaa. Frühislamische Handschriften auf Pergament', in: P. Rück (ed.), *Pergament. Geschichte-Struktur-Restaurierung-Herstellung (=Historische Hilfswissenschaften, part 2)*, Sigmaringen 1991

Driessen 1997

H. Driessen (ed.), *In het huis van de islam*, Nijmegen 1997

Drury Fortnum 1869

C. Drury Fortnum, 'On a Lamp of 'Persian Ware' made for the Mosque of Omar at Jerusalem in 1549', *Archaeologia*, vol. 42 (1869)

Dushanbe 1980

The Central Asian Art of Avicenna Epoch, Dushanbe 1980

Dyakonov 1939

M.M. Dyakonov, 'Bronzovyy vodoley 1206 g. n.e.', *III Mezhdunarodnyy kongress po iranskomu iskusstvu i arkheologii. Doklady. Leningrad, sentyabr 1935*, Moscow/Leningrad 1939

Dyakonov 1940

M.M. Dyakonov, 'Rukopis 'Khamse' Nizami 1431 g. i ee znacheniye dlya istorii miniaturnoy zhivopisi na Vostoke', *Trudy otdela Vostoka Gosudarstvennogo Ermitazha*, Leningrad 1940

Dyakonov 1947

M.M. Dyakonov, 'Bronzovaya plastika pervykh vekov khidzhry', *Trudy otdela Vostoka (Gosudarstvennogo Ermitazha)*, Leningrad 1947

Dyakonova 1962

N.V. Dyakonova, *Iskusstvo narodov zarubezhnogo Vostoka v Gosudarstvennom Ermitazhe*, Leningrad 1962

Egyed 1955

E. Egyed, *A közelkeleti allatplaztikakrol. Az iparmüveszeti museum évkönyvei*, Budapest 1955

Enderlein 1976

Enderlein, *Die Miniaturen der Berliner Baisonqur Handschrift*, Leipzig 1976

Erdmann 1940

K. Erdmann, 'Islamische Bergkristallarbeiten', *Jahrbuch der Preussischen Kunstsammlungen*, LXI (1940)

Eskenazi 1982

J. Eskenazi, *Il tappeto orientale dal 15 al 18 secolo*, Milan 1982

Evans - Wixom 1997

H.C. Evans, W.D. Wixom (ed.), *The Glory of Byzantium*, New York 1997

Falk 1976

R. Falk, 'Rothschild Collection of Mughal Miniatures', *Persian and Mughal Art*, London 1976

Falk 1985

T. Falk (ed.), *Treasures of Islam*, exhibition catalogue, Geneva 1985

Falke 1929

O. von Falke, 'Elfenbeinhörner, I', *Pantheon*, Berlin 1929

Fedorov-Davydov 1974

G.A. Fedorov-Davydov, 'Iskusstvo kochevnikov i Zolotoy Ordy', *Istoriya iskusstva narodov SSSR. T. 3. Iskusstvo XIV-XVII vekov*, Moscow 1974

Felkerzam 1915

A. Felkerzam, 'Gornyy khrustal i ego primeneniye v iskusstve', *Starye gody*, no. 12, St Petersburg 1915

Felsach 1990

K. von Felsach, *Islamic Art. The David Collection*, Copenhagen 1990

Ferrier 1989

R.W. Ferrier (ed.), *The Arts of Persia*,
New Haven, Connecticut/London 1989

Flury 1920

S. Flury, *Islamische Schriftbänder*, Basel/Paris
1920

Fotopoulos - Delivorrias 1998

D. Fotopoulos, A. Delivorrias, *Greece at the
Benaki Museum*, Athens 1998

Fraehn 1822-I

Ch. Fraehn, 'Uras-Muhammadis Chani
Kasimoviensis, quae in Academia Imp. Scientt
Museo Asiatico asservatur, theca koranica
interpretatione illustrata', *Memoires de
l' Académie Impériale des sciences de
St. Pétersbourg*, St Petersburg 1822

Fraehn 1822-II

C.M. Fraehn, *Antiquitatis Muhammedanae
Monumenta varia. Explicuit C.M. Fraehn.
Particula II*, St Petersburg 1822

Frankfort 1985

Türkische Kunst und Kultur aus osmanisher Zeit,
exhibition catalogue, Frankfort 1985

Galerie d'Orléans 1991

Galerie des Ventes d'Orléans, Paris,
21 March 1991

Gallo 1967

R. Gallo, *Il Tesoro di San Marco e la sua storia*,
(Civiltà Veneziana, saggi 16), Florence 1967

Gans-Ruedin 1984

E. Gans-Ruedin, *Indian Carpets*, transl. by
V. Howard, New York 1984

Ghouchani 1986

Ghouchani, *Katibaha-i sufal-i
Nishabur/Inscriptions on Nishapur Pottery*,
Tehran, AH 1364 (1986)

Gille 1835-1853

F. Gille, *Musée de Tzarskoe-Selo ou collection
d'armes de Sa Majesté l'Empereur de toutes les
Russies*, St Petersburg 1835-1853

Giuzalian 1968

L.T. Giuzalian, 'The bronze Qalamdan
(pencase) of 542/1148 from the Hermitage
Collection (1936-1965)', *Ars Orientalis*, VII,
Ann Arbor, Michigan 1968

Golombek - Mason - Bailey 1996

L. Golombek, R.B. Mason, G.A. Bailey,
*Tamerlane's Tableware, Mazda Publishers in
association with the Royal Ontario Museum*,
Costa Mesa, California/Toronto 1996

Grohmann 1958

A. Grohmann, 'The problem of dating early
Qur'ans', *Der Islam*, XXXIII/3, Hamburg 1958

Grube 1972

E.J. Grube, *Islamic Paintings from the 11th to the
18th Century in the Collection of Hans P. Kraus*,
New York 1972

Grube 1974

E. Grube, 'Notes on the Decorative Arts of the
Timurid Period', *Gururajamanjarike. Studi in
Onore di Giuseppe Tucci*, Naples 1974

Grube 1979

Grube, in collaboration with Dr. E. Sims,
'The School of Herat from 1400 to 1450',
The Art of the Book in Central Asia, Paris 1979

Grube 1994

E.J. Grube, 'Cobalt and Lustre. The First
Centuries of Islamic Pottery', *Nasser D. Khalili
Collection of Islamic Art*, IX, London 1994

Gyuzalyan 1949

L.T. Gyuzalyan, 'Bronzovaya kurilnitsa v forme
orla', *Sokrovishcha Ermitazha*, Moscow-
Leningrad 1949

Gyuzalyan 1953

L.T. Gyuzalyan, 'Dva otryvka iz Nizami na
izrastsakh XII-XIV vv.', *Epigrafika Vostoka*,
Moscow/Leningrad 1953

Gyuzalyan 1963

L.T. Gyuzalyan, 'Tri indzhuidskikh
bronzovykh sosuda (K voprosu o lokalizatsii
yugo-zapadnoy gruppy srednevekovoy
khudozhestvennoy bronzy Irana)', *Trudy
dvadtsat pyatogo mezhdunarodnogo kongressa
vostokovedov*, II, Moscow 1963

Hafiz 1927

Divan-i Hajji Hafiza Shirazi. Editor: Seyd
abd-ar-Rahim Halhali, Tehran 1927

The Hague 1956

Ceramiek uit de landen van de islam, exhibition
catalogue Haags Gemeentemuseum,
The Hague 1956

Hahnloser 1971

H.R. Hahnloser, 'Il Tesoro di San Marco,
opera diretta da H.R. Hahnloser, testi di
W.F. Volbach, A. Gravar, K. Erdmann,
E. Steingräber, G. Martiacher, R. Pallucchini,
A. Frolow, *et al.*', II, *Il Tesoro ed il Museo*
(Erdmann) Florence 1971

Hartner 1973-74
W. Hartner, 'The Vaso Vescovali in the British Museum', *Kunst des Orients*, IX (1973-74)

Hasson 1987
R. Hasson, *Early Islamic Jewellery*, L.A. Mayer Memorial Institute for Islamic Art, Jerusalem 1987

Hermitage 1981
Ermitazh. Istoriya i kollektsiya, Moscow 1981

Hildburgh 1982
W.L. Hildburgh, 'A Hispano-Arabic Silver-gilt and Crystal Casket', *The Antiquaries Journal*, 21, 194 (1982)

Hill 1974
D.R. Hill, *The Book of Knowledge of Ingenious Mechanical Devices (Kitab fi Ma'rifat al-Hiyal al-Handasiyyah) of Ibn al-Razzaz al-Jazari*, Dordrecht/Boston 1974

Hobson 1932
R.L. Hobson, *A Guide to the Islamic Pottery of the Near East*, London 1932

Islamic Metalwork 1953
'Studies in Islamic Metalwork-II', *Bulletin of the School of Oriental and African Studies*, v. 15, no.1 (1953)

Ivanov 1959
A.A. Ivanov (ed.), *Miniatura Irana (Nabor otkrytok).*, Leningrad 1959

Ivanov 1960-I
A.A. Ivanov, 'Mednaya chasha 811 g. ch. (1408-1409 gg.) so stikhami Khafiza', *Soobshcheniya Gosudarstvennogo Ermitazha*, Leningrad 1960

Ivanov 1960-II
A.A. Ivanov, 'O pervonachalnom naznachenii tak nazyvaemykh iranskikh 'podsvechnikov' XVI-XVII v.', *Issledovaniya po istorii kultury narodov Vostoka. Sbornik v chest akademika I.A. Orbeli*, Moscow/Leningrad 1960

Ivanov 1967
A.A. Ivanov, 'Iransky mednyy podnos XIV v.', *Epigrafika Vostoka*, Leningrad 1967

Ivanov 1972
A.A. Ivanov, 'Koltso Shakh-Dzhakhana', *Soobshcheniya Gosudarstvennogo Ermitazha*, XXXIV, Leningrad 1972

Ivanov 1979-I
A. Ivanov, 'A group of Iranian daggers of the period from the fifteenth century to the beginning of the seventeenth with Persian inscriptions', in: R. Elgood (ed.), *Islamic Arms and Armour*, London 1979

Ivanov 1979-II
A.A. Ivanov (ed.), *Iranskaya miniatura. 'Khamze' Nizami 1431 g.*, Leningrad 1979, no. 10

Ivanov 1981
A.A. Ivanov, 'O bronzovykh izdeliyakh kontsa XIV v. iz mavzoleya khodzha Akhmeda Yasevi', *Srednyaya Aziya i ee sosedi v drevnosti i srednevekovye (istoriya i kultura)*, Moscow 1981

Ivanov - Lukonin - Smesova 1984
A.A. Ivanov, V.G. Lukonin, L.S. Smesova, *Yuvelirnye izdeliya Vostoka*, Moscow 1984

Izmaylova 1960-I
T.A. Izmaylova, *Kultura i iskusstvo Perednogo Vostoka*, Leningrad 1960

Izmaylova 1960-II
T.A. Izmaylova, *Kultura i iskusstvo Perednego Vostoka (Putesestviye v proshloye po zalam Ermitazha)*, Leningrad 1960

James 1992-I
D. James, 'The Master Scribes', *The Nasser D. Khalili Collection of Islamic Art*, II, London 1992

James 1992-II
D. James, 'After Timur', *The Nasser D. Khalili Collection of Islamic Art*, II, London 1992

Jenkins - Keene 1982
M. Jenkins, M. Keene, *Islamic Jewelry in The Metropolitan Museum of Art*, New York 1982

Kammerer 1869
E. Kammerer, *Tsarskoselsky arsenal ili sobraniye oruzhiya, prinadlezhashchego ego velichestvu Gosudaryu imperatoru Aleksandru Nikolayevichu*, St Petersburg 1869

Kane 1991
C. Kane, 'Kom van turkoois glas', *De Schatkamer van San Marco*, exhibition catalogue, De Nieuwe Kerk Amsterdam 1991 (before in, a.o.: Grand Palais, Paris, The British Museum, London and The Metropolitan Museum of Art, New York)

Khalili 1996
N.D. Khalili *et al.*, 'Lacquer of the Islamic Lands', *The Nasser D. Khalili Collection of Islamic Art*, XXII, Part One, London 1996

Khalili Collection 1993
'Treasures of Islamic Art from the Nasser D. Khalili Collection', *Arts and the Islamic World*, no. 22, special issue, Spring 1993

Knauer 1980

E. Knauer, 'Marble Jar-Stands From Egypt', *Metropolitan Museum Journal*, 14 (1980)

Koechlin - Migeon 1928

R. Koechlin, G. Migeon, *Islamische Kunstwerke*, Berlin 1928

Krachovskaya 1946

V.A. Krachovskaya, *Izrastsy mavzoleya Pir-Khuseyna*, Tbilisi 1946

Kramarovsky 1985

M.G. Kramarovsky, 'Serebro Levanta i khudozhestvennyy metall Severnogo Prichernomorya XIII-XV vv. (po materialam Kryma i Kavkaza)', *Khudozhestvennye pamyatniki i problemy kultury Vostoka*, Leningrad 1985

Kryzhanovskaya 1969

M. Kryzhanovskaya, *Romanskaya plastika iz kosti i nekotorye problemy ee razvitiya. Dissertatsiya*, Leningrad 1969

Kuba-Hauk 1987

Kuba-Hauk, *Dom- und Diözesan-Museum Wien*, Vienna 1987

Kube 1925

A. Kube, *Reznaya kost*, Leningrad 1925

Kühnel 1925-I

Kühnel, *Islamische Kleinkunst*, Berlin 1925

Kühnel 1925-II

E. Kühnel, 'Three Mosul bronzes at Leningrad,' *The Year book of Oriental Art*, London 1925, part 1

Kühnel 1959

E. Kühnel, 'Die sarazenischen Olifanten-hörner,' *Jahrbuch der Museen*, Berlin 1959

Kühnel 1971

E. Kühnel, *Die islamischen Elfenbeinskulpturen*, VIII.-XIII. Jahrhundert, Berlin 1971

Kürkman 1996

G. Kürkman, *Ottoman Silver Marks*, Istanbul 1996

Kuwait 1990

Masterpieces of Islamic Art in the Hermitage Museum, exhibition catalogue Dar al-Athar al-Islamiyyah Museum, Kuwait 1990

Kverfeldt 1940

E.K. Kverfeldt, 'Cherty realizma v risunkakh na tkanyakh i kovrakh vremeni Sefevidov', *Trudy otdela Vostoka*, Leningrad 1940

Kverfeldt 1947

E.K. Kverfeldt, *Keramika Blizhnego Vostoka*, Leningrad 1947

Lamm 1928

C.J. Lamm, 'Das Glas von Samarra', *Forschungen zur islamischen Kunst*, ed. F. Sarre, III, *Die Ausgrabungen von Samarra)*, Berlin 1928

Lamm 1929-1930

C.J. Lamm, 'Mittelalterliche Gläser und Steinschnittarbeiten aus dem Nahen Osten', *Forschungen zur islamischen Kunst*, ed. F. Sarre, V, Berlin 1929-1930

Lamm 1939

C.J. Lamm, *Glass and hard stone vessels. (A survey of Persian Art from prehistoric times to the present)*, ed. A. Pope and P. Ackerman (American Institute of Iranian Art and Archaeology), Oxford/London/New York 1939

Lane 1947

A. Lane, *Early Islamic Pottery*, London 1947

Lane 1953

A. Lane, *Early Islamic Pottery, 2nd impression*, London 1953

Lane 1957-I

A. Lane, *Later Islamic Pottery*, London 1957

Lane 1957-II

A. Lane, 'Ottoman Pottery of Isnik', *Ars Orientalis*, II (1957)

Lane-Poole 1886

S. Lane-Poole, *The Art of the Saracens in Egypt*, London 1886

Leach 1998

L.Y. Leach, 'Paintings from India', *The Nasser D. Khalili Collection of Islamic Art*, VIII, London 1998

Leningrad 1967

Zhivopis srednego Vostoka, exhibition catalogue Hermitage, Leningrad 1967

Leningrad 1973

Reznaya kost, exhibition catalogue, Leningrad 1973

Leningrad 1988

Italyanskoye prikladnoye iskusstvo, exhibition catalogue, Leningrad 1988

Lentz - Lowry 1989

T.W. Lentz, G.D. Lowry, *Timur and the Princely Vision: Persian Art and Culture in the Fifteenth Century*, Washington, D.C. 1989

Levenson 1991

J.A. Levenson (ed.), *Ca. 1492: Art in the Age of Exploration*, exhibition catalogue, Washington, D.C. 1991

Lings 1976

M. Lings, *The Qur'anic Art of Calligraphy and Illumination*, London 1976

London 1931

Catalogue of the international Exhibition of Persian Art, London 1931

London 1976-I

The Arts of Islam. Hayward Gallery, 8 April - 4 July 1976, exhibition catalogue, London 1976

London 1976-II

Islamic Art, exhibition catalogue, London 1976

London 1982

The Indian Heritage. Court life and Arts under Mughal Rule, exhibition catalogue, London 1982

Louisiana Revy 1987

'Art from the world of Islam. 8th-18th century', *Louisiana Revy*, vol. 27, no. 3, March 1973

Loukonine - Ivanov 1996

V. Loukonine, A. Ivanov, *Persian Art*, Bournemouth/St Petersburg 1996

Lowry - Nemazee 1988

G.D. Lowry, S. Nemazee, *A jeweler's eye. Islamic Arts of the Book from the Vever Collection*, exhibition catalogue Arthur M. Sackler Gallery, Washington, D.C. 1988

Lucerne 1981

3000 Jahre Glaskunst von der Antike bis zum Jugendstil, Lucerne 1981

Maastricht 1994

'Treasures from the Hermitage, St. Petersburg', *The European Fine Art Fair*, Maastricht 1994

Mackie 1980

L. Mackie, 'Rugs and Textiles', in: E. Atil (ed.), *Turkish Art*, Washington, D.C./New York 1980

McLean 1994

C.C. McLean, 'Akbar's Courtier', *Carpet and Textile Art, Hali Annual I*, London 1994

Macridy 1937

T. Macridy, 'Le Musée Benaki d'Athènes', *Mouseion*, 39-40 (1937)

Maddison 1985

F. Maddison, 'al-Jazari's Combination Lock', *The Art of Syria and the Jazira 1100-1250, Oxford Studies in Islamic Art I*, Oxford 1985

Maddison - Savage-Smith 1997

F. Maddison, E. Savage-Smith, 'Science, Tools and Magic', *Nasser D. Khalili Collection of Islamic Art*, XII, Part One, London 1997

Malm 1978

V.A. Malm, 'Zolotoy braslet s persidskoy nadpisyu', *Voprosy drevney i srednevekovoy arkheologii Vostochnoy Evropy*, Moscow 1978

Mammayev 1987

M.M. Mammayev, 'O vlianii islama na srednevekovoye tvorchestvo narodov Dagestana', *Khudozhestvennaya kultura srednevekovogo Dagestana*, Makhachkala 1987

Marschak 1986

B.I. Marschak, *Silberschätze des Orients*, Leipzig 1986

Marshak 1972

B.I. Marshak, 'Bronzovyy kuvshin iz Samarkanda', *Srednyaya Aziya i Iran*, Leningrad 1972

Marshak 1978

B.I. Marshak, 'Ranneislamskye bronzovye blyuda', *Trudy Gosudarstvennogo Ermitazha*, XIX, Leningrad 1978

Martin 1908

F.R. Martin, *A History of Oriental Carpets before 1800*, Vienna 1908

Mayer 1959

L.A. Mayer, *Islamic Metalworkers and their Works*, Geneva 1959

Mexico City 1984

Arte islámico del Museo Metropolitano de Nueva York, Mexico City 1984

Migeon 1903

G. Migeon, *Exposition d'Art musulman*, Paris 1903

Migeon 1927

Migeon, *Manuel d'art musulman*, 2nd ed., Paris 1927

Miller 1972

Y.A. Miller, *Khudozhestvennaya keramika Turtsii*, Leningrad 1972

Miller 1978

Y.A. Miller, 'O nekotorykh kontaktakh iskusstva Turtsii XVI-XVII vekov s khudozhestvennoy kulturoy drugikh stran', *Trudy Gosudarstvennogo Ermitazha*, XIX, Leningrad 1978

Molinier 1888

E. Molinier, *Les trésors de la basilique de St.-Marc à Venise*, Venice 1888

Montfaucon 1702

B. de Montfaucon, *Diarium italicum sive Monumentorum venetum… noticiae singulares in itinerario collectae…*, Paris 1702

Monttraye 1727

A. de la Monttraye, *Voyages du Sieur de La Mottraye en Europe, Asie et Afrique*, The Hague 1727

Morgan 1994

P. Morgan, 'Sgraffiato: Types and Distribution', in: E.J. Grube, *Cobalt and Lustre. The First Centuries of Islamic Pottery, Nasser D. Khalili Collection of Islamic Art*, IX, London 1994

Moritz 1905

B. Moritz, *Arabic Palaeography. A Collection of Arabic Texts from the First Century of the Hidjra Till the Year 1000 (=Publications of the Khedivial Library*, Cairo, no. 16), Cairo (Leipzig) 1905

Moscow 1957

Kultura i iskusstvo Vizantii IV-XV vv., Blizhnego i Srednego Vostoka III-XVIII vv. (Putevoditel), Moscow 1957

Munich 1912

Die Ausstellung von Meisterwerken muhammedanischer Kunst in München 1910, Munich 1912

Munich 1979

Bayerisches Armeemuseum, Ingolstadt, *Osmanisch-türkisches Handwerk aus süddeutschen Sammlungen*, Munich 1979

New York 1983

Islamic Pottery: A Brief History. Bulletin of the Metropolitan Museum of Art, n.s., 40, Spring 1983

New York 1987

The Metropolitan Museum of Art. The Islamic World, New York 1987

New York 1992

Al-Andalus. The Art of Islamic Spain, exhibition catalogue, New York 1992

Orbeli 1938-I

I.A. Orbeli, 'Bronzovaya kurilnitsa XII v. v vide barsa', *Pamyatniki epokha Rustaveli*, Leningrad 1938

Orbeli 1938-II

I.A. Orbeli, 'Albanskye relyefy i bronzovye kotly XII-XIII vv.', *Pamyatniki epokhi Rustaveli*, Leningrad 1938

Orbeli - Trever 1935

I.A. Orbeli, K.V. Trever, *Sasanidsky metall*, Leningrad 1935

Osma y Scull 1916

G.J. de Osma y Scull, *Catálogo de Azabaches compostelanos precedido de apuntes sobre los amuletos contre el aojo, las imágenes del apóstol-romero y la confradia de los azabacheros de Santiago*, Madrid 1916

Öz 1951

T. Öz, *Türk kuma° ve kadifeleri*, C. 1. 2., Istanbul 1951

Paquin 1992

G. Paquin, 'Çintamani', *HALI 64* (August 1992)

Paris 1952

Trésors d'art du Moyen Age en Italie, exhibition catalogue Petit Palais, Paris 1952

Paris 1987

Splendeur et Majesté. Corans de la Bibliothèque Nationale, Institut du Monde Arabe, Paris 1987

Paris 1990

Soliman le Magnifique, exhibition catalogue Galeries Nationales du Grand Palais, Paris 1990

Paris 1998

Tresors fatimides du Caire, exhibition catalogue Institut du Monde Arabe, Paris 1998

Pasini 1885-1886

A. Pasini, *Il Tesoro di San Marco in Venezia illustrato da Antonio Pasini, canonico della Marciana*, ed. F. Ongania, Venice 1885-1886

Pauty 1931

E. Pauty, 'Sur une porte en bois sculpté provenante de Bagdad', *Bulletin de l'Institute Français d'Archéologie Orientale*, XXX, Cairo 1931

Pennendreff 1961

A. de Pennendreff, 'Les cristaux fatimides', *Connaissance des arts*, No. 112, Paris, June 1961

Persian Art 1939

A Survey of Persian Art, ed. by A.U. Pope,
London/New York 1939

Pevzner 1958-I

S.B. Pevzner, 'Nekotorye voprosy izucheniya
srednevekovykh egipetskikh tkaney',
Soobshcheniya Gosudarstvennogo Ermitazha, XIII,
Leningrad 1958

Pevzner 1958-II

S.B. Pevzner, 'Steklyannaya lampa XIV v.
iz kollektsii Gosudarstvennogo Ermitazha',
Epigrafika Vostoka, ed. XII, Moscow/Leningrad
1958

Phillips 1995

T. Phillips (ed.), *Africa: the art of a continent*,
the Royal Academy, London 1995

Philon 1980-I

H. Philon, *Islamic Art*, Athens 1980

Philon 1980-II

H. Philon, *Benaki Museum: Early Islamic
Ceramcis from the 9th to the 12th century*,
London 1980

Pijoan 1949

Pijoan, *Summa artis*, V, Madrid 1949

Pirverdyan 1969

N. Pirverdyan, 'O vremeni izgotovleniya
odnoy persidskoy tkani', *Soobshcheniya
Gosudarstvennogo Ermitazha*, Leningrad 1969

Pope - Ackerman 1938-39

A.U. Pope, P. Ackerman, *A Survey of Persian
Art*, London 1938-39

Porter 1987

V. Porter, 'The art of the Rasulids', in:
W. Daum (ed.), *Yemen. 3000 Years of Art and
Civilisation in Arabia Felix*, Innsbruck/Frankfort
1987

Pretzl 1938

O. Pretzl, 'Die Koranhandschriften', in:
Th. Nöldeke, *Geschichte des Qorans*, 3:
G. Bergsträßer, O. Pretzl, *Die Geschichte des
Korantexts*, Leipzig 1938 (reprint
Hildesheim/New York 1981)

Prisma 1995

Prisma van de Islam. Begrippen van A tot Z, ed.
by I. Arends, D. Douwes and A.J. Termeulen,
Utrecht 1995

Pugachenkova 1963

G.A. Pugachenkova, *Iskusstvo Afganistana:
Tri etyuda*, Moscow 1963

Pugachenkova - Rempel 1966

G.A. Pugachenkova, L.I. Rempel, *Istoriya
iskusstva Uzbekistana s drevneyshikh vremen i do
serediny devyatnadtsatogo veka*, Moscow 1966

Puin 1985

G.R. Puin, 'Methods of Research on Qur'anic
Manuscripts - A Few Ideas', *Masahif San'a'*,
exhibition catalogue Dar al-Athar al-
Islamiyyah Museum, Kuwait 1985

Puin 1996

G.R. Puin, 'Observations on Early Qur'an
Manuscripts in San'a", in: S. Wild (ed.),
The Qur'an as Text, Leiden 1996

Puin 1999

G.R. Puin, 'Über die Bedeutung der ältesten
Koranfragmenten aus Sanaa (Jemen) für die
Orthographiegeschichte des Korans' (=Neue
Wegen der Koranforschung II), *Magazin
Forschung* 1/1999, Universität des Saarlandes,
Saarbrücken 1999

Raby 1981

J. Raby, *Samson and Siyah Qalam*, in:
Islamic Art, I (1981)

Raby 1982

J. Raby, 'Metalwork, Silver and Gold', *Tulips.
Arabesques and Turbans*, London 1982

Raby 1999

J. Raby, *Qajar Portraits*, exhibition catalogue,
London/New York 1999

Rapoport 1975

I. Rapoport, 'Ob odnoy gruppe iranskikh
fayansovykh butyley', *Soobshcheniya
Gosudarstvennogo Ermitazha*, XL, Leningrad
1975

Rawandi 1921

*Muhammed ibn 'Ali ibn Sulayman ar-Rawandi,
Rahat-us-sudur wa ayat-us-surur*, ed. M. Iqbal,
E.J. Gibb Memorial Series, NS, II (1921)

Rezvan 1998

E.A. Rezvan, 'The Qur'an and its World: VI.
Emergence of the Canon: The Struggle for
Uniformity', *Manucripta Orientalis*, 4/2,
St Petersburg/Helsinki 1998

Rice 1949

D.S. Rice, 'The Oldest Dated 'Mosul'
Candlestick AD 1225', *Burlington Magazine*,
XCI (December 1949)

Rice 1953

D.S. Rice, 'Studies in Islamic Metalwork-II', *Bulletin of the School of Oriental and African Studies*, v. 15, no. 1 (1953)

Rice 1957

D.S. Rice, 'Inlaid Brasses from the Workshop of Ahmad al-Dhaki al-Mawsili', *Ars Orientalis*, II (1957)

Robinson 1958

B.W. Robinson, *A Descriptive Catalogue of the Persian Paintings in the Bodleian Library*, Oxford 1958

Robinson 1982

B.W. Robinson, 'A Survey of Persian Painting (1350-1896)', *Art et société dans le monde iranien*, Paris 1982

Robinson - Falk - Sims 1976

B.W. Robinson, T. Falk, E. Sims, *Persian and Mughal Art*, London 1976

Rogers 1984

J.M. Rogers, 'The Godman Bequest', *Apollo*, July 1984, pp. 24–31

Rogers 1992

J.M. Rogers, 'Itineraries and town views in Ottoman histories', *History of Cartography*, ed. by J.B. Harley and D. Woordward, Chicago/London 1992

Rogers - Köseoglu 1987

J.M. Rogers, C. Köseoglu, 'The Topkapi Saray Museum', *Treasury*, London 1987

Rogers - Ward 1988

J.M. Rogers, R.M. Ward, *Süleyman the Magnificent*, exhibition catalogue The British Museum, London 1988

Rome 1956

Mostra d'Arte Iranica, Roma, exhibition catalogue Istituto Italiano per il Medio ed Estremo Oriente, Palazzo Brancaccio, Rome 1956

Rosenberg 1918

M. Rosenberg, *Geschichte der Goldschmiedekunst auf Technischer Grundlage*, Frankfort 1918

Rotterdam 1993-1996

Dromen van het Paradijs. Islamitische kunst in het Museum voor Volkenkunde Rotterdam, exhibition catalogue, Rotterdam 1993-1996

St Petersburg 1901

Otchet imperatorskoy arkheologicheskoy komissii za 1898 g., St Petersburg 1901

St Petersburg 1902

Khudozhestvenniye sokrovishcha Rossii, St Petersburg 1902

St Petersburg 1998

Khristiane na Vostoke. Iskusstvo melkitov i inoslavnykh khristian, St Petersburg 1998

Sakisian 1929

Sakisian, A., *La miniature persane du 12e au 17e siècle*, Paris 1929

Saldern 1967/1969

A. von Saldern, 'The so-called Byzantine glass in the treasury of San Marco', *Annales du IVe Congrès International d'Etudes Historiques du Verre*, Ravenna-Venice 1967, Liège 1969

Samarkand 1969

Iskusstvo epokhi Timuridov, exhibition catalogue, Samarkand 1969

Sarre - Trenkwald 1926-1929

F. Sarre, H. Trenkwald, *Old Oriental Carpets*, transl. A.F. Kendrick, 2 vols., Vienna-Leipzig 1926-1929

Savage-Smith 1985

E. Savage-Smith, 'Islamicate Celestial Globes. Their History, Construction and Use', *Smithsonian Studies in History and Technology*, Washington, D.C. 1985

Schnyder 1985

R. Schnyder, 'Agkand', in: E. Yarshater (ed.), *Encyclopaedia Iranica*, London/Boston 1985

Segall 1938

B. Segall, *Katalog der Goldschmiede-Arbeiten*, Athens 1938

Shafi'i 1952

F. Shafi'i, 'Decorated Wood in Umayyad Style' (in Arabic), *Bulletin of the Faculty of Arts, Fouad I University of Cairo*, XVI, section 2 (1952)

Shishkin 1891

N.I. Shishkin, *Istoriya goroda Kasimova s drevneyshikh vremen*, Ryazan 1891

Shishkina 1979

G.V. Shishkina, *Glazurovannaya keramika Sogda (Vtoraya polovina VIII-nachalo XIII v.)*, Tashkent 1979

Simpson 1997

M. S. Simpson, *Sultan Ibrahim Mirza's haft Awrang*, New Haven, Connecticut/London 1997

Skelton 1998

R. Skelton, in: K. Riboud *et al.*, *Samit and Lampas*, AEDTA, Paris, and The Calico Museum, Ahmadabad 1998

Smith 1985
E.W. Smith, *The Moghul Architecture of Fathpur-Sikri*, III, 1st reprint, Delhi 1985

Smolin 1925
V.F. Smolin, 'Klad vostochnykh zolotykh predmetov iz bolgarskogo goroda Dzhuke Tau', *Vestnik nauchnogo obshchestva Tatarovedeniya*, Kazan 1925

Soltykoff 1853
Voyage dans l'Inde et en Perse par le prince Alexis Soltykoff, Paris 1853

Sotheby 1986
Sotheby's, London, 15 October 1986

Sotheby's 1989
Sotheby's, London, 11 October 1989

Soudavar - Beach 1992
A. Soudavar, M.C. Beach, *Art of the Persian Courts*, New York 1992

Sourdel-Thomine - Spuler 1973
J. Sourdel-Thomine, B. Spuler. 'Die Kunst des Islam', *Propyläen Kunstgeschichte*, 4, Berlin 1973

Soustiel 1985
J. Soustiel, *La céramique islamique. Le guide du connaisseur*, Fribourg 1985

Stchoukine 1935
I. Stchoukine, 'Portraits moghuls, IV. La collection du Baron Maurice de Rothschild', *Revue des arts asiatiques 9*, no. 4 (1935)

Stchoukine 1964
I. Stchoukine, *Les peintures des manuscrits Safavis de 1502 à 1587*, Paris 1964

Stern 1954
H. Stern, 'Quelques oeuvres sculptées en bois, os et ivoire de syle omeyyade', *Ars Orientalis I* (1954)

Stockholm 1985
Islam. Art and Culture, exhibition catalogue, Stockholm 1985

Sydney 1990
The Age of Sultan Süleyman the Magnificent, exhibition catalogue International Culture Corporation of Australia, Sydney 1990

Tait 1991
H. Tait (ed.), *Five Thousand Year of Glass*, The British Museum London 1991

Taninidi 1983
Z. Tanindi, 'Islam resminde kutsal kent ve yöre tasvirleri', *Journal of Turkish Studies*, II (1983)

Tanindi 1986
Z. Tanindi, '13.–14. Yüzyilda Yazilmis Kur'anlarin Kanunî Döneminde Yenilenmesi', *Topkapi Sarayi Müzesi. Yillik*, I (1986)

Titley 1984
N. Titley, *Persian Miniature Painting and Its Influence on the Art of Turkey and India*, Austin, Texas 1984

Trever 1960
K.V. Trever, 'Novoye 'sasanidskoye' blyudtse Ermitazha', *Issledovaniya po istorii kultury Vostoka. Sbornik v chest akademika I.A. Orbeli*, Moscow/Leningrad 1960

Turku 1995
Islamic Art Treasures from the collections of the Hermitage. 16.6 - 10.9.1995, exhibition catalogue Waino Aaltonen Museum of Art, Turku (Finland) 1995

Velyaminov-Zernov 1863-1864
V.V. Velyaminov-Zernov, *Issledovaniye o kasimovskikh tsaryakh i tsarevichakh*, St Petersburg 1863-1864

Vernoit 1997
S. Vernoit, 'Occidentalism. Islamic Art in the 19th Century', *The Nasser D. Khalili Collection of Islamic Art*, XXIII, London 1997

Veselovsky 1910
N.I. Veselovsky, *Geratsky bronzovyy kotelok 559 goda khidzhry (1163 g. po R. Kh.) iz sobraniya grafa A.A. Bobrinskogo*, St Petersburg 1910

Veymarn 1974
B.V. Veymarn, *Iskusstvo arabskikh stran i Irana VII-XVII vv.*, Moscow 1974

Vienna 1998
Schätze der Kalifen. Islamische Kunst zur Fatimidenzeit, exhibition catalogue Kunsthistorisches Museum Wien, Vienna 1998

Voronikhina 1961
L. Voronikhina, *Art Treasures of the Hermitage*. Leningrad 1961

Walker 1997
D. Walker, *Flowers Underfoot: Indian Carpets of the Mughal Era*, exhibition catalogue The Metropolitan Museum of Art, New York 1997

Ward 1991

Ward, 'Incense and incense burners in Mamluk Egypt and Syria', *Transactions of the Oriental Ceramic Society* (1990-1991)

Ward 1993

R. Ward, 'Islamic Metalwork', *BMP*, London 1993

Watson 1985

O. Watson, *Persian Lustre Ware*, London 1985

Wenzel 1993

Wenzel, 'Ornament and Amulet. Rings of the Islamic Lands', *The Nasser D. Khalili Collection of Islamic Art*, XVI, London 1993

Whitcomb 1985

D. Whitcomb, *Before the Roses and the Nightingales. Excavations at Qasr-i Abu Nasr, Old Shiraz*, Metropolitan Museum of Modern Art, New York 1985

Welch 1973

A. Welch, *Shah 'Abbas and the Arts of Isfahan*, Asia House Gallery, New York 1973

Welch 1979

A. Welch, *Calligraphy in the Arts of the Muslim world*, Asia House Gallery, New York 1979

Westerham 1985

'The King Faisal Centre for Research and Islamic Studies, Riyadh', *The Unity of Islamic Art*, Westerham 1985

Wiet

G. Wiet, *Catalogue du Musée arabe du Caire - Objets en cuivre*

Wiet 1929

G. Wiet, *Catalogue général du Musée Arabe du Caire. Lampes et bouteilles en verre émaillé*, Cairo 1929

Wiet 1930

G. Wiet, *Album du Musée Arabe de Caire*, Cairo 1930

Yakubovsky 1931

A.Y. Yakubovsky, 'K voprosu o proiskhozhdenii remeslennoy promyshlennosti Saraya Berke', *Izvestiya Gosudarstvennoy Akademii istorii materialnoy kultury*, VIII, ed. 2-3 Leningrad 1931

Yakubovsky 1938

A.Y. Yakubovsky, 'Kashgarskoye blyudo XII-XIII vv', *Pamyatniki epokhi Rustaveli*, Leningrad 1938

Yakubovsky 1939

A.Y. Yakubovsky, 'Mastera Irana i Sredney Azii pri Timure', *III Mezhdunarodnyy kongress po iranskomu iskusstvu i arkheologii. Doklady. Leningrad, sentyabr 1935*, Leningrad 1939

Zebrowski 1997

M. Zebrowski, *Gold, Silver & Bronze from Muhgal India*, London 1997

Exhibition Credits

Director
Ernst W. Veen

Guest curator
Mikhail B. Piotrovsky

Chief curator
John Vrieze

Logistics and personnel
Marijke Gelderman

Assistant curator
Mirjam Hoijtink

Exhibition design
Architectenbureau Jowa, Amsterdam

Consultant
Dineke Huizenga

Educational programme
Marijke Gelderman
Nannie den Exter

Financial administration
Carla Huisman
Margreet de Vogel

Secretariat and administration
Paulanha van den Berg-Diamant
Huibje Laumen
Marianne de Molennaar
Sander van Ooijen
Martijn van Seventer
Krijn van Veggel
Jacqueline Weg

Technical staff
Paul Brekelmans
Gerrit Schoos
Nasar Ahmed Qazi

Chief security officer
Ed Koning

Museum shop
Heleen van Ketwich Verschuur
Marianne de Raad

Transport logistics
Jan Kortmann

Transport
Gerlach Art Packers & Shippers

Production
Vechtmetaal B.V.

PR
Bureau D'Arts, Amsterdam: Paul Spies,
Maaike Nillesen and Hester Schölvinck
We thank Sue Bond, London, for her help

Audiovisual presentation
Mirjam Hoijtink
Maaik Krijgsman
We thank Fred Oster for his help

Translations Dutch into English
Wendie Shaffer
Michèle Hendricks

Catalogue Credits

Published by Lund Humphries Publishers
Park House, 1 Russell Gardens
London NW11 9NN

This book was published concurrently with
the exhibition Earthly beauty, heavenly art.
Art of Islam held in De Nieuwe Kerk,
Amsterdam, from 15 December 1999 to
24 April 2000, and organized by the
Foundation Projects De Nieuwe Kerk.

ISBN 0 85331 806 9 (hard cover edition)
ISBN 90 6611 692 7 (paperback edition)
NUGI 911, 633

British Library Cataloguing in Publication
Data
A catalogue record for this book is available
from the British Library

copyright © 1999
V+K Publishing, Blaricum
Foundation Projects De Nieuwe Kerk

Distributed in the USA by
Antique Collectors' Club
Market Street Industrial Park
Wappingers Falls
NY 12590
USA

Cover
Front: Mosque lamp (cat.no. 8), courtesy of
The British Museum, London
Back: Fragment of the *Hizam* (cat.no. 20),
courtesy of The Nasser D. Khalili Collection
of Islamic Art, London

Author of the introductory chapters
Mikhail B. Piotrovsky

General editor
John Vrieze

Editing
Arnoud Bijl
We thank Wendie Shaffer and
Michèle Hendricks

With contributions of
Adel Adamova, *The State Hermitage Museum*
Julia Bailey, *Museum of Fine Arts, Boston*
Anna Ballian, *Benaki Museum*
Milo Cleveland Beach, *Arthur M. Sackler Gallery, Smithsonian Institution*
Barbara Boehm, *The Metropolitan Museum of Art*
Hans-Casper Graf von Bothmer, *Universität des Saarlandes*
Sheila Canby, *The British Museum*
Stefano Carboni, *The Metropolitan Museum of Art*
Anatoli Ivanov, *The State Hermitage Museum*
Mark Kramarovsky, *The State Hermitage Museum*
Marta Kryzhanovskaya, *The State Hermitage Museum*
Glenn Lowry, *Arthur M. Sackler Gallery, Smithsonian Institution*
Boris Marshak, *The State Hermitage Museum*
Yuri Miller, *The State Hermitage Museum*
Mona Al Moadin, *National Museum of Syria, Ministry of Culture, General Directorate for Antiquities and Musea, Syrian Arab Republic*
Mina Moraitou, *Benaki Museum*
Michael Rogers, with the assistance of Nahla Nassar, Tim Stanley and Manijeh Bayani, *The Nasser D. Khalili Collection of Islamic Art*
Abolala Soudavar, *Arthur M. Sackler Gallery, Smithsonian Institution*

Natalja Venevtseva, *The State Hermitage Museum*
John Vrieze, *National Foundation De Nieuwe Kerk*
Daniel Walker, *The Metropolitan Museum of Art*
Rachel Ward, *The British Museum*

Translations
Wendie Shaffer
Michèle Hendricks

Photography of exhibition objects
The State Hermitage Museum:
Leonard Heifets; Yuri Molodkovets;
Darya Bobrova; Vladimir Terebenin;
Georgiy Skachkov
The Nasser D. Khalili Collection of Islamic Art:
Christopher Phillips
National Museum of Syria:
Anwar Abdel Ghafour
Photographic studios of the other lenders

Photography of architectural monuments
R. Tixador (fig. 1); F. Meyst (fig. 2);
W. Isphording (fig. 3); A. Garrido (fig. 4);
I. Lloyd (fig. 5)

Production De Nieuwe Kerk
Heleen van Ketwich Verschuur

Graphic design
Pinxit, Amsterdam
UNA, Amsterdam (cover)

Lithography
Nederlof Repro, Cruquius-Heemstede

Print
Kunstdrukkerij Mercurius, Wormerveer

Printed on Hello Silk, 150 g per sq. metre.
Supplied by Buhrmann-Ubbens BV company